Images from the Floating World

The Japanese Print

Richard Lane

Images from the Floating World

The Japanese Print

Including an Illustrated Dictionary of Ukiyo-e

Dorset Press

New York

For Chiyeko and Ettamay

© 1978 by Office du Livre, Fribourg, Switzerland

This edition published by Dorset Press, a division of Marboro Book Corp., by arrangement with Office du Livre.

1982 Dorset Press
Manufactured in the United States of America

ISBN: 0-88029-007-2

Contents

Early Genre Painting and the Rise of Ukiyo-e

Prologue

Anyone who has ever seen a decorated matchbox or Christmas card knows, even if he does not realize it, something of the Japanese color print. But beyond the best-known landscapes of Hokusai and Hiroshige, popular familiarity, even in Japan, drops markedly. And when we consider the total field of *ukiyo-e* (pronounced ookee-yoh-eh, pictures of the fleeting, floating world)—including not only the colorful prints but also the graceful paintings, vivid picture books and startling erotica—blissful ignorance is all too abundant.

Ukiyo-e constitutes a world in itself—a world into which some of the greatest collectors and connoisseurs have chosen to throw their lives and fortunes: in the West, such men as Edmond de Goncourt, Henri Vever, Isaac de Camondo, Ernest F. Fenollosa, Arthur Davison Ficke, Louis V. Ledoux, Richard P. Gale and James A. Michener; in Japan, Kobayashi, Matsuki, Mihara, Takahashi, Shibui, Hirose and Hiraki. What lies behind this profound fascination that has drawn men from such diversified backgrounds to these expensive little "slips of paper"?

Through this volume we hope to shed some light on the true nature of this, Japan's most popular art form. First, however, in this introductory essay it may be of interest to consider the general state of Japanese painting in the period when ukiyo-e first emerged.

Before Ukiyo-e: The Predecessors of the Japanese Print

The predecessors of ukiyo-e played a crucial but little-understood part in its development, and they continued to exist side by side with the new form—although they often appealed to a different class of society. During the preceding Heian, Kamakura and Muromachi periods—from the ninth to the sixteenth centuries A.D.—Japanese painting had developed on two broad fronts: one principally native and one based on continental Chinese models. The Japanese styles of painting generally emphasized gorgeous coloring and plasticity of contour and took their themes from native subjects. Originally termed *Yamato-e* (Yamato-pictures—from the old word for Japan), by the fifteenth century the paintings in this style had come to be associated mainly with the painters of the Tosa School, who enjoyed the patronage of the Kyōto court nobility, in its decline at that time. The more linear, semi-Chinese styles of painting, on the other hand, were highly varied in manner, depending upon several sources of inspiration. Most prominent among the advocates of the Chinese styles was the school of Zen ink-painters (led by the great Buddhist priest-painter Sesshu), who specialized in boldly simplified monochrome paintings of Chinese subjects.

These two schools were soon united by members of the Kanō School, who eclectically combined the features of the Chinese styles with the coloring and other devices of the Japanese-style painters. The Kanō artists were often the favorites of the military rulers, the shōguns and daimyō. Due partly to this intimate connection with the dictatorial ruling class, the Kanō School tended to be the most influential and emulated of the classical schools during the period of the development of ukiyo-e, from the seventeenth to the mid-nineteenth century.

Thus, it was only natural that several of the greatest ukiyo-e masters (Moronobu, Sukenobu, Eishi, Hokusai, among others) should have received training under Kanō teachers—although, at the same time, indirectly, they derived much from the Tosa court-painters as well. Indeed, most of the earliest ukiyo-e works—in the form of elaborate paintings, rather

than inexpensive prints—were done by Kanō or Tosa masters, induced by their subject matter into a new and modern form of depicting the genre subjects that had just become fashionable.

Ukiyo-e was, in short, a hybrid school of painting and print design that took its basic themes from the day-to-day world but adapted many classical methods to the treatment of its new subjects. After many generations of exposure to the well-worn classical Chinese and Japanese themes, it was only natural that an artistic school devoted to parodies on these same classics and to pictures of the more glamorous aspects of the modern world should find a receptive audience among art connoisseurs as well as among the populace of the cities. Ukiyo-e never quite attained the prestige of the Kanō School and other traditional schools, but it captured the hearts of the Japanese people almost immediately.

After a brief period of contact with the Western world, Japan's feudal rulers, the shōguns, decided, in the early seventeenth century, to shut off their nation from the rest of the globe. Their motives were largely political, including a fear of the encroaching colonial empires and a firm resolution to concentrate their efforts on maintaining the delicate balance of power among the dozens of feudal barons at home. This policy of *sakoku* (National Seclusion) was maintained until America forced the opening of Japan over two centuries later in 1854. Thus Japan missed the European Renaissance and the Age of Scientific Discovery. Commodore Perry opened the country just in time for the Industrial Revolution. And that was the end of ukiyo-e and of old Japan.

Ukiyo-e comprises a complete world in itself. Speak to the connoisseur of Moronobu, for example, and to his mind's eye appears a procession of vigorous picturesque figures, all the motley citizenry of old Edo. The magic name Harunobu evokes slender, ethereal girls as lovely and fragile as the first frost of winter. Utamaro, Sharaku, Hokusai, Hiroshige—each name stands for a unique and arresting kind of beauty: voluptuous femininity, masculine strength or scenic grandeur. These men, and several dozen more, represent the ultimate glory of ukiyo-e.

The ukiyo-e masters form a fitting conclusion to the long and glowing tradition of classical Japanese art. Like the era which nurtured it—the Edo Period (1600–1868)—ukiyo-e represents a unique development in Japanese art: a great renaissance based upon a largely popular foundation, whereas the earlier pinnacles of Japanese civilization had been due primarily to the aristocracy, the samurai or the priesthood. That such popularization did not result in vulgarization is one of the wonders of the world of art. This was the consequence, in part, of the innate sense of restrained form and color harmony that infused the Japanese populace as a whole. At the same time, the determined efforts of an enlightened group of artists, artisans, publishers, connoisseurs and patrons ensured that ukiyo-e standards would always remain several degrees above the level the populace considered "acceptable."

Politically and socially this was a feudal, almost totalitarian age. The masses accepted the voice of authority in most of their social activities. In the arts, too, they were willing to follow the lead of a loosely bound group of "style-dictators," much as women have sometimes followed Paris fashions in our own day. The result was two centuries of ukiyo-e woodblock prints and paintings—a continuous flow of high quality art that reflected the popular taste and also was its arbiter. And while most of the credit for this phenomenon goes to the masters who directly produced ukiyo-e, the power of the populace that supported it should not be underestimated. Even more critical than their taste was the inner need they felt to possess fine art of their own. What makes the phenomenon of ukiyo-e even more curious is the fact that the Japanese populace was obeying primarily aesthetic instincts, rather than consciously anticipating the unique art form they were to support for such a long period. Ukiyo-e's unparalleled position in Japanese art—and its unique appeal to the Japanese populace—is well mirrored in the following *senryū* [epigram] of the eighteenth century:

> *Kanō-ha mo / Tosa-ha mo kakenu / Naka-no-chō*
> [Neither Kanō nor Tosa / can paint it: / Main Street, Yoshiwara]

When it came to depicting the vibrant, plebeian life of old Japan, there was nothing quite like ukiyo-e.

The Pioneers of Ukiyo-e

Ukiyo-e, the fleeting, floating world of Japanese genre art, began in the sixteenth century. It was this period that first saw the rise of popular art and culture as a decisive factor in Japanese civilization.

What did the expression "floating world" actually mean to the people of that age? It is rare to find a single term that expresses the changing concept of an age, but ukiyo-e is such a term. In medieval Japan it appeared as a Buddhist expression which connoted first "this world of pain," with the derived sense of "this transient, unreliable world." Thus etymologically, it meant "this fleeting, floating world." But for the newly liberated townsman of the seventeenth-century Japanese Renaissance "floating world" tended to lose its connotations of the transitory world of illusion and to take on hedonistic implications. It denoted the newly evolved, stylish world of pleasure, the world of easy women and handsome actors, all the varied pleasures of the flesh.

The novelist Ryōi in his *Ukiyo monogatari* [Tales of the Floating World], ca. 1661, gives his own apt description of this concept:"... Living only for the moment, turning our full attention to the pleasures of the moon, the snow, the cherry blossoms and the maple leaves; singing songs, drinking wine, diverting ourselves in just floating, floating; caring not a whit for the pauperism staring us in the face, refusing to be disheartened, like a gourd floating along with the river current: this is what we call the *floating world....*"

By the time the suffix -*e* (meaning pictures) had been added, around the year 1680, to form the new compound *ukiyo-e* (floating-world pictures), this hedonistic significance had become predominant. Thus ukiyo-e meant something like the following to the Japanese of the age that engendered it: a new style of pictures, very much in vogue, devoted to depicting everyday life; particularly fair women and handsome men indulging in pleasure, or part of the world of pleasure pictures, as often as not of an erotic nature.

What brought about this new development in Japanese art, this revolutionary shift from the stereotyped themes of classical tradition to one of the workaday modern world?

The mid-sixteenth century was a period of social and political unrest, and the period in which ukiyo-e originated. The country was torn by civil wars; at that time even a peasant's son, Hideyoshi, could rise to become de facto ruler of the empire. The newly established feudal lords could hardly make up overnight for their ignorance of the subtleties of Chinese philosophy, literature and art, which had been the delight of their cultivated predecessors, the Muromachi shōguns. They did, however, want the symbols of victory and power immediately: magnificent castles, with their full complement of elaborately painted screens and murals. Thus the first major developments in the culture of the new age came in the fields of architecture and painting, rather than in the other arts, for liberal patronage was a primary stimulant to nearly all the great developments in traditional Japanese art. The concept of the impoverished genius painting unrewarded in his garret is a relatively recent one in Japan.

What the newly rich feudal lords demanded was not the perceptive, subtle, monochrome imagery of the Chinese-inspired paintings favored by their predecessors; nor the miniaturistic color harmonies of the Tosa court-painters; but something rich, bold and magnificent—great paintings that would burst forth like fireworks from the inside of a dimly lit castle and proclaim to all the world that a new master had arrived. As a result the characteristic art of the Momoyama Period (late sixteenth to early seventeenth century) was born: gorgeous screens and panels featuring bold patterns of trees, animals, figures or still-life, painted in vivid colors on a glowing ground of pure gold-leaf.

Who were the painters? Obviously, skilled painters could not develop overnight; what happened was simply that the traditional artists were requisitioned by the new lords and had no choice but to adapt their styles to a new age and new demands. However, in effect, this enforced change served to give new life to art, which had declined through the absence of just such fresh stimuli; and for this reason the art of the Momoyama Period, though patronized by uneducated warlords, remains one of the permanent glories of Japanese civilization.

Momoyama painting is not ukiyo-e; yet from time to time in the art of the late sixteenth century we catch fascinating glimpses of the everyday life of the times, and it is in these genre scenes that ukiyo-e found its immediate origins. An occasional interest in the details of the lives of both commoner and peasant had, it is true, been revealed in the classical scrolls of earlier periods. Yet these were but passing glimpses that never developed into a sustained interest or a specific style. However in many of the Momoyama paintings we note a continued fascination with scenes of daily life.

Clearly the feudal nobility, either fondly recalling their own humble origins, or simply being curious about the activities of the common people, had discovered that the current transitory world could form a subject just as absorbing as the traditional scenes from nature and classical legend. It goes without saying that this change in taste also owed much to the versatile genius of the artists who produced it.

Genre screens, murals and fans came to be painted in considerable numbers by the artists of the traditional schools—principally the Kanō and the Tosa. Their subjects included the elaborate excursions of lords to famous sites, the magnificent popular festivals of the great Buddhist temples and Shintō shrines but also vivid scenes of life along the highways, or detailed views of the streets of the capital, Kyōto, with the various activities of the common citizens recorded in minute detail. Such screens already existed in quantity by the time Japan was unified (around the year 1600) and the Edo Period established. From that date Japan settled down to a peaceful regime unique in world history, a strict feudal reign that soon purposefully isolated the empire from the remainder of the world and thus maintained a freedom from destructive war for more than two and a half centuries.

This period was named after the feudal capital, which was moved to Edo (the present Tōkyō), leaving the Emperor behind in the nominal capital, Kyōto, as a figurehead of ritual. The Edo Period (1600–1868) was to produce one of the most unusual bodies of culture known to man, with ukiyo-e not the least of its marvels. Whatever its sources of inspiration, ukiyo-e consistently presents a perceptive mirror of life in old Japan: an actual world now largely brushed aside by progress but preserved forever in these colorful little slips of paper, vivid scrolls and sumptuous screens.

The First Masters of Ukiyo-e

Ukiyo-e did not develop in a vacuum. Indeed, much of its success lay in its striking adaptation of the best of classical Japanese art to the new age. Although the great age of the classical picture scrolls was some three to five centuries earlier, the best of the traditional Tosa work in the later sixteenth century is of considerable interest and charm. There is no real sign of such impending developments as ukiyo-e in these works, but we do note the firm tradition of color harmony and graceful composition that was to provide the artistic background for the new art. Without this splendid artistic tradition to draw upon, ukiyo-e would, doubtless, have constituted only a crude but interesting folk art. It might never have gone beyond the bounds of such plebeian art forms as the Ōtsu-e [Ōtsu Pictures], a style of powerful but limited folk painting for tourists that flourished at the village of Ōtsu, near Kyōto, from the seventeenth century.

Contemporary with the scrolls and screens cited earlier, the new interest in everyday life as an artistic subject began to express itself in the work done by members of the traditional schools of painting (for example, the Kanō and Tosa Schools and even the followers of Sesshū) for their patrons among the feudal nobility. The scenes represented were often of the upper classes at leisure. There is a famous large screen of this type, by Kanō Hideyori, which depicts a spirited maple-viewing party at Mt. Takao; it was painted around the year 1550. We can also cite a pair of screens by Kanō Naganobu, dating from the early seventeenth century, showing dancers under cherry blossoms performing before a noble audience. Another well-known screen (showing hawking and picnicking) is clearly in the style of the Unkoku School—painters in the tradition of Sesshū. The numerous namban-byōbu [Southern-barbarian screens], depicting the European traders and missionaries in Japan

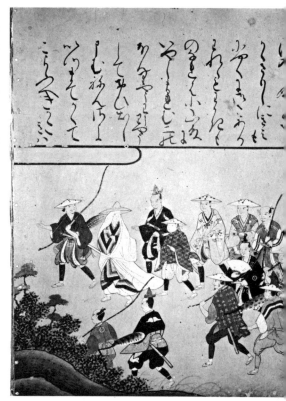

1 **Tosa/Early Genre School**: *Scene from a Tale.* From a series of manuscript miniatures in *aiban* size [for sizes, see Dictionary] in colors on paper, ca. 1630s [late Kan-ei Period]. Unsigned. [Henceforth, in the captions, if the signature is not recorded, the plates may be assumed to be unsigned.] For location of original art objects, see Acknowledgments.

In this scene, an eminent lady dressed as a nun is shown on her travels, accompanied by her retinue. Although the customs and costumes in this series reflect the medieval subject matter, the style and general mood of these paintings are clearly of the early seventeenth century. With the Momoyama Period, painters of the traditional Tosa and Kanō Schools turned gradually from idealized scenes of the past to genre and plebeian subjects. This series of miniatures in the style of Tosa Mitsunori displays well the tradition of gem-like, detailed coloring in figure painting that was to be transmitted several decades later to the Japanese color print.

during the last quarter of the sixteenth and the first quarter of the seventeenth century, reveal yet another interesting adaptation of traditional styles to contemporary themes.

Whether we may consider such works as true ukiyo-e is a matter of debate among Japanese scholars; some of whom hold that, while this early genre painting has an "ukiyo-e flavor," it lacks the plebeian atmosphere that is one of the characteristics of ukiyo-e in its full development. Carried to its logical conclusion, however, this limited definition of ukiyo-e would exclude most of the numerous, non-plebeian subjects of the later prints.

Thus it would seem reasonable to include genre screens from the Momoyama Period at least among the semi-ukiyo-e works that laid the foundation for the more fully developed style of some decades later.

The Tosa School of painters for the Imperial Court, whose colorful, graceful work we cited earlier, gradually declined—as did their patrons. Moving from the capital (Kyōto) to the port of Sakai in the turbulent sixteenth century, this school was never again to recover its formerly dominant place in Japanese painting. The Tosa painters—led by Mitsunori (1583–1638)—nevertheless continued to do refined work for the declining court nobility. Their traditions were also carried on, in modified form, in a semi-popular style called *Nara-e* [Nara Pictures]. In a period when printing was not yet widespread, and efficient color printing still to be developed, these Nara Pictures continued to meet the demand among the middle and upper classes for finely illuminated books and scrolls. The best of the Nara Pictures are done in a modified late Tosa style and rank among the loveliest miniatures in Japanese art. However the majority of them represent a less artistic, more craftsmanlike approach to this court style. The scroll seen in plate 2 belongs to the latter category. Although most of its dozens of illustrations treat the legends of the founding of the Tenjin Shrine in the traditional late-Tosa style, in the final panorama (over 5 ft./150 cm in length), of which part of the final tableau is shown, we see an intimate, realistic view of the actual populace of the

2 **Tosa/Early Genre School**: *The Tenjin Shrine Scroll*. Detail from a pair of long picture scrolls in colors on paper, height: 10 in./26 cm., ca. 1630s (late Kan-ei Period).
In this interesting example of early genre painting, pilgrims to the Tenjin Shrine in Kyōto and vendors of tea and sweets are portrayed on the right; on the left, onlookers are watching the Shrine Dance performed by three young priestesses to the accompaniment of the *kagura* shrine orchestra. The style of this painting, though clearly derived from the Tosa tradition, is cruder than that of plate 1; this scroll is doubtless the work of a lesser, journeyman Tosa artist. The scene is unusual, however, in that it includes the names and actual conversation of many of the participants and depicts the Shintō ceremonial dances from which Kabuki drama developed in the early seventeenth century.

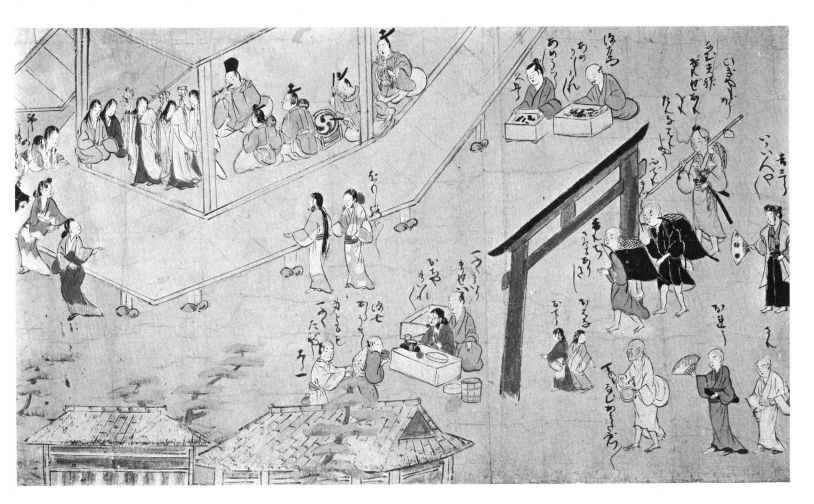

time. The Tosa style fades into ukiyo-e by the very force of the genre subject represented. This scroll shows the late Tosa and the early ukiyo-e styles side by side, produced by the same artist.

One of the remarkable features of the ukiyo-e to come will be this habit of radical adaptation of style to content. Even such later masters as Harunobu, Kiyonaga, Eishi, Hokusai and Hiroshige did many prints and paintings that hark back to aristocratic themes and, accordingly, reflect traditional Tosa or Kanō styles, rather than true ukiyo-e.

With the early decades of the seventeenth century the ukiyo-e style at last came into its own. Its finer artists were still the established masters of the older schools. Among these, however, one artist stands out as a key figure in ukiyo-e's development at this crucial stage: Iwasa **Matabei** (1578–1650).

Matabei's name is so renowned that, at one time, it was the custom in Japan to ascribe all early genre painting to him. Actually Matabei's genuine oeuvre reveals a definite individual style, but one that is closer to the Tosa work of his formal training than to the true ukiyo-e style that was to develop in full only after his death. Matabei produced a few followers of note; however, he probably exercised the greatest influence a generation after his death, when Moronobu and his contemporaries in Edo at last consolidated the ukiyo-e style into the unified form known today.

Matabei's subject-matter was still predominately the world of classical Japanese art. The next stage of development brings us to the true milieu of ukiyo-e *per se*—the world of courtesan and actor, the floating world of old Japan.

Ukiyo-e and the Japanese at Leisure

So far we have spoken mainly of artists and artistic styles in early ukiyo-e. Let us now digress a moment to consider something of the subject matter of early ukiyo-e and how well this art reflected the life of its times.

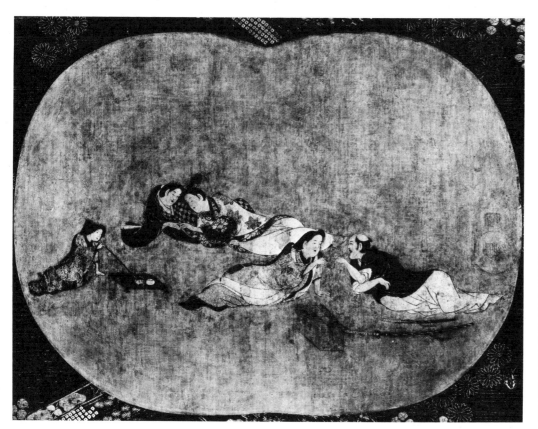

4 **Early Ukiyo-e School**: *Dance Performance by Kabuki Actresses.* Detail from a pair of large, two-fold screens in colors and gold leaf on paper, depicting the theater district of Kyōto, late 1620s (early Kan-ei Period).
Although this screen is the work of an artist trained in traditional Tosa/Kanō painting, it nevertheless represents one of the earliest genre masterpieces that may be termed true ukiyo-e: the subject matter is taken entirely from the floating world, and the style is already infused with that lively, up-to-date spirit customarily associated with ukiyo-e. Only a generation later, this style was to be transmitted to the first pioneers of the ukiyo-e print: the Kambun Master and Moronobu. This painting also represents a vital document in the history of Japanese theater; it depicts the *Onna kabuki* [Women's Kabuki], which featured courtesan-actresses, in the decade before it was officially banned around 1629. The actress in the center is seated on a huge folding chair decorated with a tiger-skin, as her companions dance on the open-air stage and patrons disport themselves in the pit and boxes.

3 **Style of Iwasa Matabei**: *Samurai and Courtesans.* Fan painting in colors on paper in *ōban* size, ca. 1640s (Kan-ei/Shōhō Period).
Although Matabei is the traditional "Father of ukiyo-e," his signed and fully documented works, while revealing a masterful, individualistic approach to the Tosa tradition, are a step removed from the style and mood of the floating world. Paintings such as this one are in the artist's style and bear his seals, but research has yet to prove conclusively whether they are the work of Matabei or of his pupils. However such paintings do show clearly the transition from classical Tosa to genre/ukiyo-e style and to the stylistic components that were to form the basis for Moronobu's work a generation later.

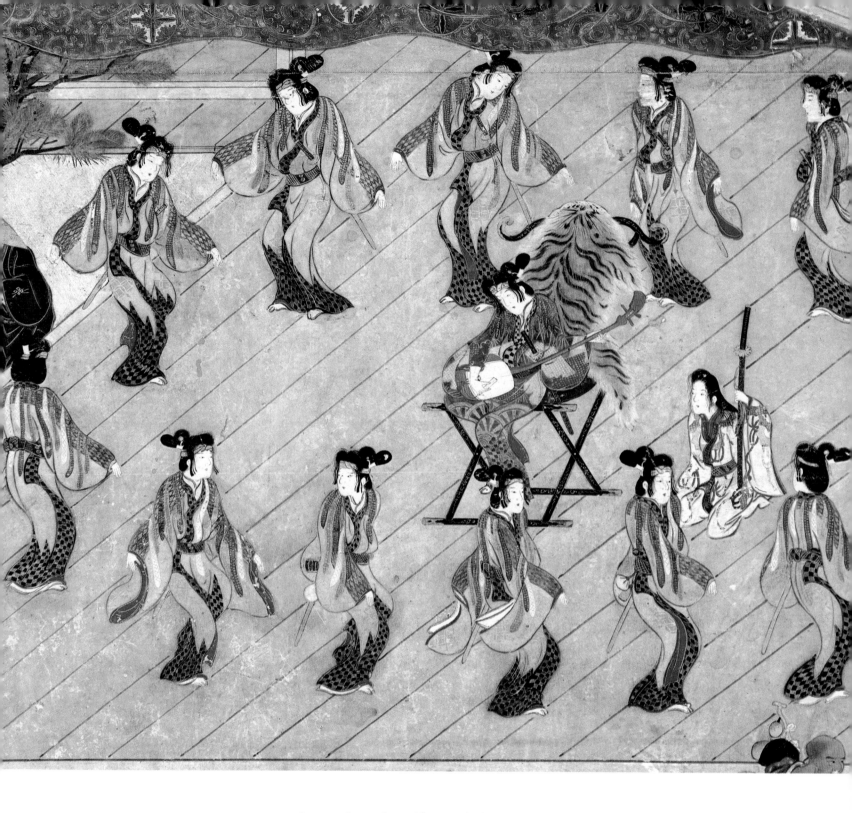

Among the earliest ukiyo-e paintings were the large screens that have already been mentioned. They depict panoramas of the streets, shops and temples of old Kyōto. With a relatively large space to work on (each screen is about 5×12 ft./150×360 cm), the artist was free to depict not only the total scene, but also the buildings and inhabitants of the capital in the utmost detail. However these screens are difficult to illustrate adequately in a book: for, when viewing the original, after taking in the overall view the observer can concentrate on the various details that happen to interest him. Here there was no choice but to arbitrarily select one detail for illustration and hope that it will convey at least a fraction of the interest of the original.

From these overall views of Kyōto, ukiyo-e progressed to rather close-up scenes of specific festivals and popular amusements. Kyōto had, from the ninth century A.D., been the major center of Japanese religion and tradition. Practically every day of the year saw the enactment of some special Shintō festival, court ceremony or Buddhist rite, many of which have been recorded in detail in the gorgeous screens and murals of the early ukiyo-e period. These festivals sometimes took the form of elaborate processions with magnificent floats; others featured mass folk dancing and merriment. But whatever their form, they are often characterized by the exuberance and abundance of energy that fills—almost bursts out of—the confines of the screen or panel. Apart from the formal festivals, each month brought its own celebration of one or another of the delights of Nature. From the elaborate New Year's celebrations to cherry-blossom outings in early spring and wisteria-viewing parties, harvest-moon-viewing excursions and maple-viewing picnics in autumn, any excuse was sufficient to set the Japanese populace to planning some festivity.

Outings were not limited to Kyōto alone: the Japanese have always been a travel-loving people, and pilgrimages to such famous sites, near or far, as Lake Biwa, Mt. Yoshino, Mt. Kōya and the Grand Shrines of Ise and Izumo were a common practice. The poorer classes even formed their own lotteries in order to raise money to visit such distant spots as Ise, patiently waiting several years until their lucky number turned up in the travel lottery.

As the artist's attention began to focus more sharply on the varied aspects of life in the old capital, close-ups of specific subjects became more frequent. For example several early series of paintings are extant on the theme of the types of artisans and shops most common in the Kyōto of those days. These paintings form a rare record of how the treasures of Japanese traditional handicrafts were made and sold.

The artists soon turned their attention to the more commercialized amusements available to commoner and samurai alike. Prominent among these was the Kabuki theater, which had originated in the late sixteenth century. It was derived from a combination of the classical Noh theater, various Shintō and popular dances and pantomimes. Early Kabuki, performed at first by ex-Shintō dancers and courtesans, was still an open-air, rather impromptu affair. But in the early seventeenth century it had already developed many of the features of Kabuki and geisha dance performances as they exist today.

The other most striking ukiyo-e subject taken from popular pleasures was the courtesan-quarter, the principal center of amusement for the male of romantic or stylish inclinations. These quarters—which were carefully regulated by the authorities—were a feature of all major Japanese towns. But that of Kyōto was the most luxurious of all. It is no wonder that these pleasure quarters, with their richly bedecked and bewitching courtesans should have fascinated the ukiyo-e artist just as they did the man in the street, whether he could actually afford their expensive pleasures or not.

Such then, were the more striking elements of city life in early seventeenth-century Japan. Each of them found abundant expression in the work of the ukiyo-e masters: artists who enjoyed a free hand in the method of depicting their subjects, but whose work closely mirrored each nuance in the taste and moods of their patrons and contemporaries. Were it not for ukiyo-e, our knowledge of these fabulous times would be poor indeed. The ukiyo-e masters, in recording the thriving life around them, put on record for posterity a precious panorama of life in old Japan that lives today just as vitally as it did some three or more centuries ago.

The Early Figure Paintings

During the first half-century of its development, before and after the turn of the sixteenth century, ukiyo-e tended to emphasize the overall scene, the total environment of Japanese daily life and pleasure that formed its major theme. In this respect, the earliest ukiyo-e followed the tradition of Japanese secular art in general—with emphasis on storytelling or the landscape-with-figure, rather than on detailed attention to the human form such as we find in Western art from the time of the ancient Greeks.

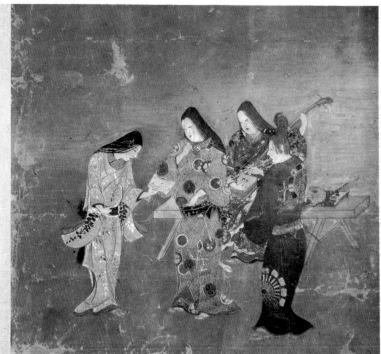

5 **Early Ukiyo-e School:** *Princess Sen and Her Lover.* Small two-fold screen in colors and gold wash on paper, ca. early 1620s (Genna/early Kan-ei Period).

This unusual screen, still owned by the Tokugawa family, is said to depict the Princess Sen (famous for her romantic affairs), receiving a billet-doux from her secret lover, the samurai Honda Heihachirō. The central female figure wears an elaborate kimono bearing the triple-hollyhock leaf of the Tokugawa crest. No ordinary person could have commissioned such a painting without risking severe penalties; if tradition is correct, the work must have been ordered by the princess herself. An essentially erotic, almost decadent, mood pervades this masterpiece, swinging it abruptly away from the limited range of classical Tosa love scenes into the vibrant world of ukiyo-e. The composition, too, is typical of ukiyo-e: the lovers are shown separated but apparently drawn together by unseen forces. (Note the massing of the princess's attendants, reinforcing her authority in an age when social position was all-important.)

From the Kan-ei Period (1624–44/45), however, the floating-world artists began to focus more closely in their paintings on the leading figures of this glamorous milieu—dancing girls and actresses, bathhouse girls, courtesans and their lovers. It was these subjects and this method of depicting close-ups that were to form the central theme of the Japanese popular print when it developed two generations later. And it is this detailed focusing on the human figure and daily human activities that distinguishes ukiyo-e from most of the other schools and styles of Japanese art.

Curiously enough, we know hardly anything of the actual artists who produced most of the early ukiyo-e masterpieces. Their work was evidently only considered as another form of artisanship or even of architectural decoration or furniture, and no one bothered to record either the names or the achievements of the individual ukiyo-e artists.

When dealing with so many varied, anonymous artists and styles it is even difficult to distinguish clear boundaries between the various sub-schools and studios that must have existed. We can only state, on the basis of studying the background details and brushwork of a painting, that the artist had training, say, in the Kanō School, the Tosa School or the Unkoku School. And we can make conjectures on dating, based on the general style and the customs and kimono patterns depicted. But beyond that, these wonderful paintings are clouded in mystery. However, only the scholar and art student regret this; for the connoisseur and art lover only the existence of the paintings matters. We can do no better here than to turn our attention straightaway to a few major works of early ukiyo-e figure-painting, a selection which may well represent the real achievement of this school.

The screen which we display in plate 5 constitutes one of the prime masterpieces of early ukiyo-e, both for its figure-painting and for its dramatic, storytelling qualities. The screen features six full-length figures: on the left, a stylish samurai, fan in hand and tasseled swords at hip, is seen about to receive a love-letter from a young maidservant. On the right, a gorgeously-clad young lady of the nobility, surrounded by three equally voluptuous female attendants, regards her lover passionately. The subject of this screen is traditionally described as the Tokugawa Princess Sen (granddaughter of the Shōgun Ieyasu) and her lover Honda Heihachirō—a surmise supported (or, perhaps, only suggested) by the Tokugawa crest displayed so prominently on the young lady's kimono. Whatever the identity of the figures, the screen represents a landmark in early ukiyo-e—a pinnacle which was never

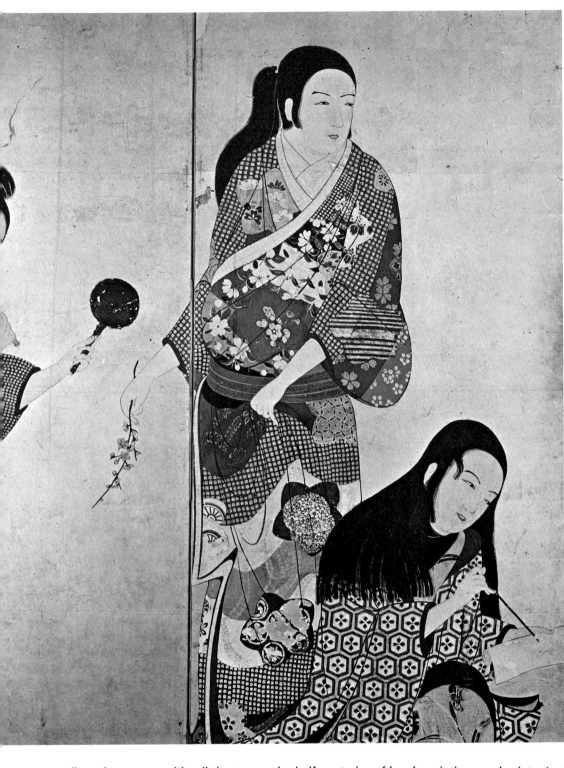

really to be surpassed in all the two and a half centuries of lovely paintings and prints that
were to follow.

Far less vividly emotional, but possessing an overpowering decorative force of its own,
is the set of large screens of which a detail is shown in plate 6. These are the so-called
Matsuura Screens, named for the daimyō family that once owned them.

These screens are exceptional for this period; their emphasis lies primarily on the beauty
of the various kimonos represented. In this sense they belong partly to the realm of ukiyo-e,
but perhaps even more to the tradition of the decorative *tagasode* screens, a genre in

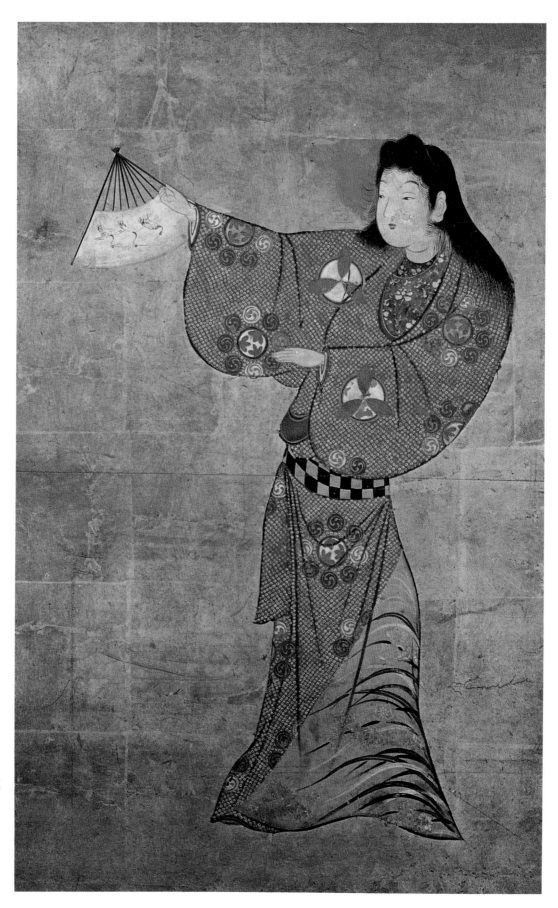

7 **Early Ukiyo-e School**: *Dancer*. Detail of one panel from a six-fold screen in colors and gold leaf on paper. 1630s (mid Kan-ei Period).
This noteworthy screen, originally one of a pair, depicts on each of its elegant panels a dancing girl with a fan in her hand. The masterpiece of an anonymous Kanō-trained artist (whose work in the traditional style may be seen in the fan designs), the subject is pure ukiyo-e, but the approach and style are languorous and decorative; the erotic modern mood of ukiyo-e is still dormant.

which the Momoyama painters sometimes took as their subject colorful kimonos hung out on racks. Here, in other words, we have a kind of kimono fashion-show, and the women represented serve more as mannequins than as objects of human, personal interest. The painter of these unusual screens may well have been an artisan—perhaps even a kimono-designer—rather than a traditionally trained artist. All these factors tend to make the *Matsu-ura Screens* difficult to place either stylistically or chronologically, and Japanese opinions on dating vary widely within the first half of the seventeenth century. Scholarly problems aside, however, the decorative power of these screens can hardly be denied.

Possessed of more human qualities, and more in the direct lineage of ukiyo-e, is the *Dancer* of plate 7, one panel of a famous screen showing six such dancers. Although the painting's abundant charm is human indeed, it is a charm quite removed from the erotic atmosphere we saw in the *Princess Sen Screen* (plate 5). The painting's attraction is also more international. One need not be especially versed in the floating world to enjoy it, and indeed, this is a figure one would not be especially surprised to see in a medieval European tapestry (accompanied, perhaps, by a unicorn). By the same token, this painting and its companions represent a kind of sublimated, classic ukiyo-e—a part of, yet somehow removed from the actualities of the floating world. The artist himself was evidently a man of austere Kanō training. His practiced brush has seen fit to remove everything that was even remotely worldly or sexual from this picture of a dancing-girl whose profession was, at times, not far removed from harlotry. In sharp contrast indeed, we turn finally to a master-piece of decadent eroticism, the *Bathhouse Girls* of plate 8. Here we see six of the voluptuous girls who, during the seventeenth century, specialized not only in back-washing and mas-sage, but also in the erotic pleasures of such baths that were the rage of Edo, Kyōto and Ōsaka both before and after they were officially banned by the government in 1657.

These *yuna* [bath-girls] made no claim to the cultural skills of the ranking courtesans; their attractions were entirely physical and erotic. Once the nature and background of these

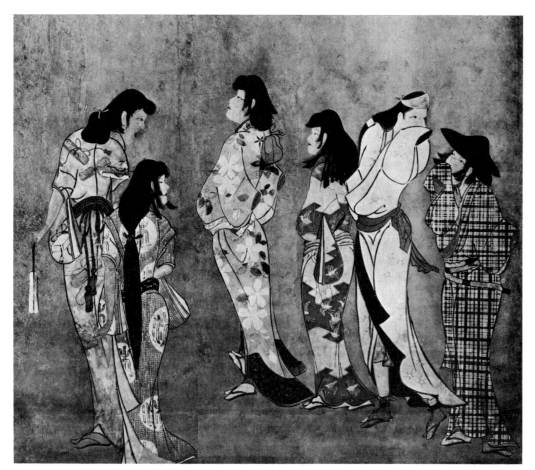

8 **Early Ukiyo-e School**: *Bathhouse Girls.* Large *kakemono* [hanging scroll] in colors on paper, ca. 1640s (Kan-ei/Shōhō Period).
Eroticism was expressed in several forms in ukiyo-e; suppressed passion, as depicted in the *Princess Sen* screen of plate 5, was perhaps the most effective. But the quite different mood of transparent volup-tuousness that we see in plate 8 doubtless was most favored by the general populace. This painting gives a candid view of the erotic masseuses of seventeenth-century Japan in all their gaudy finery and beaming openness which, with their feminine wiles, quickly led the male of old Japan to part with his spare cash. There are few examples of early ukiyo-e where the style matches the subject more perfectly.

girls are accepted, however, we may note how skillfully the anonymous early ukiyo-e artist has treated his subject. No single girl is attractive enough for individual attention; the interest of the painting lies in the total group and its magnetic interrelation. The figures stand in balanced pairs: those on the left are vividly counterbalanced by the curious figures on the right: one, strangely elongated; the other, garbed in a striking, checked kimono. In this early ukiyo-e masterpiece we already sense the first flowering of that cheerful decadence that was to color the work (nearly two centuries later) of Utamaro's final years.

Here, within the compass of four splendid samples, we have been able to survey both figure-painting in early ukiyo-e and the thematic seeds that flowered in the later prints and paintings of this genre, for all these early achievements will be found mirrored in the subsequent prints: *Princess Sen* reappears in Moronobu, Sugimura and Kiyonobu; the *Matsuura Screens* in the Kaigetsudō artists; the *Dancer* in Sukenobu, Harunobu and Chōki; the *Bathhouse Girls* in Utamaro, Eisen and Kunisada.

Nowadays the collector must perforce prefer prints to paintings—for there is little else available to him. However for the wider world of art-lovers, there can be no greater joy in ukiyo-e than these lovely painted figures of the early seventeenth century.

The World of the Courtesan

Although ukiyo-e was always concerned with genre representations of ordinary scenes from daily life, leisure and entertainment, it was soon to choose as its special domain the amusement quarters of the great Japanese cities: the courtesan districts and the Kabuki theater. These themes were to provide the basis for at least two-thirds of ukiyo-e art in the seventeenth and eighteenth centuries. When, in the early nineteenth century, ukiyo-e was dying out through lack of new subjects and themes, Hokusai and Hiroshige revived it with their fresh approach to landscape, a subject hitherto exploited only by traditional painters and hardly ever by the artists of the floating world.

Quite boldly then, much of the best ukiyo-e took as its subjects the courtesans and actors, classes which were considered parasitic outcasts by the feudal government, but which were actually the idols of the masses and the bourgeoisie alike. It must be said at the outset that anyone who finds pictures of poised courtesans and posing actors uninteresting will have difficulty in enjoying or appreciating ukiyo-e during any but the last few decades when it thrived.

The courtesan was an important person in the social life of old Japan; that fact is obvious even from a glance at the art or literature of the period. The Japanese male, his marriage arranged for him by his parents while he was still in puberty, needed some outlet for his urge to experience romantic adventure. High adventure was well-nigh impossible, for the land was ruled by a strict military dictatorship; travel outside Japan was, after the 1630s, punishable by death; and it was rare for a townsman, whatever his wealth, to rise into the glamorous samurai society. The townsman's only area for adventurous self-expression lay in the making of money and in the spending of it—the latter principally in the courtesan districts.

Though love was largely an item of commerce in these quarters, a man was at least free to choose his own sweetheart and, if he could afford it, reserve her for his own exclusive pleasure. So it was that following the establishment in each of the major Japanese cities of licensed quarters, these districts with their highly trained and educated courtesans soon became the acknowledged centers of male social life; the haunt of connoisseurs and literati, as well as of rakes and gallants.

During the first half of the seventeenth century the upper levels of this pleasure-bent society were apparently dominated by the more wealthy samurai. But from mid-century on it was the ordinary townsman who gradually came to reign supreme; for with the continued growth of a mercantile economy, the average samurai became more and more impoverished, and less and less able to afford such costly pleasures. Thus from the 1660s onwards, the demimonde became almost a monopoly of the middle- and upper-class townsman.

Such quarters as the Yoshiwara in Edo, Shimabara in Kyōto, Shimmachi in Ōsaka and

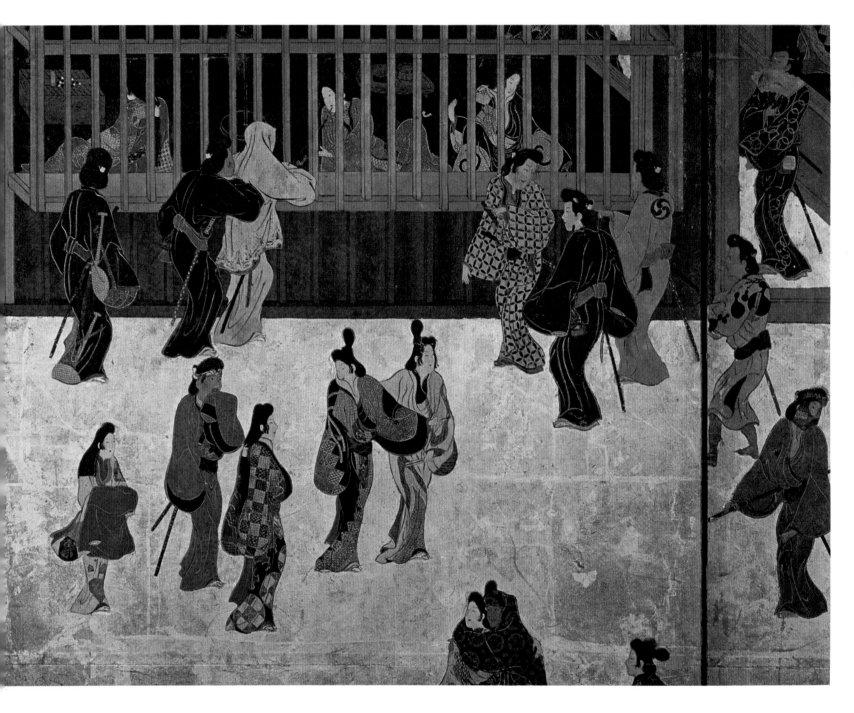

Maruyama in Nagasaki were the centers of pleasure and refined entertainment in the cities of Japan. As they grew, a large corpus of literature and art developed, which was produced almost exclusively to amuse or celebrate this world. The literature consisted of a type of witty novel that came to be called *ukiyo-e-zōshi* or "floating-world booklet." Saikaku is the best known of the authors of this literature, but he had numerous imitators and followers. In art, the result of this renaissance of gaiety was the flowering of ukiyo-e.

In a world where money reigned, it was only natural that the more strong-willed of the courtesans should develop certain standards of their own in judging a lover or would-be lover. This code and these standards were to play a major role in molding the average townsman's attitude towards the courtesan. She could be had, theoretically, for money; at the same time, a guest who tried to force himself upon a courtesan was considered a *yabo*, or "crude boor," and became the laughingstock of the pleasure quarter.

9 **Early Ukiyo-e School:** *The Kyōto Pleasure Quarter.* Detail of a medium-large folding screen of six panels in colors and gold leaf on paper, ca. 1640s (Kan-ei/Shōhō Period). [For the full screen, see figure 45.]
This panoramic view of the Kyōto licensed quarter in the mid-seventeenth century shows in the background the houses of assignation, where courtesans display their charms behind grilled windows. They recline, play instruments, write love letters or converse with prospective male guests through the grills. In the street, rakes, dilettantes, servants, travelers and girls of the quarter pass as though on parade.

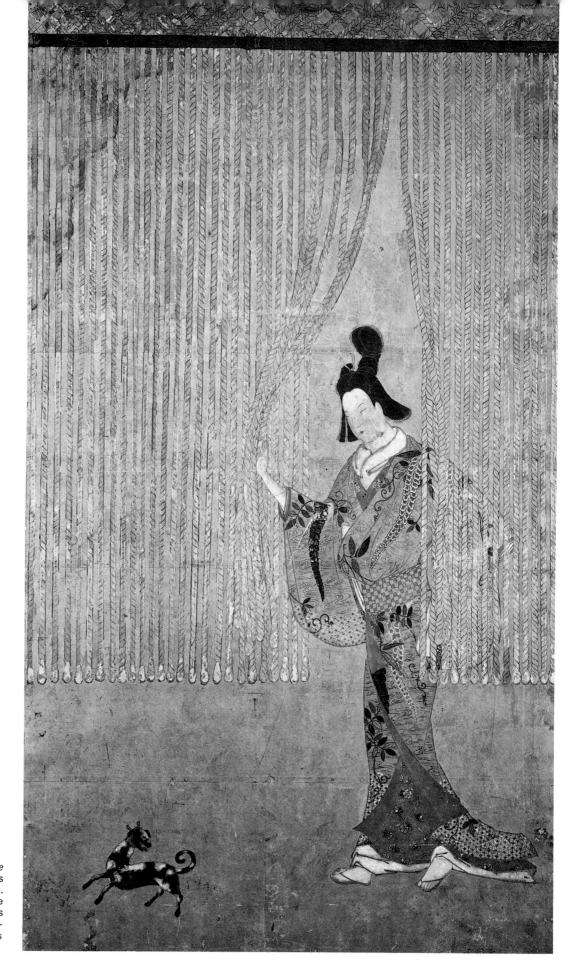

10 **Early Ukiyo-e School**: *Courtesan at Rope Curtain with Small Dog*. Large panel in colors on gold leaf, ca. 1640s (Kan-ei/Shōhō Period). A richly attired impassive courtesan parts the rope curtain to look at her yelping dog. This is one of the classics of ukiyo-e painting, a poignant evocation of the same mood as François Villon's: *Mais où sont les neiges d'antan?*

Thus, the Japanese courtesan both was and was not a prostitute. She was, indeed, bought for money; but at the same time she enjoyed a considerable degree of freedom and influence in her own limited world. It was this unique quality, plus the traditional Japanese unconcern with moral problems in this connection, that was to make the Japanese courtesan (who resembled the ancient Greek *hetaera* and yet was different from her) the subject of and the stimulus for a vast body of surprisingly excellent literature and art that was to sustain itself for nearly three hundred years. If anything, the art which celebrated the courtesan tended to be more subtle and more universal than the literature. This is surely the reason why the masterpieces of the ukiyo-e school appeal to connoisseurs the world over, whereas the literature, even when translated, interests only a small audience with a taste for the exotic.

In Western art there is, of course, a school of portraiture specializing in full-length paintings of fair ladies, most often of specific, eminent individuals. To find the equivalent of the Japanese *bijin-ga* (paintings and prints of beautiful girls and courtesans, who are the focal point of a vast, semi-popular, semi-erotic art form) we must turn to the nude in Western painting. The nude never developed as an independent form in traditional Japanese art; the emphasis in female beauty lay most often on the facial features, the long raven hair and the kimono; and it cannot be denied that the elaborate Japanese kimono was a work of art in itself, well worthy of enshrinement in the graphic arts. Perhaps more than in any other country, the dress—and the way that it was worn—became a vital criterion in the appreciation of feminine beauty.

The matter was stated very plainly by the courtesan Naoe of the Shimmachi pleasure quarter in Ōsaka. At the time of the Kansei Reforms that started in 1789—a period when the feudal government was attempting to restrict all luxuries—this redoubtable female sent a strong protest to the authorities against the ban on rich kimonos. She said, in part, "Our world is different from the ordinary world.... If we were to dress ourselves like ordinary girls, how on earth would we manage to attract lovers?"

The Floating World of Ukiyo-e

The earliest ukiyo-e depicting the pleasure quarters were incidental parts of the late sixteenth-century screens, showing panoramas of the streets of Kyōto. During the first quarter of the following century, the beginnings of the Kabuki drama received attention from genre-screen painters and were also featured in several notable scrolls and book illustrations in the Nara-Picture style.

With the full development of the elaborate, government-licensed, courtesan quarters in the 1630s and 1640s, both literature and art began to take the courtesans as a prime subject. Plate 9 shows a six-panel screen devoted to the Shimabara district in Kyōto and is one of the finest early works now extant on the theme of life in the pleasure quarters. Such a screen (originally one of a pair) required many weeks or months of careful work by a skilled painter and was generally beyond the means of any but the more wealthy samurai of the period.

Within a few decades wealth gradually began to pass into the hands of the mercantile class, but during the first half of the seventeenth century it seems probable that both genre art and the pleasure quarters themselves were supported largely by the samurai class. This taste for high living doubtless contributed to the gradual impoverishment of the samurai, although their lack of business acumen and willingness to transfer troublesome commercial transactions to the merchants was, of course, an even more important factor in their decline.

With the floating world of the time as depicted in plates 9 and 10, we may with some certainty say that the ukiyo-e style has arrived. Critics who would deny this, citing the fact that a popular audience is still missing, are putting too much emphasis on the patron and not enough on the art itself, for in these plates we find all of the world that was to inspire the highest efforts of the ukiyo-e masters and of novelists and playwrights as well for two centuries to come: the world of courtesan and gallant, the floating world of pleasure.

The panorama type of painting of the pleasure quarters (plate 9) was an extension of the numerous earlier screens depicting detailed "Scenes in and around Kyōto." The next step

in the representation of the floating world lay in the painting of individual portraits of courtesans, such as the masterpiece we show in detail in plate 10. As with most early ukiyo-e, this painting is unsigned, but the artist is clearly a master, and it is difficult to believe that no other works by him exist. They most probably do, but they probably treat non-ukiyo-e subjects and employ styles that are more traditional. For, as we have already suggested, Japanese painters often studied and practiced several styles and techniques simultaneously and varied them to suit both the subject matter and the taste of their patron. Thus we feel justified in citing works such as this among the first masterpieces of true ukiyo-e, even though its artist surely worked in other styles as well and doubtless produced it for a non-plebeian audience. In any case, this *chef d'oeuvre* was seldom surpassed in later ages.

In skilled reproductions the profound but subtle impact of this large screen painting, with mellowed hues on pure gold-leaf, can be hinted at—but its size (some 5.2×2.7 ft./160×90 cm.) or the depth achieved by the contrast between the seemingly flat planes of old gold-leaf and the heavy tempera colors that are oxidized now can hardly be suggested by a reproduction. The subject of the painting is a courtesan, a girl available to almost any man who could afford the price. Yet, as we shall see, in Japanese courtesan-portraiture the subject is actually idealized womanhood.

Though we possess a somewhat less realistic idea than the early Japanese of the necessity of the courtesan's profession, let the mists of time veil our moral judgment, so that we may perceive here feminine beauty that is no less moving because it is a courtesan's and not a debutante's or a queen's. Whereas the courtesan in plate 10 is somehow quite removed from the world of sex, another more frankly sensual type of girl is typical of ukiyo-e. We have already seen an extreme example of this type in the *Bathhouse Girls,* and other sisters of hers will be observed scattered throughout the details of plate 9.

It is perhaps unwise to suppose that the reader who catches his first glimpse of Japanese figure painting here will receive the same impression as the author; but to us, at least, the courtesan of the *Rope Curtain Screen* (plate 10) is idealized and anti-physical; she is aloof in the profound sense that no man can ever know her. The courtesans of plate 8, however, are definitely more approachable, the type of girls who accepted each lover as a new experience and never indulged in brooding. These two plates are emotionally and even artistically worlds apart, although they are from approximately the same period. Plate 10 represents a formalized, aristocratic approach to the floating world, whereas plate 8 meets that world on its own level.

Later artists such as Sukenobu, Harunobu, Chōki and Eishi were to hark back to this type of idealized vision in their prints; but it was the more worldly girl of plate 8 who was to prove the precursor of much of ukiyo-e's view of womanhood.

Perhaps the most striking example of the more formal approach to early ukiyo-e is found in the famous *Hikone Screen,* one of the monuments of Japanese art and the best-known of all early ukiyo-e paintings. This work (originally two six-panel screens) is now extant in what appears to be four panels from one screen, two from the other. (It should be added that this is the author's view; the Japanese traditionally consider it as one complete screen, even though the two right panels are obviously not part of the composition.)

Dating from roughly the same period of the 1640s as the previous screens, the *Hikone Screen* is the work of a consummate Kanō painter who adopted the subject matter of ukiyo-e. The most obvious evidence of the artist's formal training is seen in the skillful Kanō-style, *sumi-e* [monochrome] landscape which decorates the screen in the background. (The placing of the screen itself in the scene will reveal, to readers unfamiliar with Japan, the role that these folding panels played in the traditional Japanese household. Fixed furniture, as we know it, was rarely employed: one sat directly on the mats or cushions of an austerely decorated room. Then the simple furniture required for the occasion was set up, always temporarily. Even the bulkiest items of Japanese decorative furniture—screens—were usually folded up and put away when not required. They provided warmth and decoration and also served as room dividers, which were freely moved about as the occasion demanded.)

Quite apart from the background design of the *Hikone Screen,* the figures themselves reveal the somewhat formal, dry, *shibui* [astringent] touch of the Kanō School. This is

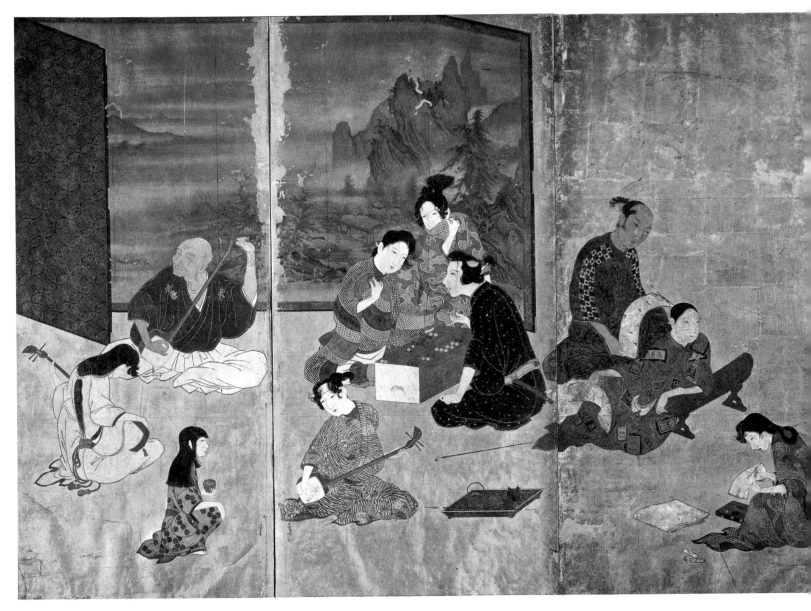

indeed the work of a master, but—as far as ukiyo-e is concerned—a master not yet fully attuned to, or part of, the floating world which he paints. He represents, so to speak, a stranger in paradise.

Ukiyo-e and Early Kabuki

Let us digress a moment to consider the early background of that other staple floating-world theme: Kabuki and the world of the actors and actresses. Kabuki as such began shortly after the year 1600 when O-Kuni, a young Shintō priestess from the Izumo Shrine, formed a small troupe in Kyōto to perform popular dances and mimes on the east bank of the River Kamo. The actual plays were undoubtedly only impromptu adaptations of traditional Shintō and folk dances; but they satisfied a need, and O-Kuni's troupe gradually grew in renown. She was even summoned, from time to time, to appear in command performances before the great feudal lords.

The country had but recently achieved peace after a century of civil wars, and it is not surprising that the early seventeenth century should have seen the reformation and renais-

11 **Early Ukiyo-e School:** *The Hikone Screen.* Medium-small screen of six panels in colors on gold leaf, ca. 1640s (Kan-ei/Shōhō Period).
This is the most famous of all early ukiyo-e paintings; in a graceful manner it depicts men, women and children at leisure: playing the samisen and backgammon, writing letters and chatting. The four panels on the left obviously represent an indoor scene, modeled on the traditional Chinese theme of the Four Classical Amusements (*Kin-ki-sho-ga*: lute, chess, calligraphy and painting), while the two panels on the right probably show an outdoor view. Whether the setting is in the entertainment quarter or a playboy mansion of the time is not certain, but the milieu is clearly that of the floating world.

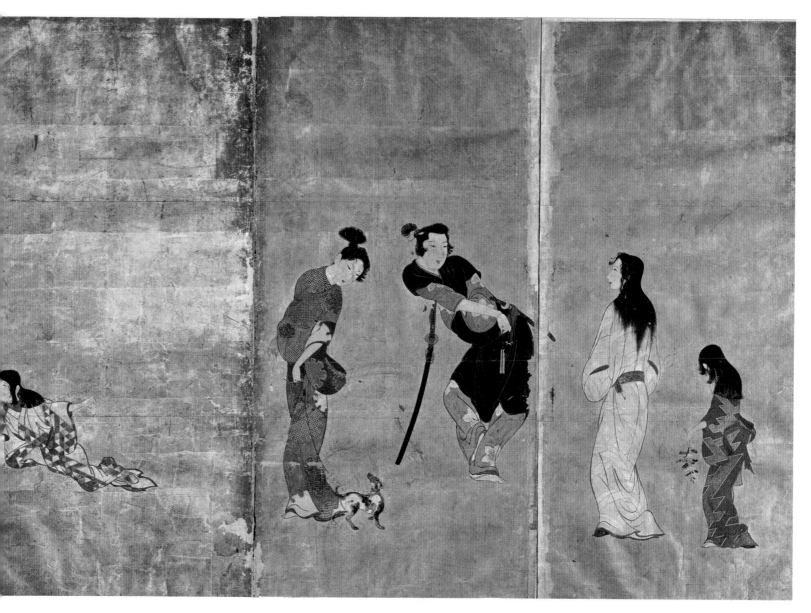

sance of all kinds of amusements and popular culture that had been driven underground during the long period of conflict.

O-Kuni, in any event, was the first to take advantage of this need, and so she is honored as the founder of Kabuki, though at the time it need not be supposed that the individual performers were considered anything more than the "curious, disorderly persons" that the term *kabuki* at first implied.

O-Kuni's theatrical innovations were soon taken up by the courtesans of Kyōto as a means of displaying their charms, in this function differing but little from the elaborate geisha dances performed even today in Kyōto and Tōkyō. The courtesans, however, not only gradually overstepped the bounds of propriety in their performances but also tended to create public disturbances among rival males. Finally, about the year 1629, the authorities found it necessary to ban all female performers from the stage.

This prohibition was to persist for fully two and a half centuries and proved a necessarily crucial factor in the development of the Japanese theater. Kabuki was by now a vital part of public amusement, however, and the government ban against actresses was circumvented at first by having handsome boys take all their parts, as in Shakespeare's London. The authorities soon found that they had only exchanged one vice for another. Certain practices, rather widespread among the Buddhist priests and among the samurai during the cam-

paigns, now found their natural center in the "Young Lads' Kabuki," which became a bed of commercialized pederasty.

Kabuki was by now too popular to be simply banned outright, so the authorities went one step further in an attempt to sever the connection between Kabuki and vice forever. In 1652 they proclaimed that henceforth only grown men could act in plays and that they had to shave off the handsome forelocks they grew so that there would be no doubt whatsoever of their sex!

Sex and Kabuki were never completely dissociated, but the authorities seemed to have realized that popular drama formed a generally healthy outlet for frustrated ladies and mildly

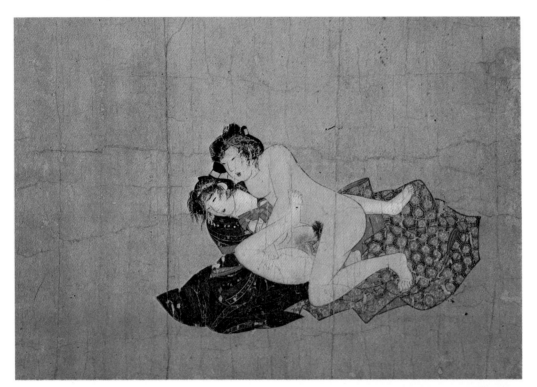

12 **Early Ukiyo-e School:** *Young Lovers.* Small *kakemono* in colors on paper, in *aiban* size, remounted from a lost *shunga* [erotica] scroll, ca. 1640s (Kan-ei/Shōhō Period).
This scroll—a work of rare quality and naïveté, representative of the best in Japanese erotic art—shows a young samurai with his love. As in all shunga, there is an attempt to display the sexual organs in the fullest possible detail, and the element of exaggeration renders them a center of interest in themselves and evokes memories of phallic worship in more primitive times.

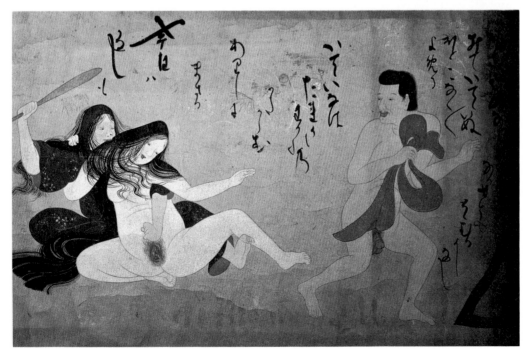

13 **Tosa/Genre School:** *Scene of Jealousy.* Detail from a shunga scroll in colors on paper decorated with gold and silver in large-*ōban* size, ca. 1660s–1670s (Kambun/Empō Period).
In this scene, possibly derived from the medieval tale *Isozaki,* a samurai husband flees as his jealous wife belabors his secret lover. This is a most unusual example of shunga work in the colorful and decorative, seventeenth-century Tosa court manner. The very apt verses on the scroll, in calligraphy of the Konoe Nobutada School, are a good reflection of the literary tastes of the Kyōto nobility.

14 **The Kambun Master**: *Courtesan and Courtier.*
Medium-size *kakemono* in colors and gold wash on
paper, ca. mid 1660s (early—mid Kambun Period).
Under a moonlit autumn sky the courtesan, in con-
temporary dress, stands on her veranda; outside the
stylish fence of reeds and chrysanthemums sits an
amorous courtier in ancient garb. Although more than
one genre artist may have been involved in this not-
able, pre-Moronobu, Edo style, for the present we
have chosen to ascribe such works to Moronobu's
shadowy mentor, the Kambun Master.

perverted gentlemen. Thus they allowed a certain amount of vice to persist, only clamping
down when some flagrant scandal besmirched their own sacred precincts. This, then, was
the robust and delinquent, colorful and déclassé world of Kabuki in the early and mid-
seventeenth century—a world that survives vividly even today, through the inspired work
of the early ukiyo-e masters.

The Ukiyo-e Primitives

Depictions of girls and courtesans in rendezvous with their lovers also accompanied the
development of individual portraits of such women. Love and the techniques of love-
making form one of the dominant themes of ukiyo-e, a theme often implicit even when only
one figure is actually shown.

It was probably not until ukiyo-e that romantic love scenes began to appear as a promi-
nent and established genre in Japanese art. To be sure, there are scattered examples of
erotic scrolls as early as the twelfth century, but we recall very few other paintings that take
love scenes as their principal and consistent theme. Those that do exist are usually incidental
parts of a series of Tosa-style illustrations for a love novel.

The prominent place played in ukiyo-e by *shunga* ("spring pictures," the Japanese term for erotica) should be noted here. It was only natural that the long tradition of Japanese erotic painting was taken to heart by the ukiyo-e masters from the start. Indeed, one surmises that shunga were among their very first commissions and that shunga played a key role in the evolution of the ukiyo-e style.

This is a theme we shall return to shortly in relation to the early print; here, we shall only illustrate some significant examples of early ukiyo-e painting in the erotic vein—details from scrolls originally commissioned by lords and magnates for their own pleasure or as wedding gifts. (It was the transfer of such manuscript shunga scrolls to the woodblock medium that produced the first ukiyo-e prints.)

Let us return now to the more romantic form of love scene depicted in early ukiyo-e: the painting shown in plate 14 is of great interest in more than one respect. First it represents an early adaptation of a classical scene to the ukiyo-e style; this trend was to continue throughout ukiyo-e. Moreover, it illustrates two schools of art within one painting: the man seated on the right is clearly modeled on the great ninth-century court poet, Narihira, hero of the *Tales of Ise.* He not only wears ancient court robes but is even depicted in the traditional Tosa art style. The girl he is courting, however, is the heroine of a new, seventeenth-century world: the stylish courtesan. She stands aloof in all the glory of her elaborate kimono, arms withdrawn into her garment in a subtle, vaguely erotic gesture typical of courtesans. Between the courtier and the courtesan chrysanthemums bloom on a rustic but stylish fence. Such elements—like every part of the scene with the exception of the girl—are all traditional Tosa work. Indeed, the first impression is that a modern girl has stepped into a ninth-century scene.

To a Japanese of the time, however, the situation would have seemed less incongruous: Narihira was the symbol of the great classical lover, like our own Paris or Adonis; and substituting a modern courtesan, the feminine ideal of the new age, for Komachi (the Japanese equivalent of Helen or Venus), was doubtless considered the height of sophistication. Certainly even today it lends the picture a flavor unique among the numerous experimental ukiyo-e paintings of the period. This painting also provides a rare example of how ukiyo-e first developed within the traditional schools: the same source could, as here, inspire a painter to produce work in two different styles that were centuries removed in both technique and spirit.

One further point to be made about this painting is its place of origin. Hitherto we have been dealing primarily with the artists of Kyōto, the ancient capital of Japan. Here, although we know nothing of the anonymous artist concerned, we can sense a certain bold wit and stylishness that were soon to become the distinguishing marks of Edo ukiyo-e. Even the courtier shows signs of a rakishness quite removed from the over-cultivated Kyōto court. The artist was probably a man trained in the Tosa tradition, but drawn to the new spirit of boom-town Edo. The gradual transplanting of ukiyo-e's roots from Kyōto to Edo during the mid-seventeenth century was a critical point in the development of this genre, and the consequent release of ukiyo-e from many of the bounds and conventions of traditional art had several significant results. On the one hand, the new ukiyo-e artists of Edo were free to develop and standardize the new styles and forms to suit their speciality—the depiction of the floating world. On the other hand, whereas the traditional, wealthy patrons of Kyōto and the provinces had overwhelmingly favored the medium of hand-painted screens, the patrons of Edo ukiyo-e tended to favor the lighter form (both in weight and in price) of the print. Thus in Edo the medium that was to bring ukiyo-e worldwide renown was born.

The development of ukiyo-e prints *per se* will be the subject of subsequent chapters. Here, let us turn to a few other notable paintings of a key period in ukiyo-e's progress, the 1660s, the age when ukiyo-e was making its first great strides in Edo. Although, unfortunately, we do not know who the artists were, these paintings have in common a bold sense of chic, a spirit of independence that tends to set them apart from the traditional elegance of the Kyōto masters. It is this fresh spirit that was to flavor the best of ukiyo-e for the next two centuries. Unlike most of the earlier ukiyo-e paintings, which were usually mounted as lateral scrolls or as standing screens or panels, these paintings were often mounted as *kakemono* (a vertical scroll hung in the alcove of the Japanese house) and rolled up for storage.

15 **The Kambun Master:** *Courtesan Portraits— Mandayū, Yūgiri, Kaguyama, Wakana.* Four of a set of *shikishi* [poem-card] miniatures of *chūban* size, in colors on decorated paper with mica ground, early 1660s (early Kambun Period).
These four scenes from a set of small portraits of noted living courtesans are done after the manner of the classical Thirty-six Poets. Each panel includes a poetic eulogy, in graceful calligraphy, describing the girl's charms, with her name incorporated in the verse.

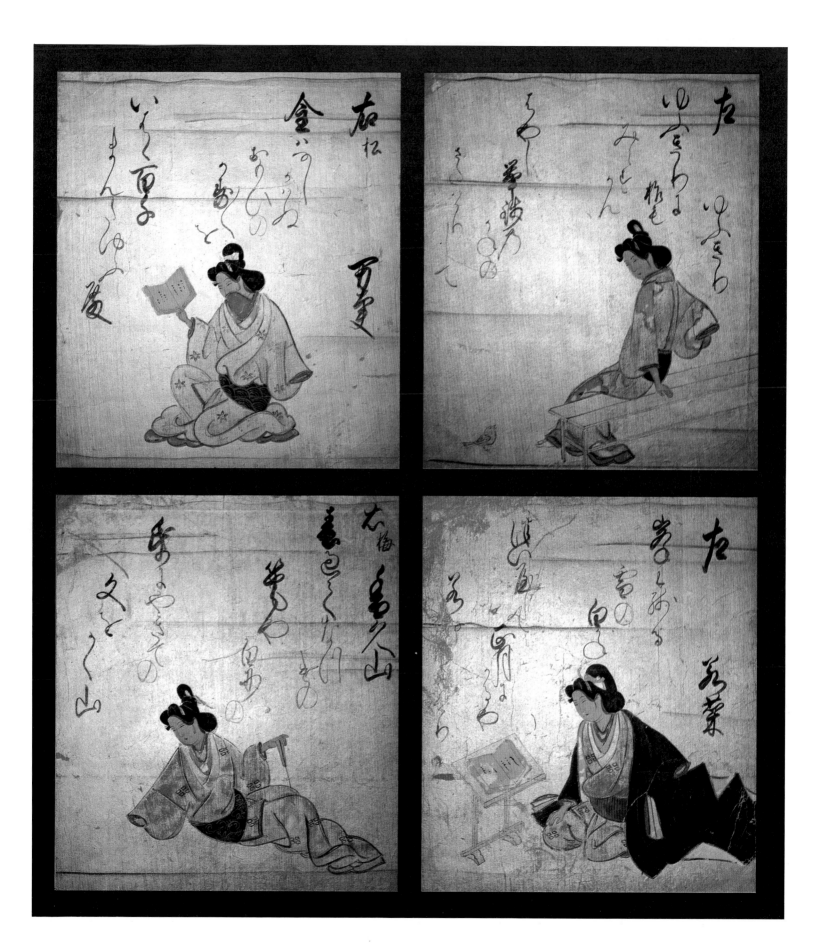

In plate 15 we meet yet another format of Japanese painting: a series of *shikishi* (poem-cards, meaning "colored papers," nearly square sheets of decorated paper some 8×7 in./ 20×18 cm in size). From quite ancient times poetry, and later portraits of the poets, had been inscribed upon these cards and collected for display. They were either preserved unmounted in lacquered boxes, or mounted in albums or on standing screens. These poem-cards are a remarkably intimate type of miniature. They are made of soft but heavy paper, just the right size for holding in one's hands, and we shall see later how the format was adapted by Harunobu and his followers for some of the most charming prints in all ukiyo-e.

Plate 15 shows some of the earliest and most engaging examples we possess of this intimate form of ukiyo-e. Characteristically, the subjects are Yoshiwara courtesans. (Their hairdos are often a variation of the pony-tail we saw in plate 14, but with the tail wound up and tied on top of the head. Naturally, all the courtesans' coiffures have their special names, and they form one of the antiquarian delights of ukiyo-e collecting.)

It is most revealing to compare these courtesans with Harunobu's idealized girls of just a century later, or with the women of Utamaro, Eishi or Chōki (without, for the moment, attempting a judgment of the relative merits of artists separated by a century or more). From such a comparison we perceive that ukiyo-e found its ultimate subject and approach almost from its inception. The only opening left to the ingenuity of later artists was in novelty of background, coloring and design. With this in mind it seems a little surprising to learn that all pre-Harunobu ukiyo-e is generally labeled as "the period of the Primitives." To be sure in this period there were artists of great charm but limited training, such as the "Ōtsu-Picture" painters and the "Nara-Picture" masters; there were also artists possessed of an elemental power such as can be seen in early book illustration and today in the modern print-master Munakata. Although the technique of full-color printing had yet to be developed in Japan, little else in seventeenth-century ukiyo-e was really primitive. Its masters had the tradition of ten centuries of Japanese painting behind them, a tradition going back to the ancient Hōryūji frescos, and which was magnificent in both line and color. When, in the seventeenth century, these painters turned to the new world of pleasure "floating" about them, they had only to make an effort—admittedly a strenuous one—to escape from the oppressive tradition of formalized subject matter. Once they had made that leap, they found themselves masters of a new dominion, free to create a new art and adapt the best of the ancient techniques to depicting a vibrant new world, a world suddenly expanding with the vigorous pangs of renaissance.

Ukiyo-e and Early Printing

Having arrived at the period of the 1660s, we are now ready to delve into the fascinating subject of the Japanese print as such. First, however, we must consider an essential prerequisite of the prints: the early development of printing itself in Japan.

In the medieval period works of history and fiction were widely read by those possessed of even a minimum of education; however, prior to the seventeenth century copies were made by hand—often in scroll format and with colorful illuminations—and circulation was necessarily limited.

Methods of printing, derived from China, had been known in the Buddhist temples of Japan from the eighth century, however; and by the twelfth century block-prints of religious images and related scenes were being produced. The printing of Buddhist works—both of sutras and literary texts—developed gradually during the eleventh to sixteenth centuries, but such printing as existed was entirely religious in nature and too expensive for the production of large numbers of books for popular consumption. Indeed, a wide literate public for such works did not yet exist.

It was not until the year 1590 that a non-religious book was printed in Japan. This was the *Setsuyō-shū,* a dictionary of Japanese and Chinese terms in two volumes. Other works of a practical nature followed, including legal codes and models for calligraphy. During this

same period a press, which employed movable metal type, was established at the Jesuit mission in the Nagasaki area, but it does not seem to have exerted a notable influence on native Japanese printing. It was, rather, the movable-type printing apparatus, which Hideyoshi's generals brought back from Korea in 1593, that led to further Japanese experiments in secular works. Four years later the first native movable type was manufactured. It was made of wood rather than metal and by Imperial decree. Even before the decisive battle of Sekigahara in 1600, the Shōgun Ieyasu, interested for both practical and theoretical reasons

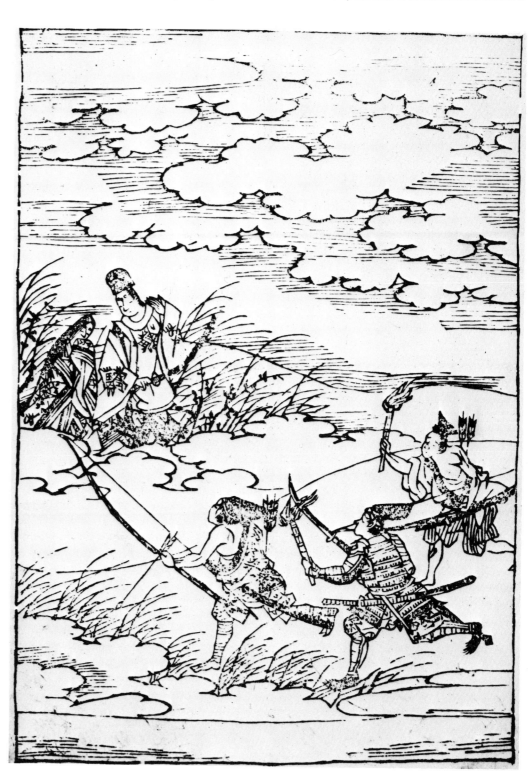

16 **Tosa School**: *Lovers Captured by Pursuers*. An illustration from the *Ise monogatari* [Tales of Ise] in the *Kōetsu-bon* edition, in *ōbon* [large book] size, 2 volumes; *sumizuri-e* [monochrome print] woodblock-printed book with text from movable type, Kyōto, dated Keichō XIII (1608).
Several different editions of this famous book were issued between Keichō XIII and XV (1608–10), and the work was widely reprinted by regular woodblock methods during the seventeenth century. The illustrations represent a simple adaptation of Tosa miniature painting to the printed form, without special attention to the unique qualities of the woodblock medium.

in the spread of learning, had caused some 100,000 movable wooden type blocks to be cut. Several publications of a political or historical nature were issued by his press, which continued its activities even after Ieyasu's retirement to Suruga in 1607. Ieyasu's political rival, Toyotomi Hideyori, also figured in the early Japanese efforts at printing; and meanwhile, private, non-official editions began to make their appearance in Kyōto.

The principal figure in the early printing of the Japanese classics was Suminokura Soan. Soan had inherited a fortune from his father, and he put the money to good use in patronizing artistic editions of the Japanese classics. Soan was himself a calligrapher and connoisseur of great taste, but much of the artistic achievement of the Suminokura press must be attributed to his advisor and associate, the great and versatile artist, Hon-ami **Kōetsu** (1558–1637). Kōetsu was perhaps the most many-sided genius of his century. He excelled equally in calligraphy, ceramics, lacquerware, book designing and a dozen other minor arts, which often achieved major proportions in his hands.

In the artistic community set up by Soan and Kōetsu at Saga, west of Kyōto, a group of skilled artists and artisans combined their efforts to produce what are considered to be the masterpieces of early Japanese printing. These volumes, known variously as Saga Books, Kōetsu Books or Suminokura Books, include both the first and the finest printed editions of the major Japanese classics.

In several respects the masterwork of the Saga Press was the *Ise monogatari* [Tales of Ise] of 1608. With text printed from movable type on paper of five different, alternating, pastel shades, this two-volume set is devoted to the earliest Japanese collection of love tales about the life and verses of the courtier-poet Ariwara no Narihira (823–80). The novel itself was compiled not long after its hero's death, and in its graceful charm it could be compared to the early Italian *Cento Novelle Antiche*. It may be of interest to translate the brief, ingenuous chapter that is the subject of the scene we illustrate here:

> There was in times of old a young courtier who, abducting the daughter of a certain personage, fled with her into the Moor of Musashi. But in his flight he was considered a thief and was forthwith ordered arrested by the Governor of the Province.
>
> Now at the time of the flight he had left the girl concealed in a thicket. One group of those who followed said, "There is a thief hiding on this moor," and was about to put the torch to it./Whereupon the girl in consternation pleaded:
>
> O burn ye not / this Moor / of Musashi today! / My young love is concealed within the grass: / and so am I. *[Musashino wa / kyō wa nayakiso / wakakusa no / tsuma mo komoreri / ware mo komoreri]*
>
> Thus did she recite, and hearing this, they captured the girl and led the two back together.

This and other famous scenes from the *Tales of Ise* appear frequently in later ukiyo-e, in both romantic and shunga versions. All of these early books were expensive, being printed largely for private distribution among connoisseurs. From the 1620s, however, with the increasing spread of literacy among townsmen and with enforced leisure of the samurai class, it became feasible to print books—modeled on the Saga editions but employing the simpler block-printing method—in larger quantities and at more moderate prices. Kyōto remained the center of this new, commercialized phase of printing.

The exceptional quality of mass printing in the 1650s was not surpassed until the development of full-scale color printing over a century later. Naturally enough, with the increasing demand for illustrated books a whole new generation of artist-illustrators developed. Sometimes these men were the pupils of the major ukiyo-e painters we discussed earlier, but often they were self-taught masters. Most of their names have not been recorded: nevertheless, the credit for translating the floating-world spirit into its first widely popular art form goes to them. They succeeded well in bridging the gap between aristocratic and popular taste and in fact were to prove the godfathers of the ukiyo-e print.

17 **Early Genre School:** *Samurai and Ladies on Travels.* An illustration from the famous historical novel *Soga monogatari* [Tales of the Soga Brothers], in *ōbon* size, 12 volumes; *tanroku-bon* (*sumizuri-e* with hand-coloring), Kyōto, Shōhō III (1646). Though primitive in style, such illustrations of the mid-seventeenth century reveal a far greater appreciation of the woodblock print's potential for bold design and decorative pattern than do those of the *Ise monogatari* (plate 16) and other classical illustrations. Certain deluxe editions of the period, called *tanroku-bon* [orange-green books] featured touches of hand-coloring predominantly in variations of orange and green. A similar technique was employed a generation later in the first ukiyo-e prints, the *tan-e.*

The Primitives and the First Century of Ukiyo-e 1660–1765

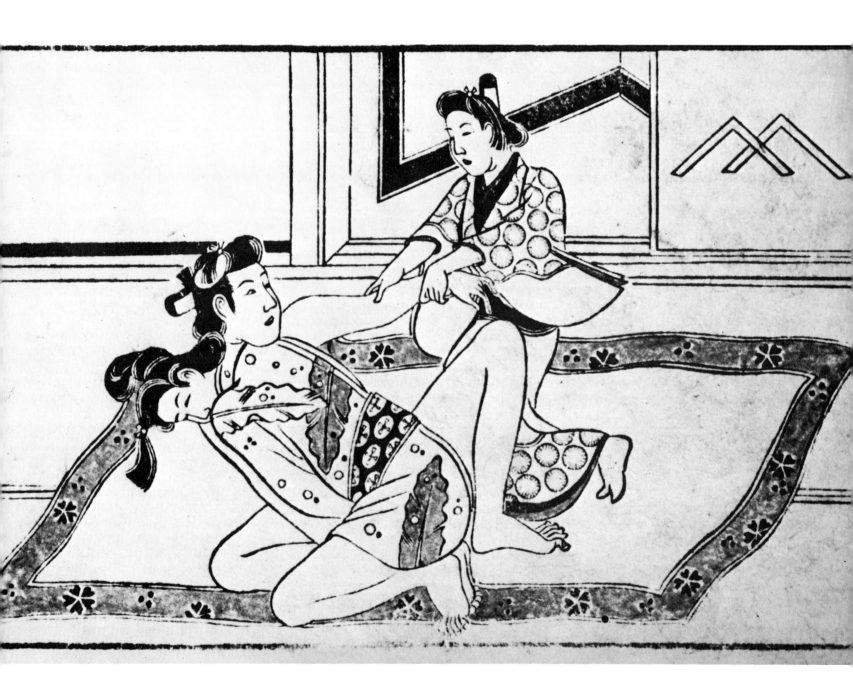

The Kambun Master

Oil Street, or Tōri-abura-chō, ran right through the middle of Edo in a generally east-west direction. Its modern counterpart lies a mile north of the center of fashionable Tōkyō but is still about as close as you can get to the commercial heart of the metropolis. On and about Oil Street were located several of the great publishers of popular books, and it is here that ukiyo-e prints were born.

If, indeed (as is the popular misconception), ukiyo-e implies prints, then its story, too has its proper beginning here. For, just at the time that the last paintings of our previous chapters were being made for well-to-do connoisseurs, some printer or publisher in Edo thought of multiplying ukiyo-e paintings by printing them from woodblocks. The resulting prints were distributed at popular prices. Contrary to what might be expected, these prints were not just cheap editions or inferior reproductions, but a whole new art form that was eventually to overshadow the ukiyo-e paintings that gave it birth, a form eventually to be recognized as one of Japan's principal contributions to world art. Since it is the prints that form the largest single glory of the Ukiyo-e School, the search for their origin has no little interest.

Curiously enough, ukiyo-e prints began as bold erotica or, at the least, as handbooks of sex that, until recent years, would have been banned in practically any other country of the world. Why this should have been so is difficult to explain conclusively. The early prints were of course limited, relatively costly experiments, and it was to be over a decade before they became inexpensive enough to appeal to a popular market. Thus, just as the later experiments of a group of dilettante connoisseurs in the 1760s produced full-color printing, so the first prints of the early 1660s seem to be a culmination of the ideas some connoisseurs of erotica had for multiplying choice specimens for limited distribution. (In this respect, the Japanese connoisseurs may well have gleaned useful hints from their fellows in China, who, for some two generations already, had also actively been producing limited editions of printed erotica, albeit of a rather less robust and lusty nature than the Japanese productions.) Of course, these erotica must be regarded in the light of seventeenth-century Japanese life and mores. Sex was considered a very natural function, and ways of increasing enjoyment of this function were felt to be more commendable than censurable. Thus if we think of the early erotica simply as very frank and detailed, yet artistic, sex manuals, we may be able to approach them with greater understanding.

Ukiyo-e book illustration preceded the production of single prints by several years. Already by the mid-1650s the ukiyo-e spirit had made itself felt in Kyōto book illustration, as we indicated in the previous chapter. In 1657, Edo, which remained the center of ukiyo-e throughout nearly all of its history, suffered a great conflagration that destroyed most of the city and, with it, whatever examples of early printed ukiyo-e might have existed there. Within two or three years after the great fire, however, the city had made its comeback and was soon to surpass the older centers of Japan in its production of art devoted to the floating world.

Plate 18 illustrates one of the earliest and finest ukiyo-e books, the *Yoshiwara-makura* [Yoshiwara Pillow] of 1660. Conveniently enough, the book combines the two most popular forms of Japanese "gallant" literature: the sex manual and the "courtesan critique" —the latter consisting of guides to the famous courtesans of the day, sometimes providing their portraits and verse eulogies but more often detailing their beauties and faults, where the girls could be located and at what price obtained. We need not try to idealize the sex life of Japan at that time; we can only marvel that the art and literature which celebrated the pleasure quarters reached such a high level, and we must concede that there was actually much good taste and refinement amidst all the overt lubricity.

The illustrations to the *Yoshiwara Pillow* consist of some forty-eight pages, each of which depicts a leading courtesan of the Yoshiwara (identified by her decorative crest rather than by name) in some intimate situation with a paramour. The scene shown here depicts a naked young gallant dallying with a courtesan, as her little maidservant tries to pull him away. The picture is only mildly suggestive, which cannot be said for most of the remainder

18 **The Kambun Master**: *Yoshiwara Scene.* An illustration from the shunga courtesan critique, *Yoshiwara-makura* [The Yoshiwara Pillow] in *yoko-bon* [small horizontal book] size, *sumizuri-e* with hand-coloring, Edo, dated Manji III (1660).
In this earliest dated work of Edo ukiyo-e, the fully formed characteristic style of that artist we have dubbed "The Kambun Master" can already be seen. Each of the small plates depicts a renowned courtesan of the time in a love scene with a paramour. The girls are identified by their *mon* [crest design], shown in the upper corner of each illustration.

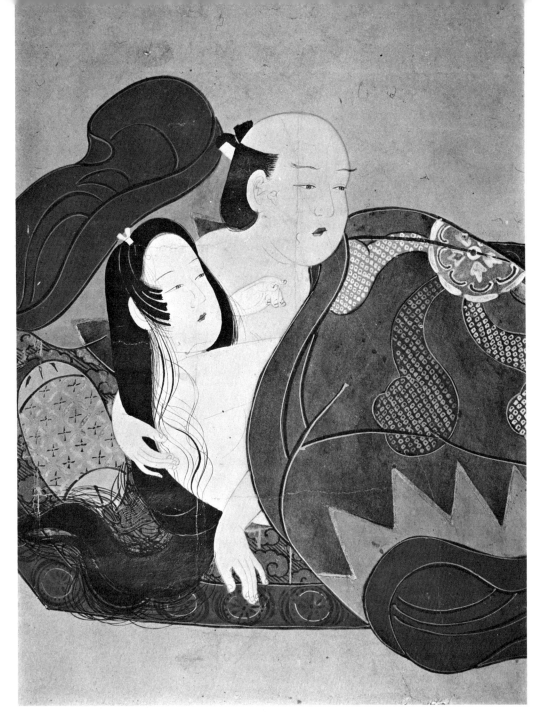

19 **The Kambun Master**: *Lovers Surprised*. Detail of a small *kakemono* in colors on paper in *ōban* size, remounted from a lost shunga scroll, Edo, late 1660s (mid Kambun Period).

One of the major extant shunga frontispiece plates, this painting is in the characteristic style of the Kambun Master's later work. In a common device of shunga, the lovers, though alone, are depicted as though interrupted by an intruder.

of the book, even though in manner and art it may seem charming. Each of the famous courtesans is, in effect, identified with one of the standard positions of love-making (in Japan, traditionally forty-eight in number) and shown with her lover, most often at the height of amorous pleasure.

We know nothing at all about the artist of this first masterpiece of printed ukiyo-e: neither his name, nor when he lived, nor any other details of his life are recorded. We know only that, from about 1660 to 1674, a new style appeared in Edo illustration. The books usually indicated the date and publisher, but there was no hint of the artist's name. At about the same time, this same style flourished both in ukiyo-e painting and in prints of beautiful girls and of erotic tableaux. From the fact that the year-cycle 1661–73 was known in Japan as Kambun, we have chosen to dub this artist the **Kambun Master**. Whether these works represent the efforts of one artist or more, we do not know; but to judge from the style and general productivity involved, one artist seems to be the central figure—exerting some influence on his equally anonymous contemporaries and producing the great Moronobu —who was either a direct or indirect pupil—a decade later.

20 **The Kambun Master:** *Courtesan and Lover. Tan-e,* hand-colored, woodblock print of *chūban* size printed in scroll format, Edo, ca. 1660 (late Manji Period).

Playing the samisen, a courtesan entertains her lover in a house of assignation. On the mats are the man's sword and fan, together with refreshments. This first masterpiece of the ukiyo-e print represents the cover sheet of a shunga scroll; another scene from the same scroll is shown in figure 456. As is the case with most shunga, the text is not on the same artistic level as the print. This will be apparent even from a rough translation: "Indeed, indeed / with all their hearts / sharing love's pillow: / stroking her Jeweled Gateway and taking / the girl's hand, causing her to grasp his / Jade Stalk: what girl's face will not / change color, her breath come faster?''

Let us turn now to the first actual print, shown in plate 20. As we have suggested, the connoisseurs of erotica of the period may well have sponsored the production of such experimental work. Again the print depicts a courtesan with her lover and dates from about the same time as the Yoshiwara book just described. This print is probably by the same anonymous hand. Perhaps the first thing to be remarked on viewing it in the original is the unusual coloring. Color printing was not widely used until well into the following century, but from the early seventeenth century, book illustrations had often featured primitive hand-coloring as a substitute. As here, the colors were most often orange and green, sometimes with yellow or mauve added; they were applied with rapid, bold strokes by skilled artisans. This type of coloring was common in the illustrated novels of the first half of the seventeenth century—called *tanroku-bon* [orange-and-green books]—and was used in ukiyo-e prints from the 1660s to the 1710s. Such pictures, termed *tan-e* [orange prints], are among the most treasured in ukiyo-e.

The choice of orange and green went back to earlier practices in painting, sculpture and architecture and proved a happy combination that was to characterize the primitive Otsu Pictures, already mentioned, and predominate in ukiyo-e coloring through the 1750s, even after elementary color printing had been established. The pigments were mineral colors and were unstable: the orange (red lead) often turned a mild bluish-black with age, and the mineral green grew dark and sometimes ate into and destroyed the paper. The example shown in plate 20, however, is well preserved.

21 **The Kambun Master:** *Yoshiwara Street Scene. Sumizuri-e* in *chūbon* [medium book] size, an illustration from the courtesan critique *Yoshiwara yōbunsho* [Yoshiwara Epistles], Edo, ca. 1661 (early Kambun Period). In this powerful work of early Edo illustration, a courtesan accusingly confronts her samurai lover with a billet-doux she has discovered, as their respective servants stand by.

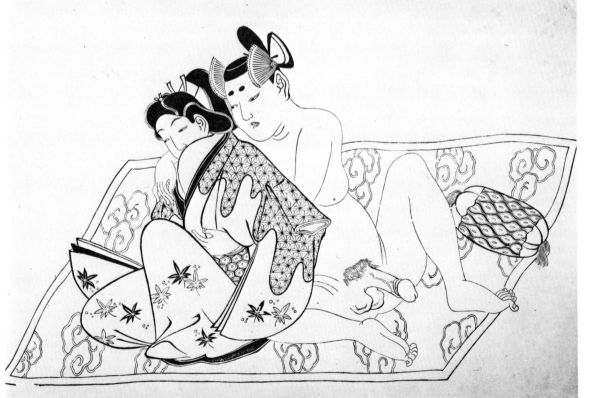

22 **The Kambun Master:** *Courtesan with Courtier. Sumizuri-e in ōban* size from a shunga series, Edo, ca mid 1660s (early-mid Kambun Period). In this unusual early print in *ōban* size, a Yoshiwara courtesan is shown in a tiff with her lover, who, as can be seen from his headgear, is a member of the court aristocracy. This is one of a set of shunga prints of which a *tan-e* version, featuring hand-coloring, is also known.

40

The format of this rare print, surely one of the most historically important in all ukiyo-e, is also of interest. What we see in the scene shown is a courtesan playing upon the samisen while her paramour reclines at ease, his short sword and fan on the mat before him together with wine cups, saké and various delicacies. Above the lovers is a written commentary [see caption] intended to stir erotic thoughts in the viewer; however, when we have the original print in our hands we see that this is by no means all. Actually, our print is one of a series of uncut prints all on one long piece of soft, heavy paper: a scroll. There must have been twelve such scenes originally, though now the scroll is torn off at the fourth one. After the first plate, the tableaux are all shunga.

Among other significant graphic works of the Kambun Master are the many *yūjo hyōbanki* [courtesan critiques] published during the 1660s. Despite their small size, they represent one of the early high points of Japanese book illustration.

The Kambun Master's most important extant work is doubtless a series of shunga prints in *ōban* size [see Dictionary section, p. 204, for print sizes], dating from the mid-1660s. Here the artist succeeds well in his first attempt to transfer his graphic mastery to a larger medium. Due to their frequently erotic content, these books and prints of the Kambun Period have remained hidden in the shadows of Japanese art; yet they form a notable first peak in printed ukiyo-e. Unfortunately they are rare, having been printed for a limited and highly sophisticated audience, and even many veteran print collectors have never seen, much less owned one. Both in style and content the prints and illustrations of this lively decade of the Kambun Master constitute some of the most fascinating work in all ukiyo-e.

The Early Edo Masters

From an aesthetic point of view the 1650s and 1660s marked one of the pinnacles of the renascent Japanese culture. The samurai class had yet to dissipate its vitality; the townsmen were beginning to feel their power but had yet to abuse it. The aristocratic or intellectual audience for art and literature was still sufficiently cultivated and wealthy to maintain the traditionally high standards of its ancestors, despite the gradual process of popularization. And popular culture itself was still a clear reflection of traditional aesthetic standards.

From their inception ukiyo-e prints, born of this exciting age of renaissance, owed their success to certain simple but vital factors. First, the necessary technical skill was already perfected—in many respects, as fully developed as it would ever be. Japanese woodblock carvers had behind them the experience of more than four centuries of careful work in the printing and illustration of Buddhist texts and Chinese classics. In addition, Japanese handmade paper was the finest in the world, peculiarly adapted to the exacting needs of woodblock printing. It was durable, absorbent, impervious to centuries of handling and was, moreover, possessed of a peculiar life of its own that made even the blank spaces of a print something of beauty. It also absorbed the natural pigments year by year so that today a print may well be even more beautiful than when it was first produced.

Artistically we may subdivide the three great contributions the Japanese tradition made to prints into line, space and coloring. The glowing line was as old as the eighth-century Hōryūji frescoes; in the fifteenth century it had absorbed the subtle influence of the great Zen ink paintings, and now it drew fresh stimulus from the resistance of the hardwood boards to the engraver's knife. Furthermore, in spacing and design the prints went back to the great traditions of Japanese arts and crafts, incorporating a sense of beauty as fully developed as any in the world. Lovely coloring too was a characteristic of Japanese painting from its inception, influenced perhaps by the exceptional beauty of the countryside and quite different from anything in Chinese or Korean art.

Perhaps the most important element of all was the fact that ukiyo-e prints were, from the beginning, designed as prints. They were not (like many Chinese and European prints) copies or reproductions of paintings; on the contrary, they consciously abandoned every element of painting that could not be better done by woodblock, and at the same time they developed methods and techniques that no paint brush could effectively imitate. These are the reasons why Japanese prints are admired today the world over.

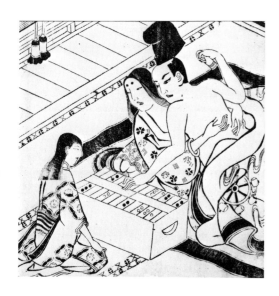

23 **The Kambun Master:** *Nobleman and His Lady at Games.* Detail from the shunga picture book *Makura-byōbu* [The Pillow-Screen], in *ōbon size,* 2 volumes; *sumizuri-e,* Edo/Ōsaka, dated Kambun IX (1669).
A creative production of the Kambun Master's final years, this book is notable for its unusual, sometimes bizarre, designs, such as this one of a nobleman and his wife combining lovemaking with backgammon (both highly popular games of the time), as a maidservant attends.

In practice, the philosophical problem: "How can a print, issued in hundreds of copies, be a work of art equal to a unique painting?" seldom arises. Or once arisen such questions cannot exist for long because the results of both art forms are totally different though equally important: a print can often express a particular aim better than it could be stated in another form. Whether or not this is clearly understood, it is a fact that the great ukiyo-e prints, even when a dozen specimens exist, may today be considered even more valuable than an equally great ukiyo-e painting, for these small "scraps of paper" speak intimately to collectors the world over in ways that paintings seldom can.

Although we devoted our introductory chapter to demonstrating that ukiyo-e began with paintings, this is not to gainsay the fact that many—perhaps a majority—of the real masterpieces of ukiyo-e are prints. It is incredibly difficult to choose between a favorite print and a major ukiyo-e painting: they may be equally loved, but in different ways and at different times. True, in a conflagration the early screen would doubtless be carried out first, but this is primarily because so few important works of that kind are now extant, whereas there are many works from the later period and even several originals of most of the significant later prints.

We have already described and illustrated the first work of the Edo print artist we dubbed the Kambun Master. What was the next development in the flowering of this new floating-world style?

Plate 23 will indicate something of the modifications in the Edo ukiyo-e style about a decade after its inception. The figures are rounder and bolder. The artist is most likely still the Kambun Master, but unfortunately nothing is known about any of the earliest ukiyo-e masters. The book from which this print comes is also an imaginative sex manual and is in some ways cruder than those shown earlier. We find in it, for example, couples making love in a bathtub and on hobby-horseback, surely a sign that the audience had become a trifle jaded with the simple sex manual and craved something more extreme.

The fact that early ukiyo-e erotica were aimed at an educated and sophisticated class of connoisseurs will be apparent from the literary content of many of these books. For example, we find erotic versions of the *Tale of Genji* as well as of the classical poets, each treated (or parodied) in a manner that assumed a good understanding of the originals. To be sure, as their popularity became widespread, the same anonymous masters also received commissions to illustrate the classical novels and didactic works of the time. But when their subjects strayed from the floating world their style, too, tended to become less flamboyant. Thus, the non-erotic works of the early ukiyo-e masters reveal a more restrained style, charming in itself but only partly liberated from the conventions of the pre-ukiyo-e Tosa masters.

Thus, at the beginning, ukiyo-e prints were principally sex manuals and guides to the courtesans, erotica exquisitely designed for members of a lively class of connoisseurs, who gave sex the same care and study that some people give golf, hi-fi or sports cars today. But there was to be more to ukiyo-e than girls and sex, though the terms "floating world" and "floating-world pictures" originally referred largely to those themes. Other popular subjects were to be adapted to the print form: warriors, actors, children, birds and animals, and finally (though well over a century later), landscapes and rustic themes. For the time being, however, the secondary subjects of ukiyo-e were great warriors of the past and Kabuki actors of the present.

The print we reproduce in plate 24 is larger than this page. It displays an armor-clad, mounted samurai charging an unseen enemy. Unlike the erotica designed for a limited audience of dilettantes, this type of print must have appealed to adolescent boys and also to older men of samurai stock or warlike disposition. In any event, these are among the first larger-sized independent prints to be found in ukiyo-e. Their designer is unknown, but was probably the same artist (or one of the artists) who produced the erotica noted earlier. As we shall often see throughout ukiyo-e, the difference in subject matter is quite sufficient to account for variation in style.

For the two decades from 1660 to 1680 independent prints remained rare. Besides this one series of warrior prints, we also know one notable actor print in the large, *kakemono-e* format that was probably designed originally for mounting as a hanging scroll. Here, again, the only extant specimen features hand-coloring very similar to that of plate 20.

24 The Kambun Master: *Mounted Samurai. Sumizuri-e* in *ōban* size, Edo, ca. mid 1660s (early–mid Kambun Period).
Several powerful *sumizuri-e* and *tan-e* warrior prints of Edo in *ōban* size are extant from the early Kambun Period, indicating the gradual widening of subject matter beyond the primarily erotic. In such prints, the potentialities of a single woodblock are at last fully exploited, and there is complete concentration on the strong black line. (This print, the only known specimen of the design, is misprinted; there is excess margin at the bottom, and the upper part of the design is cut off.)

25 Style of the Kambun Master: *Young Kabuki Actor Playing the Samisen. Tan-e* in large-*ōban* size, Edo, ca. early 1670s (late Kambun Period). Perhaps the earliest extant ukiyo-e print in this large format (23×12.5 in./58.5×32 cm.), this work is one and a half times the length of the usual *ōban*-size print. It is interesting to compare the subject with the *Dance Performance by Kabuki Actresses* of plate 4, painted some four decades earlier, before women were banned from the stage. (At this period Moronobu's work commences and that of his mentor, the Kambun Master, gradually fades out. Although we have ascribed this print to the latter, without a signature it is really not possible to state categorically which artist was involved in a borderline work such as this early masterpiece.)

For the most part, however, the more conveniently sized book illustrations remained the principal medium of the early ukiyo-e prints, and, even allowing for the smallness of format and the strong literary-historical connotations, many of the masterpieces of early ukiyo-e can be discovered in these rare little volumes.

Throughout this period, volumes of erotica continued to predominate in the work of the ukiyo-e masters: this happened to be the favorite subject of the sophisticates of that age, and the ukiyo-e artists naturally followed the lead given by their commissions. It might even be suggested that erotica functioned, in a sense, as a means of avant-garde expression. Thus, during the first decade of ukiyo-e prints, the older artists were often left to illustrate the traditional tales and novels in traditional style, while the band of new floating-world artists sought to effect a renaissance of gaiety—the past and the present seen through fresh, vital and erotically predisposed eyes.

Moronobu's Early Work

Edo ukiyo-e, from its earliest production around the year 1660, already possessed many of the qualities that were to distinguish it in later times, at least until the revolutionary development of full-color printing a century later. Nevertheless, the style still lacked the integrating leadership of a guiding genius. This was to be provided by the first major individual artist of ukiyo-e prints—Hishikawa **Moronobu,** the master who was to consolidate the hitherto scattered styles and to set ukiyo-e firmly on its feet on the long impressive path it was to follow during the next two centuries.

Moronobu was a born artist and a born leader. He has often been dubbed the founder of ukiyo-e, but it need not detract from his fame to modify that title to consolidator of the ukiyo-e style. Indeed, had this art of the floating world ended with the experiments of the 1660s, there would have been never any unified Ukiyo-e School or any lasting style worthy of a special name. Ukiyo-e required powerful, confident leadership at this point, and Moronobu was to provide that.

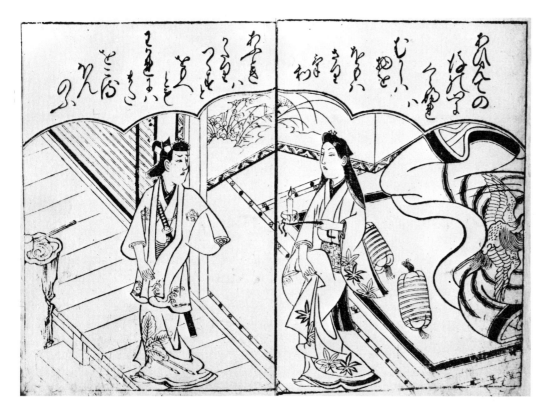

26 **Moronobu:** *Lovers Parting at Dawn.* Illustration from the shunga picture book *Wakoku bijin-asobi* [Pleasure with the Beauties of Japan], *sumi-zuri-e* in *ōbon* size, Edo, early 1670s (late Kambun Period).
Moronobu's earliest major signed book is executed in a style only a hair's breadth removed from that of his mentor, the Kambun Master. Here a young samurai (whose hairstyle, although it may look feminine, can be seen to be that of a youthful male by the shaven pate on the top of the head) is shown parting at dawn from his sweetheart, who is probably a girl of the upper classes rather than a courtesan. The rest of the book is largely explicit shunga but already displays that element of restrained intensity that was to distinguish Moronobu both from his mentor and from his many followers.

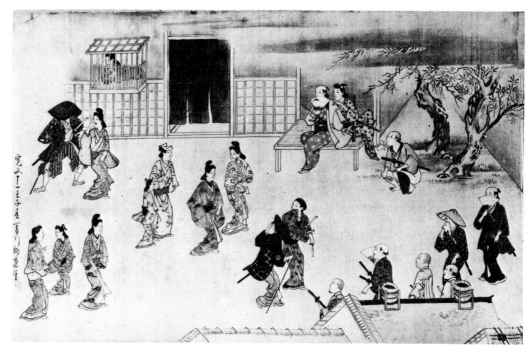

Hishikawa Moronobu (who died in 1694) was born at Hoda, on the far side of Edo Bay; his father was a famous embroiderer of rich tapestries for wealthy temples and upper-class patrons. Moronobu was doubtless tutored in his father's intricate art as well as in the painting skills that lay at its foundation. But when he came to Edo around the late 1660s, it was to the field of genre painting and illustration that he devoted his full energies. Evidently already well trained in the Kanō and Tosa painting tradition, Moronobu soon mastered the newly created style of the Edo illustrator (or illustrators), which we have shown in the previous two sections.

It is, of course, inconvenient to discuss pictures without some artist's name to which they can be attributed; hence earlier scholars have generally tried to assign all of the preliminary Edo ukiyo-e—plus, often, the even earlier Kyōto book illustrations—to Moronobu. But although Moronobu's first work naturally resembles that of his teacher or predecessor, the Kambun Master, once his own style was established, Moronobu did not deviate from it. This is the principal reason for rejecting theories that Moronobu is to be credited with the ukiyo-e done in the earlier decade.

The unknown Edo Master of the 1660s—with, possibly, an equally unknown pupil—developed a uniquely Edo style of ukiyo-e. After a brief period of imitation, Moronobu went beyond that style in the mid-1670s and continued to develop his own individual manner until his death twenty years later.

The facts, evident from a survey of the dozens of dated but unsigned illustrated books of the 1660s, point clearly to the existence of one or more Edo masters before Moronobu. It is unfortunate that we cannot know the name of Moronobu's predecessor; nevertheless, we can be sure that he existed.

In the earliest Moronobu work of plate 26, we see a refined descendant of the earlier Kambun Master. Moronobu's greatness lay in his ability to retain the elemental power of early ukiyo-e while expanding its range through his native gifts and through his training in the traditional styles of painting. Although nothing signed by him has been discovered with a date earlier than 1672, it is obvious that by that time Moronobu had already undergone considerable training both in traditional painting and in ukiyo-e itself. The first and finest examples of his early work comprise sections of a hand-painted scroll, dated Kambun XII (1672), that depict several scenes in and about the Yoshiwara, the pleasure quarter of Edo. Plate 27 shows a detail from this remarkable tour de force.

Although prints and illustrations usually form the best-known portion of an ukiyo-e artist's work, it is in the artist's paintings that we can discover his training and basic talent unconcealed by the block-cutter's knife and the printer's deft manipulations. From the painting in plate 27, it is evident that Moronobu was already a master of color, design and the intricate fashions of the time in his first work. (Without a detailed knowledge of these fashions, any ukiyo-e designer would soon have been ridiculed into abandoning his profession.) Moreover, here we see Moronobu's most striking contribution to ukiyo-e: a dynamic group composition, in which every figure takes an important part and contributes to the total effect. An examination of any one of the figures in the scene shows both how tightly interwoven the whole is and the extent to which the figures have become individuals and the composition reduced to its basic dramatic elements. There is an unseen bond between every figure in a Moronobu composition, and this, together with the dynamic line and the impassive yet sentient portraiture, is his unique contribution to ukiyo-e.

Moronobu the Illustrator

Moronobu is known in the West largely for a few rare prints. Actually, he is the supreme master of Japanese book illustration. Indeed, although Moronobu produced only several dozen prints as such, he was among the most brilliant and prolific of Japanese illustrators; at least one hundred and fifty extensive sets of book illustrations issued from his fertile brush during the 1670s and 1680s. Of these, perhaps a quarter were erotic; unlike the work of his anonymous Edo predecessor, the Kambun Master, such books formed only a portion of Moronobu's oeuvre.

Although the historical significance of Japanese book illustration, plus the interest of its subject matter, may be apparent to the average print lover, its high artistic value is less often appreciated. The smaller size and the literary format of the whole seem somehow to reduce book illustration to a matter of primarily reference value. This need not necessarily be the case. With the best of Japanese book illustration, the art lover is led from one deft and moving scene to another, the total effect far exceeding what any single print could produce. The publishers of old Japan may well have expended their greatest efforts on the prints and albums, but for the ukiyo-e artist, one feels book illustration represented his greatest and most sustained effort of creation.

To experience its optimum effect, book illustration must be examined in its total context, and if possible, the overall aim and concept of the book should be understood as well. Here, we can only provide a few select examples of the more striking single book plates from this master's wide range of work. (We may add that a selection of single plates tends to concentrate on his erotic books, for these often feature the most impressive figures and most lively scenes, as compared to the more modestly scaled work of the novels, guidebooks and miscellanea that crowd this artist's overflowing oeuvre.)

From the figures of his earliest work—evocative yet somewhat austere, even slightly wooden—Moronobu soon progressed to the more lively, dynamic style that was to characterize his mature years. Here, the designs and their backgrounds are drawn in more detail, while the figures retain in full that magnetism of group composition that characterizes this master's genius. By the late 1670s, Moronobu's figures also become fuller and more rounded. This change is perhaps in part a reflection of the increasing opulence and luxurious tastes of the coming Genroku Period (1688–1704).

In his fully developed style of the early 1680s (which is also the period of most of his single-sheet prints) Moronobu achieves a unique vision of male and female beauty that was to form the primary guiding light for most of the following century of print artists.

With the later 1680s Moronobu's achievements as an illustrator gradually began to decline, as he turned his attention more to paintings and prepared for the continuance of his unique style by training his sons and pupils. Yet even in his declining years he shows himself the preeminent ukiyo-e artist of his age, capturing, as no other master could, the charms and

28 **Moronobu:** *Young Couple.* Detail from the shunga picture book, *Imayō Yoshiwara-makura* [The *Yoshiwara Pillow* Modernized], *sumizuri-e* in *ōbon size,* 2 volumes; Edo, early 1680s (Tenna Period). The culmination of Moronobu's achievement coincides with the Tenna Period (1681–84); here he perfects a style quite removed from the Kambun Master: clean and graceful, dynamic yet fully controled. His engravers and printers surpass themselves here too by producing the ultimate from a single woodblock—a simple jet-black line.

beauties of this distinctive age of renaissance. In the rich blacks of these simple compositions, one discovers a strange power that seems almost the fountainhead and catalyst for all of ukiyo-e's later triumphs.

Moronobu and the Early Print

Strangely enough, more than half of the large album sheets and independent prints of seventeenth-century ukiyo-e consist of erotica. This is probably because these prints were still an expensive experiment, appealing primarily to the wealthy, highly select audience that also supported the erotica. In any event, there was not yet so large an audience for prints and albums as there was for illustrated books.

Most of the early prints were issued in series of twelve, bound for convenience as a folding album. Usually the first in the series of erotica and perhaps another one or two later on, were only semi-erotic in nature. One might suppose that this latter feature was an attempt to fool the censor. But in fact, the Japanese feudal government was little concerned about erotica at this period, although it was strict indeed about the printing or distribution of seditious matter or books concerning affairs thought dangerous to the stability of the government. (Curiously enough, the latter included Christianity, for the Japanese officials were much concerned that the Catholic missionaries might prove the forerunners of conquest by the Spanish and Portuguese governments which sent them.) Indeed, many of the early erotica were even imprinted with the names of both publisher and artist, whereas the ordinary books were often anonymous.

The custom of having less erotic frontispieces seems unrelated to censorship and was probably just an aesthetic device to lead the viewer more gradually into the attractions within, to provide emotional variety and perhaps also to provide something to show the children when they wanted to see the book Father (or Mother) was reading. These early albums have now generally been divided up; the rare frontispieces have gone to grace the museums of the world, while the erotic plates are collected by specialists in the subject. It is unusual nowadays to see such albums in the balanced format in which they were issued.

In this sense the album represented in plate 29 is a rarity. In its frontispieces it displays

29 **Moronobu:** *Young Lovers. Tan-e* woodblock print with hand-coloring in *ōban* size, from a shunga series, Edo, early 1680s (Tenna Period).
Flinging aside his coverlet, a naked samurai boy attempts to embrace a fully clad, somewhat older girl. This plate is from one of Moronobu's finest shunga albums, one of twelve prints among which two or three are only semi-erotic (as here); the rest are shunga (see plate 30). This famous series is known in two versions, including two alternative plates for a total of fourteen designs.

intact some of Moronobu's finest early prints, but the remainder of the album is bold shunga. The frontispiece scene we show is one sometimes found in later ukiyo-e as well: flinging aside his coverlet, a naked young samurai attempts to embrace a fully clad, older girl. It is interesting to compare this design with similar scenes by Moronobu's predecessor (see plates 18 and 22). Compared with Moronobu, the work of a generation earlier does seem a trifle primitive, for Moronobu achieves a dramatic intensity and a "magnetism of bodies" that is generally missing from his forerunners. He purposely contrasts the eager lover with the surprised girl. These designs are often done only in black and white (though hand-colored versions are also known), which are colors enough for Moronobu. Indeed, his designs are often marred, rather than improved, by the addition of hand-coloring.

We cannot but be captured by the artist's complete absorption in his subject, demonstrating an intensity of purpose that had first appeared with the Kambun Master and that will be seen, in diminished form only, in the later Primitives. This is Moronobu's famous "singing line," and no reproduction, even by woodblock on Japanese paper and with ancient ink, can recreate the marvelous art of the seventeenth-century printer, in which the blacks seem to possess an independent life of their own. The protagonists of this print are not unlike those we saw in Moronobu's early work of plate 26, but note how far he has progressed in these few years. The influence of his predecessor is now fully assimilated, and the Moronobu style appears here in its full flowering. It is a style that was to be a dominating influence on his successors.

Most of Moronobu's finest prints date from this period of the early 1680s. They come

30 **Moronobu:** *Lovers. Tan-e* woodblock print with hand-coloring in *ōban* size, from a shunga series, Edo, early 1680s (Tenna Period).
As in plate 29, a samurai boy is shown with a somewhat older girl. This print is from the same series as the previous plate.

31 Moronobu: *The Nobleman Yukihira with His Loves. Sumizuri-e* in large-*ōban* size, Edo, mid 1680s (Jōkyō Period). Title on the right: *Matsukazei Murasame.*

This is one of the rare extra-large prints which first appeared in the early 1670s (plate 25) but did not achieve popularity until over a decade later, during Moronobu's declining years. The subject is the celebrated love affair of the exiled nobleman Yukihira (brother of Narihira) with the sisters Matsukaze and Murasame (shown with the hero on the right); their story is told in the text at the top. This print is a reminder of the close relationship between ukiyo-e and Japanese history, literature and legend, as well as of the basically illustrative function of many of the prints. Here Moronobu is in his declining years; he remains the leading genre artist of his age but with a noticeable dwindling of that dynamic vitality that characterized his work just a few years earlier.

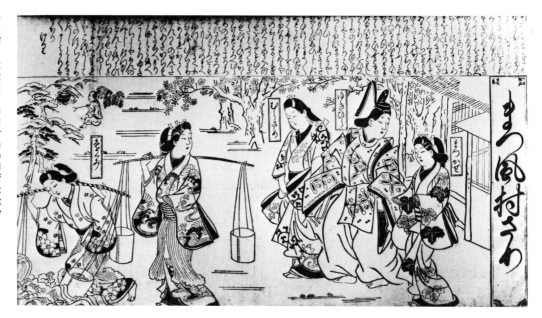

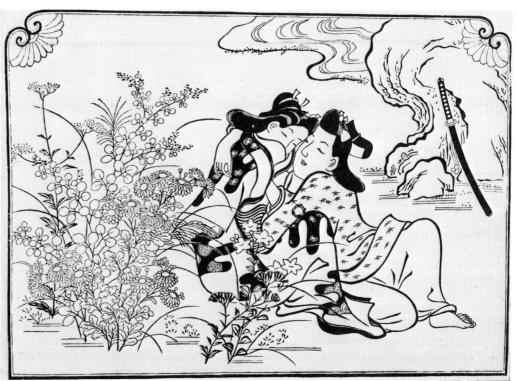

32 Moronobu: *Lovers in a Garden. Sumizuri-e* in *ōban* size from a shunga series, ca. 1682 (Tenna Period).

This is possibly Moronobu's finest print: a design in which the natural setting and the romantic mood are superbly matched in a restrained and decorative manner which surpasses the usual limitations of the shunga genre.

principally from his erotic albums, and in strength of design they are unsurpassed in ukiyo-e. Although Moronobu ranks among the important Japanese painters, it is for these bold prints that he will always be set in a world apart.

While much of his most striking work lies in the shunga genre, Moronobu also did several series of *ōban* prints devoted to the sights and scenes of Edo. A few prints in larger format have also been preserved, often taking as their subject legendary love tales, treated in a more subdued manner than in the shunga.

We close this brief chapter with another print from Moronobu's prime: the frontispiece to an erotic album, well designed to stir romantic thoughts. The bold young man on the right spontaneously hugs his bashful sweetheart as the autumn chrysanthemums bloom beside

them. It is the same setting we saw in the painting of plate 14, but here it is part of an intimate, human world quite removed from that archaic scene.

With Moronobu, all that was primitive in ukiyo-e has disappeared. Yet through his genius he was able to retain in full the early boldness and the strength of line. As long as these elements remained, ukiyo-e was to thrive and find a universal audience.

Moronobu and His School

In addition to his importance as the father of the Japanese print, there is another typical expression of Moronobu's genius—which was basically that of a figure painter—that will be found in his full-length portraits of the fair ladies of his day. Plate 33, for example, shows Moronobu at the height of his powers, in the closing decade of his active work. The girl Moronobu paints here can still be seen today on the streets of modern Tōkyō. The mind behind this girl's face is a particular one found in the work of no one but Moronobu. It is not intelligence, wit or even humor that we feel, but simply a quality (concentrated particularly about the eyes) of being vividly alive.

With this type of painting Moronobu consolidated the format of female figure portrayal *(bijin-ga)* that ukiyo-e artists were to follow throughout the years to come: a girl or courtesan, solitary or with maidservant, is depicted standing, walking or seated, often in no special setting, but eminently alive and aware that she is a symbol of all that is notable in Japanese womanhood. In such paintings as these we come as close as possible to the actual spirit of Moronobu's brushwork.

In his numerous group studies, Moronobu displays that special genius for dynamic composition that is his trademark. Whether in handscroll, screen or hanging scroll, his painting exhibits a lively beauty that symbolizes the fascinating Genroku age in which he lived and worked. Although Moronobu did not invent ukiyo-e, he did consolidate and perfect the style; he designed the first independent ukiyo-e prints; and he established, almost single-handedly, the Ukiyo-e School. It is only natural that he should be popularly considered the founder of ukiyo-e.

Moronobu seems to have been the first ukiyo-e artist to establish a true studio and teach his methods to a generation of pupils. He was not, however, particularly favored in those pupils; and as a result, the great names of the following generation—Kiyonobu, Kiyomasu,

33 **Moronobu:** *Girl Walking.* Detail of a medium-sized *kakemono* painting in colors on silk, early 1690s (early Genroku Period).
Even after his retirement from active print and book designing around 1690, Moronobu seems to have undertaken occasional special commissions for ukiyo-e paintings, such as this famous *kakemono* of a walking girl looking over her shoulder. Such works carried on the Kambun tradition of hand-painted *bijin-ga* [pictures of beautiful women] for the connoisseurs who scorned plebeian prints. These led shortly to specialized work in this genre of painting by Chōshun and the Kaigetsudō artists. For a retired master, this painting is suitably signed *Bōyō* (Moronobu's home province and place of retirement, Awa)/*Hishikawa* (surname)/*Yūchiku* (Moronobu's final nom de plume, taken after becoming a lay monk), with the seal *Hishikawa.*

34 **Moroshige:** *Ménage à Trois. Sumizuri-e* print in *ōban* size from a shunga series, mid–late 1680s (Jōkyō/early Genroku Period).
It is common in shunga to find a third party intruding in a love scene, either as a voyeur, a participant or a would-be participant (as here). Such devices were used to lend variety to a series of prints—usually twelve, as in this case—which necessarily treated the same basic theme. Moroshige's shunga work is lacking in both the intense urgency of Moronobu and the decorative eroticism of Sugimura, but in his own understated manner, Moroshige nevertheless forms a key figure in the later Moronobu School.

Masanobu, Kaigetsudō, Sukenobu—were men who, although they derived their style from Moronobu, never studied directly under him.

Moronobu's most notable immediate pupils included his son **Morofusa,** together with **Moroshige** and **Tomonobu (Ryūsen).** During the late 1680s and the 1690s, these men produced interesting, individualized book illustrations and a few rare prints. None of them appears to have turned out a continuous body of ukiyo-e work, and they often seem more like occasional artists than true professionals.

Moronobu's son Morofusa returned to a trade (dyeing and kimono design) closer to that of his ancestors after a few years as an ukiyo-e artist. This serves as a useful reminder that, however highly we honor these artists today, in their own time there was little distinction between artist and artisan, and a skilled craftsman was just as highly thought of as a worker in the fine arts. Art was so intimate a part of Japanese life at that time that it doubtless seemed artificial to make a categorical distinction between the design of a kimono, a sword blade, a teapot or a garden and the painting which decorated an alcove of the living room or the Buddhist sculpture that graced the family altar.

Sugimura

Moronobu's great tradition was continued by indirect pupils. The first of these, **Sugimura Jihei,** even seems to have been an active competitor of Moronobu's during the 1680s. Although it would be a mistake to confuse the derivative charms of Sugimura with the original greatness of Moronobu, at his best Sugimura lends a modern, profoundly erotic flavor to his prints that is his particular contribution to ukiyo-e. Indeed, this variant style was sometimes reflected more strongly in later masters, such as Kiyonobu and Kiyomasu, than was the direct force of Moronobu's own style. It is not, of course, an unknown phenomenon in art for a pupil's flashy work to outshine his master's for a time. Often, however, it was Sugimura's considerable weaknesses that were reflected in later artists, and in such cases his influence on ukiyo-e was not necessarily for the good.

Sugimura's finest work dates from the period at the end of Moronobu's prime, the mid-

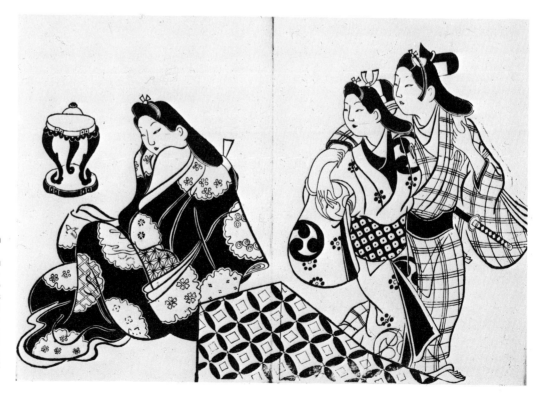

35 **Sugimura:** *Trio. Sumizuri-e* in *ōban* size, from a shunga series, Edo, mid 1680s (Jōkyō Period). With Sugimura the erotic element of ukiyo-e, long a driving force but never the sole one, becomes predominant. A voluptuous mood pervades his work to the extent that lovemaking and its preliminaries almost seem to be mankind's primary pursuit and raison d'être. In this striking monochrome composition, we sense immediately that the two lovers on the right are going off to bed and that the girl seated on the left is not too happy about it. A simple situation is portrayed here with subtle overtones that could not easily be expressed in words.

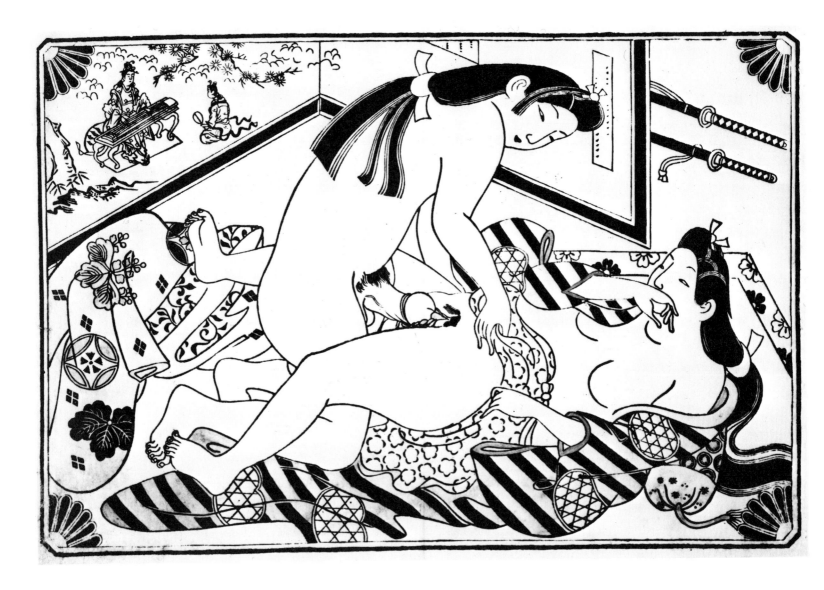

1680s. His earliest known book illustrations appeared in 1681; yet his designs of the 1690s, after Moronobu's retirement, already reveal an almost unbelievable decline (a tendency already foreshadowed in some of his earlier prints). Sugimura clearly thrived on competition and on the reflection of Moronobu's greatness and degenerated when he lost his great model.

Sugimura's prints and illustrations are remarkable in that they display a greater proportion of erotica—at least two-thirds of his work—than any other important Japanese artist. He lacked the depth and versatility of Moronobu, but he did have a flair for depicting lovers in intimate situations. In this one field, when he was at his best, Sugimura equaled Moronobu and sometimes surpassed him.

Plate 35 shows possibly the finest of Sugimura's album prints. It is taken from an erotic series of the mid-1680s. In the voluptuous softness of the plate's faces and figures, both the principal charm and the essential weakness of the Sugimura style can be seen: his designs are suffused with a decorative, decadent eroticism that fascinates at first but does not satisfy the viewer for long as does the inner strength and intensity of Moronobu.

Yet despite the spiritual emptiness in Sugimura's work, his charm is undeniable. Indeed, in his erotica he often surpasses Moronobu, whose austere grace sometimes interferes with a basically voluptuous situation. One is sorely tempted to compare Sugimura with Utamaro, that other master of sensual femininity a century later. Yet Sugimura never developed beyond the limited talent displayed in his erotica, whereas Utamaro, though perhaps

36 **Sugimura**: *Lovers. Sumizuri-e* in *ōban* size with hand-coloring, from a shunga series, Edo, mid 1680s (Jōkyō Period).

In ukiyo-e, distinguishing the boys from the girls requires a little practice: young men's coiffures, though long, usually feature a shaved tonsure at the top, although young actors often wore a cap to hide the tonsure. The patterns of young men's kimonos also tend to be somewhat less feminine than those of the girls. In this curious but striking shunga print, such clues are absent (though scarcely necessary, as the figure on the left is rather obviously male). Either the artist neglected to depict the shaven pate (a possibility that might be corroborated by the two swords laid on the floor beyond the screen), or the young man may have effected entrance into the ladies' quarters in female disguise—note the somewhat surprised expression on the girl's face.

equally "decadent," was a genius of many styles and moods and often succeeded in going far beyond the limits of the erotic subject he happened to be portraying.

Examined in conjunction, plates 20, 29 and 35 make an interesting synopsis of the development of early ukiyo-e prints: the primitive masculinity of the first, anonymous Kambun Master, the inner strength of Moronobu, the soft decadence of Sugimura.

Plate 36 represents a further example of Sugimura's work and is from another shunga album. It forms a vivid representation of frankly erotic Genroku art. This print also typifies an alternate type of hand-coloring, which existed simultaneously with the *tan-e* prints and was used mainly from the 1670s to the 1690s. The pigments are softer watercolors, similar to those employed in the *beni-e* [rose prints] and *urushi-e* [lacquer prints] of a few decades later. In Moronobu's prints such coloring tends to interfere with the bold black line; but to Sugimura's it adds a certain element of sensuality that is not without charm.

Sugimura seldom signed his prints formally, but, unusual among ukiyo-e artists, he loved to work his name into the kimono patterns (note the stylized word "Sugimura" on the kimono of the girl on the left of figure 638 and "Jihei" on the man's sash). In general, Sugimura's attention to kimono patterns might suggest that his early training lay in this field rather than in formal painting. Again, in plates 37 and 38, we see rare examples of the larger, individually issued prints of this period. Though unsigned, they bear the clear stamp of Sugimura's style and convey well the sensual mood that is his particular contribution to early ukiyo-e.

37 **Style of Sugimura:** *Scene on the Yoshida Highway.* I an-e in large-*ōban* size, Edo, early 1690s (early Genroku Period). Title on the right: *Yoshida kaidō* [The Yoshida Highway].
In one of the few extant large prints from this early period, we see here what is probably a scene from a Kabuki play: in the background O-Kuni (the founder of Kabuki) and her maidservant watch from a balcony as Ukiyo-no-suke (a foppish hero derived from the novelist Saikaku) and the effeminate young man Kantō Koroku pass on the street below. (One extant specimen of this print bears the signature of Moronobu's son Morofusa, but this is probably a later interpolation.)

38 **Style of Sugimura:** *The Poetess Koshikibu at the Kitano Shrine. Tan-e* in large-*ōban* size, Edo, early 1690s (early Genroku Period).
This is another large, rare (in this case, probably unique) print in Sugimura's distinctive style. The subject is a renowned poetess of the classical Heian Era, one of whose verses proved so moving, it was said, that even the cuckoo in an *ema* shrine painting (shown at the top) burst into song upon hearing it.

53

We have chosen Sugimura to represent Moronobu's direct followers for several reasons: he was the most prolific and successful of them in his own time, and the same decadently erotic element that fascinated his contemporaries makes him equally popular with print collectors today. Yet deviation from Moronobu's powerful, stark black line was to direct the course of ukiyo-e away from linear strength and toward more elaborate decorative coloring. With Sugimura we already sense the mutation of ukiyo-e's approach from one of linear attack to one of subtlety of mood.

Like many seventeenth-century artist-artisans, Sugimura's name, despite the popularity of his style in his own day, was almost unknown until it was uncovered by Japanese research a few decades ago. And even today, despite his distinctive style, the unsigned work of Sugimura is often classified as Moronobu in museums throughout the world.

Sugimura's success and influence stand as a reminder that popular opinion is not always a benign influence on art, even in ukiyo-e, which—at least in the prints—was by its nature a popular form, far removed from any concept of art for art's sake or of artistic integrity. Instead of lamenting the influence of popular taste, we should marvel at the extremely high level maintained by ukiyo-e during most of the two centuries it flowered. Clearly the Japanese public demanded an elevated standard of quality and taste, and the artists and publishers felt no compulsion to cheapen their works simply for some temporary gain.

The Kyōto Masters

Whereas ukiyo-e originated with the Kyōto scrolls and screens described in our first chapter, the popular prints were primarily a product of the eastern boom-town Edo. Indeed, the term *Edo-e* [Edo Pictures] is used even today in the Kyōto–Osaka region to refer to ukiyo-e in its period of full development. Quite often in early ukiyo-e it was highly trained Kyōto artists who blazed the trail, only to be outstripped later by the master artists of Edo who were less bound by convention.

Throughout most of the Edo Period (1600–1868), the popular prints of Edo failed to make much of an impression on the art lovers of Kyōto and Ōsaka. These connoisseurs preferred paintings and, at least until the nineteenth century, they favored the convenient and comprehensive picture books over the prints, which were more impressively decorative but also far more limited in scope.

When we review Japanese printing and prints during the early period, we see that—apart from several early Buddhist treatises privately published by the great monasteries—the first important, printed, illustrated books were those that appeared in Kyōto at the beginning of the seventeenth century. Initially these books were devoted to reprints of the classics, but gradually new authors, who could give expression to the tastes and ideals of the new age, began to appear. These new volumes concerned themselves primarily with love stories and secondarily with travel and practical information. The love novels were initially only pale modernized reflections of the classics, but in the mid-seventeenth century, as ukiyo-e reached its first maturity, the affairs of commoners and life in the great cities began to replace courtiers and samurai as the principal subject matter of creative literature. Indeed, it is surprising (though logical enough, for the audience was the same) how closely Japanese popular literature and ukiyo-e coincide throughout their histories. Ideals of romance, too, were undergoing a change: the high-born heroines of the earlier novels were replaced by the new heroines of the age, the courtesans, and gradually by the geisha as well as by ordinary women and girls of the cities.

Early Japanese book illustrations tended to be either classically dull or primitively crude; the latter type are interesting in one respect, however, as they were often hand-colored by artisans in the same combination of orange and green that we find in the first ukiyo-e prints. These hand-colored *tanroku-bon* [orange-and-green books] flourished all through the period from the 1610s to the 1650s, when the technique was transferred to the newly devised prints.

Though early ukiyo-e paintings were seldom dated, the new spirit of ukiyo-e can be

traced very accurately, year by year, in the illustrated books of Kyōto, some of which we show in figures 2, 3 and 4. The nascent concern with the portrayal of everyday life and customs appears in these books as early as the 1620s, but it was not until the mid-century that a new, truly ukiyo-e style developed to do it justice. At least three major illustrators worked in Kyōto during the 1650s and 1660s, but unfortunately none of their names are known, and their work was done mainly in the form of block-printed book illustrations, a maximum of 8×6 in./21×15 cm in size, so that, outside Japan, they have been neglected by collectors and scholars alike. Nonetheless, they constitute the true incunabula of printed ukiyo-e, and it was through these pioneers that the early Edo masters acquired their basic training.

The earliest Kyōto ukiyo-e illustrator known to us by name is Yoshida **Hambei,** who worked from about 1664 to 1690. He was a pupil of one of the anonymous masters mentioned above and an exact contemporary of Moronobu. During this period Hambei dominated book illustration in both Kyōto and Ōsaka, the acknowledged literary centers of Japan at the time. The sum of Hambei's oeuvre during this long period must come to well over one hundred books, totaling several thousand separate illustrations. He stands with Moronobu, Sukenobu and Hokusai as one of the most prolific Japanese illustrators. Yet Hambei does not, even in the single field of illustration, quite rank among the true masters of ukiyo-e. His illustrations are consistently adroit and well thought out but clearly the work of a talented master rather than of an artistic genius.

Probably Hambei's most famous work is his *Joyō Kimmō-zui* [Ladies' Pictorial Encyclopedia], which includes a notable series of twenty-two full-length portraits of girls modeling rich kimonos. Had these been issued as single prints in a larger size, connoisseurs and collectors today would no doubt consider Hambei on a level with such notable masters as Sugimura, the Kaigetsudō or Toyonobu. As it is, his name is known only to specialists.

We have chosen for illustration here a recently rediscovered shunga book by Hambei that reveals both his charms and his limitations. Hambei's work has achieved fame in Japan less for its intrinsic interest than for the fact that he illustrated many of the books of the famed Ōsaka novelist Saikaku, who wrote primarily during the period of Hambei's greatest activity, the 1680s. Ten of Saikaku's works boast abundant illustrations by Hambei, and some ten others are illustrated by the two anonymous pupils who succeeded Hambei after his death or retirement around the year 1690.

Interestingly enough, some of the most engaging illustrations of the late seventeenth century derive from the brush of Saikaku himself, who as an amateur illustrated some ten books of his own or by his friends, particularly during the 1680s. Saikaku's illustrations offer an interesting example of the realization of an artistic ideal in the face of inadequate formal training. Despite the occasional amateurish distortions of his designs, Saikaku often succeeds in conveying a lively realism of stylish beauty that is rare in Hambei and in other contemporary professionals. He imbues his figures with a living power that often makes up for his technical defects.

Hambei had both imitators and pupils, such as Shimomura **Shichirobei** (a complete set of the latter's *ōban* shunga prints has only recently been discovered) and other illustrators of the period include **Jōhaku, O-Tsuna** and **Genzaburō,** but in general the following decade of the 1690s represented, both in Kyōto and Edo, one of the low points of ukiyo-e. The direct pupils of both Hambei and Moronobu either died out or failed to live up to their traditions. It was not until around the year 1700 that, in Edo, such indirect followers of Moronobu as Kiyonobu and Masanobu bestirred themselves to save the cause of this precious yet nearly moribund art.

In Kyōto too, 1700 marks the rise of new figures in the ukiyo-e field, men who, though followers of Hambei, were to incorporate something of the Edo vigor in their works. One of the first of these artists was Ōmori **Yoshikiyo,** who illustrated some twenty books during the years 1702–16 and designed several large albums of courtesan prints—rare among the Kyōto illustrators—in a manner rather reminiscent of his Edo contemporary Masanobu, who was also just commencing work. In Yoshikiyo's stolid figures, in which are joined the styles of Moronobu, Kiyonobu and the Kaigetsudō, some of the most impelling designs of Kyōto ukiyo-e can be found.

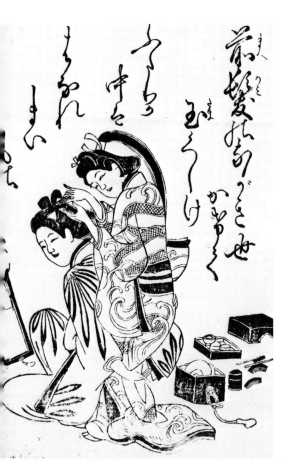

39 Hambei: *Girl Dressing Her Lover's Hair.* A plate from the shunga picture book *Uruoi-gusa* [Charmingly Wet Grasses], *sumizuri-e* in *ōbon* size, 2 volumes; Kyōto, ca. 1680 (late Empō Period).
The early ukiyo-e masters of Kyōto produced hardly any large prints and hence have been quite neglected by most collectors and curators. Their picture books contain, however, a variety of fascinating designs of which the Hambei plate shown here is a typical example. Hambei's style is obviously more formal and static than Moronobu's, but his best designs rank among the masterpieces of the early Primitive period. The appeal of his doll-like figures, once savored, is not inferior to that of his Edo competitors. Indeed, in his imaginative arrangement of background elements and accessories, Hambei may well have influenced Moronobu's follower Sugimura, who was just starting work at this time.

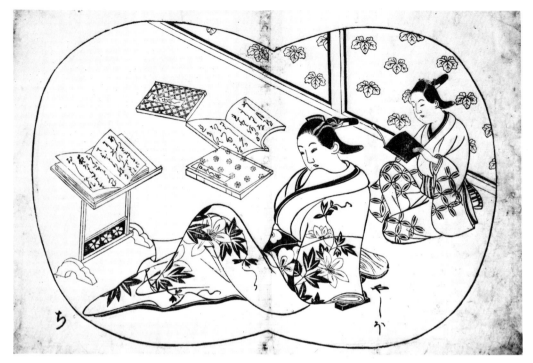

40 **Yoshikiyo**: *Courtesan and Young Maidservant. Sumizuri-e* in *ōban* size, print from an album, Kyōto, ca. 1702 (late Genroku Period).
Hambei's followers produced little work of note, and Kyōto illustration did not thrive again until the end of the Genroku Period, when Yoshikiyo and Sukenobu started to work. Yoshikiyo's style might be said to derive from Moronobu via Kiyonobu: he attempted to amalgamate the forcefulness of Edo ukiyo-e with the more static, classical Kyōto style. This plate is from an album of genre scenes depicting famous Kyōto courtesans—in this case, Yashio, shown at leisure leaning against an armrest and reading from the *Man-yō-shū* and other classics.

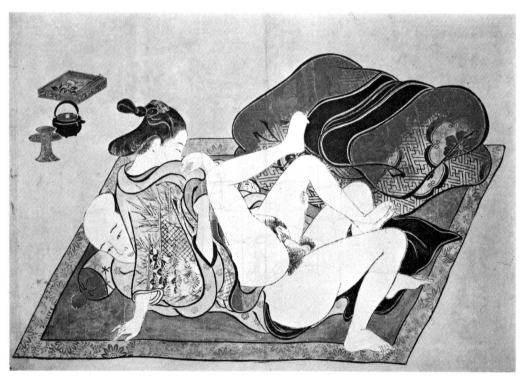

41 **Sukenobu**: *Lovers. Tan-e* in *ōban* size, from a shunga series, Kyōto, early 1710s (Shōtoku Period). Early Kamigata (Kyōto and Ōsaka) prints appeared primarily in the shunga genre; Sukenobu's rare works in this field represent some of his best designs. The style is more subdued and genteel than that of the Edo masters and, likewise in accord with the tastes of the old capital, this notable series is usually found elaborately hand-colored and mounted in scroll format.

The dominant figure in eighteenth-century Kyōto illustration was Yoshikiyo's long-lived contemporary Nishikawa **Sukenobu** (1671–1750). Sukenobu's prolific output exceeds even that of Hambei or of Moronobu and totals some two hundred books with many thousands of illustrations, which maintain a remarkably even level of quality and grace. Like several of the greatest ukiyo-e figures, Sukenobu had undergone extensive early training under noted masters of the traditional Kanō and Tosa Schools. He only turned to popular art in his late twenties, around the year 1698. His life's work was divided (apart from occasional painting) between his miniature illustrations for the novels and miscellanea of the time and

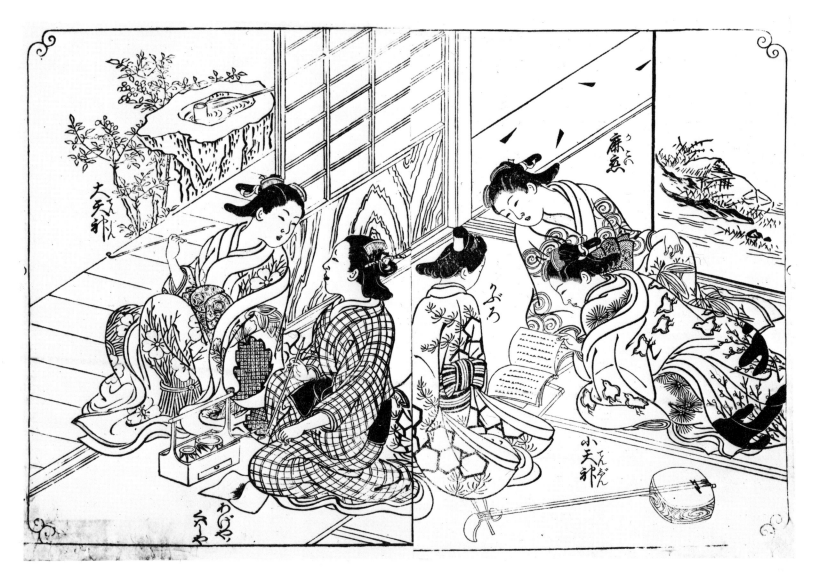

42 **Sukenobu**: *Courtesans at Leisure.* An illustration from the picture book *Hyakunin-jorō shinasadame* [A Critique of One Hundred Women], *sumizuri-e* in *ōban* size, 2 volumes; Kyōto, dated Kyōhō VIII (1723).

Sukenobu was the acknowledged master of illustration in Kyōto during the first half of the eighteenth century. The present illustration is from his most comprehensive work depicting the classes of Japanese females—from the Empress and court ladies to working women, and including several varieties of courtesans and harlots. (Because of this combination of features, the book was banned by the government for lèse-majesté.)

his picture books, in which the illustrations predominate, with only a minimum of verse or other supplementary text. Sukenobu's picture books cover a wide variety of subjects, from contemporary events, amusements and festivals to the tales and legends of antiquity. His perpetual theme, however, whatever his immediate subject, is the grace and beauty of Japanese womanhood, a theme which he never tires of depicting and which few connoisseurs have ever tired of contemplating. There is a remarkable uniformity to Sukenobu's huge output, and every collector has probably had the experience, at an auction or bookstore, of falling under the spell of a Sukenobu volume, only to find upon bringing it home, that he possessed it already! Sukenobu is, in this writer's opinion, the only ukiyo-e artist whose work is never monotonous or repetitive even though it shows so little apparent variety.

Like most of the ukiyo-e artists, Sukenobu designed erotica on commission from publishers, and several of his rare albums are in this genre, which consists of a series of a dozen large single-sheet prints bound together. In addition, Sukenobu's skill at kimono design was so great that he was often hired to create patterns for the great dyers of Kyōto, the center of Japanese textile art. He was even commissioned to produce numerous volumes of printed designs for the guidance of the kimono-makers.

However Sukenobu's most typical work lay in his dozens of volumes of graceful illustrations depicting either the dreamworld of classical romance or the daily life and amusements of the women of Kyōto. No scenes could better typify the refined, halcyon pastimes of the

old capital, a world fast disappearing today, yet preserved for eternity in the gentle pictures of Sukenobu. This artist's subdued conception of lovely, unobtrusive grace (perhaps closer to actual Japanese womanhood than that of any other artist) was to wield a far greater influence on ukiyo-e than one might have imagined. Of Sukenobu's contemporaries, few failed to absorb something of his quiet loveliness, and in the great Harunobu, he found a noble follower who was to adapt his ideal and raise it to the very pinnacle of art, so that the gentle style of this neglected Kyōto master infused its spirit into ukiyo-e for a full half-century to come.

Kivonobu

Torii **Kiyonobu** was an artist who took Moronobu's style as his model and learned his lesson well. A series of circumstances was to enable the new Torii style to practically dominate much of the ukiyo-e print world during the first half of the eighteenth century. Kiyonobu (died 1729) was born about 1664 in Ōsaka, the son of Torii Kiyomoto, an actor and occasional painter of the colorful billboards that grace the entrances to Kabuki theaters even today and are still sometimes painted by descendants of the Torii family. Kiyonobu followed directly in his father's artistic footsteps, but with a significant difference: the family moved to Edo in 1687, and young Kiyonobu immediately fell under the spell of Moronobu, producing his first work of book illustration later in the same year.

This new combination of the dynamic, disciplined vigor of Moronobu with the bombast and hyperbole of Kabuki was to dominate not only the theatrical-art world for half a century but also ukiyo-e in general for much of that period. It is probable that Kiyonobu underwent some brief training in ukiyo-e even before coming to Edo, no doubt under the influence of the Kyōto illustrator Yoshida Hambei. Kiyonobu's first signed works already show some of the inclinations of his more fully developed style: although the interrelation of his figures is not as skillful, he places a greater emphasis on action than we customarily find in Moronobu; in Kiyonobu's work each figure seems to be posing as though in a play.

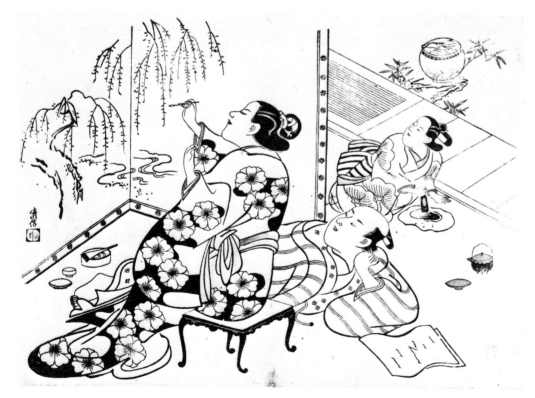

43 **Kiyonobu:** *Lady Painter with Patron. Sumi-zuri-e* in *ōban* size with hand-coloring, the frontispiece to a series of shunga prints; Edo, the last print is dated Shōtoku I (1711). Signature: Kiyonobu, with seal.
While lacking the dynamic control of Moronobu or the intense eroticism of Sugimura, Kiyonobu brings to ukiyo-e the "solid flesh" that was the ideal of his age, the early eighteenth century. Here, incidentally, the basic tools of the Japanese painter can be seen: the narrow brush for fine lines and the wide brush for thick washes. On the right, a maidservant grinds an inkstick in water to produce *sumi*, the basic black pigment of both paintings and prints.

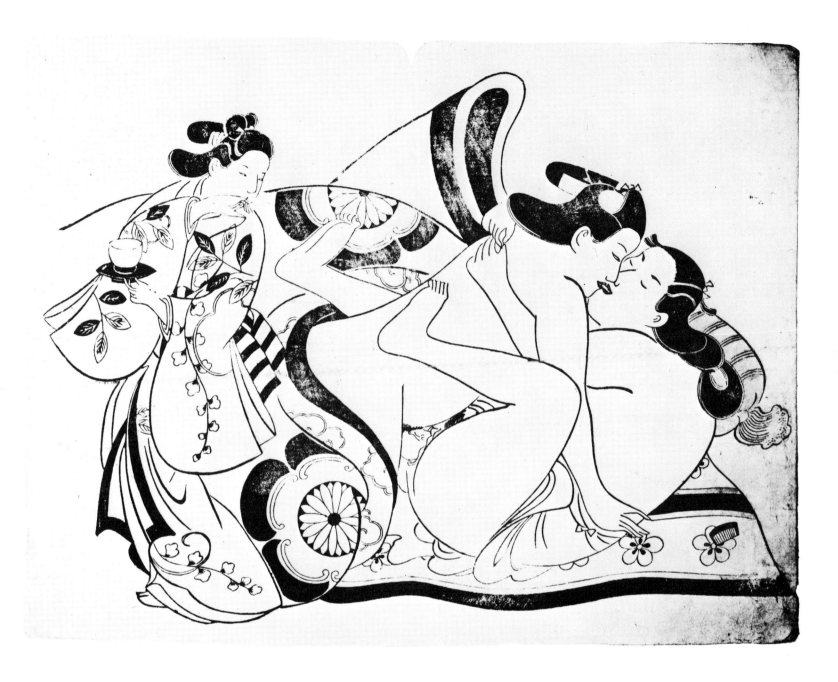

44 Kiyonobu: *Love Scene. Sumizuri-e* in *ōban* size, from a series of shunga prints, Edo, early 1710s (Shōtoku Period).
In this powerfully erotic work, a young samurai is shown with an older girl, probably a courtesan; the awed maidservant on the left carries a teacup.

Throughout the 1690s Kiyonobu continued to work at the illustration of novels and plays, as well as assisting his father with the Kabuki billboards that were fast becoming the family monopoly. Unfortunately, hardly any of these grand paintings have survived. In Kiyonobu's book illustrations of the period, however, we note an increasing attention to dramatic values, a greater stylization of human figures and a mounting awareness of the differing requirements of painting and of the woodblock print.

Kiyonobu's first large-scale illustrations date from 1700 and appear in his *Actor Book*, comprising full-length portraits of the Edo Kabuki actors in role, and in his *Courtesan Book*, an album devoted to portraits of the noted Yoshiwara beauties of the time. Although the characteristic Torii figure derives from Moronobu, so much of bombast and dramatic exaggeration has been added that we are quite ready to concede that it is Kiyonobu's unique invention. It forms the basis both of his style and of Kabuki prints for the next eighty years or more. (Indeed, it may even have influenced Kabuki itself, for Kiyonobu's vision of the actor's art at its ultimate peak of tension must surely have helped standardize and intensify the actors' poses in an age when Kabuki was still in its formative stage.)

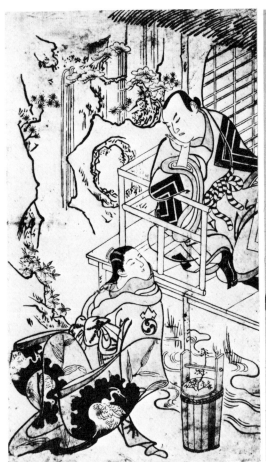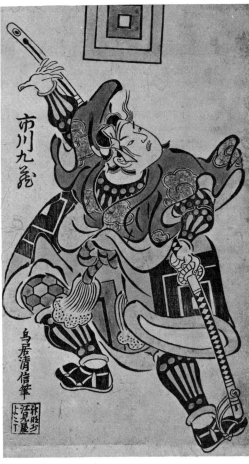

45 **Kiyonobu:** *Maiden and Ascetic. Tan-e* in large-*ōban* size, Edo [Henceforth, unless otherwise specified, the place of publication is Edo.], ca. 1715 (Shōtoku V). Signature: Torii Kiyonobu *zu [pinxit].* By the 1710s, depicting Kabuki had become practically a monopoly of the Torii artists. In this noteworthy, large *tan-e* print, Kiyonobu portrays, on the right, the famous actor Ichikawa Danjūrō II in the role of Narukami, a sinister wizard who, with his magic powers, has cut off the water supply of the capital. Below him is the Princess Taema (played by the female impersonator Nakamura Takesaburō), who has come in order to break the spell with her feminine wiles. The actors are not identified by name but by the prominent *mon* that decorate their kimonos: *mimasu* [concentric boxes] for Danjūrō and a variation on the *tomoe* [comma pattern] design for Takesaburō. This is probably a depiction of the well-known play *Narukami-shōnin* (first staged in 1684) in the performance given in the Fifth Month of Shōtoku V (June, 1715) at the *Nakamura-za* [theater] in Edo.

46 **Kiyonobu:** *Kabuki Actor on Stage. Urushi-e* in *hosoban* size, 1718 (Kyōhō III). Signature (on lower left): Torii Kiyonobu *hitsu*; publisher (recorded in box on lower left): Emi-ya.
The actor Ichikawa Kuzō (identified on the left by name) is shown here in a dramatic pose in the role of Miura Arajirō from the Kabuki play *Zen-kunen yoroikurabe* [Translation of the complex Kabuki titles with their typical plays on words and elliptical references to earlier works will not be attempted in the limited space of these captions.], performed in the Eleventh Month of Kyōhō III (December, 1718) at the Morita-za in Edo. As in the previous plate, the family *mon* of the Ichikawa line of actors is displayed prominently, both on the kimono and at the top of the print. This work represents an early example of the lacquer print [*urushi-e*], small in size when in *hosoban* format (about 12.5×6.5 in./32×16 cm.) but featuring richer and more elaborate coloring than that of the earlier *tan-e.*

Within a few years of 1700 Kiyonobu had already developed his full powers as a printmaker, both in actor prints and in the floating world of love scenes and courtesan prints. Plate 43 shows one of his finest album plates, part of an erotic series with designs vaguely reminiscent of Sugimura but displaying a solidity of composition and a rich boldness of "black coloring" that was seldom to be equaled in ukiyo-e. Kiyonobu was never quite the master of kimono design that Moronobu and Sugimura (not to mention the Kaigetsudō) were, but the total effect of such Kiyonobu plates is nevertheless one of balanced volume and latent power. These girls and men are among the boldest in ukiyo-e; features and form are clearly derived from the model of Moronobu but strikingly display the roundness and volume that distinguish Kiyonobu's figures. If the total effect is more often that of a pattern than of an erotic scene, that too is one of Kiyonobu's characteristics.

Like most of the ukiyo-e masters, Kiyonobu was an expert in erotica (including several pederastic series involving gay actors) but his love scenes are almost never sexual or sensual; they are bold, sometimes crude patterns, in which nude bodies play only a part, however integral. They form a curious chapter in Japanese erotica, prints whose sexual content is largely lost in the overpowering pattern of the participants' bodies.

Kiyonobu's varied output in the first three decades of the eighteenth century includes—in addition to his basic work in Kabuki posters and billboards—*kakemono* paintings, many volumes of book illustrations and a number of strong and masterly actor and courtesan prints in large format (many of them unsigned). Kiyonobu's late works, smaller in scale and done in a quieter, more graceful manner, are often difficult to distinguish from the oeuvre of his successor Kiyonobu II. Though charming, they reflect the gradual loss of vitality that characterized post-Genroku society as a whole. By this time the Japanese renaissance was clearly beginning to lose momentum.

Kiyomasu

Strangely enough, the characteristic prints of the early Torii School are most often signed "Torii Kiyomasu," the name of an artist who may possibly have been Kiyonobu's younger brother. **Kiyomasu** (who worked from the late 1690s to ca. the early 1720s) has always represented an enigma in ukiyo-e history. His work is often hardly distinguishable from that of his brother-artist. With close attention, however, we can discern the younger artist's softer, lighter touch and his characteristic variations in linear gradation; but the principal feature of his style lies in its relative grace and delicacy, as opposed to Kiyonobu's more primitive vitality. Even more than Kiyonobu, Kiyomasu patterned much of his early work on Moronobu's decadent competitor Sugimura, and he was one of several important ukiyo-e artists to do so. Something of the loss of masculine vigor and the lack of "seriousness of intent" that were to characterize part of the productions of the Torii School—particularly in its second and third generations—may be attributed to this displacement of Moronobu as a model.

Although large signed prints by the elder Kiyonobu are rare, those by Kiyomasu are numerous, probably indicating that the older artist spent his time at the more prestigious business of painting Kabuki billboards and designing playbills and illustrations, leaving the print field to the younger man. At the time, of course, this official work for the Kabuki theater was considered the most important function of the Torii clan and was left to the current head of the Torii School. Thus, paradoxically, we possess a great many of the popular prints of Kiyomasu, while most of the magnificent billboards and other paintings of the founder of the school have long since been lost. These large prints of courtesans or actors, whether by Kiyomasu, Kiyonobu or the Kaigetsudō, represent one of the crowning glories of the ukiyo-e print. It has been aptly remarked that the importance of a print collection can usually be judged by how well such prints are represented.

Although Kiyonobu was clearly the more active of these confreres in the fields of painting and of erotica, Kiyomasu's refined touch is apparent in the few works of these genres attributable to him. In a more intimate mood, plate 48 shows one of the finest of Kiyomasu's love scenes: a large, horizontal print in black and white, with orange and pale yellow hand-coloring. The scene is that perennial favorite of ukiyo-e artists: the interior of a Yoshiwara boudoir, showing the courtesan with her lover. Here the setting is summer, and the lover reclines within the mosquito netting, his robe loosely wrapped about him. The fine lines of the mosquito net are indicated by a faintly hand-painted pattern in yellow. In the center the majestic Yoshiwara courtesan sits with her elbow resting on a tasseled pillow, saké cup in hand. On the right squats the little maidservant, drawn, in one of the conventions of early ukiyo-e, like a miniature adult rather than a child. The man's kimono is simple enough, but the maidservant's reveals a design of large plum blossoms, and the courtesan's has a pattern of those lacquered *inrō* cases that are so favored by Western collectors today. In the background a screen displays irises near a stream. This print is of the *tan-e* [orange print] variety and is distinguished by its dramatic employment of that primitive coloring.

As was noted earlier, such scenes often served as frontispieces to erotic albums. The present work, however, is of a size much larger than usual and was almost certainly issued as an independent print. Its buyers were doubtless the rakes or would-be rakes of the day. Since a round of such pleasures as are shown here cost at least the equivalent of several hundred dollars, these pictures may well have been bought by junior clerks and rising tradesmen as a (hopefully) temporary substitute for the real thing. They also formed an excellent souvenir for the wealthy connoisseurs and dilettantes whose business affairs, or residence distant from Edo, prevented them from visiting the floating world as often as they might have wished. Whatever the nature of the contemporary audience, however, such prints stand as rare examples of the early Torii School at its peak, exhibiting a graceful, self-possessed eroticism that pleases as much by its artistic pattern as by its subject.

In the 1710s, after nearly three decades of activity, Kiyonobu seems to have turned over part of his Kabuki work to Kiyomasu. During the years 1715 and 1716 the latter designed an impressive series of black-and-white prints featuring the great actor Danjūrō II in his various

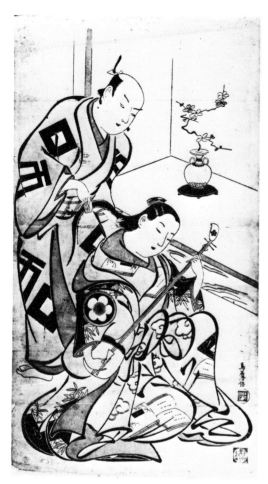

47 Kiyomasu: *Courtesan and Lover. Tan-e* in large-*ōban* size, early—mid 1710s (Shōtoku Period). Signature: Torii Kiyomasu, with seal; publisher (seal on lower right): Nakajima-ya.
Kiyomasu excelled in depicting powerful love scenes in large format, such as this remarkable design showing a courtesan playing the samisen as her lover combs her long black tresses. From the prominent *mon* on the kimonos, this is very probably a Kabuki print, picturing Katsuyama Matagorō as the patron and Uemura Kohachi as the courtesan in a Soga Brothers play. Genre works of this type are perhaps best enjoyed for their splendid design and romantic mood, rather than as souvenirs of a specific theatrical performance long since forgotten.

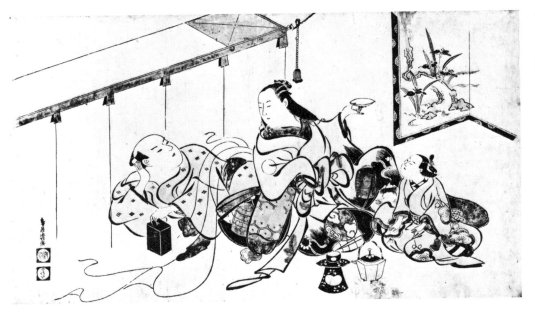

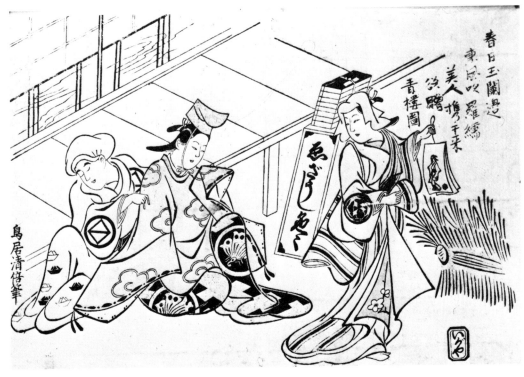

48 **Kiyomasu**: *Courtesan with Her Lover. Tan-e* in large-*ōban* size, early–mid 1710s (Shōtoku Period). Signature: Torii Kiyomasu, with seal; publisher (lower seal): Nakajima-ya.
This Yoshiwara summer scene takes place in a house of assignation: a patron reclines under the mosquito netting as a courtesan holds a saké cup and a little maidservant sits in attendance. The hand-coloring makes bold and effective use of rich orange and mustard-colored pigments, including unusually detailed hatching for the netting. (The screen at the rear bears the seal of the early Japanese art dealer Wakai: the practice of marking an acquisition in this way would not be condoned today.)

49 **Kiyomasu**: *Masseur, Young Nobleman and Girl Bookseller. Urushi-e* in *chūban* size, ca. 1717 (Kyōhō II). Signature: Torii Kiyomasu *hitsu*; publisher (seal on lower right): Iga-ya. On the right is a manuscript verse added by an early owner.
This print has been described in the text and provides a good example to illustrate the basic methods and problems of dating Kabuki prints. From its artistic style and printing technique, this work can be classified as a product of Edo ukiyo-e from between 1716 and 1720 (early Kyōhō Period); this first stage of inquiry is of course vital in delimiting the approximate dates of the plays and actors. To be accurate, such dating must obviously be based on experience, but a careful study of accurate reference works will provide basic guidelines. From his butterfly crest, the center figure may be identified as the Edo actor Sanjō Kantarō (fl. 1711—19). A similar *mon* was used by the earlier actor Nishikawa Kōnosuke (fl. 1700–1702), who worked, however, before the stylistic period of this print. Judging again by the crest, the female figure on the right represents the Kamigata actor Ichimura Tamagashiwa, who appeared in Edo Kabuki only during the years Shōtoku V/11 to Kyōhō III (i.e. late 1715 to 1718). [The Japanese lunar calendar fell several weeks later than the Gregorian, hence dates are necessarily approximate.] Thereafter he returned to Ōsaka and thus is not recorded in general reference books on ukiyo-e. By assiduously studying early Kabuki chronologies, it may be ascertained that Kantarō and Tamagashiwa appeared together only at the Ichimura-za and only from Kyōhō I/11 (December, 1716) to Kyōhō III (1718). Of those plays in which these two stars appeared together, this is most likely *Kinkazan yoroi-biraki*, performed in Kyōhō II/11 (December, 1717); but descriptions of this particular scene have yet to be discovered. Thus, the print can be dated, as an educated guess, at about 1717. Having arrived at this approximate date, the authorship of the print must be reviewed, for although the style and signature seem to be clearly those of Kiyomasu I, by some accounts (probably erroneous) that artist died in Kyōhō I/5 (ca. June, 1716). This example will demonstrate that a simple caption to a simple print can bring the student face to face with problems practically insoluble on the basis of our present fragmentary knowledge.

roles. An equally notable Kabuki print is shown in plate 49. It was originally a "lacquer print": the hand-coloring was accomplished with lustrous vegetable pigments, in imitation of lacquerware, with "gold dust" (actually brass) sprinkled on some of the wet pigments to give sparkle to the print. Today the colors are faded, and the print is just about as effective in monochrome, as shown here. The scene is from a Kabuki drama and features three well-known actors: the one on the left plays the role of a blind masseur, in the center is a fair young man of the nobility and on the right a lovely girl (doubtless some princess in disguise) reduced to selling picture books and prints on the streets. A potential love story is implied in the girl's amorous glance and the young man's shy response. Apart from its considerable artistic interest, this print is notable as one of several that show how books and prints were hawked about the streets of eighteenth-century Edo in a period when each printshop and bookshop was its own publisher and its own retailer. The batch of prints that the girl dangles

from her left hand is of the narrow lacquer-print format just coming into vogue at that time. This print is of a reduced size that was both inexpensive and ideally suited to intimate portrayals of the actors or reigning beauties of the day. It represents a late work of the artist, at a time when his style was evolving into the more miniaturistic manner that was to characterize his successor, Kiyomasu II.

Although few early ukiyo-e dates are reliable, Kiyomasu appears to have died fairly young, probably in the early 1720s. He was not the energetic and startling innovator that Kiyonobu was, but he did create an ideal of fluent grace that was to dominate the work of the Torii School for the next half-century. It was Kiyonobu who established the bold, dynamic forcefulness of the Torii School, but it was Kiyomasu who adapted that style to portraying serene beauty whether on the stage or in the outer world.

Kabuki and the Early Print Masters

We have already briefly outlined the development of the Kabuki theater in seventeenth-century Japan. Although the effect was by no means immediate, the banning of women and pretty boys from the stage and the discouragement of sex exploitation in performances had, by the end of the century, resulted in a trend toward an emphasis on acting ability rather than on good looks (though the graceful actors who specialized in female roles still did their best to act like women in all too many ways, both on stage and off). The ideal in acting in general began to tend toward the kind of elaborately stylized realism that still characterizes Kabuki today.

The Genroku Era around the turn of the century was in many ways the consolidating period of Kabuki: to the dance performances of the earliest "O-Kuni Kabuki" were added the simple dramas of mid-seventeenth-century Kabuki. More advanced plots, music and methods of staging were also adapted from Japan's unique puppet drama—which was technically far more advanced than the theater of the live actors. With Genroku also came a cleavage between the rough, violent style of Edo Kabuki and the more romantic, polished manner favored in Kyōto and Ōsaka. Although the *Kamigata* (Kyōto-Ōsaka) region was to remain the literary center of Japan for some years yet, from the Genroku Period onwards both the Kabuki and the ukiyo-e that celebrated it were primarily centered in Edo, where they have remained until modern times.

Ukiyo-e prints form a good barometer of the state of Kabuki at any given period, and it is no coincidence that the great Kabuki prints of Kiyonobu and Sharaku lie within the two greatest periods of Kabuki development, the beginning and the end of the eighteenth century. Just as the Yoshiwara formed the center of the sophisticated Edo male's social life, so the Kabuki theater constituted, in a different sense, the primary amusement of Edo womanhood. This alone is enough to explain the huge number of actor prints produced during the eighteenth and nineteenth centuries. Indeed, in terms of buying power the three thousand secluded and sexually neglected ladies-in-waiting of the Shōgun's harem in Edo formed enough of a print audience alone to support several artists and publishers. As is apparent from the occasional scandals of the period, this enthusiasm on the part of the tycoon's ladies sometimes went too far; but for the most part it must have been a tragically sublimated attachment to the actors that brightened their abstinent lives within the confines of Edo Castle.

Like practically everything else in Japanese life, the Kabuki theaters were strictly regulated by the feudal authorities. Edo was limited to four theaters with their troupes; when one of these was closed down because of a major scandal in 1714 (involving a handsome actor and a high-ranking court lady), the number was reduced to three and not enlarged until after the Meiji Restoration of a century and a half later. Due to the danger of fire, performances were limited to the daylight hours, though mirrors and other clever devices were used to achieve various special lighting effects. The basic stage was patterned on that of the classical Noh drama, and this was gradually adapted to the special needs of Kabuki. In the mid-1730s the *hanamichi* [flower path] was added, a narrow extension of the stage that

50 **Kiyomasu:** *Gorō Uprooting Bamboo. Tan-e* in large-*ōban* size, ca. early 1700s (late Genroku Period). Signature: Torii-*uji* [family name] Kiyomasu *zu*, with seal; publisher (lower seal): Iga-ya.
This powerfully designed, boldly colored, early Kabuki print represents the celebrated actor Danjūrō I, founder of the Ichikawa line of actors, in the role of the Soga brother Gorō. He is shown here uprooting a giant bamboo tree to vent his anger. Danjūrō returned to Edo from his Kamigata apprenticeship on New Year's Day of Genroku X (February, 1697) and first performed this role at the Nakamura-za in the Fifth Month of the same year, as well as several times subsequently before his death in 1705 (he was stabbed by a fellow actor). Several other early representations of this renowned role exist. Once a brilliant role became inextricably associated with one actor, depictions of the role were doubtless issued without reference to any specific current performance of the play. On purely stylistic grounds we would tend to date this print to several years after the first performance of the role; indeed, it is the writer's conviction that stylistic considerations should always take precedence over supposed literary evidence.

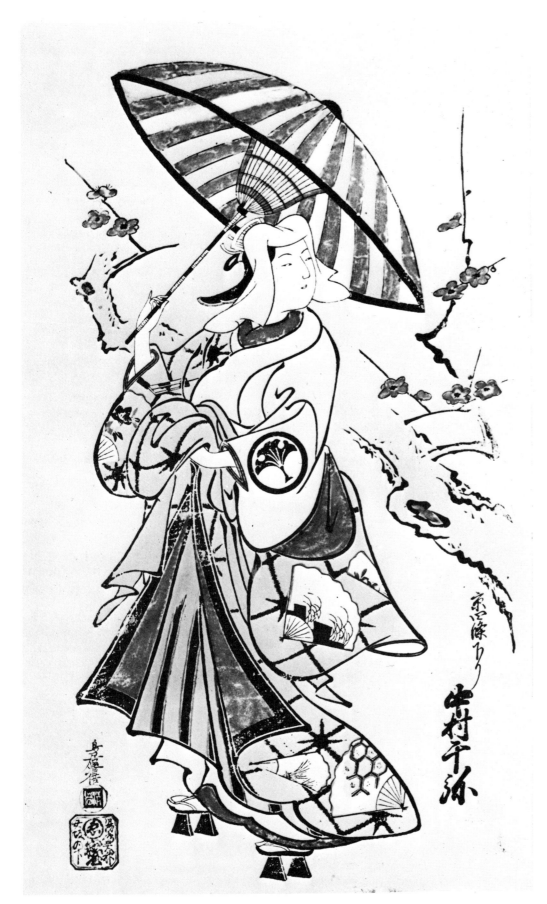

51 **Kiyomasu:** *Maiden with Parasol. Tan-e* in large-*ōban* size, 1716 (Kyōhō I). Signature: Torii Kiyomasu, with seal; publisher (lower seal): Komatsu-ya.

In one of the foremost designs of the Torii School, the female impersonator Nakamura Senya is shown here in the role of the maiden Tokonatsu, standing beside an aged but flowering plum tree. Bold *tan-e* coloring ideally complements the strong yet gracefully feminine design. The legend in the lower right-hand corner identifies the actor with the notation *Kyō-Shijō-kudari*, "newly arrived from the Kyōto Kabuki"; he played this role in Kyōhō I/11 (December, 1716) at the Nakamura-za in the drama *Mitsu-domoe katoku-biraki.* This famous design is known to exist in three different versions with block variations; surprisingly, the interrelationship of the various states has yet to be fully studied.

stretched right through the midst of the audience to the back of the theater, and some three decades later, the revolving stage was introduced.

Just as the Kabuki theaters were kept under close surveillance by the government, so life among the troupes and the actors themselves was quite strictly governed by matters of precedence and protocol, as it still is today. Obviously no ordinary artist could be trusted to prepare the complex theatrical billboards and playbills. Thus from the end of the seventeenth century, the Torii clan became the exclusive official artists of Edo Kabuki. Of course, their "exclusive rights" pertained only to official publications of the theaters. But actually, as long as the Torii artists maintained their artistic predominance, a majority of the popular prints from the first half of the eighteenth century (sold as souvenirs of each performance) issued from their studios as well. To this artistic monopoly we owe some of the finest and most powerful of all ukiyo-e prints: evocative records of masterful performances and consummate actors, who would otherwise be known to us today in name only.

Masanobu

If one master were chosen to demonstrate the wide range of forms in ukiyo-e, it would surely be Okumura **Masanobu**. This artist's long life (ca. 1686–1764) spans the period from the early black and white prints and the great hand-colored *tan-e* through the *urushi-e* ["lacquer prints"], small and large, to the *benizuri-e* [rose-printed prints] that precede the development of full-color printing. In addition, Masanobu worked in practically all the experimental ukiyo-e forms of the first half of the eighteenth century (and may have invented several of them): triptychs, bust portraits, Buddhist subjects, "stone-rubbing" prints, large perspective prints, elongated pillar prints, the early landscape and flower-and-bird prints. Moreover, unlike several other long-lived ukiyo-e artists, Masanobu's production is surprisingly even. From his first black-and-white prints, done in his early teens, to his last "rose print" designed in his mid-seventies, there is no flagging of that inventive genius and native wit that characterize all his work. Two long-lived artists, Masanobu and Hokusai,

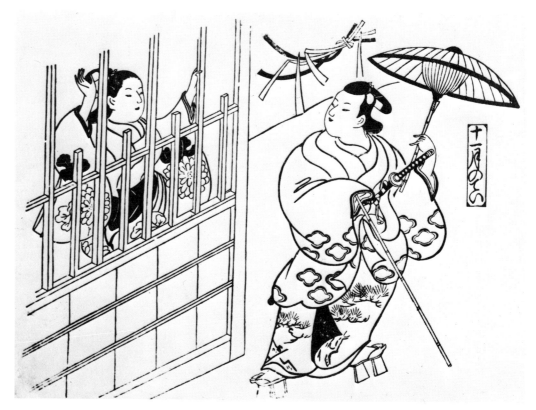

52 Masanobu: *Courtesan and Young Dandy. Sumizuri-e* in *ōban* size, an album plate from a series on the Twelve Months; the last plate is dated New Year's Hōei III (February, 1706). Signature (on final plate only): *Yamato-eshi* [Japanese artist] Okumura Masanobu *kore-wo-zu-su* [*pinxit*], with seal; publisher: Kurihara.
Masanobu was a master of the genre album format: a series of twelve witty designs on related themes. This is the "Eleventh Month" of the series, a Yoshiwara scene with a courtesan fondly regarding a fair young man posing—as though in a Kabuki play—outside the house of assignation. This early work (Masanobu was only twenty at the time) shows the strong influence of Kiyonobu.

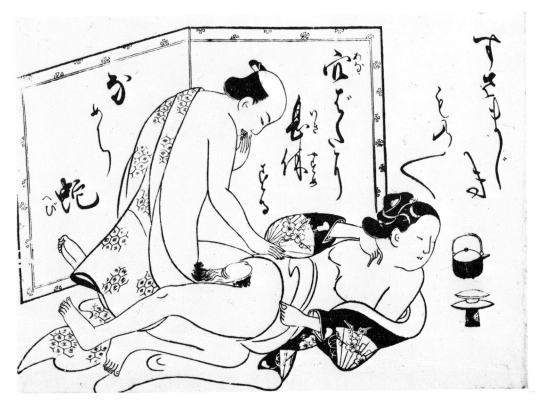

53 **Masanobu:** *Love Scene. Sumizuri-e* in *ōban* size, from a shunga album, ca. 1710 (late Hōei Period).

Masanobu's work in the album format naturally extended to the shunga genre, which usually appeared in album or book form. Often, during this period, the final print of the album was signed, but in the present case, the other prints in the set have yet to be traced. Because of the style and the idiosyncratic calligraphy, however, the print can be attributed to Masanobu. The subject is a married lady or widow (her eyebrows are shaved) at pleasure with her lover, who is younger than she.

represent practically the total range of ukiyo-e in their oeuvre; it may well be that Masanobu wielded the greater influence of the two.

Masanobu seems to have been self-taught, and his earliest known prints appear in a *Courtesan Album* published in the year 1701. Its designs are obviously modeled on the work of Kiyonobu, published the previous year. But although the compositions are frequently derivative, the figures already tend to be characteristically Masanobu's. In place of the solid power of Kiyonobu we see the beginning of that Edo wit and verve that was to distinguish the best in eighteenth-century ukiyo-e and that owed its origins above all to Masanobu.

Masanobu was undoubtedly the greatest Japanese master of the album, as Moronobu had been of the illustrated book. Ukiyo-e albums were, in effect, a series of a dozen horizontal prints on a given theme: they were folded in the middle and bound together for convenience. Moronobu had already produced several such albums, erotic and otherwise, in the 1680s, as had Sugimura; but it was Masanobu who devoted much of his early work to that form. His *Courtesan Album* appeared in several later versions, redesigned and expanded; but his greatest albums display his more fanciful approach to the floating world. Masanobu designed at least a dozen such albums: each containing a dozen prints and each devoted to witty and paradoxical approaches to the classics as seen through modern eyes; among them one will find series of parodies on the austere Noh drama, on familiar Kabuki and puppet-drama themes, on the *Tale of Genji* or on themes from classical Chinese and Japanese poetry or legend, as well as witty shunga (often, with accompanying verses by the artist). Although he was self-taught in ukiyo-e, Masanobu was a literary amateur of some pretensions and a pupil of the noted poet and novelist Fukaku. Masanobu's skillful retelling of the *Tale of Genji* in modern terms (which he illustrated and published in three series of six volumes each around the year 1707) was one of several such literary-artistic efforts on his part. We may assume that the texts of the many children's books that he illustrated also issued from his brush. Indeed, Masanobu can be compared with Harunobu in consistent and unified employment of literary themes in his prints.

Masanobu's black-and-white albums range through the whole first half of his career, from the early 1700s to the 1730s; his picture books and illustrated novels continued to be produced in numbers almost to the end of his days. Simultaneously with his early albums

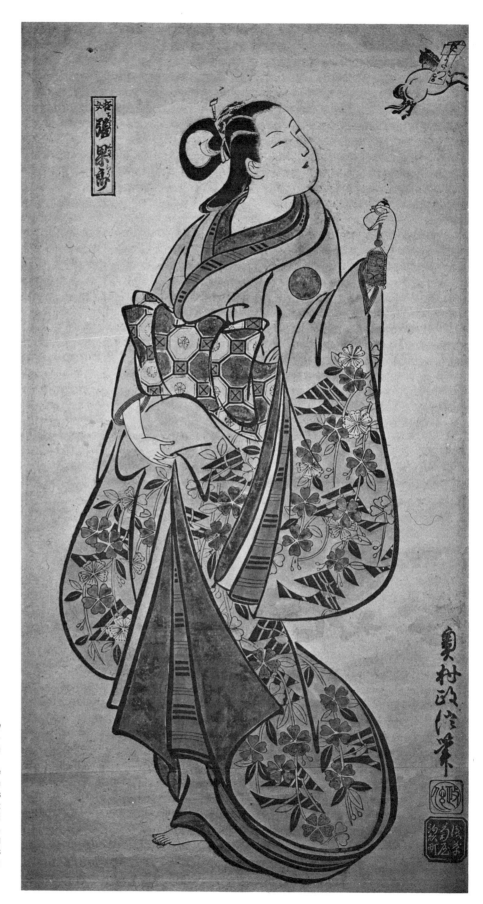

54 **Masanobu**: *Courtesan and Flying Pony. Tan-e* in large-*ōban* size, early 1710s (Shōtoku Period). Signature: Okumura Masanobu *hitsu*, with seal; publisher (lower seal): Kiku-ya. Title (on upper left): *Yūjō Chōkarō* [The Courtesan Chōkarō].

Masanobu's large figure prints of the 1710s mark perhaps the peak of his long career; they feature designs more graceful than the figures of Kiyonobu and Kiyomasu, more human than the girls of the Kaigetsudō. This is one of his masterpieces from this period: a *tan-e* print (colored in orange and mustard) depicting a fanciful pastiche on the legend of the Taoist Chōkarō [Chang Kuo-lang], a Chinese magician and immortal, who was fond of producing a pony from his gourd. In the present parody, the courtesan holds an *inrō* [lacquered medicine case] with a small, carved, netsuke toggle in the shape of a gourd, as the pony flies off with a billet-doux, doubtless intended for some lucky patron.

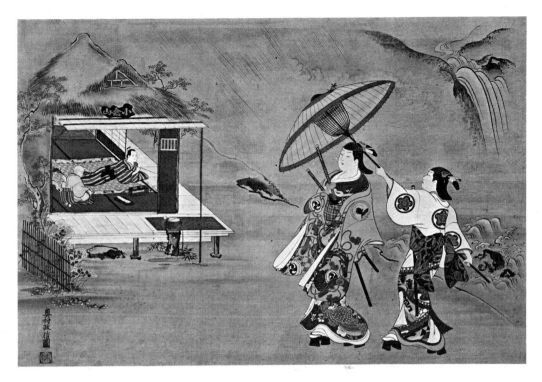

Masanobu began designing large prints of girls and courtesans, sometimes in the form of hand-colored orange prints, which, at their best, rank with the Kaigetsudō beauties in power and grandeur and sometimes surpass them in grace and wit. As though these varied productions were not enough, Masanobu was also a master of ukiyo-e painting, an example of which appears in plate 55. Even on the hand-colored prints, the strength of the colors the artist or artisan could employ was necessarily limited, for hues that were too vivid would obscure the lines of the woodblock. In his paintings, however, Masanobu could give full expression to his love for color, and the work pictured is one of the most visually brilliant, gemlike paintings in Japanese art.

Masanobu's achievements in his later years will be the subject of another section. Here, we mainly want to point out his prominent place in the constellation of early eighteenth-century ukiyo-e. He is an unflamboyant master who nevertheless ranks with Moronobu and Hokusai as one of the principal innovators, catalysts and stabilizers in the realm of ukiyo-e.

Kaigetsudō Ando

Moronobu created a sentient ideal of feminine beauty that was to inspire ukiyo-e throughout its existence. It remained for one of his followers, **Kaigetsudō Ando**, to turn this ideal into a symbol for the entire Ukiyo-e School and, abroad, for the whole civilization of old Japan.

Kaigetsudō Ando (traditional dates, 1671–1743), the founder of the Kaigetsudō School, was active from some time shortly after 1700 until the year 1714, when he became enmeshed (probably as a go-between) in the "Lady Ejima Affair," a scandal involving a high court lady and a handsome Kabuki actor. All the principals were banished forthwith from Edo.

Ando was an artist of Edo, living in the Suwa-chō district of Asakusa. The site of the great Kannon Temple since very early times, Asakusa was (as it is today) in a sense the epitome of Edo and a center of the new plebeian renaissance. (It was, indeed, in this quarter that the present writer chose to live when he commenced his studies of Edo literature and art nearly three decades ago.) Asakusa had been the home of such popular heroes as Banzuiin Chōbei and Sukeroku, the Robin Hoods of their time, who are still immortalized

in the Kabuki theater today. Asakusa had a history and a tradition; it was the birthplace or inspiration for much of the culture of Edo. Asakusa had also, at its northern extremity, the Yoshiwara, the most famous demimonde of Edo and the haunt of the literati as well as of rakes and tourists. The Yoshiwara contained some two thousand women, including, no doubt, some of the fairest in Japan. Kaigetsudō Ando lived somewhat more than a mile south of this quarter, directly on the main road to and from the Yoshiwara.

In view of Ando's broad, majestic manner of painting—each work standing as though it were framed and set up in a shrine—it has been suggested that his early training may have been in painting *ema,* votary tablets with large pictures of horses, warriors and such, which were contributed to temples and shrines as offerings. Ando's residence, practically next door to the renowned Suwa and Komagata shrines and only half a mile south of the great Asakusa Kannon Temple, surely lends support to this surmise. Clearly his manner of painting with thick outlines and majestic poses owes much to *ema,* but he combined this powerful style with a grace and artistic sense that was partly his own contribution and partly derived from the works of predecessors such as Moronobu and contemporaries such as Kiyonobu.

At any rate it is clear that tourists, pilgrims, rakes and literati passed daily in front of Ando's studio on their way to and from the Kannon Temple and the Yoshiwara. Whether he was a painter of temple *ema* murals or simply an aspiring painter of the genre scene, Ando began taking as his special subject the beauties of the Yoshiwara. His fame spread, and soon he almost monopolized the field of courtesan painting.

But there is something more to the Kaigetsudō paintings than a picture of a courtesan; indeed, in order really to enjoy these paintings to the fullest degree, one must develop something of the Japanese love and appreciation for the kimono as a work of art. And they are indeed works of art. It is only necessary to glance at such paintings as are reproduced

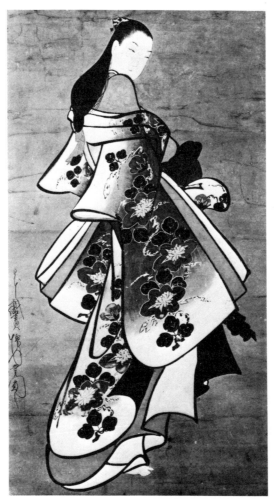 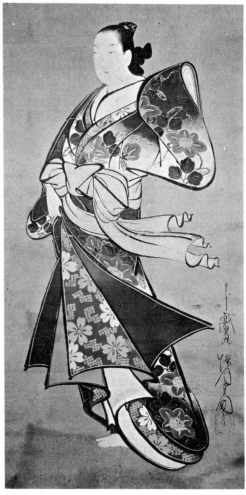

56 Kaigetsudō Ando: *Standing Courtesan.* Large *kakemono* painting in colors on paper, ca. early 1700s (Hōei Period). Signature: *Nihon-giga* [Japanese cartoon] Kaigetsudō *kore-wo-zu-su,* with seal. Despite the beauty of the girl's face, hair and figure, it is the design of the outer robe, half slipping from her shoulders, that dominates this painting. The Kaigetsudō girls are often described as stout or robust. In this instance, however, we catch a glimpse of the girl beneath the layers of kimono—a frail thing, slim and supple, more shy and pensive than aloof. Enveloped in the folds of this almost oppressively beautiful robe, her figure exudes a feminine attractiveness that is neither deliberately provocative nor positively renitent.

57 Kaigetsudō Ando: *Courtesan in a Breeze.* Large *kakemono* painting in colors on paper, ca. early 1700s (Hōei Period). Signature: *Nihon-giga* Kaigetsudō *kore-wo-zu-su,* with seal.
Coloring that is bold yet tasteful, rich yet refined: therein lies much of the beauty of the Kaigetsudō paintings. The costume decorated with clematis above and cherry blossoms below is obviously the main attraction, although the girl herself is intriguing. In this painting, one of the masterpieces by Ando (founder of the school), the courtesan stands with one hand holding her trailing skirt as she prepares to walk and the other hand lifting her sleeve up to her shoulder. Playful winds grasp at her skirt, but the girl remains unmoved, a Bodhisattva of the demimonde.

here to see that they depict something more than a simple girl; there is, shall we say, a whole culture involved in the appreciation of even one such painting. In the hands of a master such as Ando, the individual courtesan can somehow rise above the elaborateness and elegance of the kimono and impress the viewer with her sensual, human charm. With several of Ando's pupils and followers, however, the painting often stands or falls on the beauty and originality of the robes alone.

The tremendous and almost instantaneous success of Ando's courtesan paintings marked the turning point in his artistic career. He was established as *the* painter of beautiful women in Edo, and his preeminence may well have been a deciding factor in the decline of the dominant Moronobu School of painting within a decade or so after that artist's death in 1694.

As might be expected in the work of the founding genius of a school, the paintings of Kaigetsudō reveal an originality, strength and freshness that is seldom mirrored with perfection in the work of even his finest pupils. At the same time, Ando's courtesans often display a certain austere yet thoughtful mien, which tends to remove them from the realm of simple pin-up girls, i.e. the objects of plainly erotic attention. Ando's women are not, however, of only one type. There are, on the one hand, the austere, stately figures, more goddesses than objects of sexual attention, such as those shown in plate 57. But there is yet another girl in Ando's work, a girl much more of our own world, who may be appreciated without any great immersion in Japanese taste. We find this girl most strikingly in plate 56: hers is a willowy, sinuous figure that belies the weight of the fine robes wrapped about her. She stands detached, yet somehow intimate and approachable. Others of Ando's women (and those of most of his pupils) stand somewhere between these two extremes: they are more feminine than the former, less lovable than the latter. However, judging from numbers, it was the aloof, goddess-like beauty that appealed to the Edo connoisseurs of Ando's time. It remained for Sukenobu, Ando's contemporary in Kyōto, to exploit fully the theme of the more intimate "girl next door."

The Kaigetsudō Prints

The only reason why the Kaigetsudō, a school of painters unsurpassed in their day, are known in the West is because one year in the 1710s they issued, quite as a sideline, two or three sets of woodblock prints. These prints—some extant only in a single specimen—of which some twenty-three designs out of a probable several dozen are known today, are sought by collectors the world over. Each sells for tens of thousands of dollars on the rare occasions when one appears on the market; at the time they were issued, the prints sold for about what a reproduction costs today.

The artistic success of the Kaigetsudō prints was not a matter of chance: behind them lay the rich tradition that had been established by the master painter Kaigetsudō Ando. It is a tradition which, despite being based on colors and brush, was eminently suited to being translated to the medium of the woodblock print. The massive contours of Ando's paintings could be transferred directly to the block; masses of black and intricate but boldly patterned designs could be effectively substituted for the magnificent coloring. Often, suggestive colors could be applied by hand, and several of the extant Kaigetsudō prints are of the *tan-e* variety—black-and-white prints with bold coloring added by hand. The present price of Kaigetsudō prints (on the average, the highest in the field) is doubtless due in a large part to their rarity; their remarkable qualities as prints, however, are another matter.

There is no need to try to rate the courtesan prints of Moronobu, Sugimura, Kiyonobu, Kiyomasu and the Kaigetsudō comparatively; each is great in its own way. Yet of all these artists, it is the Kaigetsudō alone who have become the symbol of ukiyo-e and of the golden age of Japanese culture. The Kaigetsudō prints stand apart because they are not illustrations of some scene or depictions of some famous actor in a given role. These solitary women exist for themselves alone; they are characteristic of, yet stand clearly aloof from, the world that bore them. We have already described the general style (or styles) of the founder of

this school, Kaigetsudō Ando. Now let us examine the work and manner of his pupils, seeing what each brought to, or omitted from, the style created by the founder.

Kaigetsudō **Anchi**'s characteristic style is rather more coyly erotic than that of his teacher. Whereas Ando's women can often pass for maidens or ladies of quality, Anchi's girls are manifestly courtesans, lovely but at the same time somehow predatory. They seem to be thinking only of themselves; most men would think twice before putting their love into such hands. To one degree or another, this is the feeling one gets from each of Anchi's paintings. Quite possibly it has little to do with his own character: some of the greatest rogues have painted the sweetest girls. It does, however, indicate his own taste in women: aristocratic, self-absorbed, disdainful; Anchi probably liked cats. Anchi's prints are in several ways artistically superior to his paintings. He was not, of course, a professional print designer. His few prints were only a minor experiment, probably done on some special commission. The fact remains that his style, somewhat too cold and unyielding for the intimacy of painting, proved eminently suited to the woodblock technique. We accept the stiffness of these "primitive" prints as one of their charms. Under the block-cutter's knife, the sharply feline quality of Anchi's women is blunted into a certain vapid childishness. Somehow, his faults are lost in the technique of early printmaking.

The women of Kaigetsudō **Doshin**, on the other hand, are characterized by a certain air of quiet detachment that is reminiscent of the master Ando, though lacking his psychological insight. In most of Doshin's paintings it is the brilliant robes and not the faces that capture the viewer's attention. From Doshin's prints, however, we experience quite a different impression. There is still a certain ponderousness, a tendency for the figure to weigh down the face, but in contrast to the paintings—where the blue-gray pigments used for the delicate facial features tend to recede and the brilliant reds and browns of the kimono to dominate—a reduction of the whole to black masses and lines unifies the composition. These prints strike a happy balance between the kimono and the girl. Plate 59 is a good example of Doshin's powers as a print designer.

58 Kaigetsudō Anchi: *Courtesan Arranging Hairpin. Sumizuri-e* in large-*ōban* size, ca. early 1710s (Shōtoku Period). Signature: *Nihon-giga* Kaigetsu *matsuyō* [follower] Anchi *zu,* with seal.
The standing courtesan adjusts her hairpin, drawing our eyes upward over a patterned kimono ranging from black chrysanthemums tossed about in the sea, to the same flowers in splendid bloom. Apart from its boldly graceful design, this print is conspicuous for the brilliance of its printing, thanks to its execution by a skilled and inspired (albeit anonymous) printer and to the fact that it is an early impression.

59 Kaigetsudō Doshin: *Standing Courtesan. Sumizuri-e* in large-*ōban* size, ca. early 1710s (Shōtoku Period). Signature: *Nihon-giga* Kaigetsu *matsuyō* Doshin *zu,* with seal; publisher (lower seal): Naka-ya.
This courtesan stands with hands hidden in her voluminous sleeves; her skirts are in a raised position for walking. Her coiffure is of the popular "Katsuyama style," named after the seventeenth-century Yoshiwara courtesan who devised it. As with most of the larger formats, this print consists of two sheets of paper, joined here at knee level. There is a good possibility that the Kaigetsudō prints were issued in two or more series of twelve, each design related to a month of the year. If such be the case, the previous "Chrysanthemums" of Anchi would represent the Ninth Month (October in the modern calendar) and the present work, featuring a design of falcon's feathers and thongs, would stand for the Eighth Month (September), the season for falconry.

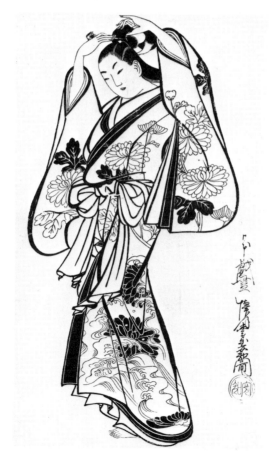

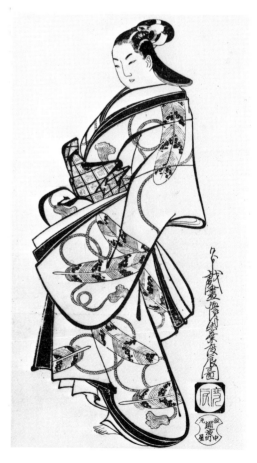

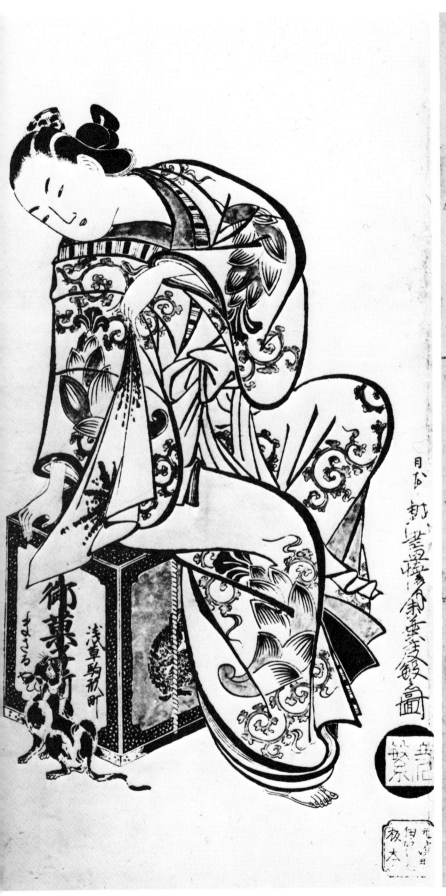

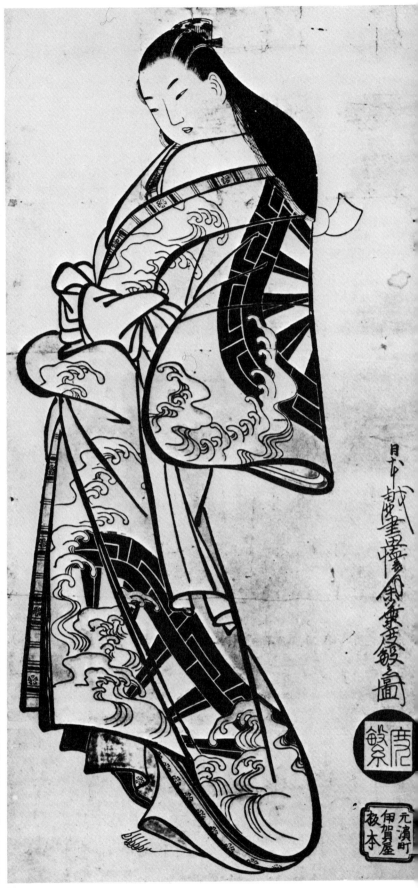

One of the best of Ando's pupils was Kaigetsudō **Doshu** (Noritane). Like Ando, he did no prints, but in the best of his paintings he approaches the finest work of his master. A close examination of his women will, it is true, reveal the lack of that indefinable spark of psychological insight that characterizes the best of Ando's work. Yet in his better painting he achieves a kind of distant, respectful intimacy that comes close to the perfection of Ando's rare masterpieces. Had Doshu's work extended to the field of prints, one feels that he, like Ando, might well have rivaled Kiyomasu and Masanobu in the representation of a feminine grace whose appeal knows no boundaries of time or country.

The oeuvre of Kaigetsudō **Doshū** (Doshiu/Norihide), the fifth member of the Kaigetsudō group, is also limited to paintings. Although Doshū's extant works are few, they rank with the former Doshu's in their consistent excellence. His women display a detached yet forceful mien that places them in the lineage of Ando and Doshu and sets them apart from the feline women of Anchi or the recessive, passive women of Doshin.

Kaigetsudō **Dohan**, the last of the immediate pupils of Ando, was the least skillful as a painter but produced the most prints. Dohan's paintings are not particularly distinguished. They display a certain stiffness and lack of freshness notable even in a school where originality of pose was not the main concern. Dohan's prints are another matter again. We possess a sufficient number of them to enable us to be critical, and indeed, the average level of Dohan's prints is rather below that of Anchi and Doshin in inspiration and liveliness. Having said that however, we must turn to plate 61, one of the loveliest works in all ukiyo-e. In this print one of the lesser members of the Kaigetsudō School has somehow distilled the essence of the school in a single work. The pose itself is somewhat improbable, but we are rendered blind to this fact by the perfection of balance of the whole. Dohan, a painter of no particular genius, achieves greatness here by simply following, in a moment of rare inspiration, the dictates of his tradition.

Kaigetsudō Ando and his immediate pupils were followed by a dozen or more lesser imitators in the field of ukiyo-e courtesan paintings. Some of them—**Shigenobu, Chikanobu, Eishun**—must be counted among the minor masters of the eighteenth century, but none of them added anything remarkable to the style established by Ando.

We have made no attempt to date each of the individual painters of the Kaigetsudō School—indeed, this is impossible at the present time. Still, it is clear that Ando and his immediate pupils must have flourished from about 1700 to 1725 and their imitators in the style, about 1720 to 1750. Thus the Kaigetsudō contribution to ukiyo-e would seem to have lasted about a half-century.

Ukiyo-e was never the same after the appearance of Kaigetsudō Ando. He created an overpowering ideal of feminine beauty that lingers somewhere in the mind of every perceptive male who ever saw his work, an ideal that has since passed far beyond the seas, to men for whom the vision of these timeless, solitary figures sometimes seems more real than life itself.

The Golden Age of the Lacquer Print (1)
Kiyonobu II, Kiyomasu II, Kiyotada, Kiyoshige

The Kyōhō Period (1716–36) marks a turning point in the development of the Japanese print: government sumptuary edicts were, for a time, to reduce its size and grandeur; and few new artists of genius appeared to surmount such obstacles. The two decades from 1720 to 1740 reveal an increasing emphasis on elaborate hand-coloring in the prints, culminating a generation later in the full-color *nishiki-e* ["brocade prints"]. Thus a discussion of this and the following period is best organized by techniques, rather than by schools.

Torii Kiyomasu seems to have ceased work around the beginning of the 1720s, and Kiyonobu (the consolidator of the school) was dead by the end of the same decade. However each had trained his successor, sons or adopted sons. Indeed, in the late work of both artists (but particularly of Kiyonobu) we may sometimes detect the hand of the pupil, and the authorship of Torii prints of the 1720s is often difficult to settle, for none of the prints make any distinction between the teacher and the pupil; they are simply signed Kiyonobu

or Kiyomasu, and such designations as Kiyonobu I and Kiyonobu II are merely our modern attempts to distinguish the two generations.

Plate 62 depicts the fair young actor Izaburō as a youthful samurai in the midst of a stylized dance before a pine tree. He holds a fan in his right hand and grasps his long sword with his left. The wide sleeves of his outer robe and the tips of his ceremonial skirt are caught in a moment of arrested movement as he strikes a precarious but balanced pose. The print, datable from the Kabuki records as 1726, is signed Torii Kiyonobu and is either the finest extant work of **Kiyonobu II** (who worked from the 1720s to about 1760) or one of the major late works of his father. Possibly it represents a collaboration; but the signature, at least, seems to be that of the son. Here is a glimpse of the Torii style at its zenith in its middle years: the primitive vitality of the early Kiyonobu is gone, and in its place we see the quintessence (in miniature) of the graceful, restrained vigor that was Kiyomasu's contribution to his school. However, something of the bombast and movement of a Kabuki performance is still retained, and the print is at once part of a tableau and an idealized record of a great Kabuki dancer at his best. At the same time, this print is a masterpiece of the hand-colored *urushi-e* [lacquer print] genre, prints that were decorated after the manner of miniature lacquerware. The colors glisten and sparkle almost as vividly as on the day they were painted; the rich black pigment on the actor's shoulder and the gold dust on the lower right lend a strange depth and unity to the coloring. These same pigments sometimes resulted in garish failures, but here, in the hands of a master, hand-coloring—which was usually the work of an artisan in the employ of the publisher—produces effects of richness and vitality that were never surpassed by all the ramifications of later color printing. Whether any kimono could ever reproduce the variety of coloring we see here was not, of course, the concern of the colorist. Kabuki itself knew no limitation in methods of producing an effect through color and hyperbole. Few, indeed, are the actual pine trees that combine a trunk of pink with needles of mustard-yellow, olive green and red: this is clearly a work of the imagination.

The last of the quartet in the direct Torii line, **Kiyomasu II** (who worked from the 1720s to the early 1760s), is often maligned by critics who have seen only his poorer work. The average prints of either Kiyomasu II or Kiyonobu II are rather stereotyped, lacking in vitality or fertility of invention. Yet in perhaps a quarter of their prints they manage to rise above the confines of their own limited talents and produce work of rare grace and charm.

Plate 63 shows an unusual, uncut triptych by Kiyomasu II: three courtesans posed before a house of assignation. The small print is resplendent in light pigments augmented by gold dust and powdered mica. Even in monochrome its graceful ideal of feminine loveliness is striking; this is the girlish face that remained the ideal of the Torii School during the whole second quarter of the eighteenth century when it flourished, and that brightens so many of the Torii prints and children's books produced in such quantity during that period.

We have suggested earlier that something of the change in ukiyo-e from austere power to sensual grace may have lain in the supplanting of Moronobu by Sugimura as a basic influence. However this readily apparent weakening of artistic force and originality during the 1720s and 1730s was also indicative of a far more profound and general trend of the times that is visible in Japanese art in general, as well as in other cultural forms. On the other hand there is a natural slackening of vitality after the highly dynamic Japanese renaissance, which began in the late sixteenth century and culminated in the Genroku era. On the other hand, government interference must be blamed in part for the attenuation of this first flowering of Japanese plebeian culture. Early in his reign the eighth Tokugawa Shōgun, Yoshimune (who ruled from 1716 to 1745), found both the government and the country at large in serious financial difficulties. Therefore he determined to enforce an austerity program upon the nation, aimed at raising the general standard of morality and returning to the "simple, austere life of former times." The curiously detailed bans and warnings that his government issued seem almost consciously aimed at killing all that was joyous and creative in plebeian life. For example, consider these edicts from the year 1721:

The use of gold and silver foil and metal utensils is prohibited. Large, decorated battledores and shuttlecocks are prohibited. Dolls over eight inches tall are prohibited.... The use of gold and silver coloring on toys, children's clothing, dollstands, etc. is forbidden.

62 Kiyonobu II: *Kabuki Dance. Urushi-e* in *hosoban* size, 1726 (Kyōhō IX). Signature: *eshi* [artist] Torii Kiyonobu *hitsu*; publisher: Murata.
Here is one of the most brilliant surviving examples of the lacquer-print genre, in mint condition. As with many *hosoban,* this print is one of a set: the left and center panels feature female figures. The design of this right-hand panel is by far the finest and is a masterpiece in its own right. The play represented seems to be *Hinazuru Tokiwa Genji,* performed at the Ichimura-za in Kyōhō IX/11 (December, 1726). This featured Wakana and Kantarō as the ladies Hotoke and Tokiwa, and Ogino Isaburō (depicted here) as the samurai Araoka Genta.

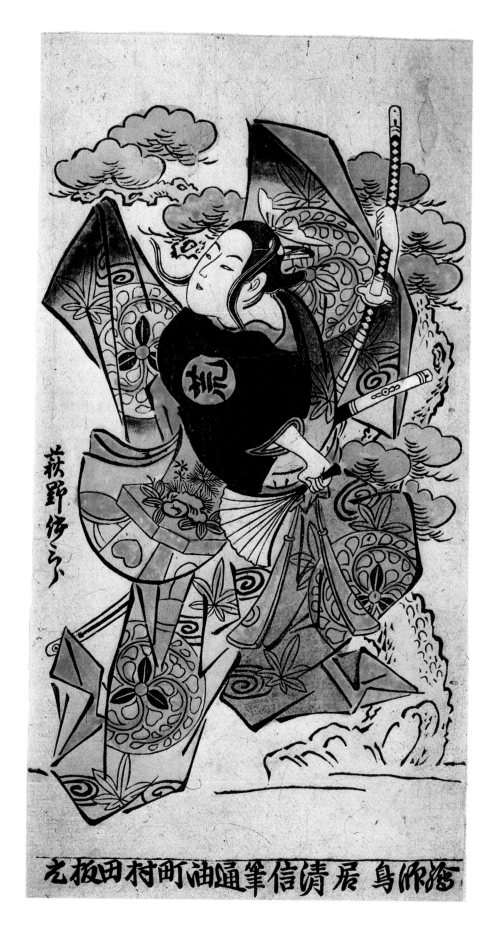

The production of anything new in the field of books and booklets is forbidden. (However, if there be any real necessity for such, applications may be made to the Office of the Magistrate, requesting instructions. For the time being, single-sheet prints, etc. may be printed, but are not to be put on public sale....)
Such articles as the above have existed for some time, and at first their form was quite simple. But gradually methods changed and they have become elaborate, colorful and also very expensive. Therefore do we order use of the simpler forms of earlier days. (Of course, when these articles are for official use, the above does not apply.)

Fortunately, the Japanese townsman was too resilient and clever to give such authoritarian trivia anything more than lip service. Thus, in obeying something of the letter (but seldom the spirit) of these oppressive edicts, the Japanese commoners in the end succeeded in preserving their rising heritage of reborn culture. Nevertheless, the manifestations of plebeian culture could not but be adversely affected by these totalitarian ordinances, and it is this writer's opinion that we have a misguided, financially oppressed dictator to thank for the weakening of many popular art forms, such as ukiyo-e prints, during the 1720s and 1730s.

Although our emphasis has been placed on the members of the immediate Torii family line, there were other artists of great talent who followed the Torii style and were often direct pupils employing the family name. Among them were:

— Torii **Kiyotomo** (who worked from the 1720s to the 1740s) was probably a late pupil of Kiyonobu I. His work greatly resembles that of his fellow pupil Kiyonobu II, both in its strong points and its weaknesses.

63 **Kiyomasu II**: *Courtesans from the Three Capitals. Urushi-e* in *hosoban* size, uncut triptych, ca. late 1720s (mid Kyōhō Period). Signature: *eshi* Torii Kiyomasu *hitsu*; publisher: Urokogata-ya.
In impressiveness the relatively small designs of the *hosoban* format cannot compete with the large-*ōban* masterpieces of the preceding generation, but for the collector they form one of the intimate treasures of early ukiyo-e. This particular example boasts some six different colors applied by hand; such triptychs were designed so that each panel could be enjoyed independently and were normally cut up for sale, but the present example has been preserved unsevered. The subject is renowned courtesans from the three capitals. From left to right: Ōsaka, Kyōto and Edo; the styles of dress and the coiffures of the three localities are clearly distinguishable. The legends in the background give the name, house and address of each of the courtesans. Several other variations on this theme are known. The great Masanobu was probably the innovator of the basic format.

64 Kiyotada: *Kabuki Theater. Urushi-e* in double-*ōban* size, datable to 1743 (Kampō III). Signature: *eshi* Torii Kiyotada *hitsu*; engraver: Tsurumi Kashichirō; publisher (triangular trademark): Urokogataya.

Such perspective pictures in double-*ōban* size are among the rarer treasures of early ukiyo-e. The present example, of which a similar design exists by Masanobu, reveals to us every corner of the interior of the Kabuki theater during the period of its consolidation in the mid-eighteenth century. The artist's point of view is surprisingly objective: the leading actor (Danjūrō, seen on the left near the entrance to the *hanamichi*) is almost lost in the crowd, which seems as much occupied with refreshments as with the play. There are many interesting details to note: the actors' crests displayed on the lanterns hung from the ceiling (Danjūrō's is in

the place of honor on the far right), the attendants in the top right-hand corner, removing sliding doors to let in more light (lanterns were banned because of the danger of fire), the inner stage roof and other features derived from the Noh drama, the name of the play, *Mitsugi Taiheiki* (performed at the Nakamura-za in Kampō III/11 [December, 1743]) on the right pillar and the title of Act I, posted on the left pillar, the upper and lower balcony seats for affluent patrons and, in the pit, the motley crowd of plebeian playgoers. The resplendently garbed actor on the left, the great Danjūrō II (Ebizō), is engaged in a dramatic *Shibaraku* ["Wait a moment!"] interlude. Once the hand-colored print reached this elaborate stage, only polychrome printing could provide a solution to the publishers' dilemma of how to satisfy public demand for color prints at popular prices.

- Torii **Kiyotada** (who worked from the 1720s to the 1740s) seems also to have been a pupil of the first Kiyonobu. He fused the styles of Kiyonobu and Masanobu and gives the impression of possessing more talent than either Kiyotomo or Kiyonobu II. It is unfortunate that so little of his work is now known. Plate 64 shows an impressive panorama of the interior of a Kabuki theater by Kiyotada. The technique is still that of the lacquer print, but the larger size—a revival of the early 1740s—permits detailed rendering of a large subject, which is enhanced further by the curious *uki-e* technique that imitates Western perspective.
- Torii **Kiyoshige** (who worked from the late 1720s to the early 1760s) was a late pupil of Kiyonobu I and often gives a rather stiff, angular note to his prints. His book illustrations and his large pillar prints in the Masanobu manner rank among the masterpieces of the Torii School. In a large lacquer print such as plate 65, one of the early pinnacles of ukiyo-e art can be seen.

The Golden Age of the Lacquer Print (2)
Masanobu and Toshinobu

Any discussion of the development of ukiyo-e prints during this period would be incomplete without giving further attention to Okumura **Masanobu,** whom we have already cited as a most influential figure in the first two decades of the eighteenth century. In the 1720s Masanobu succeeded in opening his own publishing house in Edo, in order both to increase his control over the final results of his designs and, no doubt, to retain the lion's share of the profits from his popularity, profits that had hitherto gone to his various publishers. (By the late 1730s Masanobu's son Okumura Genroku seems to have taken over the actual operation of the publishing concern, leaving his father free for his artistic endeavors.)

It was just at this time that the fashion was changing (partly under government influence) from the large orange prints and medium-sized album plates to the smaller and more intimate lacquer prints, about 12×6 in./30×15 cm in size. This easily handled format dominated Masanobu's print production during the first two decades he was his own publisher, and in it he created an impressive percentage of the minor masterpieces of ukiyo-e.

In tune with the taste of the times, Masanobu, like his contemporaries the Torii masters, often took current Kabuki dramas as his theme. His small and warmly intimate lacquer prints of the actors form a pleasant contrast to the more conventionalized pictures of the Torii artists. Unlike many of his contemporaries, however, Masanobu searched far and wide for themes, and many of his best prints depict non-Kabuki subjects: scenes from classical and modern literature and legend, birds and animals, landscapes, girls and courtesans, and depictions of the festivals and events that constituted the fascinating street scenes of Edo. He also experimented with the curious "stone-rubbing" prints [*ishizuri-e*], woodblock prints in which the lines are shown in reverse, white against a rough black background, in the manner of Chinese stone rubbings. Masanobu also made major contributions to the shunga genre.

By the year 1740 print fashions had once again changed, and larger prints were back in style. Masanobu, always a pioneer in such trends, led the field from the outset. Not only did he design some of the finest of the new actor and courtesan prints, but he also began experimenting with Western-style perspective, producing a number of excellent prints—usually featuring large interior scenes in horizontal format—in which the receding lines are made to correspond to Western, rather than Oriental, perspective. The effect of these prints seems oddly quaint to us today, but they were a startling innovation to Masanobu's contemporaries (see the example by Kiyotada in plate 64). However the best of Masanobu's large lacquer prints were his vertical prints featuring figures of actors and girls, together with such varied compositions as the one we see in plate 68. With the Kaigetsudō masters and the Masanobu of these plates, the Japanese print achieves a magnificence of coloring and dimensions that places it on a competitive level with the rich *kakemono* [hanging scroll] paintings and even with the smaller Western oil paintings (not, of course, that such dis-

65 **Kiyoshige:** *Actor on Stage. Urushi-e* in large-ōban size, mid 1740s (Kampō–Enkyō Period). Signature: Torii Kiyoshige *hitsu,* with seal; publisher (trademark on lower right): Urokogata-ya.
This is another important large lacquer print. The school, date and publisher are the same as the print in plate 64. This time an individual actor, Bandō Hikosaburō, is shown in samurai role with a fan in his hand and a large key and clan heirloom clasped to his abdomen. From this advanced stage, the artists depicting Kabuki were only one step away from the Golden Age of Shunshō in the following generation.

66 Masanobu: *Ménage à Trois. Urushi-e* in *ōban* size, ca. early 1740s (Kampō Period). Verse on the left sealed with Masanobu's pen name, Tanchōsai. Signature (on the right, probably a later interpolation): *Okumura Bunkaku Masanoba zu.*
This is the frontispiece to Masanobu's most famous shunga series, *Neya-no-hinagata* [Models of the Boudoir]. This series is invariably found hand-colored throughout in the elaborate lacquer-print style seen here. Three figures are reclining in a house of assignation: in the center a patron, fondly regarding a fair young man (probably his lover) writing a letter; on the right is a high-ranking courtesan. (Such dual relationships were common enough among the playboys of old Japan—love affairs being prized for the *élan* with which they were conducted, regardless of the sex of the chosen partner.) The landscape panel in the background gives us a glimpse of Masanobu's expertise in the older, Kanō tradition of painting.

similar genres should be compared). By the same token, such prints lose the intimacy of the smaller designs and become principally objects for exhibition, either mounted in place of a *kakemono* painting (as they were in the eighteenth century) or in a museum today. Due to the rarity of these big *kakemono* prints they have commanded among the highest prices of all ukiyo-e prints. One wonders, however, whether the individual collector can get as much personal pleasure out of these impressive showpieces as from the little poem-cards at a tenth the price. Be that as it may, the grand *kakemono* prints flourished particularly during the Kaigetsudō period around the 1710s, during the 1740s with Masanobu and his contemporaries, and again briefly in the landscapes of Hokusai and Hiroshige a century later. They were never to usurp the central position held by the smaller prints, but they do constitute a noteworthy and magnificent attempt on the part of popular artists to exceed the normal limits of the print format.

Only one important artist, Okumura **Toshinobu** (who worked from about 1717 to the 1740s) seems to have studied directly with Masanobu. Toshinobu, who may have been Masanobu's adopted son, specialized in small, intimate lacquer prints featuring one or two figures of actors or girls. This was a field in which Masanobu himself excelled during the middle decades of his career, and it is saying much for Toshinobu's genius that he often equaled his master in this one field. Plate 69 shows a good example of Toshinobu's polished charm, in a hand-colored lacquer print that retains its balanced harmony equally well in black and white.

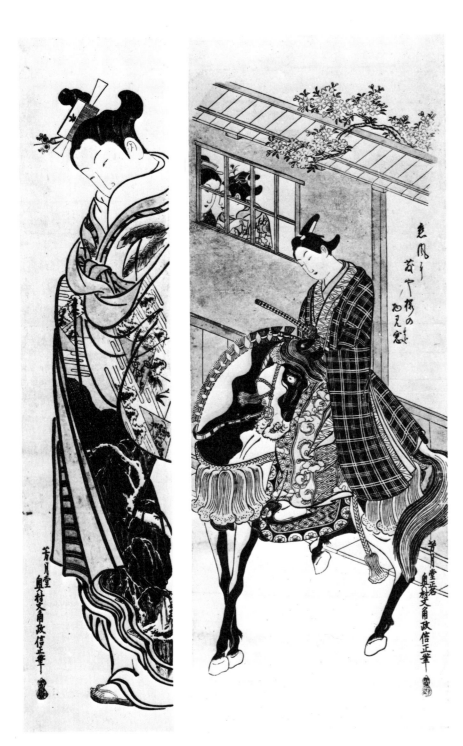
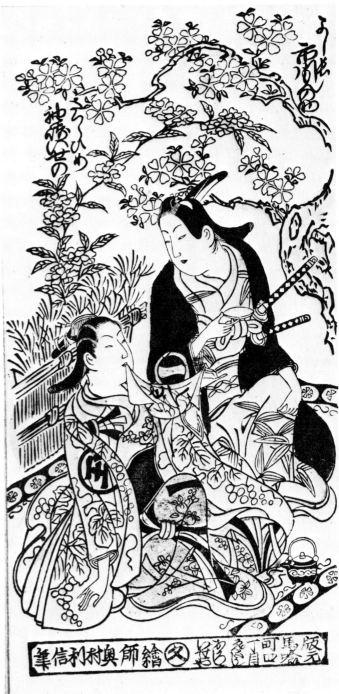

Toshinobu's small prints constitute one of the minor glories of ukiyo-e and provide an example of how a talented pupil can sometimes equal his master by assiduous practice of a more limited discipline. One of ukiyo-e's minor riddles, incidentally, is why Toshinobu's prints were often issued by publishers other than his teacher. Quite possibly Masanobu, the publisher, had his hands full simply with his own prolific output. Equally likely, however, was a desire on the part of teacher that his pupil should benefit from outside editorial guidance and, now that he had completed his basic training, make a name for himself in the world, away from the shadow of his master's great name.

Contemporary with Masanobu, and influenced by him, were several other artists of considerable talent whose work deserves mention. Hanekawa **Chinchō** (ca. 1679–1754) pro-

67 Masanobu: *Standing Courtesan. Urushi-e* in wide-*hashira-e* size, ca. early 1740s (Kampō Period). Signature: Hōgetsudō Okumura Bunkaku Masanobu *shōhitsu* [genuine work by], with Tanchō-sai seal.

Achieving impressive size at minimal cost, such pillar prints (27×6.5 in./68×16 cm. in the early period, later some 1.25 in./3 cm. narrower) were designed to be mounted as hanging scrolls for decoration on pillars or in narrow alcoves—a kind of poor man's *kakemono*. The format was artistically a difficult one to handle, but the ukiyo-e masters from Masanobu to Utamaro exploited its limitations very effectively. Here a courtesan appears as though out for a winter stroll in an elaborate kimono. Her outer robe has a design of snow-covered willow at night, plus a felicitous New Year's pattern of pine, bamboo and plum blossom.

68 Masanobu: *Young Samurai on Horseback. Urushi-e* in double-*ōban* size, ca. mid 1740s (Enkyō Period). Signature: Hōgetsudō *shōmei* [true name] Okumura Bunkaku Masanobu *shōhitsu*, with Tan-chōsai seal.

A stylish samurai lad in his teens is seated upon an elaborately caparisoned horse. Above his head are cherry blossoms, and through a window two older girls peek at him admiringly in the manner of the verse on the right: "In love's zephyr / cherry petals fall / beside the picture window." These larger prints (about 26×11 in./68×27 cm.) are often termed *kakemono-e* or *hashira-gake,* referring to their original, practical function as hanging scrolls.

69 Toshinobu: *Young Lovers. Urushi-e* in *hoso-ban* size, 1727 (Kyōhō XII). Signature: *eshi* Okumura Toshinobu *hitsu*; publisher: Ise-ya.

The charm of the smaller lacquer prints is hardly apparent from afar, for they were designed to be appreciated at close range, preferably held in one's own hands. Here Masanobu's leading pupil, Toshi-nobu, has created a minor masterpiece typical of his middle years. He depicts the actors Iseno and Monnosuke drinking saké under the cherry blossoms that protectively encircle the two lovers. To the viewer of the time, as to the art lover today, such a print was first a lovely representation of a romantic dream world, and second a picture of two popular actors on stage. Our aim in these notes has been to put first things first. A more formal title would read: Sodezaki Iseno as Princess Sakura and Ichikawa Monnosuke as the young samurai Yoshinaga, from the Kabuki play *Konrei Otowa-no-taki,* performed at the Nakamura-za in Edo in Kyōhō XII/3 (April, 1727).

70 Masanobu: *Priest and Maiden. Benizuri-e* in ▷ *hosoban* size, 1751 (Hōreki I). Signature: Hōget-sudō Okumura Bunkaku Masanobu *ga* [*pinxit*].

This is the first example of color printing in this book. Note what a varied effect results from the simple addition of rose and green to the basic key-block. On the left the noted actor Sanokawa Ichi-matsu, in the role of the priest Nichiren, approaches the maiden Tamazusa, played by Azuma Fujizō; the latter is brushing snow off her gate with a broom. This scene is taken from the play *Honryō Hachi-no-ki-zome,* performed in Hōreki I/11 (December, 1751) at the Nakamura-za in Edo.

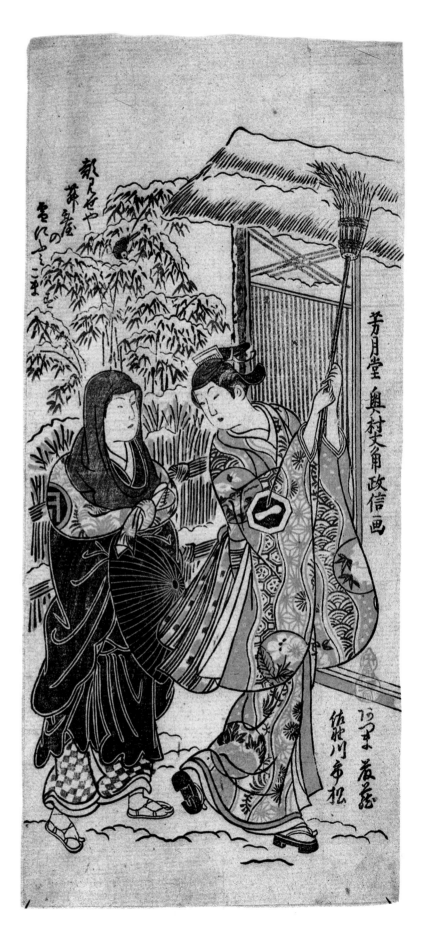

duced few prints but all were of distinction. He is famous among ukiyo-e artists for being of samurai stock and working at his artistic calling only when the spirit moved him. Allied in style to Chinchō is Kondō **Kiyoharu** (who worked from the early 1700s to the 1730s); he likewise produced few prints that are still extant, but a number of graceful children's books and illustrated novels.

Workers in the later Masanobu style include a number of lesser figures, among them "Mangetsudō," notable as having deftly pirated several of Masanobu's finest designs during the late 1740s (his name may be the nom de plume of a publisher rather than of an individual artist) and Furuyama **Moromasa,** who was nominally a follower of Moronobu (and possibly the son of Moroshige) but worked principally in the late Masanobu manner.

The Early Color Print (1): Masanobu

Around the year 1740, at exactly the same time as the large lacquer prints were coming into vogue, Masanobu began experimenting with, and perhaps helped to invent, the first real color prints. Our discussion has dealt with ukiyo-e prints starting with the early masterpiece shown in plate 20; in the subsequent eighty years of its development, the Japanese print depended entirely upon hand-coloring for its hues. Not that color printing was unknown in the Far East: it had been practiced on a limited scale in China. In Japan several different colors had been employed with success as early as 1627 in an illustrated arithmetic text and in 1644 in a seven-volume almanac. Yet these were to prove scattered experiments, repeated in subsequent years only for special works, such as poetry collections in limited editions. Most probably early color-printing methods were troublesome and expensive, as yet unsuited to mass production. However, by the 1720s public demand for more color had reached the point where the varied hand-coloring of a print like plate 62 or plate 64 must have cost far more than the original print itself. By the late 1730s artist-publishers such as Masanobu and Shigenaga had perfected the technique of easy color registration, and the way was now open for the mass production of pictures printed in two or more colors.

The actual method of printing was as follows. The artist submitted the completed design in *sumi* [India ink] on thin paper. This (or an artisan's copy) was pasted, face down, on a smooth slab of hardwood such as catalpa or cherry. An artisan then carved and gouged away the portions of the woodblock that were not to be printed, leaving only the fine outlines of the original sketch. This block was then cleaned and inked, fine absorbent mulberry paper laid upon it and the back of the paper vigorously rubbed by hand with a hard round pad called a baren. The resulting impression in black on cream paper was the *sumizuri-e* [ink print], the basis of all Japanese printing and ukiyo-e prints and the backbone of full-color prints. During the early decades of ukiyo-e, this print was often sold as it was, simply for its rich black-and-white effect; or, hand-colored by artisans, it became the vivid, primitive orange print or the more rich and varied lacquer print of the end of the 1710s and later.

In order to produce true color prints, however, another stage was required. For the color prints of the 1740s and later, after the initial black-and-white key block was prepared, the artist was given several copies of the black-and-white impression, on which he marked his suggestions for color printing. Due to the expense involved in making a small edition for an audience that was still limited, early color prints (ca. 1740 to 1764) featured a very restricted range of colors: usually the basic rose and green that had characterized ukiyo-e from the beginning. Sometimes yellow, blue or gray were added or substituted; and by the late 1750s three or four colors were achieved, either by the employment of a full complement of blocks or by printing one color over another to produce a third one.

The artist noted each of the areas that was to receive a given color. In plate 70, for example, the green areas could either be marked in that color or simply with the word "green." More often, one proof sheet was reserved for each color, and any addition on that sheet would imply "green." The same was done for the rose, a fugitive vegetable color now usually faded to pink. (Since this was the characteristic color of these prints, they are termed *benizuri-e* [rose-printed prints].) In effect then, the manufacture of the print shown in plate 70 may be

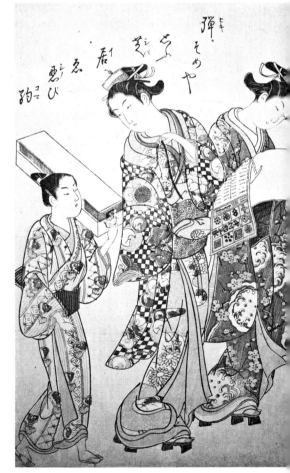

71 **Masanobu:** *Girls on Their Way to the Theater. Benizuri-e* in large-*ōban* size, trimmed, mid 1750s (early Hōreki Period).
In this monumental early color print, two girls are walking: the one on the right is reading a playbill (with actors' crests at its head); the one on the left is followed by a pert little servant, who is carrying a samisen box. According to the playful verse at the top, the two girls have set out for their first music lesson of the New Year but instead seem intent on making a secret detour to the theater. This print exemplifies problems sometimes faced by critics (and by collectors and curators); though unsigned, this treasure from the Musée Guimet is obviously by Masanobu and, moreover, it is a design superior to any of the unsigned Masanobus we could trace for this period. It was therefore decided to use it in this book, just as any creative collector would have added it to his collection. Subsequently, this decision was justified by the discovery of another impression in the British Museum and a proof impression from the key-block in the Art Institute of Chicago; these are untrimmed and bear, on the left, the artist's full signature: Hōgetsudō Tanchōsai Okumura Bunkaku Masanobu *ga*, with seals.

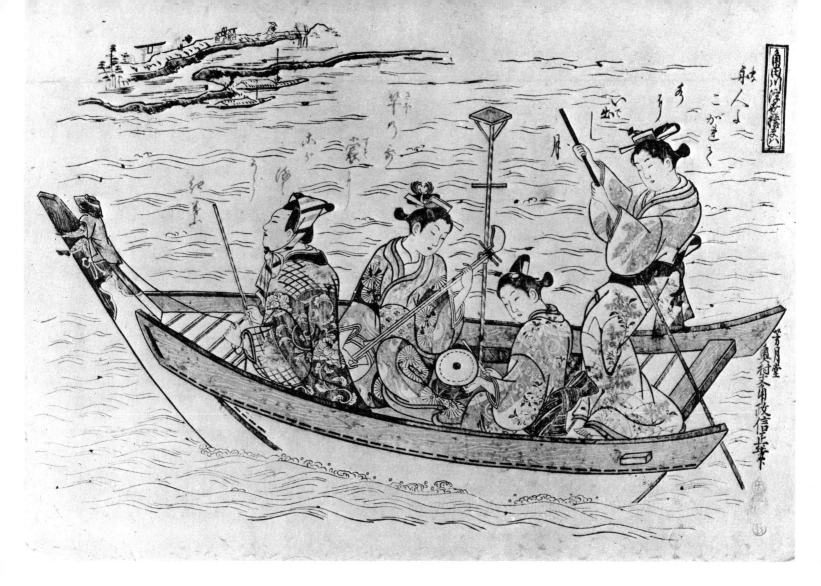

72 **Masanobu:** *Boating on the Sumida River. Benizuri-e* in large-ōban size, mid 1750s (early Hōreki Period). Signature: Hōgetsudō Okumura Bunkaku Masanobu *shōhitsu,* with seal.

A mixed crowd is being taken in a punt across the Sumida River to the Mimeguri Shrine: on the left, a young monkey-trainer and his charge; in the middle, a courtesan playing a samisen and a fair young man the drum; on the right, another courtesan, punting the boat. The group is vaguely reminiscent of a favorite New Year's subject, the Seven Gods of Luck in a Treasure Ship. The neat pairing of sexes naturally gives rise to romantic fancies, which are encouraged further by the elliptical verses printed at the top. Whereas Masanobu's small "rose prints" (plate 70) are among the most intimately enjoyable works of the period, his larger masterpieces in the same technique rank with the major treasures of ukiyo-e. This combination of rose, green and white went back to early Japanese architecture, sculpture and shrine icons; here it results in one of the most charming of Japanese prints. The rose (*beni*) is, alas, a most fugitive vegetable pigment, often fading simply from prolonged exposure to air. Whatever proof of possession the eager collector or curator feels he must record on the back of a print, he should never touch the front surface, especially of a fragile *benizuri-e*. Indeed, in viewing this masterpiece in the original, one's first impression is how near the collector's vermilion seal (on the lower right, in the *kana* syllabary: "Henri Vever") comes to upsetting the delicate balance of the original colors.

visualized in four stages: the fine cream paper, the jet-black outlines, the green patterns and the rose patterns. Combined, these simple elements were to produce some of the loveliest of Japanese prints. Plate 70 not only exemplifies the technique of early color printing, but it is also one of Masanobu's quiet masterpieces in this genre. It is not as striking as many in this book, yet in the original its firm but gentle lines and colors give the viewer some of the most satisfying experiences in ukiyo-e. This plate represents a Kabuki scene, but, as always, the dynamic primitive force of the stage is never allowed to intrude on Masanobu's theatrical prints. He seeks a refined ideal of beauty that bears little relation either to the bombast and exaggeration of Edo Kabuki or to the hurly-burly of the Edo streets. Quite incidentally, this print is also a reminder of the importance of the Japanese kimono in ukiyo-e: try to imagine these figures in any other garb.

In spite of his towering place in eighteenth-century ukiyo-e, as savior and renovator of the form after the death of the early Torii masters, Masanobu established no important school of his own. Most of his contemporaries learned and (as he himself often complained) copied from him. However Masanobu was himself so great and long-lived that no line of pupils was really needed to perpetuate his style.

The Early Color Print (2): Shigenaga, Toyonobu, Kiyohiro, Kiyomitsu, Kiyotsune

Although Masanobu was the great innovator and renovator of the Japanese print in the first half of the eighteenth century, there is another artist who, though not possessed of Masa-

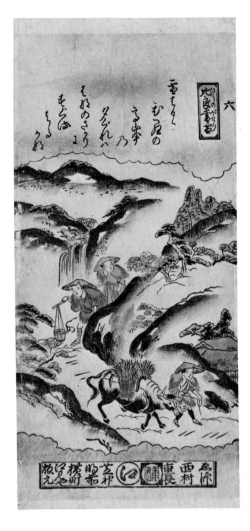

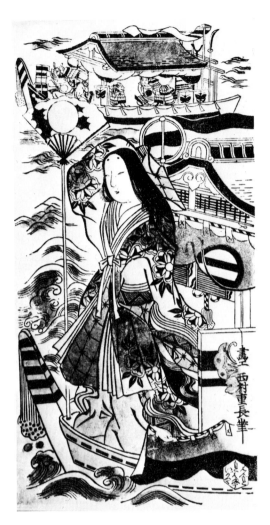

nobu's charismatic genius, contributed nearly equally to the progress of ukiyo-e during this difficult transition period from hand-coloring to color-printing. To Nishimura **Shigenaga** (ca. 1697 to 1756) has been attributed the invention or at least the development, of most of the new forms of ukiyo-e that he and Masanobu exploited so charmingly: perspective prints, the triptych form, "stone-rubbing" prints, "water prints" [*mizu-e*] and the semi-nude. Like Masanobu, he produced important prints of birds and flowers, actors and courtesans; and his work spans the period from the lacquer print to *benizuri-e* prints.

One of his most significant innovations, however, was the type of landscape-with-figures that we see in plate 73. This print, which features subdued hand-coloring, marks the beginning of the landscape as a separate form in ukiyo-e. A century divides Shigenaga and Hiroshige, but the latter owes more than is usually thought to this pioneer of ukiyo-e landscape. Plate 73 is significant in several ways: it is one of a series of eight prints celebrating the famous views of Lake Biwa (near Kyōto) and helped popularize a format that was to persist throughout ukiyo-e. Shigenaga's prints of famous places were both caused by, and helped to encourage, the trend toward travel to famous places that had been spreading, since the seventeenth century, in a country where travel abroad was forbidden by law. Shigenaga's cramped little figures will doubtless never be counted among the greatest beauties of ukiyo-e, but they do possess a compelling, rustic charm.

He was also a master of girl prints, his best work in this genre ranking with that of Masanobu and the Torii, while his prints of children are among the treasures of this genus. Nevertheless, many of Shigenaga's prints belong to the "period pieces" of the school. Their charm is dependent on an era and is not the universal kind that appeals to the average Western connoisseur. Yet though Shigenaga lacked Masanobu's powerful genius, his

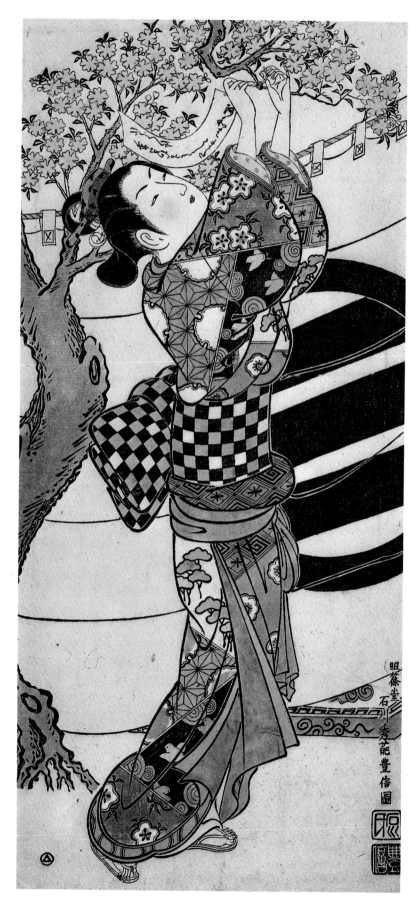

75 Toyonobu: *Girl Tying Verse to Cherry Branch. Urushi-e* in large-*ōban* size, ca. late 1740s (Kan-en Period). Signature: Tanjōdō Ishikawa Shūha Toyonobu *zu,* with seals; publisher (seal on lower left): Urokogata-ya.
Before a crested curtain (enclosing the festivities of a cherry-blossom-viewing party), a girl in her late teens is seen straining to tie a wistful love poem to a high branch. This large, hand-colored print, in perfect condition, represents one of the glories of ukiyo-e toward the end of the Primitive period.

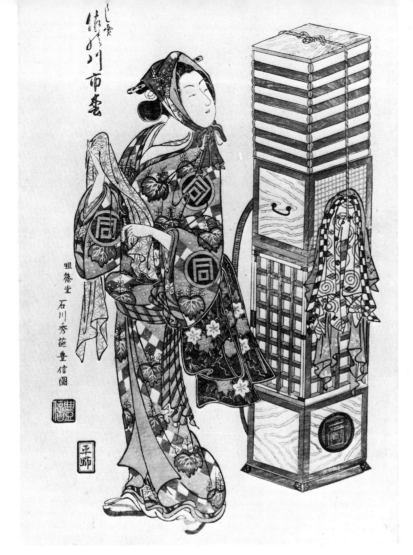 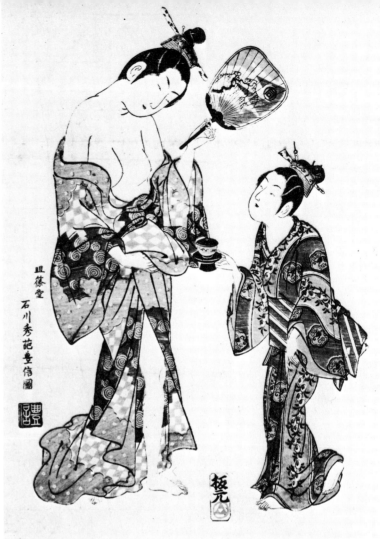

partially formulated ideal of art did not die with him, for he was one of the greatest of all ukiyo-e teachers: such masters as Shigenobu, Toyonobu and Harunobu are said to have received their basic training in his studio and went on to create some of the glories of Japanese art.

Nishimura **Shigenobu,** perhaps Shigenaga's earliest pupil, remains a kind of phantom in ukiyo-e history. Clever scholars have tried to claim that his name is simply the one taken initially by the more famous Ishikawa Toyonobu, but this seems doubtful. Shigenobu worked principally in the 1730s and early 1740s, specializing in small lacquer prints of actors and courtesans which, at their best, are among the minor masterpieces of this genre.

One final master in this group is Ishikawa **Toyonobu** (1711–85). He was a pupil of Shigenaga but also learned much from Masanobu's style; there is a certain grand impassivity to his figures that suggests a Kaigetsudō influence as well. Critics vary in their attitude toward Toyonobu, some ranking him very high. However, his prints are generally lacking in variety and a certain human touch that many seek in art, a quality that may be found in the best of even the impassive Kaigetsudō girls. Like Masanobu, Toyonobu created an impressive number of large lacquer prints of actors and standing girls during the 1740s, some of which, like that shown in plate 75, rank among the true masterpieces of ukiyo-e. He was also one of the pioneers of color printing during this and the ensuing decade but gradually gave up his ukiyo-e work with the ascendancy of his fellow-pupil Harunobu in the 1760s.

Plate 77 shows Toyonobu in another color-printed example. The subject offers more variety than is customary with this artist, and the semi-nude was an innovation in which he excelled. Before him, Shigenaga, Masanobu and Kiyohiro had each experimented briefly with the nude, but it was not to prove a lasting trend in premodern Japanese art; it was

76 **Toyonobu:** *Girl Cloth Peddler. Benizuri-e* in large-*ōban* size, mid 1750s (early Hōreki Period). Signature: Tanjōdō Ishikawa Shūha Toyonobu *zu,* with seal; publisher (seal on lower left): Hirano.
In one of the major works of early color printing, the famous female impersonator, Sanokawa Ichimatsu I, is shown here in the role of a vendor of *sarashi* [printed cotton cloth], which is displayed in the girl's hand and on the portable rack on the right. The two basic colors, rose and green, combine dramatically with jet black to form a powerful, cohesive composition.

77 **Toyonobu:** *Courtesan after Her Bath. Benizuri-e* in *ōban* size, mid 1750s (early Hōreki Period). Signature: Tanjōdō Ishikawa Shūha Toyonobu *zu,* with seal; publisher (seal at lower center): Urokogata-ya.
In this impeccable composition, a Yoshiwara courtesan is seen coming from her summer-afternoon bath, fan in hand (the fan bears the crest of the actor we saw in the previous plate); she is greeted by her little maidservant, who proffers a cup of green tea.

78 Kiyohiro: *Lovers Eloping. Benizuri-e* in *hoso-ban* size, the center panel of an uncut triptych, late 1750s (mid Hōreki Period). Signature: Torii Kiyohiro *hitsu*; publisher (seal on lower right): Urokogata-ya. In this graceful design, young lovers are seen eloping near a willow-shaded stream. The verse alludes to a similar scene in the classic *Tales of Ise.*

79 Kiyomitsu: *Kabuki Dance. Benizuri-e* in large-*ōban* size, early 1760s (late Hōreki Period). Signature: Torii Kiyomitsu *ga,* with seal; publisher (signature and seals on lower left): Nishimura-ya (Eijudō). This impressive early Kabuki print features the actor Ichimura Uzaemon (crest, role and name on upper left) in the role of a samurai child, dancing with a hobbyhorse under cherry blossoms. When color printing reached this degree of complexity, the "brocade prints" of Harunobu were only one step further.

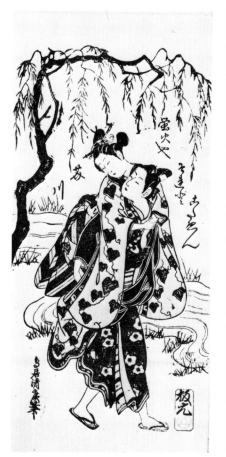

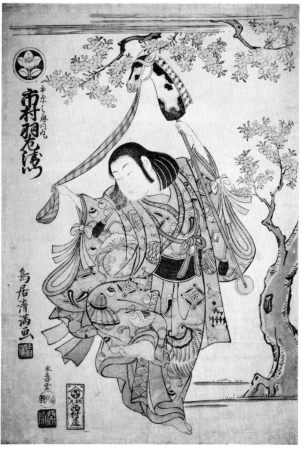

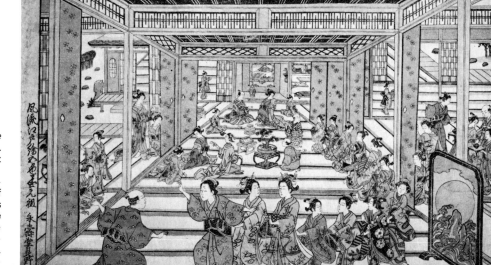

80 Kiyomitsu: *Yoshiwara Party Scene. Benizuri-e* in large-*ōban* size, early 1760s (late Hōreki Period). Signature: Torii Kiyomitsu *ga,* with seal; publisher: Nishimura-ya (Eijudō).
At a lively party scene in the Yoshiwara, the courtesans and their maidservants are playing a game of "follow the leader" in the center, as other courtesans attend on the patron in the background. This notable print gives a striking display of the favorite device of *uki-e* [perspective pictures]: an exaggerated employment of foreign-derived perspective techniques. As the publisher's blurb on the left indicates ("Originator of Elegant Edo Prints in Five Pigments"), this advanced stage of *benizuri-e* was only a hair's breadth removed from the *nishiki-e* ["brocade prints"] of a few years later.

81 Later Torii School: *Girl at Bath. Benizuri-e* in *hosoban* size, early 1750s (early Hōreki Period). Publisher (seal on lower right): Yamamoto (Maruya).

This is an unusual example of the nude in ukiyo-e, a category of prints which appeared from time to time after the government bans against the more explicit erotica in 1721 and the following years. The anatomical details hark back to shunga conventions. These mildly erotic ukiyo-e are *abuna-e,* which translates literally as "risqué pictures." Although this interesting print has been customarily ascribed to Torii Kiyomitsu, who indeed designed a very similar scene in *hashira-e* format, the somewhat austere style is perhaps closer to a contemporary of his early years, Torii Kiyoshige.

82 Kiyotsune: *Young Samurai. Benizuri-e* in *hosoban* size, 1767 (Meiwa IV). Signature: Torii Kiyotsune *ga*; publisher (seal on lower left): Matsumura.

The popular actor Sanokawa Ichimatsu II is shown here in the role of a young samurai standing under a plum-tree holding a bamboo flute in his hands. The inscription gives the actor's name and the notation "formerly Aizō," which helps to date the print, for Ichimatsu II's accession to that name occurred in late 1767. This print is a graphic reminder that, even after the development of the "brocade prints" in 1765, publication in the older, *benizuri-e* tradition continued for several years even in Edo.

usually employed, as here, for its mildly suggestive eroticism rather than as a glorification of the human form such as we find in Greek art. Nevertheless, whatever the motives for its exploitation, the occasional nudes and semi-nudes of these artists (and later, Kiyomitsu. Kiyonaga, Utamaro) form an unusual bypath of ukiyo-e. With this device ukiyo-e might well have managed to escape from the domination of the kimono when depicting female beauty, if Japanese lovers of feminine beauty had but followed the artists' leads.

Toyonobu produced one notable pupil himself, Ishikawa **Toyomasa,** possibly his son, who during the 1770s designed some of the most charming ukiyo-e prints depicting children at play.

Last to be mentioned in the rose, *benizuri-e* period are the third generation masters of the Torii School.

Torii **Kiyohiro** worked from the 1750s to the 1760s, and although he modeled his figures closely on those of Kiyomitsu and Toyonobu, his overall compositions reveal a special genius of his own.

The final major figure in the traditional Torii School was Torii **Kiyomitsu** (ca. 1735–85), son of Kiyomasu II and nominal head of the third generation of the Torii. Kiyomitsu worked almost entirely in the period of the *benizuri-e*, rose prints, the stage from about 1740 to 1764 when primitive color printing had gradually replaced hand-coloring. Kiyomitsu's work is about evenly divided between Kabuki scenes and girl pictures. He produced an enormous quantity of Kabuki prints—many of them prosaic—for his was not a dynamically original talent. With prints of girls and young men he was more successful, and in this category he was one of the greatest figures of his time. Sometimes he even equaled Harunobu, the genius of girl prints, who was just beginning his work. Historically plates 79 and 80 are also of great interest, for they display the last peak of the rose prints that were, within two or three years, to be displaced by the more colorful "brocade prints" of Harunobu. Up to five blocks were employed in these *benizuri-e* prints (including rose, yellow, sienna, gray, mustard and black) but the technique and color harmonies belong to the traditional age of ukiyo-e rather than to the new, full-color palette soon to be developed by the younger generation of artists under Harunobu's leadership.

Kiyomitsu's greatest follower was Torii Kiyonaga, a pupil of his late years, who founded a tradition that dominated ukiyo-e after Harunobu's brief decade of fame; Kiyonaga will be discussed in a later chapter. Kiyomitsu's chief traditional pupil was Torii **Kiyotsune** (who worked from the late 1750s to the 1770s). At his finest, he was one of the great ukiyo-e masters of naive, effeminate delicacy; in this quality he sometimes equals Harunobu himself. Kiyotsune's prints greatly resemble those of his master, but the innocent frailty of his figures often saves them from the monotony of some of Kiyomitsu's work.

With the graceful, faultlessly designed color prints of Masanobu, Shigenaga, Toyonobu and such late Torii masters as Kiyohiro, Kiyomitsu and Kiyotsune, ukiyo-e was ready to proceed to its technical and spiritual culmination under Harunobu. First, however, the neglected charms of early to mid-eighteenth century ukiyo-e painting must be surveyed, for in this genre and in Chōshun in particular, can be found much of the key to the dreamlike grace and color that were to enrich the later prints.

Some Painters and Illustrators: Chōshun, Chōki, Settei; Itchō, *Ōtsu-e* and *Ema*

Miyagawa **Chōshun** (1683–1753) was a rare genius of Edo who painted ukiyo-e all his long life but is hardly given more than passing mention in any book on the subject. For, as we have already noted in relation to the Kaigetsudō, it is the readily available prints that have always interested Western collectors. Scholars and critics who have never been to Japan have had to follow the collectors' leads, for they have had little access to the treasures of ukiyo-e painting, and moreover, perhaps they feared that their studies would lack an appreciative audience. Be that as it may, there are few greater, and few more greatly neglected, ukiyo-e artists than Chōshun; and plates 83 and 84 may be submitted as partial evidence.

Chōshun devoted nearly half a century to ukiyo-e painting and founded an important Edo school, yet neither he nor his pupils are known to have designed a single print. This artist acquired a firm groundwork in Japanese painting under Kanō and Tosa teachers, but it was the ukiyo-e style and subjects that were his real love, and Moronobu his real mentor. Indeed, a recently discovered, early handscroll of his bears the signature *Hishikawa* Chōshun, indicating perhaps a closer relationship to the Moronobu School than had hitherto been suspected.

Both in line and coloring Chōshun's paintings are reminiscent of Moronobu's, but in the works of his maturity, from the 1710s, we find an added element of the statuesque that derives from the Kaigetsudō. However, there is also a softness and a remarkable quality of warm femininity in Chōshun's girls that is uniquely his own. Though we may speak of influences upon him, in the end his is one of the most uniquely individual styles in ukiyo-e, and in coloring Chōshun may well rank first among all ukiyo-e artists.

More than any other artist except the Kaigetsudō, Chōshun's subject was preeminently girls and women. Apart from the atypical, early handscroll of plate 83, there is rarely a male figure in his pictures. Our second Chōshun, plate 84, ranks among the masterpieces of ukiyo-e; it depicts a seated Yoshiwara courtesan, luxuriously enveloping herself in the scent of rare incense, which is seen escaping upward in a faint vapor from her bosom. The implements of incense burning (a highly refined art and pastime in old Japan) are seen at her feet, and in the background there is a screen painted in the Kanō manner. The scene is one of complete sensuality: the girl is lost in a dream of voluptuous pleasure; yet we do not find the least hint of crudity or decadence, only a rarely intimate glimpse into a feminine absorption with the senses. The pose and atmosphere are almost orgasmic, but there is no self-indulgence here, only an all-pervading voluptuousness somehow reminiscent of Correggio. Of all Japanese painters Chōshun must surely rank as the master of the sensual female, as Moronobu does of the sentient female.

Chōshun was rather fortunate in his pupils: Miyagawa **Chōki,** possibly his son (and no relation to the later print artist Chōki), sometimes equaled Chōshun's portrayals of soft, catlike femininity. In his group compositions he went a step beyond the more limited subject matter of his master. Other significant pupils were **Isshō** and **Shunsui;** the latter is best known as the teacher of the master Shunshō, whose elegant prints and paintings will be a subject for later discussion, and who in turn taught the great Hokusai, among others. Thus

84 **Chōshun:** *Seated Courtesan.* Detail of a ▷ medium-large *kakemono* painting in colors on silk, 1720s (mid Kyōhō Period). Signature: *Nihon-e* [Japanese painting] Miyagawa Chōshun *zu,* with seal.
Alone in her boudoir a courtesan, seated on a *sugoroku* [backgammon] board, surrenders herself to the warm fragance of an incense burner. This is one of the most voluptuous of all ukiyo-e works.

83 **Chōshun:** *Rake with Catamites.* Detail from a handscroll in colors on silk, ca. early 1700s (late Genroku Period). Signature (at end of scroll): Hishikawa [*not* Miyagawa] Chōshun *hitsu,* with seals.
In this detail from a recently discovered scroll painting, we see the late Moronobu style fusing into the more voluptuous mood of the early eighteenth century. The subject of the scroll is unusual, being devoted to scenes of pederasty that are often depicted in a restrained manner, one step removed from shunga. On the left of the tableau shown, a young catamite plays the samisen as his companion on the right spurns the advances of an importunate townsman.

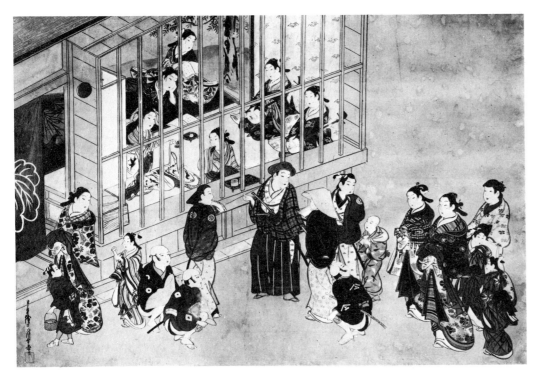

85 **Chōki**: *Yoshiwara Scene.* Large *kakemono* painting in colors on paper, 1730s (late Kyōhō Period). Signature: *Nihon-e* Miyagawa Chōki *sho* [*pinxit*], with seal.

Miyagawa Chōki excelled in group scenes, such as this view of the facade of a Yoshiwara courtesan house. Behind the barred window, the women at leisure reveal their richly bedecked charms, while outside two groups of courtesans flank a wealthy patron and his retinue.

86 **Otsu-e**: *A Devil on Pilgrimage.* Medium-sized *kakemono* painting in colors on paper, ca. early 18th century (mid Edo Period).

This is an outstanding example of *Ōtsu-e*, that style of genre folk painting that developed concurrently with ukiyo-e. Depicted in powerful, primitive strokes and colors, the subject is the popular *Oni-no-nembutsu*, in which a devil (with one bent horn) is satirically shown on a Buddhist alms-gathering pilgrimage, chanting a prayer and beating a gong, with a subscription list in one hand and an umbrella strapped to his back.

Chōshun's remarkable tradition of warm color and subdued grace flavored ukiyo-e painting until its demise over a century after his own passing.

Among other notable Edo painters in the first half of the eighteenth century the following may be mentioned in passing: Tamura **Suiō**, whose poised style reflects the dual influence of Sugimura and Chōshun; Ogawa **Haryū** (Haritsu), the most famous lacquerware designer of his age, who executed a number of lovely paintings of beautiful women partly as a hobby; Hozumi **Kōgyū**, whose angelic figures lie somewhere between the beauties of Chōshun and Harunobu, together with a host of Kaigetsudō followers and imitators.

Though his work lies outside the scope of this book, Hanabusa **Itchō** (1652–1724) must also be cited as a brilliantly original Kanō-trained painter, who devoted his life to witty representations of much the same genre world as ukiyo-e did but in a style and manner never quite a part of the ukiyo-e tradition. Itchō sired a host of followers, and the work of his school forms a fascinating byroad which winds its way for over a century between the Kanō and ukiyo-e styles.

We have already had occasion to mention **Ōtsu-e** [Ōtsu Pictures], a variety of folk art produced by anonymous artisans in the Ōtsu region of the Tōkaidō highway from the seventeenth century. Although *Ōtsu-e* subjects often found their way into later ukiyo-e prints, they are not themselves ukiyo-e but, rather, a unique variety of folk painting, of which one notable example is given here, showing that most popular of *Ōtsu-e* subjects, "The Devil on Pilgrimage."

And while we are on the byroads of ukiyo-e, mention should be made of the *ema*, votive wooden plaques made to be hung in Shintō shrines and accompanied by prayers for success in life, recovery from illness and the like. The *ema* is, of course, a format rather than a school of painting; *ema* have been produced by practically all types of artists—though Kanō, Tosa and ukiyo-e styles tend to predominate. However whatever the original training of the artist, when his subject is contemporary life the style tends to border on ukiyo-e. One such *ema* shown here is probably by a Tosa artist but bears interesting overtones of the Kambun Master and the Moronobu School.

To conclude this account of the variegated but miscellaneous styles of the mid-eighteenth century let us turn once again to the Kyōto-Ōsaka region, the birthplace of ukiyo-e in the early seventeenth century, whose leadership had been taken away by the more vigorous artists of Kambun and Genroku Edo.

87 *Ema* **Folk Painting:** *Women with Uncovered Breasts.* Painting in *ōban* size in colors on wood, ca. early 18th century (mid Edo Period).

Painted most often by plebeian artisans, *ema* were votive icons prepared for offering to shrines in connection with specific prayers: for success in business or life, recovery from illness, etc. The present charming example is in Tosa-*cum*-ukiyo-e style and may well represent the prayer of two sisters that their breasts yield milk for their children.

88 Shūsui: *Courtesan with Lover. Sumizuri-e* in *ōban* size, from a series of twelve shunga prints, ca. later 1760s (Meiwa Period).

Although Shimokōbe Shūsui produced dozens of volumes of adept illustrations in the Sukenobu manner, this series of *ōban*-sized shunga comprises one of his few major works. In the scene illustrated, a courtesan rejects her lover's dildo in preference for the real thing. In addition to the man's natural enthusiasm to try out his newly acquired tortoise-shell gadget, his offer also reflects a sentiment common among Japanese gallants: giving a lady pleasure is more important than satisfying oneself.

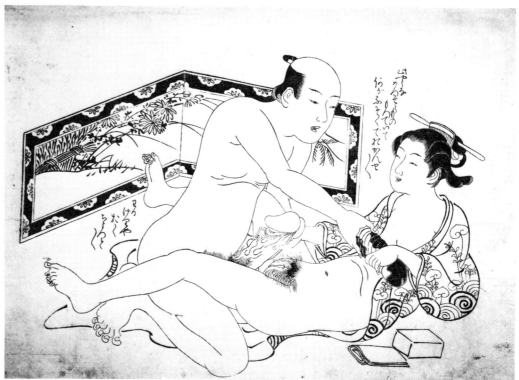

Like many other ukiyo-e masters, the Kyōto leader Sukenobu was not too fortunate in his direct pupils: his son **Suketada,** and **Sukeyo** (possibly his daughter) continued his tradition faithfully but without notable talent. Other Kyōto-Ōsaka illustrators such as Kawashima **Nobukiyo,** Kaga **Yūzen** (more famous as a dyer), Takagi **Sadatake,** Ōoka **Michinobu,** Hasegawa **Mitsunobu,** Shimokōbe **Shūsui,** Kitao **Tokinobu** and the painters of the Kawamata School: **Tsuneyuki** and **Tsunemasa,** adapted his style to their own talents and produced charming though derivative work. In Edo, Yamazaki **O-Ryū** (Ryū), who worked from the early 1700s to the 1730s and was one of the few important women paint-

ers in Japanese history, combined the Moronobu and Sukenobu styles to create some of the most graceful paintings to be seen in the eastern capital.

In closing our discussion of these neglected early to mid eighteenth-century masters, a place must be set aside for Sukenobu's principal successor among the Kyōto-Ōsaka illustrators and painters, Tsukioka **Settei** (1710–87). At first a student of the Kanō School, Settei soon reached his forte in a unique combination of the Moronobu and Sukenobu styles—an attempt to unite the force of the one with the grace of the other. The amalgamation was achieved admirably, though there is little question that Settei lacked the genius of either of his preceptors. Settei's work covers a large number of book illustrations and paintings, particularly of classical Japanese subjects handled partly in the ukiyo-e manner. In this respect Settei's work, like that of Sukenobu, well reflects the tastes of Kyōto and Ōsaka, where the Imperial Court and court culture in general were still the primary objects of veneration and interest. Quite the opposite was true in Edo, where the courtesans and actors—principal subjects of ukiyo-e throughout the seventeenth and eighteenth centuries—were all the rage.

Settei was also one of the most active creators of erotica in western Japan. Plate 89 shows a scene from a shunga series of large color prints mounted in scroll form. A geisha and her lover are depicted in an embrace in which the swirl and color of the bedding almost obscure the figures. One amusing story about Settei has come down to us: during the late 1760s part

89 **Settei**: *Courtesan with Lover. Benizuri-e* in large-*ōban* size, from a series of twelve shunga prints, one of which includes the artist's surname "Tsukioka" in the kimono pattern, ca. later 1760s (Meiwa Period).
The most prominent Kamigata illustrator and painter after Sukenobu, Settei likewise achieved his most impressive prints in the shunga field. The present series, due to its large size, is usually found mounted in scroll format and features decorative yet powerful employment of the *benizuri-e* technique (which persisted in Kyōto and Ōsaka publications for at least a decade after it had been supplanted in Edo).

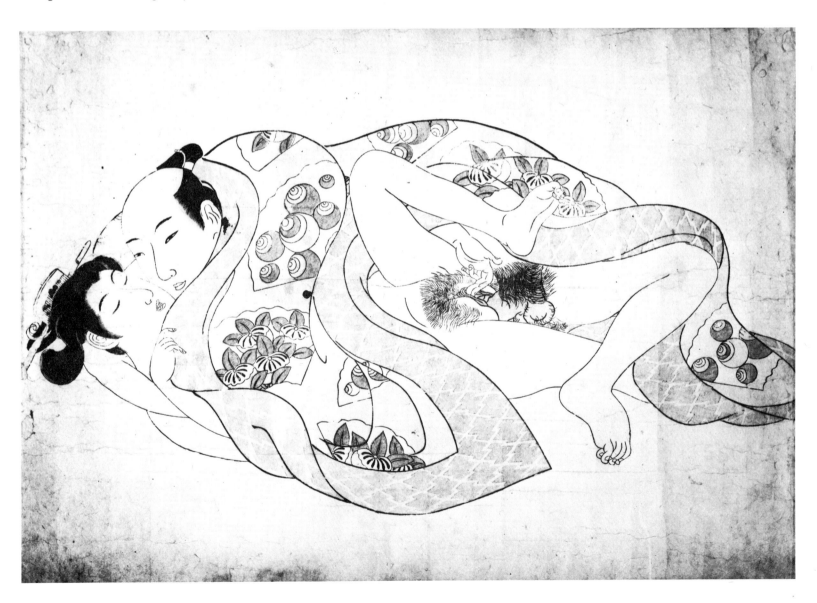

of Kyōto was laid waste by a great conflagration, but one lone storehouse remained strangely untouched by the fire. Upon opening it, a box of Settei's erotic pictures was found inside. From this time forward the price of Settei's erotica is said to have risen tenfold, since the male citizens of Kyōto sought them out as a pleasurable kind of fire insurance!

The school of painting founded by Settei flourished, and his influence was also felt throughout the later history of Kyōto-Ōsaka illustration. Among his pupils and followers were his own sons, **Sessai** and **Sekkei,** as well as **Buzen, Munenobu, Kangetsu, Gyokuzan** and **Shunchōsai.**

Settei was typical of the painters who satisfied the tastes of the well-to-do Kyōto and Ōsaka citizenry during the period that Edo ukiyo-e was making the tremendous advances that were to earn it worldwide renown. It is well to recall, as we consider the coming golden period of ukiyo-e prints, that a fair majority of Japanese art lovers preferred their floating-world pictures to have a close and persisting link with the traditional outlook and styles of the past. A lack of immediate appreciation has, of course, been the fate of new art in other societies as well. As the golden fire of Harunobu's genius swept the Edo horizon for a brief decade, there were many, even among Japanese connoisseurs, who never noticed him and whose descendants were not to recognize the extent of his genius until well over a century later, after enthusiastic foreigners had succumbed to his bewitchment and carried away most of his pictures to their own far shores.

The First Century and a Half of Ukiyo-e

In concluding this introduction to the pleasures and beauties of ukiyo-e in its initial century and a half of development, it may be of interest to review the formats and techniques that characterized this fascinating primitive period.

The earliest examples of real floating-world art date from the beginning of the seventeenth century and are most frequently found on the large screens (*byōbu*) with which the feudal lords, nobility and magnates decorated their castles, palaces and mansions. Such screens usually come in pairs of from two to eight panels each, from 3 to 6 ft./90 to 180 cm. in height. A ground of strong, handmade mulberry paper was usual for these screens, and often gold-leaf played a significant part in the effectiveness of these masterpieces of the Momoyama Period and later. The designs painted directly on a background of pure gold-leaf, or gold-leaf and gold-wash, were added to the painting later to fill out the blank areas of the design. In a period when the interior lighting consisted of candles and small oil lamps, the illuminating effect of these brilliant screens in a huge hall or temple can well be imagined. Many of the early screens may be seen today in their original form, but others are found dismounted, single panels or fragments being either framed or remounted as hanging scrolls (*kakemono*). Many of the more impressive ukiyo-e *kakemono* of this early period probably derive from such dismounted screens.

The *kakemono* was also a format frequently employed in early ukiyo-e, particularly for the smaller and more intimate paintings designed to be hung in the alcove (*tokonoma*) of the Japanese parlor or guest-hall. *Kakemono* paintings were executed either on paper or on silk, and it is surprising how little the pigments have been affected by thousands of rollings and unrollings. The picture scroll (*emakimono*), horizontal counterpart of the *kakemono,* also appears now and then in early ukiyo-e, particularly in panoramic themes related to Kabuki and to the Yoshiwara, as well as in storytelling themes and depictions of intimate love scenes. The latter were termed "spring pictures" (*shunga*), and formed a major category of ukiyo-e throughout its long history.

Genre painting is also seen occasionally in illustrated book manuscripts, albums and other miniatures, though most often in the *Nara-e-hon* [Nara-Picture book], a genre that mixed folk art and Tosa-ukiyo-e styles.

Other miniaturistic formats of Japanese painting are also seen occasionally in early ukiyo-e, e.g. fan painting (*semmen*), and square or oblong poem-cards (*shikishi* or *tanzaku*).

With the second half of the seventeenth century, the ukiyo-e genre finally developed

that intimate connection with woodblock printing that would be the source of its world-wide fame. The first printed ukiyo-e appeared in the form of book illustrations: first in Kyōto and soon in Edo as well. Larger and more independent print designs made their debut in Edo shortly thereafter. At first they consisted mainly of sets of prints—usually mounted either in scroll or album form—devoted to erotic subjects, as well as samurai and literary-legendary themes. The standard print format was the *ōban* (about 15×10 in./38×25 cm.) and, to a lesser extent, the *chūban*, just half that size. In the early period these appeared most often in sets of a dozen prints, folded and mounted as albums. The black-and-white *sumi-zuri-e* print predominated in the period before the perfection of color printing; but in the orange *tan-e*, hand-coloring (primarily in orange, green, yellow) was used to enhance the effect of a design.

Book illustration was to flourish throughout the life of ukiyo-e prints, and already by the 1660s the picture book (*ehon*) took predominance in the field with its large, impressive illustrations and only a minimum of text.

From the 1670s the *kakemono-e,* both in monochrome and *tan-e* versions, was gradually introduced; it is a larger format of independent print (about 23×12 in./58×30 cm) that was often mounted as a hanging scroll, to form a kind of "poor man's *kakemono*" for those who could not afford the expensive paintings. This and a slightly smaller size, the large-*ōban*, were also used occasionally in horizontal format, for presenting scenes of wide-screen size. It is ironical that the *kakemono-e* and large-*ōban*, which at the time were considered a form of cheap reproduction, now often bring higher prices than original paintings. This is in part a reflection of the preponderant number of Japanese-print collectors today, as against the few collectors interested in the more esoteric ukiyo-e paintings. It is also an indication that the prints are more strikingly modern and immediately appealing to the connoisseur, whether in the West or in Japan, than are the more tradition-bound paintings.

As with the smaller prints, the early *kakemono-e* and large-*ōban* often featured hand-coloring in *tan-e* technique, and at their best they represent one of the high points of Japanese graphic art.

Ukiyo-e was always a creature of the times and, following popular taste, the more refined, detailed coloring of the *beni-e* [rose print] or *urushi-e* soon came into fashion. This was accompanied by a trend (encouraged by government edicts) towards reduction in size of the prints to the more intimate narrow print (*hosoban*) size, about 12×6 in./30×15 cm, that was most often printed in triptych form and then divided. Larger sizes returned to fashion in the 1740s.

The careful hand-coloring of the lacquer prints entailed considerable labor, and eventually publishers perfected simplified methods of color printing, in which a different woodblock was engraved for each color on the final print. This innovation featured *beni* (rose) as one of its predominant colors and thus was called *benizuri-e* [rose-printed print]. The smaller, *hosoban* format enjoyed continuing popularity, though for decorative purposes the large *kakemono-e* remained in favor as did the more economical size, about a third the width, termed *hashira-e* [pillar print] because it was designed to decorate the pillar of the alcove in a typical Japanese parlor.

This chapter brings to a close our brief outline of the beauties and mysteries of ukiyo-e in its initial, primitive period. In a broad sense, the second decade of the eighteenth century marked the termination both of the bold black-and-white print and of ukiyo-e painting as vital independent forces in this genre. The dominant form in the new era of ukiyo-e was the color print in its various manifestations: from the rich, hand-colored lacquer prints, through the delicately color-printed *benizuri-e,* to the elaborate "brocade prints" of Harunobu and his followers, to whom we now turn our attention.

The Golden Age of the Color Print
1765–1810

Harunobu and the "Brocade Print"

The brocade-print (*nishiki-e*) period is the era of Harunobu and his followers, the age of glorious color in the Japanese print. A misguided Shōgun's whims had reduced the scale and grandeur of Japanese prints in the 1720s. The free and easy, often corrupt government of another administrator, Tanuma Okitsugu, went hand in hand with a new flourishing of the print—beginning in the mid-1760s—that was to surpass in color and variety anything seen before. The early leadership of this artistic revolution went to Harunobu, and during the brief six years of his ascent, some of the greatest glories of ukiyo-e were produced.

Suzuki **Harunobu** (ca. 1725–70) is said to have been a pupil of the pioneer innovator Shigenaga, but their relationship is by no means clear. Certainly the strongest influence in the work of Harunobu's maturity is that of the Kyōto master Sukenobu—of whom recent research suggests Harunobu's direct teacher may have been—together with that of Kiyomitsu, Toyonobu and the Kawamata School of ukiyo-e painters. Harunobu also shows evidence of Kanō training and, both in his coloring and his ideal of frail femininity, something of the manner of such sixteenth-century Chinese genre masters as Ch'iu Ying and T'ang Yin.

Harunobu's apprentice work from the late 1750s consists of deft adaptations of the styles of these predecessors. In particular, his early prints, whether their subject be actors or girls, show the obvious influence, both in design and coloring, of the late Torii masters Kiyomitsu and Kiyotsune. Strangely enough, within a decade these artists were themselves imitating Harunobu's fully developed style. Yet Harunobu might have remained the potentially great but obscure designer of his first decade of work had not a fortunate chain of circumstances thrust him into a new style, a new technique, a whole new art. What happened was this. For some years well-to-do connoisseurs and amateur poets in Edo had tended to form clubs and cliques for the appreciation and publication of each other's verses and ideas. Among these groups, even acting as their leaders, were several wealthy samurai who, typical of the age, were concerned more with aesthetic culture than with the military arts of their ancestors. Around the year 1764 the interests of these groups, like those of their Chinese predecessors, came to be directed toward the realm of contemporary art and to ukiyo-e in particular. On some impulse the various groups decided to concentrate their dilettante efforts upon the production of unusual New Year's and greeting cards for the coming year. Harunobu, both on the basis of personal contacts and from the quality of his own literate, refined style, was chosen as the professional guide and executor of the amateur efforts of the groups.

These New Year's cards served a dual purpose. Calendar publication was a government-controlled, monopolistic enterprise at this time, a field denied to the general publishers. Yet the Japanese lunar calendar was so arranged that the months were either short (twenty-nine days) or long (thirty days); if one but knew which months of the year were short or long, the other calculations were relatively simple. Thus these *e-goyomi* [calendar prints], as they are often called, contrived to work the numbers of the long or short months unobtrusively into the design of the picture; and the ingenuity with which this was done, together with the artistic and technical quality of the print itself, governed its success in the friendly competitions these highly critical amateurs held at regular intervals.

Although Toyonobu and one or two other ukiyo-e artists are known to have designed a few calendar prints at this time, Harunobu was, in effect, the acknowledged master and produced a considerable number of prints in this medium, particularly for the years 1765 and 1766. Several features are remarkable in the calendar prints. First, only the finest materials were employed. Until then the popular prints had usually been published rather inexpensively on thin, strong paper with ordinary pigments. Now, however, the wealthy aesthetes wanted only the finest paper, colors and techniques; as a result, the cost of Harunobu's new "brocade prints" [*nishiki-e*], as they came to be called from their variegated colors, was about ten times that of the rose prints that he himself had designed in his youth.

By the same token, no expense was spared in the development of new techniques in printing: formerly catalpa wood had most often been used for the blocks; now the finer cherrywood was employed. Not only were more expensive colors used, but the new prints featured a thicker application of pigment; there was a striving for the opaque rather than

the transparent, a return to the quality of coloring found in the early orange prints but with a full range of colors, all of which benefited from the uniformity of outline, tone and surface pattern that was achieved through the medium of the woodblock. Most important of all, with expense and trouble now no consideration, the number of blocks was increased to as many as were needed for the most effective reproduction of the varied colors. As many as ten blocks were employed for some of the first experiments of late 1764 to 1765.

The fact that full-color printing evolved in this way in the space of a few months would seem to make it clear that the techniques were ready and only awaiting the financial backing necessary to put them into practice. Indeed, plates 79 and 80, done only a few years earlier by Kiyomitsu, already show much of the technique that was to make Harunobu world-famous. They lack only a somewhat more brilliant, opaque coloring to qualify as brocade prints.

The third notable feature of these refined, personalized greeting cards was that they nearly always bore the name of the patron who commissioned them but often omitted that of the artist. This has led to all sorts of controversies among ukiyo-e scholars, but the fact seems to be simply that the signature, for example "By Kyosen" (the samurai leader of the largest club), on such a print signifies that he commissioned it for distribution among his friends and most probably suggested the idea and even the design to be used. But the final painting, which was carved on the woodblocks, came from Harunobu's anonymous brush. This fact can be readily proved by an examination of the successive versions of the print: the first and finest impression is always the limited edition done for the connoisseur who signed the print; in the later commercial editions the connoisseur's name is removed and that of the artist, Harunobu, added. The calendar marks, out of date by this time, are also removed; and the print is sold to the general public simply for Harunobu's lovely picture. Of course, this phenomenon applies principally to the calendar prints and other series commissioned for the years 1765 and 1766. Once Harunobu was established as the new master of ukiyo-e, most of his prints were issued directly by the publisher, often bearing the artist's name from the beginning and attempting in quality of printing to equal the standards set by the pioneer amateurs. Interestingly enough, however, a great many of Harunobu's prints are unsigned throughout his career; whether they were done on special commission or whether his style was simply thought inimitable is not known. Since a publisher's seal is also seldom seen, it may be that the connoisseurs of the time considered that such additions marred the pristine beauty of the print. Again, some of Harunobu's most luxurious prints were originally issued in series of two to twelve prints, in which case the paper wrapper (now usually lost) bore the name of the series, the publisher and the artist.

Conversely, some of the early calendar prints bear the name not only of the patron and the artist, but also of the engraver and the printer as well. The latter's names are often to be found recorded in the colophons to illustrated books. But in the prints these skilled artisans, who contributed so much to the success of a print, received published recognition only briefly in this period and again in the early to mid-nineteenth century when another even ·more luxurious form of ukiyo-e greeting card came into vogue.

It may be well to review here the stages and agents that went into the production of a Japanese color print; for though the artist—given paper, paints and brush—could go on to produce a painting single-handedly, both the production and the success of a print depended upon many factors beyond the artist's control. The situation might, indeed, be likened to that of the sculptor who must delegate the casting of his statue to a specialist in that field.

The first agent was, of course, the connoisseur or publisher who commissioned the work, most often suggested the subject and sometimes even specified the design. He also provided the capital and the tasteful direction and control upon which the quality and details of the project often depended. Second came the artist, who worked out the final design, what might be called the physical expression of the idea, and imbued it with whatever artistic value the print was to have. Third were the engraver and the printer, each of whom worked under the close supervision of the publisher and upon whose skill depended the technical excellence of the final result.

There is some confusion among critics regarding the actual place of the artist in the print-making process. But whatever his technical indebtedness to publisher, patron, engraver and

printer, he is still the only artist in the group and without him there is no design worth printing.

Although there is no need to belittle Western art in order to glorify our subject, it must be pointed out that the woodblock print, and more particularly the color print, was technically and aesthetically further advanced in Japan than anywhere else. European wood engravers, from the early Germans until Thomas Bewick, could have done justice perhaps to the pre-Moronobu primitives; but beginning with late seventeenth-century Japanese woodblock prints, a perfection (which was never to be achieved in the West) was reached and

90 **Harunobu:** *Courtesan Reading a Love Letter near a Snowy Window. Nishiki-e* in *chūban* size, datable to 1765 (Meiwa II).
The intricate coloring of the "brocade prints" was an innovation resulting from friendly competition among connoisseurs to produce the ultimate in New Year's cards, the so-called *e-goyomi* (literally, "picture calendars"). In this simple but effective design, a lovely courtesan is shown unrolling a billet-doux on which the calendrical data for the year involved are recorded. The concept is reminiscent of a popular pose in ukiyo-e: a courtesan reading a love letter while mounted on a white elephant, a pastiche on the Buddhist *Fugen-bosatsu/ Eguchi-no-kimi* theme in which the courtesan is seen as a manifestation of Buddhahood. As with many *e-goyomi,* the artist's name is not recorded, but the seal of the patron appears at the bottom left.

sustained. This fact was noted somewhat later by the first Americans to visit and write about Japan, members of the Perry expedition of 1852 to 1854, one of whom wrote of a print by Hiroshige (still alive and active at the time):

> The chief point of interest in this illustration, considered in an artistic sense, is, that, apart from its being a successful specimen of printing in colors—a process, by the way, quite modern among ourselves—there is a breadth and vigor of outline compared with which much of our own drawing appears feeble, and, above all things, undecided.

Harunobu's Masterpieces

Many of the early Harunobu calendar prints are remarkable more for cleverness of design than for artistic appeal. Though they represent some of the technical crowning points of color printing, the artist's true genius was, naturally enough, hampered by having both subject and treatment dictated. We sense this lack of freedom in the somewhat stiff lines and formalized treatment of the figures.

A notable exception is the print reproduced in plate 91, which marks the beginning of Harunobu's maturity as a free artist. The calendar numbers (2, 3, 5, 6, 8, 10) are concealed adroitly enough in the calligraphy above the pail on the left, but the print itself stands as a masterpiece quite independent of its original function. (Note that in this second impression for general sale, the signatures of the designer, artist and engraver have been removed, although the unobtrusive calendar markings have been retained.)

To some critics all Harunobu's subjects seem like children; in this case, however, the subject is an actual child, one of the young boys who used to trudge about the streets of Edo selling pure well water for use in making tea. The boy carries his wares balanced on the end of a pole, the bucket on the left bearing the implements of the tea ceremony. He is clad in a red loincloth and a purple *happi* coat, with a straw hat to keep off the summer sun. All this is simple enough; but, in the first sign of Harunobu's characteristic genius, the boy is surrounded by a remarkable pink background that suffuses the entire print and serves, in some inexplicable manner, to complete and unify the whole picture. Atmospheric background was a characteristic innovation of Harunobu's art. Before him, Moronobu, Sugimura and Sukenobu had employed it to a limited degree; but never, of course, with the advantage of the rich color harmonies that Harunobu had at his disposal. Yet Harunobu was not only the pioneer of colorful background, he was also the greatest exponent of it in all ukiyo-e. Harunobu made particularly effective use of the *tsubushi* technique shown here, the whole background in a wash of one color—opaque pink, blue, gray or black; later artists imitated this technique closely but, somehow, never with the same startling effect as this bold but gentle pioneer.

Harunobu's art was unique not only in color but in subject matter as well. Glancing at the work of Harunobu's predecessors shown in the previous chapter, we find much powerful or charming work, but a certain limitation in subject matter. Somewhere in their scores of picture books Moronobu and Sukenobu had, of course, treated practically every subject of Japanese life; but it remained for Harunobu to immortalize the ordinary world of daily life in the print. Here, too, no later artist was quite to equal him. He set the new ideal both in color and in subject, but was himself the only artist fully to attain it. In art, it would seem that individual genius is more important than laws of progress and evolution.

Although Harunobu is most apt to be thought of as an idealist, the nature and background of his work are realistic. He lived in an age where the laxity and corruption of the supposedly austere feudal government gave a touch of satirical realism to the outlook of the common man and to that of literature and art as well. Thus ukiyo-e came to deal more and more realistically with the everyday world, rather than simply with the pleasure quarter and the theater, which were almost a world of make-believe.

The new emphasis on coloring, too, might well be interpreted as a striving for greater physical and emotional realism, an attempt to depict things closer to the way they actually were—or, at any rate, the way they were imagined to be. The formal, the conventional and

91 **Harunobu:** *Boy Water Vendor. Nishiki-e* in *chūban* size, datable to 1765 (Meiwa II).
In another of Harunobu's first calendar prints, a young water and tea vendor is seen trudging the streets of Edo, the background being sublimated into an all-encompassing pink ground. The notations for the long months of the year—the ostensible excuse for the print—are incorporated in the two characters on the boy's sign (from right to left): 10, 8, 6, 5, 3, 2. Our plate represents the second state of this famous print. The first (in the Art Institute of Chicago) features a light gray background, the signature and seal of the patron and the signature of the artist (Suzuki Harunobu *ga*) as well as of the engraver (Takahashi Rosen *chō*); furthermore, no printed pattern appears on the sign: this was added later to obscure the calendar markings when the print was put on sale commercially. As sometimes happens, the second state is the more effective print, if only because of the glorious pink background.

the stylized, were gradually being replaced by forms which, though still refashioned in the mould of art, were far nearer to the actual world.

The print in plate 92 illustrates Harunobu's special province, one in which he surpassed all other Japanese artists—eternal girlhood in unusual and poetic settings. In spiritual affinities Harunobu's girls are closest to Sukenobu's; they derive physically from Kiyomitsu's and Toyonobu's. Yet in the end these girls are Harunobu's creation alone, and they surpass, in their own special world, the work of any other artist.

The setting of this print could well evoke fright: a girl's midnight pilgrimage to a Shintō shrine in the midst of a driving rainstorm. Her umbrella is shattered; her lantern nearly extinguished; dark cypress trees rustle wildly in the background; not another soul is in sight. Yet there is no fear here, nor in any of Harunobu's prints, only beauty. Can anyone rearrange

92 **Harunobu**: *Girl on Night Pilgrimage. Nishiki-e* ▷
[Henceforth all prints are *nishiki-e* unless otherwise noted.] in *chūban* size, late 1760s (mid Meiwa Period).
In the evening in the midst of driving rain, a girl with a tattered umbrella visits a Shintō shrine, doubtless to offer prayers about some romantic affair. In the background loom the shrine archway and fence and the sacred cryptomerias; in the girl's frail hand a flimsy lantern flickers tenuously. This print dates from Harunobu's prime and represents one of the supreme achievements of ukiyo-e.

93 **Harunobu**: *Girl at Shrine. Chūban* size, late 1760s (mid Meiwa Period).
In a daylight setting otherwise similar to that of the previous print, a girl stands before the ablution fountain of a Shintō shrine, as cryptomeria trees stand solemnly in the background. The subject may well be Harunobu's favorite model O-Sen, the famous teahouse beauty of the Kasamori Shrine in Edo.

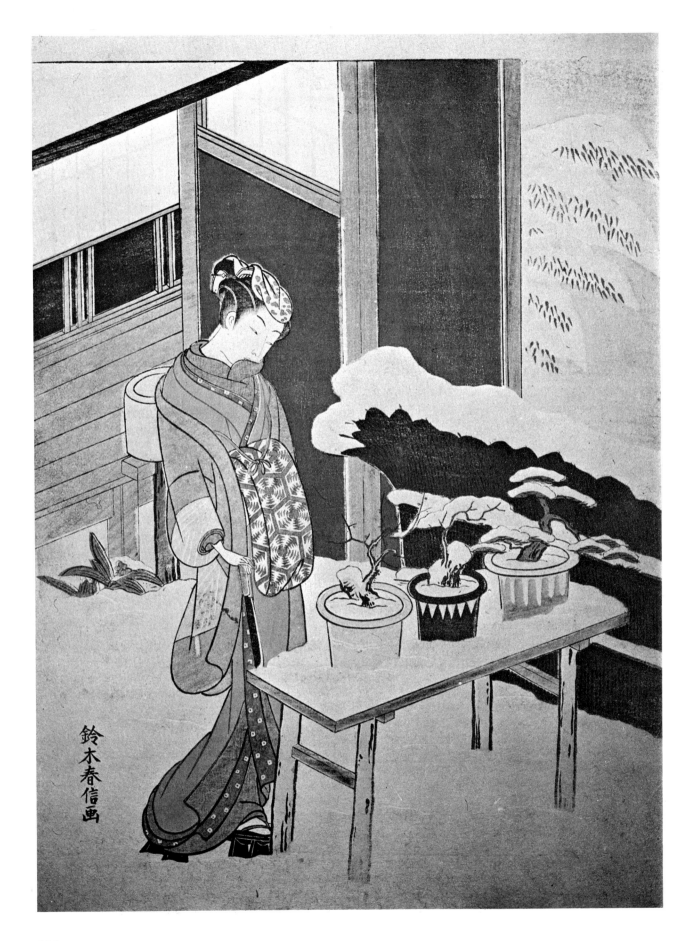

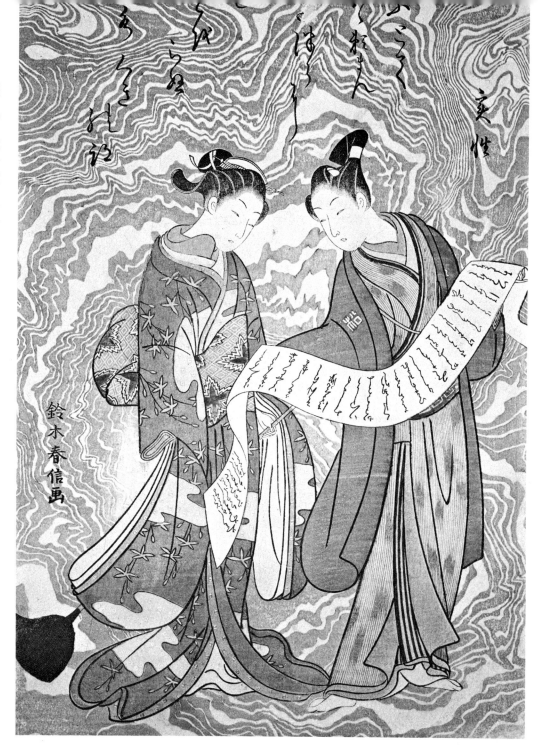

95 Harunobu: *Young Couple.* Large-*chūban* size, late 1760s (mid Meiwa Period). Signature: Suzuki Harunobu *ga.*

This effective design is clearly a pastiche on the Zen theme of the monks Kanzan and Jittoku (customarily depicted holding a scroll and a broom), here portrayed as a young couple reading a lengthy billet-doux. The design is given dramatic complexity by the addition of a background pattern after the manner of *sumi-nagashi,* a type of marbled paper made by brief immersion in water containing uneven strata of ink. Without this striking feature, the print would differ surprisingly little from the work of Harunobu's predecessors a decade earlier.

◁ **94 Harunobu:** *Courtesan with* Bonsai *in Snow.* *Chūban* size, late 1760s (mid Meiwa Period). Signature: Suzuki Harunobu *ga.*

A courtesan stands in the snow thoughtfully regarding three potted *bonsai* [dwarfed trees]. In her hand is a cleaver: clearly, this is a pastiche on *Hachi-no-ki,* the story of an impoverished samurai who sacrificed his treasured *bonsai* for firewood to entertain a priestly guest (who turned out to be the shōgun in disguise). Whether or not the scene bears erotico-masochistic, "castration-complex" overtones may be left to the viewer to decide.

this complexity—bold *torii,* a slim girl whose kimono is blown open, a paper lantern and a broken umbrella, a post fence and four straight trees—into a more perfect composition or even come near to evoking the magic mood expressed here?

The artisans who produced full-color printing would merit our gratitude if only for this one print. Note the flawless placement of the complex colors: red, blue, yellow, purple, green, several browns, several grays and black. Observe, moreover, Harunobu's mastery of kimono design and at the same time his refusal to let the kimono dominate the print, as was so often the case with his predecessors. (The technique of gauffrage or embossing, seen on the paper lantern, is used often by Harunobu to lend texture to white surfaces.)

Let us take a further look at Harunobu's idealized, ageless girl, as shown in plates 93, 94, 95. Even in Japan, it is difficult to imagine actually viewing scenes of ingenuous beauty so perfect; yet a viewer must be unfeeling indeed not to be captured by such a dream nor long to possess something of it.

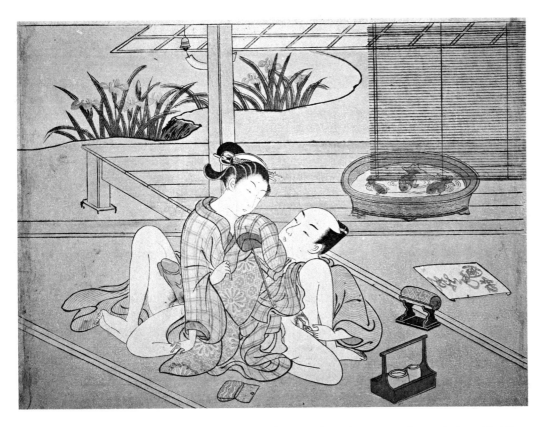

96 **Harunobu:** *Lovers in Summer. Chūban* size, one of a series of twelve shunga prints, late 1760s (mid Meiwa Period).
In a parlor opening onto a garden, lovers recline in dishabille, escaping the summer heat. In the background irises bloom and goldfish frolic. In common with his other work, Harunobu's shunga are gentle reveries on the exigencies of love. There is little physical passion; it is replaced by sublimated ecstasy.

These plates represent more sweetness but less art than the masterpiece of plate 92. They are cited not only for their lovely designs and coloring but also to illustrate the uniformly high standard of Harunobu's prints: the artist made nearly two hundred such designs each year during the final six years of his foreshortened life.

Harunobu's principal forte consisted in opening new vistas on the beauty of delicate girlhood in all walks of life; at the same time, he was the master of charming scenes portraying mother and child and children in general. His later prints also reveal some of the loveliest erotica in the world, as well as enchanting prints of the famous local beauties of the day, O-Sen and O-Fuji. This was a period when the beauty of the everyday world was at last coming into its own, and the pretty girls in the local shops were appreciated as much as the Yoshiwara belles. Earlier writers on Harunobu have tried to invent some strange romance between Harunobu and the lovely O-Sen, but it seems most likely that he simply chose her as an earthly representative of his feminine ideal and was not as much in love with her as he was with beauty in general.

The beauties of the Yoshiwara were not unknown to Harunobu, however, and he immortalized them, particularly during his later years, in a number of prints of which plate 97 is one of the finest. Harunobu's courtesans—like those of Sukenobu before him—seem like gentle maidens dressed for a masquerade. The slight hardness of features noticeable in this print is more a characteristic of one facet of Harunobu's (or his engraver's) work than of the artist's approach to the Yoshiwara. Such prints represent Harunobu toward the end of his brief career, but we would be the last to say that he had worked himself out. True, in the space of the six years before his early death in 1770, he had designed well over a thousand wonderful prints that attest both to his prolific production and to his popularity. Harunobu dominated ukiyo-e during those years; although he came perhaps close to exhausting the possibilities of that miniature vision of beauty he had described so extensively and so well, the new age of the 1770s was to reveal new dimensions of ukiyo-e, and Harunobu could well have expanded with his medium. In the final year or two of his life, he himself was one of the first to forsake the poem-card, *chūban* size and reemploy the larger print formats that were to dominate ukiyo-e for the coming century. But alas, Harunobu died suddenly in his forties, only half a dozen years after finding his true style. For some, it is pleasant to think

97 **Harunobu:** *Courtesan on Veranda. Chūban* size, late 1760s (mid Meiwa Period). Signature: Harunobu *ga.*
Her sash loosely bound, a courtesan in a white outer kimono stands on a veranda contemplating an inner garden with blooming globeflowers. Silhouetted on the *shōji* behind her are the shadows of a lively geisha party. This print expresses, perhaps unconsciously, one facet of life in the pleasure quarter: that moment of reflection when the entertainer must feel the squalor, the folly of it all and long, if only momentarily, for some other way of life.

98 **Harunobu:** *Girl in the Snow. Hashira-e,* late 1760s (mid Meiwa Period). Signature: Suzuki Harunobu *ga.*
With her sleeve pulled over her hand, a maiden grasps her parasol and trips gracefully through the falling night snow. Harunobu was a master of this difficult pillar-print format, filling the attenuated frame completely yet leaving enough of the subject obscured to achieve a subtle sense of mystery and a lingering mood.

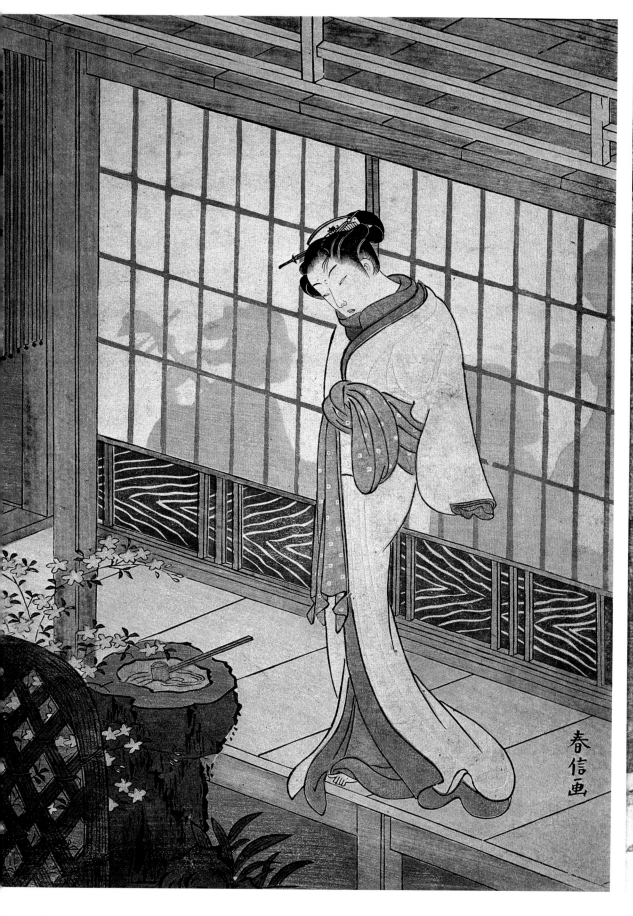

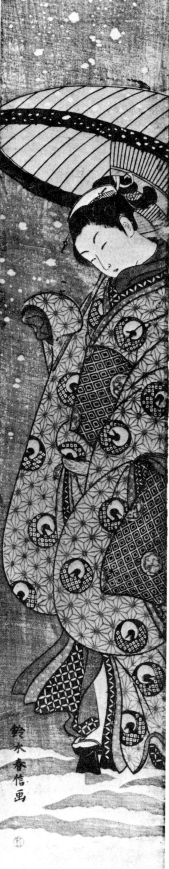

109

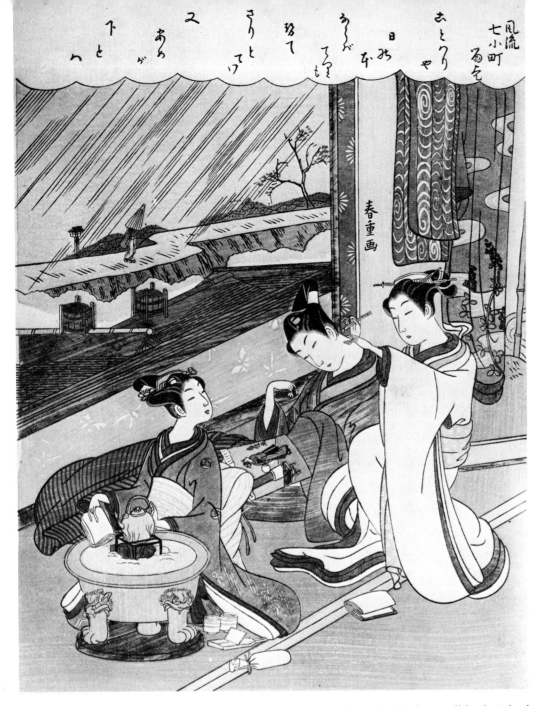

風流七小町

スゝしや
おとつや
日みか
さりとても
あてて
まあたか
またガ
スも
あふ
下と
へ

春重画

99 **Harushige**: *Yoshiwara Parlor Scene. Chūban* size, early 1770s (late Meiwa Period). Signature: Harushige *ga*.
According to his diary, the versatile artist and innovator Shiba Kōkan produced skilled Harunobu forgeries for some time after that popular artist's death in 1770; later he reverted to his own *nom d'artiste* as a member of the Harunobu School, Harushige. The Harushige signature is found on this interesting design, but in the center a print by Harunobu is displayed in veiled homage to that dead master. The scene is a Yoshiwara parlor in winter: the courtesan on the right cleans her lover's ear, as the little maidservant prepares water for tea. In the distance is the rain-swept entrance path to the Yoshiwara. This is one of a series on the Seven Aspects of Komachi, with that poetess's famous "Rain Verse" inscribed at the top.

100 **Koryūsai**: *Courtesan with Dolls. Hosoban* size, early 1770s (late Meiwa Period). Signature: Koryūsai *ga*.
At his finest, Koryūsai's coloring equals that of Harunobu; often he added (as here) an opaque orange-brown pigment that harks back to the *tan-e* and lends an element of modeled plasticity to the effect of the print. The present design is a curious but lovely one, featuring a Kabuki female impersonator, probably Yoshizawa Ayame IV, in the role of a courtesan shown standing on a veranda with an elaborate wheeled smoking stand, evidently supported by two little dolls.

101 **Koryūsai**: *Courtesans at Their Toilette. Chūban* size, early 1770s (late Meiwa Period). Signature: Koryūsai Haruhiro *ga*.
In this unusual backstage scene, a courtesan sits at a mirror stand, while behind her another courtesan stands holding coiffure ties. On the right, a maidservant delivers a love letter to the seated courtesan, and in the background before a screen of classical calligraphy, squats a cat, perhaps waiting to see whether anything edible will emerge from the activity.

that he passed on still in his prime, his vision of beauty unimpaired. It is possible that, had he lived, his vision would have changed and taken on new forms, perhaps (as with his own successors Koryūsai and Kiyonaga) less lovely, but still a firm impetus to the cause of ukiyo-e, which was a delicate art form always in danger of lapsing into decadence.

Harunobu's vision was idealistic but always focused on reality—the real as it should be but seldom is. Analyzed scientifically, his girls seem almost all alike; yet every print is different. It is the total atmosphere that changes and with it the creatures that live and breathe within its frame.

Though in several ways Harunobu represents the highest pinnacle achieved in the Japanese print, his direct influence on the ukiyo-e world, all-powerful during the height of his fame, persisted in full force for only a few years after the artist's death. Adroit imitators such as **Harushige** (Shiba **Kōkan**), **Yoshinobu** and **Masunobu** only worked during the brief gap created by his death; greater artists like Koryūsai, Shigemasa, Shunshō and Kiyonaga soon escaped from his strong influence; Kiyomitsu and Kiyotsune, who were established masters before his advent, became indirect disciples of his during Harunobu's maturity. But Harunobu's dream was too personal to provide the basis for a permanent school; it de-

pended too much upon the atmosphere that only the genius of Harunobu could engender. To all intents and purposes, his art, one of the most perfect realizations of an ideal that the world has ever seen, died with him.

Koryūsai and Bunchō

Although his imitators were legion, Harunobu's principal direct pupil was his friend Isoda **Koryūsai,** a former samurai living in Edo. Koryūsai seems to have been trained first in the Kanō style of painting, turning to ukiyo-e in the mid-1760s, shortly after Harunobu's rise to fame. His work includes both the popular prints of this period and his more aristocratic ukiyo-e paintings of the 1780s.

Koryūsai's prints only rarely succeed in evoking the dreamlike genius of Harunobu, but at his best, in the late 1760s and early 1770s, he does sometimes come close to equaling his teacher. Unfortunately, however, Koryūsai proved deficient in the inventiveness that might have made him a great master. Often, upon inquiry into one of his more striking designs, one finds that it is derived from a Harunobu print. This is the case with the charming print in plate 102. Probably designed soon after Harunobu's untimely death in 1770, it is doubtless modeled on a print by the older master showing a similar herd-boy playing a flute riding on an ox's back, with a small companion walking at his side. Yet once Koryūsai's source of inspiration is known, it must be conceded that he produced an entirely new print, quite

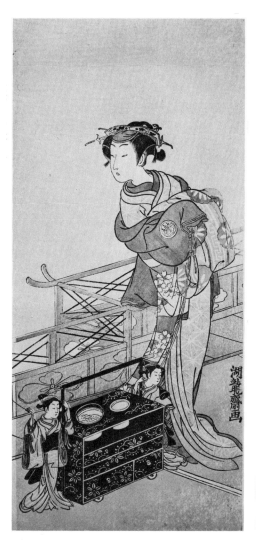

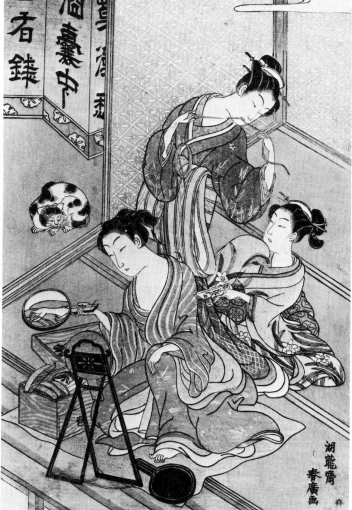

removed in spirit from the more rarefied work of his master. In comparison to Harunobu, Koryūsai's genius was more earthy, and his boys really boys. This tendency towards realism is doubtless Koryūsai's principal point of divergence from Harunobu. At its best, as here, it results in a feeling of intimacy with real life; at its least successful the effect is one of approaching grossness and awkward verisimilitude.

Realism was a tendency that was to characterize ukiyo-e in the 1770s and the following decades; had he lived, Harunobu could hardly have resisted its influence. In this sense the drints of Koryūsai provide some hint of the direction in which Harunobu's work might have gone. Koryūsai (like Bunchō) is also notable for the development of a unique style of rich decorative coloring and especially for his (or his printer's) reintroduction of opaque orange (formerly red lead but now often iron oxide), which had characterized the hand-colored orange prints of several generations earlier.

Although the mentor, Harunobu, had produced a number of adroit works in such less well known media as the pillar print, erotica, flower-and-bird prints and ukiyo-e paintings, it was the pupil who fully explored the possibilities of these forms. In particular, Koryūsai deserves praise as the master of the *hashira-e* [pillar print], a difficult, elongated form about 28×5 in./66×13 cm in size, made to be displayed on the narrow supporting pillars of a Japanese home. Due to their unusual proportions, pillar prints do not conveniently fit into book format, but a glance at the Harunobu of plate 98 will reveal the basic pattern of vertical composition, which could be reduced to only one-fifth of the height and still retain its essential features. Indeed, the format often resulted in an increase of dramatic effect due to the severe cropping involved. And of course the form made possible a print suitable for use as a hanging scroll at a fraction of the price of the full-width *kakemono-e* prints like those of plates 68 and 75. (It is just possible that such long, narrow formats may gradually have influenced the artistic fashion for attenuated human figures as well.)

The characteristic feature of the pillar prints was the employment of the dramatic close-up, on vertical wide screen, as it were. (There were also horizontal pillar prints; but they were employed, logically enough, principally for erotica.) No doubt the impressive size of the figures and affinities with the large dimensions of Western painting are what have made the

102 **Koryūsai**: *Boys Playing on an Ox. Chūban* size, one of twelve prints representing the signs of the Zodiac, early 1770s (late Meiwa Period). Signature: Koryūsai *ga*.
In a parody on a classical theme, three young oxherds gambol on a complaisant ox, playing flutes and stealing flowers. This is an uncommon theme, quite removed from the floating world in subject matter, yet incontestably ukiyo-e in approach and emotional effect.

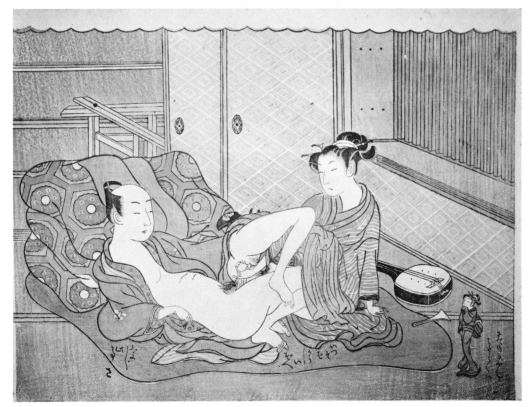

103 **Koryūsai**: *Courtesan and Lover. Chūban* size, one of a series of twenty-four shunga prints, early–mid 1770s (early An-ei Period).
Earlier Harunobu had designed a series of twenty-four shunga prints depicting the adventures of a voyeuristic male homunculus. Koryūsai's sequel features a miniature female, who likewise spies on a series of erotic scenes with suitable commentary. The lovely pastel coloring of this series produces a remarkably refined atmosphere for the curious erotic events displayed.

104 Koryūsai: *Seven Puppies.* Chūban size, early–mid 1770s (early An-ei Period). Signature: Koryū *ga.*

Here seven plump puppies are resting beneath a cluster of flowering narcissi, probably parodying some classical theme such as the Seven Gods of Luck. This is another theme taken from sources other than the floating world, yet (like plate 102) it is portrayed with the wit, humor and verve of ukiyo-e.

105 Koryūsai: *Courtesan with Maidservant and Dog.* Ōban size, mid 1770s (mid An-ei Period). Signature: Koryūsai *ga;* publishers (seals on lower right and left): Kōshodō (Tsuta-ya) and Eijudō (Nishimura-ya).

With the return to popularity of the larger, ōban format, ukiyo-e lost the miniaturistic intimacy of the Harunobu period but achieved more impressive compositions. Here the Yoshiwara courtesan Someyama is walking on a veranda with her maidservant; she is interrupted by a large black dog. This is one of the finest prints of the noted series *Hinagata wakana-no-hatsumoyō* [First Designs of Model Young Leaves]. Many of the other prints in this series are too formalized to rank with Koryūsai's best work.

pillar prints popular among collectors; however, as an expression of intimate beauty they can seldom compete with the more easily handled conventional sizes, for an ukiyo-e print is most effective viewed at arm's length, not from afar.

Oddly enough, Koryūsai's most original contribution to ukiyo-e probably lies in the field of erotic prints. Here his relation to his master is very much like that of Sugimura to Moronobu nearly a century earlier. Whereas Koryūsai's style was sometimes gross in its attempts at depicting the dream world of Harunobu, in the field of sexual art he excelled, expressing colorful vitality which is sometimes even more effective than his mentor's. In color and line, in the creation of the total atmosphere of physical love, the best of Koryūsai's erotic color prints are unsurpassed in Japanese art; and this explains the high esteem in which he is held, for few peoples have ever pursued the cult of artistic erotica as assiduously as the Japanese.

Koryūsai was also one of the first print masters to produce *kachō-e* [flower-and-bird pictures] in any quantity, although there had been notable early experiments by Moronobu, Kiyomasu, Shigenaga and Harunobu. This was a set form in traditional Far Eastern painting that, despite the limits suggested by the name, includes a wide range of subjects and features a close-up of plants or flowers, with accompanying birds, insects or animals. Plate 104 shows a sample of Koryūsai in this genre, a rather unobtrusive example, but one of the most charming. Seven fat puppies are seen drowsing beside narcissi; in the background

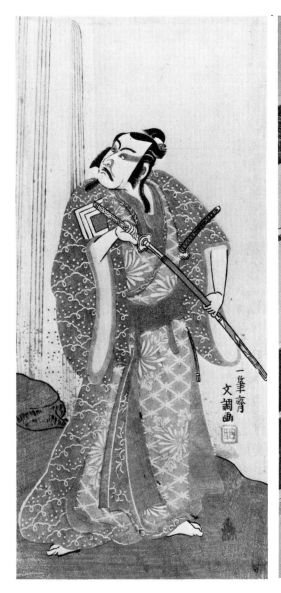

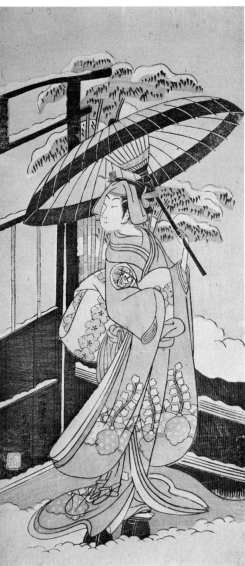

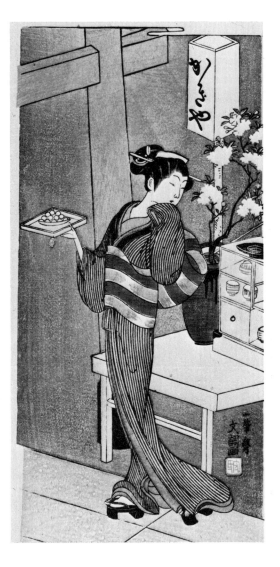

there are stylized clouds and the sketchily drawn thatched roof of a shelter. Although it is difficult to imagine puppies remaining still for so long, one of the leaves, perhaps half wilted by the heat of the animal's plump furry body, is resting on the back of the dark puppy.

The most renowned works of Koryūsai's later years are his extended series of large prints featuring courtesans with their attendants. The best of these are effective compositions and impressive prints, but they are often hard to love. Gone is Harunobu's happy influence: these prints are characterized by a tendency toward sharp, often somewhat gross realism. Such impassivity and spiritual emptiness was to plague much of later ukiyo-e figure work. The relatively large, ōban format (15×10 in./38×25 cm), which Harunobu also used briefly in his last years, was to predominate in the final century of ukiyo-e. The consequent loss in intimacy marked the whole mood of prints after the passing of Harunobu.

We conclude our discussion of this decade with one of the most disturbing and fascinating artists in all ukiyo-e, Ippitsusai **Bunchō**, who worked during the period of Harunobu's prime and during the decade after that master's death in 1770. Bunchō's greatness lies in his original and eminently personal approach to the dreamlike ideal that Harunobu had created for his age. To this surface lyricism Bunchō adds an acrid realism that may owe something to his contemporary, Shunshō, but is more suggestive of Sharaku two decades later. Lyricism and biting realism may seem mutually antagonistic; nevertheless in their mixture lies the essence of Bunchō's peculiar charm.

106 **Bunchō**: *Samurai before Waterfall. Hosoban* size, datable to 1768 (Meiwa V). Signature: Ippitsusai Bunchō *ga*, with seal; publisher (seal on lower right): Tsuru-Shin.
In this unusual early print by Bunchō the elaborate Kabuki kimono is printed without use of a keyblock outline, lending it a peculiarly three-dimensional effect. From the triple-box crest, the actor can be identified as Ichikawa Danjūrō IV, appearing in the role of Matsunaga Daizen from the drama *Gion-sairei shinkōki*, performed at the Nakamura-za in Meiwa V/7 (August, 1768).

107 Bunchō: *Lady with Umbrella in the Snow. Hosoban* size, ca. 1771 (late Meiwa Period). Signature: Ippitsusai Bunchō *ga*, with seal.

In this striking design, the Kabuki actor Nakamura Kumetarō is dressed as a samurai's lady and is standing outside a gate in the snow holding an umbrella. As is the case of many prints from this early period, the orange pigment of the gate and fence has oxidized, and the lavender of the kimono has faded to light gray. This phenomenon often occurs from simple exposure to air and does not necessarily decrease the artistic value of a print. The degree of mutation may also vary from one specimen to another, depending upon the printer's admixture of pigments for that particular day.

108 Bunchō: *The Waitress O-Sen. Hosoban* size, ca. 1770 (late Meiwa Period). Signature: Ippitsusai Bunchō *ga*, with seal.

The famous teahouse beauty O-Sen is shown at her shop near the Kasamori Shrine in Edo. In her hand is a tray of earthen cakes, an offering for the shrine god, and behind her are tea utensils, a pot of cherry blossoms and the sign of her shop, "Kagi-ya."

109 Bunchō: *Courtesan and Secret Lover. Chūban* size, ca. 1770 (late Meiwa Period). Signature: Ippitsusai Bunchō *ga*, with seal.

Replete with the erotic atmosphere of the pleasure quarter, this print shows a famous Yoshiwara courtesan, Morokoshi, half coyly and half apprehensively greeting her secret lover. The little maidservant watches for intruders, and the lover wears a scarf over his head to conceal his identity from passersby. In this case (cf. plate 107) although the lavender pigment of the man's scarf and inner robe has faded, the extensive orange areas have not oxidized appreciably. Had the mineral content of the pigments been greater and become patinized to metallic blue, the effect of the print would be quite different—more brooding and ominous—but, nonetheless, effective and aesthetically appealing. Such fortuitous variations and mutations in coloring are one of the interesting characteristics of Japanese prints throughout much of their long history.

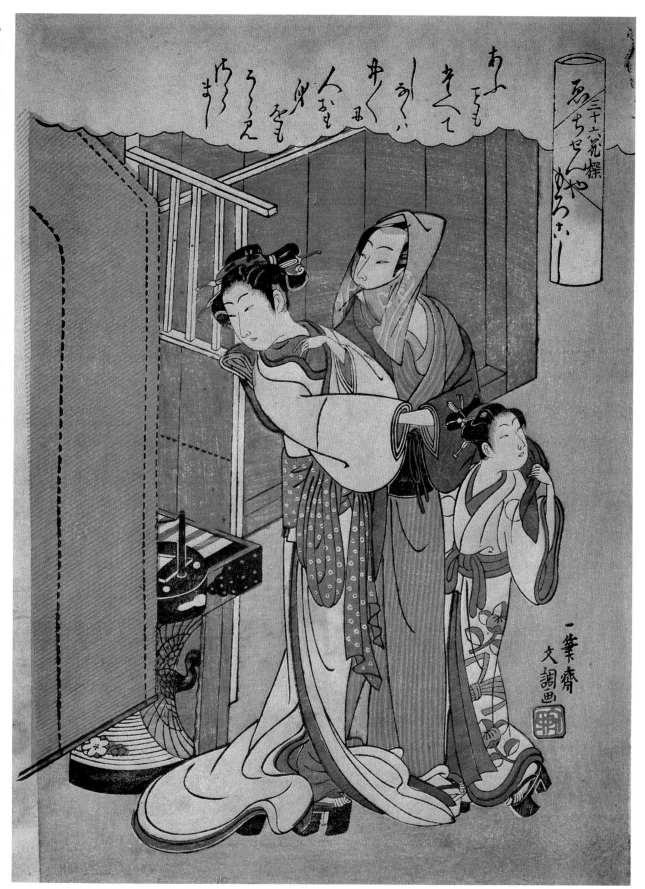

Bunchō is sometimes called an artist's artist, perhaps to explain the fact that he is seldom appreciated without long and careful study. There is always something awkward about him, something brilliant but untutored, as well as something that is best expressed by the Japanese term *shibui*: astringent, not cloying, unfathomable.

His best-known work is his Kabuki prints: they are mostly pictures of one or two actors in some conventional pose, shrouded by the color and mystery inherent in Bunchō's artistic vision. For the quality of his coloring Bunchō is indebted to Harunobu and ranks almost as his equal; Bunchō's more restrained colors well suit his remarkable style. His Kabuki prints capture moments of intense drama; Bunchō brings to the bombast of Kabuki the controlled mystery of the Noh drama.

Bunchō's output was tremendous but nevertheless matches Harunobu in its splendid evenness. Though his actor prints have made his name, Bunchō's greatest single works sometimes depict girls or courtesans with their lovers. The first examples shown are in the narrow *hosoban* format, like most of Bunchō's actor prints. The last is in the nearly square *chūban* size, a format made popular by Harunobu; it displays the bold use of orange that was also Koryūsai's forte. Yet in the curious restraint of a potentially violent love scene, Bunchō evokes an oddly haunting mood; the forms remind us of Harunobu, but all the sweetness is gone; the burning fires of love are left half smouldering. The courtesan greets her eager lover half turned away; the little attendant grasps his sleeve and looks elsewhere; the lover, his face partly concealed by a scarf, half embraces his sweetheart. Everything is restrained, almost nonchalant; later there will be time for love's consummation. Concealing the lovers' overt emotions, the artist draws a lasting picture of passion all the more impressive for its control. We may end our eulogy of Bunchō by noting that he has not always been praised without reserve. The nervous haunting brilliance of his work led one perceptive critic (Arthur Davison Ficke) to imagine him afflicted with "an intangible spiritual abnormality." Perhaps, but it is the same compelling quality found in Memling, Grünewald and El Greco.

Harunobu, Koryūsai, Bunchō: three happier geniuses have seldom coincided. One immediately visualizes brilliant opaque color and a newly created dreamlike vision that ukiyo-e was seldom to capture so well. It is possible to spend a lifetime in the company of these three artists, oblivious of the clamor and commotion of the outside world. They saw a dream and gave it immortality.

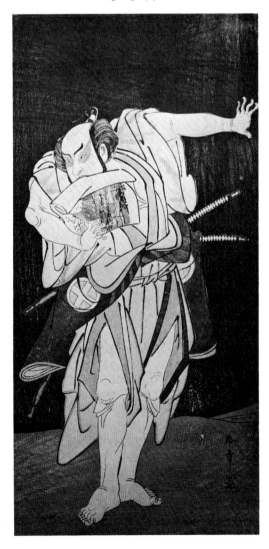

110 **Shunshō**: *Samurai Hero. Hosoban* size, late 1770s (later An-ei Period). Signature: Shunshō *ga*. The actor Otani Hiroji III is shown here in a dramatic pose from a night tableau. He is depicted with his outer robe flung off, ready for action; in his teeth he grasps a map of Mt. Fuji, doubtless an allusion to the planned revenge of the Soga Brothers. The color patterns are simple but exceedingly effective. (As often happens, the original lavender pigments have faded to shades of light gray.)

Shunshō and the Katsukawa School

Like ukiyo-e, Kabuki suffered from the repressive government edicts of the second quarter of the eighteenth century, as well as from the excessive popularity of the puppet theater. It was not until the 1760s that a great theatrical revival renewed the vigor of the living stage. From this period to the end of the century was the second golden age of Kabuki, one in which most of the elements of the art were developed and refined to form the Kabuki we know today. Many of the great actors who are remembered to this day, and without whom the art could never have survived, also appeared then.

Kabuki was the mind and heart of the Edoite, and Katsukawa **Shunshō** was its artist par excellence. Shunshō (1726–93)—who, recent research has suggested, may have been the love-child of Sukenobu—studied in the studio of Katsukawa Shunsui, an adept painter of women and a pupil of the master Chōshun, whose work was shown in plates 83–84. Shunshō thus had a firm groundwork in the principles of ukiyo-e painting; moreover he possessed an original, realistic view of the stage that was to distinguish his work almost as soon as he turned to the production of popular prints in the mid-1760s. This period was, it will be remembered, the time of Harunobu's full ascendancy. Shunshō, too, could not help but be influenced by that master. Indeed, for a few years his style followed that of Harunobu closely; but by the time of the latter's death in 1770, Shunshō had already shaken this influence and begun the long line of realistic Kabuki portraits that was to make his name.

111 Shunshō: *Courtesan in a Parlor. Hosoban* size, ca. mid 1770s (early–mid An-ei Period). Signature: Shunshō *zu.*

Against a screen painted with bamboo in *sumi,* the actor Iwai Hanshirō IV is seen in the role of a courtesan, carrying a lacquered box and paper. This is presumably a night scene, as the courtesan's sash is tied in an informal manner. The color patterns are among the principal charms of these early Kabuki prints although, as usual, the orange pigment of the *obi* is oxidized and the olive areas (on the kimono and cap) were doubtless originally purple.

112 Shunshō: *Samurai Hero. Hosoban* size, ca. late 1770s (late An-ei Period). Signature: Shunshō *ga.*

With the later An-ei Period, figures in the prints become more slender and graceful, and the coloring less plastic and palatable—gradually obliterating some of the more primitive (yet appealing) qualities of depiction and technique found in the earlier prints. The present remarkable design shows the famous Ichikawa Danjūrō V in his characteristic stock role of "Shibaraku"; this role was played by him so many times that it is not possible even to hazard a guess as to which performance is depicted here.

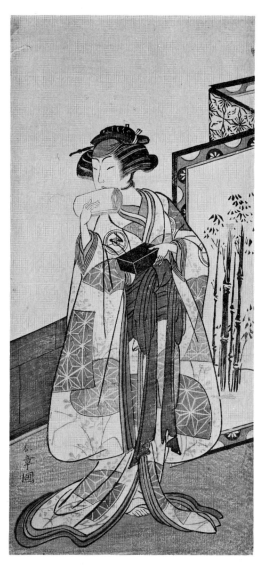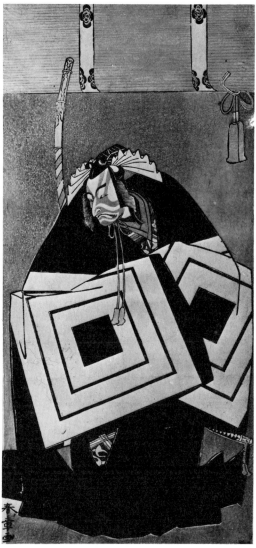

Shunshō's art represented a basic revolt from the formalism of the Torii School of Kabuki specialists. Essentially their prints were generalized, highly stylized billboards meant to attract the crowd with their bold line and color. Unless the Torii print was labeled, or identified by a crest, it was difficult to tell one actor from another in it. In other words, the artists chose the role as their subject, not the individual actor in that role. That the results were effective can hardly be denied, for the pageantry and bombast of Kabuki made it peculiarly suited to such representation. But realism was starting to dominate the new age, and the late Torii actor prints had lost the stylized power of their forerunners, being reduced to delicate tableaux bearing little relation to the dramatic nature of Kabuki. With Shunshō, theatergoers were able to recognize the features and the special artistic idiosyncracies of their favorite performers for the first time. The individual actor was suddenly brought to life by Shunshō's brush. His success with the Kabuki aficionados was both natural and immediate, and his portrayals of living actors as actually seen on the stage led the way toward the realism that was to characterize the final quarter of the eighteenth century. A first glance at the prints shown in plates 110, 111, 112 will hardly suffice to make Shunshō's contribution clear, for he has retained the flat perspective, the formalized pose and the costume of the theater: there could be nothing more "Japanese" than these prints. Compare, however, the traditional Torii approach of a mere decade earlier in plate 79 and notice how much closer Shunshō has come, even in his early work, to portraying individual actors rather than idealized types. The full development of psychological portraiture in ukiyo-e had to await the

appearance of Sharaku and Utamaro two decades later; but in the genius of Shunshō it had its experimental beginnings.

Shunshō's relationship to Bunchō, the other great Kabuki artist of his day, has yet to be explained satisfactorily. The usual claim that Shunshō greatly influenced Bunchō seems doubtful; the present writer considers that they both developed at first in Harunobu's shadow, and that by the time they had achieved their own styles of depicting Kabuki, they had also influenced each other. Interestingly enough, the two collaborated on a remarkable series of actor portraits published in book form in 1770, *Ehon butai-ōgi* [Fan Pictures of the Stage] in which the styles that were to distinguish their careers are already apparent. Of the two, Bunchō's was probably the greater genius, but his style was so personal that it practically died with him. Shunshō's perfect art, however, could be understood by all, and he proved one of the greatest teachers in ukiyo-e; not the least of his pupils was Hokusai. Plates 107 and 111 offer a good basis for comparison of Bunchō and Shunshō: the former is arresting, formal, profound and vaguely awkward; the latter, a master of portraiture and composition, but so perfect as to seem monotonous at times. In any event, Bunchō and Shunshō together mark a crowning point of Kabuki art.

Much of Shunshō's glory lies in his use of remarkable coloring. He adapted the rich palette of Harunobu to the dramatic needs of Kabuki and made particularly effective use of strong blacks, browns and oranges. His versatility is often forgotten, but it forms one of his major claims to artistic greatness. His studies of the massive *sumō* wrestlers are certainly among the finest in ukiyo-e, and even such great pupils of his as Hokusai never surpassed him in this genre (compare plate 161). Shunshō also designed powerful warrior prints, haunting courtesan portraits, colorful rustic scenes and illustrated numerous books, including some extraordinarily sedate erotica.

Still another major aspect of Shunshō's versatility remains to be noted, and that is his painting. Skill in traditional painting techniques lay at the base of Shunshō's sustained success as a print designer; and, like Moronobu, Koryūsai and Eishi, he devoted most of his final years to this more exacting and prestigious profession. (It should not, however, be assumed that all the great print artists were fine painters. Harunobu and Bunchō, true geniuses of the print, were only mediocre painters.) Shunshō has always been considered one of the principal figures in ukiyo-e painting, and in his own time there was even a saying: "A Shunshō painting is worth a thousand pieces of gold." (That is to say, worth its weight in

114 **Shunjō**: *Courtesan and Intruder.* Diptych, each panel of *hosoban* size, 1781 (Temmei I). Signature Shunjō *ga.*
This is a summer scene with the courtesan Komurasaki (played by Segawa Kikunojō III) in dishabille emerging from a mosquito net to grasp the scabbard of an intruder (played by Ōtani Hiroji III), who carries a chest strapped to his back. This scene is from the drama *Muromachi-dono eiga-butai,* staged in Temmei I/7–8 (August–September, 1781) at the Ichimura-za in Edo. Shunjō's women, though derived in style from those of his master Shunshō, exude a strangely appealing eroticism that reflects one facet of contemporary Kabuki taste. It is a pity that he did not live long enough to elaborate further on this style.

113 **Shunshō**: *Samurai's Servant.* Fan painting in *ōban* size, in colors on paper with a mica ground, ca. late 1770s (later An-ei Period). Signature: Shunshō *ga,* with handseal.
Shunshō's best known paintings are his large genre scenes in rich colors on silk (of which there are, however, numerous forgeries). The present more humble but charming miniature was surely destined for those who could not afford his "thousand-pieces-of-gold" masterworks. The seven different Nihon-bashi addresses inscribed in cubistic patterns on the right probably indicate the residences of the anonymous patrons of the actor depicted. Such fans were usually designed for actual use, hence the fold-marks and their scarcity today. The painting depicts Nakamura Sukegorō II in the role of a *yakko* [samurai's servant], possibly from a *Chūshingura* play.

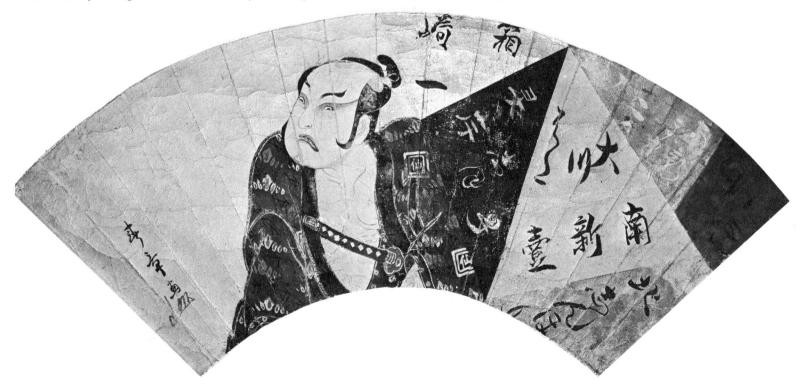

119

gold, only more so.) At any rate, his luxurious paintings present a sharp contrast with the multitude of prints Shunshō made for his Kabuki clientele. It is gratifying to think of him retiring in his old age from the frenetic hubbub of the print publishers and their public to apply himself to leisurely painting, secure in the knowledge that a painting of his was "worth a thousand pieces of gold."

We have already alluded to Shunshō's eminence as a teacher: from his studio came such great names as Shunkō, Shun-ei, Shunchō and Shunrō (Hokusai). The last two artists will receive separate treatment later, but the first pair followed directly in their master's footsteps as artists of Kabuki and will be discussed here. There has been a tendency of late to praise Shunkō and Shun-ei at Shunshō's expense. Certainly it is true that their Kabuki work is sometimes more striking than his and may often seem more appealing because it is formally less perfect. But after a careful study of Shunshō, one must ask what new elements his pupils contributed to his style; were they great creative geniuses in their own right? To these questions our answer must be a tentative no, and we have accordingly devoted much of the available space to displaying the extent of the master's achievements. That is not to say that

115 **Shunkō**: *Samurai with Parasol. Hosoban* size, ca. 1780 (late An-ei Period). Signature: Shunkō *ga.* This dramatic Kabuki pose features the actor Ichikawa Danjūrō V as a ferocious samurai with a lantern and parasol in his hands and two swords in his sash, the whole print being suffused with a remarkable variety of harmonious coloring. (In this case, the *mon* is only partially visible on the cloak on the right, but the actor's identity is also evident from his distinctive make-up.)

116 **Shunkō**: *Samurai Portrait. Ōban* size, ca. 1789 (Temmei IX). Signature: Shunkō *ga.* This powerful Kabuki bust portrait [*ōkubi-e*] shows Nakamura Nakazō I, probably in the role of Kudō Suketsune, from a New Year's play performed at the Nakamura-za in Temmei IX (1789). Before Sharaku, such prints are all bombast and color; there is little attempt to delineate subtle nuances of character.

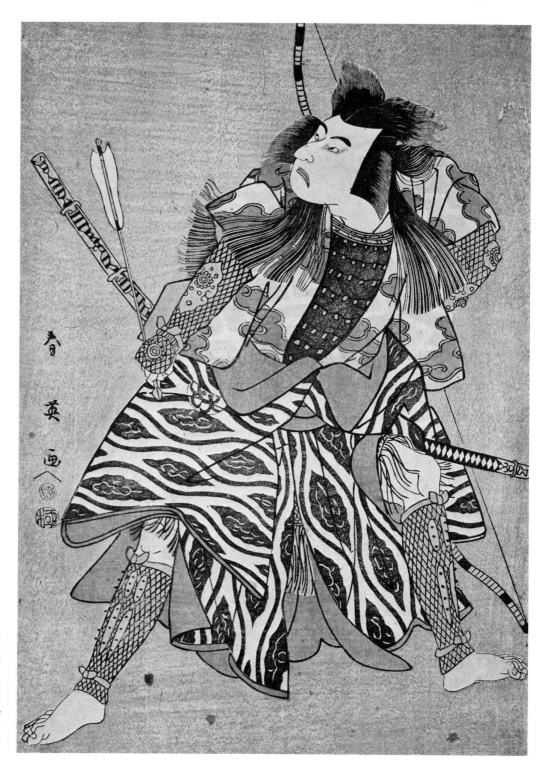

117 **Shun-ei**: *Samurai Archer. Aiban* size, mid
1790s (mid Kansei Period). Signature: Shun-ei *ga*;
publisher (crane seal): Tsuru-ya, with censor's
kiwame seal.
Though trimmed and somewhat faded (the olive
areas were doubtless originally purple), this print
is one of the finest of Shun-ei's Kabuki/warrior
designs; it is greatly enhanced by the *nezu-tsubushi*
[solid gray] background. The actor's *mon* is barely
visible under his right sleeve, but it permits us to
identify him as Bandō Mitsugorō II.

Shunkō and Shun-ei (as well as **Shunjō, Shundō, Shunzan** and other lesser pupils) did
not do much work of interest.

Shunkō (1743–1812) ranks first among the pupils of Shunshō who devoted their work
to the theater, and his finest Kabuki prints fully equal those of his master. Shunkō's work
extends from the early 1770s through his final years; in the late 1780s his right arm became
paralyzed but, switching to his left hand, he continued to produce the type of large actor
heads that were one of his main contributions to ukiyo-e. He also excelled in prints of
wrestlers.

Shun-ei (or Shun'ei, ca. 1762–1819), another major pupil of Shunshō's, contributes a modern touch to the Katsukawa School, as well as a pronounced element of facial exaggeration that adds to the individuality and dramatic force of his actor prints. In lesser hands it was to lead to the decline of figure work in the nineteenth century. Sharaku and, most of all, Toyokuni were among those influenced by Shun-ei's style, which is most appealing when it is least bombastic.

Sharaku

At the commencement of the eighteenth century, Torii Kiyonobu had opened the path to the artistic Kabuki print, and his style dominated this world for nearly seventy years. Shunshō replaced the Torii formalized art with a new, realistic vision of the actor as an individual that held sway for three decades. Then, for only ten brief months in the years 1794 to 1795, there appeared a haunting, ephemeral genius who was to bring Kabuki portraiture to its culmination: Sharaku.

Tōshūsai **Sharaku** represents an extreme example of the prevailing obscurity regarding the lives of the masters of ukiyo-e. His contemporaries mention him only in passing: "Sharaku designed portraits of the Kabuki actors, but in attempting to achieve an extreme of realism he drew people as they are not and was thus not long in demand, ceasing his work within a year or two." "He was a Noh actor in the service of the Lord of Awa.... In his brushstrokes there is power and elegance worthy of note." And that is about all we know of Sharaku's life and identity even today, after decades of research both in Japan and abroad. In this respect the simple lover of art has an advantage over the critic and scholar, for he need only concern himself with knowing what he likes. Sharaku has been a favorite of print collectors almost since the first rediscovery of ukiyo-e in the late nineteenth century.

If there is any dominating element in Japanese art, it is certainly the force of tradition. However great and original the artist, we can always trace quite clearly his origins and his indebtedness to earlier masters, whether Japanese, Chinese or Western. Whatever his native genius, a good part of his style is generally derivative, and he is judged almost as much for his mastery of the traditional styles as for his original contribution to his own school.

Sharaku represents the exception, probably the most extreme one in Far Eastern art. His art seems to spring forth fully formed at birth. Only toward the end of his brief, frenzied career does he decline enough in inventiveness to reveal the influence of the style (Shunshō and his group) that should have been his logical model. We find it difficult to admit, however, that miracles can occur in an artist's stylistic development. Whatever his native genius, whatever the skilled guidance provided by his publisher (the great Tsuta-ya Jūzaburō), Sharaku's tremendous, evenly balanced output cannot be explained as the sudden inspiration of an untrained amateur. Attempts to identify Sharaku with other contemporary artists (Maruyama Ōkyo, Tani Bunchō, Kita Busei, Shiba Kōkan, Sakai Hōitsu, Hokusai, Torii Kiyomasa or Kabukidō Enkyō, for example; or Chōki whose name we once proposed as another fascinating if wild hypothesis)—as well as with the publisher Tsuta-ya himself—have so far proved abortive; but we have a strong suspicion that somewhere in the vast mass of uncatalogued, eighteenth-century, Japanese manuscripts, paintings and prints the key will someday be found.

One possible Sharaku print, datable to 1799, has already come to light to confuse the issue, as have one or two dated fan paintings, which would suggest either that Sharaku did occasional later work or that another of the men who employed that nom de plume also dabbled in art. In short, though Sharaku's career remains the greatest single mystery in ukiyo-e history, we believe it will prove to be a mystery with a clear and logical explanation, whether or not such is discovered in our own lifetime.

In point of fact, we can discern certain general contemporary influences in Sharaku's work, though they contribute a far smaller percentage to his total effect than is the case with any other ukiyo-e artist. Sharaku's Kabuki figure compositions, for example, owe a good deal to Bunchō, Shunshō and the early Hokusai; his large heads and close-up portraits to

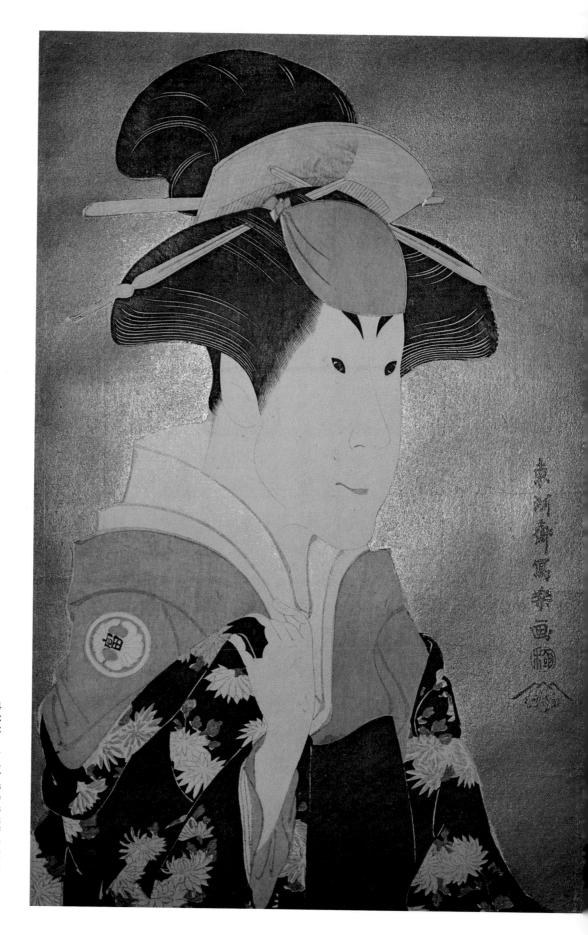

118 Sharaku: *Samurai Lady. Ōban* size, 1794 (Kansei VI). Signature: Tōshūsai Sharaku *ga;* censor's *kiwame* seal; publisher (lower seal): Tsuta-ya.

Whereas hitherto the *onna-gata* [female impersonators] in Kabuki had been depicted as fair women, Sharaku chose to portray the human, imperfect actor behind the role. Today the result is beautiful to us as art, but to the actors' fans such was hardly the case, and it is understandable that Sharaku's prints failed to sell well. Here Segawa Tomisaburō II is depicted in the role of Yadorigi, a samurai lady of rank, in the mixed Soga Brothers/*Chūshingura* play entitled *Hana-ayame Bunroku Soga,* performed at the Miyako-za in Kansei VI/5 (June, 1794). The opulent mica ground of such prints adds considerably to their impressiveness but can, alas, only be hinted at in reproduction.

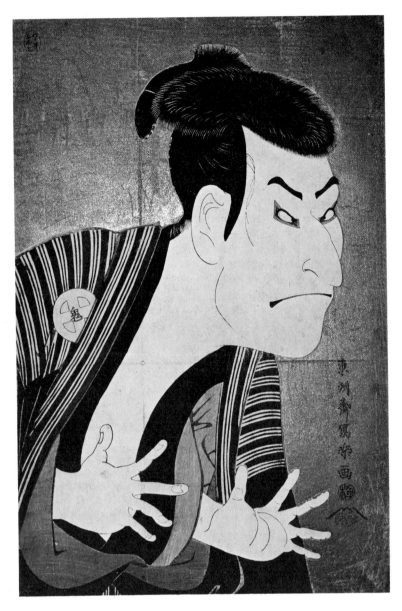

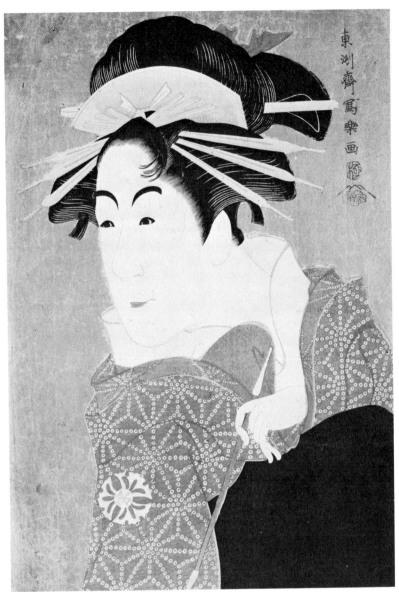

Shunkō and Shun-ei. The influence of the Ōsaka masters Suifutei and Ryūkōsai is also marked. The psychological element in Sharaku's portraiture may have been stimulated by Utamaro's intuitive probing of female vanity, as were some of the technical effects employed in his prints.

The strong flavor of realism and near caricature that forms the basis of Sharaku's style owes perhaps more than is generally suspected to Western art, particularly as introduced into Japan by such students of things Occidental as the painters Hiraga Gennai, Shiba Kōkan and Maruyama Ōkyo. Certainly Sharaku is the least conventional, the least Japanese of any major ukiyo-e artist. It is no coincidence that he should be among the most highly praised artists in the West, while in his own day he was considered outlandish, unpoetical and inartistic.

Sharaku's extant prints and manuscript designs total at least a hundred and sixty; since they are largely pictures of specific Kabuki performances, they can be exactly identified. They date almost entirely from the middle of the year 1794 to the beginning of 1795, a total artistic career of only ten months. Despite the brevity of Sharaku's artistic life, his prints change as much during that time as the work of an ordinary artist does during a decade or more.

During his first period, the Fifth Month of 1794, Sharaku issued some twenty-eight

119 Sharaku: *A Samurai's Manservant. Ōban* size, 1794 (Kansei VI). Signature: Tōshūsai Sharaku *ga*; censor's seal; publisher (lower seal): Tsuta-ya.
Here Ōtani Hiroji II is portrayed as the evil man-servant Edobei, shown with his hands thrust out dramatically from inside his kimono in a *mie* [climactic pose] gesture, typical of Kabuki. This is a scene from the play *Koi-nyōbo somewake-tazuna,* staged at the Kawarazaki-za in Kansei VI/5 (June, 1794).

120 Sharaku: *Courtesan. Ōban* size, 1794 (Kansei VI). Signature: Tōshūsai Sharaku *ga*; censor's *kiwame* seal; publisher (lower seal): Tsuta-ya.
Although Sharaku depicts the actor as well as the role here, this is nevertheless the most pleasant of his *onna-gata* representations, as is only fitting considering the subject (a courtesan) and the actor, who was known for his beauty. This is Matsumoto Yonesaburō as the maiden Shinobu, who has become a courtesan (under the name Kewaizaka-no-shōshō) in order to trap and wreak vengeance on the murderers of her father. The play, entitled *Katakiuchi noriai-banashi,* was performed at the Kiri-za in Kansei VI/5 (June, 1794).

124

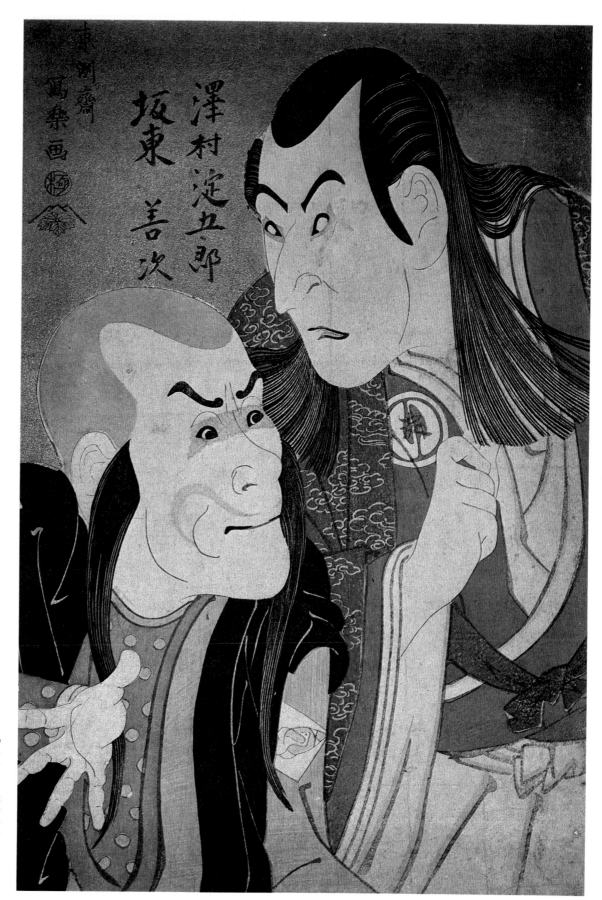

121 **Sharaku**: *Rascal and Hero*. Ōban size, 1794 (Kansei VI). Signature: Tōshūsai Sharaku *ga*; censor's seal; publisher (lower seal): Tsuta-ya.

Here Sharaku depicts a rascal, apostatized priest, shown confronting a valiant temple official. The scene is from a finale appended to the play depicted in plate 119. The actors (whose names were inscribed on the print by an early owner) are minor—Bandō Zenji as Oni-no-Sadobō and Sawamura Yodogorō II as Kawatsura Hōgen—but the print itself is one of Sharaku's finest.

ōban prints, principally bust portraits such as those shown in plates 118, 119, 120, 121. These works constitute his most famous, his most lovely or most powerful prints. It is at this period that the mystery behind Sharaku is most strongly felt: whatever his genius, could he have translated direct observation, however astute, into such remarkably designed and accurately executed Kabuki prints without either formal art training or long familiarity with the popular theater? To the writer, at least, this seems unlikely.

In his second period, the Seventh and Eighth Months of 1794, Sharaku issued some forty-six prints and drawings—comprised of *ōban* designs showing pairs of full-length figures and smaller prints of single figures—all viewed from a unique angle, as though seen from the audience in a seat slightly below the stage. Plates 122 and 123 are typical of his masterworks of this period; they feature dynamic group compositions that are among the most effective in all Kabuki art.

Sharaku's third and final period encompasses some eighty-six prints and designs in *ōban, aiban* and *hosoban* sizes, issued in the Ninth Month of 1794 and the first month or two of 1795. There are several bust portraits, but the majority are full-length portraits; a few *sumō* wrestling prints, miscellaneous subjects, paintings and unpublished designs are also extant. The Sharaku enthusiast cannot help being disappointed in this final half of the artist's career, for it is characterized by a general decline in quality and a tendency toward mannerism rather than fresh creativity. Leaving behind the inspired stylization of Sharaku's earlier work, we find a strong element of caricature and cartoon-like exaggeration in his later work, which can hardly ever be classified as great art. Also for the first time, we note the use of complex backgrounds; however, they fail to make up for the decline in the quality of figure work. Sharaku's sense of design remains competent, but he hardly ever shows that flash of perceptive genius that characterized a good majority of his earlier works. Even now he often equals the late work of Shunshō and his pupils, as well as the best of Toyokuni and Kunimasa; but in this period nothing better can be said of him—a genius who in his prime just a few months earlier had seemed almost capable of sweeping ukiyo-e off its very foundations.

What happened to Sharaku in these final months? Quite possibly he simply worked himself out as far as this limited genre was concerned and had no opportunity to expand into other fields of ukiyo-e; perhaps overwork and illness sapped his energies. We will probably

122 Sharaku: *Two Kabuki Characters. Ōban* size, 1794 (Kansei VI). Signature: Sharaku *ga*; censor's *kiwame* seal; publisher (lower seal): Tsuta-ya. Although the identity of the actors is obvious from their *mon*—Ōtani Oniji II and Ichikawa Omezō— their exact roles have been the subject of controversy since the full text of the play is not extant. The drama is *Nihon-matsu Michinoku-sodachi*, performed at the Kawarazaki-za in Kansei VI/7 (August, 1794). This is one of Sharaku's most effective group compositions.

123 Sharaku: *Kabuki Scene.* Triptych, each panel of *hosoban* size, somewhat trimmed, 1794 (Kansei VI). Signature: Tōshūsai Sharaku *ga*; censor's *kiwame* seals; publisher (lower seals): Tsuta-ya. In this rare triptych by Sharaku, we see the loyalist general Nitta Yoshisada (played by Ichikawa Komazō II) and two women attendants (Iwai Hanshirō IV and Osagawa Tsuneyo II), all disguised as Court gardeners and on guard against a plot on the Emperor's person. The play is *Matsu-wa-misao onna-Kusunoki*, performed at the Kawarazaki-za in Kansei VI/11 (December, 1794). While most prints in *hosoban* format were originally issued as diptychs, triptychs or pentaptychs, they are seldom found extant in complete form today. This is even more true with Sharaku's work. Due to their transitory subject matter, luxurious printing and, moreover, to their lack of immediate popularity, his prints were only issued in limited editions. In the present case, no other impressions of the center and right sheets are known. The existence of other specimens of the left sheet may be due to the popularity of Hanshirō in this role or to the fact that, of the three prints, it stands alone best and may have been sought after singly by the Kabuki patrons of the time.

never be able to solve the puzzle of his sudden decline, any more than we can explain his sudden appearance on the Edo horizon. All we know is that he lived a rich and full artistic life in the space of a mere ten months and then disappeared from view as suddenly as he had appeared, leaving a body of masterpieces that was unappreciated until a full century later.

Sharaku's prints, although they do have romantic elements, represent a culmination of the early realistic movement. He depicted the ideal of Kabuki impressionism, his portrayals fusing the dramatic role and the individual actors. In addition his prints display a depth of psychological insight quite lacking in the surface realism and external beauty of his predecessors Bunchō and Shunshō. But psychological perception was seldom the forte of Japanese art, which excelled in design, style, color and surface appeal. Thus Sharaku is the least Japanese of the ukiyo-e artists in his mental attitude, and as portraits or as Kabuki interpretations, his prints must have seemed as outlandish to his contemporaries as they do to the uninitiated Western viewer today. It is not surprising that the playgoers of his time did not vociferously demand more of the same; it is a wonder, rather, that he should have survived so long in such a predominately popular art form as ukiyo-e prints.

Whoever Sharaku may have been, we clearly owe his artistic career to one man, his publisher **Tsuta-ya** Jūzaburō. Tsuta-ya as an individual was the greatest of the print publishers; he discovered and supported such varied talents as Utamaro, Chōki, Kyōden and many others. Toward Sharaku's work, however, Tsuta-ya clearly felt some attraction that exceeded even his usual devotion to ukiyo-e prints, a commercial art that customarily surpassed much of the fine art of the times. Sharaku's approximately one hundred and fifty prints were published entirely by Tsuta-ya and included many issued in expensive and luxurious format. Although Sharaku's style was evidently admired by a few connoisseurs of the time, even a great publisher could not create popular taste, and thus the weak public reception may well have had as much to do with Sharaku's artistic decline as anything. Perhaps Sharaku, in his third period, just gave up his unique style and attempted, with nearly disastrous results, to conform to prevailing taste?

In a sense, Sharaku's work represents a kind of anti-ukiyo-e, an unconscious attempt to create an avant-garde within an essentially popular form. The new elements of sharp realism and the psychological caricature that Sharaku introduced were basically opposed to the colorful and highly stylized nature of ukiyo-e. To express his true genius and to be appreciated as such, Sharaku appeared not only in the wrong age but in the wrong country. In the lands of Holbein, Hogarth, Goya and Daumier, he might have found a more perfect medium and more receptive audiences for his special inspiration. Sharaku is the one ukiyo-e artist who, despite the characteristically Japanese nature of his subject matter, would seem to belong less to his own time and country than to the world.

Even though he was condemned or dismissed by the Edo populace, Sharaku's actual influence on ukiyo-e portraiture and the depiction of Kabuki was to prove considerable. He had minor imitators such as **Enkyō,** Shuntei and such Ōsaka artists as Shōkōsai. However his most important followers were Toyokuni and Kunimasa (whom we will discuss later) together with Shun-ei and Ryūkōsai, the very artists who had helped form something of Sharaku's own basic pattern of design.

A gradually widening misinterpretation of Sharaku's semi-caricaturistic style spread through nineteenth-century portrayals of Kabuki, particularly in Toyokuni and his followers. Some works of interest were produced in this style, but also many horrors. None of this was Sharaku's fault, of course. He himself simply had a startling vision of the Kabuki actor as an all-too-human individual, and he recorded this vision with rare technical skill heightened by simple but striking color effects. Nor was it the fault of Shunshō and Sharaku that the very realism that distinguished their work was, in the end, to help kill ukiyo-e. They were pioneers in a unique style, recording a fresh, colorful and probing view of theatrical art, a vision that suddenly brought the stage alive on paper and that makes the Kabuki of that age so real and living for us yet today.

124 **Enkyō**: *Samurai Hero. Ōban* size, 1796 (Kansei VIII). Signature: Kabukidō *ga.*
Here Nakamura Nakazō II is shown in the role of the samurai leader Matsuō-maru, from the well-known drama *Sugawara-denju tenarai-kagami*—celebrated for its "Tera-koya" scene (adapted by John Masefield under the title *The Pine*)—as it was performed at the Miyako-za in Kansei VIII/7 (August, 1796). Although Kabukidō Enkyō was perhaps only an enlightened amateur, his few prints are among the minor masterpieces of the era.

Shigemasa and Kyōden

Beautiful women were always a major source of inspiration in ukiyo-e. In Japan at the time of Harunobu and the generation that followed, feminine beauty received perhaps the greatest tribute that it has ever known. At the same time, the new age of the 1770s and 1780s was accompanied by a gradual change in feminine ideals, from the frail delicacy of Harunobu to the more robust beauty of the later Koryūsai and Shigemasa. This trend culminated in Kiyonaga and Shunchō, only to be replaced in the 1790s by another unreal ideal: the slim and over-elongated beauties of Utamaro and Eishi.

Such action and reaction are almost the rule in ukiyo-e, which mirrored the contemporary taste on which it was based. Before this, in the beginnings of ukiyo-e, Moronobu had established a fashion for the robust female; this ideal had been continued by Kiyonobu and the Kaigetsudō; it was gradually modified and attenuated until Harunobu created a new extreme of idealized frailty. After Eishi, in the early nineteenth century, there was a return to the more solid female figure; this style dominated almost to the end of ukiyo-e.

This new ideal of robust womanhood gradually developed in the years immediately after the death of Harunobu. By the year 1776, when Shunshō and Shigemasa published their famous book of colored illustration, *Seirō bijin-awase sugata-kagami* [Collected Beauties of the Green Houses], the new ideal was consolidated. Shunshō was discussed in a previous section; his collaborator Shigemasa was to prove one of the major forces in directing the destinies of ukiyo-e through this little-understood transition period.

Kitao **Shigemasa** (1739–1820), son of an Edo publisher, may have received preliminary training under some obscure Kanō painter but appears to have been largely self-taught. Throughout his career he was an expert and careful draftsman, greatly respected by his contemporaries as an artist's artist. Shigemasa's early experiments in ukiyo-e date from the rose-print period and are frequently after the manner of Kiyomitsu. His first characteristic prints, however, appeared in the late 1760s. They are in a style somewhere between Harunobu and Shunshō, but pointing in the direction in which all future ukiyo-e figure work was to tend.

Doubtless Shigemasa's greatest single contribution to the Japanese print lay in a rare series of prints depicting groups of geisha (these were entertainers, dancers, musicians—quite separate from the courtesans); one of the finest of these is shown in plate 125. In style vaguely reminiscent of Harunobu and Koryūsai, there is a freshness of concept that stems from neither, a filling out of forms and a sense of tight group composition that helped to set the style for the coming generation. The print documents the transition point in the changing ideal of womanhood; Harunobu's delicacy still remains, but the dream of beauty has come closer to the forms of real life. These striking geisha prints by Shigemasa represent a new development in figure work after Harunobu; the increasingly massive forms are characterized, in addition, by a broad and effective grouping of opaque color patterns. Yet for reasons incomprehensible to us today, Shigemasa preferred the more miniature work of book illustration; he never followed up these rare examples of a magnificent figure style that could well have dominated ukiyo-e for the rest of the century (and did in a sense, though more through the influence of prints by Shigemasa's followers, such as Kiyonaga, than through the work of Shigemasa himself).

Besides being a fine artist in his own right, Shigemasa, like his good friend Shunshō, was one of the great teachers of his age. His pupils have eclipsed him in fame, if not in innate genius: Kyōden (Kitao Masanobu), Masayoshi, Shumman, together with such unofficial followers as Utamaro and Hokusai.

The most precocious of Shigemasa's several brilliant pupils was a young man named **Kyōden,** who entered Shigemasa's studio in his early teens and eventually received the artist name of Kitao **Masanobu**. (Although the spellings in Japanese are quite different, in romanized form it is impossible to distinguish this "Masanobu" from the great pioneer of that name; hence we shall employ here the name Kyōden, which the artist used on much of his oeuvre.) Kyōden (1761–1816) was already producing remarkable work by his late teens, especially in the combined genre of picture novels, which he wrote and illustrated himself. Eventually his popular and critical success as a novelist was to take him almost entirely

125 **Shigemasa:** *Two Geisha with Attendant. Ōban* size, late 1770s (mid An-ei Period).
On the right, two geisha—entertainers rather than courtesans—are seen followed by an attendant carrying their samisen in a box. (Skill on this guitar-like instrument has always been a necessary accomplishment of the geisha, and there was a special class of male or female servant called the *hakoya,* who carried it and helped the geisha with changes of clothing.) Though few in number, Shigemasa's geisha prints were the harbingers of a new age in figure design; most of them are unsigned, but another impression of the present design bears the signature "Kitao Shigemasa *ga.*"

126 Kyōden [Kitao Masanobu]: *Courtesans in a Parlor.* Double-*ōban* size, ca. 1783 (Temmei III). Signature: Kitao Rissai Masanobu *ga,* with seal; publisher (seal on lower left): Tsuta-ya.

At the center of this design, the Yoshiwara courtesans Matsubito (seated) and Segawa (standing) are depicted in regal splendor, surrounded by attendants. This is one of a series of seven large color prints of noted beauties in the Yoshiwara, accompanied by verses in their own calligraphy, from the album *Yoshiwara-keisei shin-Bijin-awase jihitsu-kagami* [Yoshiwara Courtesans: A New "Collection of Beauties"—An Autographic Mirror], published early in Temmei IV (1784); at least some of these luxurious prints are thought to have been first issued separately during the preceding year, and one bears the date Temmei III/2 (March, 1783).

away from the print field, though he continued to produce witty ukiyo-e paintings in his characteristic style throughout most of his career.

Kyōden's most famous work is undoubtedly his magnificent courtesan album, designed and published in 1783 to 1784, one leaf of which is reproduced in plate 126. The album may have been originally published as separate sheets; it features seven plates devoted to strikingly original, candid scenes of Yoshiwara courtesans at leisure, accompanied by verses in the girls' own handwriting. In the plates of this album—in giant format twice the size of an ordinary print—there is an intricacy of coloring and design hardly ever seen before in ukiyo-e. These are real "brocade prints." Their basic design is almost overpowered by their elaborate technique, yet the series remains one of the landmarks in the development of the Japanese color print. The faces and figures derive directly from Kyōden's teacher Shigemasa, but in the interval between the prints shown in plates 125 and 126, the forms have somehow become solidified and elongated. It is rather doubtful that even such masters as Shigemasa, Kyōden and Kiyonaga could have inaugurated such a radical change in the ideals of beauty; yet certainly they (like our modern illustrators and fashion photographers) did much to effect its rapid acceptance by the populace.

From the time of his graduation from Shigemasa's studio, Kyōden seems to have been closely associated with that famous publisher and patron, Tsuta-ya Jūzaburō, whom we have already mentioned in relation to Sharaku. Possibly at Tsuta-ya's advice, only a decade after his first masterpieces, Kyōden gave up his part-time work in prints to devote himself to the evidently more satisfying and lucrative field of literature and occasional book illustrations. Kyōden might well have developed into an artist to rival the great Kiyonaga, but his loss to art is not a great tragedy, for Kyōden's name brightens one of the most fascinating chapters in Japanese literature, and he ranks as the major literary humorist and satirist of his time.

A less striking figure than Kyōden, his fellow pupil Kitao **Masayoshi** (1764–1824) nevertheless ranks close to him in importance. Masayoshi was a master of several styles, both ukiyo-e and neo-Kanō, and a precursor of Hokusai in his numerous colorful sketchbooks; however, in these sketchbooks he specialized in strong, impressionistic renderings rather than in detailed work of draftsmanship.

Kiyonaga, Shunchō, Shumman

Although ukiyo-e never declined in its apparent charms, in the 1770s it was clearly waiting for some bold master to lead it to new heights, to resuscitate and expand it as Moronobu, Masanobu and Harunobu had for their generations. Kiyonaga, an artist perhaps more important as an innovator and consolidator than as a personal creator of beauty, provided the necessary creative effort. Some critics, however, eschew such distinctions and would place him at the very pinnacle of ukiyo-e.

Torii **Kiyonaga** (1752–1815), son of an Edo bookseller, was a leading pupil of Kiyomitsu, last of the great figures in the traditional Torii line. Kiyonaga succeeded his master as head of the Torii family, and much of his work was thus devoted to depicting Kabuki, as in plate 127. This print comes well before the time of the great Sharaku, whose acrid realism was to revolutionize Kabuki prints. Yet if we compare Kiyonaga's print with the work of his master Kiyomitsu (plate 79), we will perceive a revolution in the depiction of Kabuki as important as that produced by Sharaku. The total effect is one of realism rather than idealism, of an actual Kabuki performance on a real stage. It is difficult to imagine what the work of Sharaku might have been without this intermediate revolution.

The scene depicted is one of the most popular in all Kabuki: the hero is Sukeroku parading through the Yoshiwara at cherry-blossom time. He is shown here, parasol in hand, sword and flute stuck in his sash, striking a pose of defiance toward corrupt authority. Sukeroku is the Japanese Robin Hood, a seventeenth-century figure who had come to stand for the spirit of heroic independence in the midst of a feudal organization that denied all human rights. Besides the new realism in design and setting, we observe in this print most of the other characteristics of Kiyonaga's style. Although he was indebted to the later Koryūsai manner and to Shigemasa, by the late 1770s Kiyonaga was already part of, and soon after leading, the movement toward large figures and greater naturalism of treatment. Kiyonaga represents the culmination of this trend and was extravagantly praised by the earlier "morality" school of Western critics for his "inherited loftiness of aim and nobility of taste" (von Seidlitz), as well as for his "large-limbed, wholesome, magnificently normal figures as the symbols of his magnificently normal mind" (A.D.Ficke). This is all doubtless very true

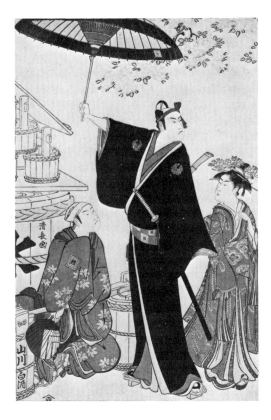 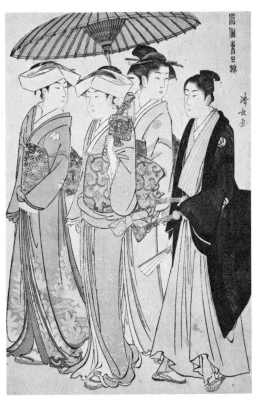

129 Kiyonaga: *Bathroom Scene. Hashira-e,* ca. mid 1780s (mid Temmei Period). Signature: Kiyonaga *ga.*
Two young women are shown in this graceful pillar print: the one on the right has just emerged from her bath and is exchanging gossip with a girl outside the bamboo window. The effect of this print must have been quite different in the original colors—the purple of the robes is now faded to buff, and the orange of the woodwork has become oxidized to a metallic blue. Yet whether as an illustration for this book or as an acquisition for a collection, such a splendid print would always be our first choice, for the quality of its design rather than for the perfection of condition.

130 Kiyonaga: *Riverside Scene at Dusk. Ōban* size, ca. 1784 (Temmei IV). Signature: Kiyonaga *ga.*
A plebeian wife in a black summer kimono is seen seated on the bank of the Sumida River, flanked by a young teahouse attendant and by a girl with a fan in her hand. This is the left-hand sheet of one of Kiyonaga's major diptychs: the object of the three women's gaze is two geisha and their attendant, shown walking on the right in the companion print (which, however, is not as outstanding a design.)

127 Kiyonaga: *Kabuki Scene. Ōban* size, 1784 (Temmei IV). Signature: Kiyonaga *ga*; publisher (seal on lower left, trimmed): Eijudō.
The plebeian hero Sukeroku strikes an attitude of defiance in a Yoshiwara setting, parasol in hand, sword and flute stuck in his sash; he is flanked by a wine seller and a courtesan's attendant. The play is *Soga musume-chōja/Sukeroku yukari-no Edo-zakura,* performed at the Nakamura-za in Temmei IV/3 (April, 1784). Ichikawa Yaozō III appeared as Sukeroku and Ichikawa Monnosuke II as his brother, disguised as a saké vendor. This print can stand as an individual masterpiece, but it was originally designed as the left sheet of a diptych; the design on the right shows Sukeroku's sweetheart, the courtesan Agemaki (Nakamura Rikō), and his rival, the aged Ikyū (Danjūrō V).

128 Kiyonaga: *Ladies and Young Man Walking. Ōban* size, ca. 1783 (Temmei III). Signature: Kiyonaga *ga.*
On the left, two ladies of quality are seen walking, followed by a maidservant with a parasol and by a young samurai. This print is from *Fūzoku Azuma-no-nishiki* [Modern Customs: Brocade of the East], a series of some twenty *ōban* designs (two of them diptychs) depicting the leisure-time occupations of the upper classes, both samurai and townsmen, and published between 1783 and 1785.

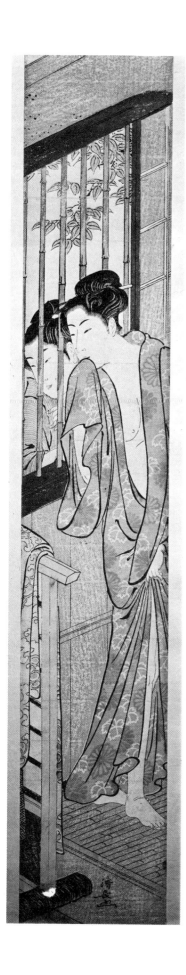

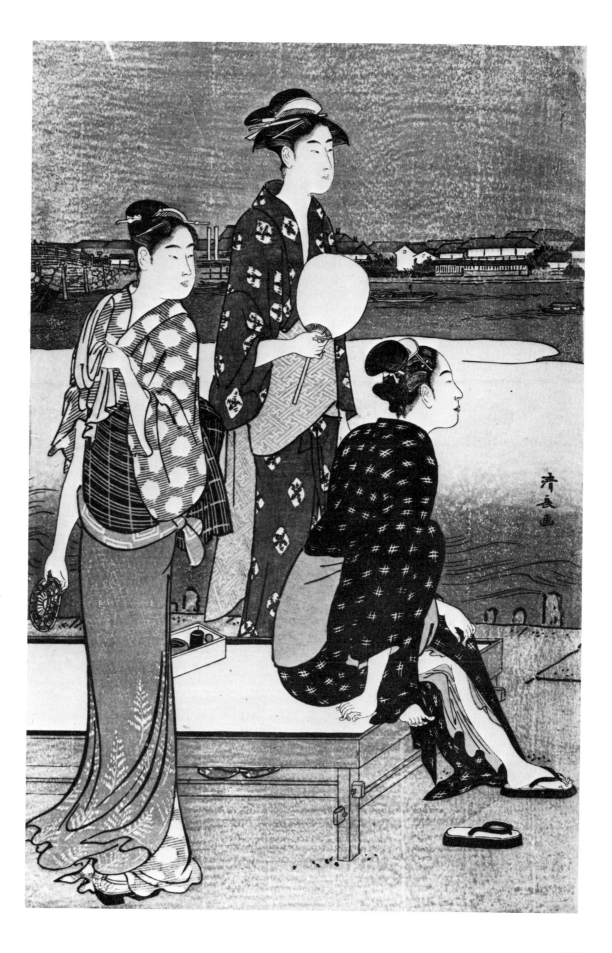

131 **Kiyonaga:** *New Year's Scene at Nihon-bashi.*
Diptych, each panel of *ōban* size, ca. 1786 (Temmei VI). Signature: Kiyonaga *ga*; publisher (seals on lower left): Eijudō.
In this elegant New Year's tableau, a maidservant on the left is carrying plum blossoms and a child's kite and is walking with a matron in a black hood. In front of them is a girl whose large hat bears the legend: "Enoshima, Monthly Pilgrimage," while on the right, a maiden of quality is accompanied by two maidservants and a boy. Beyond the pillars of the bridge there are warehouses, Gofuku Bridge, Edo Castle and, in the distance, Mt. Fuji.

(though one wonders how these Victorian critics would have explained Kiyonaga's abundant erotica), but does not necessarily make us love the artist. Indeed, for all his perfection, there is a certain dullness about much of Kiyonaga's work, and the viewer may well find himself turning in relief from this persistent perfection to less impeccable but more human contemporaries such as Chōki, Utamaro and even Shunchō.

Following the general trend of the times, Kiyonaga discarded the graceful exaggeration and idealism of the earlier artists and strove above all for naturalism in his designs; he produced figures of healthy proportions that have been aptly compared with the achievements of Greek art. However, this progress in surface accuracy does not necessarily mean that Kiyonaga produced greater prints than the earlier artists, for what he gained in naturalism he lost in stylization. His figures have become realistic dolls positioned in real space; backgrounds are usually carefully delineated, the compositions impeccable; but the results are certainly less individualized than the figure prints of Masanobu or Harunobu. The composition or the coloring makes the greatest impression, while the individuals portrayed may leave the viewer cool. However, with the masterpieces of plates 128, 129, 130, Kiyonaga achieves a rare vision of personal, feminine beauty seldom surpassed in ukiyo-e. These

132

132 **Shunchō**: *At Dusk by the Sumida River.* Diptych, each panel of *ōban* size, mid 1780s (mid Temmei Period). Signature: Shunchō *ga,* with seal; publisher (seals at lower left corners): Shūeidō.
Shunchō at his best is quite the equal of his mentor Kiyonaga, as we readily perceive in this important diptych. Four young women are seen about to embark at dusk on a boat on the Sumida River, for a summer picnic. In the center, a teahouse maid carries a lantern and delicacies on a tray; on the lower right, a boy servant steadies the covered boat. In the distance, the shore of Mukōjima can be seen.

plates date from about the last decade of his career as a print artist, when, perhaps, he at last awakened to the importance of such sparks of personal animation under the influence of his followers such as Shunchō.

One unexpected effect of Kiyonaga's naturalism is often a greater "masculinity" in his portraits. The frail, dreamlike grace of the Harunobu period is gone; and, conversely, Kiyonaga's men are sometimes more attractive than his women, who, in their excess of naturalism, frequently appear almost sexless. (Perhaps it was this element that so attracted the Victorians to Kiyonaga?) This feature even carries over into Kiyonaga's erotica, where one is likely to be more interested by the perfect compositions and lovely coloring than by the curious activities displayed.

Although he excelled in the representation of stylish young men, statuesque girls and courtesans against broad and finely detailed backgrounds depicting Edo, Kiyonaga was the head of the Torii School and eventually had to give up prints to devote himself exclusively to theatrical posters and to the training of Kiyomitsu's grandson as his successor. That Kiyonaga was truly in his prime then is proven by the masterpiece shown in plate 131, published shortly after his official retirement from the print world.

Although we cannot agree with critics who have placed Kiyonaga at the summit of

ukiyo-e, we do not deny his key place in the crucial decade of the 1780s. He invented a new manner of depicting Kabuki realistically, presented a fresh concept of background integration, was one of the great masters of ukiyo-e composition, the first to perfect the unified diptych and triptych and a fine painter as well. Above all, it was Kiyonaga who decisively formed the style that was to dominate figure prints for a century to come, but he was a giant whose ideal was perhaps better realized in the work of his followers than in his own prints.

Kiyonaga's major direct follower was not really a pupil of his but a convert from Shunshō's school. This was Katsukawa **Shunchō**, who worked from the late 1770s to the end of the century. Though much indebted to his master Shunshō for his perfect color harmonies, Shunchō found his ideal model in the work of Kiyonaga at his peak and seldom deviated from it. We are accustomed to judging artists according to their originality, and by this standard Shunchō must be relegated to the second rank. His actual prints, however, are often quite the equal of Kiyonaga's. They lack the latter's magnificence of concept but possess a peculiar ethereal quality seldom found in Kiyonaga and a luminous harmony of coloring that is unsurpassed in ukiyo-e. Shunchō followed Kiyonaga's manner with a brilliance which, though imitative, frequently charms us more than the greater genius of the teacher. There is, moreover, often a haunting mystery to Shunchō's women, an element unfortunately lacking in Kiyonaga's suave creations. Like Kiyonaga, Shunchō was a master

133 **Shunchō**: *Courtesan in Summer. Hashira-e,* mid 1780s (mid Temmei Period). Signature: Shunchō *ga,* with seal; publisher (seal on lower right): Chichibu-ya.
Here is another summer scene along the Sumida River by Shunchō. This time he portrays a courtesan in the pillar-print format in which he excelled. The girl is standing holding her fan with a smoking kit at her feet. Through the barred window, pleasure boats can be seen on the river. (Although the pillar prints were engraved on one long block of wood, paper of that size was not readily available, and thus two sheets were usually joined near the center, as is quite apparent in this example.)

134 **Shumman**: *Girls by a Stream.* Part of a six-sheet composition, each panel of *ōban* size, mid 1780s (mid Temmei Period). Signature: Kubo Shumman *ga,* with seal; publisher (seal on lower right): Fushimi-ya. (Complete composition: see figure 616.)
Three fashionable girls are walking along a surging stream in the wilds of Mt. Kōya. The scene is quite imaginary, being part of a set of six prints depicting lovely girls in the rustic setting of the "Six Jewel Rivers." This print is one of the *beni-girai* [sans-pink] variety, featuring muted harmonies of black and gray with only slight touches of pastel coloring, issued during a period when government sumptuary edicts were in force.

of such difficult forms as the vertical pillar print, the diptych and the triptych. Shunchō was also one of the great masters of ukiyo-e erotica; in this field, indeed, he sometimes surpassed his mentor Kiyonaga.

Another pupil of Shunshō who later made Kiyonaga his model was **Shunzan,** a talented artist, who, however, never equaled Shunchō.

One of the most striking figures of this period is Kubo **Shumman** (1757–1820), who studied with Shigemasa but was particularly influenced by Kiyonaga—though in his mastery of subdued coloring and complex patterns, the influence of Shunshō and Shunchō is evident as well. If anything, Shumman at his rare best represents an improvement over his ultimate model, Kiyonaga, principally through the evocative quality of atmosphere. This is well displayed in plate 134, one of a series of six consecutive prints showing views of the Six Tamagawas—a group of geographically unrelated Japanese rivers each bearing the same name, Jewel River. Besides revealing that subtlety of mood and atmosphere so seldom achieved by his contemporaries, Shumman's print shows his characteristically subdued coloring, in which pale greens and grays pervade the scene; the more dominant colors were purposely excluded.

Shumman belongs to that group of fine artists, including Shigemasa and Kyōden, whose prints are scarce because their main efforts were directed to book illustration or literature. For example, besides his extensive career in the field of ukiyo-e painting, Shumman was a gifted writer of light verse and devoted much of his artistic efforts to the rare *surimono* [gift prints] and illustrated albums that specialized in collecting such verses for publication.

The brief career of Kiyonaga's son and pupil **Kiyomasa** may be cited in passing as one of the minor tragedies of feudal convention. He revealed considerable talent in his early work of the years 1793 to 1795, but his artistic career seems to have been halted by his father at that time, so as not to interfere with the succession of Kiyomitsu's grandson **Kiyomine**—who, unfortunately, never developed any marked talent in the field of ukiyo-e.

Utamaro

The 1790s mark a climax and a turning point in the development of ukiyo-e. Technically, the color print was at its height despite attempts by the feudal authorities to limit its increasing luxuriousness. With Sharaku and Toyokuni the realistic actor print reached its culmination; and with Utamaro, Eishi and Chōki, the female face and figure received perhaps the greatest and most concentrated tribute since the beginnings of Japanese art. Yet, in view of the decline that figure prints were to undergo in the following decade, we cannot escape the impression that the 1790s represent a brief and final glory before the fall. Whether the trend of that time should be termed decadent or not is largely a problem of definition; certainly it is clear that ukiyo-e prints, after only a century of full growth, were entering a period of decline and that even the force of genius could only slow, but not halt, the downward course.

Just as Kiyonaga dominated the 1780s, so Utamaro ruled the decade that followed. Kitagawa **Utamaro** (1753–1806) was a pupil of the influential genre painter and teacher Toriyama Sekien, but owed his greatest debt to Kiyonaga. The first decade or so of Utamaro's published work was devoted mainly to book illustration, culminating in the famous *Insect, Shell* and *Bird* albums of 1787 to 1791, remarkable artistic tributes to the rising spirit of scientific inquiry.

By the late 1770s Utamaro had already been taken in as protégé by the great publisher Tsuta-ya and, within a decade, had begun to establish his own mature style. To the boldly graceful, lifelike women of Kiyonaga he added a strong element of eroticism based on an intuitive grasp of the nature of female psychology. It is this element that has made Utamaro the best known in the West of the dozens of able Japanese portrayers of womanhood: his girls and women speak directly to the viewer in terms of a frankly sensual beauty. Behind this surface attraction, in Utamaro's finest works, we sense the mind of the eternal female, seemingly oblivious to her own charms, yet well aware of their effect upon her male audience

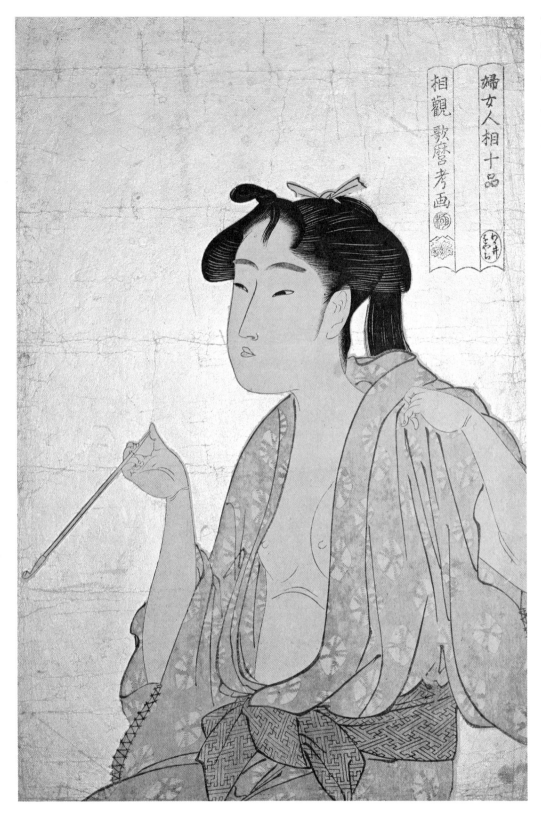

相觀 歌麿考画
婦女人相十品

135 **Utamaro:** *Courtesan in Dishabille.* *Ōban* size, early 1790s (early–mid Kansei Period). Signature: *sōkan* [inspector] Utamaro *kōga* [researched print]; censor's *kiwame* seal; publisher: Tsuta-ya.
Eight prints are known from this combined series of *Fujo ninsō juppin/Fujin sōgaku juttai* [Ten Views of Female Physiognomy], several of which rank among Utamaro's masterpieces. The present design displays the open charms of a courtesan at leisure, smoking a long pipe after a bath in the summer. Effective use is made of the mica background. A subtle embossed effect hardly visible in reproduction gives an added realistic touch: a stream of smoke issuing from the girl's lips.

and of their profound influence upon her own life and her concept of happiness. Despite his varied talents, Utamaro's fame will always rest principally on this new ideal of womanhood that he helped create: elongated figures, reserved yet subtly erotic in demeanor and

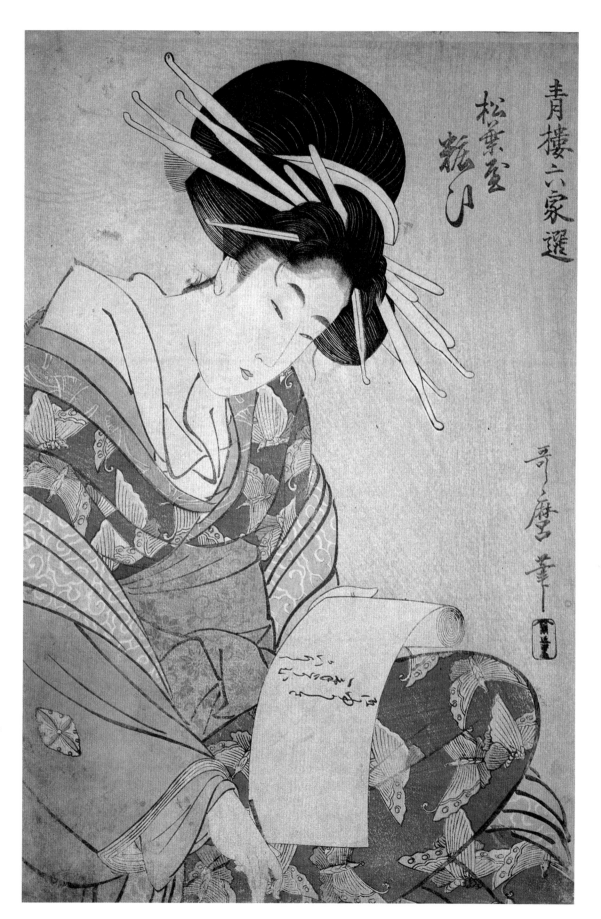

青楼六家選

松葉屋
粧ひ

哥麿筆

136 Utamaro: *Courtesan Writing a Letter.* *Ōban* size, early 1800s (Kyōwa Period). Signature: Utamaro *hitsu*; publisher (seal on lower right): Omi-ya.
This is one of the noteworthy half-length series of courtesan portraits, *Seirō rokka-sen* [Six Poets of the Yoshiwara], of which four designs are known. In this masterly composition, the renowned courtesan Yosooi is holding a writing brush and intently regarding a billet-doux she has just started to write to a lover. The mood of the print is heightened by the use of a light gray background; this work gives us a glimpse of Utamaro toward the end of his brilliant career.

with majestic carriage; they were more feminine than the women of the prints had been since the graceful dreams of Harunobu, but they were quite another type of woman.

Utamaro's early informal prints reveal a freshness that is never quite regained in the more impressive work of his maturity. Utamaro is probably at his most typical in his prints of the Kansei-Kyōwa Period, the famous bust portraits depicting courtesans and teahouse girls, poised and resplendent in rich robes, often against a luxurious background created by applying mica dust to the prints. Equally renowned are Utamaro's scenes of women at work and his magnificent murals composed of three to six prints in series. These are but a brief sample of the wide range of Utamaro's representations of the female form. His work also includes psychological portraits of women in love, idyllic outdoor scenes, Yoshiwara festivals and drinking bouts, beauties from history and legend, pairs of famous lovers, scenes of lightly veiled erotic mother love, bathers and shell divers, and toilet and boudoir scenes galore. In fact, he used practically all the devices ever invented by Japanese artists to display female beauty but with many embellishments distinctively his own.

It is no accident that the book in which Edmond de Goncourt revealed Utamaro to the West was subtitled *Le Peintre des Maisons Vertes*: Utamaro is the artist preeminent of the demimonde, in both its psychological and sensual aspects. It is not surprising, then, to discover that he was one of the greatest and most prolific artists of erotica in the long annals of Japanese art. Except for a few works by Moronobu, Sugimura, Koryūsai and Hokusai, there are no prints as effective as Utamaro's in this field.

The introductory plates and frontispieces to Utamaro's erotic books and albums are usually only vaguely suggestive. Such a picture is shown in plate 141, the frontispiece to one of the more outstanding of Utamaro's erotic series. The scene is one familiar to us,

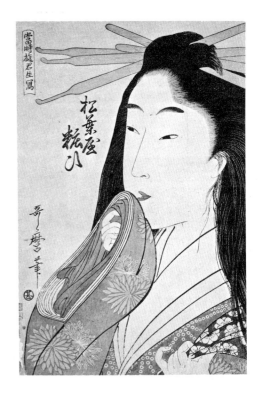

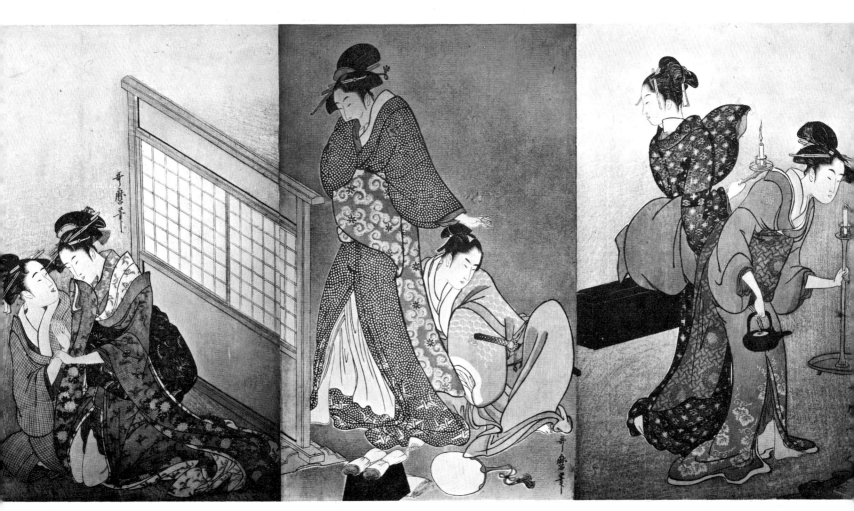

137 Utamaro: *The Courtesan Yosooi.*
Ōban size, early 1800s (Kyōwa Period).
Signature: Utamaro *hitsu;* publisher
(seal on lower left): Maru-Jin (Maru-ya
Jimpachi).
This intriguing design appears to be the
only print known from the series *Tōji
jŭkun shō-utsushi* [Modern Courtesans
Depicted from Life]. It dates from the
end of the artist's finest years and stands
as a remarkably candid portrait of the
same girl we saw depicted more formally
in plate 136.

138 Utamaro: *Scene in a House of
Assignation.* Triptych, each panel of
ōban size, mid 1790s (mid Kansei Pe-
riod). Signatures: Utamaro *hitsu.*
In this lively Yoshiwara scene, an older
courtesan on the left is cajoling a fledg-
ling; in the center, a courtesan stands
next to a fair young man; and on the far
right, two girls are carrying away lamps
and a saké pot. There are a pair of lac-
quered pillows in the foreground. This
scene probably hints at the impending
initiation ceremony of the fledgling
courtesan, with overtones from the
"Yūgao" chapter of the *Tale of Genji.*
The freshness of vision glimpsed here
is typical of the best of Utamaro in his
middle years.

139 Utamaro: *Matron in Love.* *Ōban*
size, late 1780s (late Temmei Period).
Signature: Utamaro *hitsu;* publisher
(seal on the left): Tsuta-ya.
Prominent among Utamaro's essays at
female portraiture is the series *Kasen:
koi-no-bu* [Selected Love Poems], of
which some five designs are known.
The print illustrated here is the master-
piece of the group and depicts a middle-
aged married woman (or widow) suf-
fering the pangs of love: her eyes are
narrowed in passion, jealousy or some
related emotion. This significant early
experiment at psychological portraiture
is likewise a tribute to the woodblock
printer's art; it makes effective use of a
mica ground and of kimono patterns in
predominantly somber hues.

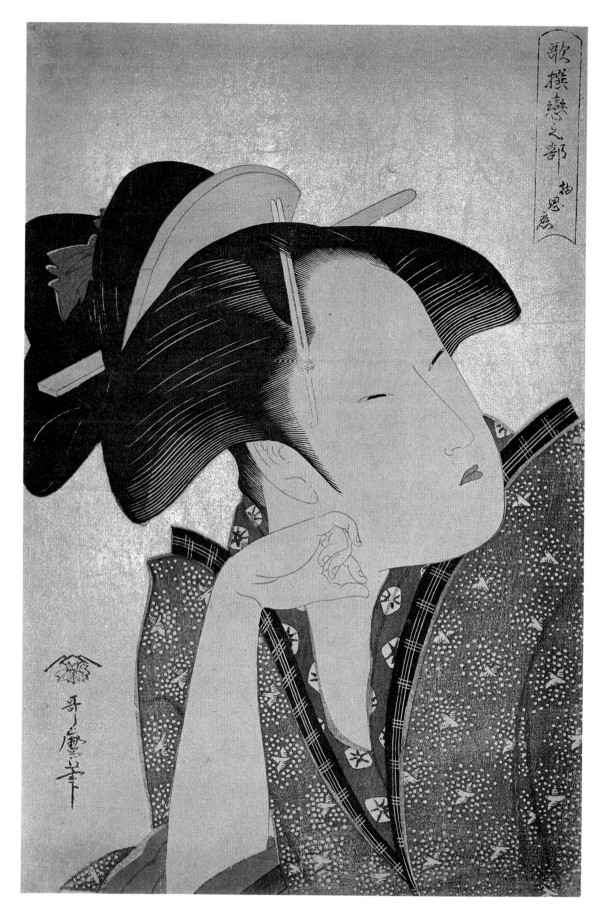

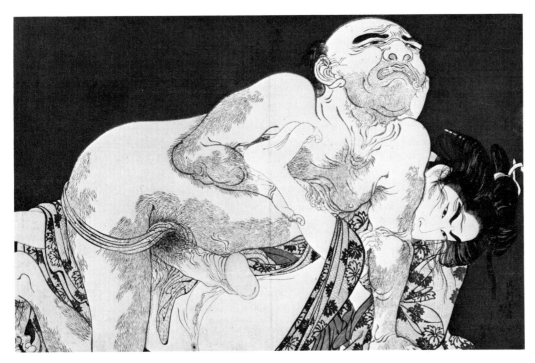

140 **Utamaro**: *Rape Scene. Ōban* size, from the shunga album *Uta-makura* [Pillow of Song], datable to Temmei VIII (1788).
Several of Utamaro's early masterpieces appeared in the form of *yokoban* [horizontal album prints], published by Tsuta-ya, of which the famous *Uta-makura* shunga series is the most impressive. The twelve prints of the set display a variety of settings and of classes of protagonists—from an underwater scene with a pearl diver and *kappa* [demon] to an exotic Dutchman and his wife in amorous embrace. This is one of the most dramatic scenes: a plebeian maiden being attacked by a middle-aged laborer and putting up stiff resistance.

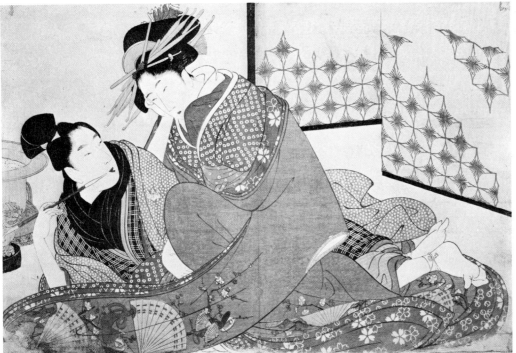

141 **Utamaro**: *Lovers in a House of Assignation. Ōban* size, from the shunga album *Negai no itoguchi* [The Prelude to Desire], datable to Kansei XI (1799). For another of the series, see figure 721.
Following a number of significant works in shunga book illustration, Utamaro published his second major erotic print series in 1799, the album of twelve prints called *Negai no itoguchi,* of which this print is the frontispiece. Gone is the inflexibility and hardness of line we saw in the artist's early work (plate 140); here Utamaro succeeds in combining linear fluency with a rarely evocative erotic power.

an intimate view of a fair courtesan and her handsome lover in a Yoshiwara house of assignation. It is winter, as evidenced by the heavy robes and the brazier on the left. The sleeves and skirt of the courtesan's outer robe bear a seasonal design of plum blossoms and court caps and fans; in the background is the folding screen that shuts the lovers off from the outer world. In viewing here what Japanese connoisseurs have sometimes considered the ultimate in idealized figure work—the equivalent, perhaps, of the nude in Western art—it is of interest to refer to the long line of erotic and semi-erotic masterpieces that preceded it: plates 20, 29, 66, to cite only a few notable prints with similar motifs.

The reader (whether indignant or pleased) may wonder whether there were no authorities to censor the occasional licentiousness of the ukiyo-e artists and publishers. There was,

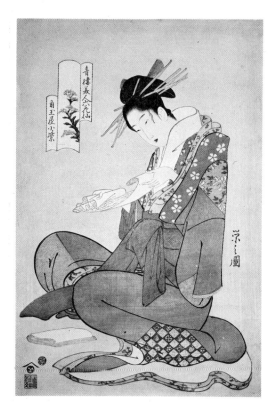

indeed, an elaborate system of censorship that affected all phases of Japanese life during the Edo Period. Yet as far as publication went, the only real offenses in the eyes of the law were publication of seditious matter and publication without the censor's seal of approval. The publication of pornography as such was not considered a very serious crime, and as late as Koryūsai in the 1770s, artists often signed their true names to their erotica. When at last Utamaro did run into difficulties with the authorities in the year 1804, it was not for his erotica but for some uncensored historical prints depicting the sixteenth-century Shōgun Hideyoshi, whose heir had been deposed by the current Tokugawa regime and about whom the governors naturally felt the pangs of a guilty conscience. (Utamaro's punishment consisted of a brief term of imprisonment, but he seems never to have recovered from the experience: the prints of his final two years are lacking in power and were often doubtless the work of his assistants.)

With Utamaro's decline, the great period of ukiyo-e figure work ended and true decadence set in. However there remain a number of notable contemporaries of Utamaro to be discussed, men who had developed in the period of Kiyonaga, but who found their principal inspiration in the greatness of Utamaro.

Eishi, Eishō, Eiri, Chōki

Utamaro's immediate pupils and imitators were numerous and frequently skillful, yet they contributed nothing new to the master's style and need only be mentioned in passing: direct pupils such as **Kikumaro (Tsukimaro), Hidemaro, Shikimaro, Yukimaro, Toyomaro** and **Utamaro II,** and such notable imitators as **Banki, Sekijō** and **Shūchō.** The greatest of Utamaro's followers, however, was a samurai named Eishi, who had the most unusual origins of any ukiyo-e artist.

Chōbunsai **Eishi** (1756–1829) was the eldest son of a noted samurai official in Edo; as such his future was assured in the form of a generous annual stipend from the shōgun. Eishi first studied painting under official Kanō-School teachers and even served as official

142 Eishi: *The Courtesan Komurasaki.* Ōban size, mid 1790s (mid Kansei Period). Signature: Eishi *zu*; censor's *kiwame* seal; publisher: Eijudō.
Eishi's courtesans are more refined, aristocratic and statuesque than Utamaro's, if less lively and human. The collector or critic may choose his favorite on the basis of personal taste. Utamaro is the more original artist, but this concession hardly diminishes our pleasure in the masterpieces of Eishi. Here Komurasaki is reading a love letter. This print is from the series *Seirō bijin rokkasen* [Six Poems on Yoshiwara Beauties as Flowers]; each print in the series features a seasonal blossom in the cartouche. The heavier colors and block lines employed in the lower part of the figure lend a peculiar solidity to the design, belying the slender figure of the girl herself.

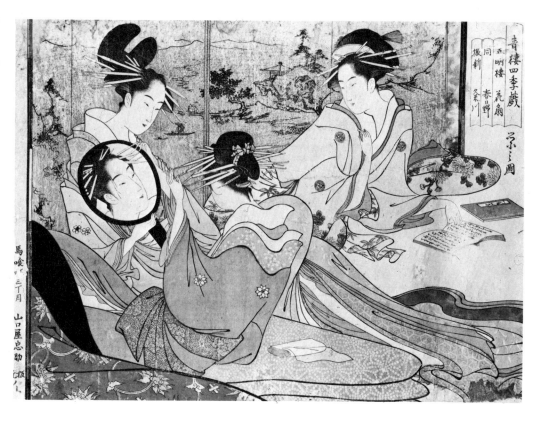

143 Eishi: *Courtesans at Leisure.* Double-*ōban* size, late 1790s (late Kansei Period). Signature: Eishi *zu*; publisher: Yamaguchi-ya.
This rare print is important first for its large, double-*ōban* size but also for its informal approach to the belles of the demimonde. The two leading courtesans Hanaōgi and Kasugano, with their attendant Kumegawa, are at leisure in their rooms before a screen in classical Kanō style (a style in which Eishi was an acknowledged master before he turned to ukiyo-e). This print is from the series *Seirō shiki-no-tawamure* [Four Seasons of Pleasure in the Yoshiwara]; however, only this one design is known today.

painter to the shōgun for several years. Then abruptly, around the age of thirty, Eishi gave up his noble heritage and turned wholeheartedly to the plebeian ukiyo-e prints that had been his first though hidden love for some years. It says something for the influence and tolerance of the artist's family that he was allowed to make this drastic step down into the masses without complete ostracism or even direct government interference; indeed, he was even allowed to retain his art name Eishi ["He Glorifies"], which had been bestowed on him in admiration by the shōgun himself.

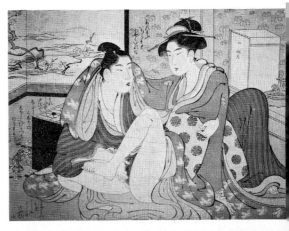

Eishi's early prints date from the period of Kiyonaga's dominance, yet already reveal a refined sweetness that was to remain his trademark. Like his later mentor Utamaro's work, Eishi's was devoted principally to designs of girls, whether courtesans of the Yoshiwara or idealized maidens in idyllic surroundings. He was also a master of erotica; his shunga were only one extension of that dream-world he depicted so often and so well.

Eishi's prints are often at their best in the evocative idyll, of the type shown in plate 145. Here we see girls from an upper-class family engaged in the stylish summer pastime of firefly hunting, an elegant form of recreation popular to this day in Japan. But while the girls are real and the situation a common one, in Eishi's magic hands a new enchantment is cast over the scene, creating a poetry of mood that almost equals the rare gems of his contemporary Chōki.

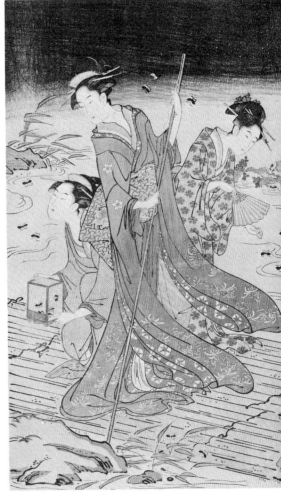

With the coming of middle age Eishi's work shows a trend toward increasing elongation of the human figure, a style that has disturbed many critics, who call it abnormal and decadent, but which seems hardly worth complaining about as long as the end result is beautiful. However, it is of interest to compare the different aspects of this fashion for svelte figures as drawn by Eishi and by Utamaro. Utamaro is universally conceded to be the greater artist, yet as was the case with Kiyonaga, we may find ourselves loving the lesser artist the more. There is no doubt, of course, that Kiyonaga, and later Utamaro, formed the basis for Eishi's style; yet in the final analysis an Eishi print is a world apart from these masters of the robust or the erotic. For Eishi stands with Chōki as one of the true aristocrats of ukiyo-e; his work may lack power but never refinement or grace. Despite his aristocratic upbringing (or in reaction to it) the prints of Eishi's middle years concentrate more and more on the Yoshiwara courtesans, in particular showing them in the variegated costumes of their ceremonial parades through the entertainment quarter.

By the turn of the century Eishi seems to have realized that he was, at the insistence of his publishers and his wide audience, being forced into a rut; at the same time he was doubtless at least subconsciously aware of the overall decline of the figure print in general at this time. Eishi was no great innovator, or he might have effected a revival (as Masanobu, Harunobu and Kiyonaga had done in earlier periods); instead, he simply quit the field of popular prints to devote the remaining decades of his life to painting hand scrolls and alcove paintings, depicting courtesans and life in Edo. These works were the delight of the wealthy connoisseurs of the day; one such hand scroll, showing scenes along the Sumida River, so impressed Eishi's aristocratic patrons that they took this masterpiece all the way to Kyōto and presented it at a special showing before the Imperial family—an honor perhaps never accorded to any ukiyo-e artist before or after.

Eishi's principal activity as an ukiyo-e painter extends over three decades, from the 1790s to his final years. Because of his genius and his "blue blood" origins, he was accorded far greater acclaim by aristocrats than any other ukiyo-e artist. Therefore his paintings are still extant in considerable number today, although there are many forgeries. It is fortunate for us that Eishi had the courage necessary to abandon his noble heritage, renounce a lifetime of tracing conventionalized landscapes of a China he had never seen and devote his artistic talents to painting the subjects he himself treasured and understood best. Although, coming as he did at the end of an epoch, Eishi did not create any long-lived school; his pupils, though ephemeral, are among the most fascinating secondary figures in ukiyo-e history.

Chōkōsai **Eishō** (who worked in the 1790s), for example, brings Eishi's idyllic beauties down to earth, endowing them with a certain robust element that is reminiscent of both Kiyonaga and Utamaro. Eishō's principal innovations in technique were in his bust portraits of beautiful girls. This artist's women lack the aristocratic refinement of Eishi's, but they are sometimes more human, more lifelike; the sweetly childish, slightly silly look on the faces

145 **Eishi**: *Girls on a Raft.* Ōban size, mid 1790s (mid Kansei Period). Signature: Eishi *zu*; publisher (seal on the right): Sen-Ichi (Izumi-ya).
In this elegant panel from a triptych, three girls are shown on a raft, catching fireflies on a summer evening. The subject offers a welcome change from Yoshiwara themes and, as is often the case with multiple sheet prints, the single panel, telephoto view tends to be more enjoyable than the overpowering complexity of the complete panorama (see figure 30).

144 Eishi: *Young Lovers.* *Ōban* size, from a shunga series, late 1780s (late Temmei Period).

This scene from the newly discovered series *Jūnikō hana-no-sugata* [Passion Flowers of the Twelve Seasons] represents Eishi's charming work in the shunga genre and the naive new style he developed while still under the influence of the Kiyonaga. Young lovers interrupt a New Year's game of backgammon for erotic dalliance, against background elements—a Kanō-style screen and *Tale of Genji* book box—which remind us of Eishi's classical upbringing.

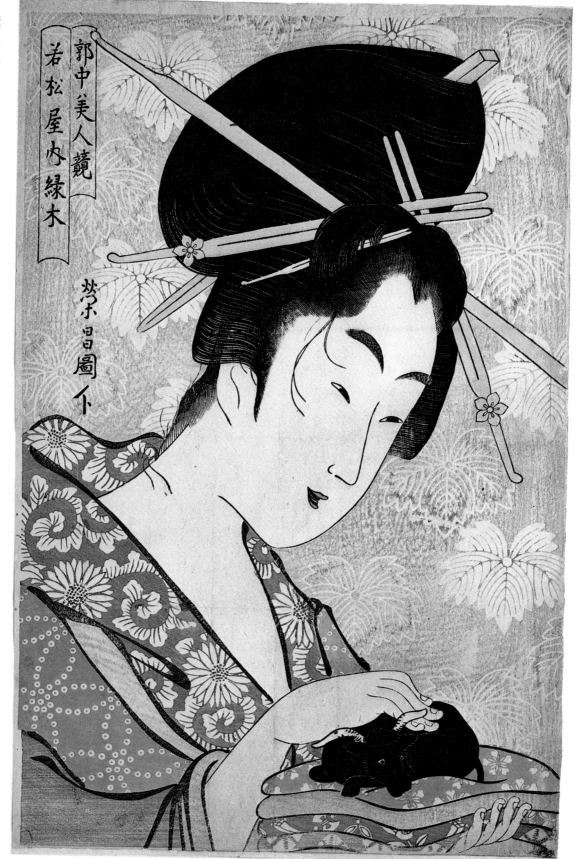

146 Eishō: *The Courtesan Midorigi.* *Ōban* size, mid–late 1790s (mid–late Kansei Period). Signature: Eishō *zu*; publisher (seal below the signature): Yamaguchi-ya. Among the glories of the Golden Age of ukiyo-e are the *ōkubi-e* [close-up portraits] of courtesans by Eishō. This notable example depicts the courtesan Midorigi from the Wakamatsu-ya bordello; she is depicted against a decorated ground, holding an ornamental sculpture of an ox. This print is from the artist's major series of bust portraits, *Kakuchū bijin-kurabe* [Beauties of the Pleasure Quarter] of which some twenty designs by Eishō and four by other Eishi pupils are known. Such portraits are quite lacking in the psychological insight of Utamaro or Sharaku, but they excel in the expression of the decorative beauty and childish verve that lay at the center of Edo taste.

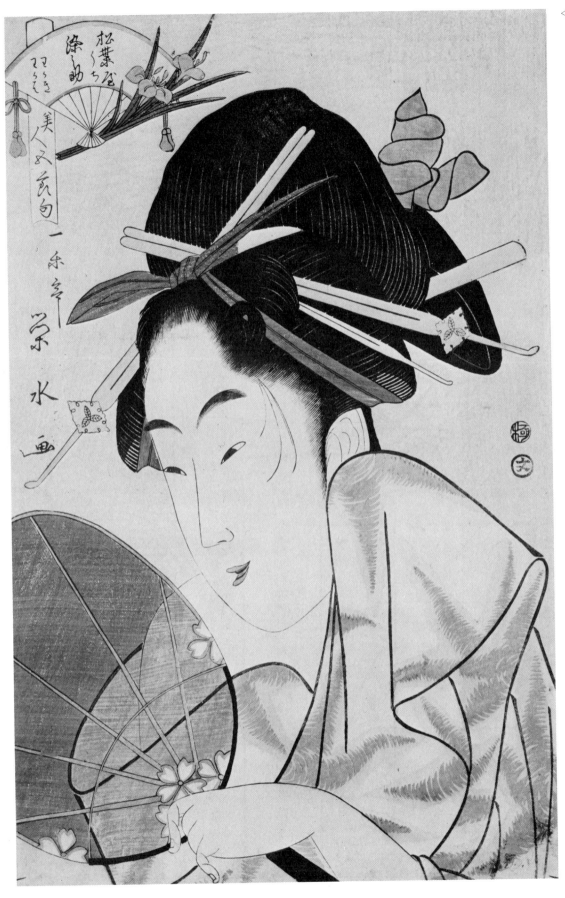

147 Eisui: *Courtesan after Her Bath*. Ōban size, late 1790s (late Kansei Period). Signature: Ichirakutei Eisui *ga*; censor's *kiwame* seal; publisher (seal on the right): Maru-Bun (Maru-ya Bun-emon).
Although he does not achieve Eishō's grandeur, Eisui's bust portraits are charming in their own graceful manner; this design portrays the courtesan Somenosuke holding a gossamer fan and with a bathrobe half thrown about her shoulders. It is from the series *Bijin go-sekku* [Beauties of the Five Festivals].

148 Chōkyōsai Eiri: *Streetwalker*. Ōban size, mid–late 1790s (mid–late Kansei Period). Signature: Eiri *giga* [playful picture]; publisher (trademark on lower right): Ya-maguchi-ya.
Although it is not difficult to comprehend the popular idolization of the higher-ranking courtesans of the Yoshiwara, this idealized portrait carries us a good step further down the rungs of Edo society. One of a set of three prints from the series entitled *Sanka-notsu sōka bijin-awase* [Fair Streetwalkers of the Three Capitals], this design is subtitled "O-Tatsu of Ryōgoku in Edo." Such girls were available to all comers, and it is an interesting aspect of Edo taste that even they became the subjects of idealized artistic masterpieces as exemplified by this series. It is customarily assumed that the artist of this print is identical with Rekisentei Eiri (figures 22–24; however, though similarly pronounced, the names are quite different in written Japanese). Based on stylistic grounds, the writer considers them different artists; this Eiri's figures are solid yet svelte, a long step removed from the debilitated charms of the other master.

149 Chōki: *Two Geisha of Ōsaka*. Ōban size, ca. mid 1790s (mid Kansei Period). Signature; Chōki *ga*; publisher (seal on the right): Tsuta-ya.
Chōki ranks with Sharaku in the masterful handling of half-length, double portraits. His work is much enhanced by the taste and skill of his publisher Tsuta-ya and his printers. Here a geisha and her attendant are depicted walking, against a mica ground that lends a three-dimensional quality to the print. The subjects of this print and others of the series, which was doubtless specially commissioned by the Edo publisher, are Kamigata women, an unusual feature for Edo ukiyo-e.

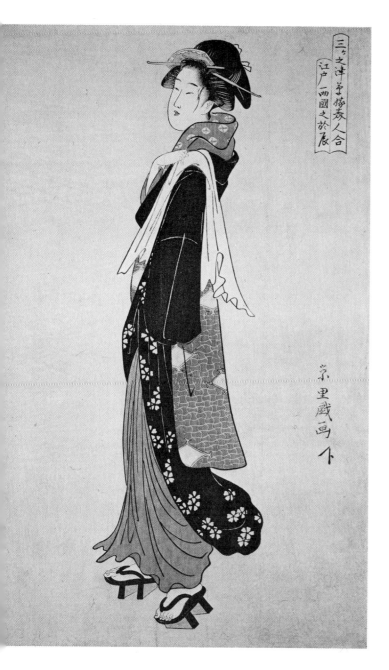

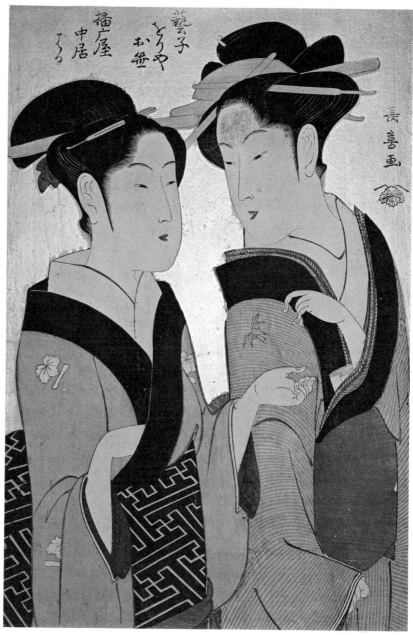

of his courtesans mirrors, perhaps unconsciously, one strong element of personality found in the Edo courtesan quarter.

Rekisentei **Eiri** (who also worked in the 1790s) represents another facet of the Eishi manner but in the opposite direction: his girls are sometimes almost excessively fragile and doll-like, yet on occasion their sumptuous charm approaches that of Chōki. In his sets of prints depicting lovers and in his erotica, Eiri sometimes succeeds in creating a mood of romantic drama rather rare in ukiyo-e.

Chōkyōsai [Shikyūsai] **Eiri** (fl. 1790s) is another notable artist in the Eishi manner, famed for his rare portraits and sumptuous shunga, which are sometimes confused with the work of Eishō. His figures are characterized by a solid, worldly charm and are rather more humanized than those of his contemporaries other than Chōki.

Of Eishi's remaining pupils we shall mention but one, Ichirakutei **Eisui** (who also worked in the 1790s); with Eishō and Eiri he excelled occasionally in portraying large heads of girls. We should add that these *ōkubi-e* [bust portraits], though they identify the courtesan by

name and address, are not really intended as portraits but are generalized pin-ups for the patrons or, more likely, the would-be frequenters of the Yoshiwara. They bear even less relation to the originals than our cinema posters do to the film itself; yet they do convey a mood and a certain stylized beauty, and we would certainly be loath to trade them for the best realistic paintings or photographs. They demonstrate the magic of ukiyo-e art, which can distort reality and depart so much from it and yet still express a sensitive human beauty.

Finally in this brief chapter on some of the later eighteenth-century masters of female portraiture, tribute must be paid to one artist whose work was perhaps the loveliest of all, Eishōsai **Chōki,** who worked from the 1760s to the early 1800s. In Chōki we can perceive myriad sources of influence: Kiyonaga, Eishi, Sharaku, Utamaro and indirectly—perhaps strongest of all—Harunobu. The wonder of it is that, although Chōki was not the equal of any of the men he studied, in a small number of his finest prints he somehow surpassed them all in the evocation of poetic atmosphere and in the creation of an ideal of feminine beauty that is second to none in ukiyo-e.

One of the most impressive prints by Chōki is shown in plate 151; it is a design that might well be chosen to represent all ukiyo-e and, perhaps, even to epitomize Japanese life and ideals in the Edo Period. The scene is a simple one: an innocent girl rests her arm upon a manservant's shoulders as the latter bends to clean the snow off her sandals. What is remarkable is the breathtaking color, the bold and startling composition, the idealized girl, the sum of traditional Japanese culture wrapped up within the confines of one simple print.

Chōki's compositional technique is worthy of further comment. Bust portraits had come into fashion with the 1790s, and Sharaku had made striking employment of two actors' heads in a single print. Yet apart from Chōki no artist handled so well this difficult compositional form of a close-up with secondary figure. Imagine, for a moment, this print with full-length figures, such as Harunobu used so frequently. The picture would still be charming, but hardly as profoundly impressive. What Chōki does, in effect, is to give us the total scene with a telephoto effect; it is reduced to its essentials, cut more than any photographer would dare to trim. But it is this very boldness of concentration that makes the print great. Once we realize the situation, there is no longer any need to see the remainder of the figure or any more background than the gently falling snow. The picture is complete and inviolable; it is one of the few perfect prints.

Toyoharu and the Early Landscape Print

From the golden age of the 1790s we must now return briefly to the preceding generation in order to describe the origins and development of a school that was to dominate much of ukiyo-e during its final half-century. This was the Utagawa School, and its founder was Toyoharu.

Utagawa **Toyoharu** (1735–1814) is, with Shigemasa, surely the most neglected ukiyo-e master of his period. Born in the western regions of Japan, Toyoharu first studied painting in Kyōto. In the mid-1760s he emigrated to Edo, where he seems to have become a pupil of the Kanō-School genre artist Sekien and possibly of ukiyo-e masters as well. In the late 1760s and early 1770s Toyoharu produced notable prints of girls and actors, often under the strong influence of Harunobu; soon after, however, he began to develop his real speciality: historical or genre group subjects and landscapes in perspective, most often combining the two types. In this field Toyoharu can be considered the major precursor of Hokusai in his maturity.

We have already noted, in passing, some of the occasional appearances of landscape in ukiyo-e, from the early topographical screen paintings and Moronobu to the first full-scale development of the *uki-e* [perspective print] and the landscape-with-figures at the hands of Masanobu and Shigenaga. Even the early panoramas and landscapes of the last two masters may well have been influenced by Western art, for it was during that period (the 1720s and 1730s) that the government authorities allowed the importation of foreign books

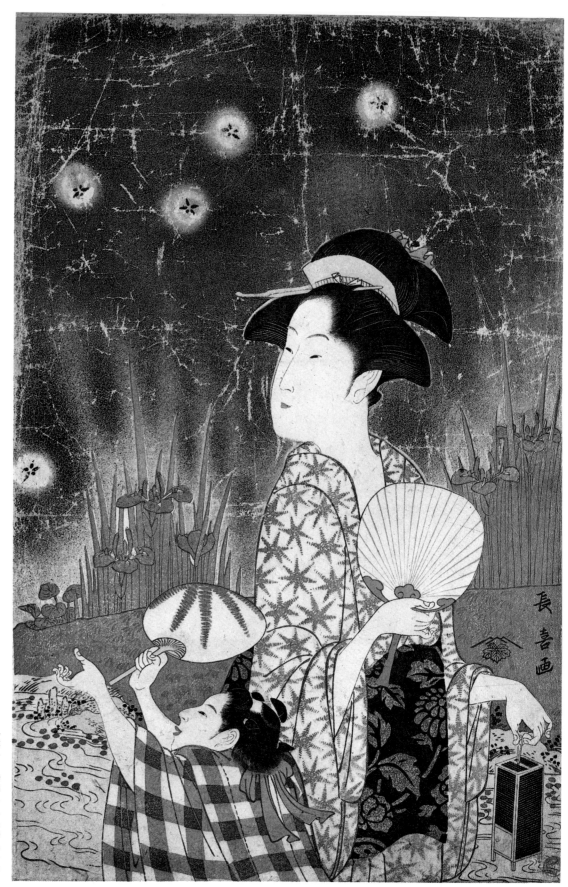

150 **Chōki**: *Catching Fireflies*. Ōban size, mid 1790s (mid Kansei Period). Signature: Chōki *ga*; publisher (seal on the right): Tsuta-ya.

In one of the most evocative of all Japanese prints. Chōki has portrayed a young woman and her little boy engaged in a favorite pastime: catching fireflies on a summer evening. The child wields a fan to capture the insects, as the girl holds a little cage for them; beside the pair winds a stream with irises in bloom. The fireflies are depicted against a *sumi*-and-mica ground that has been creased by the ravages of time.

147

for the first time in nearly a century. In the mid-eighteenth century, the methods and styles of Western painting and etching had (often via Chinese imitations) come to be felt more directly by several artists both in and out of the Ukiyo-e School. The aim of some of these, such as Gennai and Kōkan, was to depict Japanese scenes in frankly Western style; while others, such as Ōkyo and Toyoharu, strove to create a new form of Japanese art based on a blending of the foreign with the native. Meanwhile, the traditional landscape styles were also being adapted to ukiyo-e by such masters as Harunobu and Shigemasa, with only a minimal degree of foreign influence.

Toyoharu's special contribution to ukiyo-e was the *uki-e* [perspective print], an innovation which, in its primitive form, had been employed as a novelty by Masanobu, Kiyotada and others a generation earlier. Now for the first time it became an integrated form of Japanese art. By the age of the great landscapes of Hokusai and Hiroshige in the following century, the perspective style had become so completely assimilated that Western students first seeing Japanese prints almost invariably choose these two late masters as representatives of the pinnacle of Japanese art, little realizing that part of what they admire is the hidden kinship they feel with their own Western tradition. (Ironically enough, it was this work of Hokusai and Hiroshige that helped to revitalize Western painting toward the end of the nineteenth century, through the admiration of the Impressionists and the Post-impressionists.)

To appreciate the change Toyoharu effected in Japanese landscape and panorama prints, we must digress a moment to consider traditional Japanese (and Chinese) concepts of perspective. Somewhat akin to perspective in Egyptian art, Japanese perspective was basically subjective rather than optical; the size of an object depended more upon its importance to the design and the purpose of the picture than on its distance from the viewer. This is shown very graphically in Shigenaga's topographical print in plate 73: since the center of interest is human life, foreground details are small as are trees, houses, mountains and anything else that would tend to interfere with the emphasis placed on the principal travelers. The same method will be found throughout much of early ukiyo-e landscape work, which follows a definite plan and logic and thus can hardly be considered distorted. It might be better termed subjective or stylized perspective. By the time of Harunobu and Shigemasa, this subjective view had already been insensibly modified by the gradual influence of Western art; Toyoharu was to bring the wide-angle lens to ukiyo-e, contributing an extremity of optical perspective that, in combination with his mastery of traditional Japanese techniques and subject matter, was to be all the rage in his day.

Although the majority of Toyoharu's perspective prints feature historical or legendary subjects, we have chosen for illustration two of his masterpieces depicting the contemporary world. The perspective print in plate 153 reveals, as probably no other medium could, the incredible color and confusion of the Kabuki district of Edo at dusk toward the end of the year. The foreground, however, is kept relatively clear, the figures carefully selected and placed. Apart from its importance to the composition, the latter device impresses upon us the vast variety and inherent interest of the mass of heads seen bobbing in the background. A long vista in exaggerated perspective is the characteristic of this type of print. The plate is typical of Toyoharu's best work in that it combines exotic style with carefully assimilated native subject matter and relates each part to the whole for a unified effect. Certainly this type of print is about as close as we can ever get to knowing the actual teeming, variegated life that occupied the streets of old Edo.

Toyoharu's perspective prints—a bridge, in effect, between ukiyo-e and Western art—were widely imitated by many of the fledgling artists who were soon to become the masters of the following decades. Such prints represent a significant, though little-known facet of the early work of such different artists as Utamaro, Masayoshi, Eishō, Toyokuni, Hokusai and several others.

The contribution to ukiyo-e made by Toyoharu's perspective prints is, however, somewhat difficult to evaluate, for the prints themselves were popular principally during the 1770s and 1780s, after which time Toyoharu turned to his secondary speciality: sumptuous paintings of girls and courtesans. His contribution to the landscape print, besides the intrinsic merit of his own work, lies chiefly in the prints of his followers. Toyoharu created almost

151 Chōki: *Girl in the Snow.* *Ōban* size, mid 1790s (mid Kansei Period). Signature: Chōki *ga*; censor's *kiwame* seal; publisher (seal on the left): Tsuta-ya.

In this, one of the most perfect of all Japanese prints, a girl in her late teens holds a snow-laden umbrella as her manservant cleans her sandal. Note Chōki's skillful employment of the auxiliary figure as an unobtrusive accent. His achievement in developing this type of close-up with a secondary figure is only surpassed by his wonderful portrayal of the girl. At one time this print was thought to represent a portrait of the Genroku poetess Shūshiki, but that seems unlikely. The design is reminiscent of several full-length portrayals of related scenes by Sukenobu, Toyonobu, Kiyotsune and Harunobu. The snowflakes appear to have been stenciled or sprinkled by hand and vary with each example of this rare print.

152 **Toyoharu:** *Fireworks at Ryōgoku Bridge.* *Ōban* size, ca. late 1770s (late An-ei Period). Signature: Utagawa Toyoharu *ga*; publisher: Iwato-ya.

Toyoharu's principal achievement was the development of the *uki-e* or perspective print, which forms a kind of bridge between ukiyo-e and the Western landscape print. This splendid example shows the former Ryōgoku [Two Provinces] Bridge, which spanned the Sumida River and provided one of the focal points of Edo life, especially in summer when the great fireworks displays were held. Against a starlit sky, a great rocket burst is watched by the populace from boats and from the riverbank as well as from the bridge itself. Admittedly, Toyoharu's *uki-e* compositions lack the dramatic power and concentration of the later Hokusai (who was to do extensive work in this genre himself a decade or so later), but their fascinating details of the life of the times compensate amply for this deficiency.

153 **Toyoharu:** *Theater District at Night. Ōban* size, early 1780s (early Temmei Period). Signature: Utagawa Toyoharu *ga*; publisher: Nishimura-ya.

The artist would have us experience here the hurly-burly of the Kabuki district of Edo just after dusk toward the end of the year. Actors, playgoers, sight-seers and tradesmen mingle before the gaudy facades of the principal Kabuki and puppet theaters that stretch off into the distance with the exaggerated perspective typical of *uki-e.*

single-handedly the new popular interest in landscape prints and, at the same time, introduced historical and legendary incident as an integral part of landscape art. In this sense he might well be considered the father of the two forms that were, with the actor prints, to become the staple of nineteenth-century ukiyo-e. Certainly it is difficult to envisage Hokusai's most characteristic work without detailed reference to this much-neglected preceptor.

Toyokuni and the Utagawa School

Although it was Toyoharu who founded the Utagawa School of ukiyo-e, to his pupil Toyokuni must go the credit for making the name known throughout the world. Utagawa **Toyo-**

kuni (1769–1825) entered the studio of his neighbor Toyoharu at an early age, producing his first book illustrations in his mid-teens. He lacked the classical background of such contemporaries as Utamaro and Eishi, having been trained entirely in the ukiyo-e tradition. Toyokuni's most impressive early prints are his dramatic landscapes after the manner of his teacher. Toyokuni was, however, the great eclectic of ukiyo-e, and soon he was reaching out over the whole range of his contemporaries for styles to emulate. He studied successively the work of Kiyonaga, Shumman, Chōki, Eishi and Utamaro in the field of pictures of beautiful women; and that of Shunshō, Shun-ei and Sharaku for prints of actors. Plate 154 shows Toyokuni at his best during his Utamaro-Eishi period. While Toyokuni's talent is predominantly imitative, it must always be added that his work, in whatever style, would never be mistaken for another master's and sometimes, as here, even manages to equal or surpass the original model. Yet it is not so much Toyokuni's tendency to emulate his betters that relegates him to secondary rank in ukiyo-e history, as his basic insensitivity as an artist. For although he produced many a strong and notable design, Toyokuni only rarely succeeded in achieving the grace or delicacy of any of his masters. Thus he is inevitably at his best in work where the bold and coarse form a desirable element (in some of his historical prints and Kabuki scenes), as well as in a few prints of girls in which the poster coloring compensates for any inherent crudity of insight or design.

Toyokuni worked in many fields, but it was in the portrayal of Kabuki actors that he made his greatest name, dominating the field for nearly three decades. Toyokuni's best-known actor prints are the several dozen minor masterpieces issued in the years 1794 to 1796 under the title *Yakusha butai no sugata-e* [Views of Actors on Stage]. These, and the impressive "large heads" of actors, pale beside the grandeur of Sharaku's work in the same months, yet show that Toyokuni could almost achieve greatness under the proper stimulus.

Ukiyo-e figure prints were already moribund before Utamaro died. In Toyokuni's work in figure prints, the decline that occurred with the coming of the nineteenth century is the most pronounced of all. Whatever charm he had conveyed in his youth or under the influence of greater men is gone, and what is left is mainly sound and fury, repetitious posturing. (This late work is printed, nonetheless, with immaculate skill, for the artisans retained their crafts-

154 Toyokuni: *Girls Playing in the Snow*. Triptych, each panel of *ōban* size, ca. late 1790s (later Kansei Period). Signature: Toyokuni *ga*; censor's *kiwame* seal; publisher: Sen-Ichi (Izumi-ya).

To the later detriment of his fame, Toyokuni was imitative and over-productive, yet in his finer work during the 1790s he produced several masterpieces that rank with the best work of either Utamaro or Eishi. The present triptych represents his triumph in the multi-sheet genre, depicting girls of the samurai class enjoying refined pleasure in the snow. Toyokuni's females of this period are clearly derived from Utamaro; they display, withal, a special character of their own—more impassive and less openly erotic—a distinctive creation that we should be loath to see disappear from the ukiyo-e galaxy.

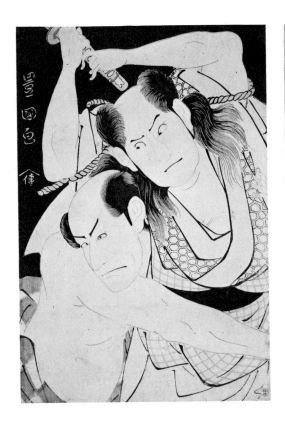

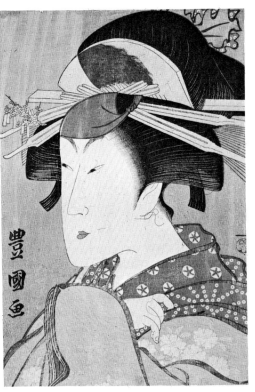

155 Toyokuni: *Actors in Combat. Ōban* size, ca. 1797 (Kansei IX). Signature: Toyokuni *ga*; publisher: Yama-Den (Eiyūdō).
Inspired by Sharaku, Toyokuni also produced his finest actor prints during the second half of the Kansei Period. In place of Sharaku's piercingly realistic view, this print portrays the world of decorative bombast that is, in a sense, really closer to the true nature of Kabuki. Although the play has not been identified, the actors would appear to be Sawamura Sōjūrō III and Arashi Ryūzō, in a drama that was performed about 1797.

156 Toyokuni: *Actor in Female Role. Ōban* size, ca. late 1790s (late Kansei Period). Signature: Toyokuni *ga*; publisher (seal on the right): Tsuru-Kin (Tsuru-ya Kinsuke).
Toyokuni's bust portraits of actors in the later Kansei Period mark a high point in his career; they convey the atmosphere of the Kabuki stage while revealing much of the character of the individual actor. Toyokuni was favored as well by master printers with remarkable results such as we see in this portrayal of the noted female impersonator Segawa Kikunojō III, whose feminine manner was thought so bewitching that it was even emulated by the geisha of the time.

manship long after the great figure designers were gone.) Occasionally Toyokuni does manage to rise above the clamoring demands of mass production, but he does this most often in a rare print where a certain coarseness and vapid horror successfully convey the gruesomeness of a macabre Kabuki tableau.

The causes of this decline in the figure print have never been adequately explained, but they clearly lie in a combination of declining talent among the artists, overproduction for a mass audience and deteriorating taste on the part of a changing public for prints. In the century and a half of development of ukiyo-e figure work, the prints changed gradually from decorations for a connoisseur's chamber to pin-ups for the laborer and clerk. Theoretically the latter form could have been the equal of the former; in practice, however, mass production led to decline both in taste and in quality. Ukiyo-e figure design of merit did survive, but only fitfully, into the nineteenth century and far more often in the commissioned paintings than in the popular prints.

A fellow pupil of Toyokuni under Toyoharu was Utagawa **Toyohiro** (1763–1828). Certainly of equal talent with Toyokuni, Toyohiro chose to leave the gaudy popular aspects of ukiyo-e to his confrere and devoted his life to a quieter, less hurried view of life and beauty. His work is thus relatively rare. The ladies of Toyohiro's prints characteristically display a certain weary detachment, together with a far greater sense of refinement than those of his fellow pupil. This quality links Toyohiro most of all to Eishi. Toyohiro is best known today as teacher of the great Hiroshige. The teacher's few landscapes form a necessary prelude to the achievements of his pupil, and there is little doubt that Hiroshige's art would have been quite different without the patient guidance of this humble and restrained master.

Of Toyokuni's all-too-numerous students, several will be noted in a later chapter on the landscape print. The most important pupil who followed him in depicting Kabuki scenes was Utagawa **Kunimasa** (1773–1810), who began his work early and died young, thus escaping the general artistic decline of his generation. Kunimasa excelled in actor portraits that strove to combine the intensity of Sharaku with the decorative pageantry of his master Toyokuni. He succeeded in the latter attempt but not in the former, and thus it has been his inevitable fate to be treated as a "minor Sharaku." Kunimasa may appeal to those who find the biting genius of Sharaku disquieting. Certainly he achieves a more valid portrayal of the bombast

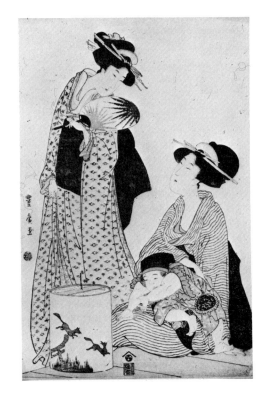

158 Kunimasa: *Actor in Female Role. Ōban* size, ca. late 1790s (later Kansei Period). Signature: Kunimasa *ga*; censor's *kiwame* seal; publisher: Uemura (Yohei).

Toyokuni's early pupil Kunimasa fully equals his master here in depicting the character actor Iwai Kiyotarō in the role of O-Chiyo, from the play *Sugawara-denju tenarai-kagami,* as performed at the Kiri-za in Kansei IX/9 (October, 1797). Indeed, the print is quite evocative of the peculiar atmosphere of the actor and the role, which is emphasized by the restrained color scheme and the immaculate printing.

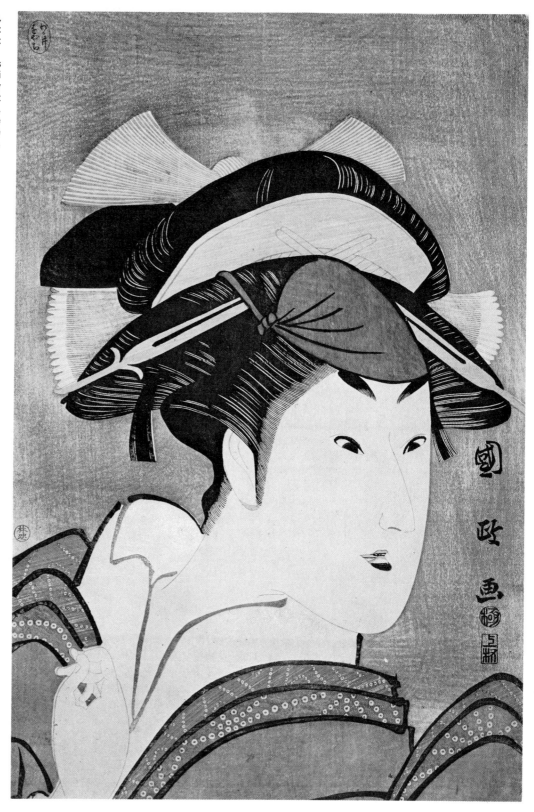

157 Toyohiro: *Domestic Scene in Summer. Ōban* size, ca. early 1800s (Kyōwa Period). Signature: Toyohiro *ga*; censor's *kiwame* seal; publisher (seal at bottom): Eijudō.

Toyohiro's personality lacked the vitality and verve necessary for him to achieve leadership in the frenetic ukiyo-e print world. Yet he left his share of quiet masterpieces, such as this view of an Edo family at dusk in summertime: the baby is reaching for a revolving lantern on which a silhouette of Inari fox-gods is reflected.

and pageantry of a Kabuki performance than Sharaku, who in his genius depicts not only an artistic goal seldom reached by even the greatest performers but also the human failings of the person behind the role.

The myriad pupils of Toyokuni literally overwhelmed the final half-century of ukiyo-e figure prints, and it is almost exclusively their work that crowds the shelves of print shops

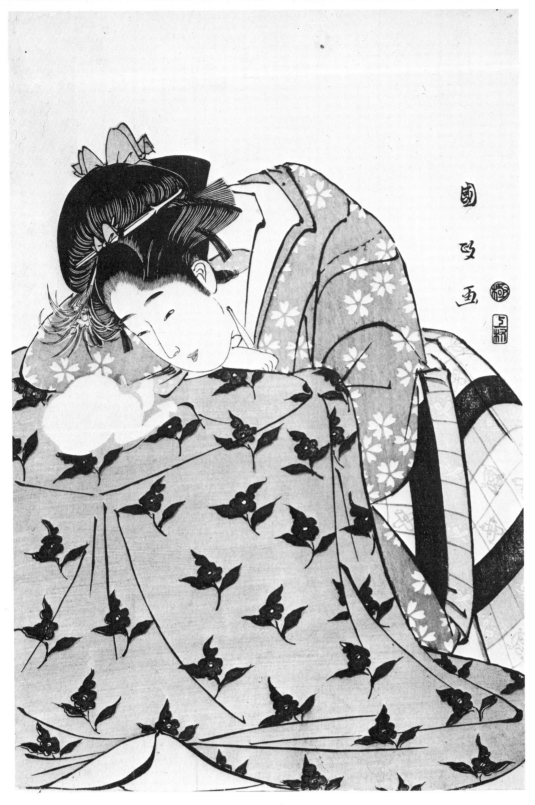

the world over, while the more sought-after masters are carefully hidden in the dealers' vaults or hoarded in the chambers of collectors. With careful searching and discrimination, however, notable figure prints may be discovered even in the declining days of ukiyo-e. Such Toyokuni pupils as Kunisada, Kuniyoshi, **Kuniyasu, Kunihisa, Kuninao,** and such later followers of the Utamaro manner as Eizan, Eisen, **Shunsen, Goshichi,** deserve further study by amateurs and scholars. Yet there is no denying that it is rare to discover an occasional gem in their work and that the great period of the figure print was gone forever at least a generation before Commodore Perry's Black Ships (as the Japanese called them) battered down the doors of Japanese resistance to the Western world.

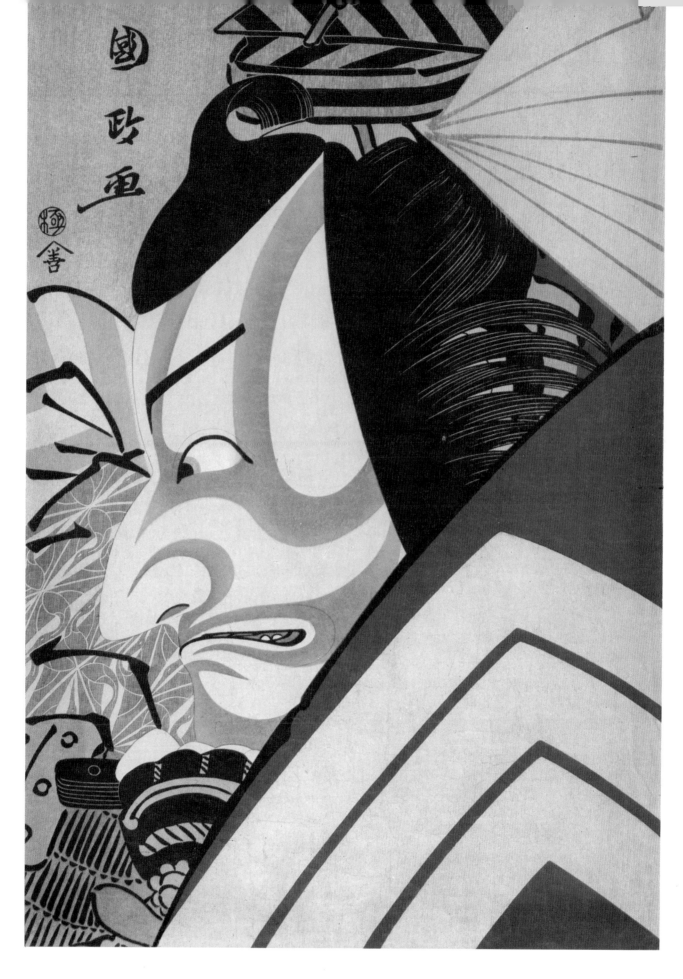

155

Hokusai, Hiroshige and the Japanese Landscape
1810–1880

Hokusai's Early Work

There are certain figures in art history who command our attention as much for their personalities and eccentricities, their single-minded purposefulness, as they do for their work. Hokusai represents the outstanding example of this phenomenon in Japanese art. Yet Katsushika **Hokusai** (1760–1849), long considered in the West the prime consolidator of the Ukiyo-e School, was in fact, one of the last great figures in its development. In his long career, this famous Japanese artist embodied the essence of the ukiyo-e print, illustration, sketch and painting during their final century of development. At the same time, in its seventy years of continuous artistic creation, his stubborn genius represents the prototype of the single-minded artist, striving only to complete a given task. Moreover, since the later nineteenth century, Hokusai is a figure who has impressed artists, critics and art-lovers alike in the Occident—more, probably, than any other single Asian artist.

Born in the Ninth Month of the year 1760 in the Honjo quarter just east of Edo, Hokusai took an interest in drawing from the early age of five. He was adopted in childhood by the prestigious artisan family Nakajima, but was never accepted as heir; this may support the theory that, although he was the true son of Nakajima, he had been born of a concubine. As a youth Hokusai is said to have served as clerk in a lending bookshop, and from the age of fifteen to eighteen he was apprenticed to a woodblock engraver. This early training in the book and printing trades obviously influenced his development.

The earliest contemporaneous mention of Hokusai dates from the year 1778 when, at the age of eighteen, he became a pupil of the leading ukiyo-e master Katsukawa Shunshō. Hokusai's first published works appeared in the Eighth Month of the following year under the name Shunrō, the first in a long series of pen names. They were, quite naturally, prints of actors of the Kabuki theater, the genre which Shunshō and the Katsukawa School practically dominated. Hokusai's early work was directly derived from the style of Shunshō but was already almost the equal of the master's in all but originality. Hokusai remained nominally within the Shunshō School for a dozen years, though he soon came to be influenced as much by such contemporaries as Shigemasa and Kiyonaga as by his original master. Under the shadow of Shunshō, Hokusai produced several illustrated novelettes and a number of notable prints of actors, wrestlers and girls, as well as many historical landscapes in the pseudo-European perspective-print manner. Although he still followed the manner of Shunshō, in the *sumō* wrestlers done during his period of apprenticeship, Hokusai found the first subject that stimulated his interest in the gross and realistic. Plate 161 is one of Hokusai's earliest masterpieces, an arresting print that captures the essence of *sumō*.

Hokusai's efforts in the *surimono* genre during the subsequent decade represent some of his best early work. (*Surimono* were prints issued privately for special occasions: New Year's and other greetings, musical programs and announcements, private verse selections. They were issued in limited editions and featured immaculate printing of the highest quality.)

To judge from the ages of his several children, Hokusai must have married in his mid-twenties. Possibly under the calming influence of family life, his designs from this period turned from prints of actors and girls to historical and landscape subjects, especially to *uki-e*, semi-historical landscapes using Occidental-influenced perspective techniques, and to prints of children. The artist's book illustrations and texts also left Kabuki and Yoshiwara themes for historical and didactic subjects.

These were years of great changes in Hokusai's personal life: his master Shunshō died early in 1793 and his young wife somewhat later, leaving a son and two daughters. With Shunshō's death Hokusai, who was thirty-three, took the opportunity to escape from the confines of Shunshō's school and set out on his own. Tradition maintains that he was expelled from the group by Shunshō. If so, it is probable that Hokusai's lack of proper feudal regard for his school led to his expulsion, but the expulsion does not seem to have occurred officially until after Shunshō's death and then principally because of the exposure of Hokusai's period of secret study under the Kanō-School painting-master Yūsen. A feudal society could not allow a man to serve two masters. For Hokusai, however, there could be no such limitations to the range of his study, and throughout the first half of his long career he was attracted in rapid succession by a dozen or more masters and schools,

continually striving to produce a truly unique amalgamation of styles and often almost succeeding.

In addition to the basic tenets of direct observation and stylized realism, Shunshō gave Hokusai a clear grasp of the special qualities inherent in the woodblock print and the most effective means of using bold but limited coloring. From the Kanō School (a style which Shunshō, like many ukiyo-e artists, had studied indirectly), Hokusai learned the importance of brushwork in painting and became adept at employing the whole world of Chinese imagery that was to flavor so much of his sketching and, unfortunately, encourage some of his dullest work. Moreover Hokusai studied the ink paintings of the ancient master Sesshū (for a time, Hokusai called himself the "Thirteenth-generation Descendant of Sesshū"); the decorative paintings in the Kōrin and the Tosa styles of his contemporaries Tōrin, Sōri and Hiroyuki; and the whole range of later Chinese painting, in particular the flower-and-bird paintings and the figure paintings of the Ming and Ch'ing periods. In the words of a contemporary, "Calling this the 'Hokusai Style,' he painted ukiyo-e with the brushstrokes of Ming painting; Hokusai was the founder of the style of Japanese painting modeled on the ancient and modern Chinese styles." Although Hokusai's work in the direct Chinese manner (for example, the famous series of small color prints with birds and flowers) has at times been exceedingly popular in the West, it hardly ranks among his great creative achievements. It will doubtless be relegated to its proper secondary place once collectors come to appreciate the clear distinctions between Chinese and Japanese art and the special features of both.

Hokusai's eclecticism was not even bounded by the Orient, and he studied Western prints and paintings avidly from what limited materials were available in late eighteenth-century Japan. As a pupil of Shunshō he had already in the 1780s designed a number of perspective prints, applying a limited conception of Western perspective to Japanese scenes and techniques. Often he was quite equal to the achievements of Toyoharu or Toyokuni in bringing this curious style to its logical perfection within the Japanese format. In 1796 Hokusai is said to have had the opportunity of studying under the great pioneer of Western-style painting and engraving, Shiba Kōkan, and this artist was certainly to provide one of the major influences on Hokusai's later landscapes. For a period in the early 1800s Hokusai produced several series of notable landscapes in direct imitation of the manner of European copper engravings, though the subjects and part of the coloring styles were quite Japanese. In these series Hokusai combined the pseudo-Occidental techniques of the perspective prints with the style of direct sketching used by Ōkyo, Gennai and Kōkan, to produce curiously compelling woodblock prints in a basically unpromising medium. However none of this derivative work—whether following the Shunshō, Chinese or Occidental styles—ranks with Hokusai's best work.

In the year 1797, the artist remarried and adopted the nom de plume that was to become his trademark, Hokusai—"Northern Studio." The artist was thirty-seven, and this change of name marks the beginning of the golden age of his work, which was to continue for an incredible half-century. Because he would not subscribe to the concept of allegiance to a single master and school, Hokusai had no easy time in the fickle field of commercial art; for a while he was even forced to make his living as a peddler of condiments and calendars. Nonetheless he managed to find his first great style just as the other masters of figure prints were beginning to decline: Hokusai's girls of the late 1790s and early 1800s represent the crowning point in his portrayal of frail womanhood. All his figures of this period display a tenuous delicacy that harks back to Harunobu—and even more to Bunchō—but is nevertheless a modern and original invention. It was during this period (from about 1798 to 1805) that Hokusai produced his stylish love scenes, his long surimono greeting prints and his finest colored book illustrations: Itako zekku-shū [Songs of Itako], Tōto meisho ichiran [Famous Views of the Eastern Capital], Sumida-gawa ryōgan ichiran [Views of Both Banks of the Sumida River], and Yama-mata-yama [Mountain upon Mountain]. During this cycle of his work Hokusai achieved an originality, and a naturalness in graceful figure design amidst harmonious landscape elements, that he was seldom to capture again in his period of greater fame.

Although in his expression of the frailty of idealized womanhood he did not quite reach the universality of Harunobu or Chōki, Hokusai was not far behind them. Had his work

161 **Hokusai:** *Sumō Wrestlers. Chūban* size, late 1780s (late Temmei Period). Signature: Katsu [kawa] Shunrō (Hokusai's pen name under the tutelage of Shunshō). Collector's seal (on lower right): Hayashi Tadamasa (the most active early Japanese dealer in prints living overseas).
After the manner of two amorous pachyderms, the massive professional wrestlers Dewanoumi and Kimenzan embrace stoically: each is trying to assess his opponent's weak points before an attempted throw. This is an early example of Hokusai's eminently human approach to a standard subject of ukiyo-e.

162 **Hokusai:** *Mother and Daughter on an Outing. Ōban* size, from the series *Fūryū nakute nana-kuse* [Seven Fashionable Bad Habits], of which only two designs are known. (For the remaining scenes, see figure 359.) Ca. late 1790s (late Kansei Period). Signature: Kako (Hokusai's principal pen name at the turn of the century); publisher: Tsuta-ya.
In this daringly bold telephoto view, Hokusai displays his early mastery of the figure print in a composition reminiscent of his contemporary Chōki. The print is enhanced by dramatic use of coloring, including a background half in yellow and half in mica. Only two examples of this masterpiece are known to be extant; this version represents, as far as we know, the first publication of this near pristine specimen. A comparison of this plate with the similar, better-known, but faded impression in the Ikenaga Collection (Kōbe, Japan) strikingly reveals the fugitive nature of the vegetable coloring employed in Japanese prints through the early nineteenth century: the cobalt blue parasol has faded to light gray, the purple robe to brown, the red to pink, the brown of the telescope to light orange; mustard has turned to light yellow and pink to light saffron. Note that the keyblock in this case is printed in gray; the deeper blacks are rendered by a separate block employing a lacquer-type pigment. At the top on the left is the excess margin of the print, which was normally trimmed off.

風流無間夢くも

可佐画

161

ended around 1805, he would be remembered as a first-rate figure artist of equal rank, and mystery, with Bunchō or Chōki. However Hokusai went on for another full generation or more; his tremendous output equaled that of a dozen other artists combined.

Hokusai discovered his first strikingly individual style in the mid-1790s, and this type of frail, wistful female figure was highly popular at the time under the designation of the "Sōri style" (from one of Hokusai's pen names of the period). In addition to these rare and lovely prints, to the exquisite color plates for books of light verse, to poetic guides to Edo and the Tōkaidō highway and to the elaborate greeting cards and souvenir sheets so popular in those years, Hokusai began receiving painting commissions from wealthy patrons. While forgeries are numerous, at least a dozen *kakemono* masterpieces from this early period are still extant, displaying—in addition to their other charms—a dexterity of brush-stroke seldom equaled in the annals of ukiyo-e. (For though all ukiyo-e's great artists were masters of design and coloring, they often betrayed their origins in the *Yamato-e* and Tosa Schools through a certain weakness of brush-stroke, visible most clearly in their paintings and sketches.)

In format, Hokusai's oeuvre from this period covers the gamut of ukiyo-e art: single-sheet prints, *surimono,* picture books and picture novelettes, illustration for verse anthologies and historical novels, erotic books and album prints, hand paintings and sketches. As for his subject matter, Hokusai only occasionally (in a few notable prints, in paintings and erotica) chose to compete with the acknowledged master of voluptuous figure prints, Utamaro; but apart from this limitation Hokusai's work encompassed the whole range of the genre school, with particular emphasis on landscape views and historical scenes, in which the figures were often of secondary interest.

Hokusai's Maturity

Around the year 1805, following his experiments with Western techniques, Hokusai began a period of concentrated study of Chinese painting and illustration in connection with the voluminous illustrations he was called on to prepare for the lengthy, Chinese-style, "Gothic" novels *(yomihon)* then in vogue in Japan. He brought a new precision and dramatic power to such works, and his thousands of illustrations show a remarkable consistency of execution. The importance contemporaries attached to the illustrations in these novels can

164 Hokusai: *The Night Attack.* Ōban size, 1806 (Bunka III). Final print of the series *Kana-dehon Chūshingura* [The Syllabary *Chūshingura*]. Series title (at top right): *Kana-dehon Chūshingura. act XI;* publisher (seal on lower right): Tsuru-ya Kinsuke, whose abbreviated name (Tsuru-Kin) is also given in the *kana*-syllabary nameplates of four of the *rōnin* on the lower right. [There is also a later reissue by the alternative publisher Sen-Ichi.] Though not signed, the print is done in Hokusai's characteristic style. Two other prints in the series bear the date-seals of the Year of the Tiger: Bunka III (1806). Hokusai was obviously fascinated by the *Chūshingura,* Japan's most famous historical tale of loyalty and vendetta; during the late eighteenth and early nineteenth century, he did five different series on this theme, containing 11 or 12 prints each. The present scene is from the last and most impressive of these series. It dates from the year when the artist began to turn—under Chinese influence and in keeping with the taste of the times—from delicate figure designs to robust and heroic themes. This is the final scene from the *Chūshingura*: the perseverance of the forty-seven *Rōnin* [disenfeoffed samurai] is repaid; they attack the enemy's stronghold and at long last achieve vengeance against the villain who caused their lord's disgrace and death. As part of a series, the print is essentially an illustration, but it ranks among the artist's masterpieces in this genre.

165 Hokusai: *Girl Diver and Octopi.* Hanshi-bon size, 3 vols., an illustration to *Kinoe-no-komatsu* [Young Pine Shoots], ca. Bunka XI (1814).
With his insatiable curiosity about all varieties of human and artistic experience, it was only natural that Hokusai should have turned to shunga, the branch of ukiyo-e devoted to erotica. Not unexpectedly, his achievement in this field is both original in approach and startling in execution. Hokusai's erotica date mainly from the decade after 1810, just when popular and artistic taste had changed from frail figures to more robust ideals of feminine beauty. His teacher Shunshō had produced notable shunga illustrations of diving girls subjected to seduction and rape at human hands, but here Hokusai goes one step further: on the right, a large octopus ravishes the girl with adroit cunnilingus, while a smaller octopus (his son?) assists on the left. Yet, however bizarre the concept, the effect is neither comic nor pornographic; in this fantasy of a passionate shell diver, we discover a new facet of Hokusai's genius and a consummate work of erotic art.

be readily appreciated when we learn that the great Japanese novelist Bakin had to be dismissed in the midst of one publishing venture and another novelist retained, when Hokusai found himself unable to work compatibly with the former. Under the influence of these extended historical novels, Hokusai's style began to suffer important and clearly visible changes in the years 1806 and 1807. His figure work became more powerful but increasingly less delicate; there is greater attention to classical themes (especially, samurai and Chinese) and a turning away from the contemporary floating-world. Although Hokusai's figure

drawing, partly under the influence of his Chinese studies, developed a certain hardness that detracts from its beauty, his skill as a draftsman, nature painter and landscapist had increased to such an extent that he was certainly the greatest artist of the age in these fields. At the same time, an enhanced sense of drama is apparent, for example in the noted series of *Chūshingura* prints, depicting the famous story of the vendetta of the Forty-seven *Rōnin* [disenfeoffed samurai].

About 1812 Hokusai's eldest son died. This tragedy was not only an emotional but also an economic event, for as adopted heir to the affluent Nakajima family, this son had been instrumental in obtaining a generous stipend for Hokusai. As a result the artist had not needed to worry about the uncertainties of income from his paintings, designs and illustrations, which at this period were paid traditionally in the form of "gifts" more often than with set fees. Whether for economic reasons or not, from this period Hokusai's attention turned gradually from illustrations for novels to the picture book, and particularly to the type of woodblock-printed copybook designed for amateur artists, including the famous *Hokusai manga* books of sketches for art students, a series whose publication extended from the year 1814 to well after his death. Very likely his intention was to find new pupils and hence new patronage, and in this he succeeded to some degree. The artist's dramatic series of erotic books and albums were also published during this middle period of his life.

Then for several years beginning about 1830, Hokusai published his best-known and most unified series of prints: the *Fugaku sanjū-rokkei* [Thirty-six Views of Mt. Fuji], which, with a supplement, was to number forty-six prints in all. Here the sacred mountain was viewed from every conceivable distance and angle, in all seasons and moods. This series was an entirely new revelation in ukiyo-e and included some of the true masterworks of Hokusai's career. "Mt. Fuji at Dawn," "Mt. Fuji in Storm" and "Fuji under the Wave at Kanagawa" are justifiably famous, although they are not typical of Hokusai's fundamental approach to landscape, since they suppress the importance of man. Only slightly less renowned are the prints illustrated in plates 169 and 170, showing a fine balance of interest between the figures and the landscape. This series is a remarkable synthesis of all Hokusai had learned from both Eastern and Western art and features masterful use of all the most effective devices of the printer's craft. It is worth repeating that Hokusai's great landscapes in this series represent, in a sense, the final assimilation and culmination of Occidental concepts in traditional Japanese art. This hidden aspect has contributed immeasurably to making Hokusai, with Hiroshige, the best loved of Japanese print artists; a subtle Western influence echoes somewhere in the modern viewers' mind turning the image into a thing not wholly alien.

In many respects the Fuji series also constitutes the first real high point of the independent Japanese landscape print, as well as the pinnacle of this artist's career. Hokusai himself must have realized its significance later when he wrote of this period, "I finally apprehended something of the true quality of birds, animals, insects, fish and of the vital nature of grasses and trees." For a time, with his children now married or deceased, Hokusai's household was reduced to husband and wife only. Soon, however, his eldest daughter divorced and returned home. Hokusai adopted his divorced daughter's son as his own; but as the lad matured, he proved an incorrigible delinquent. In this unaffluent household, which united a cantankerous artist, his second wife, the daughter of his first wife and a spoiled grandchild, there lay the seeds of considerable discord.

Though famous for his detailed prints and illustrations, Hokusai was also fond of displaying his artistic prowess in public—for example making huge paintings (some fully two hundred square meters in size) of mythological figures—before festival crowds in Edo and Nagoya. Once he was even summoned to show his artistic skills before the shōgun.

In the summer of 1828 Hokusai's second wife died. The master was then sixty-eight, afflicted intermittently with paralysis and left alone, evidently, with only his profligate grandson (who was now in his late teens; his mother was dead). It is probably no coincidence, therefore, that before long Hokusai's favorite daughter (and pupil) O-Ei broke her unhappy marriage with a minor artist, Tōmei, and returned to her father's side, where she stayed until his death. Accustomed to hard work, Hokusai rose early and continued painting until well after dark. This was the customary regimen of his long, productive life. Not

166 **Hokusai**: *Mt. Fuji at Dawn.* Ōban size, from the series *Fugaku sanjū-rokkei* [Thirty-six Views of Mt. Fuji], early 1830s (early Tempō Period). Signature: Hokusai *aratame* [changed to] Iitsu *hitsu*. Subtitle: *Gaifū kaisei* [Fine Wind, Clear Morning]. (For detailed listing and illustration of the complete set of forty-six Fuji prints, see dictionary entry under the Japanese series title, *Fugakū sanjū-rokkei*, found under Hokusai print series, figures 368–413.)
Many artists had depicted Mt. Fuji before, but it was Hokusai who made the sacred dormant volcano into a worldwide symbol of ukiyo-e and of Japan. This splendid view of Fuji at dawn was produced with a minimum number of woodblocks: the shading effects are the result of wiping off a part of the color by hand before printing; the patterns on the mountain mirror the natural grain of the cherrywood itself. (Several alternative color schemes exist for this famous print. In many the colors are lighter, and there is even a state with the mountain in white and blue, rather than brown; there, only the upper strata of cirrocumulus clouds are visible, and a part of the sky is printed in brown.) Although he did not make use of the full resources of the complex, brocade-print technique, the artist has succeeded in producing a masterwork by reducing his design to its essentials, concentrating, so to speak, his whole art on this one print. We have accused Hokusai often of lacking discrimination; we see the full extent of the tragedy when faced with the perfection he achieved when he really tried.

167 **Hokusai**: *Mt. Fuji in Storm.* Ōban size, from the series *Fugaku sanjū-rokkei* [Thirty-six Views of Mt. Fuji], early 1830s (early Tempō Period). Signature: see plate 166. Subtitle: *Sanka haku-u* [Rainstorm beneath the Summit]. (Complete series, see figures 368–413.)
Though not quite on the same artistic level as the "Red Fuji," as it is popularly known in Japan, of plate 166, this unusual Hokusai landscape provides an attractive contrast: the sacred mountain rises majestically above a thunderstorm that belabors its lower reaches with lightning. In this print Fuji is shown from quite a different angle, with lower mountains in the background and conventionalized thunderclouds in the distant sky. This and the "Red Fuji" are the only prints in the series in which the entire mountain is shown in close-up, quite dominating the design. The rare specimen illustrated, in which the publisher neglected to trim the excess right and lower margins, provides an interesting insight into the techniques of the Japanese woodblock printer.

169 **Hokusai:** *Mt. Fuji Seen from Kajikazawa.* *Ōban* size, from the series *Fugaku sanjū-rokkei* [Thirty-six Views of Mt. Fuji], early 1830s (early Tempō Period). Sign. cf. 166. Subtitle: *Kōshū Kajikazawa* [Kajikazawa in Kai Province]. Seals (appear on some impressions): *kiwame* (censor) and Eijudō (publisher). (Complete series, see figures 368–413.)

To the present writer, this is the most evocative of all Hokusai's prints. As with all of his best designs, it represents a simple setting simply organized: a fisherman stands on a sharp promontory, his taut nets cast in the turbulent river, while his little son adds a touch of pathos to the scene and, typical of Hokusai's method, the whole group forms a triangular composition that is reflected by the mist-shrouded Mt. Fuji in the background. Although the basically blue mood is retained, as in many Japanese prints, there are variations in coloring from one impression to another of this design; some versions include a pink or saffron-colored band in the sky and yellow or yellow-green on the rocks on the lower left, and some limit the coloring entirely to shades of blue.

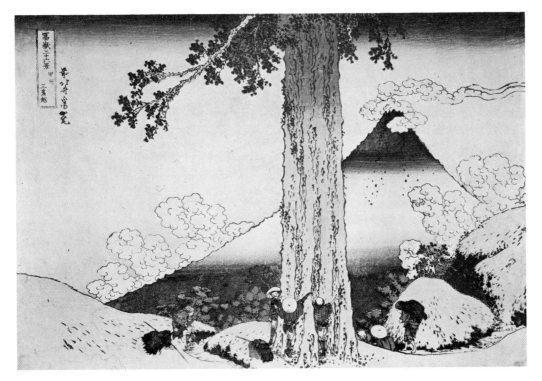

170 **Hokusai:** *Mt. Fuji Seen from Mishima Pass.* *Ōban* size, from the series *Fugaku sanjū-rokkei* [Thirty-six Views of Mt. Fuji], early 1830s (early Tempō Period). Sign. cf. 166. Subtitle: *Kōshū Mishimagoe* [Mishima Pass in Kai Province]. (Complete series, see figures 368–413.)

This is the first Japanese print that captivated the writer, and, over thirty years later, it still charms; its human touch remains, although it is doubtless not a major work. Here Mt. Fuji is seen from the top of Mishima Pass (northwest of Hakone); the mountain, split into three color bands, is shown in the summer, bedecked with decorative clouds. However the center of interest is not the mountain but the three travelers in the foreground who, expressing their childlike wonder at an ancient cryptomeria tree, are trying to encircle it in their cooperative embrace. Hokusai has succeeded admirably in expressing the feeling of exuberance one has after climbing a rugged mountain pass and at last reaching a summit of breathtaking splendor.

much more is known of Hokusai's family life than that he married twice and had several sons and daughters; two of the latter studied painting under his direction and, after unsuccessful marriages, returned at various times to live with their father.

The same movement that characterized his continuous search for new styles in art marks much of Hokusai's personal life as well. For example, he used some thirty-one pen names during his lifetime, each one supposedly signifying a mutation in style or approach. Besides his principal noms de plume (roughly, one per decade)—Shunrō, Sōri, Kakō, Hokusai (the

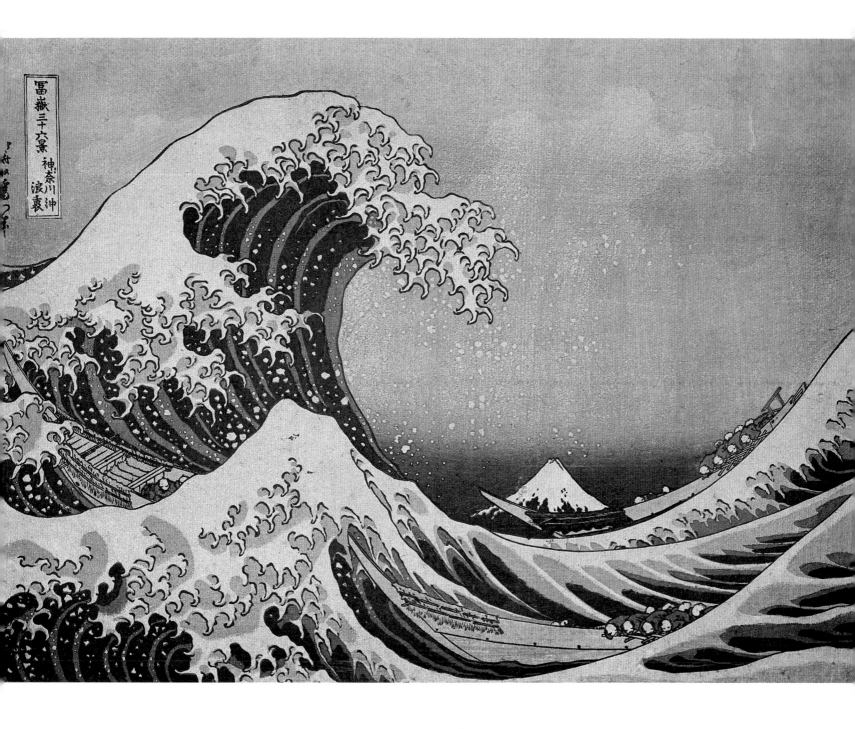

168 **Hokusai:** *Under the Wave at Kanagawa. Ōban* size, from the series *Fugaku sanjū-rokkei* [Thirty-six Views of Mt. Fuji], early 1830s (early Tempō Period). Signature: see plate 166. Subtitle: *Kanagawa-oki namiura* [Beneath the Wave off Kanagawa]. (For the complete series, see figures 368–413.)

Although, once again, it does not quite achieve the perfection of plate 166, Hokusai's "Great Wave" represents one of his masterworks; it contrasts majestic nature and diminutive mankind. The influence of Western perspective looms large in the design: where the artists of a generation or two earlier would have had to present a telephoto view, with the wave hardly reaching the height of the mountain, Hokusai is able to project us into the midst of the action, with a wide-angle close-up in which Mt. Fuji is reduced to a part of the background. The print is so strongly decorative in design that we almost tend to overlook the human element— three cargo boats with their oarsmen clinging on for dear life as the sea batters them at will. Interestingly enough, Hokusai had experimented with very similar scenes in his early *uki-e* prints (see figures 361–4), but only now, a generation later, did he succeed in combining Western concepts with native tradition to finalize his concept of the landscape print. It was, incidentally, this "Great Wave" more than any other Japanese print that astounded and delighted the Impressionists and Postimpressionists in Paris at the close of the nineteenth century; Debussy is said to have used it as his inspiration for the orchestral piece *La Mer* (1905).

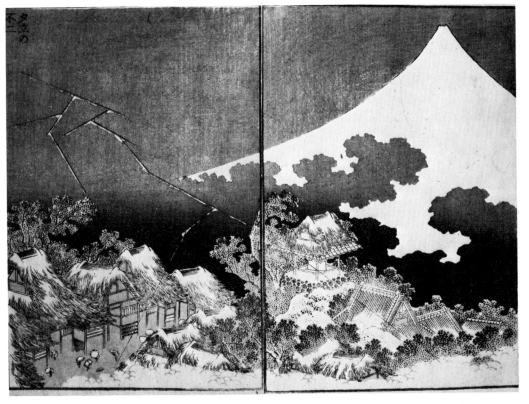

171 **Hokusai:** *Thunderstorm near Mt. Fuji.* An illustration from *Fugaku hyakkei* [One Hundred Views of Mt. Fuji], Series II, printed with *sumi* and tones of gray, in *hanshi-bon* size, Edo/Nagoya, Tempō VI (1835). Title (on upper left): *Yūdachi no Fuji* [Fuji at Dusk in a Thunderstorm]; turnover title: *Fugaku hyakkei,* Series II, with sheet number and name of engraver, Wasuke.

One of the world's masterpieces of illustration, Hokusai's three-volume *One Hundred Views of Mt. Fuji* shows all the varied aspects of Japan's sacred peak in both urban and rural settings, with the artist's entire resources concentrated on presenting the mountain's character in full dramatic power. Many of the designs, like the present one, could easily have been included in the *ōban*-size print series of a few years earlier (plates 166–170). Indeed, it is interesting to compare the present design with plate 167: the addition of a rustic village and temple creates an entirely new print in which the interaction of nature and man is superbly balanced.

172 **Hokusai:** *Bullfinch and Drooping Cherry Blossoms.* *Chūban* size, early 1830s (early Tempō Period). Signature: *zen* [formerly] Hokusai Iitsu *hitsu*; censor's *kiwame* seal; publisher: Eijudō. For others of the series, see figures 424–25.

Strongly influenced by Ming painting, Hokusai's series of medium and large bird-and-flower prints of the 1830s rank among the masterpieces of this genre and form an interesting contrast to Hiroshige's more naturalistic works of the same period. Composition is always the keystone with Hokusai, accompanied by a precise rendering of natural forms. Characteristically his birds and animals are individualized creations, often too humanized to be very lovable. This is one of an untitled series containing ten known designs. On the upper right are given the names of the bird (*uso*) and flower (*shidare-zakura*) and a verse by Raiman ("A single bird comes out/drenched by the dew: the morning cherry blooms"). Such verses often refer to the human world—here, for example, to the picture of a young man returning at dawn from a night of love in the Yoshiwara.

173 **Hokusai:** *The Ghost of O-Iwa.* *Chūban* size, from the series *Hyaku-monogatari* [Ghost Tales], ca. 1830 (Tempō I). Signature: *zen* Hokusai *hitsu*; publisher: Tsuru-Ki (Tsuru-ya Kiemon). For others of the series, see figure 414.

Giving expression to his taste for the bizarre, Hokusai is most startlingly successful in this rare series of ghost prints, of which five designs are known. O-Iwa was the famous heroine of the Kabuki ghost tale *Yotsuya kaidan*: cruelly murdered by her husband, she came back from the grave to wreak bloody vengeance. Here, we see her dismembered visage metamorphosed into the smouldering Buddhist lantern offered to her departed soul. On the lantern appears the Buddhist invocation *Namu Amida-butsu* [Hail to Amitabha Buddha], *zokumyō Iwa-jo* [secular name: Ms Iwa]; on O-Iwa's forehead is an approximation of a Sanskrit letter. The title is placed on the upper right: *O-Iwa-san/Hyaku-monogatari.*

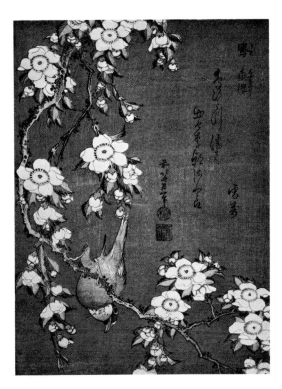

latter often with the prefix Katsushika), Taito, Gakyō, Iitsu, Manji—the artist had some two dozen other occasional pseudonyms, though these were normally used as adjuncts to his principal alias of a given period. Moreover the artist changed his residence at least ninety-three times (a contemporary directory lists him as "of no fixed address"); obviously he was never satisfied with his current position, whether artistic or geographical.

174 **Hokusai**: *Chinese Warrior with Arquebus.* An illustration to *Ehon Wakan-homare* [Picture Book in Praise of Chinese and Japanese Heroes], *sumizuri-e* in *hanshi-bon* size, Edo/Nagoya, Tempō VII (1836). Caption (on lower right): Cheng Chih-lung Repelling the Sea Demon on the Lotus Sea. [Cheng Chih-lung was a Chinese pirate-generalissimo of the late Ming Period, father of the famous Coxinga.] Despite his long life and prodigious career, Hokusai seems to have remained vigorously active until practically the day he died and, in a sense, even long after his death, for the posthumous publication of his remaining sketchbooks ran on into the Meiji era. The mid-1830s, when the master was in his mid-seventies, mark the beginning of this last phase of his oeuvre and include many notable works in the fields of prints, paintings and book illustrations. The combination of Chinese warrior and European weapon, which we see in this plate, is arresting enough in itself; but what raises this illustration from the ordinary are the marvelously delineated "phantom clouds" that loom ominously above the wild sea. One can almost visualize Hokusai himself in this defiant figure, refusing to submit to Providence's attempt to limit his human life to a mere seventy-five years.

Hokusai was already seventy-three in 1833 when Hiroshige, thirty-seven years his junior, published his tremendously popular landscape series, *Tōkaidō gojūsan-tsugi* [Fifty-three Stations of the Tōkaidō]. Hokusai, who had been temporarily satisfied by the success of his own great Fuji series, was once again driven to surpass himself. This time the result was the three-volume picture book *Fugaku hyakkei* [One Hundred Views of Mt. Fuji] published in the following two years and one of his most unified artistic works. Republished in London in 1880 it was to have a notable influence on European art.

This work was preceded or accompanied by several major series of prints which were in a manner new for Hokusai, though they never quite matched the achievement of the early delicate figures or the *Thirty-six Views of Mt. Fuji*. Neither could they revive the public acclaim that had met his earlier works. The world now belonged to Hiroshige.

In the late spring of 1849 Hokusai died at the age of eighty-nine, having written this as his parting *haiku* verse:

> Even as a ghost / I'll gaily tread / The summer moors.

Hokusai's Achievement

Hokusai's production was extravagant in more than one respect. During his lifetime he painted well over thirty thousand designs, an average of nearly two works for every day of his long artistic life. He was fond, too, as has been seen, of public exhibitions of his skill (for example dramatically painting a great Buddha on a huge expanse of paper before an admiring crowd of spectators). Hokusai neither drank nor smoked nor ever knew the state of his own finances; though he loved to travel, he seems quite literally to have devoted his life to art. Gakyō-rōjin, Hokusai's favorite pen name of his later years, "Old Man Mad with Painting," typifies his nature. His famous declaration, made in his mid-seventies, sums up his character as a painter: "From the age of five I have had a mania for sketching the forms of things. From about the age of fifty I produced a number of designs, yet of all I drew prior to the age of seventy there is truly nothing of any great note. At the age of seventy-two I finally apprehended something of the true quality of birds, animals, insects, fish and of the

169

vital nature of grasses and trees. Therefore, at eighty I shall have made some progress, at ninety I shall have penetrated even further the deeper meaning of things, at one hundred I shall have become truly marvelous, and at one hundred and ten, each dot, each line shall surely possess a life of its own. I only beg that gentlemen of sufficiently long life take care to note the truth of my words."

Strangely, although on many later occasions Hokusai equaled the level of his best early figure work, after the turn of the eighteenth century the average quality of his work declined sharply. Anyone examining his total oeuvre often receives an impression of over-abundant production, of indiscriminate energy and too little selectivity. The famous *Hokusai manga,* some fifteen volumes of random sketches compiled as copybooks for art students, displays a marvelous fecundity and energy but far too little of it has permanent value as art. (The original sketches, now largely lost, must have been of great artistic quality. Today, unfortunately, we can only judge from the block-printed published form.)

The difficult task of the critic, then, is to be discriminating where Hokusai is not and to attempt to assess the cream of this work rather than the totality of it, which despite its high level of draftsmanship and variety, tends to obscure rather than illumine Hokusai's undoubted genius. Hokusai's primary greatness lies in the rare figure prints and paintings of his middle years and in the well-known Fuji landscapes of the eighth decade of his life. Judging from these series alone, Hokusai stands out as a master of two unique styles, each sufficient to place him in the first rank of ukiyo-e artists.

Whether one can forgive Hokusai his lack of discrimination is another matter; the best Japanese critics long relegated him to a secondary rank for this fault and have only changed their views under the influence of foreign opinion. It is difficult to disagree with the Japanese; for having once experienced the tastelessness and crudity of the lower levels of Hokusai's work, it is indeed hard to view his genius with complete detachment. However this is obviously a matter of personal taste and need not lessen our appreciation of Hokusai's true masterpieces, for he possessed in abundance all the qualities of genius, excepting only discrimination. All Hokusai's work is so full of humanity as almost to obscure the true quality of his artistic talent. One has the strong feeling that he would not understand why we call certain of his works marvelous creations of beauty and others simply products of competent draftsmanship.

For the most part ukiyo-e prints were essentially a product of the middle and upper classes of Edo's bourgeoisie and accordingly were replete with an urbane and cosmopolitan atmosphere. Although Hokusai had mastered this manner perfectly in his earlier works, it seems to have been alien to his own nature. Once he had escaped from the restraining influence of his masters, the plebeian, provincial qualities of his character came more and more to the fore. Therefore, his prints and books reveal, more than those of any other ukiyo-e master, the realities of life among the lower classes, without the romantic, sophisticated idealization one finds in artists who never used their eyes for direct observation. It is this essentially provincial quality of much of Hokusai's late work, together with the lack of discrimination already mentioned, that has lowered his stature in the eyes of the traditional Japanese critics.

This trait is readily apparent when comparing Hokusai's work with that of late contemporaries such as Hiroshige. In Hiroshige's landscapes every element is subjected to the overall mood; travelers become a part of the total pattern and seldom live as separate beings. Hokusai, however, chose the most difficult goals of any ukiyo-e artist: depicting the everyday man as an individual amidst the elements and achieving a total effect of beauty rather than simple genre realism. He did not always succeed, even in the eyes of his greatest enthusiasts, and it is significant that the prints by Hokusai most often given international recognition—"Mt. Fuji at Dawn," "Fuji under the Wave at Kanagawa," "Mt. Fuji in Storm"— are least typical of his work; they subordinate the human elements to the natural and often omit the former altogether. To acclaim such works alone is to ignore the essential Hokusai; although to know all of him is, as we have suggested above, sometimes to lose sight of his abstract greatness.

Commonplace humanity is the essential element of Hokusai's theme, but design is the keystone of his artistry. His human figures may sometimes distract from the total effect, but

his sense of proportion never fails. It is this element, coupled with his bold visions of nature, that has made him the favorite of modern artists and amateurs alike. Even in the numerous prints that one cannot honestly love, the sense of proportion and the originality of design are always impressive. Among modern Japanese painters and print designers it is common to hear such views as, "Hokusai is greater; but I love Hiroshige more," or "Hokusai is a greater artist but tires one with his overflowing energy; Hiroshige is a lesser artist, but somehow fills one with the greatest delight." Indeed, all too often admiration of Hokusai's impeccable technique is cited as the basis of his greatness, rather than the total impression he creates, though the latter must be the ultimate criterion of great art.

In any event, Hokusai devoted his long, full life to expressing the world as he saw it; he painted anything and everything and he loved everything (whether animal or mineral, attractive or not) equally and without discrimination. Doubtless, he would neither have understood nor appreciated our demand for greater selectivity. It is only fitting that the most strikingly individual figure in the Ukiyo-e School should have been almost the last and that Hokusai, who epitomized the total range of Far Eastern art and combined it with all he could learn of Western painting and prints, should have been the major figure in the introduction of ukiyo-e to the Occidental world. To his own countrymen Hokusai seemed only a prodigious eccentric, but to Europeans of the late nineteenth century he appeared as an overpowering genius. Perhaps he was both. At any rate, Hokusai was the first Japanese artist to combine the two worlds successfully into an artistic whole. He formed the necessary bridge between Eastern and Western tastes. It is a pity that this goal was never again attained by any artist of equal genius.

Hokusai's Pupils and Followers

Although Hokusai's pupils were numerous, few had original talents of any great consequence. Probably the most interesting is Shōtei **Hokuju,** who worked from the late 1790s to the mid-1820s, and who took up and carried out the development of the perspective print that Hokusai had begun under Western influence in the early 1800s. Whereas Hokusai went on to amalgamate this alien manner with powerful native elements and produced the great Fuji prints, Hokuju was content to devote his work entirely to skillful variations on the

175 **Hokuju:** *View of Satta Pass. Ōban* size, ca. early 1820s (early Bunsei Period). Signature: Shōtei Hokuju *ga*; censor's *kiwame* seal; publisher (trademark at bottom): Eikyūdō.
Hokuju's landscapes were strongly influenced by Western art, but at the same time he could well be considered a precursor of the Impressionist and Cubist movements. In this dramatic view of the Tōkaidō at Yui, Mt. Fuji and the wayfarers take second place to the junk and to the boulders looming in the foreground. (The latter are perhaps influenced by the animistic approach to nature of the eighteenth-century eccentric painter Shōhaku.) If this print by Hokuju is compared with views by Hiroshige and others of the same site, it will be noted that the composition is reversed, possibly in imitation of the method of copperplate engravings (cf. figure 17).

176 **Gakutei**: *Boat and Bridge at Tempo-zan.* *Ōban* size, from an album including six prints, entitled *Tempo-zan shōkei ichiran* [Fine Views of Tempo-zan], Ōsaka/Edo, Tempō V (1834).
The work of Hokusai's pupil Gakutei (Gogaku) is principally in the form of small *surimono* and book illustrations, but during his stay in Ōsaka he produced a remarkable set of landscape prints of which one plate is shown here: a covered pleasure boat with geisha and guests is being poled under the "Fan Bridge" as the autumn moon looms over the scene. The design and printing are detailed and immaculate, lying somewhere between ukiyo-e and *surimono* techniques, and the setting could easily be translated intact to a Kabuki stage.

traditional style. His early emphasis on cubistic forms in landscape, though derived from Hokusai, is one of the most striking elements of his work.

Shinsai, Hokkei, Hokuba, Joren, Gosei, Gakutei and Yanagawa **Shigenobu** are other artists who leaned heavily on Hokusai for artistic inspiration. Some of their best work is in the *surimono* genre. (In their later manifestations, the *surimono* were, in effect, the result of the technique of lacquerware design applied to the woodblock medium. They were usually rather far removed from ukiyo-e. Their interest lies in their decorative and technical aspects, for they did not evoke much of the floating world.)

Equally imitative of Hokusai—with far greater excuse—were his two daughters, already mentioned. **O-Ei** (**Ōi**) is the better known of these girls; she worked from the 1810s to the 1840s. In addition to assisting her father in his work, O-Ei proved adept at book illustration and paintings of girls and produced, as did her father, some of the more remarkable erotica of the period. Like Hokusai himself, O-Ei was unfortunately little concerned with household matters, and thus proved of small help in keeping her father's finances in order. Several years after her father's death O-Ei left her house one summer day and was never seen again. Another of Hokusai's daughters, less famous but equally talented, was **O-Tatsu,** who painted girls in a manner more delicate but otherwise hardly distinguishable from the work of her father in the 1810s. She seems to have died young, perhaps in the early 1820s, and her work is rare.

Hiroshige's Early Work

As one travels the highways of Japan, or gazes from the window of a speeding express train, Hiroshige flashes into mind many times a day. This is particularly true when some special aspect of nature—rain, snow, fog, mist, dawn, dusk—has lent to the landscape the poetic sheen that distinguishes the best of Hiroshige's works. In a sense Hiroshige really taught people to see the inherent poetry of nature, whereas the earlier Chinese and Japanese landscape masters never quite succeeded in reaching the heart of the common man with their more subtle and exalted essays upon the rhythms of nature. At the same time, this

noted Japanese print artist was the last major figure in the development of ukiyo-e. In particular, he completed Hokusai's work of consolidating the landscape print as an independent genre and, for the first time, depicted the whole range of his nation's scenic beauties in a manner that the common man could readily appreciate. When the Japanese print was rediscovered in Europe at the end of the nineteenth century, it was Hiroshige who gave Western artists—Whistler, Cézanne, Toulouse-Lautrec, Gauguin and Van Gogh—a new vision of nature.

Hiroshige was born in 1797. His father was Andō Gen-emon, warden of the Edo fire brigade, who was entrusted with the protection of Edo Castle and stationed nearby in the Yayosu-gashi quarter. Hiroshige had three sisters, two of them considerably older than himself. Various episodes indicate that the young Hiroshige was fond of sketching and probably came under the tutelage of the fireman Okajima Rinsai, who had studied under a master of the traditional Kanō School. In the spring of 1809, when Hiroshige was twelve, his mother died. Shortly thereafter his father resigned his post, passing it on to his son. Such early succession to hereditary posts was not uncommon at the time, but when, early the following year, his father died as well, Hiroshige's responsibilities naturally increased.

In times of actual conflagration, Hiroshige conducted himself with distinction. Despite holding a position of some prestige, the young fire-warden's actual daily duties were minimal, and the emolument was small. It was doubtless these factors—plus his own natural bent for art—that led him to enter the school of the ukiyo-e master Utagawa Toyohiro in 1811, when he was fourteen. In the following year he was rewarded with the *nom d'artiste* "Utagawa Hiroshige." (The appellation "Andō Hiroshige," his actual surname, plus pen name, was never used by the artist himself and is a relatively modern corruption.) Hiroshige is said to have applied first to the school of the more popular Toyokuni and was turned down because of the latter master's large number of applicants. Toyokuni's less renowned confrere, Toyohiro, is said to have also refused the lad at first and only acquiesced after persistent requests had been made. Had Hiroshige been accepted as a pupil by Toyokuni, he might well have ended his days as a second-rate imitator of that artist's specialty of gaudy prints of girls and actors. The more modest and refined taste of Toyohiro helped form Hiroshige's own style and eventually led his genius to find full expression in the new genre of the landscape print.

Although he received name and school license at the early age of fifteen, Hiroshige was no prodigy; and it was not until six years later, in 1818, that his first published work appeared,

177 **Hiroshige:** *Moonlight at Takanawa. Ōban* size, ca. 1831 (early Tempō Period). Signature: Ichiyusai Hiroshige *ga*. For others of the series, see figures 198–99.
In this striking design from the early series of ten prints, *Tōto meisho* [Famous Places of the Eastern Capital], Hiroshige lends his special touch to an otherwise stereotyped scene by the deft placing of a flock of wild geese against the harvest moon. (Decorative margins such as the one on this print seem not to have conformed to Western taste and were often trimmed off by early collectors, thus reducing the commercial value of such prints by about a third today.)

 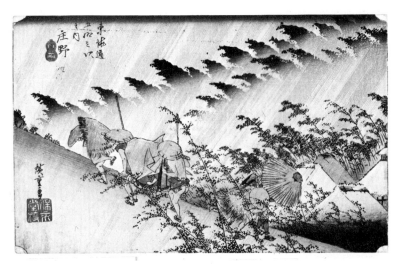

in the field of book illustration, bearing the signature Ichiyūsai Hiroshige. No earlier signed works are extant, but it is likely that during this student period he did odd jobs for the Toyohiro studio (inexpensive fan paintings and the like) and also studied, on his own, the Chinese-based Kanō style and the impressionistic Shijō style, both of which were to strongly influence his later work.

As soon as he was able, Hiroshige transferred the post of fire-warden to his own son and devoted himself to art. As is customary with artists of the plebeian Ukiyo-e School, biographical material about Hiroshige is scarce. He and his confreres were considered, in the Japanese society of the time, as no more than artisans. Although their works were widely enjoyed and sometimes even treasured, there was little interest in the personal details of their careers. Thus we must trace Hiroshige's adult years largely through his works.

Hiroshige's artistic life may be divided into several stages: his student period, from about 1811 to 1830, when he largely followed the work of his elders in the field of figure prints: girls, actors and warriors; his first landscape period, from 1830 to about 1844, when he created his own romantic ideal of landscape design and flower-and-bird prints and brought them to full fruition with his famed *Tōkaidō gojūsan-tsugi* [Fifty-three Stations of the Tōkaidō] (a product of his sketching journey on that highway in 1832) and with such later series as *Honchō meisho* [Famous Views of Japan], *Kyōto meisho* [Famous Views of Kyōto], *Ōmi hakkei* [Eight Views of Lake Biwa], *Kiso-kaidō rokujūkyū-tsugi* [Sixty-nine Stations of the Kiso Highway] and various series of views featuring Edo and environs; and finally, his later period of landscape and figure-with-landscape designs, from 1844 to 1858, during

178 (A–D) **Hiroshige:** *Sudden Rainstorm at Shōno.* Four alternative impressions and states of the design shown in color plate 179.

Each set of printings involves a different variety of pigments and another approach by the publisher/printer to shading, mood and emphasis. Since it depends so much upon the skill and taste of the printer, a second impression may sometimes be more successful than the first. With very late impressions, however, printing was often slipshod and the number of blocks sometimes reduced for the sake of economy. In the present instance, the final example shown (plate 178D) omits the auxiliary title and publisher's name on the umbrella on the right.

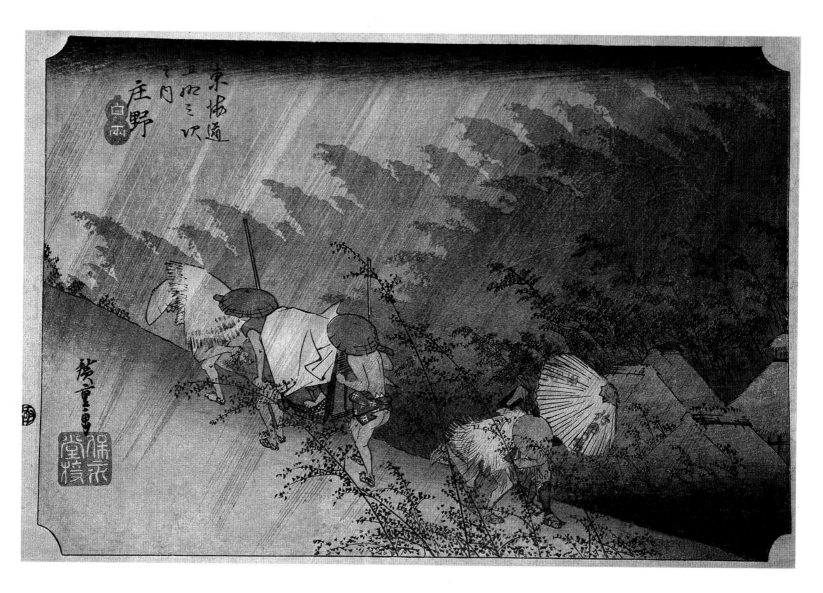

179 **Hiroshige:** *Sudden Rainstorm at Shōno.*
Ōban size, from the series *Tōkaidō gojūsan-tsugi*
[Fifty-three Stations of the Tōkaidō], Tempō IV
(1833). Signature: Hiroshige *ga*; censor's *kiwame*
seal (in left margin); publisher (seal in red): Hōeidō,
plus the publisher's surname, Takenouchi, on the
umbrella on the right. [For detailed listing and
illustration of the complete fifty-five Tōkaidō prints,
see dictionary entry under the Japanese series title,
Tōkaidō gojūsan-tsugi, found under Hiroshige print
series, figures 70–124.] See also plate 178.
In this most famous of all Hiroshige's prints, way-
farers and palanquin bearers scurry from a sudden
summer rainstorm. For Hiroshige the composition
is a dynamic one: the space is divided into bold
triangles of varying depth, and the two groups of
figures are running in opposite directions out of
the frame. The successive rows of bamboos lend a
peculiar sense of movement to the design, which
effectively contrasts the violent yet measured
rhythms of nature with the hurried activities of man.
It is significant that the two major designs of this
series, "Shōno" and "Kambara" (plate 180), depict
localities quite lacking in features that would
interest an ordinary tourist, leaving the artist much
creative license.

which years overpopularity and overproduction tended to reduce the quality of his oeuvre.

Hiroshige's early work as a pupil of Toyohiro consisted generally of undistinguished prints of actors and of warriors. In his mid-twenties he shifted to making prints of girls in the manner of Eizan and Eisen, rather decadent artists who had become eminent by default after the passing of Utamaro. Hiroshige was thirty-one when his master died; for some reason he declined the customary privilege as the leading pupil of adopting the name "Toyohiro II" and of taking over Toyohiro's atelier. Instead, he turned to a field which had long attracted him: landscape and nature studies. At this time Eisen and other figure-print artists were also turning to landscape; the reason for this was clearly Hokusai's great step in developing the Japanese landscape print as an independent genre.

Hiroshige's Maturity

In 1831, after a few initial experiments in which he directly emulated Hokusai, Hiroshige was already able to produce his first landscape prints in a unique style. These were the *Tōto meisho* [Famous Places of the Eastern Capital], a series of ten prints that established Hiroshige's name almost overnight. For the striking qualities of the bold, unconventional compositions and the Occidental overtones, Hiroshige was certainly indebted to Hokusai;

but the rare and sustained poetic mood was clearly his own innovation and one that was thereafter always to distinguish his finest work. In the following year Hiroshige really hit his stride; he began production of the masterly series *Honchō meisho* [Famous Views of Japan]. This series reveals both his superficial indebtedness to Hokusai and the elements of sinuous grace and forceful beauty of coloring Hiroshige contributed from his own genius.

The next year Hiroshige had already begun his first and finest version of the *Tōkaidō gojūsan-tsugi* [Fifty-three Stations of the Tōkaidō]. It was probably his greatest single production, and the one that was to bring him both enduring fame at home during his lifetime and world renown in later generations.

The Tōkaidō highway between Kyōto and Edo, built in early times, rose to prominence at the beginning of the seventeenth century with the selection of Edo (now Tōkyō) as the military capital of Japan. Officially, the highway was provided for the visits to the capital imposed on the various feudal lords, but the average travel-loving Japanese also profited greatly by its development. The wealthy traveled by palanquin or horse, the average man went on foot. The trip was not always an easy one, requiring up to two weeks for the three hundred-odd miles between Edo and Kyōto, but it offered a variety of adventures otherwise denied the citizens of a nation that had purposely cut itself off from the outside world. In the richly varied traffic on the highway—the great daimyō processions, pilgrims, messengers, itinerant priests, merchants and entertainers—the wayfarer could view a miniature cross-section of Japan. The pleasures of the road, the lovely new sights and tastes, the hot bath at dusk and the enjoyment of easy and willing female companionship in the evenings, afforded both physical and aesthetic stimulation. A body of legend grew up around the great highway, an aura of romance that suffused even wayfarers who had traveled it many times. The market for guidebooks and pictorial maps intended for those planning the trip, as well as prints and paintings for those who could not go, grew increasingly.

The Tōkaidō highway was divided into fifty-three convenient stages or rest stops, with inns and restaurants at each. Both factual and fictional guidebooks and scrolls devoted to the sights of the highway were already popular in the seventeenth century. However, the Tōkaidō theme was rather slow in breaking into the print market. Before the nineteenth century a full set of the fifty-five prints (the fifty-three stations plus the cities of Edo and Kyōto at either end of the highway) would have been beyond the means of the average citizen, and representations of portions of the highway were not very meaningful to a citizenry interested primarily in the subject matter rather than in the art itself.

As prints came to be mass produced for a more plebeian audience, however, their price (and sometimes their quality) fell, and more extensive series on a particular theme became feasible. More important was the fact that at the same time interest in travel and in the various details of Tōkaidō life increased, and the way was paved for a "Tōkaidō boom" in both literature and art. In literature the most notable production was Ikku's famous *Tōkaidō hizakurige* [By Foot along the Tōkaidō] published between 1802 and 1809, a novel that related with great wit the ribald adventures of a pair of Edo rascals on a trip to Kyōto. In art, Hokusai, the great innovator of the independent landscape print, was probably the first popular artist to depict the Tōkaidō extensively, but his several remarkable series were produced at a period when Hokusai was still placing primary emphasis on figures rather than on landscape. His greatest influence on Hiroshige was probably in the Tōkaidō-related scenes of his great Fuji series, created during the years immediately preceding Hiroshige's first major work. The more restrained, simplified landscape prints of Hokusai's pupils, Hokuju and Shinsai, may also have had a strong influence on Hiroshige's style. (Hiroshige's own teacher Toyohiro also produced a series of Tōkaidō prints, but these show surprisingly little direct relation to the pupil's later work.)

It was in the Eighth Month of 1832 that Hiroshige began his first tour of the Tōkaidō, as a minor retainer in an official mission of the shōgun to the Kyōto court. Hiroshige's duties appear to have included the sketching of certain ceremonies involved in the mission; the commission doubtless resulted from his status as a former official of the fire brigade and did not mark any governmental recognition of ukiyo-e. The most significant result of Hiroshige's sketches along the way was his great print series, the *Fifty-three Stations of the Tōkaidō.* These designs began to appear shortly after his return and, in their unique combi-

180 **Hiroshige:** *Night Snow at Kambara.* Ōban size, from the series *Tōkaidō gojūsan-tsugi* [Fifty-three Stations of the Tōkaidō], Tempō IV (1833). Signature: Hiroshige *ga*; censor's *kiwame* seal (in left margin); publisher (seal in red): Hōeidō. For the full series, see figures 70–124.

Where "Shōno" (plate 179) represents the most strikingly innovative scene of Hiroshige's Tōkaidō series, "Kambara" reflects the more traditional tastes and methods. It is saved from being merely picturesque, however, by the perfect composition and the broodingly dark sky. Compare figure 85a for what is presumed to be the first impression of this design, with a flaw on the knee of the figure on the right. In viewing the originals, a connoisseur's choice would normally be the sharper, first impression. But in this instance, the writer's own feeling is that the alternative impression is more effective for reproduction. Note that these variations all involve manipulations of the same blocks; the printer could heavily ink either the upper or lower portion of the sky block, wiping off part of the darker pigment to effect gradation, but he could not print the sky totally black without obliterating the lettering of the title. For such a total night effect, the title would have been incised in the sky block, as in "Miya" of the same series (figure 111) and been printed white like the snowflakes. In very late impressions of this design, the troublesome gradations are omitted, and the sky appears only in a flat gray that very much reduces the dramatic effect.

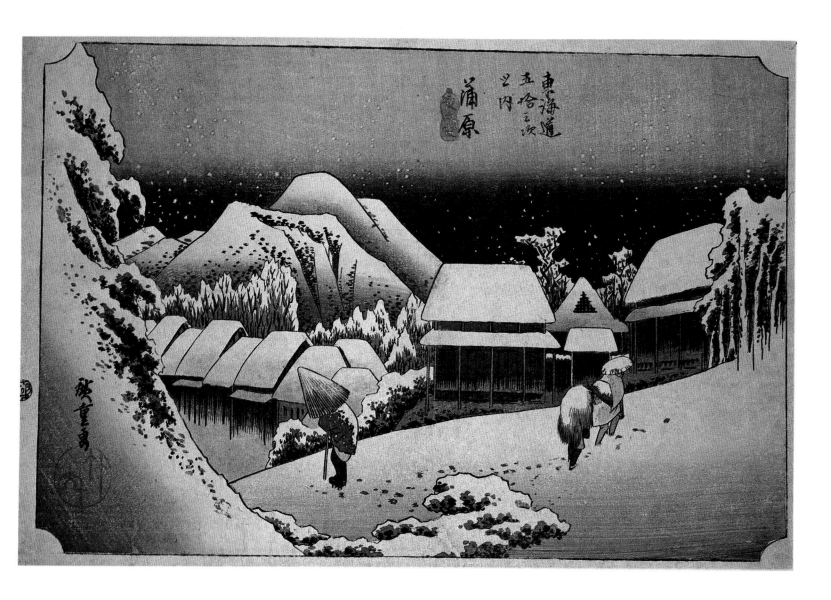

nation of romance and realism, set a new trend in Japanese prints. At the same time, they proved a tremendous success. Hokusai was spurred to even greater efforts in the landscape field at this time, as we have seen, but he never regained his old popularity. Thus, in the same year that an old star was slowly falling, a new one rose.

The fifty-five prints of this series were sold separately at first, but on their completion in 1834 they were also issued as an album complete with preface and colophon. Despite a number of guidebooks and scrolls and Hokusai's dramatic but somehow impersonal depictions of the region, this was the first time that the viewer of a Tōkaidō print could feel that he really knew the great highway. There was a human touch to these prints that no artist had achieved previously; they revealed a beauty which seemed somehow tangible and intimate, even to men who had hitherto thought little of nature's wonders. Among the dozen or more masterpieces of Hiroshige's first Tōkaidō series, there is a forceful union of temporal man and eternal nature that Hokusai seldom achieved. The landscape and coloring embody a restful beauty that remains in the mind even after the memory of the human figures has departed. We recognize these scenes; they could occur at any moment, even though they seldom do. We feel a rapport between ourselves and the anonymous figures, for like ourselves they are part of a landscape that will remain long after they themselves are out of the picture.

Despite a venerable tradition in Chinese and Japanese painting, before Hokusai and Hiroshige the landscapes in prints served mainly as backgrounds for figures. Hokusai was

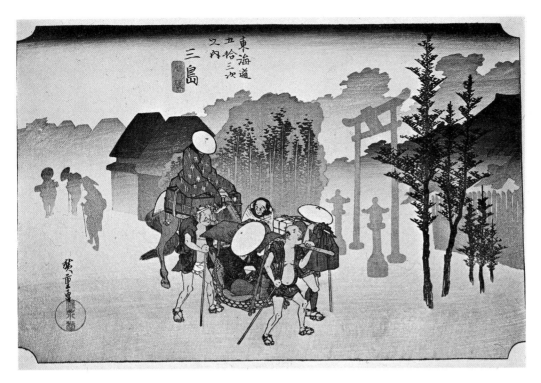

181 **Hiroshige:** *Morning Mist at Mishima.* Ōban size, from the series *Tōkaidō gojūsan-tsugi* [Fifty-three Stations of the Tōkaidō], Tempō IV (1833). Signature: Hiroshige *ga*; censor's *kiwame* seal (in left margin); publisher (seal in red): Hōeidō. For the full series, see figures 70–124.

While not ranking with Hiroshige's major works, "Mishima" is typical of the secondary masterpieces still readily available to collectors today. This scene evokes admirably the feeling of a chilly dawn departure toward Hakone Pass. In the center an affluent traveler is borne by two palanquin bearers; beside him a lone pedestrian carries his heavy burdens on a pole, followed by a pack driver in a straw raincape with his mounted passenger. The three parties are clustered together as they pass the entrance to the Mishima Shrine; on the left single pilgrims proceed in the opposite direction through the misty dawn. In technique this print is notable for its omission of keyblock outlines in the background elements, a device doubtless derived from the impressionistic Maruyama-Shijō School and which appears again in such Hiroshige masterpieces as "Miyanokoshi" (plate 185).

182 **Hiroshige:** *Night Rain at Karasaki.* Ōban size, from the series *Ōmi hakkei* [Eight Views of Lake Biwa], ca. 1834 (Tempō V). Signature: Hiroshige *ga*; censor's *kiwame seal* (in left margin, trimmed); publisher (seal on the right): Eikyūdō. For the complete series, see figures 328–34.

The ancient pine tree of Karasaki, sheltering a shrine beneath its stilt-supported branches, stands brooding in the heavy night rain. Delineated in shades of blue and black, quite devoid of human figures, this is among the simplest yet most evocative of all Hiroshige's prints.

the innovator of the pure landscape print. Hiroshige, who followed him, was a less striking, less dominating personality; but as an artist he frequently achieved quiet masterpieces to equal his predecessor's. Hokusai's approach is powerful, realistic and closer to the Chinese styles that he had studied. Hiroshige lacked Hokusai's vast but intensive training in many styles; however, he created his own genial poetic view out of the tradition of Japanese popular painting.

Despite being based on actual sketches, Hiroshige's prints are far from realistic in a superficial sense; one seeks in vain the actual scenes he drew. Moreover, he not only adapted

183 Hiroshige: *Wild Geese by Moonlight. Chū-tanzaku* size, ca. early 1830s (early Tempō Period). Signature: Hiroshige *hitsu,* with seal; publisher (seal at top): Shō-eidō (Kawaguchi Shōzō).

Three wild geese, surrounded by a spacious sky, are seen in flight across the face of the moon. As in many of Hiroshige's bird groups, one wild goose bends his neck, lending variety to the composition. The verse reads: *Konna yo ga/mata mo arō ka/tsuki ni kari* [Will there ever be/a night like this one:/wild geese in the moonlight]. It is interesting to compare the print with the artist's earlier "Moonlight at Takanawa" (plate 177). The seal seen at the bottom of this print is the most striking of several such decorative designs employed by Hiroshige. The right-hand figure is the word *fuku* [happiness], designed like a seated deer; the left-hand figure is the word *ju* [long life], drawn to resemble a horse seen from the rear. The combination "horse-deer" gives the Japanese word *baka* [fool]. In most other extant examples of this print, the initial stroke of the verse is lacking, presumably due to block damage after the first printing.

184 Hiroshige: *Owl on a Pine Branch by Moonlight. Chū-tanzaku* size, ca. early 1830s (early Tempō Period): Signature: Hiroshige *hitsu,* with Yūsai [an alternate *nom d'artiste*] seal.

In what is possibly the most charming of all Japanese *kachō* [flower-and-bird] prints a little owl is seen drowsing on the branch of a pine tree, above a crescent moon. The capricious verse is by Hiroshige's poet-friend Hachijintei and reads: *Mikazuki no/fune yūsan shite/mimizuku no/mimi ni iretaki/matsukaze no koto* [The crescent moon-boat picnics on the shore:/into the eared-owl's/ear I'd love to lay/the pine-breeze zither-sounds].

and altered landscape details but also the seasons (his first Tōkaidō journey took place in autumn) to suit the particular mood he envisaged. Yet when we speak of seeing any number of typical Hiroshige's scenes beyond the Westernized districts of modern Japan, we are not exaggerating. He had absorbed both the natural and the human beauty of Japan into his subconscious, and it was this ideal image that found expression in his evocations of specific scenes. At the urging of his publishers Hiroshige was to issue nearly two dozen other series of Tōkaidō prints at various periods. Each contained its share of interesting designs, but none was ever to equal the first in unity of conception and general excellence.

About the time that he finished his first Tōkaidō series, Hiroshige designed a small group of pictures of an even higher quality, the *Ōmi hakkei* [Eight Views of Lake Biwa]. These scenes, transposed from a classical Chinese poetic and artistic theme, had been popular in Japanese art for several centuries. Hiroshige's new series was considerably influenced by the Literati School of landscape painting, and he seems to have taken special pains to produce his unique effects through the use of as little coloring as possible. Plate 182 shows one of the greatest prints in the series; it stands with Hokusai's "Mt. Fuji at Dawn" as an eternal tribute to nature little influenced by man. As with much of Hiroshige's most appealing work, it is the more spectacular forces of nature—snow, mist, rain, dusk, moonlight—that lend the final enchantment to a graphic composition anchored in a bedrock of natural quietude.

Other souvenirs of Hiroshige's Tōkaidō trip were soon to appear, notably his celebration of the ancient capital in the ten prints *Kyōto meisho* [Famous Views of Kyōto]. Hiroshige was, however, normally at his best in sketching unexploited themes. In depicting the Imperial capital Kyōto, he often succumbed to the temptation to utilize traditional artistic conventions and to employ designs derived from guidebooks. He may even have been compelled to do so, either by his publisher or by the fact that those familiar with so well-known a spot would demand greater accuracy than they would for less celebrated scenes along the Tōkaidō. Perhaps he was thinking of the type of critic who says, "Yes, it's a nice design; but of course you can't actually *see* Mt. Fuji from that spot." Particularly as a designer of prints for popular circulation, Hiroshige was doubtless dogged by such critics throughout his career; this may have contributed as much to the curtailment of his imaginative powers as did overwork and natural factors. Whatever the causes, the more Hiroshige attempted to design realistically, the less successful were his overall compositions and the total effect of the moods he was attempting to convey. His was the difficult task of depicting actual scenes with sufficient accuracy to identify the place and satisfy the critics, yet creating a poetic masterpiece of sustained mood and impeccable composition. It is a wonder he succeeded as often as he did.

After more than two decades of largely undistinguished work, Hiroshige's sudden maturity appeared in several fields. In the same year that he commenced his first Tōkaidō prints, he also began important works in the field of flower-and-bird prints, another area where Hokusai then reigned almost supreme. Plates 183 and 184 show some of the finest of Hiroshige's works in this time-honored genre of Far Eastern art. We feel that nine-tenths of Hiroshige's prints in this field are too sugary and mawkish to rank with his major works. However, in the examples shown, the coloring and approach are more restrained, and the total effect is closer to nature than the sentimental image that pervades much of this genre. Even so, Hiroshige's sentimental birds and flowers are usually preferable to Hokusai's frequent descents into unnatural realism when the latter essayed the same field. Neither artist, however, ever quite rivaled his forerunners in China, Korea and Japan, many of whom used the simplest of mediums—black ink on paper—to create a living world of nature unequaled by more elaborate methods.

Hiroshige's Later Work

Although Hiroshige's most impressive individual works date from his first few years as a landscape designer, it was not until about 1838 that he was clearly able to escape the

185 (A–B) **Hiroshige:** *Moonlit Night at Miyanokoshi. Ōban* size, from the series *Kiso-kaidō rokujū-kyū-tsugi* [Sixty-nine Stations of the Kiso Highway], done jointly with Eisen (see plate 194), late 1830s (mid–late Tempō Period). Signature: Hiroshige *ga*, with Ichiryūsai [an alternate *nom d'artiste*] seal; censor's *kiwame* seal (in margin, trimmed); publisher (seal on the upper left): Kinjudō (Ise-ya Rihei). For the complete series, see figures 127–97. One of the most modern of all Hiroshige's designs, this masterpiece eschews the block outline entirely for the background elements, producing a splendid impressionistic effect of moonlit silhouettes and patterns. A family is walking across the bridge in the foreground; life in the Kiso mountains was never easy, and whether they are fleeing debtors at night with their only belongings or simply returning from a visit to relatives, we cannot know. This pair of plates illustrates, in color, the printing variations quite normally found in ukiyo-e from one example to another. Our interest here is not in the specialized problem of variant states and block revisions, but in the subtle differences apparent even in specimens of approximately equal excellence of impression and from identical blocks. In a case like this, the "ideal" impression cannot really be designated; the problem becomes a matter of taste and of what mood or hidden meanings one seeks in this particular print.

influence of earlier landscape views of Japan. His *Edo kinkō hakkei* [Eight Views of the Suburbs of Edo] and the *Kiso-kaidō rokujūkyū-tsugi* [Sixty-nine Stations of the Kiso Highway] are noteworthy works of this period, though they never quite equal the sustained level of the first Tōkaidō series.

Hiroshige's coloring is one of his acknowledged charms; yet shades of black, gray and white predominate in many of his finest compositions. He surrounds us today with such a variety of inferior greeting-card miniatures that it is easy for his more casual admirers to grow tired of him without realizing why. With all the print masters it is advisable to study the original in an early edition; with Hiroshige it is mandatory, for his woodblocks were used by avaricious publishers for thousands upon thousands of printings, even well after they were worn down. In Japan, Hiroshige impressions are classed in nine grades. The average collector is lucky to acquire even a medium grade in fine condition, although even this may differ greatly from the first impression. Often the first impressions were the only ones made with special care and under the artist's supervision, for they were frequently made for distribution among the connoisseurs of the time (cf. plates 178–179 and 185 A/B for variant printings of two of the artist's major works).

When Hiroshige was forty-four, the Tempō Era reforms (1841–1843—another attempt to alleviate the financial and other difficulties of the Japanese government through austerity edicts and the like) had an unfortunate influence on his work. Popular demand forced him, at first, to turn from landscapes to historical prints; and then, when the reform had failed, to

186 **Hiroshige**: *Autumn Moon at Seba. Ōban* size, from the series *Kiso-kaidō rokujūkyū-tsugi* [Sixty-nine Stations of the Kiso Highway], done jointly with Eisen (see plate 194), late 1830s (mid–late Tempō Period). Signature: Hiroshige *ga*, with Ichiryūsai seal; censor's *kiwame* seal (in margin, trimmed); publisher (seal on the upper left): Kinjudō (Ise-ya Rihei). For the complete series, see figures 127–97.

Where "Miyanokoshi" (plate 185) was strikingly modern and innovative, "Seba" is a model of classical perfection, more in the manner of *nanga* [literati painting] than of ukiyo-e. In this view of the lonely region beyond Lake Suwa, we see a bargeman and a raftsman poling their craft in the same direction, as wind-bent willows lean over the blue Narai River under the harvest moon at dusk. As with "Shōno" and "Kambara" from the Tōkaidō series (plates 178–180), neither "Miyanokoshi" nor "Seba" possess landmarks of specific interest, thus freeing the artist to create his own idealized image of nature's wonders.

187 Hiroshige: *Evening Squall at Ōhashi.* Ōban size, from the series *Meisho Edo hyakkei* [One Hundred Famous Views of Edo], issued between Ansei III/2 and Ansei V/12 (ca. March, 1856 through January, 1859). Signature: Hiroshige *ga*; censor's *aratame* seal (in the upper right margin) plus date-seal ("Year of the Snake 9" [Ansei IV/9, October, 1857]); publisher (black seal on the lower left): Uo-Ei (Uo-ya Eikichi) [red seal = early collector]. For the full series, see figures 209–326.

Plebeian citizens of Edo, caught on the Great Bridge across the Sumida River at Atake, shield themselves from a sudden shower. On the river a logger poles his raft and in the distance dimly, the houses and temples of Fukagawa and Honjo can be seen. The legend reads: *Ōhashi* [Great Bridge], *Atake no yūdachi* [Sudden Shower at Atake]. The word Atake is almost always omitted from descriptions of this famous print, doubtless due to the difficult calligraphy. It was the lowest class red-light district of Fukagawa and stood just east of the bridge shown here. Well-known in the West even before Van Gogh's copy in oils (1888, see figure 326c), Hiroshige's "Ōhashi" stands as the final monument of his career and was produced only a year before his death. Gone is the bold grandeur of concept found in the best of this artist's early work; in its place, in common with other prints of the time, we find careful craftsmanship, incredibly precise engraving and elaborate attention to the details of printing. In this late period of ukiyo-e, even more than previously, the quality of an impression is of paramount importance both in collecting and connoisseurship. The points to note in the present design (though even the example illustrated is not the very first impression) are the tricolored square cartouche, the uneven lowering clouds, the gradations in the blue of the river above and below the bridge and, of course, the sharpness of the impression in general. In an alternate early state (see figure 260) two additional rafts appear faintly on the river on the right. This may represent an earlier "proof" state, the additional rafts having been routed from the block and the design simplified for the later standard version.

the prints of girls that were once again in vogue. Although, in the main, the government policy banned elaborate or extended editions and prints of actors and girls, the resulting sudden rise in popularity of historical, didactic and warrior prints forced Hiroshige into works far from where his strength lay. Publishers' demands for landscapes soon grew again, however, and Hiroshige was either unable to say no, or his mode of life forced him to produce in quantity to gain sufficient income. Whatever the reason, the general quality of his work declined sharply; nevertheless, from the thousands of prints he produced in his late years, enough still stand as masterworks to prove that he had certainly not lost his inspiration.

During this period Hiroshige also received a daimyō's commission to paint a number of *kakemono* landscape scrolls; his paintings are skillful enough, but all too often they fall back (perhaps by the nature of his official commission) upon traditional Kanō methods and coloring and reveal little of the artist's talent for massive design and bold color effects; Hiroshige's genius is most intimately apparent in his *dessins* and impromptu sketches.

We have commented on Hiroshige's popular triumph over Hokusai, yet we doubt that there was ever any feeling of rivalry on the part of the younger man. Hiroshige's work is far closer to his own nature than is that of the complex and eclectic Hokusai. Hiroshige owed much to the older master but seems to have absorbed his debt in the natural process of maturing during the years of Hokusai's great landscape prints. Thus he studied—and suffered— far less than Hokusai. In his lifetime Hiroshige developed but one distinct style and followed it to his death. He did not pretend to be versatile or a genius; he preferred to enjoy life rather than take solitary pleasure serving an abstract god or art. In his later years, if Hiroshige produced far more than he could with any regard to quality, this was simply to meet the demands of clamoring publishers and his own financial requirements, not—as in the case of Hokusai—to fill a gnawing inner need for continuous artistic expression. Thus, by all odds, Hokusai should be classed as a rare and wonderful genius and Hiroshige as a popular craftsman of only moderate talent. This, however, is not the case. Although it is easy to admit Hokusai's genius, we do not always love him for it, and even though it is clear that Hiroshige's personality was lacking in some of the inner drive of genius, his work gives enormous pleasure and, in the end, it must be concluded that his real masterpieces are quite the equal of Hokusai's and just as numerous as well. Hiroshige lacked Hokusai's dramatic immaculate draftsmanship, but he possessed a rare vision of nature as poetry. When he had the time to evolve his theme at leisure, his inspiration, his evocation of the totality of a mood, is unsurpassed in art. When, however, he was forced to work without inspiration, the results are only mediocre, well below the level of Hokusai's draftsmanship, which was always admirable. In a word, Hiroshige was inspired by overall moods, Hokusai by the total composition. The poet was at a loss without inspiration, whereas the draftsman was not. It is a rare print of Hokusai's in which the mood overpowers the design; with the best of Hiroshige the mood always comes first, and the design follows. In Hokusai, surface movement predominates, whereas Hiroshige moves through an inner emotion. Hokusai's pictures are full of the artist, Hiroshige confronts us directly with nature.

Hiroshige, unlike Hokusai, lived a relatively uneventful life—his life was his work. He was a largely self-taught artist, who limited himself to the devices and capacities of his own nature. Hiroshige was fond of travel, loved wine and good food, and in his other tastes was a true citizen of Edo. Dying (in the midst of a cholera epidemic in the autumn of 1858) he did not, like Hokusai, demand of heaven additional years to prove his greatness. He only enjoined his family to refrain from excessive funeral ceremony, quoting an old verse that well expresses the hedonism of old Edo:

"When I die / don't cremate me, don't bury me; / just throw me in the fields / and let me fill the belly of / some starving dog."

Hiroshige's own farewell verse went:
"Leaving my brush behind / in Edo / I set forth on a new journey: / Let me sightsee all the famous views / in Paradise!"

188 **Toyokuni II**: *Night Rain at Ōyama.* Ōban size, from the series *Meisho hakkei* [Eight Famous Views], early 1830s (early Tempō Period). Signature: Toyokuni *hitsu*, with Utagawa [school] seal; publisher (seal on the upper left): Ise-Ri (Ise-ya Rihei).
Toyokuni II is seldom mentioned among the masters of ukiyo-e, but in this print he achieves a rare combination of striking design and masterly coloring that raises him for a brief moment, to the level of Hokusai and Hiroshige. Driving rain, fantastically colored by the alternate light and shadow of dusk, beats down on the sacred mountain Ōyama and on its temple to the god Fudō. Designed with an eye to massive forms rather than relying on keyblock outlines, this print is a notable example of the fresh approach of a non-specialist to the landscape genre. How Toyokuni II's talents would have developed had he been given free rein and longer life, we shall never know.

Later Figure Prints and Landscapes: Kunisada, Kuniyoshi, Toyokuni II

Hokusai and Hiroshige are quite justly chosen by critics to epitomize the final half-century of ukiyo-e's greatness. In this same period the prints were at the peak of their popularity among the general populace, with a consequent multiplication of skilled artists to fill this need. Thus, the critic approaching the nineteenth century is always faced with the problem of dealing with masses of secondary figures, several of whom were once considered at least the equal of Hiroshige, and some of whom are even today the favorites of certain Japanese and foreign collectors, often for other than artistic reasons. Although the writer cannot agree with the harsh critics who dismiss the whole nineteenth century with the exception of Hokusai and Hiroshige, it is true that few of its artists are geniuses equal to the masters of the first century of ukiyo-e prints. We rather doubt that this was entirely the fault of the times.

Toyokuni was the popular giant of the new ukiyo-e; just to list his pupils would take a full page. Two, however (in addition to his early pupil Kunimasa, who has already been

大當狂言内　大工六三郎

立圓斎
國貞人画

189 **Kunisada**: *Actor in the Role of a Carpenter.*
Ōban size, ca. 1814 (Bunka XI). Signature: Gototei
Kunisada *ga*; censor's *kiwame* seal; publisher
(lower seal): Kawaguchi (Kawaguchi-ya Uhei).
Kunisada started publishing prints in 1809 and
already by the early 1810s was producing prints
comparable to those of his master Toyokuni, such as
this striking actor portrait that owes its three-
dimensional quality to the use of a rich mica ground.
Onoe Shōsuke II is portrayed here as the carpenter
Rokusaburō from the drama *Mijikayo ukina-no-
chirashigaki.* The actor performed this role at the
Nakamura-za in Bunka X/7 (August, 1813). This
Ōatari kyōgen [Popular Plays] series of commemo-
rative prints seems likely to have been issued a year
or so after the actual performance.

discussed), stand out as nearly the equal of their master, which is to say that their artistic
failures outnumber their successes and their fame was greater in their own day than it is
likely ever to be again.

Kunisada (1786–1865), like all the pupils of Toyokuni and Toyohiro, bore the art sur-
name Utagawa. The whole Utagawa School in the nineteenth century bears the mark of the

190 **Kuniyoshi**: *Strong Woman Subduing a Wild Horse. Ōban* size, ca. mid 1830s (mid Tempō Period). Signature: Ichiyūsai Kuniyoshi *ga,* with handseal; censor's *kiwame* seal; publisher (seal on the lower left): Kinkōdō. Exact title: *Ōmi-no-kuni no yūfu O-Kane* [The Strong Woman O-Kane of Ōmi Province].

O-Kane was a legendary amazon and courtesan of Lake Biwa, renowned for her feat of subduing a wild horse with one stamp of her sandal; she appears several times in ukiyo-e. In striving to make his version different from any other, Kuniyoshi resorted to the outlandish idea of depicting a modern ukiyo-e beauty standing in the midst of a scene otherwise quite European in derivation—modeled on the etchings and illustrations that had been imported to Japan during and after the eighteenth century. The print is rescued from the static quality of most Western-derived designs by Kuniyoshi's dynamic touch and by the superb quality of the printer's technique.

stereotyped style that Toyokuni had adopted following the death or retirement of his betters at the opening of the century. Kunisada, who had also studied the style of Itchō, was the most famous and prolific figure-print artist of his day. He is still admired by Japanese connoisseurs of the decadent days of old Edo, particularly for his prints of girls and courtesans and for his erotica. (The latter genre flourished as never before, reaching the lower strata of Edo society probably for the first time now. This genre appealed more and more to tastes less and less artistic. Even Hiroshige was tempted into the genre, though the results do not rank among the best of his work.) Kunisada is easily dismissed by the casual admirer of the earlier masters, but it must be admitted that throughout his long career he produced huge quantities of prints of courtesans and actors consistently more adept than that of any but one or two of his rivals. As a whole, his work typifies the neurotic and unstable tendencies of his age doubtless better than that of any other artist. At the same time, Kunisada's rare landscape prints reveal a talent far more universal than what we glimpse in his figures. It is of interest, though somewhat chilling, to imagine the results had publishers or popular demand forced Hiroshige and Kunisada to change places in the print world. Kunisada would certainly be the better known of the two today, even though his actual achievement in the landscape genre never approached that of Hiroshige.

Kunisada's great fellow-pupil in the atelier of Toyokuni was Utagawa **Kuniyoshi** (1798–1861), who should not be confused with the modern Japanese-American painter of similar name. Kuniyoshi was the last important, active figure in traditional ukiyo-e. In

191 Kuniyoshi: *Mt. Fuji Seen from Edo Bay.* Ōban size, from the series *Tōto Fuji-mi sanjūrokkei* [Thirty-six Views of Mt. Fuji Seen from Edo], early 1840s (late Tempō Period). Signature: Ichiyūsai Kuniyoshi *ga*; censor's "Mura" seal (in the left margin, trimmed); publisher (seal on the left): Murata (Jirōbei). Subtitle: *Tsukuda-oki kaisei no Fuji* [Fuji on Fine Day from off Tsukuda].
Inspired by Hokusai's famous Fuji series of over a decade earlier, Kuniyoshi, in the early 1840s, began designing his own rival series of which, however, only five prints are known. Typically, the emphasis is on foreground figures, and there is a semi-Western approach to perspective and shading. The results are sometimes bizarre and always interesting but never on the same aesthetic plane as Hokusai's. As with the preceding plate, it is impeccable printing that brings the scene to life. (In a later state of this print, the design is simplified by the omission of the verse in the sky at the top left.)

addition his frequent experiments at consolidating Western styles pointed the way for the inevitable future development of Japanese art in general.

Kuniyoshi resembles Hokusai in his intense study of many styles and masters: from Toyokuni, Shuntei, Tōrin III, Zeshin and European etchings to the works of Hokusai himself. Kuniyoshi's great forte was the historical print: particularly, powerful portrayals of ancient warriors in violent combat. In this field he certainly reigned supreme in his age, although before judging his rank in ukiyo-e as a whole, it would be well to compare his work with the less bombastic, yet even more effective, warrior prints and book plates of Moronobu and his fellows from the beginnings of ukiyo-e. (Compared with the great Japanese battle scrolls of the medieval period, Kuniyoshi's work in this field would certainly fall even further in our estimation.) Somehow battle scenes and prints of bloody combat have never appealed strongly to the modern rediscoverers of ukiyo-e. After all, these usually depict early historical scenes, representing figures in an age the artists knew only indirectly: they are not "ukiyo-e" in subject matter, even though they appealed strongly to the audience of the floating world.

Kuniyoshi was also a master of the figure print, but his efforts in two other fields (satire and landscape) have more significance for us today. Satire has been a minor element of Japanese art throughout its course, a mild outlet for emotions all too often suppressed in a predominantly feudal society. The gradual weakening of the feudal government, evidenced by the failure of the aforementioned Tempō Era reforms, led to the increasing appearance of satire in ukiyo-e, and Kuniyoshi was perhaps the greatest master of this genre. Once, when he went too far in his lampooning, he was punished by the government for such prints; the fact that this put no damper on his efforts speaks both for his own strength of character and for the weakness of the declining feudal government. Of greater artistic interest than Kuniyoshi's political cartoons are his print satires featuring animals (and sometimes, even plants) in human roles.

Despite the interest of Kuniyoshi's historical and social prints to students of old Japan, as an international artist he—like Kunisada and Eisen—must stand or fall on the quality of his landscapes. Compared to other contemporary specialists in the figure print, Kuniyoshi produced a relatively large number of landscapes, which sometimes combine historical or legendary elements that were omitted, doubtless on purpose, by Hiroshige. Less picturesque than Hiroshige's, Kuniyoshi's Edo landscape scenes with plebeian figures placed prominently in the foreground are typical of his new attitude to landscape: a photo-journalistic

192 Eizan: *Three Beauties on a Veranda.* Triptych, each panel of *ōban* size, ca. 1810 (mid Bunka Period). Signature: Kikukawa Eizan *hitsu*; censor's *kiwame* seal; publisher (seals at the bottom trimmed): Yama-Shō (Yamada Shōjirō). Exact title: *Fūryū yu-suzumi san-bijin* [Three Fashionable Beauties Enjoying the Cool of the Evening].
Three courtesans, who have for the moment left the frenetic party glimpsed in silhouette behind them, cool off with a cup of tea on the veranda. Eizan's early work comes close to emulating Utamaro, and there is a decadent flavor to his women that appeals to modern Japanese collectors. The figures lack the solid foundation of draftsmanship that characterized the earlier master but do possess a charm typical of the first quarter of the nineteenth century.

approach influenced by Western art. (This tendency would be more strongly reflected in the prints of Kiyochika in the following generation.)

Of the dozens of lesser pupils of Toyokuni, there is one whose artistic life was brief, and many of whose prints are worthless, but who, with one rare series of landscapes, justified his existence: **Toyokuni II** (1802–ca. 1835). Theoretically he was the first Toyokuni's legitimate successor, but he only succeeded to his father-in-law's name, upon the latter's death in 1825, against the jealous objections of such older pupils of Toyokuni as Kunisada, who insisted upon calling himself and signing his prints "Toyokuni II." (Today he is usually referred to in Japan as "Toyokuni III.") Whatever his lineage, the earlier "Toyokuni II" produced little of great merit among his figure prints and miscellaneous subjects, but in the series *Meisho hakkei* [Eight Famous Views], he somehow managed to design several prints the equal of all but the finest work of his more famous contemporaries. One print, plate 188, may be favorably compared with the best of Hiroshige. How Toyokuni II accomplished this is a mystery; certainly he owed much to Hokuju and to Hokusai, as well as to skillful engravers and printers. But one gets the strong impression that Toyokuni II might have ranked with Eisen, Kunisada and Kuniyoshi had he been given further opportunities to develop his unique view of landscape.

The Decline of Ukiyo-e: Eizan, Eisen, Yoshitoshi; *Kamigata-e*

Although it is always somewhat perilous to characterize an alien society, from the late eighteenth century Japanese city-dwellers seem to have entered upon a period of ferment, of dissatisfaction with the dead end reached by their inbred society, and frustration grew

as there was no means of escape. Gradually, to relieve this boredom, they turned to novelty and meaningless variation; at the same time government interference in the arts was increasing continuously.

The result in figure design in ukiyo-e of the nineteenth century was often a confused combination of superficial realism and escapist fantasy, a period of decadence and of decline in much of Japanese art. Connoisseurship was also tainted with the general deterioration in taste and in the "Edo spirit." Furthermore, at the beginning of the nineteenth century the vital interest of the Edo connoisseurs in fine prints had gradually lessened; they

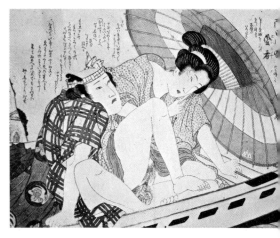

193 **Eisen**: *Geisha and Boatman on the Sumida River*. Ōban size, from the shunga album *Kyōka-dai koi-no-michigusa* [Wayward Songs of Love], preface datable to Bunsei VIII (1825).
Eisen carried the decadent trends of Bunka-Period figure design to their extreme, producing several hundred deft prints featuring courtesans, geisha and girls of the town in contemporary settings. Since all of his figure work is permeated with an erotic flavor, it is not surprising that he excelled in shunga. In this print an Edo boatman is seen dallying with a stylish geisha under a parasol in the summer. As in many shunga prints, the amatory conversation of the participants is recorded in detail.

194 (A–B) **Eisen**: *Bridge on the Ina River*. Ōban size, from the series *Kiso-kaidō rokujūkyū-tsugi* [Sixty-nine Stations of the Kiso Highway], done jointly with Hiroshige (see plates 185–186), ca. 1836 (mid Tempō Period). Signature (on example A only): Keisai *ga*; censor's *kiwame* and *Take* seals (in margin of example A), *kiwame* seal only (example B); publisher's seals (on the left): Takenouchi, Hōeidō. For complete series, see figures 127–97. At Nojiri, torrents cascade beneath a bridge famous for framing with its undersurface an imaginary view of Mt. Fuji. Eisen's landscapes lack the consummate draftsmanship of Hokusai and the masterful moods of Hiroshige, but at their best they offer a fresh and untrammeled view of otherwise familiar scenes. Our two examples of this design demonstrate the interesting variations that are sometimes found between different states of the same print. Although the basic color scheme is retained, in the second state (below) the range of mountains, visible on the upper left and upper right as well as under the bridge, has been simplified; the wild geese have been omitted, and Eisen's signature has been removed. For reasons of economy, the number of blocks was often reduced in later impressions. In this case, since the second state was issued at a relatively early date, the changes were probably aimed at making the design less complex. Following Eisen's break with the publisher in 1837, his signature was removed: the publisher no doubt hoped that Eisen's contributions to the series would be taken for the work of the other collaborator, Hiroshige, who was the more popular landscape artist.

195 Sadahide: *Rustic Night Scene.* Fan print in ōban size, ca. 1830s (Tempō Period). Signature: Gountei Sadahide; publisher: Iba-ya.

Although Sadahide is known primarily for his Yokohama Prints, he was a master of pictures of beautiful women, as well as of such unusual landscape designs as this rare *uchiwa-e* [fan print], which was originally issued for mounting as a summer fan. Sadahide's intriguing view of nature is derived from his master Kunisada—with influence from Utamaro's album *Kyōgetsubō* as well—but displays a new approach that one wishes he could have been permitted to explore further. This unusual design is enhanced by immaculate printing, with only the slightest use of color to achieve a brooding effect. We may add that nearly every collection has its share of such rarities: minor prints that on objective grounds one is not justified in keeping, but which, nevertheless, give the owners keen pleasure.

had supported and directed much of the glory of Harunobu; their taste, as arbiters, had guided many other artists and publishers during the last quarter of the eighteenth century. With these refined critics gone, the ukiyo-e print was gradually reduced to a more distinctly popular art and soon declined to the level of this new audience. Coincidentally, despite an inherited sense of design that continued to serve the later ukiyo-e artists, not many of the nineteenth-century artists were the equal of even the secondary masters of the previous century. In effect, imaginative leadership was lacking among both the critics and the artists themselves. This lack was fatal in an art form that trod a narrow line of sensitive artistry above a base of semipopular support. Only when the artists escaped to nature, from the world of man, were they able to revive a beauty that had seemed almost lost in ukiyo-e.

With the death of Utamaro and the retirement from the field of figure prints of such masters as Kiyonaga, Shumman, Chōki and Eishi, the genre lost much of its impetus as a creative art form. It soon fell into a conventionalized type of plebeian pin-up which, despite its general effectiveness in design and printing, rarely ranks as fine art. The early prints of Shuntei, Shunsen and Kunisada sometimes effectively reflect the glory of Utamaro, and Eizan at his best is very good indeed; but by the 1810s one must plow through literally thousands of figure prints to find one worthy of comparison with even the minor achievements of two decades earlier.

Eizan's pupil **Eisen** (1791–1848) stands with Kunisada as the most popular and prolific figure-print designer of the nineteenth century, but despite his obvious skill and consistently careful craftsmanship, he was unable to escape the corrupt conventions into which the figure print had insensibly fallen. Some of his best work is in the shunga genre; however, not unlike others of his contemporaries, Eisen produced his aesthetically most memorable work in the sideline of landscape prints. It was Eisen who commenced the series, *Kisokaidō rokūjūkyū-tsugi* [Sixty-nine Stations of the Kiso Highway], which Hiroshige concluded. In comparing Eisen's rather neglected landscape prints of the series with the work of Hiroshige, which has been so often reproduced, there is always the danger of mistaking variety for quality. Nevertheless, Eisen's compromise between the overpowering draftsmanship of Hokusai and the evocative poetry of Hiroshige, often achieved a stimulating

effect not far below the average of the greater masters. The designs of plate 194 A/B could be analyzed as "Hokusai foreground, Hiroshige background"; but the total effect is impressive and occurs consistently throughout Eisen's landscapes. It may well justify giving him prominent secondary rank (with Hokuju and Kuniyoshi) in the world of ukiyo-e landscapists of the late Edo Period.

Ukiyo-e prints of the third quarter of the nineteenth century were largely the products of the pupils or followers of Kunisada, Kuniyoshi or Hiroshige, but there are only a few names deserving even passing mention here. Among these, Kunisada's brilliant pupil Utagawa **Sadahide** (1807–73), who worked principally in the Yokohama-Print genre but also produced figure prints and landscapes of interest, should not be neglected. Hiroshige's successor and principal pupil **Hiroshige II** (1826–69) also designed notable Yokohama Prints, as well as skilled landscapes in the later style of his mentor. The semi-ukiyo-e artist **Gengyo** (1817–80) specialized in such "accessories" of ukiyo-e as cover- and title-page designs, fans and decorative *surimono*. Similar work was also done by Shibata **Zeshin** (1807–91), a Shijō painter and lacquerware master who designed numerous, skilled *surimono*. Perhaps the finest print designer of this late period, however, was Taiso **Yoshitoshi** (1839–92), a Kuniyoshi pupil who stands almost alone in ukiyo-e at that time, preserving vigor in the figure print during these years of social, political and artistic upheaval. While he was only an occasional worker in the ukiyo-e medium, Kawanabe **Kyōsai** or Gyōsai (1831–89), at one time a pupil of Kuniyoshi, also deserves mention here.

Let us digress briefly to consider here the later *Kamigata-e,* prints and paintings of the Kyōto-Ōsaka region. As we have already seen, Kamigata ukiyo-e, throughout the seventeenth and eighteenth centuries, was comprised primarily of paintings and illustrated books. This trend continued during the final century of ukiyo-e; but from the 1790s Kyōto-Ōsaka interest in Kabuki increased notably, and in the resultant flood of actor prints, Kamigata ukiyo-e—particularly from the 1820s—came to be strongly influenced by the Edo masters, producing that phenomenon known abroad as the "Ōsaka Prints."

Following a number of experimental productions starting in the mid-eighteenth century, these prints first became prominent in the work of the Ōsaka master **Ryūkōsai** Jokei (fl. ca. 1772–1816). We have already had occasion to mention this interesting artist in connection

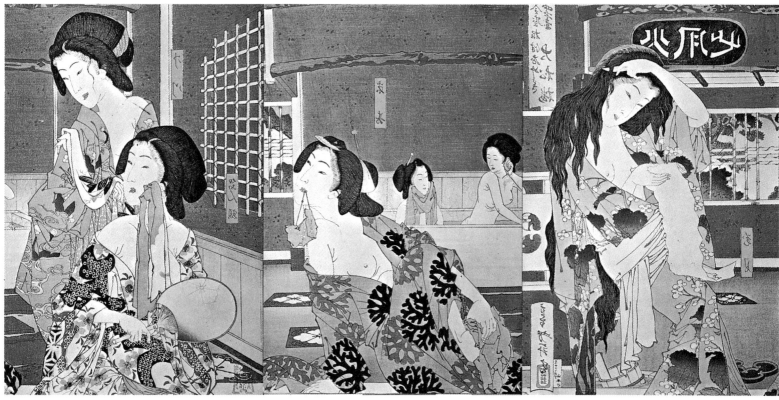

with Sharaku: he probably influenced that master and was, in turn, influenced by Sharaku himself in his later works. Ryūkōsai's prints, almost exclusively of Kabuki actors and in the narrow *hosoban* format, form an interesting footnote to ukiyo-e history, but basically they are awkward and lacking in the verve and style that characterized Edo ukiyo-e.

Alas, this may be said of the Ōsaka Prints in general—whether by Ryūkōsai's pupils **Shōkōsai** Hambei (fl. 1795–1809) and Yūrakusai **Nagahide** (fl. 1799–1840), or by such later masters as **Hokushū, Ashiyuki, Hokuei, Yoshikuni, Shigeharu** and **Hirosada.** (Hokusai's followers in Ōsaka—Shigenobu, Gakutei, *et al.*—belong in a different category; they were generally Edo men transplanted into the commercial capital of the west.)

However this is not to deny the manifest interest of the Ōsaka Prints. They are most often skillfully drafted and immaculately printed; indeed, *surimono* and other special editions of Edo prints were sometimes subcontracted to the masterly Ōsaka artisans. What these prints lack is the special élan and flavor of Edo ukiyo-e, a characteristic that removes them (together with *Nara-e, Ōtsu-e, Nagasaki-e, Yokohama-e* and most *surimono*) from the mainstream of the ukiyo-e tradition.

In addition to the prints and book illustrations of this period, ukiyo-e painting also flourished in the Kamigata region, particularly in Kyōto, where the influence of the naturalistic Maruyama-Shijō School was strongly felt. The most striking Kyōto master was Gion **Seitoku** (ca. 1781–1829), whose semi-realistic geisha paintings form a curious amalgamation of Maruyama and ukiyo-e styles. He was followed by Mihata **Jōryū** or Jōryō (fl. 1830s to 1840s), who was the direct pupil of the leading Shijō master Toyohiko, and who formed a school that dominated Kamigata ukiyo-e painting throughout the remainder of the century.

Kiyochika and the Demise of Ukiyo-e

For the most characteristic figure of late nineteenth-century ukiyo-e prints, we must turn to Kobayashi **Kiyochika** (1847–1915), who is unique in that he represents both the last important ukiyo-e master and the first noteworthy print artist of modern Japan. However, since the ukiyo-e print tradition practically died with Kiyochika, it is probably more accurate to regard him as an anachronistic survival from an earlier age, a minor hero whose best efforts to adapt ukiyo-e to the new world of Meiji Japan were not quite enough.

Kiyochika was the son of a minor government official, but lost his inheritance with the revolution, i.e. the Meiji Restoration of 1868. Subsequently he studied the new art of photography under a Japanese pioneer in Yokohama and Western-style painting under the English artist Charles Wirgman, who was the correspondent in Japan for the *Illustrated London News.* Thus, ironically yet logically, Kiyochika, the last of the ukiyo-e masters, directly embodied in his own art the two innovations that were to spell the doom of ukiyo-e. Just as in Western painting photography is often seen as the cause of the decline in the art of portraiture, so too it hastened the demise of ukiyo-e. By the mid-nineteenth century, the Japanese "pictures of the floating world" were being sold principally to a popular audience that little understood or appreciated the unique art form it was supporting. When a more novel and cheaper method of depicting the current scene appeared—mass-produced photoengraving—ukiyo-e prints were automatically doomed. (Ukiyo-e paintings, however, with a more aristocratic and stable basis of support, have continued in mutated form to the present day.)

Of course had photography and English art proved the principal sources of Kiyochika's work, he would hardly require mention here. However, he had been a self-taught artist from an early age, and had subsequently studied under such masters of traditional Japanese painting as Kyōsai, Zeshin and Chingaku. When in 1877 Kiyochika started producing his famous landscape prints, the results combined not only those varied influences but above all a strong flavor of ukiyo-e, most probably derived from a study of the works of Hiroshige and Kuniyoshi.

198 **Kiyochika:** *Shrine in the Rain. Ōban* size, 1877 (Meiji X). Signature: Kobayashi Kiyochika.
A woman hidden by her umbrella walks in the mud; a coolie squats by his rickshaw station. The scene is set at the melancholy Umewaka Shrine in Tōkyō, which was built in memory of a kidnapped child who died there in ancient times.

雪夜通甼本

199 **Kiyochika:** *Street Scene on a Snowy Night. Ōban* size, 1880 (Meiji XIII). Signature (on the left): Kobayashi Kiyochika *hitsu*; publisher (notation on the right): Fukuda Kumajirō. Exact title: *Honchō-dōri yoru no yuki* [Night Snow on Main Street, Nihon-bashi].
Its driver barely visible, a Western-style horsecart speeds through Tōkyō's snowy streets that are lit by gas lamps. This is the Meiji world, and ukiyo-e is approaching its final moment.

Kiyochika's new style of print design was a logical extension of Kuniyoshi's earlier work in a semi-Western manner. For the first time in woodblock prints the popular Japanese audience found their local scenes depicted in a manner both exotically foreign yet not as alien as the copperplate experiments of Kōkan and Denzen nearly a century earlier.

Kiyochika's prints were a popular success, and he produced them in great numbers during the years 1876 to 1881, which marked an early peak in his art. Kiyochika continued to sketch and publish throughout most of his long life, but his extensive work in book, magazine and newspaper illustration, his cartoons and his large triptychs glorifying the

battles of the Sino-Japanese and Russo-Japanese wars, seldom equal his early still lifes or his abundant genre scenes of the Tōkyō landscape that form such a fascinating contrast to those of Hiroshige.

Indeed, in Japan, Kiyochika is often dubbed the Hiroshige of the Meiji Era; but to the foreign viewer their similarities are largely restricted to subject matter. Certainly what Kiyochika most lacks is the dramatic vision, the unified poetic view of nature that pervades the best work of Hiroshige. In contrast to that earlier master, Kiyochika is most often a successful but hardly a great realist, an artist whose prints may cause pleasant pangs of nostalgia for the Japan of the 1870s and 1880s. More often his prints seem to be a substitute for creative photography rather than an outstanding artistic achievement. Of course the traditional Japanese criticism of Hiroshige himself says: out of one hundred prints, eighty are dull, ten excellent, nine superior, one breathtaking. Although Kiyochika never reached the level of Hiroshige's breathtaking work, a similar assessment could doubtless apply to his oeuvre; a successful Kiyochika print, such as those shown in plates 198 and 199, surely ranks with the landscapes of Kuniyoshi and Kunisada. With Kiyochika, however, a non-artistic factor intervenes, an element that may well put his work permanently outside the range of collectors whose only interest in Japan is in its prints.

This problem arises from the age in which Kiyochika lived and worked—the first period of wholesale adoption of the appurtenances of Western civilization in Japan. Thus, although we are able to savor appreciatively and perhaps nostalgically the quaint flavor of our own nineteenth-century engravings, there is something incongruous and basically ugly to us in the image of a sedate Japanese gentleman sporting English bowler and black umbrella in the midst of an otherwise enchanting landscape. To the Japanese of Kiyochika's time such elements had, on the contrary, considerable fascination; they were symbols of a great but only half-known civilization that was soon to overwhelm the Japanese nation and conquer at least the superficial side of its life. Kiyochika's lack of popularity in the West today rests in his honest realism and in the indiscriminately catholic tastes of his contemporary audience. The bowler and black umbrella may be splendid symbols of the superficial encroachments of Western civilization in Meiji Japan, but to Westerners they are incompatible with an idealized image of old Japan, and hence (at least until the Western visitor knows Japan well enough to feel his own kind of nostalgia for its nineteenth century) they are repelled by the un-Japanese elements in Kiyochika and may well prefer to state categorically, "ukiyo-e died with Hiroshige."

The new Western elements were so popular in the Japan of Kiyochika's time that they probably pervade his prints far more than they did the actual lives of many of his contemporaries. For the sake of restoring Kiyochika to his proper place as the last of the important ukiyo-e print artists, it would certainly be useful to form a collection of the many prints in which foreign elements are absent or play but a minor role. Such a selection would, however, omit a majority of his most notable prints, so predominant was the taste for exotic foreign elements in his day—and ever since. Even in plate 198, the foreign elements only escape us due to our own forgetfulness: though the rickshaw seems very Oriental to us today, it appears actually to have been the invention of an American missionary in the Japan of Kiyochika's youth!

More than anything else, it was Daguerre's invention that spelled the end of Kiyochika's art and that of notable disciples such as **Ryūson** and **Yasuji.** By the time the public started to comprehend vaguely that photography, however wonderful an invention, could only rarely approach even the minor achievements of a Kiyochika, the habit of buying prints was dead forever; and so for the main part were the remarkable artisans who had made the prints possible.

Europe's discovery of the Japanese print came, moreover, too late to effect a revival. Even had foreign enthusiasm erupted decades earlier, it is painful to imagine a man like Kiyochika having to cater to rose-colored foreign tastes, reverting to archaic Hokusai-Hiroshige concepts as the only alternative to abandoning his art. The ever-changing ukiyo-e print was always an essentially Japanese art, deeply rooted in the native soil; at its best, it was guided by an inspired group of artists and critics, but in its later stages it was seldom more than a hair's breadth removed from the dictates of popular taste.

Before and After the Opening of Japan

With the Meiji Restoration of 1868, in all cultural fields Japan underwent a change so revolutionary that it would be difficult to believe were not the effects so evident today in the life of modern Japan. The change was all the more abrupt for following two and a half centuries of strict seclusion, during which contact with the rest of the world was strictly limited to trade with a few Dutch and Chinese ships per year in the isolated port of Nagasaki. Curiosity about the West was practically at fever pitch by the time Japan was opened to foreign influences, even among those who, for political and personal reasons, opposed the move in principle.

We have already seen how, in ukiyo-e, vaguely comprehended concepts of Western art had been seized upon as ultramodern, enjoying a wider popularity than the artistic results justified. It may be well to recall here some of the non-ukiyo-e pioneers of Western-style art in Japan, the men to whom such artists as Toyoharu, Hokusai, Hiroshige, Kuniyoshi and Kiyochika owed their basic acquaintance with Western-style perspective and realistic depiction.

Gennai, Kōkan, Denzen and several minor artists had pioneered the production of Western-style oil paintings and engravings in the eighteenth century. Though these men often chose contemporary Japanese scenes as the subjects of their work, such etchings, prints and paintings were hardly ukiyo-e and, in general, bore little relation to any of the traditions of Japanese art. However several ukiyo-e artists soon followed the lead of these early experimenters, applying semi-Western techniques to Japanese scenes. The results were usually ukiyo-e, despite their superficially Occidental overtones. By the time Hokusai produced his great landscapes, these foreign elements had been well digested and provided a needed stimulus to a revolt against the worn-out conventions into which ukiyo-e figure and landscape depiction had fallen. With Hokusai and Hiroshige this foreign element became so well integrated that it is imperceptible to the average viewer today; nevertheless, its subconscious influence has, in the West, rendered these two artists the best loved (or at least, the most readily understood) Japanese masters to the exclusion of dozens of equally admirable artists, in ukiyo-e as well as in many other styles.

One subdivision of Japanese prints may be mentioned incidentally here, the *Nagasaki-e* [Nagasaki Prints]. These were a group of folk-art prints, produced in Nagasaki mainly from the mid-eighteenth to the mid-nineteenth century, usually by anonymous artists of only moderate ability. They served as souvenirs for visitors to the only port with foreign connections and depicted, principally, quaint Chinese and Dutch scenes and figures in a semi-foreign style. In general they were printed according to local adaptations of traditional ukiyo-e methods. The Nagasaki Prints form an interesting chapter in Japanese cultural history but are seldom of major artistic significance. Nevertheless, they have attracted a passionate group of collectors. The *Nagasaki-e* are generally most successful as art when representing exotic animals and foreign ships on the open sea, where the combination of detailed observation plus excellent color printing often produces an effective pattern of folk art.

Similar remarks apply to the *Yokohama-e* [Yokohama Prints], which depict the early foreign traders in that port after the opening of Japan in the 1850s. The Yokohama-Print designers were generally ukiyo-e artists, among the best of whom were Sadahide, Hiroshige II, Yoshitoyo, Yoshikazu and Yoshitora. The genre flourished mainly during the early 1860s, when Japanese curiosity about the strange foreigners was strong. Only rarely, however, do the *Yokohama-e* escape from the bounds of their exotic subject matter and succeed in achieving the status of fine art.

200 **Nagasaki Print:** *Chinese Ship. Ōban* size, ca. later 1840s (Kōka Period). Publisher (seal on lower left): Yamato-ya.
Eisen's pupil Bunsai brought his knowledge of Edo ukiyo-e techniques back to his home town Nagasaki in the 1840s and effected a revival of the *Nagasaki-e* [Nagasaki-Print] genre, which had by then sunk to the level of a repetitive folk art. Here two large Chinese trade junks are seen entering Nagasaki Bay with their flags flying. The design and printing are immaculate—a characteristic of the Nagasaki Prints as issued by Yamato-ya.

Neo-ukiyo-e

This concluding section is an attempt to provide a link between the past and the present. Therefore, it seems best to begin with a brief consideration of ukiyo-e's last struggles in the revolutionized world of new Japan.

Preface

It was well over two decades ago that James Michener suggested to this writer the idea of an encyclopedia of ukiyo-e, encompassing all the extant knowledge on this intricate subject. Alas, funds were not forthcoming for what would have been a long-term project, and the present, far more modest *Illustrated Dictionary of Ukiyo-e* represents instead a summary of the preliminary notes made over the last twenty years while the author was in the midst of other, less academic activities. In effect, it is an alphabetization of the mass of facts and conjectures that clutter the mind (and sometimes even interrupt the dreams) of any serious student in the field. The following notes summarize the writer's attempt in this book to wrest some kind of order out of this embarrassment of riches:

Biographical Entries: In these, the artist's best-known name is given first, followed by dates (often only approximate, those of his known active life) and by a concise biography. An asterisk precedes the school and/or family surname (alternate names are in parentheses) and various given names and *noms d'artiste* (alternate readings of the Japanese characters are given in brackets in the same list). For the more significant artists, the names are followed by lists of print series and titles of books and albums where available. In smaller type, there may be a specialized bibliography and, preceded by an arrow, cross references to other entries in the Dictionary itself, as well as to the main text and plates. For incidental literary and historical figures, the entries are more simplified. Japanese characters (and a number of artists' signatures) have been added in the margins to the biographical entries for the more important names that — with many others — are also cross-referenced in a separate index at the end of the Dictionary.

Other Entries: In addition to a full glossary of ukiyo-e, these include geographical, historical, literary and theatrical terms related to ukiyo-e, with bibliographical references and Japanese characters for the more noteworthy entries.

Romanization: For ease of comprehension, abundant use has been made of hyphens in Japanese words; these are always based on etymological units. Apart from this the main deviations from standard romanization consist in a preference for the hyphen rather than the apostrophe after glottal n (e.g. Kan-ei rather than Kan'ei) and the use of internal capitalization within titles only where an earlier title is quoted *(Ehon Suikoden)* and within names where an honorific prefix or an abbreviated form occurs (O-Sen, Tsuta-Jū). To facilitate reference to prior works on ukiyo-e, alternate readings, archaic romanization and even some common misreadings are often included in brackets after the more correct form.

Captions and Dating: Whereas the captions to the plates are as complete as possible, including data on the subject, medium, size, date (with *nengō*), series title, signature, seals, publisher, background etc., and whereas Japanese titles are translated wherever space permitted (which was not the case with Kabuki plays, for the titles are only incidental to the discussion), the captions to most Dictionary figures give only a concise identification of the artist, subject, size and date. However certain Dictionary figures have longer captions than the others; these are items of special significance, which could not be included in the main plates because of space limitations. The form "Genroku XI/2/3" (11th year, Second Month, 3rd day) is used for *nengō* dates, but "II/3/1698" is used when referring to the lunar calendar with the approximate Gregorian year. When a print can only be dated by making an educated guess, the form given is "late 1690s," but more specific dates (ca. 1698, 1697–99) are often retained where these appear in established monographs, on Moronobu, Kiyonaga, Eishi, Hokusai, Kuniyoshi, or the Ōsaka Prints.

Inconsistencies and Matters of Controversy: A certain effort has been made to avoid overemphasizing those byways of ukiyo-e in which the author has specialized but which may not be of great general interest: the Primitives, book illustration, ukiyo-e painting and shunga. In the case of Hokusai, however, some years of specialized study plus a helpful subsidy made it possible to prepare a lengthy entry, nearer to the writer's ideal than the others. With the publisher's permission this has been included in full, despite its disproportionate, near monographic size. In order to make the Dictionary more nearly comprehensive, numerous brief entries have also been included on such neglected, semi-ukiyo-e subjects

The Contemporary Audience of Ukiyo-e.
See Moronobu, figure 552

as genre painters of other schools, *surimono,* Osaka Prints, *dōban* and neo-ukiyo-e, though these may prove of more use to future generations of students and collectors than to the present one.

Ukiyo-e Research: For the serious student, this book can only provide a springboard into the fascinately complex field of ukiyo-e studies. Nine-tenths of the subjects in this volume have never been examined in detail even in Japan; practically every entry deserves an essay; many of them a book. Indeed it is not without a tinge of regret that this first, necessarily rudimentary endeavor is passed on to the printer, for it is an effort doomed from its inception to imperfection, but which may, it is hoped, point the way for future research.

<div align="right">

Kyōto-London-Paris-Fribourg
late Spring, 1978

</div>

Table of Approximate Print and Book Sizes

Common Japanese print and book sizes mentioned in the text and captions are roughly as follows:

Prints

aiban:	13×9	in.	34.2×22.5 cm
chūban:	10×7½	in.	26×19 cm
hashira-e:	28¾×4¾	in.	73×12 cm
hosoban:	13×5⅝	in.	33×14.5 cm
kakemono-e:	30×9	in.	76.5×23 cm
large-*ōban:*	22¾×12½	in.	58×32 cm
ōban:	15×10	in.	38×25.5 cm
[chu-] tanzaku:	15×5	in.	38×13 cm

Books

chūbon:	7×4¾	in.	18×12 cm
hanshi-bon:	9×6¼	in.	23×16 cm
ōbon:	10½×7½	in.	27×19 cm
yokobon:	4¼×6¾	in.	11×17 cm

[For convenience, smaller painting sizes are cited in print dimensions; for greater detail on sizes, see Dictionary entries.]

List of Signs

* for artists: school and/or family surname (alternate names in parentheses) and *noms d'artiste* (alternate readings in brackets)

▷ cross references to other dictionary entries and/or to the pages and plates of the main text

● in bibliographies, indicates titles of special interest; in print series, indicates particularly important works

Italic numbering is continuous throughout the Dictionary; larger series have, in addition, a separate numbering within the series.

A

Abe-kawa: river flowing through Suruga (39 miles/63 km long)

Abeno: a plain in Settsu, scene of several battles

abuna-e: risqué pictures: mildly erotic ukiyo-e
▷ plate 81

actors' crests: *mon,* or heraldic .crests, were widely used among the samurai to identify their possessions and accouterments, and this practice was adopted as well by the Kabuki actors, with the *mon* often forming a striking decorative pattern on their robes. In the prints, this crest is often the only positive key to identifying the actor. Since several generations of actors often used the same *mon,* specific identification of the individual actor may well require a study of the dating of the print from other angles (printing, coloring, artist, Kabuki chronology, style, etc.).

The following charts are arranged by shape: squares, circles, miscellaneous forms. Dates of stage activity given are sometimes approximate, and only the more prominent actors have been included, with emphasis on the main period of Kabuki development, the 18th and early 19th centuries. In addition to their best known stage name (*geimei*), which was often changed several times during their careers, actors were sometimes known as well by a *yagō,* or "house-name," and they frequently adopted a *haimyō,* or nom de plume, as well; these alternate names are given here in italics within the parentheses. The *mon* themselves include the *jōmon* or "standard crest," and the less common *kaemon* or "alternate crest." The notation M or F indicates the roles (male or female), for which the actor was most famous. Where known, dates of various name-changes are recorded as well.

Yoshida, Teruji. *Ukiyo-e jiten.*
Nihon engeki daijiten.
Binyon, Laurence and J. J. O'Brien, Sexton. *Japanese Colour Prints.*
▷ plate 49

 Ichikawa Danjūrō I (*Narita-ya, Saigyū*): fl. ca. 1671–1704

 Ichikawa Danjūrō II (*Sanshō, Hakuen*); Kuzō (1703); Ebizō (1735): M., fl. 1697–1756; also used by Raizō I

Ichikawa Danjūrō V (*Narita-ya, Sanshō, Hakuen*; Matsumoto Kōzō; 1754, Kōshirō III; 1791, Ebizō III): M., fl. 1754–1802; also used by Kōshirō II, 1754–70; by Danzō III and by Danjūrō VI

 Nakamura Shichisaburō I: fl. 1700–07

 Ichikawa Danzō I (*Shikō*): M., fl. ca. 1695–1740; from late 1731 removed the crossbar

 Nakamura Shichisaburō II (1770, *Shōchō*): M., fl. 1711–73

 Onoe Kikugorō I (*Baikō*): fl. 1742–73

 Ichigawa Masugorō (*Sanshō,* 1735, Danjūrō III fl. 1727–41): M., sometimes used *mon* without center character

 Ichikawa Yaozo I (*Matsujima,* Yaozō also Yaozō II and Yūjirō): M., fl. 1747–59

 Ichikawa Danzō IV (*Mikawa-ya, Shikō*; Kame-ya, Torazō; 1763, Nakamura Torazō; 1768, Ichikawa Tomozō; 1772, Dansaburō): M., fl. 1768–1801

 Ichikawa Kōmazō II (*Kōrai-ya, Kinshō,* Danzō): M., fl. 1770–1801; from late 1801 became Matsumoto Kōshirō V; same *mon* with "o" in center: Omezō

 Sawamura Kodenji: fl. 1700–02

 Sodezaki Nuinosuke: fl. 1702–11

 Nishikawa Kōnosuke: fl. 1700–02

 Nakamura Senya: fl. 1716–18

 Iwai Sagenda: fl. 1700–12

 Matsushima Hyōtarō: fl. 1700–25

 Yoshizawa Ayame I: fl. 1713–14

 Tsutsui Kichijurō: fl. 1704–15

 Arashi Kiyosaburō: fl. 1707–13 (also used by other actors playing "O-Shichi" role)

 Ichikawa Monnosuke I: fl. 1700–27; also Monnosuke II

 Iwai Hanshirō II: M., fl. 1700–10; also sometimes used by Hanshirō III, fl. 1722–56

 Tomizawa Hansaburō: M., fl. 1710–18

 Nakajima Kanzaemon I: M., fl. 1700–1710; also used by Nakajima Mioemon I: M., fl. 1714–62; and by Mioemon II [Miozō]: fl. 1755–82

 Matsumoto Kōshirō I: M., fl. 1700–29

 Ogawa Zengorō: M., fl. ca. 1711–32

 Nakamura Kichibei: M., fl. ca. 1716–1739

 Sodeoka Shōtarō: F., fl. ca. 1716–33

 Bandō Hikosaburō I (*Shinsui*): M., fl. 1729–49

 Arashi Sangorō (*Raishi*): M., fl. 1726–1729

 Ōtani Hiroemon II (*Ryūzaemon*): M., ca. 1725–47

 Sawamura Sōjurō I (*Tosshi*): Chōjūrō, 1747; Suketaka-ya Takasuke, 1753; M., fl. 1718–55; also Sōjuro III and Yūjirō

 Sodezaki Miwano: F., fl. ca. 1725–35

 Hayakawa Shinkatsu: F., fl. ca. 1703–1738

 Yamashita Kinsaku I: F., fl. 1711–42

 Anegawa Shinshirō: M., fl. 1732–34 (*kaemon*)

 Segawa Kikunojō I (*Rokō*): F., fl. 1730–48; also Kikunojō II, III and Yūjirō

 Kaemon of Ogino Isaburō and of other Ogino actors

 Ogino Isaburō: fl. ca. 1724–47

 Sodezaki Iseno: F., fl. ca. 1726–45

 Sanjō Kantarō: Hanai Saisaburō II, 1746, fl. 1714–49

 Ōtani Hiroji I (*Jitchō*): M., fl. 1701–1743; also Hiroji II (Bunzō) 1736, Bandō Matatarō; 1743, Ōtani Oniji I, M., fl. 1735–56, also used by Hiroji III

 Ichimura Uzaemon VIII (*Kakō*, Takenojō; 1737, Uzaemon): M., fl. 1709–59 (Also used by Uzaemon IX)

 Yoshizawa Ayame II (*Shunsui*, Sakinosuke II): F., fl. 1745–52; also Ayame IV (*Tachibana-ya, Shunsui*) Yamashita Koshikibu, Ichigorō; 1755, Yoshizawa Goroichi; 1764, Sakinosuke III

 Arashi Wakano: fl. 1722–58

 Tsuuchi Monsaburō (*Shōkō*, Ōtani Rokuzō, Tsuyama Tomozō, 1751): M., fl. 1732–51

 Tsuru-ya Namboku: M., fl. 1732–52

 Arashi Koroku I (*Sanchō*): F., fl. 1746–55; also used by Arashi Hinaji: fl. 1763–74

 Nakamura Sukegorō I (*Gyoraku*, Kumetarō; 1736 Sengoku Sukegorō): M., fl. 1725–63; also Sukegorō II

 Matsumoto Kōshirō II (*Gōryū*, Shichizō; Danjūrō IV 1754–1770; Ichikawa Ebizō II 1772): M., fl. 1719–76; also Kōshiro IV

 Takinaka Kasen (Takenaka, Tosshi; Utagawa Shirogorō, 1743; Sawamura Sōjūrō II, 1749): fl. 1734–69

 Nakamura Utaemon I (*Kaga-ya Issen*, Utanosuke): M., fl. 1757–70

 Segawa Kikujirō (*Sengyō*): F., fl. 1731–55

 Ichikawa Danzō III (*Mikawa-ya Shikō*, Bandō Jirosaburō; Ichikawa Jirosa-burō; 1739, Ichikawa Dansaburō II): M., fl. 1739–72

 Nakamura Denkurō II (*Maizuru*, Katsujūrō, Kanzaburō VIII, 1775): M., fl. 1733–75

 Tomizawa Montarō: F., fl. ca. 1730–49

 Tamazawa Saijirō: fl. ca. 1733–51

 Sanokawa Ichimatsu I (*Seifu*): fl. 1741–1762

 Ichimura Uzaemon IX (*Kakitsu*, Manzō; 1745, Kamezō): M., fl. 1731–85 (*kaemon*); *jōmon* ▷ Uzaemon VIII

 Osagawa Tsuneyo I: F., fl. 1750–66

 Morita Kanya VI (*Zankyō*, Takinaka Shigenoi; 1740, Sawamura Shigenoi; 1746, Sawamura Kodenji): fl. ca. 1736–70

 Yamashita Kinsaku II (*Tennōji-ya Rikō* and Nakamura Handayū): F., fl. 1752–94

 Sakata Hangorō II (Sengoku Sajūrō): M., fl. 1742–82; also, Hangorō III (Bandō Kumajirō, Kumajurō, Sakata Hanjūrō): 1756–95

 Bandō Hikosaburō II (Kikumatsu): fl. 1749–68; also, Hikosaburō III

 Iwai Hanshirō IV (*Yamato-ya Tojaku*, Matsumoto Chōmatsu; 1762, Shichizō): fl. 1753–1800; also, Kumesaburō

 Sawamura Sōjūrō III (*Kinokuni-ya Tosshi*, Tanosuke): M., fl. 1759–1800

 Osagawa Tsuneyo II (*Wata-ya Kyosen*, Shichizō): F., fl. 1763–1808

 Nakamura Nakazō II (*Sakai-ya, Shūkaku*, Ōtani Nagasuke; 1778, Haruji II; 1787, Oniji III): M., fl. 1778–96

 Ichikawa Danjūrō VI (*Narita-ya Sanshō*. Tokuzō; 1782, Ebizō IV): M., fl. 1782–99 (*kaemon*)

 Kamimura Kichisaburō: fl. 1700–08

 Nakamura Takesaburō: fl. 1700–20

 Hayakawa Hasse: fl. 1703–28

 Nakamura Denkurō I (*Maizuru*): fl. 1700–13; also used by Nakazō I (often with "*naka*" in center)

 Yamanaka Heikurō (*Senka*): fl. 1700–1722

 Katsuyama Matagorō: fl. 1707–23

 Ichikawa Sōsaburō: M., fl. 1731–53

 Sanokawa Mangiku: fl. 1718–43

 Fujimura Hanjūrō (Handayū): fl. ca. 1714–58

 Arashi Otohachi (*Wakō*, Otanosuke): M., fl. 1732–68

 The *kaemon* of Nakamura Shichisaburō II, fl. 1711–73

 The *kaemon* of Kōshirō II

 Jōmon of Onoe Kikugorō I

 Nakamura Tomijūrō I (*Keishi*): fl. 1731–78

 Nakamura Kiyosaburō: F., fl. 1749–58

 Azuma Tōzō I (Ikujima Daikichi; Agemaki Rinya, 1756–60): F., fl. 1730–74

 Nakamura Kumetarō I (*Richō*): F., fl. 1748–55

 Ichikawa Raizō I (*Tokai-ya Gempei, Arashi Tamagashiwa*; 1753, Ichikawa Masuzō): fl. 1743–66 (*kaemon*)

 The *kaemon* of Hangorō II

 Ichikawa Yaozō II (*Chūsha*, Nakamura Denzō): M., fl. 1751–77 (*kaemon*)

 Nakamura Nakazō I (*Sakae-ya Shūkaku, Ichijurō*): M., fl. 1745–89 (*kaemon*) Same as above 1785–86 (*Nakayama Kojūrō*)

Matsumoto Kōshirō IV (*Kōrai-ya Kinkō*, Segawa Kinji; 1757, Ichikawa Takejūrō; 1763, Somegorō; 1763, Komazō I): M., fl. 1754–1800

Segawa Kikunojō II (*Hamamura-ya Rokō*, Kichiji): F., fl. 1750–72 (*kaemon*)

Nakamura Matsue (*Rikō*, Matsuemon; 1773, Rikō): F., fl. 1761–85

Same, ca. 1769, of Nakamura Matsue

Ichikawa Monnosuke II (*Takino-ya Shinsha*, Takinaka Tsuruzō; 1759, Hidematsu; 1762, Benzō): M., fl. 1756–94 (*kaemon*)

Onoe Matsusuke (*Otowa-ya Sanchō*): fl. 1756–1814

Bandō Mitsugorō I (*Yamato-ya Zegyo*): M., fl. 1766–82; also Mitsugorō III

Nakamura Sukegorō II (*Sengoku-ya Gyoraku*, Sengoku Sukeji): M., fl. 1761–98 (*kaemon*)

Ōtani Hiroji III (*Maru-ya Jitchō*, Haruji; 1758, Oniji II): M., fl. 1755–98 (*kaemon*)

Bandō Mitsugorō II (*Yamato-ya Zegyo*, Onoe Monsaburō; 1799, Ogino Isaburō II): M., fl. 1774–1829 (*kaemon*)

Segawa Yūjirō (*Kinokuni-ya Kiin*, Sawamura Kimbei; 1767, Shirogorō; 1769, Segawa Yūjirō; 1777, Shirogorō; 1779, Ichikawa Yaozō III; 1809, Suketaka-ya Takasuke): fl. 1764–1808 (*kaemon*)

The *kaemon* of Hanshirō IV

Segawa Kikunojō III (*Hamamura-ya Rokō*, Tomisaburō; 1807, Senjō): F., fl. 1774–1810 (*kaemon*)

Nakamura Noshio I: F., fl. 1770–77

Bandō Hikosaburō III (*Otawa-ya Shinsui*, Ichimura Kichigorō): M., fl. 1759–1811 (*kaemon*)

Iwai Kumesaburō (*Baiga, Tojaku*): F., fl. 1787–1804, when changed to Hanshirō V

Ichikawa Omezō (*Takino-ya Shinsha*, Bennosuke): M., fl. 1776–1824

Adachi-ga-hara: dwelling-place of a legendary old cannibal woman of Ōshū, sometimes represented with a kitchen knife preparing to kill a child

Adams, Will (d. 1620): English pilot on the Dutch ship "Erasmus," stranded at Bungo in 1600; he was engaged by the Japanese to build schooners and employed in commercial transactions with the Dutch and English; in Japanese known as Anjin [The Pilot]

agemaku: vestibule to the *hanamichi*

age-ya: house of assignation to which ranking courtesans were summoned by patrons

ai ▷ pigments

aiban (*ai-nishiki*): print size between *chūban* and *ōban*, about 13×9 in./34×22.5 cm (half of a *hōsho* sheet; *kō-bōsho*)

ai-kyōgen: comic interlude in dramas

Ainu (Ebisu): the aboriginal race of Japan

Aioi-jishi: a variation of the traditional "lion dance"

airō ▷ pigments

Aizen Myōō: Buddhist deity, a manifestation of Dainichi Nyorai

ai-zuri [blue prints]: the *ai-zuri-e* technique of repeated printings in shades of blue was a fairly successful attempt to evade the government's austerity edicts of 1842 against the more colorful *nishiki-e*

aka-hon: a form of children's illustrated booklet, popular ca. 1675–1735; also, books printed in red, given to smallpox patients as a talisman

Akagi-san: a volcano in eastern Kōzuke

Akahito, Yamabe no (early 8th century): important *waka* poet of the *Man-yō-shū*; one of the gods of *waka* poetry

Akazome-emon: early 11th-century court lady, remarkable for her poetical and literary talents

Akemi, Tachibana (1823–68): *waka* poet of the late Edo Period

Akera Kankō (1740–1800): noted *kyōka* poet of Edo
*Yamazaki, Kagetsura

Akimichi: a medieval tale of vendetta, probably 15th century

Akinari, Ueda (1734–1809): noted fiction writer and *waka* poet of the mid Edo Period

Akisue, Fujiwara no: *waka* poet of the late Heian Period

aki no nana-kusa [The Seven Grasses of Autumn]: traditionally powdered and used to season New Year's soup and as such symbols of the New Year: *hagi* (lespedeza), *susuki* (eularia) or *obana* (miscanthus), *kusu* (pueraria), *nadeshiko* or *tokonatsu* (dianthus), *ominaeshi* (patrinia), *fuji-bakama* (lupatorium), *asagao* (convolvulus)

Aki-no-yo-no naga-monogatari: a noted medieval tale of pederasty, probably 15th century

Akita: capital of Ugo Province, governed by the Satake *daimyō*

Akita School: artists of Akita who specialized in pseudo-Western painting in the 18th century

Akitsu-shima [Land of the Dragon-fly]: term used in poetry to designate Japan

Akō: town in Harima, famous for its *daimyō* Asano Naganori and the "Forty-seven *Rōnin*"

Akoya: famous courtesan of Kyōto, mistress of the Heike captain Kagekiyo

ama ▷ *bikuni*

ama-dera: a nunnery

amado: wooden shutters

Amakusa-no-ran: the Shimabara Rebellion

Ama-no-hashidate: a famous scenic landscape in Tango

Ama-no-kawa [Heavenly River]: the Milky Way

Amaterasu (ō-mikami): the Sun Goddess, the ancestral divinity of Japan

Amida: the Buddha Amitabha

Amida no honji: a Buddhist tale of the previous existence, probably 15th century

Anchi (fl. ca. 1710s): ukiyo-e painter and print artist, a leading master of the Kaigetsudō School; possibly the son of Ando

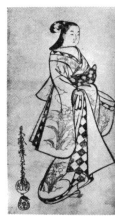

1

Anchi: *Standing Courtesan.* Large-*ōban sumizuri-e*, ca. early 1710s

*Kaigetsudō, Anchi [Yasutomo] Chōyōdō ▷ Ando; p. 71, plate 58

anchor [*ikari*]: symbol of security

Ando (fl. early 18th century): famous ukiyo-e painter in Asakusa, Edo. We know nothing of Ando's actual training but certain influences are clearly evident in his work: most important is that of Moronobu and his pupils, notably Moroshige and Sugimura; the works of the Kyōto illustrators Hambei and Yoshikiyo should also be compared with the early Kaigetsudō paintings. From the details of these masters' works, Ando perhaps learned the basic pattern of his style. Again, the genre/courtesan paintings of the mid 17th century might well be considered the direct inspiration for Ando's majestic female figures. The influence of Ando's younger contemporaries Kiyonobu, Kiyomasu, Masanobu and Chōshun may also be cited, though they probably learned more from Ando than they taught him
*Kaigetsudō Ando
Lane, Richard. *Kaigetsudō*. Tōkyō, 1959
Ficke, Arthur Davison. "The Prints of the Kwaigetsudo." In *The Arts.* vol. IV, no. 2 (New York, 1923)
▷ Kaigetsudō School; pp. 68–71, plates 56–57

andon: a type of oil lamp with a stand

An-ei (1772–81): the An-ei [An'ei] Period dates from XI/16/1772 to IV/2/1781 and forms an intermediate stage between the glories of Meiwa (1764–72) and the Golden Ages of Temmei and Kansei (1781–1801). During the An-ei era, Koryūsai, Shigemasa, Toyoharu, Shunshō and his pupils Shunkō and Shunjō did their best work. For the masters of the coming decade—Kiyonaga, Shunchō, Utamaro—this was a period of apprenticeship. ▷ *nengō*

aniline colors ▷ pigments

Ansei (1854/55–1860): this period, which dates from XI/27/1854/55 to III/18/1860, is notable for the Great Earthquake of Ansei II (1855), Townsend Harris's arrival the following year, a cholera epidemic (in which the great Hiroshige died), treaties with America, Russia, Holland, England and France in Ansei

V (1858) and the opening of Yokohama port in the following year. As far as ukiyo-e is concerned, the masters of the prior age merely continued their abundant output on over-used themes. Certain of Hiroshige's *Hundred Views of Edo* were a rare exception to the general decline in quality. ▷ *nengo*

Antoku: 81st sovereign of Japan (1181–83), replaced by his brother Go-Toba; perished at the Battle of Dan-no-ura, when only 7 years old

亜欧堂田善 **Aōdō Denzen** (1748–1822): western-style painter, print artist; studied copperplate etching with an unidentified Dutchman in Nagasaki and with Shiba Kōkan
*Nagata, Zenkichi, Chūta, Aō-chinjin, Jotan, Seizandō
▷ *dōban*

青本 **aohon**: illustrated booklets, predecessors of the *kibyōshi*

aragoto [rough stuff]: a type of flamboyant Kabuki acting developed by Danjūrō I (1660–1704) for heroic roles

改 **aratame**: censorship seal, used from early 1854 to 1871; or "name changed to" used by artists when adopting a new nom de plume ▷ censor's seals

Arima: village in Settsu, renowned for its hot springs

Arimaro, Kada no (1706–51): scholar of Japanese classics during the mid Edo Period

Aro-kassen monogatari: fictional parody on a war tale, probably 15th century

Asahina [Asaina] **Saburō**: mythical warrior of the 12th–early 13th century, son of Tomoe-gozen. His feats include a descent to Hades, as well as assisting the Soga Brothers in their vendetta

Asaka-yama: volcano in Shinano; erupted in 1783

asa-murasaki ▷ pigments

Asatada, Chūnagon (10th century): classical *waka* poet

Asazuma-bune: boat used by "floating harlots"

Ashiaki (fl. ca. 1820s): ukiyo-e print artist, Ōsaka School

芦舟 **Ashifune** (fl. ca. 1814–25): ukiyo-e print artist, Ōsaka School

芦広 **Ashihiro** (fl. ca. 1820): Ōsaka ukiyo-e print artist; pupil of Ashikuni
*Harukawa Ashihiro

Ashihisa (fl. 1810s): ukiyo-e print artist, Ōsaka School

Ashikaga-gakkō: a celebrated medieval school, center of the study of Confucianism

Ashikaga Period: the period of the Ashikaga shogunate, from 1336 to 1573

芦清 **Ashikiyo** (fl. ca. 1810s): ukiyo-e print artist, Ōsaka School

Ashikizu (fl. ca. 1820): ukiyo-e print artist, Ōsaka School

芦国 **Ashikuni** (ca. 1775–1818): leading Ōsaka ukiyo-e print artist; pupils include Ashimaro, Ashitomo, Ashiyuki
*Asayama (Nunoya), Chūzaburō, Kyōgadō, Ran-eisai, Ransai, Roshū, Seiyōsai
▷ Ōsaka-Print School

ashi-naga: long-legged mythical personages

芦貫 **Ashinuki** (fl. ca. late 1810s): ukiyo-e print artist, Ōsaka School

芦郷 **Ashisato** (fl. ca. 1800s–10s): ukiyo-e print artist, Ōsaka School
*Fūchikukan

芦尚 **Ashitaka** (fl. ca. 1817): Ōsaka ukiyo-e print artist, pupil of Ashikuni

芦 *Ashihisa, Ashinao

芦友 **Ashitomo** (fl. ca. 1804–30): Ōsaka ukiyo-e

print artist, pupil of Ashikuni

芦幸 **Ashiyuki** (fl. first half 19th century): Ōsaka ukiyo-e print artist, pupil of Ashikuni
*Ashigadō, Gigadō (1818–32), Nagakuni (1814–21)
▷ Ōsaka-Print School

ason: the second rank among the nobles of the Court

Asuka-yama: hill at Ōji, north of Edo, famous for its cherry blossoms

Atago: Shintō god who protects towns from fires; also a hill in the Shiba district of Edo, with a famous shrine to this deity

Ataka: Noh drama relating the famous story of Benkei and Yoshitsune at the Ataka Barrier Station; known in Kabuki under the name *Kanjin-chō*

Atami: a seaport on Izu, renowned for its hot-springs

atari: a successful stage play

atenashi-bokashi: "random shading," a technique of color printing

ato-zuri: late impression of a print

Atsuko, Saisho (1825–1900): *waka* poetess of Kyōto, Satsuma and Tōkyō

Atsumori: Noh drama relating the remorse of the priest Renshō (formerly Kumagae no Naozane) who had killed the fair young Atsumori at the Battle of Ichi-no-tani

Atsumori, Taira (1169–84): young warrior who fought bravely at Ichi-no-tani but was killed by Naozane

Atsuta: town in Owari, celebrated for its Great Shrine

awabi: the abalone

ayatori: the game of cat's cradle

azana: a type of nom de plume

Azari no Hara, Jōjin (early 11th century): *waka* poetess and writer of the mid Heian Period

Azuchi: place in Ōmi where Nobunaga built his magnificent castle

–azukari: chief artist of the *e-dokoro* and keeper of the Imperial collections

Azuma and Yogorō: famous lovers of the 18th century, often celebrated in ukiyo-e ▷ Hokusai (Series 21)

Azuma [The East]: poetic name for the Eastern Provinces, or for Edo

Azuma-asobi: early folk songs of the East

Azuma-kagami: a history of Japan, treating the years 1180 to 1266

Azumamaro, Kada no (1669–1736): scholar of Japanese classics and *waka* poet

Azuma nishiki-e [Edo embroidery pictures]: a flowery term for ukiyo-e prints

azusa: catalpa, wood used for early printing blocks

B

Baen (fl. ca. 1790s–1800s): ukiyo-e print artist, Ōsaka School, pupil of Hokusai

Baien (fl. ca. late 1810s): ukiyo-e print artist, Ōsaka School

梅寿 **Baiju** (1847–99): ukiyo-e print artist and illustrator in Tōkyō and Yokohama, pupil of Kunisada

楳樹 *Yamamura, Kunitoshi, Kiyosuke, Baiju-hōnen, Baiō

Baika (fl. ca. 1819–30s): ukiyo-e print artist,

Ōsaka School; possibly the *nom d'artiste* of the actor Nakamura Tomijūrō II

Baikan (1784–1844): *nanga* painter, did genre work in his youth
*Sugai, Tōsai, Gaku (Tomoyoshi), Gakuho, Shōkei, Baikan-sanjin

Baikei (fl. mid 1810s): ukiyo-e print artist, Ōsaka School
*Nenkorō

Baikōsai (fl. ca. 1805): ukiyo-e print artist, Ōsaka School

bai-ōban [double-ōban]: print size, about 18×13¾ in./46×35 cm; frequent in the Primitives, 1660–1765

Bairei (1884–95): pupil in Kyōto of the Maruyama-Shijō painter Raishō; then, at 27, of the Shijō-School artist Bunrin; did some genre work
*Kōno (Yasuda), Naotoyo, Shijun, Kakusaburō, Chōandō, Hoppo, Kakurokuen, Kisencharyō, Kōun, Kōun-shinsho, Kumo-no-ie, Musei-shioku, Nyoi-sanshō, Ōmu, Rokuyū, Sanshu-kashitsu, Seika-zembō, Seiryūkan, Shumpūrō, Zaigoan

Baisetsudō (fl. ca. mid 1750s–mid 1760s): Kyōto ukiyo-e print artist
*Sadamichi

Baitei (1734–1810): *nanga* painter, some genre work
*Kino, Kyūrō, Kyūrō-sanjin, Tokitoshi, Bin, Shikei, Baika, Gan-iku

馬琴 **Bakin, Takizawa** [Kyokutei] (1767–1848): leading writer of popular fiction in the *yomihon* and *kusa-zōshi* genres during the late Edo Period, often collaborated with Hokusai

baku: mythical animal who feeds on bad dreams, having the appearance of a goat-like tapir

bakufu: the successive military dictatorships of Japan, extending from 1200 to 1868

Bakusui, Hori (1718–83): *haiku* poet of the mid Edo Period

bamboo: symbol of virtue, fidelity

bamboo and sparrows [take-ni-suzume]: a common art theme, symbolic of gentleness and friendship

Bandō: the Tōkaidō provinces

banishment [tsuihō]: under the Tokugawa regime there were 6 degrees: *tokoro-barai*, being forbidden to enter one's native place; *Edo-barai*, prohibited from entering Edo; *Edo jūri-shihō-barai*, prohibited from approaching within 10 leagues of Edo; *kei-tsuihō*, prohibition from Nikkō, the Tōkaidō, Ōsaka and Kōfu as well; *chū-tsuihō*, forbidden as well to the Kiso-kaidō and Kyōto and Wakayama, Nagoya, Mito, Nara, Sakai, Fushimi and Nagasaki; *jū-tsuihō*, residence forbidden in any of the major cities and provinces ▷ punishments

Banri [Manri] (fl. ca. early 1780s): ukiyo-e print artist, influenced by Kiyonaga; possibly a pseudonym of Hokusai

Bansho shirabe-dokoro: a school founded in 1856 at Edo for the study of European sciences

Banzuiin Chōbei shōin-manaita: a Kabuki drama, commonly called *Suzu-ga-mori*, first staged at the Nakamura-za in 1789; the role of Chōbei was acted by Kōshirō IV and Gompachi by Hanshirō V

banzuke: a program for dramas, wrestling, etc.

baren: a circular rubbing pad used in woodblock printing

Bashō (1644–94): distinguished *haiku* poet; painted *haiga* as a hobby

bat [kōmori]: traditional symbol of good fortune

Beisen (1852–1906): Kyōto genre painter; pupil of Hyakunen
*Kubota, Hiroshi, Kampaku, Jinkai-tōda, Kinrishi, Kusa-no-ya, Shirōken
bekkakko: derisive gesture of pulling down the lower eyelid
beni: red/pink pigment extracted from the *benibana*, safflower
▷ pigments

紅絵 **beni-e**: a *sumizuri-e* hand-colored in vegetable colors such as orange or red, yellow, blue, green (in older books sometimes confused with *benizuri-e*: in the 18th century almost synonymous with *urushi-e*; due to its ambiguity, not used here)
beni-gara ▷ pigments
beni-girai-e: color prints having no pink pigments

紅摺絵 **benizuri-e**: a true color print in rose and green, sometimes with yellow, blue or gray, all printed from blocks (sometimes with overprinting to produce three colors from two blocks)
Benkei [Musashibō Benkei]: 13th-century soldier-monk of Hieizan; later, trusted adviser to Yoshitsune
Ben-no-naishi (mid 13th century): *waka* poetess of the late Kamakura Period
Benten [Benzaiten; Sarasvati]: goddess of learning and good fortune, often represented with *biwa* (lute); one of the Seven Gods of Luck
bijin: beautiful girl
bijin-ga (bijin-e): figure painting or print depicting beautiful girls
bikuni: a Buddhist nun; also a disguise adopted by itinerant prostitutes
Bimbō-gami: the god of poverty
Bimyō, Yamada (1868–1910): novelist, poet and scholar of the Japanese language
bin: side wing of coiffure
bin-sashi: a strip of thin bone used in the wings of a coiffure
Bishamon [-ten] (Vaisravana): one of the Seven Gods of Luck, customarily shown with spear and pagoda
biwa: a lute with four strings (Chinese *p'i p'a*)
biwa-hōshi: blind minstrels who played the *biwa*
Biwa-ko [Lake Biwa]: in Ōmi Province, near Kyōto, renowned for its beautiful scenery, the so-called "Eight Views"
Bizen-za: an Edo puppet theater
Black Ships [kuro-fune]: the Japanese expression for Perry's fleet
blind men: most often shown as shampooers and musicians
Blomhoff, J. Cock: director of the Factory at Deshima in 1817
bodhisattva (Japanese: *bosatsu*): Buddhist deity
bokashi: graded color-printing
bōkoku-bon: books printed privately in the early 17th century

墨僊 **Bokusen** (1736–1824): Nagoya ukiyo-e painter, print and *dōban* artist; when Hokusai came to Nagoya in 1812, Bokusen helped in the designs for the first volume of the *Manga*; also a pupil of Utamaro
* Maki, Utamasa Shin-ei [Nobumitsu], Hokutei, Hyakusai, Tokōro
Bokutō (early Meiji): *dōban* artist
*Ishida Bokutō
bombori: candlestick with handle
bon: the Festival of the Dead, celebrated from the 13th to the 15th days of the Seventh Month

Bonchō (d. 1714): *haiku* poet of the early to mid Edo Period
Bō-no-tsu: Satsuma port for foreign ships
bonsai: dwarfed, potted trees
Bonten: the god Brahma
Bontō, Asayama (ca. 1349–1427): a *renga* poet of the early Muromachi Period
Book Illustration, Early Ukiyo-e: Japanese printed book illustration began with Chinese-derived Buddhist texts in the early 13th century but did not feature designs in native style until the work of the Saga Press, notably the *Tales of Ise* of 1608 (plate 16). Such early works were executed in the traditional Tosa style, but with the Kan-ei Period (1624–1644/45) the influence of genre painting increased, leading eventually to the development of the Ukiyo-e School of illustration from the late 1640s (plate 17)
Although the names of Hanada Takumi and of Shōgorō are recorded as Yoshida Hambei's predecessors in the field of Kyōto ukiyo-e, no signed works by them exist. Nevertheless it is possible to discern the hands of at least 3 different artists working in the field of ukiyo-e book illustration in Kyōto during the period ca. 1647–63. These may be classified under the title of the best-known books by them:
Kyōto Style I: The Master of *Isoho monogatari* (1659) fl. ca. 1647–62: some 40 works of book illustration exist in this style, characterized by slim, graceful figures: *jōruri* plays, Buddhist tales, historical novels, didactic works, courtesan critiques and even a Japanese adaptation of *Aesop's Fables*

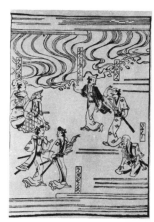

2

Style I: *Aesop and the Man Who Promised to Drink up the Ocean.* Illustration to *Isoho monogatari* [Aesop's Tales], *ōbon*, Kyōto, 1659

Kyōto Style II: The Master of *Onna-kagami* (1658) fl. ca. 1658–63: over 60 works of book illustration may be attributed to this master whose style features strong, heavy-set figures; he was the immediate predecessor of the Kambun Master and Moronobu in Edo. His prolific output includes guidebooks, novels and tales, classical literary texts, Buddhist works, actor critiques and numerous didactic works and textbooks. He may be considered a key figure in the evolution of ukiyo-e from early genre painting to woodblock prints
Kyōto Style III: The Master of *Tōkaidō meisho-ki* (ca. 1659) fl. ca. 1658–62: only 9 works are known by this master, whose style is as much influenced by the Tosa tradition as it is by ukiyo-e.

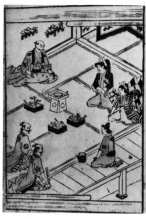

3

Style II: *Scene of Samurai Household.* Illustration to *Onna-kagami*, *ōbon*, Kyōto, 1658

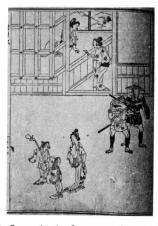

4

Style III: *Scene in the Courtesan Quarter.* Illustration to *Tōkaidō meisho-ki*, *ōbon*, Kyōto, ca. 1658

Lane, Richard. *Studies in Edo Literature and Art.*
Lane, Richard. *Studies in Ukiyo-e.*
Miuztani, Yumihiko. *Kohan shōsetsu sōga-shi.*
▷ pp. 32–34
Bōryōken [Banryūken] (fl. ca. 1720s): Kaigetsudō-School painter, exhibiting a graceful style of his own, perhaps closest to the manner of Shigenobu
Bōshin-no-eki: the civil war of 1868
Bōtō-ni, Nomura (1806–67): *waka* poetess of the late Edo Period
bōzu: Buddhist monk, a bonze
bugaku: a type of ceremonial court dance
bugyō: head of an administration
bukan: book of heraldry, with details regarding all of the *daimyō*
buke: the military class
bumbuku-chagama [The Lucky Teakettle]: story of a priest of Morinji and his magic teakettle, which assumes the shape of a badger and runs about
Bummei (d. 1813): Maruyama-School painter in Kyōto; pupil of Ōkyo but did some genre work
*Oku, Teishō [Sadaaki], Hakki, Junzō, Rikuchinsai, Seika
Bumpō (1779–1821): leading Kishi-School painter in Kyōto, did some genre work; his albums influenced the landscapes of Kuniyoshi and Kunisada
*Kawamura, Shunsei, Basei, Chikurikan, Goyū, Hakuryūdō, Shuyōkan, Yūmō

文調 **Bunchō** (fl. ca. 1765–92): ukiyo-e painter, print artist; a samurai who first studied Kanō painting; later, influenced by Harunobu. In 1770 he collaborated with Katsukawa Shunshō in the noted *Ehon butai-ōgi*, three volumes of portraits of stage celebrities. Bunchō combined the lyricism of Harunobu with the realism of Shunshō to produce some of the most uniquely individual prints in ukiyo-e. The depiction of actors was his speciality, but part of his greatest work lay in the girls and courtesans.
*Kishi, Uemon, Ippitsusai, Seishi, Hajintei, Sōyōan
▷ pp. 111–116, plates 106–109

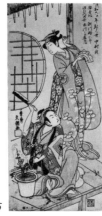

5

Bunchō: *Komazō and Yūjirō in a* Hachi-no-ki *Play. Hosoban*, 1769 (as is recorded in the early manuscript inscription on the print)

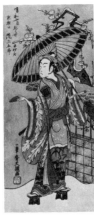

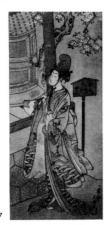

6 7

Bunchō: *Sangorō in Kabuki Role. Hosoban*, 1770

Bunchō: *Hanshiro V as Kiyohime* (standing by the Dōjōji bell). *Hosoban*, 1770

文朝 **Bunchō** (fl. ca. mid 1760s–90s): ukiyo-e painter, print artist and illustrator; first studied Kanō-style painting, then became a pupil of Ippitsusai Bunchō
*Yanagi, Nanryūsai
Bunchō II (fl. late 18th century): ukiyo-e painter, pupil of Yanagi Bunchō
Bungorō, Daidōzan: famous child wrestler of the Kansei Period
▷ Sharaku figs
bunjin: man of letters (associated with the scholar-painters of the *nanga* School)
bunjin-ga ▷ *nanga*
文化 **Bunka** (1804–1818): the Bunka Period, dating from II/11/1804 to IV/22/1818, represents the commencement of the Decadent Age of

ukiyo-e figure prints, a clear reflection of the turbulent times. The Government was too concerned with the threatening approach of Russian ships and missions to attend to necessary reforms at home. The merchant class flourished and gained an increasing economic hold over the samurai, but unlike the Temmei era a generation earlier, during the Bunka Period wealth was expressed in unrestrained luxury rather than in refined dilettantism. In literature, wit was gradually replaced by broad comedy (as in the works of Ikku and Samba) and genre romantic fiction by tales of vendetta, the supernatural and Chinese-derived extravaganzas (Bakin). Kabuki themes showed the same transmutations; many roles lost their impromptu nature and were standardized in the set forms still prevalent today. Utamaro died in Bunka III (1806) and with him ended the great age of the figure print, for none of his followers possessed sufficient genius to lead this genre to new heights, even if the epoch had been more receptive
The world of the figure print turned increasingly to depicting Kabuki, a field largely dominated by Toyokuni and his school, who were skilled artists but lacking in imaginative genius. Only Hokusai (already in his mid forties) stood apart from this trend, but he too could not remain uninfluenced by the taste of the times, turning from stylish genre design to illustration and paintings in the Chinese manner and producing copy-books for art students. ▷ *nengō*
Bunkyō (1767–1830): ukiyo-e print artist, illustrator, author; pupil of Eishi
*Sakura (Sakuragawa), Jihinari
文久 **Bunkyū** (1861–1864): the Bunkyū Period, which dates from II/19/1861 to II/20/1864, saw an increasingly weak central government vainly attempting to control the nation with empty decrees and reforms. After Kuniyoshi's death in Bunkyū I (1861), only Kunisada remained of the older masters; despite their limitations probably the flourishing *Yokohama-e* should be considered the main contribution to ukiyo-e from this period. ▷ *nengō*
Bunraku: Bunraku-za, the Ōsaka puppet theater; later, used for the puppet theater in general
Bunrin (1808–77): Shijō-School painter, did some genre work
*Shiokawa, Shion, Zusho, Chikusai, Kachikusai, Kibutsuan, Kibutsu-dōjin
文浪 **Bunrō** (fl. 1800–10): ukiyo-e print artist; first a pupil of Ippitsusai Bunchō, later influenced by Utamaro

8

Bunrō: *Kontoki and Yamauba. Ōban*, ca. early 1800s

Bunryūsai (fl. mid–late 18th century): ukiyo-e print artist, teacher of Eishi
*Torii Bunryūsai
Bunsan (mid 19th century): *dōban* artist, pupil of Ryokuzan and Shuntōsai
*Nakamura, Seigyokudō, Taizan, Saishū
文政 **Bunsei** (1812–1830/31): the Bunsei Period dates from IV/22/1818 to XII/10/1830/31 and formed an extension of the decadent trends in art and literature that characterized the preceding Bunka Period. With the government preoccupied by ceremonial duties and frustrated by foreign affairs, the leaderless populace expressed itself in pleasure and ostentation, retaining few vestiges of the refined dandyism of earlier generations. In the provinces, Ōsaka and Nagasaki Prints flourished and with Toyokuni's death in Bunsei VIII (1825), Kunisada, Kuniyoshi and Eisen took the lead in Edo figure design. The major development in ukiyo-e lay in the landscape print; Hokusai produced his great *Fuji* series during the late Bunsei Period, and Hiroshige began his own career as a landscapist. ▷ *nengō*
Bunshō sōshi: a tale of success and social advancement, probably 15th century
Busei (1776–1856): *nanga* painter, did some genre work
*Kita, Kaan, Shinshin, Goseidō, Kakuō
bushi: a warrior
bushidō: the way of the samurai
Buson (1716–83): *nanga* painter and poet, did some genre work
*Yosa (Taniguchi, Sha), Nobuaki, Shinshō, Busei, Chōkō, Sha Shunsei, Sha-in, Shunsei, Yahan-ō, Yahantei
busshari: the Buddha's remains; also name of a theatrical farce
butsuga: a painting on Buddhist themes
武禅 **Buzen** (1783–1810 or 1734–1806): Ōsaka ukiyo-e (later *nanga*) painter; studied with Settei
*Sumie (Osada), Dōkan, Michihiro, Shizen, Sozō, Mōrosai, Shingetsu, Shinrōsai, Bokkōsai
byōbu: a folding screen
Byōdō-in: a temple of the Tendai sect at Uji, south of Kyōto

C

calendar, Japanese: dates employing *nengō* [era-names] are relatively easy to calculate, but the Japanese used other, more complex systems of dating as well, which will be outlined here.

1 Year-cycles [*kanshi*]: these consisted of 60-year units, commencing (for the ukiyo-e period) in 1624, 1684, 1744, 1804 and 1864. They were recorded by means of the *eto*, a combination of the *jikkan* (10 "celestial stems") and *juni-shi* (12 zodiacal signs), which are summarized below:

1 kinoe ne (rat)	甲 子
2 kinoto ushi (ox)	乙 丑
3 hinoe tora (tiger)	丙 寅

4 hinoto u (hare)

5 tsuchinoe tatsu (dragon)

6 tsuchinoto mi (snake)

7 kanoe uma (horse)

8 kanoto hitsuji (goat)

9 mizunoe saru (monkey)

10 mizunoto tori (cock)

11 kinoe inu (dog)

12 kinoto i (boar)

13 hinoe ne (rat)

14 hinoto ushi (ox)

15 tsuchinoe tora (tiger)

16 tsuchinoto u (hare)

17 kanoe tatsu (dragon)

18 kanoto mi (snake)

19 mizunoe uma (horse)

20 mizunoto hitsuji (goat)

21 kinoe saru (monkey)

22 kinoto tori (cock)

23 hinoe inu (dog)

24 hinoto i (boar)

25 tsuchinoe ne (rat)

26 tsuchinoto ushi (ox)

27 kanoe tora (tiger)

28 kanoto u (hare)

29 mizunoe tatsu (dragon)

30 mizunoto mi (snake)

31 kinoe uma (horse)

32 kinoto hitsuji (goat)

33 hinoe saru (monkey)

34 hinoto tori (cock)

35 tsuchinoe inu (dog)

36 tsuchinoto i (boar)

37 kanoe ne (rat)

38 kanoto ushi (ox)

39 mizunoe tora (tiger)

40 mizunoto u (hare)

41 kinoe tatsu (dragon)

42 kinoto mi (snake)

43 hinoe uma (horse)

44 hinoto hitsuji (goat)

45 tsuchinoe saru (monkey)

46 tsuchinoto tori (cock)

47 kanoe inu (dog)

48 kanoto i (boar)

49 mizunoe ne (rat)

50 mizunoto ushi (ox)

51 kinoe tora (tiger)

52 kinoto u (hare)

53 hinoe tatsu (dragon)

54 hinoto mi (snake)

55 tsuchinoe uma (horse)

56 tsuchinoto hitsuji (goat)

57 kanoe saru (monkey)

58 kanoto tori (cock)

59 mizunoe inu (dog)

60 mizunoto i (boar)

2 Long months [*dai-no-tsuki*, 30 days] and short months [*shō-no-tsuki*, 29 days]: as noted in the text, the Japanese months were of two lengths only (with an intercalary month inserted occasionally to take up the excess days—indicated here by the symbol +). *E-goyomi* [calendar prints] usually include a list of the long or short months of the year (sometimes both), plus the zodiacal symbol or pictorial representation of them, sometimes the complete *eto*, and (rarely) the *nengō* as well. The following chart combines the data for (1) *nengō* year, (2) number in the 60-year cycle, (3) Gregorian dates, (4) long and short months.

NENGŌ				LONG MONTHS	SHORT MONTHS
Tenna	I	天和	(58) II/9/1681–I/28/1682	2, 6, 8, 10, 11. 12.	1, 3, 4, 5, 7, 9
	II		(59) I/29/1682–I/17/1683	2, 3, 7, 9, 11. 12.	1, 4, 5, 6, 8, 10
	III		(60) I/18/1683–II/5/1684	1, 3, 5, 7, 9, 11.	2, 4, 5+, 6, 8, 10, 12
Jōkyō	I	貞享	(1) II/6/1684–I/24/1685	2, 3, 5, 7, 10. 12.	1, 4, 6, 8, 9, 11
	II		(2) I/25/1685–I/13/1686	2, 4, 5, 7, 9, 11.	1, 3, 6, 8, 10, 12
	III		(3) I/14/1686–II/1/1687	1, 3, 4, 6, 7, 9, 11.	2, 3+, 5, 8, 10, 12
	IV		(4) II/2/1687 I/22/1688	1, 4, 6, 7, 9, 10, 12.	2, 3, 5, 8, 11
Genroku	I	元禄	(5) I/23/1688–I/10/1689	2, 5, 7, 9, 10, 11.	1, 3, 4, 6, 8, 12
	II		(6) I/21/1689–I/29/1690	1, 2, 5, 7, 9, 10, 11.	1+ 3, 4, 6, 8, 12
	III		(7) I/30/1690–I/18/1691	1, 3, 6, 9, 10, 12.	2, 4, 5, 7, 8, 11
	IV		(8) I/19/1691–II/6/1692	1, 2, 4, 7, 9, 10, 12.	3, 5, 6, 8, 8+, 11
	V		(9) II/7/1692–I/25/1693	1, 3, 4, 7, 10, 12.	2, 5, 6, 8, 9, 11
	VI		(10) I/26/1693–I/14/1694	1, 2, 4, 6, 8, 11.	3, 5, 7, 9, 10, 12
	VII		(11) I/15/1694–II/2/1695	1, 2, 4, 5, 6, 8, 10.	3, 5+, 7, 9, 11, 12
	VIII		(12) II/3/1695–I/23/1696	1, 3, 4, 6, 8, 9, 11.	2, 5, 7, 10, 12
	IX		(13) I/24/1696–I/12/1697	1, 4, 6, 7, 9, 10, 12.	2, 3, 5, 8, 11
	X		(14) I/13/1697–I/31/1698	2, 4, 6, 8, 9, 11, 12.	1, 2+, 3, 5, 7, 10
	XI		(15) II/1/1698–I/20/1699	2, 5, 8, 9, 11, 12.	1, 3, 4, 6, 7, 10
	XII		(16) I/21/1699–II/8/1700	1, 3, 6, 9, 10, 11, 12.	2, 4, 5, 7, 8, 9+
	XIII		(17) II/9/1700–I/27/1701	1, 3, 6, 9, 11.	2, 4, 5, 7, 8, 10
	XIV		(18) I/28/1701–I/16/1702	1, 3, 5, 7, 10, 12.	2, 4, 6, 8, 9, 11
	XV		(19) I/17/1702–II/4/1703	1, 3, 4, 6, 8, 10, 12.	2, 5, 7, 8+, 9, 11
	XVI		(20) II/5/1703–I/24/1704	2, 3, 5, 6 8, 10.	1, 4, 7 9, 11, 12
Hōei	I	宝永	(21) I/25/1704–I/13/1705	1, 3, 5, 6, 8, 9, 11.	2, 4, 7, 10, 12
	II		(22) I/14/1705–II/1/1706	1, 4, 5, 7, 8, 10, 11.	2, 3, 4+, 6, 9, 12
	III		(23) II/2/1706–I/22/1707	1, 4, 7, 8, 10, 11, 12.	2, 3, 5, 6, 9
	IV		(24) I/23/1707–I/11/1708	2, 5, 8, 10, 11, 12.	1, 3, 4, 6, 7, 9
	V		(25) I/12/1708–I/29/1709	1, 3, 5, 8, 10, 11, 12.	1+, 2, 4, 6, 7, 9
	VI		(26) I/30/1709–I/18/1710	2, 3, 6, 9, 11, 12.	1, 4, 5, 7, 8, 10
	VII		(27) I/19/1710–II/5/1711	2, 3, 5, 7, 9, 11.	1, 4, 6, 8, 8+, 10, 12
Shōtoku	I	正徳	(28) II/6/1711–I/26/1712	1, 2, 3, 5, 7, 10, 12.	4, 6, 8, 9, 11
	II		(29) I/27/1712–I/14/1713	2, 5, 7, 8, 10.	1, 3, 4, 6, 9, 11, 12
	III		(30) I/15/1713–II/3/1714	1, 2, 3, 5, 6, 7, 9, 10, 12.	4, 5+, 8, 11
	IV		(31) II/4/1714–I/23/1715	3, 5, 7, 8, 10, 11.	1, 2, 4, 6, 9, 12
	V		(32) I/24/1715–I/13/1716	1, 2, 4, 7, 8, 10, 11, 12.	3, 5, 6, 9
Kyōhō	I	享保	(33) I/14/1716–I/30/1717	2, 4, 7, 9, 10, 12.	1, 2+, 3, 5, 6, 8, 11
	II		(34) I/31/1717–I/19/1718	1, 2, 5, 8, 10, 11.	3, 4, 6, 7, 9, 12
	III		(35) I/20/1718–II/7/1719	1, 2, 4, 6, 9, 10+, 12.	3, 5, 7, 8, 10, 11
	IV		(36) II/8/1719–I/27/1720	1, 2, 4, 6, 9, 11.	3, 5, 7, 8, 10, 12
	V		(37) I/28/1720–I/16/1721	1, 2, 4, 5, 7, 10, 12.	3, 6, 8, 9, 11
	VI		(38) I/17/1721–II/4/1722	2, 4, 5, 7, 8, 10, 12.	1, 3, 6, 7+, 9, 11
	VII		(39) II/5/1722–I/24/1723	2, 4, 6, 7, 9, 11.	1, 3, 5, 8, 10, 12
	VIII		(40) I/25/1723–I/14/1724	1, 3, 6, 7, 9, 10, 12.	2, 4, 5, 8, 11
	IX		(41) I/15/1724–II/1/1725	1, 4, 6, 8, 9, 10, 12.	2, 3, 4+, 5, 7, 11
	X		(42) II/2/1725–I/21/1726	1, 4, 7, 9, 10, 12.	2, 3, 5, 6, 8, 11
	XI		(43) I/22/1726–I/10/1727	1, 3, 5, 8, 10, 12.	2, 4, 6, 7, 9, 11
	XII		(44) I/11/1727–I/29/1728	1, 1+, 3, 5, 8, 10, 12.	2, 4, 6, 7, 9, 11
	XIII		(45) I/30/1728–I/7/1729	1, 3, 4, 6, 9, 11.	2, 5, 7, 8, 10, 12
	XIV		(46) I/8/1729–II/5/1730	1, 3, 4, 6, 8, 9+, 11.	2, 5, 7, 9, 10, 12
	XV		(47) II/6/1730–I/26/1731	1, 3, 5, 6, 8, 10, 12.	2, 4, 7, 9, 11
	XVI		(48) I/27/1731–I/15/1732	2, 4, 6, 8, 9, 11.	1, 3, 5, 7, 10, 12
	XVII		(49) I/16/1732–II/2/1733	1, 3, 5+, 7, 8, 9, 11.	2, 4, 5, 6, 10, 12

NENGŌ	LONG MONTHS	SHORT MONTHS
XVIII (50) II/3/1733–I/23/1734	1, 3, 6, 8, 9, 11. 12.	2, 4, 5, 7, 10
XIX (51) I/24/1734–I/12/1735	2, 4, 7, 9, 11, 12.	1, 3, 5, 6, 8, 10
XX (52) I/13/1735–I/31/1736	1, 3, 4. 7, 9, 11. 12.	2, 3+, 5, 6, 8, 10
Gembun I 元 (53) II/1/1736–I/19/1737	2, 3, 5, 8, 11, 12.	1, 4, 6, 7, 9, 10
II 文 (54) I/20/1737–II/7/1738	2, 3, 4, 6, 9, 11, 12.	1, 5, 7, 8, 10, 11+
III (55) I/8/1738–I/27/1739	2, 3, 5, 7, 9, 11.	1, 4, 6, 8, 10, 12
IV (56) I/28/1739–I/17/1740	1, 3, 5, 6, 8, 10, 12.	2, 4, 7, 9, 11
V (57) I/18/1740–II/4/1741	2, 5, 6, 7+, 8, 10,12.	1, 3, 4, 7, 9, 11
Kampō I 寛 (58) II/5/1741–I/24/1742	2, 5, 7, 8, 10, 11.	1, 3, 4, 6, 9, 12
II 保 (59) I/25/1742–I/14/1743	1, 3, 6, 8, 10, 11, 12.	4, 5, 7, 9
III (60) I/15/1743–II/2/1744	2, 4, 6, 9, 10, 11, 12.	1, 3, 4+, 5, 7, 8
Enkyō I 延 (1) II/3/1744–I/20/1745	2, 4, 7, 10, 11.	1, 3, 5, 6, 8, 9, 12
II 享 (2) I/21/1745–II/8/1746	1, 2, 3, 5, 8, 11, 12.	4, 6, 7, 9, 10, 12+
III (3) II/9/1746–I/29/1747	1, 2, 4, 6, 8, 11, 12.	3, 5, 7, 9, 10
IV (4) I/30/1747–I/18/1748	2, 4, 5, 7, 9, 11.	1, 3, 6, 8, 10, 12
Kan-en I 寛 (5) I/19/1748–II/5/1749	2, 3, 5, 7, 8, 10, 11.	1, 4, 6, 9, 10+, 12
II 延 (6) II/6/1749–I/26/1750	1, 4, 6, 7, 9, 10, 12.	2, 3, 5, 8, 11
III (7) I/27/1750–I/15/1751	2, 5, 7, 9, 10, 11.	1, 3, 4, 6, 8, 12
Hōreki I 宝 (8) I/16/1751–II/3/1752	1, 3, 6, 7, 9, 10, 12.	2, 4, 5, 6+, 8, 11
II 暦 (9) II/4/1752–II/2/1753	1, 3, 6, 9, 10, 12.	2, 4, 5, 7, 8, 11
III (10) II/3/1753–I/22/1754	1, 2, 7, 10, 11.	3, 4, 5, 6, 8, 9, 12
IV (11) I/23/1754–II/10/1755	1, 2, 3, 4, 7, 10, 12.	2+, 5, 6, 8, 9, 11
V (12) II/11/1755–I/30/1756	1, 2, 4, 6, 8, 11.	3, 5, 7, 9, 10, 12
VI (13) I/31/1756–II/17/1757	1, 2, 4, 6, 7, 9, 11.	3, 5, 8, 10, 11+, 12
VII (14) II/18/1757–II/7/1758	1, 3, 4, 6, 8, 9, 11.	2, 5, 7, 10, 12
VIII (15) II/8/1758–I/28/1759	1, 4, 6, 8, 9, 10, 12.	2, 3, 5, 7, 11
IX (16) I/29/1759–II/16/1760	2, 5, 7, 8, 9, 11, 12.	1, 3, 4, 6, 7+, 10
X (17) II/17/1760–II/4/1761	2, 5, 8, 9, 11, 12.	1, 3, 4, 6, 7, 10
XI (18) II/5/1761–I/24/1762	1, 3, 6, 9, 11, 12.	2, 4, 5, 7, 8, 10
XII (19) I/25/1762–II/12/1763	1, 2, 4, 6, 9, 11, 12.	3, 4+, 5, 7, 8, 10
XIII (20) II/13/1763–II/1/1764	1, 3, 5, 7, 10, 12.	2, 4, 6, 8, 9, 11
Meiwa I 明 (21) II/2/1764–II/19/1765	1, 3, 4, 6, 8, 11, 12+.	2, 5, 7, 9, 10, 12
II 和 (22) II/20/1765–II/8/1766	2, 3, 5, 6, 8, 10.	1, 4, 7, 9, 11, 12
III (23) II/9/1766–I/29/1767	1, 3, 5, 6, 8, 9, 11.	2, 4, 7, 10, 12
IV (24) I/30/1767–II/17/1768	2, 4, 6, 8, 9, 10, 11.	1, 3, 5, 7, 9+, 12
V (25) II/18/1768–II/6/1769	1, 4, 7, 8, 10, 11, 12.	2, 3, 5, 6, 9
VI (26) II/7/1769–I/26/1770	2, 5, 8, 10, 11, 12.	1, 3, 4, 6, 7, 9
VII (27) I/27/1770–II/14/1771	1, 3, 6, 8, 10, 11, 12.	2, 4, 5, 6+, 7, 9
VIII (28) II/15/1771–II/3/1772	2, 4, 6, 9, 11, 12.	1, 3, 5, 7, 8, 10
An-ei I 安 (29) II/4/1772–I/27/1773	2, 3, 5, 7, 10, 12.	1, 4, 6, 8, 9, 11
II 永 (30) I/28/1773–II/17/1774	2, 3, 4, 5, 7, 10, 12.	1, 3+, 6, 8, 9, 11
III (31) II/11/1774–I/30/1775	2, 3, 5, 7, 9, 11.	1, 4, 6, 8, 10, 12
IV (32) I/31/1775–II/18/1776	1, 3, 5, 7, 8, 10, 11.	2, 4, 6, 9, 12, 12+
V (33) II/19/1776–II/7/1777	1, 3, 5, 7, 9, 10, 11.	2, 4, 6, 8, 12
VI (34) II/8/1777–I/27/1778	1, 4, 7, 9, 10, 11.	2, 3, 5, 6, 8, 12
VII (35) I/28/1778–II/15/1779	1, 2, 5, 7+, 9, 10,11.	3, 4, 6, 7, 8, 12
VIII (36) II/16/1779–II/4/1780	1, 3, 5, 8, 10, 11.	2, 4, 6, 7, 9, 12
IX (37) II/5/1780–I/23/1781	1, 2, 4, 6, 9, 11.	3, 5, 7, 8, 10, 12
Temmei I 天 (38) I/24/1781–II/11/1782	1, 2, 3, 5, 6, 9, 11.	4, 5+, 7, 8, 10, 12
II 明 (39) II/12/1782–II/1/1783	1, 2, 4, 6, 8, 10, 12.	3, 5, 7, 9, 11
III (40) II/2/1783–I/21/1784	2, 4, 5, 7, 9, 11.	1, 3, 6, 8, 10, 12
IV (41) I/22/1784–II/8/1785	1, 2, 4, 6, 7, 9, 11.	1+, 3, 5, 8, 10, 12
V (42) II/9/1785–I/29/1786	1, 3, 6, 7, 9, 10, 12.	2, 4, 5, 8, 11
VI (43) I/30/1786–II/17/1787	2, 4, 7, 9, 10, 10+,12.	1, 3, 5, 6, 8, 11
VII (44) II/18/1787–II/6/1788	1, 4, 7, 9, 10, 12.	2, 3, 5, 6, 8, 11
VIII (45) II/7/1788–I/25/1789	1, 3, 5, 8, 10, 12.	2, 4, 6, 7, 9, 11
Kansei I 寛 (46) I/26/1789–II/13/1790	1, 2, 4, 6, 8, 10, 12.	3, 5, 6+, 7, 9, 11
II 政 (47) II/14/1790–II/2/1791	1, 3, 4, 6, 9, 11.	2, 5, 7, 8, 10, 12
III (48) II/3/1791–I/23/1792	1, 3, 4, 6, 8, 10, 12.	2, 5, 7, 9, 11
IV (49) I/24/1792–II/10/1793	2, 3, 5, 6, 8, 10, 12.	1, 2+, 4, 7, 9, 11
V (50) II/11/1793–I/30/1794	2, 4, 6, 8, 9, 11.	1, 3, 5, 7, 10, 12
VI (51) I/31/1794–II/18/1795	1, 3, 6, 8, 9, 10,11+.	2, 4, 5, 7, 11, 12
VII (52) II/19/1795–II/8/1796	1, 3, 6, 8, 9, 11, 12.	2, 4, 5, 7, 10
VIII (53) II/9/1796–I/27/1797	2, 4, 7, 9, 11, 12.	1, 3, 5, 6, 8, 10
IX (54) I/28/1797–II/15/1798	1, 3, 5, 8, 10, 11, 12.	2, 4, 6, 7, 7+, 9
X (55) II/16/1798–II/4/1799	2, 3, 5, 8, 11, 12.	1, 4, 6, 7, 9, 10
XI (56) II/5/1799–I/24/1800	2, 3, 4, 7, 9, 12.	1, 5, 6, 8, 10, 11
XII (57) I/25/1800–II/12/1801	1, 3, 4, 5, 7, 9, 11.	2, 4+, 6, 8, 10, 12
Kyōwa I 享 (58) II/13/1801–II/2/1802	1, 3, 5, 7, 8, 10, 12.	2, 4, 6, 9, 11
II 和 (59) II/3/1802–I/22/1803	2, 5, 7, 8, 9, 11.	1, 3, 4, 6, 10, 12
III (60) I/23/1803–II/10/1804	1, 2, 5, 7, 8, 10, 11.	1+, 3, 4, 6, 9, 12

NENGŌ	LONG MONTHS	SHORT MONTHS
Bunka I 文 (1) II/11/1804–I/30/1805	1, 3, 6, 8, 10, 11, 12.	2, 4, 5, 7, 9
II 化 (2) I/31/1805–II/17/1806	2, 4, 8, 9, 10, 11.	1, 3, 5, 6, 7, 8+, 12
III (3) II/18/1806–II/6/1807	1, 2, 4, 8, 10, 11.	3, 5, 6, 7, 9, 12
IV (4) II/7/1807–I/27/1808	1, 2, 3, 5, 8, 11, 12.	4, 6, 7, 9, 10
V (5) I/28/1808–II/13/1809	2, 3, 5, 6+, 8, 11.	1, 4, 6, 7, 9, 10, 12
VI (6) II/14/1809–I/3/1810	1, 2, 4, 5, 7, 9, 11.	3, 6, 8, 10, 12
VII (7) II/4/1810–I/24/1811	2, 4, 5, 7, 8, 10, 12.	1, 3, 6, 9, 11
VIII (8) I/25/1811–II/12/1812	2+, 4, 6, 7, 9, 10, 12.	1, 2, 3, 5, 8, 11
IX (9) II/13/1812–I/31/1813	2, 5, 7, 9, 10, 11.	1, 3, 4, 6, 8, 12
X (10) II/1/1813–II/19/1814	1, 3, 7, 9, 10, 11, 12.	2, 4, 5, 6, 8, 11+
XI (11) II/20/1814–II/8/1815	1, 3, 7, 9, 10, 12.	2, 4, 5, 6, 8, 11
XII (12) II/9/1815–I/28/1816	1, 2, 4, 8, 10, 12.	3, 5, 6, 7, 9, 11
XIII (13) I/29/1816–II/15/1817	1, 3, 4, 6, 8, 11	2, 5, 7, 8+, 9, 10, 12
XIV (14) II/16/1817–II/4/1818	1, 3, 4, 6, 8, 11	2, 5, 7, 9, 10, 12
Bunsei I 文 (15) II/5/1818–I/25/1819	1, 2, 4, 6, 7, 9, 11.	3, 5, 8, 10, 11
II 政 (16) I/26/1819–II/13/1820	2, 4, 5, 6, 8, 9, 11.	1, 3, 4+, 7, 10, 12
III (17) II/14/1820–II/2/1821	2, 4, 6, 8, 9, 10, 12.	1, 3, 5, 7, 11
IV (18) II/3/1821–I/22/1822	2, 5, 7, 9, 10, 12.	1, 3, 4, 6, 8, 11
V (19) I/23/1822–II/10/1823	1, 2, 6, 8, 9, 11, 12.	1+, 3, 4, 5, 7, 10
VI (20) II/11/1823–I/30/1824	1, 3, 7, 9, 11, 12.	2, 4, 5, 6, 8, 10
VII (21) I/31/1824–II/17/1825	1, 2, 5, 8, 9, 11, 12.	3, 4, 6, 7, 8+, 10
VIII (22) II/18/1825–I/6/1826	1, 3, 5, 7, 10, 12.	2, 4, 6, 8, 9, 11
IX (23) II/7/1826–I/26/1827	1, 3, 4, 6, 8, 11.	2, 5, 7, 9, 10, 12
X (24) I/27/1827–II/14/1828	1, 3, 4, 6, 7, 8, 11.	2, 5, 6+, 9, 10, 12
XI (25) II/15/1828–II/3/1829	1, 3, 5, 6, 8, 10, 11.	2, 4, 7, 9, 12
XII (26) II/4/1829–I/24/1830	2, 4, 6, 8, 9, 11, 12.	1, 3, 5, 7, 10
Tempō I 天 (27) I/25/1830–II/12/1831	3, 4, 7, 8, 10, 11, 12.	1, 2, 3+, 5, 6, 9
II 保 (28) II/13/1831–II/1/1832	2, 6, 8, 10, 11, 12.	1, 3, 4, 5, 7, 9
III (29) II/2/1832–II/19/1833	1, 3, 7, 9, 11, 11+.	2, 4, 5, 6, 8, 10. 12.
IV (30) II/20/1833–II/8/1834	2, 4, 7, 9, 11, 12.	1, 3, 5, 6, 8, 10
V (31) II/9/1834–I/28/1835	2, 3, 5, 8, 10, 12.	1, 4, 6, 7, 9, 11
VI (32) I/29/1835–II/16/1836	2, 3, 5, 6, 8, 10, 12.	1, 4, 7, 7+, 9, 11
VII (33) II/17/1836–II/4/1837	2, 4, 5, 7, 9, 11	1, 3, 6, 8, 10, 12
VIII (34) II/5/1837–I/25/1838	1, 3, 5, 7, 8, 10, 12.	2, 4, 6, 9, 11
IX (35) I/26/1838–II/13/1839	2, 4, 7, 9, 10, 12.	1, 3, 4+, 5, 6, 8, 11
X (36) II/14/1839–II/2/1840	2, 5, 7, 9, 10, 11.	1, 3, 4, 6, 8, 12
XI (37) II/3/1840–I/22/1841	1, 2, 6, 8, 10, 11, 12.	3, 4, 5, 7, 9
XII (38) I/23/1841–II/9/1842	1+, 3, 6, 8, 10, 11.	2, 4, 5, 7, 9, 12
XIII (39) II/10/1842–I/29/1843	1, 2, 4, 7, 9, 11.	3, 5, 6, 8, 10, 12
XIV (40) I/30/1843–II/17/1844	1, 2, 3, 5, 8, 9+, 11.	4, 6, 7, 9, 10, 12
Kōka I 弘 (41) II/18/1844–II/6/1845	1, 2, 4, 6, 8, 10, 12.	3, 5, 7, 9, 11
II 化 (42) II/7/1845–I/26/1846	2, 4, 5, 7, 9, 11.	1, 3, 6, 8, 10, 12
III (43) I/27/1846–II/14/1847	1, 3, 5, 6, 7, 9, 11.	2, 4, 5+, 8, 10, 12
IV (44) II/15/1847–II/4/1848	1, 3, 5, 7, 9, 10, 12.	2, 4, 5, 8, 11
Ka-ei I 嘉 (45) II/5/1848–I/23/1849	2, 5, 7, 9, 10, 11.	1, 3, 4, 6, 8, 12
II 永 (46) I/24/1849–II/11/1850	1, 3, 5, 7, 9, 10, 12.	2, 4, 4+, 6, 8, 11
III (47) II/12/1850–I/31/1851	1, 3, 6, 8, 10, 12.	2, 4, 5, 7, 9, 11
IV (48) II/1/1851–I/20/1852	1, 2, 4, 7, 9, 11.	3, 5, 6, 8, 10, 12
V (49) I/21/1852–II/7/1853	1, 2, 3, 4, 7, 9, 11.	2+, 5, 6, 8, 10, 12
VI (50) II/8/1853–I/28/1854	1, 3, 4, 5, 8, 10, 12.	2, 5, 7, 9, 11
Ansei I 安 (51) I/29/1854–II/16/1855	2, 4, 6, 7, 8, 10, 12.	1, 3, 5, 7+, 9, 11
II 政 (52) II/17/1855–II/5/1856	2, 5, 6, 8, 9, 11.	1, 3, 4, 7, 10, 12
III (53) II/6/1856–I/25/1857	1, 4, 6, 8, 9, 10, 12.	2, 3, 5, 7, 11
IV (54) I/26/1857–II/13/1858	2, 5, 6, 8, 9, 11, 12.	1, 3, 4, 5+, 7, 10
V (55) II/14/1858–II/2/1859	2, 5, 8, 9, 11, 12.	1, 3, 4, 6, 7, 10
VI (56) II/3/1859–I/22/1860	1, 3, 6, 9, 11, 12.	2, 4, 5, 7, 8, 10
Man-en I 万 延 (57) I/23/1860–II/9/1861	1, 3, 3+, 6, 9, 11, 12.	2, 4, 5, 7, 8, 10
Bunkyū I 文 (58) II/10/1861–I/29/1862	2, 3, 5, 7, 9, 12.	1, 4, 6, 8, 10, 11
II 久 (59) I/30/1862–II/17/1863	1, 3, 4, 6, 8, 9, 11.	2, 5, 7, 8+, 10, 12
III (60) II/18/1863–II/7/1864	2, 3, 5, 7, 8, 10, 12.	1, 4, 6, 9, 11
Genji I 元 治 (1) II/8/1864–I/26/1865	3, 5, 7, 8, 9, 11.	1, 2, 4, 6, 10, 12
Keiō I (2) I/27/1865–II/14/1866	1, 4, 5+, 7, 8, 10, 11.	2, 3, 5, 6, 9, 12
II 慶 (3) II/15/1866–II/4/1867	1, 3, 7, 8, 10, 11, 12.	2, 4, 5, 6, 9
III 応 (4) II/5/1867–I/24/1868	2, 4, 8, 10, 11, 12.	1, 3, 5, 6, 7, 9
Meiji I 明 (5) I/25/1868–II/10/1869	2, 3, 5, 8, 10, 11.	1, 4, 4+, 6, 7, 9, 12
II 治 (6) II/11/1869–I/31/1870	1, 2, 3, 6, 9, 11, 12.	4, 5, 7, 8, 10
III (7) II/1/1870–II/18/1871	2, 3, 5, 7, 9, 11.	1, 4, 6, 8, 10, 10+ 12
IV (8) II/19/1871–II/8/1872	1, 2, 4, 5, 7, 9, 12.	3, 6, 8, 10, 11
V (9) II/9/1872–XII/31/1872	2, 4, 5, 7, 8, 10, 12.	1, 3, 6, 9, 11

3 Calendric notations often appear in archaic script forms, the most frequent of which are given below:

First [Month]
Second
Third
Fourth
Fifth
Sixth
Seventh
Eighth
Ninth
Tenth
Eleventh
Twelfth
Intercalary

kinoe
kinoto
hinoe
hinoto
tsuchinoe
tsuchinoto
kanoe
kanoto
mizunoe
mizunoto
ne (rat)
ushi (ox)
tora (tiger)
u (hare)
tatsu (dragon)

mi (snake)
uma (horse)
hitsuji (goat)
saru (monkey)
tori (cock)
inu (dog)
i (boar)

carp [*koi*]: often represented leaping a waterfall, symbolic of great aspirations
catfish [*namazu*]: traditionally thought to be the cause of earthquakes
cats [*neko*]: often credited with supernatural powers
censors' seals: from its nature as a feudal, Confucian oriented, totalitarian government, the *bakufu* was ever jealous of its authority, inflicting severe penalties for such offenses as lèse-majesté, sedition and any other actions thought deleterious to the status quo. Before the later 18th century, censorship was carried out on general lines by local magistrates; from the year 1790, however, a more formal system was instituted in which (nominally, at least) a semi-official seal of approval was required for all prints and books prior to publication. Such seals, in various formats, appear on many of the prints of the period 1790–1874 and often form a valuable guide to dating such publications. (Censors' seals are normally absent from private, limited editions such as *surimono* and from outlaw publications such as shunga and pirated works, which were evidently condoned—or overlooked—when issued discreetly.) The following outline includes the main categories of censors' seals found in this period.

I *kiwame* (approval) seal alone: 1790/91–1804

II *kiwame* seal, often with separate seal showing the zodiacal year and the month (for a guide to the archaic calligraphic styles of such seals, and to calendar problems, see entries under calendar and *nengō*): 1805–10; sample shown: *kiwame*; Tiger XI [= Bunka III, 1806]

III *kiwame* seal, plus name of the responsible official of the publishers' guild (in this case, Iwato[-ya Kisaburō]): 1811–14

IV *kiwame* seal alone: 1815–42 (sometimes difficult to distinguish from no. I, though the calligraphy is generally more angular and geometric in form)

V Seal of ranking publication official (in the example shown, Taka[no]): 1843–47

VI Seals of two ranking publication officials (in the examples shown, Take[guchi], Wata[nabe]): 1847–52

VII Same, plus seal with year and month: II/1852–XI/53 (example of the latter seal shown: Rat VI [1852])

VIII *aratame* [approved] seal plus year month seal: XII/1853/54–XI/1857 (example shown: Hare VII [1855])

IX Year-month seal alone: XII/1857/58–XII/1858/59 (in the example shown, Horse XII, the Twelfth Month mainly falling in January 1859 of the Gregorian calendar)

X Single seal combining year-month with *aratame*: I/1859–1871 (examples shown: Monkey IV[1860], Cock X [1861], Tiger III [1866])

XI Year-month seal alone: 1872–75 (examples shown: Cock VI[1873], Dog VII [1874])

XII (From 1876 the system of censors' seals was abolished, but artists were often required to include their names, addresses and the date on prints.

Ishii, Kendō. *Nishiki-e no kaiin no kōshō* (in Japanese). Tōkyō, rev. ed. 1932.
Binyon, Laurence and J. J. O'Brien Sexton. *Japanese Colour Prints.*
▷ plates 48, 72

cha-bōzu: a servant in charge of making tea
cha-ire: a tea jar
chambara: swordfighting in Kabuki dramas
cha-no-iro ▷ pigments
cha-no-yu: the tea ceremony
Charakusai (fl. ca. 1810s): Kyōto ukiyo-e print artist
*Seikoku

chaya[-jaya]: a teahouse, restaurant; house of assignation
chidori: a sanderling or plover
Chigami-no-otome, Sano no (early 8th century): *waka* poetess of the *Man-yō-shū*
Chigo-no-sōshi [The Catamites' Scroll]: a major early shunga work, still preserved in the Sambō-in Temple of Daigo-ji

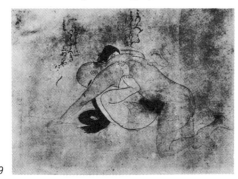

9

Chigo-no-sōshi. Painting in colors on paper, dated 1321

Chihaya: site in Kawachi province, where the patriot Kusunoki Masashige built his famous castle
Chikafusa, Kitabatake (1293–1354): *waka* poet and politician of the Northern and Southern Court Period
Chikage, Tachibana (1735–1808): noted *waka* poet and scholar of Japanese studies
周 春 **Chikaharu** (fl. second half 19th century): ukiyo-e print artist, pupil of Kunichika
*Toyohara (Hasegawa), Takejirō, Kaiōsai, Keishū
Chikako [Shinshi] (late 13th century): *waka* poetess of the late Kamakura Period
千 歌 国 **Chikakuni** (fl. ca. early 1820s): ukiyo-e print artist, Ōsaka School; pupil of Ashikuni and Yoshikuni
Chikamatsu, Monzaemon (1653–1724/25): leading playwright of the Takemoto-za in Ōsaka, author of many well-known puppet plays, later absorbed into the Kabuki repertoire
親 信 **Chikanobu** (fl. ca. 1720s): ukiyo-e painter, Kaigetsudō School. Chikanobu appears to have been one of the most popular painters of his day
*Matsuno, Hakushōken
▷ Eishun
Chikanobu (fl. early 19th century): ukiyo-e print artist, pupil of Utamaro
*Kitagawa Chikanobu
周 延 楊 洲 **Chikanobu** (1838–1912): ukiyo-e painter and print artist, studied under Kunichika
*Toyohara (Hashimoto), Naoyoshi, Ikkakusai, Kunitsuru II, Yōshū
周 重 **Chikashige** (fl. second half 19th century): ukiyo-e print artist, pupil of Kunichika
*Morikawa, Otojirō, Ichibaisai, Kichōsai
Chikubu-shima: island in Lake Biwa with temple to the goddess Kannon
Chikudō (1826–97): *nanga* painter, did some genre work
*Ki, Nei
Chikurin shichi-kejin [*Chu-lin ch'i-hsien*]: The Seven Sages of the Bamboo Grove (China, 3rd century A.D.): Kyōshū (Hsiang Hsiu), Keikō (Chi K'ang), Ryūrei (Liu Ling), Santō (Shan T'ao), Genkan (Yüan Hsien), Genseki (Yüan Chi), Ōjū (Wang Jung)
珍 重 **Chinchō** (1679–1754): ukiyo-e painter and print artist; follower of Torii Kiyonobu, in-

珍 重 fluenced by Okumura Masanobu. Chinchō's works are few; he is famous among ukiyo-e artists as being of samurai stock and working at his artistic calling only when the spirit moved him; there is a certain rough element in the Chinchō prints which lends them a unique flavor
*Hanegawa, Chinchō [Chinjū], Torii (Manaka), Motonobu (Okinobu), Ōta, Bengorō, Kaijōsai

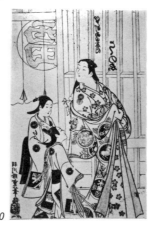

10

Chincho: *Courtesan with Maidservants.* Tan-e in large-*ōban* size, ca. 1710s (trimmed at base and some restoration, e.g. on lower left skirt)

chinzei: the military government of Kyūshū
縮 緬 絵 **chirimen-e**: creped print, reduced in size by crinkling between two beveled boards

11

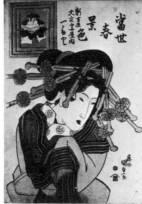

Kunisada: *The Courtesan Hitomoto.* 1830 (on the left, *chirimen-e* creped version; on the right, the *ōban* original)

Chitora (1835–1902): Nagoya genre painter, studied under Gessai; later, pupil of Mitsubumi
*Kawasaki, Chitora [Senko], Genroku, Tomotarō, Tomo-no-ya
Chiyo, Kaga no (1703–75): *haiku* poetess of the mid Edo Period
chō: surface measure, about 1 hectare
-chō: a street, section of a city
-chō [-hori]: suffix meaning "engraved by"
Chōdo uta-awase: a medieval tale whose protagonists are inanimate objects, probably 15th century
Chōei (1848–92): Ōsaka *dōban* artist, pupil of Ryokuzan
*Wakabayashi, Hōsuntei, Hanaya-an, Shunsuidō, Yūryūdō

Chōjirō (Meiji): *dōban* artist, pupil of Suisan
*Nakagawa, Kōzan
Chōkarō: the Chinese immortal Chang Kuo, often depicted producing a horse out of a gourd
長 亀 **Chōki** (fl. early-mid 18th century): ukiyo-e painter, pupil of Miyagawa Chōshun (perhaps his son)
*Miyagawa Chōki
▷ p. 90, plate 85
長 喜 **Chōki** (fl. late 18th to early 19th century): ukiyo-e painter, print artist, illustrator; pupil of Sekien. Chōki's art is in some respects as

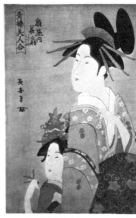

12

Chōki: *Hanaōgi with Maidservant. Ōban,* from the series *Seirō bijin-awase,* mid 1790s

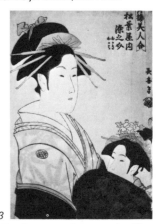

13

Chōki: *The Courtesan Somenosuke. Ōban,* ca. mid 1790s, from the series *Seirō bijin-awase*

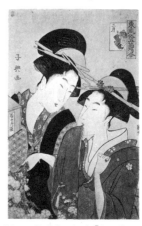

14

Chōki: *Geisha at Doll Festival. Ōban,* from the series *Azuma-fūzoku gosekku-awase,* ca. early 1800s (signed with late name, Shikō)

栄
松
斎

子
興

長
喜

子
興

baffling as Sharaku's. Amidst a quantity of ordinary prints and book illustrations we discover a small number of color prints that rank with the finest ever produced by any ukiyo-e master. Chōki studied (together with Utamaro) in Sekien's studio and his work reflects the influence of both artists, as well as something of the Sharaku manner. His idealized girl is more reminiscent of Harunobu than of Utamaro and, with his unique close-up compositions, was his greatest contribution to ukiyo-e. Though Chōki has never achieved the popular renown accorded to some of his contemporaries, a study of his few masterpieces makes one wonder if he did not surpass them all in the evocation of poetic atmosphere
*Momokawa, Eishōsai, Shikō, Shōtei
▷ p. 146, plates 149–51
choki-bune: a small open boat
Chōkō (Meiji): *dōban* artist, pupil of Chōei
*Nagai Chōkō
choku-han: Imperial editions of the classics printed from large movable type at the command of Emperor Go-Yōzei between 1593 and 1603
chōnin: the townsmen; the artisan and merchant class in the cities
Chō-ryō: the Chinese Chang Liang, a general of the Han Dynasty; also the title of a Noh drama; in ukiyo-e he is usually depicted under a bridge, picking up a sandal for his mentor, Kōseki-kō (Huang Shih-kung)
Chōryu [Nagaru], **Shimokōbe** (1624–86): *waka* poet and scholar of Japanese literature
chōshi: pot with 2 spouts

長
松

Chōshō (fl. early 19th century): ukiyo-e print artist, pupil of Chōki
*Ichirakusai
Chōshōshi, Kinoshita (1569–1649): *waka* poet of the early Edo Period

長
春

宮
川

Chōshun (1683–1753): leading ukiyo-e painter, born at Miyagawa in Owari Province but lived and died in Edo. In 1751 the aged Chōshun was commissioned by a Kanō master to do restoration work at the Nikkō Shrines; on his not being paid, an altercation ensued in which his son killed the Kanō man. For his part in this Chōshun was banished from Edo for a year. One of the masters of ukiyo-e painting, Chōshun's greatest debt was to Moronobu
*Miyagawa (Hasegawa), Chōshun [Nagaharu], Kiheiji, Chōzaemon
▷ pp. 89–90, plates 83–84

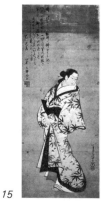

15

Chōshun: *Standing Courtesan. Kakemono* in colors on paper, ca. 1720s

Chōsui (fl. second half 19th century): ukiyo-e print artist, specializing in *surimono*
chōyō [*chōjō*]: the Chrysanthemum Festival,

9th Day of the Ninth Month
chōzu-bachi: a water-cistern, basin for washing hands
chronology of ukiyo-e ▷ *nengō*
chrysanthemum [*kiku*]: a symbol of purity (the 16-petal variety is the Imperial badge)

中
判

chūban: small print size, about 10×7½ in./ 26×19 cm (one quarter of an *ō-bōsho* sheet) ▷ *ōgata-chūban*

中
本

chūbon: the most common small book size, ca. 7×4¾ in./18×12 cm
chūgen: a samurai's manservant
Chūgoku: the 16 provinces of San-yō-dō and San-in-dō
chūhon: a variation on *yomi-hon* fiction
Chūjo-hime: heroine of the Taima-dera *mandara* legend
chūkei: a large folding fan
Chūkin (mid 19th century): *dōban* artist
chūnagon: counsellors at the Court
chū-nikai: a mezzanine
Chūshingura ▷ *Kana-dehon Chūshingura*
chū-tanzaku/tanzaku: print size about 15×5 in./38×13 cm (half of an *ōban* sheet, cut lengthwise)
Chūya, Marubashi: leader of a revolt against the Shōgun Ietsuna in 1651, for which he was arrested and crucified
cock on drum: a symbol of peace, the wardrum having fallen into disuse
Cocks, Capt. Richard: chief of the English Factory at Hirado, 1613–21
Collections of ukiyo-e: Allen Memorial Art Museum, Oberlin College, Oberlin, Ohio Andrew Dickson White Museum of Art, Cornell University, Ithaca, New York Art Institute of Chicago, Illinois Art Museum, Princeton University, New Jersey Ashmolean Museum, Oxford Atami Art Museum, Shizuoka-ken Baltimore Museum of Art, Maryland Bibliothèque Nationale, Paris British Museum, London Brooklyn Museum, New York California Palace of the Legion of Honor, San Francisco, California Center of Asian Art and Culture: Avery Brundage Collection, San Francisco, California Cincinnati Art Museum, Ohio City Art Museum of St Louis, Missouri Cleveland Museum of Art, Ohio Dayton Art Institute, Ohio Denver Art Museum, Colorado Detroit Institute of Arts, Michigan Fine Arts Museums of San Francisco, California Fitzwilliam Museum, Cambridge, England Fogg Art Museum, Cambridge, Massachusetts Freer Gallery of Art, Washington, D C. Gotō Art Museum, Tōkyō Grunwald Graphic Arts Foundation, University of California Hakone Art Museum, Gōra, Kanagawa-ken Homma Art Museum, Sakata, Yamagata-ken Honolulu Academy of Arts, Hawaii Idemitsu Art Gallery, Tōkyō Ishikawa Prefectural Art Museum, Kanazawa Itsuō Art Museum, Ōsaka Kagoshima Municipal Art Museum, Kagoshima-ken Kamakura National Treasure House Kiyomizu-dera, Kyōto Kōbe Municipal Art Museum Kotohira Shrine Museum, Kagawa-ken Kyōto City Art Museum Kyōto National Museum Lake Biwa Cultural Hall, Ōtsu Los Angeles County Museum of Art, California Metropolitan Museum of Art, New York M. H. de Young Museum, San Francisco, California Minneapolis Institute of Arts, Minnesota Musée d'Art et d'Histoire, Geneva Musée Guimet, Paris Musées Royaux d'Art et d'Histoire, Brussels Museum für Kunst und Gewerbe, Hamburg Museum für Ostasiatische Kunst, Cologne Museum für Völkerkunde, Vienna Museum of Fine Arts, Boston, Massachusetts Museum voor Land- en Volkenkunde, Rotterdam Naga-

saki Municipal Museum Nagoya Castle Treasure House National Museum, Copenhagen Nelson Gallery-Atkins Museum, Kansas City, Nebraska Newark Museum, New Jersey New York Public Library, New York Nezu Art Museum, Tōkyō Ōkura Shūko-kan, Tōkyō Ōsaka Municipal Art Museum Östasiatiska Museet, Stockholm Österreichisches Museum für angewandte Kunst, Vienna Philadelphia Museum of Art, Pennsylvania Portland Art Museum, Oregon Rhode Island School of Design, Providence, Rhode Island Riccar Art Museum, Tōkyō Rijksmuseum, Amsterdam Rijksmuseum voor Volkenkunde, Leiden Royal Ontario Museum, Toronto Seattle Art Museum, Washington Sendai Municipal Museum, Miyagi-ken Sensō-ji, Tōkyō Shitennō-ji, Ōsaka Springfield Museum, Massachusetts Staatliche Museen Berlin, Ostasiatische Kunstabteilung Stanford University Art Gallery and Museum, California Suntory Art Gallery, Tōkyō Tokiwayama Collection, Kamakura Tokugawa Art Museum, Nagoya Tōkyō National Museum Tōkyō University of Arts Toledo Museum of Art, Ohio University Art Museum, University of California, Berkeley University of Michigan Museum of Art, Ann Arbor Victoria and Albert Museum, London Wadsworth Atheneum, Hartford, Connecticut Walters Art Gallery, Baltimore, Maryland Waseda University Theater Museum, Tōkyō Worcester Art Museum, Massachusetts Yale University Art Gallery, New Haven, Connecticut Yamagata Art Museum, Yamagata-ken Yamatane Museum of Art, Tōkyō Yamato Bunkakan, Nara Yasaka-jinja, Kyōto
collectors' seals: the practice of placing a collector's seal on the face of a delicate Japanese print—whether by an individual, institution, dealer or auction house—is a barbarism no longer condoned today. It was, however, the fashion during some earlier periods of collecting, and the following list includes some of the better-known examples. (Many of the major collectors of Japanese prints are absent from this list—a silent testimonial to their good taste.) ▷ plates 48, 72

Baron Le Barbier de Tinan P. Blondeau G. Cognacq

Hanns Crzellitzer Theodore Duret H. E. Field

L. Gonse Tadamasa Hayashi A. Maroni

Arthur Morrison A. H. Rouart Toni Straus-Negbaur

S. Tuke H. Vever

Confucianism [*Jukyō*]: a code of morals based on filial piety and submission to authority: the foundation of official *bakufu* political and educational policy

crane: a symbol of longevity; attribute of Jurōjin, Fukurokuju, Yoritomo, *et al.*

crow [*karasu*]: thought to be a messenger of the gods; also held responsible for sunspots

cuckoo [*hototogisu*]: a symbol of summer

D

daibutsu: giant statues of Buddha

Daibutsu-kuyō: Noh drama concerning the Heike warrior Kagekiyo and the Minamoto chief Yoritomo

daidaiban/dai-ōban ▷ large-*ōban*

dai-dai-kagura: a sacred dance performed at the Ise Shrine

daijin: a minister of State

dai-kagura: juggling dances, etc., performed from house to house in the New Year's season

daikan: administrators of the domains of the shōgun

Daikoku [Mahahala]: one of the Seven Gods of Luck; usually depicted standing or seated on rice bags, mallet in hand, a large bag on his back, often accompanied by a mice

Daikoku-mai: a festive dance

daikon: a giant radish

-dai-me: suffix meaning generation number, used for families of actors, etc.

daimyō: a major feudal lord

dainagon: ranking counsellors at the Imperial Court

Dainichi-nyorai: the Supreme and Eternal Buddha

daisen: printed slip pasted on the cover of a book; also, the cartouche on a print giving the title data

-daishi [saint]: an honorific title for monks

dai-shō: the long and short months ▷ calendar, Japanese

dai-shō surimono: *e-goyomi* in which the calendrical markings (*dai-shō*) are incidental to the design

daisu: a stand for tea utensils

Dakki [Ta-chi]: a concubine of the Chinese Emperor Chou, noted for her cruelty

dammari: a type of short Kabuki scene in pantomime, often played as though in darkness

dango: a dumpling

Danjō, Nikki: legendary leader of a rebellion at the castle of Sendai, who was said to have the power of transforming himself into a large rat

Danjūrō ▷ actors' crests, *Jūhachi-ban*

danna-dera: a parish temple (After the prohibition of Christianity, the temple priests kept an obligatory register of parishioners in order to prove the latter were not Christians.)

Dan-no-ura: Bay in Nagato; in 1185, site of the naval battle that signaled the ruin of the Taira clan and the triumph of the Minamoto forces

dansen: a flat fan or fan-shape

達磨 **Daruma** [Bodhidharma]: Indian monk who came to China in 520; founded the Ch'an

(Zen) sect of Buddhism

deer [*shika*]: a symbol of longevity

degatari: a form of orchestra in Kabuki, comprised of chanters and musicians

denden-taiko: a toy drum

dengaku: a rustic mime; also fried bean curd

Denzūiin: a temple at Koishikawa in Edo

-dera: a suffix meaning "Buddhist temple"

detchō: the single-leaf style of book binding

diptych [*nimai-tsuzuki*]: a composition of 2 prints side by side

銅版 **dōban**: copperplate printing, first attempted in Japan after European sources, by Shiba Kōkan in 1783, followed by Aōdō Denzen and a host of other artist-artisans

Nishimura, Tei. *Nippon dōbanga-shi* (in Japanese). Tōkyō, 1941

Hosono, Masanobu. *Nagasaki Prints and Early Copperplates.* (trans. by L. A. Craighill) Tōkyō, 1978.

▷ Kōkan

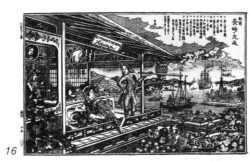

16

Shuntōsai: *Dutchmen with Courtesan at Maruyama, the Nagasaki Pleasure Quarter. Koban dōban*, 1857 (signed Shuntō, with surname [Okada] in romanized form)

dō-bori: engravers who carve the less delicate areas of the woodblock

dōbuku: a long coat

dōchū: parade; also term meaning traveling

Doeff, Hendrik: director of the Deshima factory, 1805–17

Dōgen (1200–53): poet and Zen monk of the early Kamakura Period, founder of the Sōtō branch of the Zen sect

dōgō: shop name, commercial pseudonym

Dohan (fl. ca. 1710s): ukiyo-e painter, print artist, pupil of Kaigetsudō Ando. In his paintings Dohan was the least inspired member of the

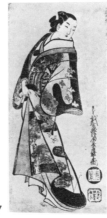

17

Dohan: *Standing Courtesan. Large-ōban tan-e*, ca. early 1710s

Kaigetsudō School, but in his prints he ranks among the ukiyo-e greats. Like the other members of his school he treated the gorgeous Japanese kimono as sufficient *raison d'être* for his work and fairly consistently avoided other means of creating atmosphere

*Kaigetsudō Dohan [Norishige]
▷ pp. 72–73, plates 60–61

Dōjōji: Noh and Kabuki dance-drama derived from the legend of the maiden Kiyohime, who fell in love with the handsome monk Anchin and, when rebuffed, changed into a serpent and cremated him at Dōjōji [Temple] where Anchin hid under a large bell

Dōkan, Ōta Sukenaga (1432–86): warlord who, in 1456, built the first castle at Edo; frequently depicted in ukiyo-e being offered flowers by a girl

dōke-gata (*dōke-yaku*): the role of comedian in Kabuki

Dōkyō (d. 772): a Buddhist monk who exercized great influence over the retired Empress Kōken; their alleged affair is often depicted in shunga

Donshū (d. 1857): Shijō-School painter, did some genre work

*Ōhara, Donshū [Tonshū], Kon, Konron

泥絵 **doro-e**: semi-ukiyo-e landscape folk paintings done in *uki-e* style with heavy, gouache-like pigments, mainly during the 19th century

dōsa: a preparation applied to paper or silk as a sizing agent

度辰 **Doshin** (fl. ca. 1710s): ukiyo-e painter, print artist, pupil of Kaigetsudō Ando. Of Doshin's three extant prints, two display that same mien of quiet detachment that we have come to associate with his paintings; his third print (plate 59) is in another vein: indeed, it is perhaps the strongest of the two dozen Kaigetsudō prints. Its frequent use in ukiyo-e advertisements, exhibition posters and the like would indicate that the general public has chosen it out of all ukiyo-e to epitomize the unique civilization of Japan

*Kaigetsudō Doshin [Noritoki Noritatsu]
▷ Ando; p. 71, plate 59

18

Doshin: *Standing Courtesan. Large-ōban sumizuri-e*, ca. early 1710s

Doshu (fl. ca. 1710s): ukiyo-e painter, pupil of Kaigetsudō Ando

*Kaigetsudō Doshu [Noritane]
▷ Ando; p. 73

度秀 **Doshū** (fl. ca. 1710s): ukiyo-e painter, pupil of Kaigetsudō Ando

*Kaigetsudō Doshū [Doshiu/Norihide]
▷ Ando; p. 73

dōso-jin: god of the roads, often stone statues placed at crossroads, guardians of travelers

dotera: an informal wadded kimono

Dote-shita: a courtesan quarter in Honjo, east of Edo

Dōton-bori: the Ōsaka theater district

double-ōban [*bai-ōban*]: a print size, about 18×13¾ in./46×35 cm

double-yokonagaban: a print size, ca. 15¾×22¾ in./40×58 cm, frequent in *surimono* where the text sheet is still intact

dragon [*ryū*]: a concept imported from China, the dragon is full of remarkable powers, a sign of majesty and high aspirations; depicted ascending in clouds across Mt. Fuji it is a symbol of success in life

dragonfly [*akitsu*]: a symbol of Japan and of victory

dreams [*yume*]: New Year's dreams of Mt. Fuji, falcons and eggplants were considered lucky omens
▷ *baku, shinkiro*

E

-e: a suffix meaning picture or print

eban-giri: a print size, ca. 7½×20 in./19×51.5 cm (also called *naga-surimono*), most often intended as letter-paper, hence printed in pale tones

Ebira: a Noh drama concerning the warrior Kajiwara Kagesue

Ebikane (fl. ca. late 1820s): ukiyo-e print artist, Ōsaka School

Ebisu: one of the Seven Gods of Luck, guardian of fishermen; usually depicted with sea bream and fishing rod

Ebisu-kō: a festival on the 20th day of the Eleventh Month, in honor of Ebisu

eboshi: head covering of many styles, used to distinguish official ranks

Eboshi-ori: a Noh drama concerning the young Ushiwaka (later known as Minamoto Yoshitsune) and a band of robbers led by Kumasaka Chōhan

Echizen-no-kami, Ōoka, Tadasuke (1677–1751): a remarkable administrator and magistrate, as well as organizer of the Edo corps of firemen

e-daisen: an illustrated title slip, often seen on the covers of picture novels
▷ *Kiyoshige*

江戸 **Edo**: the early name of Tōkyō and of the historical period from ca. 1600–1868. Ōta Dōkan built the first castle here in 1456; in 1590 Tokugawa Ieyasu selected Edo for his major residence, which became the seat of the shogunate. Conflagrations: 1621, 1657, 1668, 1845; earthquakes: 1633, 1650, 1703, 1707, 1855; prominent early constructions included: Nihonbashi (1603), Asakusa Kannon Temple (1618), Kan-ei-ji (1626), Ryōgoku-bashi (1659), Higashi-Honganji (1680), Eitai-bashi (1698)

Edo and Environs: On the map (p. 218), the first letter of each location indicates its approximate place. For Hiroshige's systematized depiction of 118 of the most famous Edo scenes, see entry Hiroshige, series 22; for references to some of the specific locations, see main entries and index.

There is a detailed map of the Tōkaidō and

Kiso-kaidō under Highways; for a detailed city map, see p. 218

Edo-e [Edo picture]: woodblock prints of Edo

Edo gonin-otoko [five chivalrous men of Edo]: *otokodate* under the leadership of Banzuiin Chōbei

Edo, Great Fire ▷ *Meireki*

Edo hanjōki: a set of essays on Edo (1832–1836), by Terakado Seiken

e-dokoro: the Imperial Bureau of Painting; it officially appointed artists at the court, temples, shrines or in the *bakufu*

Edo Period: the period of the Tokugawa shōgunate in Edo from 1600 (or 1603) to 1868; also called the Tokugawa Period

edori-bon: early printed books with hand-colored illustrations

e-fūtō: pictorial envelopes

絵暦 **e-goyomi** [calendar print]: print in the design of which are concealed symbols for the months of the year, made famous by Harunobu

19

Shigenaga: Early *e-goyomi. Hosoban benizuri-e,* dated Enkyo V (1748); a courtesan riding on a love letter (rather than a carp), which bears the long and short months of the year

Eguchi: a Noh drama concerning the courtesan Eguchi-no-kimi

絵本 **ehon**: a picture book; often the prefix or heading to a book title

ehon banzuke: an illustrated souvenir booklet of a Kabuki performance

Ehon Taikōki: a Kabuki play, first written for the puppet theater in 1799, relating Mitsuhide's assassination of Nobunaga and his subsequent death at the hands of Hideyoshi

栄文 **Eibun** (fl. ca. early 19th century): ukiyo-e painter, print artist, pupil of Eishi
*Sugawara, Toshinobu, Ikkikusai

栄晁 **Eichō** (fl. ca. early 19th century): ukiyo-e painter, print artist, pupil of Eishi; influenced by Hokusai
*Takada, Bunwasai [Bunkasai]

Eifuku-mon-in (1271–1342): *waka* poetess of the late Kamakura and Northern and Southern Court Periods

栄雅 **Eiga** (fl. ca. 1790s): ukiyo-e painter, pupil of Eishi
*Suigetsusai

Eiga monogatari: a noted historical tale of the mid 11th century

Eigyō (fl. ca. 1820s): ukiyo-e print artist, pupil of Eishi in his later years
*Genjusai

Eigyoku (fl. ca. 1790s): ukiyo-e painter, pupil of Eishi
*Takusai

Eii (fl. ca. 1790s): ukiyo-e painter, pupil of Eishi
*Chōbokusai

栄寿 **Eiju** (fl. ca. 1790s): ukiyo-e print artist, pupil of Eishi
*Eijusai, Chōtensai
Two print series are known by Eiju:
1 *Chōji-ya-uchi...,* ōban, ca. 1795–96
2 *Shi-tennō goban-tsuzuki,* ōban, ca. 1800

英寿 **Eiju** (fl. ca. 1830s–50s): ukiyo-e print artist, Eisen and Ōsaka Schools
*Sakai, Senju, Eisai, Keisai, Ippitsuan, Isaburo

Eikai (1803–74): Japanese-style painter, also did some genre work
*Satake, Eiji, Aisetsu, Aisetsurō, Kyūseido, Shūson, Ten-ei, Tensui, Yūhōshi

Eikō (fl. ca. 1790s): ukiyo-e painter, pupil of Eishi
*Rōshunsai

Eiko (1835–1909): Japanese-style painter, studied under Ichiga and Eikai
*Satake (Katō), Kintarō, Shishō, Kaikaidō-sanjin, Taige

栄京 **Eikyō** (fl. ca. 1790s): ukiyo-e painter, pupil of Eishi
*Chōgyokusai

栄里 **Eiri** [Chōkyōsai] (fl. ca. 1790s–early 1800s): ukiyo-e painter, print artist, important pupil of Eishi
*Chōkyōsai
Print series by Chōkyōsai Eiri:
1 *Edo-no-hana... natori,* ōban, ca. 1795

20

Eiri [Chōkyōsai]: *Portrait of Kyōden. Ōban,* from the series *Edo-no-hana... natori,* ca. 1795

2 *Kakuchū bijin-kurabe,* ōban, ca. 1795–96
3 *Seirō bijin, Itsutomi,* ōban, ca. 1795–96
4 *Seirō bijin-awase,* ōban, ca. 1795–96
5 *Sankanotsu sōka bijin-awase,* ōban, ca. 1795–97 [plate 148]
6 *Matsuba-ya uchi Somenosuke,* hashira-e, ca. 1795–97
7 *Fumi no kiyo-gaki,* ca. 1801; album of 12 ōban-size shunga prints

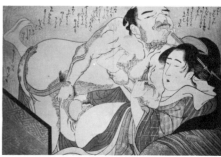

21

Eiri [Chōkyōsai]: *Rape Scene. Ōban,* plate from the shunga album *Fumi no-kiyo-gaki* 1801, designs derived from Utamaro (cf. plate 140)

▷ Eishi; p. 145, plate 148

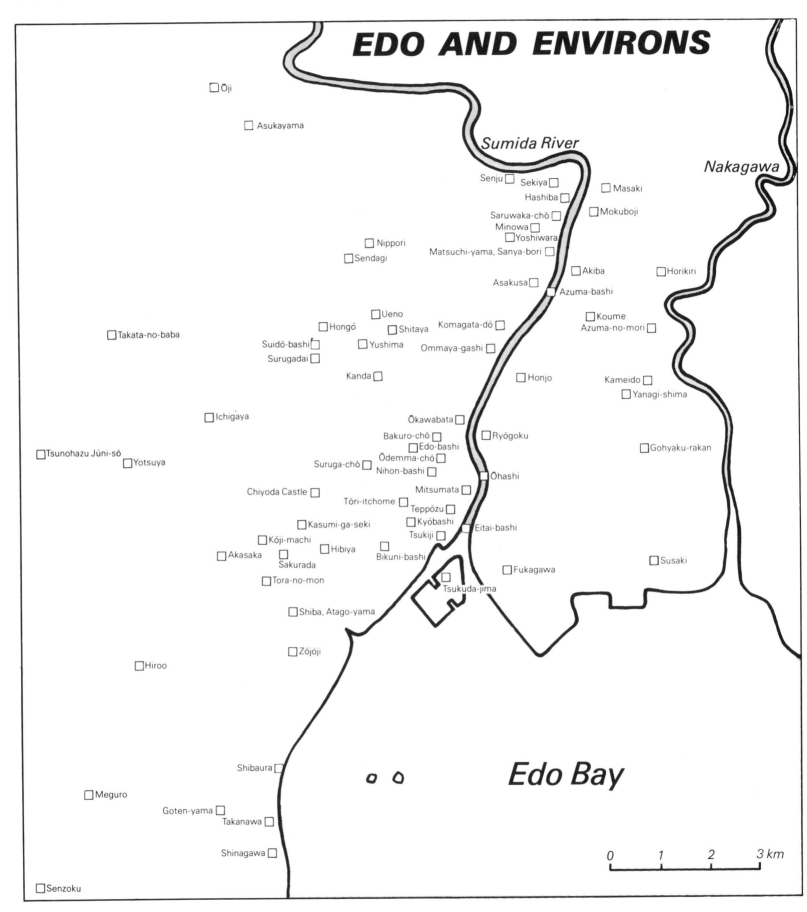

EDO AND ENVIRONS

Ōji

Asukayama

Sumida River

Nakagawa

Senju
Sekiya
Masaki
Hashiba
Saruwaka-chō
Mokuboji
Minowa
Yoshiwara
Nippori
Matsuchi-yama, Sanya-bori
Sendagi
Akiba
Horikiri
Asakusa
Azuma-bashi

Ueno
Koume
Takata-no-baba
Hongō
Shitaya
Komagata-dō
Azuma-no-mori
Suidō-bashi
Yushima
Ommaya-gashi
Surugadai
Kanda
Honjo
Kameido
Yanagi-shima
Ichigaya
Ōkawabata
Tsunohazu Jūni-sō
Bakuro-chō
Ryōgoku
Gohyaku-rakan
Yotsuya
Edo-bashi
Suruga-chō
Ōdemma-chō
Nihon-bashi
Ōhashi
Chiyoda Castle
Mitsumata
Tōri-itchome
Teppōzu
Kasumi-ga-seki
Kyōbashi
Kōji-machi
Tsukiji
Eitai-bashi
Hibiya
Akasaka
Bikuni-bashi
Susaki
Sakurada
Fukagawa
Tora-no-mon
Tsukuda-jima

Shiba, Atago-yama

Hiroo

Zōjōji

Shibaura
Edo Bay

Meguro

Goten-yama
Takanawa

Shinagawa

| 0 | 1 | 2 | 3 km |

Senzoku

礫
川
亭

Eiri [Rekisentei] (fl. ca. 1790s): ukiyo-e print artist, illustrator, follower of Eishi
*Rekisentei, E[h]iri, Busentei

22

Eiri [Rekisentai]: *Yoshiwara Lovers. Ōban*, ca. 1800

Print series by Rekisentei Eiri:
1 *Fūryū onna-Imagawa, ōban*, ca. 1796–98

23

Eiri [Rekisentei]: *Courtesan and Secret Lover. Ōban*, from the series *Fūryū onna-Imagawa*, ca. 1796–98

2 *Fūryū jūni-tsuki geisha natori-awase, ōban*, ca. 1797–99
3 *Ōgi-ya uchi Tsukasa, ōban*, ca. 1797–99
4 *Daimonji-ya-uchi Tagasode, ōban*, ca. 1797–1800
5 *Fūryū shiki-bijin, ōban*, ca. 1798

24

Eiri [Rekisentei]: *Girl with New Year's Toys*, from *Fūryū shiki-bijin, ōban*, ca. 1798

6 *Fūryū ukiyo mu-Tamagawa, ōban*, ca. 1800
▷ Eishi; p. 145

英
里

Eiri (fl. ca. 1820s): ukiyo-e painter, print artist, pupil of Eizan
*Kikukawa (Fukui) Eiri
e-iri-bon: illustrated books
e-iri kyōgen-bon: an illustrated Kabuki scenario

栄
鱗

Eirin (fl. ca. 1790s): ukiyo-e painter, pupil of Eishi

栄
綾

Eiryō (fl. ca. 1790s): ukiyo-e painter, pupil of Eishi
*Chōkisai

栄
隆

Eiryū (fl. ca. 1790s): ukiyo-e painter and print artist, pupil of Eishi
*Nakamura, Katsudō
Only one print series is known by Eiryū:
Wakana hatsu-moyō, ōban, ca. 1796–97

英
泉

渓
斎

渓
泉

Eisen (1790–1848): ukiyo-e painter, print artist and illustrator; pupil first of the Kanō-School artist Hakkeisai, then of the ukiyo-e artist Eizan. Author of *Zoku-ukiyo-e-ruikō*, a re-editing of the main source books for the history of ukiyo-e. Eisen is best known in Japan for his prints of voluptuous girls and his erotica, in the West for his series of landscapes done in collaboration with Hiroshige. He was also influenced by Chinese painting of the Sung and Ming Periods as well as by Hokusai's works.
*Ikeda, Keisai, Yoshinobu, Konsei, Zenjirō, Teisuke, Hokugō, Hokutei, Ippitsuan, Kakō, Kakushunrō, Mumeiō
Imanaka, Hiroshi. *Eisen chogasaku mokuroku.* (in Japanese) Ōsaka, 1956.
Hayashi, Yoshikazu. *Empon-kenkyū: Eisen.* (in Japanese) Tōkyō, 1966.
——— *Empon-kenkyū: O-Ei to Eisen.* (in Japanese) Tōkyō, 1967.
▷ pp. 191–92, plates 193–194

25

Eisen: *Harlots at Toilette. Ōban*, from the series *Ukiyo-e shijūhatte*, ca. late 1810s

26

Eisen: *Night Scene. Ōban* triptych, ca. early 1820s

27

Eisen: *Girl with Dog. Ōban*, from the series *Tōsei kōbutsu-hakkei*, ca. 1830s

28a 28b

Eisen: *Views of Ocha-no-mizu*, (left) and of *Takanawa Offing* (right). *Chū-tanzaku*, from the series *Edo meisho*, ca. 1830s

Eisen (1864–1905): neo-ukiyo-e painter and illustrator, pupil of Eitaku
*Tomioka, Hidetarō, Sōsai
Eisen-in II (1730–90): Kanō-School painter, teacher of Eishi
*Kanō, Fuminobu [Sukenobu], Shōzaburō, Eisen, Hakugyokusai

栄
之

鳥文斎

Eishi (1756–1829): leading ukiyo-e painter, print artist and illustrator. Scion of an important samurai family, Eishi had been fully trained in the studio of the official painter Kanō Eisen-in before he turned to the popular ukiyo-e style. It was in the early 1780s that Eishi resigned his official duties for the work he loved; he designed first in the style of Shigemasa but soon took (as did most of his contemporaries) Kiyonaga, and later Utamaro, as his models in the portrayal of beautiful women.
It is no accident that Eishi's art ranks as the most aristocratic in ukiyo-e; his was not a strikingly original genius, but neither did he have to cater to the whims of popular taste; his women, whether of the nobility or of the demimonde, inhabit a special world untouched by mundane thoughts and passions. During the latter half of his career, with the general decline in print quality, Eishi devoted himself to ukiyo-e paintings, a field in which he reigns supreme for this period.
*Hosoda (Hosoi, Fujiwara), Chōbunsai, Jibukyō, Tokitomi, Kuzaemon [Kyūzaemon], Yasaburō

29

Eishi: *Contest of Beauties. Ōban,* ca. early 1790s (from left to right: maidservant, Kisegawa, O-Hisa, O-Kita, Takigawa)

30

Eishi: *Girls on Raft. Ōban,* triptych, mid 1790s, detail ▷ plate 145

Print series and titled prints by Eishi:
[Dating for Eishi and pupils generally follows Klaus J. Brandt, *Hosoda Eishi*]

1 *Fūryū tōto-sunago, chūban,* ca. 1786–1787
2 *Edo hakkasho, chūban,* ca. 1786–87
3 *Goshiki no asobi, chūban,* ca. 1787–88
4 *Miyako yae-no-nishiki, chūban,* ca. 1787–1788
5 *Fūryū nana-Komachi, ōban,* ca. 1788
6 *Fūryū jūni-tsuki, chūban,* ca. 1787–88
7 *Edo hakkei, chūban,* ca. 1788–90
8 *Edo hachigi-kata, chūban,* ca. 1788–90
9 *Fūryū jūni-yō, chūban,* ca. 1788–90
10 *Ukiyo jūni-tsuki, chūban,* ca. 1788–90
11 *Fūryū yatsushi-Genji, ōban,* ca. 1789–1790
12 *Rokkasen, ōban,* ca. 1789–90
13 *Seirō Edo-murasaki, ōban,* ca. 1790
14 *Kinki-shōga, chūban,* ca. 1790
15 *Koto hakkei, chūban,* ca. 1790
16 *Ryaku Edo hakkei, chūban,* ca. 1790
17 *Tsumagoi no iro, koban,* ca. 1790
18 *Kai-awase, ōban,* ca. 1791
19 *Jūni-toki, chūban,* ca. 1791
20 *Shochō jūni-kai, chūban,* ca. 1791
21 *Nana-Komachi, chūban,* ca. 1791
22 *Fūryū jūni-tsuki, chūban,* ca. 1791
23 *Seirō manzai niwaka, chūban,* ca. 1791
24 *Ryaku mu-Tamagawa, ōban,* ca. 1791
25 *Seirō manzai niwaka, chūban,* ca. 1791
26 *Sen-kyoku, aiban tate-e,* ca. 1792
27 *Ise monogatari, ōban,* ca. 1793
28 *Genji hana-no-en, ōban,* ca. 1793
29 *Seirō niwaka ueki-uri, ōban,* ca. 1793
30 *Bijin kagan-shū, ōban,* ca. 1793
31 *Fūryū ryaku rokkasen, ōban,* ca. 1793
32 *Genji ... ryaku, hashira-e,* ca. 1793
33 *Fūryū-mitate goyō no matsu, ōban,* ca. 1793
34 *Ryaku Ōmi hakkei, chūban,* ca. 1793–94
35 *Matsuba-ya sammai-tsuzuki, ōban,* ca. 1794
36 *Seirō bijin rokkasen, ōban,* ca. 1794 [see plate 142]
37 *Fūzoku ryaku-rikugei, ōban,* ca. 1794

38 *Fūryū go-sekku, ōban,* ca. 1794–95
39 *Seirō bisen-awase, ōban,* ca. 1794–95

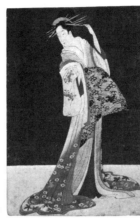

31

Eishi: *The Courtesan Takigawa. Ōban,* left sheet of the triptych entitled *Seirō bisen-awase,* ca. 1794–95 (black mica ground)

40 *Seirō bijin-rokkasen, ōban,* ca. 1794–95
41 *Fukujin takara-awase, ōban,* ca. 1795
42 *Meisho sakazuki-awase, ōban,* ca. 1795
43 *Fūzoku-awase jūni-yō, chūban,* ca. 1795
44 *Seirō geisha-sen, ōban,* ca. 1795
45 *Kyokusui-no-en, ōban,* ca. 1795
46 *Wakana hatsu-ishō, ōban,* ca. 1795–96
47 *Shin rokkasen, ōban,* ca. 1795–96
48 *Matsuba-ya shintaku mise-biraki, ōban,* ca. 1795–96
49 *Shichi-kenjin ryaku bijin-shinzō-zoroe, ōban,* ca. 1796
50 *Yūkun rokkasen, ōban,* ca. 1796
51 *Fūzoku Edo-muraski, ōban,* ca. 1795–96
52 *Ryaku rokkasen, ōban,* ca. 1796

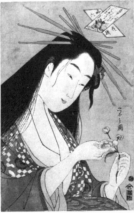

32

Eishi: *Courtesan as Komachi. Ōban,* from the series *Ryaku rokkasen,* ca. 1796

53 *Mitate...-sakura, ōban,* ca. 1796
54 *Wakana hatsu-moyō, ōban,* ca. 1796–97
55 *Seirō moyō-awase, ōban,* ca. 1796–97
56 *Waka sanjin, chūban,* ca. 1795–1797
57 *Ryaku sambuku-tsui, ōban,* ca. 1797
58 *Ukiyo sambuku-tsui, ōban,* ca. 1797
59 *Fūryū sambuki-tsui, ōban,* ca. 1797
60 *Kaiun nanatsu me-awase, koban,* ca. 1797
61 *Seirō shiki-no-tawamure, double-ōban,* ca. 1798 [see plate 143]
62 *Ukiyo Genji hakkei, ōban,* ca. 1797–99

63 *Mu-Tamagawa, ōban,* ca. 1797–99
64 *Ryaku Tsurezure-gusa, ōban,* ca. 1798–1800
65 *Bijin-hitoe, chūban,* ca. 1798–1800
66 *Bijin jūni-hitoe, chūban,* ca. 1798–1800

Books and albums illustrated by Eishi:
1 *Sono yukari kōtokuji-mon,* ca. 1785
2 *Enshoku wakakusa-zōshi,* ca. 1785
3 *Ehon oki-no-ishi,* ca. 1785
4 *Reichōshaku momoiro kazunushi,* ca. 1785–88
5 *Takaimo hikuimo imo no yo-no-naka,* ca. 1785–88
6 *Michitose ni naru chō uwabami,* ca. 1787
7 *Bakemono tsurezure-zōdan,* ca. 1788
8 *Ryūgo Momotarō,* ca. 1788
9 *Momonga ima-kaidan,* ca. 1788
10 *Kaidan shikō-gane,* ca. 1788
11 *Yowai no nagajaku momoiro-jusu,* ca. 1788
12 *Kyōka saitan Edo-murasaki,* ca. 1795
13 *Jūni-kō hana-no-sugata,* album of twelve *ōban*-size shunga prints, late 1780s [see plate 144]
14 Untitled album of twelve *aiban*-size shunga prints, late 1780s
15 *Kyōka-bon yomo-no-haru,* ca. 1796
16 *Yanagi no ito,* ca. 1797
17 *Otoko dōka,* ca. 1798
18 *Nishiki-zuri onna sanjū-rokkasen e-zukushi,* ca. 1798
19 *Ehon kasen-shū,* ca. 1799
20 *Anata yomo-no-haru,* ca. 1800
21 *Yomo-no-haru,* ca. 1810s

Brandt, Klaus J. *Hosoda Eishi 1756–1829, der Japanische Maler und Holzschnittmeister und Seine Schüler.* Stuttgart, 1977.
Lane, Richard. *Studies in Ukiyo-e.*
▷ pp. 141–45, plates 142–144

栄昌 **Eishin** (fl. ca. mid 1790s–1810s): ukiyo-e painter and print artist, pupil of Eishi
*Toyokawa, Chōensai
Two print series are known by Eishin:
1 *Ōgi-ya-uchi Hanaōgi, ōban,* ca. 1796–97
2 *Fūryū zashiki-gei jikkei, ōban,* ca. 1800

昌栄堂 **Eishō** (fl. ca. 1790s): ukiyo-e painter and print artist, pupil of Eishi; the most impressive of Eishi's pupils, Eishō worked in several forms, but it was in his large heads of girls that he achieved results both original and on a level with the art of his master. Eishō's girls lack the aristocratic refinement of Eishi's, but they are often more human, more lifelike.
*Hosoda, Chōkōsai, Shōeidō

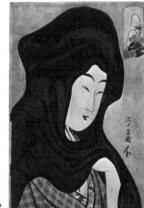

33

Eishō: *Girl in Snood. Aiban,* ca. mid 1790s (mica ground)

Print series and titled prints by Eishō:
1 *Kakuchū bijin-kurabe*, ca. 1795–96 [see plate 146]

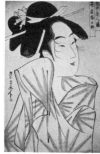

34

Eishō: *The Courtesan Kasugano after Bath. Ōban,* from the series *Kakuchū bijin-kurabe*, ca. 1795–96

2 *Tōsei san-bijin,* ōban, ca. 1795–96
3 *Tōsei bijin-awase,* ōban, ca. 1795–96
4 *Yūkun waka sanjin,* aiban, ca. 1795–96
5 *Shin-Yoshiwara Naka-no-chō,* ōban, ca. 1795–96
6 *Seirō bijin-awase,* ōban, ca. 1795–97

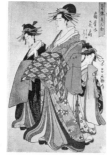

35

Eishō: *The Courtesan Hanaōgi with Attendants. Ōban,* from the series *Seirō bijin-awase,* ca. 1795–97

7 *Ryōgoku Sumida-gawa hakkei,* chūban, ca. 1795–97
8 *Ōgi-ya Hanaōgi yoso-yuki,* ōban, ca. 1795–97
9 *Ryaku Genji hakkei,* chūban, ca. 1796–1797
10 *Seirō shiki bijin-awase,* ōban, ca. 1796–97
11 *Wakana hatsu-moyō,* ōban, ca. 1796–1797
12 *Seirō bikun dōchū,* aiban, ca. 1796–97
13 *Waka sanjin,* ōban, ca. 1796–97
14 *Fūryū go-sekku,* aiban, ca. 1796–97
15 *Tōsei bijin-awase,* chūban, ca. 1796–97
16 *Shusse san-bijin,* aiban, ca. 1796–97
17 *Chōji-ya hiru-mise,* ōban, ca. 1796–97
18 *Ōgi-ya mise-ryaku,* ōban, ca. 1796–97
19 *Fūryū warabe-asobe,* aiban, ca. 1796–98
20 *Fujin jūni-waza,* koban, ca. 1796–98
21 *Ryaku rokkasen,* ōban, ca. 1796–98
22 *Narihira-ason ui-kammuri ryaku,* ōban, ca. 1796–98
23 *Fūryū jūni-tsuki,* aiban, ca. 1796–98
24 *Fūryū mu-Tamagawa,* ōban, ca. 1796–98
25 *Ōgi-ya mise ryaku,* ōban, ca. 1796–98
26 *Fūzoku jūni-tsuki,* chūban, ca. 1797–98
27 *E-kyōdai bijin-awase,* ōban, ca. 1797–98
28 *Bijin rokkasen,* chūban, ca. 1797–98
Some books illustrated by Eishō:
1 *Hate mezurashiki futatsu no utsuwa,* ca. 1798
2 *Fukuro-minato takara no noriai,* ca. 1798
3 *Shiki-utushi fude no mawarigi,* ca. 1798

4 *Sokuseki oryōri,* ca. 1798
▷ Eishi; pp. 142–146, plate 146

栄尚 **Eishō** (fl. early 19th century): ukiyo-e painter and print artist, pupil of Eishi
*Ikkansai

Eishō (fl. ca. 1820s): ukiyo-e print artist, pupil of Eizan
*Kikukawa, Kōitsu

栄舟 **Eishū** (fl. ca. 1790s): ukiyo-e painter, pupil of Eishi
*Tōgensai Eishū

永春 **Eishun** (fl. ca. 1720s): ukiyo-e painter and print artist of the Kaigetsudō School, sometimes thought to be identical with Hasegawa Mitsunobu. Eishun ranks among the most popular painters of his day; his painting style greatly resembles that of Chikanobu, and the two were perhaps in some way associated. (Eishun's studio-name Baiōken, would also seem to indicate some direct relationship with Katsunobu, whose studio was named Baiyūken.) Eishun's courtesans are tall and slim and rather more serious in facial expression than those of Chikanobu. These two artists might be considered the center of a kind of "Kaigetsudō revival" that characterizes one important element of Edo painting during the third and fourth decades of the 18th century.
*Eishun [Nagaharu], Baiōken

栄水 **Eisui** (fl. ca. 1790–1823): ukiyo-e print artist, pupil of Eishi
*Hosoda, Ichirakusai, Ichirakutei
Print series by Eisui:
1 *Bijin go-sekku,* ōban, ca. 1795–97 [see plate 147]

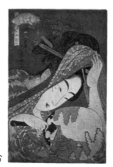

36

Eisui: *Takigawa under Mosquito Net. Ōban,* from the series *Bijin go-sekku,* ca. 1795–97

2 *Shichi-Fukujin...,* ōban, ca. 1796–98
3 *Ōgi-ya Hanaōgi,* ōban, ca. 1796–98
4 *Hyōgo-ya-uchi Tsukioka,* ōban, ca. 1796–1798

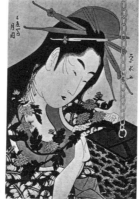

37

Eisui: *The Courtesan Tsukioka. Ōban,* entitled *Hyōgo-ya-uchi Tsukioka,* ca. 1796–98

5 *Hyōgo-ya-uchi Mitsuhama,* ōban, ca. 1796–98
6 *Hyōgo-ya-uchi Tsukioka,* ōban, ca. 1796–1798
7 *Tsuru-ya-uchi Mutsu,* ōban, ca. 1796–1798
8 *Seirō bijin-kurabe,* chūban, ca. 1796–1800
9 *Echizen-ya-uchi Morokoshi,* ōban, ca. 1797
9a *Bijin-awase jōruri-kagami,* aiban, ca. 1797–99
10 *Matsuba-ya-uchi Kisegawa,* ōban, ca. 1798–1800
11 *Echizen-ya-uchi Morokoshi,* ōban, ca. 1800
12 *Tama-ya-uchi Shizuka,* ōban, ca. 1800
13 *Hana no dai,* ōban, ca. 1799–1801
14 *Chōji-ya-uchi Karauta,* ōban, ca. 1799–1801
15 *Matsuba-ya-uchi Takigawa,* ōban, ca. 1800
16 *Chōji-ya-uchi Hinazuru,* ōban, ca. 1800–1803
17 *Komurasaki/Shirai Gompachi,* hashira-e, ca. 1800–03
18 *Take-ya-uchi Takehito,* ōban, ca. 1800–1803
19 *Ōgi-ya-uchi Hanaōgi,* ōban, ca. 1800–1803
Books illustrated by Eisui:
1 *Yarō no tamago,* ca. 1801
2 *Ebira no ume,* ca. 1801
3 *Kataki-uchi ayatsuri-gusa kiku no magaki,* ca. 1801–03
4 *Abe-kawa kataki-uchi,* ca. 1801–1803
5 *Kyōka chikara-kurabe,* ca. 1827
▷ Eishi; pp. 145–46, plate 147

永濯 **Eitaku** (1843–90): Japanese-style painter, pupil of Kanō Tatsunobu; specialized in historical subjects and figures
*Kobayashi, Shūjirō, Issensai, Sensai

永徳 **Eitoku** (1543–90): leading Kanō-School painter in Kyōto, did some genre work
*Kanō, Kuninobu, Mochishige, Shigenobu, Genshirō

栄鳥 **Eiu** (fl. ca. 1790s): ukiyo-e print artist, pupil of Eishi
Only one print series is known by Eiu: *Kakuchū bijin-kurabe,* ōban, ca. 1795–96

英山 菊川 **Eizan** (1787–1867): ukiyo-e painter and print artist; studied first with his father, then with Nanrei and Hokkei; also influenced by Utamaro and Hokusai
*Kikukawa (Ōmiya), Toshinobu, Mangorō, Chōkyūsai
▷ pp. 189–91, plate 192

38

Eizan: *Geisha in Snow. Ōban,* from a series of 3 prints entitled *Fūryū meisho setsugekka,* ca. 1810

ekiba: the relay horses for express messengers of the government

絵金 **E-Kin** (1810–76): noted ukiyo-e and folk painter of the Tosa region
*Hirose, Kinzō, Ryūei, Tōi, Yūchikusai, Jakuō

Ekken, Kaibara (1630–1714): a noted Confucian author

e-kyōdai: a picture with inset analogue

elephant [zō]: traditionally a symbol of wisdom ▷ Fugen, Eguchi

絵馬 **ema** [painted horse]: votive pictures, dedicated to shrines and temples
▷ p. 92, plate 87

emaki, emakimono: picture scrolls, lateral handscrolls

e-mekiki: the post of inspector of imported paintings (mainly Chinese) at Nagasaki

Emma (Emma-ō; Yama-raja): the King of Hades who pronounces judgement on the dead

emmusubi: the arrangements for a marriage

Emon-zaka: slope outside the main gate of the Yoshiwara

延宝 **Empō** (1673–1681): the Empō Period, dating from IX/21/1673 to IX/29/1681, marks a decade of cultural activity in many spheres. The first full-length Kabuki dramas developed, and the great Danjūrō I appeared in Edo, where Moronobu was at work consolidating the ukiyo-e style in his paintings and numerous illustrated books, while in Kyōto, the works of Hambei were also being published widely.
▷ nengō

engawa: a veranda or balcony

engi: work dealing with the legends about the founding of temples or shrines

Enjaku (fl. ca. 1858–65): ukiyo-e print artist, Ōsaka School

艶鏡 歌舞妓堂 **Enkyō** (1749–1803): ukiyo-e print artist; by profession a writer of Kabuki plays; only seven prints are known by him, all after the style of Sharaku
*Nakamura, Kabukidō, Jūsuke

39

Enkyō: *Omezō in the Role of Kingorō*. Ōban, 1796

延享 **Enkyō** (1744–1748): the Enkyō Period dates from II/21/1744 to VII/12/1748 and represents a period of final consolidation of the Kyōhō Reforms. In ukiyo-e, color printing at last took precedence over hand-coloring, while the perspective print continued to flourish. With the increased interest in color printing, Chinese art texts were reprinted in full color, influencing the ukiyo-e artists almost as much as the *nanga* painters. During this period the *jōruri* drama, so long a guiding influence in Kabuki, at last succumbed to the rising popularity of theater with live actors. ▷ nengō

Enoshima: a hilly island near Kamakura, containing a popular shrine to Benten

Enryakuji: a temple at the summit of Hieizan; seat of the Tendai sect

円志 **Enshi** (fl. ca. late 1780s): ukiyo-e print artist, perhaps a pupil of Shunshō but influenced by Kiyonaga and Eishi
*Angyūsai

era names ▷ nengō

eshi: a painter

eta: pariahs, people such as flayers, tanners, curriers

eto: calendric symbols ▷ calendar, Japanese

e-zōshi: an illustrated novelette or booklet

F

fans [*sensu, ōgi, dansen, uchiwa*]: finding a fan is an omen of fortune; but a fan carried attached to a bamboo branch was the sign of a madwoman

Fenollosa, Ernest F. (1835–1908): American orientalist and educator, who went to Japan in 1878 to lecture and did pioneer research on ukiyo-e

Fontanesi, Antonio (1818–81): Italian painter who lived in Japan and influenced early Japanese Western-style painting

fox [*kitsune*]: often thought to be an evil creature, capable of demoniacal possession; but also the popular representation of Inari, the benign god of rice

Francis Xavier, Saint (1506–52): religious leader of the Company of Jesus; he visited Kagoshima in 1549, Hirado in 1550, Hakata, Yamaguchi and Kyōto in 1551

frogs [*kawazu, kaeru*]: Ono no Tōfū, the famous calligrapher, was encouraged in his studies by watching a frog persistently trying to get at a willow leaf hanging over a stream

Fuchū: the capital of a province; on the Tōkaidō, it refers to the city of Shizuoka

fude: a brush; or appended to an artist's signature to mean painted by, *pinxit*

Fudō (Fudō-son; Aryāacalanatha): important Buddhist deity, usually portrayed in a rage, with flames of fire on his back, sword in his right hand and rope in his left

Fugen [-bosatsu]: Bodhisattva of Wisdom; usually depicted riding an elephant (in ukiyo-e, often replaced by a beautiful courtesan)

40

Harunobu: *Chūban*, ca. 1769. The poet-priest Saigyō is shown praying to the Courtesan of Eguchi, who appeared to him in a vision as an avatar of the deity Fugen.

Fuji-kawa: the river (73 miles/ 118 km long) that flows from the west of Mt. Fuji and empties into Suruga Bay

ふじ国 **Fujikuni** (fl. mid 1820s): ukiyo-e print artist, Ōsaka School
*Jushōdō

藤麿 **Fujimaro** (fl. ca. 1800s–10s): ukiyo-e painter, print artist; influenced by Utamaro
*Kitagawa, Hōshū, Kōkasai, Shihō

fuji-musume: a maiden holding a wistaria-branch (a favorite *Ōtsu-e* subject)

藤信 **Fujinobu** (fl. ca. 1750s–60s): ukiyo-e print artist, thought to have been a pupil of Shigenaga but influenced by Harunobu. His prints are rare, and the name may well be only a nom de plume of the ukiyo-e publisher Yamamoto Kohei (Maru-ya), employed for his occasional creative work.
*Yamamoto Fujinobu

Fuji-no-makigari: phrase used for the hunting exhibitions of the Kamakura shōgun on Mt. Fuji

Fuji-san [Mt. Fuji]: volcano in Kai and Suruga Provinces, highest mountain (3780 m/12,398 ft.) in the Japanese Empire; last eruption: 1707–08; alternate names: Fugaku, Fuji-no-yama ["Fujiyama" is a foreign corruption]
▷ Thirty-six Views, Hokusai, series 119

Fujito: a Noh drama concerning Benkei, Shizuka-gozen and her lover Yoshitsune

Fujitsuna, Aoto: a minister of the 13th century celebrated for his righteousness; once he dropped 10 coins in the Nameri River at night and spent 50 coins to recover them; he justified this as providing needful employment for others.

Fujiwara: the de facto ruling family of Japan during the Heian Period

不韻斎 **Fuinsai** (fl. 1765–80): Ōsaka-Print artist, influenced by the *megane-e* of Ōkyo

fūkei-ga: a landscape print or painting

fukibokashi (*fuki-e, fuki-botan*): the method of shading by partially wiping off pigment on the woodblock; also, stipple or spray stenciling.

fukkō Yamato-e: neo-*Yamato-e* painting in the 19th century

fukujusō: Adonis plant (symbol of New Year)

Fukurō: the tale of the owl who mourns his bullfinch love, probably 15th century

Fukuro-hōshi ekotoba [The Priest in the Bag]: a famous early shunga scroll

41

Fukuro-hōshi ekotoba. Scroll in colors on paper, from a copy, ca. late 18th century, after an original of the 14th century

Fukurokuju: one of the Seven Gods of Luck, incarnation of longevity; represented as an old man accompanied by a white stork

fukuro-toji: the double-leaf style of book binding, in which the sheet of paper is folded once and bound at the open end

fukusa: a silk napkin

fukusei: a reproduction, facsimile

Fukusuke: a humorous figure, symbolizing prosperous business

Fukutomi-sōshi: a tale of fame and fortune, probably 15th century

fumi (-bumi): writings, letters

fumi-e: religious images trodden underfoot to prove that one did not belong to the proscribed Catholic religion

Fumizuki: a poetic name for the Seventh Month

furisode: a long-sleeved kimono worn by unmarried young women

furoshiki: a cloth used for wrapping objects to be carried

fūryū: fashionable, *à la mode,* elegant

房信 **Fusanobu** (fl. ca. 1750–60s): ukiyo-e print artist, studied under Shigenaga. Originally a dealer in *nishiki-e* and publisher in Edo; after his firm went bankrupt he turned to print-making

*Tomikawa (Yamamoto), Kyūzaemon, Ginsetsu, Hyakki, Maru-ya

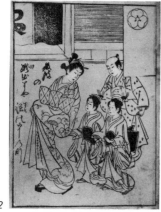

42

Fusanobu: *Yoshiwara Scene.* Detail from *Yoshiwara hana-no yosooi,* hanshi-bon, Edo, 1765

房種 **Fusatane** (fl. ca. 1850s–60s): ukiyo-e print artist, pupil of Sadafusa, but much influenced by Hiroshige

*Utagawa (Murai), Shizuma, Ippyōsai, Isshōsai, Ōsai

Fuse-hime: the heroine of Bakin's *Hakkenden,* often shown with her pet dog (and lover)

Fushimi: town south of Kyōto; in 1593 Hideyoshi's magnificent Momoyama castle was built here.

Fushimi-ban: classical books printed at Fushimi (near Kyōto) at the command of the Shōgun Ieyasu between 1599 and 1606

Fushimi: 92nd sovereign of Japan (1265–1317); *waka* poet of the late Kamakura Period

Fusō [-koku]: the ancient name for Japan

fusuma: a heavy sliding door

Fūten: the Wind god

futon: padded bedding

Fuwa-no-seki: barrier station in Ōmi Province at Seki-ga-hara

Fūyō (fl. ca. 1790s): ukiyo-e print artist, influenced by Kiyonaga

*Hōgokujin

fūzoku-ga: pictures depicting customs and manners

G

ga: a picture; term meaning *pinxit,* "drawn by," used as a suffix to artists' signatures

gafu: an album

gagaku: classical court music based on Chinese models

Gaishindō (mid-19th century): *dōban* artist

岳亭 **Gakutei** (ca. 1786–1868): ukiyo-e print artist, studied under Tsutsumi Shuei and Hokkei; much influenced by Hokusai. Gakutei often employed the nom de plume Gogaku and left a number of skilled *surimono* and book illustrations, among which his impressionistic landscape scenes are notable. Though a native of Edo, Gakutei lived in Ōsaka during the early 1830s, and the album-plate shown in plate 176 is one of several souvenirs of that sojourn from his best-known work, the series of landscapes *Tempo-zan shōkei ichiran* [Fine Views of Tempo-zan (Ōsaka)], published in 1834, this consisted of six *ōban*-size plates bound in album form (today usually seen dismounted).

*Yashima (Sugawara), Gogaku, Harunobu, Teikō [Sadaoka], Hōkyō, Maruya Onokichi, Gakuzan, Horikawa Tarō, Ichirō, Kaguradō, Kōen, Nanzan, Ryōsa, Shingakudō, Shinkadō, Yōsai, Yōsei

Illustrated books by Gakutei include:
Ichirō gafu (1 vol., 1823)
Asagao hyakushu kyōka-shū (1 vol., 1830)
Haikai waka suigyo-shū (3 vols., ca. 1840)
Kyōka Nihon fudo-ki (2 vols., 1831)
▷ p. 172, plate 176

43

Gakutei: *Squall at Tempo-zan* from the album *Tempo-zan shōkei ichiran,* ōban, 1834

Gama-sennin: a legendary immortal, often shown with his pet toad

Gammon ▷ Gembun

gampi: a strong handmade paper

gan[kari]: wild geese

Ganji ▷ Genji

Ganku (1749/56–1838): noted Kishi-School painter, also did some genre work

*Kishi (Saeki), Ku [Koma], Masaaki, Funzen, Utanosuke, Dōkōkan, Kakandō, Kayō, Kotōkan, Kyūsorō, Tansai, Tenkaikutsu

ganshu: the sponsor (of a buddhist text or *ema*)

Ganrei (1816–83): Kishi-School painter, did some genre work

*Kishi, Rei, Sakon, Shōsō, Shitei, Hokuhō, Umpō

Ganryō (1798–1852): Kishi-School painter, also did some genre work

*Kishi, Ryō, Hamaya (Saeki) Gorō, Shiryō, Utanosuke, Gaunrō

Gantai (1782–1865): Kishi-School painter, also did some genre work

*Kishi (Saeki), Tai, Kogaku, Kunchin, Chikuzennosuke, Dōkōkan, Shisui, Takudō

garan: a Buddhist temple

gasan: a picture with a calligraphic inscription or a suffix meaning drawn and inscribed by

geigi, gi ▷ geisha

芸子 **geiko**: the geisha of Kyōto/Ōsaka

geimei: a stage name

芸者 **geisha**: a woman entertainer, accomplished in music, dancing, conversation; popular from the 1750s onward

Geki-za: name of Edo's puppet theater

月耕 **Gekkō** (1859–1920): genre painter and print artist; worked first in the style of Yōsai, then studied ukiyo-e by himself

*Ogata (Tai), Masanosuke, Nagami Shōnosuke, Kagyōsai, Meikyōsai, Nen-yū, Rōsai

gembuku: the ceremony of entering manhood or womanhood

Gembuku Soga: a Noh drama about the Soga Brothers

元文 **Gembun** (1736–1741): the Gembun Period, dating from IV/28/1736 to II/27/1741, represents a continuation of the Kyōhō Reforms, restricting both conduct and the publication of books and prints. The older ukiyo-e artists, Masanobu, Sukenobu, Chōshun, continued work, and new masters such as Toyonobu appeared; but the more original artists had no choice but to mark time in this age. One interesting development of the Gembun Period was the fashion for *uki-e,* a type of print influenced by Chinese and European graphic art. Masanobu was the pioneer in this field, followed by Shigenaga and others. ▷ *nengō*

Gempei: Minamoto and Taira, the two leading warring families of the medieval period

Gempei seisui-ki [History of the Rise and Fall of Minamoto and Taira]: a historical work covering the period from 1160 to 1185; a composite version of the *Heike monogatari,* late Kamakura Period

玄々堂 **Gengendō** (1786–1867): leading *dōban* artist, pupil of Isaburō; influenced by Aōdō Denzen and Kōkan; produced many copperplate engravings of Edo and Ōsaka in the Western style

*Matsumoto (Matsuda), Yasuoki, Gihei

玄魚 **Gengyo** (1817–80): genre print artist and designer; held a position under the *bakufu*

*Miyagi, Baiso, Baisotei, Fūen, Katōshi, Suisenshi

44

Gengyo: *Ravens in Moonlight. Aiban,* fan-print (with lacquer on the ravens), ca. 1860s. This masterly design, published by T. Duret in the *Gazette des Beaux Arts* of 1882, seems likely to have influenced Van Gogh.

源氏 **Genji**: the Minamoto family; also the hero of the *Genji monogatari*

元治 **Genji** (1864–1865): the brief Genji [Ganji] Period: dating from II/20/1864 to IV/7/1865; witnessed increasing friction between the *bakufu* government and imperial restoration factions. Kunisada, the last of the older ukiyo-e masters, died in this period. The younger generation—Sadahide, Yoshiiku, Yoshitoshi, Hiroshige II, Kyōsai—proved unable to revive the moribund art that was ukiyo-e. ▷ *nengō*

Genji-kuyo: Noh drama featuring Lady Murasaki, authoress of the *Tale of Genji*

Genji monogatari [The Tale of Genji]: the greatest novel of classical Japanese literature, written by Lady Murasaki in the first decade of the 11th century, detailing the love adventures of Prince Genji and his circle. The "Fifty-four Chapters" of *The Tale of Genji* [*Genji gojūyo-jō*] are listed below, together with the *Genji-mon* [Genji crests] with which they are often associated in the later ukiyo-e prints:

1	Kiritsubo	17	E-awase
2	Hahakigi	18	Matsukaze
3	Utsusemi	19	Usugumo
4	Yūgao	20	Asagao
5	Waka-murasaki	21	Otome
6	Suetsumuha na	22	Tama-kazura
7	Momiji-no-ga	23	Hatsune
8	Hana-no-en	24	Kochō
9	Aoi	25	Hotaru
10	Sakaki	26	Tokonatsu
11	Hana-chiru-sato	27	Kagaribi
12	Suma	28	Nowaki
13	Akashi	29	Miyuki
14	Miozukushi	30	Fuji-bakama
15	Yomogyū	31	Maki-bashira
16	Sekiya	32	Umega-e
33	Fuji-no-uraba	44	Takegawa
34	Wakana-no-jō	45	Hashihime
35	Wakana-no-ge	46	Shii-ga-moto
36	Kashiwagi	47	Agemaki
37	Yokobue	48	Sawarabi
38	Suzumushi	49	Yadorigi
39	Yūgiri	50	Azumaya
40	Minori	51	Ukifune
41	Maboroshi	52	Kagerō
42	Niou-no-miya	53	Tenarai
43	Kōbai	54	Yume-no-ukihashi

Genjō: a Noh drama featuring the famous lute player Moronaga

Genki (1747–97): Maruyama-School painter, also did some genre work
*Komai, Ki, Shion, Yukinosuke

元和 **Genna** (1615–1624): the Genna [Genwa] Period, dating from VII/13/1615 to II/30/1624, saw the consolidation of the Tokugawa regime and the beginning of two and a half centuries of peace. The courtesan quarters of Ōsaka and Edo were founded, forming—with the established quarter of Kyōto—centers of urban social life and culture. In Kabuki and the courtesan quarters, genre painting found its perennial theme, and the ukiyo-e style began to achieve that characteristic form that was to be developed in painting and book illustration during the following generation. ▷ *nengō*

Gennai (1726–79): pioneer painter in Western style, also did some genre work
*Hiraga, Kunitomo, Fukunai-kigai, Fūrai-sanjin, Kyūkei, Mukonsō, Shinra-banshōō, Shōraishi, Tenjiku-rōnin
Lane, Richard. *Studies in Ukiyo-e.*

genre painting, early [*shoki fūzoku-ga*]: painting in genre style by artists of the tradi-

45

Early Genre Painting: *The Kyōto Pleasure Quarter.* Medium-large folding screen of 6 panels in colors and gold leaf on paper. Kan-ei/Shōhō Period (ca. 1640s), detail ▷ plate 9

tional schools during the late 16th and early to mid 17th centuries, before the development of the Ukiyo-e School
Tanaka, Kisaku. *Shoki ukiyo-e shūhō* [Collection of Early Ukiyo-e Masterpieces]. (in Japanese) Tōkyō, 1927.
Kondō, Ichitaro. *Japanese Genre Painting—The Lively Art of Renaissance Japan.* (tr. by R. A. Miller). Tōkyō, 1961.
Lane, Richard. *Studies in Ukiyo-e.*
▷ pp. 9–14, 24, 29–30, 34; plates 1–13, 17

genre painting, later [*fūzoku-ga*]: painting in genre style by non-ukiyo-e artists of the Ōtsu-e, Hanabusa, Maruyama, Shijō and other schools.
Lane, Richard. *Studies in Ukiyo-e.*
▷ p. 92, plates 86, 87

源六 **Genroku** (fl. ca. 1710s–20s): ukiyo-e print artist, pupil and adopted son of Okumura Masanobu; after Masanobu started as a publisher, Genroku seems to have joined the business and stopped designing prints.
*Okumura Genroku

元禄 **Genroku** (1688–1704): the Genroku Period, as an era-name, dates only from IX/30/1688 to III/13/1704, but it stands as a symbol of the plebeian renaissance that evolved in Japan during the second half of the seventeenth century. Among its principal cultural figures were the novelist Saikaku, the haiku poet Bashō, the playwright Chikamatsu and the ukiyo-e artist Moronobu. In many respects, the decade preceding Genroku represented the real height of "Genroku culture," while the 1690s were more of a caesura, an undistinguished period between Moronobu, Kiyonobu and Masanobu as far as ukiyo-e is concerned. ▷ *nengō*

Genshirō (fl. ca. 1720–40): ukiyo-e print artist
*Kiyomitsu Genshirō

Genwa ▷ Genna

人倫訓蒙図彙 **Genzaburō** (fl. ca. 1690): the name "lacquer-artisan Genzaburō" appears at the end of vol. III of the pictorial encyclopedia *Jinrin Kimmō-zui* of 1690. The illustrations to that fascicle differ from the other volumes of the work (which are by Hambei's anonymous follower) and show some evidence of lacquerware technique in the details. The custom in Japan of ascribing later Saikaku illustrations to Genzaburō comes from the mistaken assumption that the remainder of the volume is by him as well.
源三郎 *Makieshi Genzaburō

Mizutani Yumihiko. *Kohan shōsetsu sōga-shi.* [whose basic assumptions on pp. 136–142 are untypically erroneous].

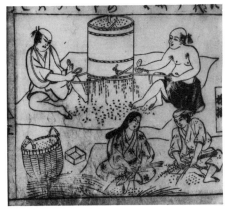

46

Genzaburō: *Rice Farmers.* Detail from *Jinrin kimmō-zui, hanshi-bon*

gesakusha: writers of popular fiction

Gessai (1787–1864): Nagoya painter and print artist; studied under Bokusen, then under Hokusai during the latter's stay in Nagoya
*Numata, Masatami, Utamasa, Shii, Hanzaemon, Ryōun

Gessai II (fl. mid 19th century): Nagoya ukiyo-e painter and print artist; pupil and successor to Gessai
*Haniwara, Kunai, Utamasa II

Gesshō (1772–1832): Shijō-School painter and illustrator, also did some genre work
*Chō, Yukisada [Gyōtei], Genkei, Kaisuke, Shinzō, Suikadō

geta: high wooden sandals

Getsurei (1846–1917): dōban artist, studied with Kyokuzan and Ryūsetsu
*Shutsu-sanjin, Seiunkaku

geza: Kabuki chorus and orchestra located at the side in the theater

gi: Japanese word for righteousness

Gidayū-bushi: a dramatic chant developed by Takemoto Gidayū to accompany the puppet plays of Chikamatsu

Gidayū, Takemoto (1651–1714): famous dramatist and chanter of jōruri

Gifu: the capital of Mino

giga: term meaning "drawn for amusement"

Gikei-ki: a fictional record of the hero Yoshitsune's life, dating from the early Muromachi Period

Ginjirō (Meiji): dōban artist
*Nomura Ginjirō

Ginkakuji: the "Silver Pavilion," palace of Yoshimasa, northeast of Kyōto

Ginkō (fl. ca. 1874–97): ukiyo-e print artist, correspondent and illustrator during the Sino-Japanese war
*Adachi, Heishichi, Shinshō, Shōsai, Shōunsai

ginza: the guild for the coining of silver money

Giō: a Noh drama featuring the two dancers Giō-gozen and Hotoki-gozen

Gion: the eastern ward of Kyōto, including the principal geisha quarter; also the popular name for the major Shintō shrine there, Yasaka-jinja

giri-ninjō: the conflict of obligation versus human feelings, a common theme in Kabuki and jōruri dramas

go: a board game of skill, "Japanese checkers"

gō: a type of pen name

goban: heavy, low table for playing go

Gochō (fl. ca. 1820s): ukiyo-e print artist, Ōsaka School

Go-Daigo (1288–1339): waka poet and 96th sovereign of Japan

Goemon, Ishikawa: a famous robber, executed with his son in 1595 by boiling in oil

gofun: opaque white ▷ pigments

gohei: white ceremonial paper attached to a lathe, used in Shintō purification rites

Gohei, Namiki (1747–1808): a Kabuki dramatist of the mid Edo Period

Go-kaidō: the 5 great highways which started from Nihon-bashi in Edo
▷ Highways, Provinces of Old Japan

gōkan-mono: the illustrated fiction of the kusa-zōshi genre in the 19th century

go-kenin: minor retainers of the shogunate

go-kō (mi-yuki): the term for a journey by the Emperor

Gokyō (fl. 1790s): ukiyo-e print artist, pupil of Eishi

Go-Murakami (1328–68): waka poet and 97th sovereign of Japan

gongen: the gods of Shintō; also, posthu-

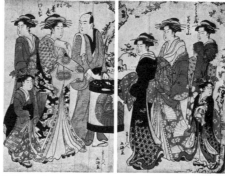

47

Gokyō: *Courtesan Procession.* Ōban diptych, ca. early 1790s

mous name of Tokugawa Ieyasu

Gorō, Matano no: an ancient wrestler, often depicted throwing a huge stone

Gosei (fl. ca. 1800s–30s): ukiyo-e painter, print artist, and illustrator in the style of Hokusai
*Sunayama, Hōtei

48

Gosei: *Terrapins.* Chūban surimono, from the series Tōto meibutsu-awase, ca. 1830s

go-sekku: the five traditional festivals in Japan:
jinjitsu (New Year's, 1st day of the First Month),
jōmi (hina-matsuri 3rd day of the Third Month),
tango, (5th day of the Fifth Month),
tanabata (7th day of the Seventh Month),
chōyō (9th day of the Ninth Month)

Gosen-waka-shū: a collection of waka verses, ordered in 951 by the Emperor Murakami

Goshichi (ca. 1776–1831): ukiyo-e print artist, pupil of Harukawa Eizan; an official in Edo but moved to Kyōto about 1818; designed surimono and figure prints after the Utamaro manner
*Harukawa (Aoki), Hōshū, Kamiya, Kamesuke, Hōrai-sanjin, Kiyū

Go-Shirakawa (1127–92): waka poet and 77th sovereign of Japan

gosho: the Imperial Palace in Kyōto

gosho-guruma: a ceremonial vehicle used by the nobility

[Go-] shuin-bune: ships authorized to carry on trade with foreign countries

Go-shūi-shū: an Imperial verse anthology, completed in 1086

Goshun (1752–1811): painter, founder of the Shijō School of artists, also did some genre work

*Matsumura, Toyoaki, Gekkei, Hakubō, Impaku, Yūhō, Bunzō, Kaemon, Hyakushōdō, Katen, Shōutei, Sompaku, Sonjuhaku, Sonseki

Go-Taiheiki shiraishi-banashi: a noted Kabuki play (first staged with puppets at the Geki-za, Edo in 1780), the story of two sisters, Miyagino and Shinobu, avenging their murdered father

Goten-yama: a hill at Shinagawa noted for its cherry blossoms

Go-Toba Jōkō (1180–1239): 82nd sovereign of Japan and waka poet of the early Kamakura Period

Goyō (1880–1921): painter and print artist. A major neo-ukiyo-e artist who studied Japanese-style painting with Hashimoto Gahō, then Western-style painting under Kuroda Seiki; Goyō soon developed a love for traditional ukiyo-e, actively engaging in research and writing on the subject. The effect of these studies appeared in creative form during the last six years of his life: a series of impressive studies of women done in modern adaptation of ukiyo-e technique, often printed under the direct supervision of the artist
*Hashiguchi, Kiyoshi

49

Goyō: *Woman at Toilette.* Double-ōban, 1918

goyō-eshi: an official painter employed by the court or bakufu

gozan-ban: the books printed by the Zen temples of Kamakura and Kyōto during the Kamakura and Muromachi Periods

gozan (Zenrin) bungaku: Zen literature

-gozen: an honorary title added as a suffix to the name of ladies of eminence

Gukei (1631–1705): Edo Sumiyoshi-School painter, son of Jokei; in 1682 appointed official painter to the Shōgun Tsunayoshi; did some genre work
*Sumiyoshi, Naiki, Hirozumi

gumbai-uchiwa: a heavy fan used as a baton

gunki monogatari [tales of war]: the narrative works of feudal pageantry written in the Kamakura and Muromachi Periods

gwa: archaic spelling of ga (e.g., Mangwa)

Gyokkō (fl. ca. 1790s): ukiyo-e print artist, Ōsaka School
*Tamaki Gyokkō

Gyokuansai (fl. ca. later 1770s): ukiyo-e print artist and illustrator, Ōsaka School

Gyokudō (1873–1957): Japanese-style painter, produced some genre work
*Kawai, Yoshisaburō, Gyokushū

Gyokuhō (1822–79): Shijō-School painter, also did some genre work
*Hasegawa, Shiei, Shishin, Tōsai

玉
山

Gyokusen (fl. ca. mid 1830s): ukiyo-e print artist, Ōsaka School

Gyokushū (fl. ca. mid 1830s): ukiyo-e print artist, Ōsaka School

Gyokusō (fl. ca. 1830s): ukiyo-e print artist and illustrator, Ōsaka School
*Mizuhara Gyokusō

Gyokuyo-shū: Imperial verse anthology, published in 1313

Gyokuzan (1737–1812): ukiyo-e painter and illustrator in Ōsaka; studied with Settei and Kangetsu
*Okada, Shōyu [Naotomo], Shitoku, Kinryōsai
Illustrated books by Gyokuzan include:
Sumiyoshi meishō-zue (5 vols., 1794)
Morokoshi meishō-zue (6 vols., 1805; with Minsei and Bunki)
Ise monogatari zue (3 vols., 1825)

Gyokuzan II (fl. late 18th–early 19th century): Ōsaka painter and illustrator, pupil of Gyokuzan; later moved to Edo
*Ishida, Shūtoku, Shishū

gyōsho: an informal style of calligraphy
Gyōsui (1868–1935): genre painter, daughter of Kyōsai
*Kawanabe Gyōsui

H

-ha: suffix indicating a school of painting or other art form

haboku: the splash technique in monochrome ink painting

hachimaki: the cloth head-band worn in preparation for strenuous activity

Hachiman: a Shintō deity, the god of War

八
文
字
屋

Hachimonji-ya Jishō: (1676–1745): leading Kyōto publisher of popular books, many of them illustrated by Sukenobu

Hachi-no-ki: a famous Noh drama in which an impoverished samurai (Sano no Tsuneyo), visited by the shōgun (Hōjō Tokiyori) disguised as a priest, chops up his treasured dwarfed trees to provide firewood. The theme was frequently adapted to Kabuki
▷ plate 94

hagi: the lespedeza plant (a symbol of autumn)

Hagi-dera: a Buddhist temple at Kameido, east of Edo; famous for its garden of *hagi*

hagoita: a battledore (used for New Year's Day festivities)

hagoromo: the legendary "feather robe" and the Noh drama and dance derived from it

Haifū yanagi-daru: the 1765 verse collection of *senryū*, compiled by Karai Senryū (1718–1790), with many supplements, published up to 1838

haiga: sketches illustrating themes of *haiku* poetry, usually drawn by the poets themselves

haigō: a pen name used in poetry

haikai: originally comic *waka*; now synonymous with *haiku* poetry

haikai no renga: humorous linked verse

haiku (also *haikai, hokku*): a 17-syllable poetical epigram. Bashō (1644–84) was the greatest poet in this form, in which suggestive reference to seasonal phenomena form a major element.

hakama: wide trousers or culottes

hakama-gi: the ceremony for a boy of five when he begins to wear *hakama*

Hakata: major port of Chikuzen (where a tempest destroyed Kublai Khan's fleet in 1281)

hakkake: the technique of overprinting

八
犬
伝

hakke (Chinese *pa-kua*): the Eight Divinatory Trigrams (from the *Book of Changes, I-Ching*)

Hakken-den ▷ *Nansō Satomi hakken-den*

hako-ya: a servant who accompanies a geisha

Haku Rakuten: a Noh drama featuring the Chinese poet Haku Rakuten (Po Chü-i)

Hakuseki, Arai (1656–1725): a celebrated historian

Hakutei (1882–1958): western-style painter and print artist; also did some genre work
*Ishii Mankichi

Hamamatsu chūnagon monogatari: an early tale, about 1058

Hamaomi, Shimizu (1776–1824): a *waka* poet and scholar of Japanese studies

半
兵
衛

Hambei (fl. ca. 1664–89): the leading ukiyo-e illustrator in the Kyōto/Ōsaka region during the later 17th century. Hambei illustrated at least 90 books during his long career: novels, tales, guidebooks, Buddhist works, encyclopedias and textbooks, *jōruri* and Kabuki plays, music texts, verse anthologies, courtesan critiques, kimono-pattern books and shunga. He was the first Kamigata ukiyo-e artist to sign his publications (1685–86). Hambei's style is derived from the work of his mid 17th century predecessors, the anonymous genre artists and illustrators of Kyōto. His mentor is said to have been one Shōgorō, of whom, however, no signed work is extant. Hambei is famous for his illustrations to Saikaku's novels of the period 1686–89. He is always competent and inventive, but the miniaturistic limitations of book illustration, as opposed to the more impressive picture books and albums (which were yet to appear in the Kyōto of this period), prevented him from achieving brilliance other than in a few scattered shunga works. Hambei's oeuvre is thought to end about the year 1689, when an anonymous follower, of similar style but diminished force and creativity, took up his tradition and carried it on to the beginning of the following century.
*Yoshida Hambei [Hanbei], Sadakichi
▷ p. 55, plate 39
Mizutani, Yumihiko: *Kohan shōsetsu sōga-shi*.
Lane, Richard. *Shunga Books of the Ukiyo-e School: V—Hambei and the Kamigata Masters.* [7 vols. of reproductions, plus text volume.] Tōkyō, in press.
Lane, Richard. *Studies in Edo Literature and Art.*

女
用
訓
蒙
図
彙

50

Hambei: from *Joyō Kimmō-zui* (on the right are 2 of the *daisen* or title-slips, and on the left, the colophon of this, the 2nd edition of Genroku I (1688), with the three publishers – Kyōto, Ōsaka, Edo – recorded at the bottom with their addresses)

花
見

hammoto: term for publisher, published by
han: a fief governed by a *daimyō*
-han: a suffix meaning "published by", *excudit*
hanami: flower-viewing (usually cherry blossoms), a popular leisure-time activity

hanamichi: in Kabuki two raised patforms leading from the stage to the rearl of the orchestra seats

Hanami-zuki: the poetic name fort he Third Month

Hanazono (1297–1348): 95th sovereign of Japan and *waka* poet of the la Kamakura Period

hanetsuki: the game of battledore and shuttlecock, favored at New Year's time

hanga: a print; woodblock print (sometimes erroneously used to mean *sōsaku hanga*)

hangi: a woodblock
hangi-shi: engraver

hangonkō [the Spirit in the Incense Smoke]: subject of the Kabuki play *Meiboku Sendai-hagi*, where the ghost of the slain Yoshiwara courtesan Takao appears to her lover in the fragrant smoke

Hanji, Chikamatsu (1725–83): a *jōruri* dramatist of the mid Edo Period

hanji-e: a print based on a rebus

Hanjō: the Noh drama featuring the girls Hanago and Yoshida-no-shōshō

hankoku: a reprint

han-satsu: paper money issued by the *daimyō* and valid only in their own fief

hanshi-bon: the most common medium book size, ca. 9×6¼ in./23×16 cm

hanashita-e: a design for engraving

Hanzan (fl. ca. 1850–82): ukiyo-e print artist and illustrator in Ōsaka
*Matsukawa, Yasunobu, Gikyō, Takaji, Chokusui, Kakyo, Suieidō
Illustrated books by Hanzan include *Naniwa meisho* (3 vols., 1855) and *Kyō-miyage* (2 vols., 1866).

張
交

naori: a coat worn over the kimono
happi: a short jacket
harimaze: prints of two or more subjects on one sheet

Harris, Townsend: first Consul of the U.S.A. to Japan; concluded a treaty with Japan at Kanagawa in 1858

Haruga (fl. ca. 1810s): ukiyo-e print artist; pupil of Utamaro II
*Koikawa Haruga [Shunga]

haru-goma [spring pony]: a New Year's dance

春
次
(治)

Haruji [Harutsugu] (fl. ca. 1770): ukiyo-e print artist, pupil of Harunobu

春
子

Haruko (d. 1860): ukiyo-e print artist, Ōsaka School, possibly same person as Shun-yōsai Shunsui

Harukuni (fl. ca. early 1820s): ukiyo-e print artist, Ōsaka School

春
町

Harumachi (1744–89): ukiyo-e print artist, illustrator and novelist. A samurai serving Lord Matsudaira of Suruga; in Edo, he became a pupil of Toriyama Sekien, writing and illustrating the first *kibyōshi, Kinkin sensei eiga-no-yume*. Arrested for satirizing the Kansei Reforms, he committed suicide.
*Koikawa, Harumachi [Shunchō], Kurahashi Kaku, Juhei, Kakuju-sanjin, Sakenoue no Furachi, Shunchōbō

春
政
晩
器

Harumasa (fl. ca. 1800s–10s): ukiyo-e painter and print artist; influenced by Utamaro
*Koikawa, Banki

Harumi, Murata (1746–1811): *waka* poet and scholar of Japanese studies during the mid Edo Period

Harunobu (fl. ca. 1720s): ukiyo-e painter, an early Kaigetsudō pupil, in style perhaps closest to Eishun

*Takeda Harunobu

Harunobu (ca. 1724–70): major ukiyo-e print artist. Although Harunobu's role in the technical development of full-color prints has been often exaggerated, there is no doubt that he ranks among the great geniuses of ukiyo-e. He is said to have studied first under Shigenaga, but his early prints are in the Torii and Toyonobu manner. By 1762, however, he had already developed his unique style, which was soon to dominate the ukiyo-e world. Toward the end of 1764, Harunobu was commissioned to execute a number of designs for calendar prints for the coming year. Various noted literati of Edo contributed designs and ideas, and the printers outdid themselves to produce technically unusual work. From this combination of talents was born the *nishiki-e* [brocade picture] or full-color print, where formerly only two or three colors had been featured. These prints were issued at New Year, 1765; the designs are a bit harsher than the more supple work of Harunobu's maturity, but we can already see here the spirit of parody and lyricism that was to characterize his later work. Though we know nothing of Harunobu's formal education, he was certainly one of the most literate of the ukiyo-e designers. In many of his prints, verses and design are wedded in a happy combination seldom seen before or after. But whatever the literary or legendary implications of a Harunobu print, it is his color and his wonderful ideal of femininity that remain in the viewer's mind after all else is forgotten.

*Suzuki (Hozumi), Chōeiken, Shikojin

51

Harunobu: *Shōki Carrying Girl in Rain.* Chūban, 1765; second state, unsigned

52

Harunobu: *Courtesan and Lover.* Chūban, late 1760s

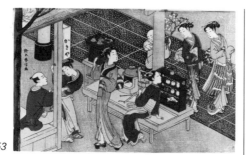

53

Harunobu: *Scene at O-Sen's Tea-shop.* large-ōban late 1760s

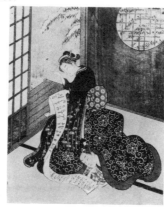

54

Harunobu: *Lovers Reading Letter.* Chūban, calendar print for 1765

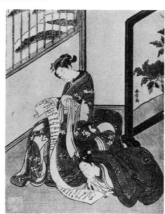

55

Harunobu: *Lovers Reading Letter.* Chūban, ca. 1768. A later version of figure 54, done in Harunobu's maturity

56

Harunobu: *Girl and Child with Hobby-horse.* Chūban, late 1760s

57a

57b

Harunobu: *Lovers in the Snow.* Chūban, ca. 1768. Of the two known versions of this famous print, the second one shown here (b) is probably spurious.

58

Harunobu: *Yoshiwara Scene.* Chūban, ca. 1768. After a design by Sukenobu; on the right, two rustic pilgrims offer prayers, mistaking the resplendant courtesan for a bodhisattva

Some print series by Harunobu:
1 *Ōmi hakkei no uchi,* ca. 1763
2 *Rokkasen,* ca. 1763
3 *Zashiki hakkei,* ca. 1766
4 *Fūryū utai hakkei,* ca. 1767
5 *Fūryū yatsushi nana-Komachi,* ca. 1767
6 *Fūryū setsugekka,* ca. 1768
7 *Fūzoku shiki-kasen,* 1768

227

8 *Fūzoku mu-Tamagawa,* ca. 1768
9 *Fūryū enshoku Mane-emon,* ca. 1768
10 *Fūryū Edo hakkei,* ca. 1769
11 *Fūryū rokkasen,* ca. 1769
12 [*Shell* series] ca. 1769
13 *Tōsei* (*Ukiyo*) *shichi-fukujin,* ca. 1769
14 *Ukiyo bijin yosebana,* ca. 1769

59

Harunobu: *Evening Bell. Chūban,* from the series *Zashiki hakkei,* ca. 1766. Signature and seal of the "conceiver," Kyosen; in the first issue, Harunobu's name appears only on the wrapper to the set.

Illustrated books by Harunobu include:
Ehon kokinran (3 vols., 1762)
Ehon shogei-nishiki (3 vols., 1762)
Ehon hana-kazura (3 vols., 1764)
Ehon kotowaza-gusa (3 vols., 1765)
Ehon sazare-ishi (3 vols., 1766)
Ehon haru-no-tomo (3 vols., 1767)
Ehon chiyo-no-matsu (3 vols., 1767)
Ehon buyū nishiki-no-tamoto (3 vols., 1767)
Ehon warabe-no-mato (3 vols., 1767)
Ehon zoku-Edo-miyage (3 vols., 1768)
Ehon yachiyo-gusa (3 vols., 1768)
Ehon take-no-hayashi (3 vols., 1769)
Ehon ukiyo-bukuro (3 vols., 1770)
Yoshiwara seirō bijin-awase (5 vols., 1770)
Ehon haru-no-nishiki (2 vols., posthumous, 1771)
Ehon iroha-uta (1 vol., posthumous, 1775)
Ehon misao-gusa (2 vols., posthumous, 1778)
Ehon haru-no-yuki (3 vols., n.d.)

Kurth, Julius. *Suzuki Harunobu.* Munich and Leipzig. 1910 (rev. ed. 1923).
Fujikake, Shizuya. *Harunobu.* (in Japanese) Tōkyō, 1939.
● Noguchi, Yone. *Harunobu.* London and Yokohama, 1940.
● Yoshida, Teruji. *Harunobu zenshū.* (in Japanese) Tōkyō, 1942.
Hájek, Lubor. *Harunobu.* London, n.d. (Originally published in German: *Harunobu und die Künstler seiner Zeit.* Prague, 1957.)
Kondo, Ichitaro. *Suzuki Harunobu.* (*English adaptation by Kaoru Ogimi*) Rutland, Vt., and Tōkyō, 1956.
● Waterhouse, D.B. *Harunobu and His Age.* London, 1964. [See our corrections in "Floating-world Morals vs. Ukiyo-e Scholarship," *Ukiyo-e Art* No. 12 (1966).]
Hayashi, Yoshikazu. *Empon kenkyū: Harunobu.* Tōkyō, 1964.
● Hillier, J. *Suzuki Harunobu.* Philadelphia, 1970.
● Gentles, Margaret O. (ed. Richard Lane). *The Clarence Buckingham Collection of Japanese Prints: Harunobu, Koryusai, Shigemasa, Their Followers and Contemporaries.* Chicago, 1965.
▷ pp. 99–110, plates 90–98

Harusada (1798–1849): Kyōto ukiyo-e painter
*Yasukawa
Harushige ▷ Kōkan
破
笠 **Haryū [Haritsu]** (1663–1741): genre painter, potter and lacquerer in Edo. A pupil of Itchō, he painted (perhaps as a hobby) notable *bijin-ga* after the Kaigetsudō manner.
笠
翁 *Ogawa (Kinya), Heisuke, Kan, Shōkō [Naoyuki], Ryūō [Ritsu-ō], Bōkanshi, Hanabusa Issen, Kanshi, Muchūan, Sōu
hasami-bako: a lacquered wooden box with carrying pole attached
Hasegawa School (of painting): founded by Hasegawa Tōhaku
hashibami: a clamp used to prevent woodblocks from warping
Hashi-Benkei: a Noh drama featuring the battle of Benkei and Ushiwaka at Gojō Bridge
hashi-gakari: bridge forming a passage to Noh theater stage
Hashikuni (fl. 1820s): ukiyo-e print artist, Ōsaka School
hashira: a pillar; also, the column at the outside edge of a Japanese book giving title, volume, page number
柱
絵 **hashira-e (hashira-gake):** narrow, upright print size, ca. 28¾×4¾ in./68–73×12–16 cm "pillar prints," made by pasting two sheets together longitudinally; but size varies with each period
Hassaku: the festival celebrated on the 1st day of the Eighth Month
hatamoto: a special class of the shōgun's retainers
Hatsukuni (fl. ca. 1820s): ukiyo-e print artist, Ōsaka School
*Hōkokudō, Hōkadō
Hearn, Lafcadio [Koizumi Yakumo] (1850–1904): noted American writer of fiction, essays and travel accounts, particularly concerning Japan, where he lived from 1890 until his death
He-gassen [The Fart Battle]: a famous early shunga scroll, sometimes copied by ukiyo-e artists

60

Detail from *He-gassen.* Scroll in colors on paper; mid Edo copy after an original, now lost, of the 12th century

Heian: the early name for Kyōto; also the historical period from 794–1185
Heihachirō, Ōshio (1792–1837): an officer of the Ōsaka police, a distinguished Confucianist and revolutionary
Heiji monogatari [Tale of the Heiji]: an early historical novel about the Heiji insurrection of 1159
Heike-gani: tiny crabs, popularly thought to represent the ghostly remains of the Heike warriors, killed at the battle of Dan-no-ura in 1185
Heike monogatari [Tales of the Heike (Taira) Clan]: important historical novel of the

early Kamakura Period; source of many of the subjects of ukiyo-e warrior prints: the Taira clan under the tyranny of Kiyomori, strife among the Buddhist monasteries of Nara and Mt. Hiei, intrigues involving the ex-Emperor Go-Shirakawa, the Minamoto clan and its leader Yoritomo, Kiso no Yoshinaka, Yoshitsune, the battles of Ichinotani and Yashima, Tadamori, Shigemori, Saikō and Mongaku, Tadanori, Atsumori, Koremori, Kenrei-mon-in, and Kumagai no Naozane (who killed the fair young Atsumori and lamenting, entered religious life), ending with the defeat of the Taira and the death of the boy-emperor Antoku, drowned in the sea at the Battle of Dan-no-ura.
henge-mono: a Kabuki dance based on many quick changes in costume
Henjō-sōjō (816–90): *waka* poet of the early Heian Period
hensha: a compiler or editor
henshū: term meaning "compiled" or "edited by"
Heusken J.: secretary to Consul-General Harris; assassinated at Edo in 1861
hexaptych: a continuous series of 6 prints
hibachi: a charcoal brazier
hichiriki: a short oboe-type instrument used in *gagaku*
Hidaka-gawa: a river in Kii (137 miles/220 km long), site of the *Dōjōji* legend
Hidehira, Fujiwara (1096–1187): the *daimyō* of Mutsu Province, protector of Yoshitsune
英
国 **Hidekuni** (fl. mid-1820s): ukiyo-e print artist, Ōsaka School
*Toyokawa Hidekuni
秀
麿 **Hidemaro** (fl. early 19th century): ukiyo-e print artist, pupil of Utamaro
*Kitagawa, Shōrinsai
Hidemaro (fl. ca. mid 1820s): ukiyo-e print artist, Kyōto School
英
信 **Hidenobu** (fl. ca. mid 1760s–70s): Ōsaka ukiyo-e painter
*Hidenobu [Eishin], Ungeisai
秀
信 **Hidenobu** (fl. 1800s): ukiyo-e print artist and painter, Ōsaka School
*Kose Hidenobu
Hidetada, Tokugawa (1579–1632): 2nd shōgun, ruled from 1605–22; maintained and developed his father's policies
Hidetsugu, Toyotomi (1568–95): adopted son and favorite of Hideyoshi; later, falling into disfavor, he was forced to commit *harakiri,* and his wife, daughters and ladies-in-waiting were decapitated, 34 people in all.
Hideyori (fl. ca. 1540): Kanō-School painter in Kyōto, famous for his screen painting, "Maple-viewing at Mount Takao"; its genre scene forms a notable precursor of the Ukiyo-e School.
*Kanō, Jōshin (Shōshin)
Hideyori, Toyotomi (1593–1615): son of Hideyoshi and Yodo-gimi; entrusted to Ieyasu's care but later betrayed, his castle in Ōsaka being reduced to ashes, and Hideyori and Yodo-gimi perishing in the flames
秀
頼 **Hideyoshi, Toyotomi** (1536–98): famous warlord and first consolidator of feudal Japan, military dictator of Japan from 1582 until his death; after early campaigns for Nobunaga, Hideyoshi soon allied with Ieyasu and built a castle at Ōsaka, later at Nagoya and Fushimi as well; in grandeur and richness these fortresses surpassed anything that had been seen in Japan hitherto. Turning his attention to Korea, Hideyoshi sent an expedition there in 1592 and, in a short time, all Korea was in the possession of the Japanese; the occupation proved diffi-

cult, however, and in 1598, Hideyoshi fell sick and ordered Ieyasu to call back the remnants of the Japanese army from Korea.

Hiei-zan-ban: the books printed by the Hiei-zan temples near Kyōto

hige-daimoku: the elaborate calligraphy used by the Nichiren sect of Buddhism

Highways of Central Japan: Tōkaidō and Kiso-kaidō/Nakasendō ▷ map, pp. 230–31, Hiroshige print series 1, 9

hiki-mawashi: a punishment in which the criminal was led on horseback through the streets before being executed

hikinuki: changes of costume during a scene (in Kabuki, usually for purely decorative reasons)

hikite-jaya: a teahouse in the pleasure quarter

hikitsuke: in woodblock printing, the draw-stop of the *kentō*-register system

hikkō: a copyist

彦国 **Hikokuni** (fl. ca. 1820s): Ōsaka ukiyo-e print artist, pupil of Ashikuni, also influenced by the Edo Utagawa School

Hikone Screen [*Hikone-byōbu*]: an early example of genre painting dating from the early to mid 17th century; perhaps the most famous of all early ukiyo-e paintings, registered in Japan as a National Treasure; so named as it was for a long time possessed by the *daimyō* family Ii, of Hikone ▷ pp. 25–27, plate 11

Hiko-san/ a mountain in Buzen with temples of the Yamabushi sect

Hikoshichi, Ōmori: a vassal of Takauji, at the battle of Minato-gawa in 1342 he met a beautiful woman and carried her on his back across a stream; but from her reflection in the water he discovered that she was a witch and slew her on the spot, so it is said

-hime: suffix and title equivalent to princess or her ladyship

Himemiko, Ōku no (661–701): *waka* poetess, daughter of Emperor Temmu

hina (hiina): a doll

hina-dan: shelf for festival dolls

hinagata (hiinagata): a kimono pattern or motif

hinawa: tug-of-war

hinin (*eta*): outcasts, pariahs

hinoki: Japanese cypress, used for the boards of theater stages

hiragana: one of the two phonetic Japanese scripts

hiragana-majiri: Chinese characters and *hiragana* used together in a text

Hiratsuka, Un-ichi (1895–): painter and printmaker, teacher and quiet leader of the modern print movement. Hiratsuka's work goes back to the ancient Buddhist prints of Japan, the strong *sumi-e* of Sesshū and the black and white work of such early ukiyo-e masters as Moronobu.

広景 **Hirokage** (fl. ca. 1855–65): ukiyo-e print artist, pupil of Hiroshige
*Utagawa Hirokage

Hironobu (fl. ca. 1851–70): Ōsaka ukiyo-e print artist, pupil of Hirosada
*Kinoshita, Tōrin, Ashinoya, Gohotei, Goyōtei, Hakusui, Hakusuisai

Hironobu II (1844–ca. 1890s): Ōsaka ukiyo-e print artist, pupil of Hironobu
*Kinoshita, Hirokuni, Ashimi, Hakuhō, Ryūtō

広貞 **Hirosada** (fl. ca. 1820s–60s): Ōsaka ukiyo-e print artist, pupil of Kunimasu; possibly the same artist as Sadahiro
*Utagawa, Gosōtei
▷ Ōsaka Print School

広重 **Hiroshige** (1797–1858): this last major master of the Ukiyo-e School (d. IX/6/1858) was born in 1797, son of an Edo fire warden. Hiroshige succeeded to his father's hereditary post early but in 1811 entered the studio of the ukiyo-e master Utagawa Toyohiro, soon receiving the *nom d'artiste* Hiroshige. His first published work, in the field of book illustration, dates from 1818; during the following decade Hiroshige published capable work in the field of figure prints: actors, warriors and girls. From the year 1831 he began (under the influence of the great Hokusai) the series of landscape prints that were to make his name: *Fifty-three Stations of the Tōkaidō,* and later *Famous Views of Japan, Famous Views of Kyōto, Eight Views of Lake Biwa, Sixty-nine Stations of the Kiso Highway.* Though not the prodigious eccentric that Hokusai was, Hiroshige nevertheless made a large contribution to the development of the landscape print, as well as to the field of flower-and-bird prints (these revealing his inclination toward the Kyōto Shijō School more than toward ukiyo-e).

In effect, Hiroshige consolidated the landscape form and adapted it to popular taste, thereby diffusing the form to all strata of society. But eventually this also led to overproduction and declining standards of quality. At his best, however, Hiroshige was a master of the impressionist, poetic view of nature, and he remains the best-loved of all Japanese artists.

— Among his pupils were Hiroshige II, Shigekatsu,
立斎 Shigekiyo and Hiroshige III.
*Utagawa (Andō), Tokutarō, Jūbei, Jūemon,
立斎 Tokubei, Ichiyūsai, Ichiryūsai, Ryūsai, Tōkaidō Utashige

HIROSHIGE'S PRINCIPAL SIGNATURES AND THE APPROXIMATE PERIODS OF THEIR USE:

1818 1821 ca. 1832

ca. 1840 1848 ca. 1857

SAMPLE HIROSHIGE SEALS:

62

Kunisada: *Memorial Portrait of Hiroshige.* Ōban, 1858 (Hiroshige's farewell verse appears on the upper left)

63 64

Hiroshige: *Courtesan in Boudoir.* Ōban, from the series *Soto-to-uchi sugata-hakkei,* ca. early 1820s

Hiroshige: *Rabbits and Moon.* Chū-tanzaku, ca. 1830s

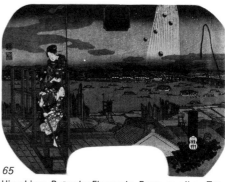

65

Hiroshige: *Ryōgoku Fireworks.* From an *aiban Tōto meisho* series of fan-prints, 1839

61

Hiratsuka, Un-ichi: *Shōsōin, Nara.* Extra-large ōban sumizuri-e, 1958

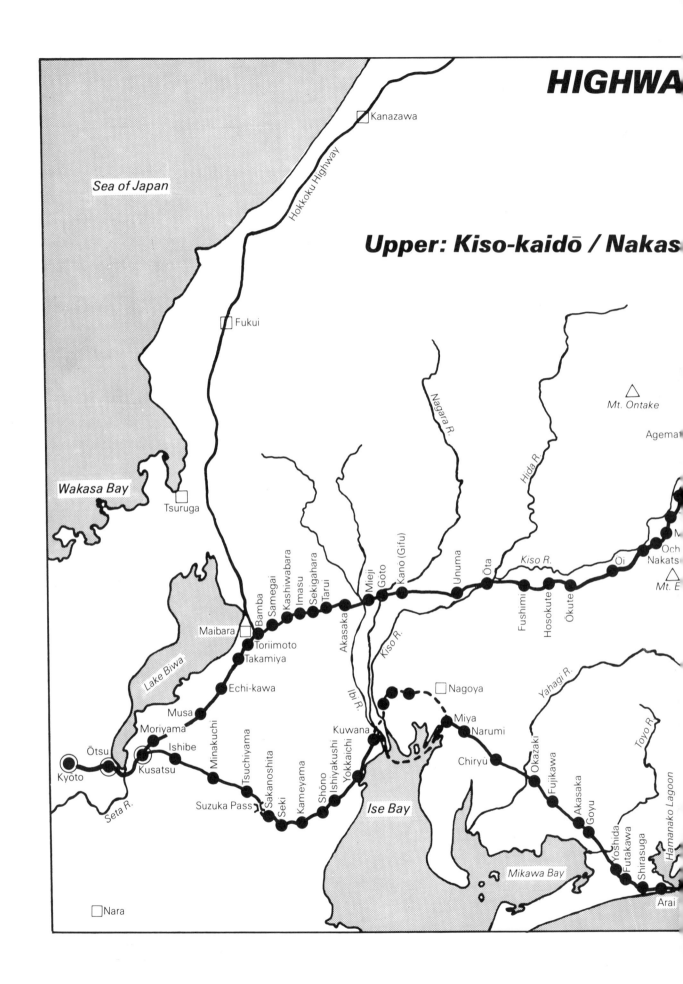

Sea of Japan

Upper: Kiso-kaidō / Nakas

Kanazawa

Hokkoku Highway

Mt. Ontake

Agema

Fukui

Wakasa Bay

Nagara R.

Tsuruga

Hida R.

Kiso R.

M
Och
Nakats

Bamba
Samegai
Kashiwabara
Imasu
Sekigahara
Tarui
Mieji
Gotō
Kano (Gifu)
Unuma
Ōta
Fushimi
Hosokute
Ōkute
Oi
Mt. E

Maibara
Akasaka
Kiso R.

Toriimoto
Takamiya

Lake Biwa

Echi-kawa

Ibi R.

Nagoya

Yahagi R.

Musa

Moriyama
Kuwana
Miya

Ōtsu
Ishibe
Minakuchi
Narumi
Toyo R.

Kyoto
Kusatsu
Tsuchiyama
Shōno
Ishiyakushi
Yokkaichi
Chiryū
Okazaki
Fujikawa

Seta R.
Sakanoshita
Kameyama
Akasaka
Goyu

Suzuka Pass
Seki
Ise Bay
Yoshida
Futakawa
Shirasuga
Hamanako Lagoon

Mikawa Bay

Nara
Arai

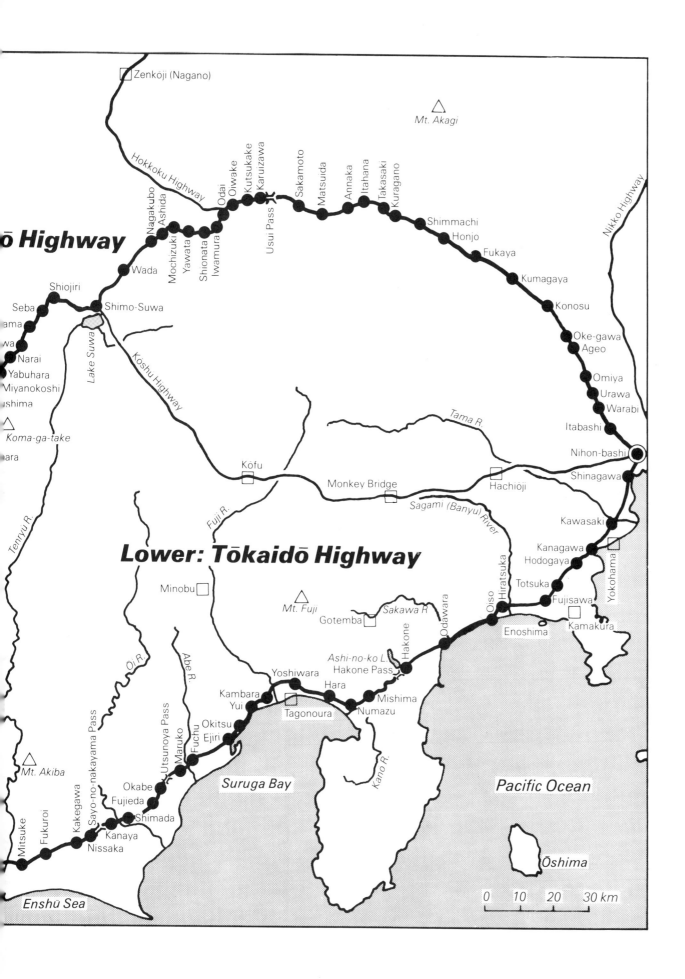

□ Zenkōji (Nagano)

△ Mt. Akagi

Hokkoku Highway

ō Highway

Nagakubo
Ashida
Mochizuki
Yawata
Shionata
Iwamura
Odai
Oiwake
Kutsukake
Karuizawa
Usui Pass
Sakamoto
Matsuida
Annaka
Itahana
Takasaki
Kuragano
Shimmachi
Honjo
Fukaya
Kumagaya
Konosu
Oke-gawa
Ageo
Omiya
Urawa
Warabi
Itabashi
Nihon-bashi

Wada
Shiojiri
Seba
ama
wa
Narai
Yabuhara
Miyanokoshi
ushima

△ Koma-ga-take
ara

Shimo-Suwa
Lake Suwa

Kōshu Highway

Nikko Highway

Kōfu

Monkey Bridge

Tama R.

Hachiōji
Shinagawa

Fuji R.

Sagami (Banyu) River

Kawasaki

Lower: Tōkaidō Highway

Kanagawa
Hodogaya
Yokohama

Tenryu R.

Minobu □

△ Mt. Fuji
Gotemba

Sakawa R.

Totsuka
Oiso
Hiratsuka

Odawara

Enoshima
Kamakura

Fujisawa

Ōi R.
Abe R.
Utsunoya Pass
Maruko
Fuchu

Hakone
Ashi-no-ko L.
Hakone Pass

△ Mt. Akiba

Okabe
Fujieda
Shimada

Okitsu
Ejiri

Yoshiwara
Hara

Kambara
Yui
Tagonoura

Mishima
Numazu

Kano R.

Suruga Bay

Pacific Ocean

Mitsuke
Fukuroi
Kakegawa
Sayo-no-nakayama Pass
Kanaya
Nissaka

Ōshima

Enshū Sea

0 10 20 30 km

66

Hiroshige: *Snow on the Sumida River. Ōban* triptych, ca. 1846

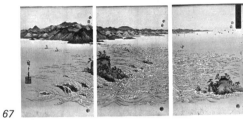

67

Hiroshige: *The Whirlpools of Awa. Ōban* triptych, 1857

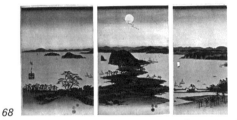

68

Hiroshige: *Night View of Kanazawa. Ōban* triptych, 1857

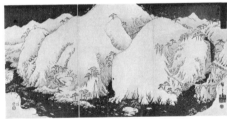

69

Hiroshige: *Mountains and Rivers of Kiso. Ōban* triptych, 1857

I SELECTED PRINT SERIES BY HIROSHIGE

Hiroshige's productive artistic life may best be summarized through his more important print series. They are arranged in the following order: 1–8 various Tōkaidō series; 9 Kiso-kaidō; 10–22 Edo series; 23–34 provincial series; 35–39 miscellaneous series.

東海道五十三次 1 *TŌKAIDŌ GOJŪSAN-TSUGI NO UCHI* (From the Fifty-three Stations of the Tōkaidō) 55 prints, *ōban*, ca. 1833–34; publishers: Hōeidō, Senkakudō
▷ Highways, map

70 1 *Nihon-bashi, asa-no-kei* (Morning View); subtitle of second state: *gyōretsu furude* (Processional Standard-bearers)

71 2 *Shinagawa, hinode* (Sunrise); subtitle of second state: *shokō detachi* (Daimyōs' Departure)

72 3 *Kawasaki, Rokugō watashi-bune* (Ferry at Rokugō)

73 4 *Kanagawa, Dai-no-kei* (Hilltop View)

74 5 *Hodogaya, Shimmachi-bashi* (Shimmachi Bridge)

75 6 *Totsuka, Motomachi-betsudō* (Motomachi Detour)

76 7 *Fujisawa, Yugyōji* [Temple]

77 8 *Hiratsuka, Nawate-michi* (Nawate Road)

78 9 *Ōiso, Tora-ga-ame* (Tora's Rain)

82 13 *Numazu, tasogare-zu* (Dusk Scene)

85a 16a *Kambara, yoru no yuki* (Night Snow), second state

79 10 *Odawara, Sakawa-gawa* (Sakawa River)

83 14 *Hara, asa no Fuji* (Fuji in the Morning)

86 17 *Yui, Satta-mine* (Satta Pass)

80 11 *Hakone, kosui* (The Lake)

84 15 *Yoshiwara, hidari Fuji* (Fuji from the Left)

87 18 *Okitsu, Okitsu-gawa* (Okitsu River)

81 12 *Mishima, asagiri* (Morning Mist) [plate 181]

85 16 *Kambara, yoru no yuki* (Night Snow) [plate 180]

88 19 *Ejiri, Miho embō* (View of Miho)

89 20 *Fuchū, Abe-kawa* (Abe River)

93 24 *Shimada, Ōi-gawa Sungan* (Suruga Bank of Ōi River)

97 28 *Fukuroi, dejaya no zu* (Tea Stall)

90 21 *Maruko, meibutsu cha-mise* (Famous Tea Shop)

94 25 *Kanaya, Ōi-gawa engan* (Distant Bank of Ōi River)

98 29 *Mitsuke, Tenryū-gawa zu* (Tenryū River View)

91 22 *Okabe, Utsu-no-yama* (Utsu Mountain)

95 26 *Nissaka, Sayo-no-nakayama* (Sayo Mountain Pass)

99 30 *Hamamatsu, fuyugare no zu* (Winter Scene)

92 23 *Fujieda, jimba tsugitate* (Changing Porters/Horses)

96 27 *Kakegawa, Akiba-yama embō* (View of Akiba Mountain)

100 31 *Maisaka, Imagiri shinkei* (View of Imagiri)

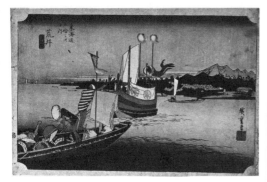

101 32 Arai, watashi-bune no zu (Ferryboat)

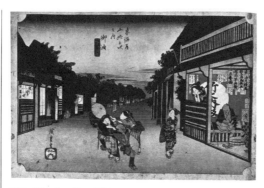

105 36 Goyū, tabibito tome-onna (Women Soliciting Travelers)

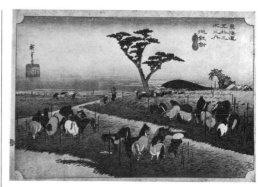

109 40 Chiryū, shuka uma-ichi (Summer Horse Fair)

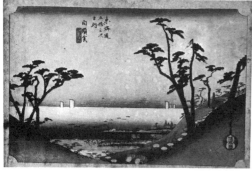

102 33 Shirasuga, Shiomi-zaka zu (View of Shiomi Slope)

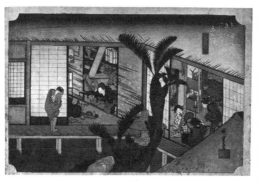

106 37 Akasaka, ryosha shōfu no zu (Inn with Serving-Maids)

110 41 Narumi, meibutsu Arimatsu-shibori (Arimatsu Cloth)

103 34 Futakawa, Saru-ga-baba (Monkey Plateau)

107 38 Fujikawa, bōhana no zu (Scene at Post Outskirts)

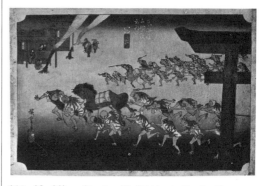

111 42 Miya, Atsuta shinji (Atsuta Festival)

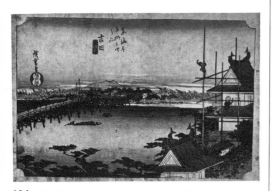

104 35 Yoshida, Toyokawa-bashi (Toyokawa Bridge)

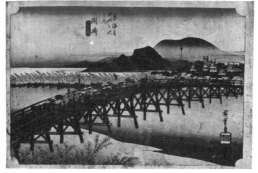

108 39 Okazaki, Yahagi-no-hashi (Yahagi Bridge)

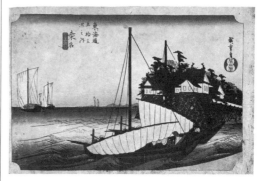

112 43 Kuwana, Shichi-ri watashi-guchi (Port of Kuwana)

113　44　*Yokkaichi, Mie-gawa* (Mie River)

117　48　*Seki, honjin hayadachi* (Early Departure of *Daimyō*)

121　52　*Ishibe, Megawa-no-sato* (Megawa Village)

114　45　*Ishiyakushi, Ishiyakushi-ji* (Ishiyakushi Temple)

118　49　*Sakanoshita, Fudesute-mine* (Fudesute Mountain)

122　53　*Kusatsu, meibutsu tateba* (Posting House)

115　46　*Shōno, haku-u* (Driving Rain) [plates 178–179]

119　50　*Tsuchiyama, haru no ame* (Spring Rain)

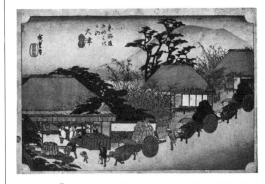

123　54　*Ōtsu, Hashirii cha-mise* (Hashirii Teahouse)

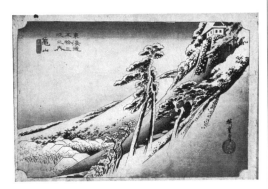

116　47　*Kameyama, yukibare* (Clear Weather after Snow)

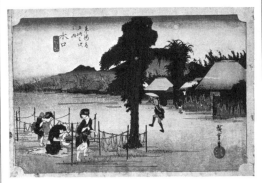

120　51　*Minakuchi, meibutsu kampyō* (Noted Pickles)

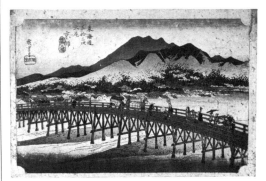

124　55　*Keishi, Sanjō-ōhashi* (Kyōto, Great Sanjō Bridge)

狂歌東海道

2 *TŌKAIDŌ GOJŪSAN-TSUGI* (The Fifty-three Stations of the Tōkaidō)
56 prints, *chūban,* ca. 1840; publisher: Sano-Ki (known as the "*Kyōka Tōkaidō,*" from the *kyōka* verses on each print.) For list of the highway stages see Series 1, above. [The 56th print is an additional Kyōto scene, showing the Imperial Palace.]

行書東海道

3 *TŌKAIDŌ GOJŪSAN-TSUGI NO UCHI* (From the Fifty-three Stations of the Tōkaidō)
55 prints, *aiban,* ca. 1841–42; publishers: Ezaki-ya, Yamada-ya (This series is known as the "*Gyōsho* Tōkaidō," from the cursive calligraphic style of the cartouches.) For list of highway stages see Series 1, above.

125a

125b

Hiroshige: *Nihon-bashi* and *Ishiyakushi* from the series *Tōkaidō gojūsan-tsugi no uchi*

隷書東海道

4 *TŌKAIDŌ*
55 *ōban* prints, ca. 1848–49; publisher: Maru-sei (known popularly as the "*Reishō* Tōkaidō," from the formal calligraphic style of the cartouches.) For list of the highway stages see Series 1, above.

126

Hiroshige: *Hamamatsu,* from the series *Tōkaidō*

5 *TŌKAIDŌ GOJŪSAN-TSUGI* (The Fifty-three Stations of the Tōkaidō)
54 prints, *chūban,* ca. 1850; publisher: Tsuta-ya. For list of the highway stages see Series 1, above [Shimada (24) and Kanaya (25) are combined].

6 *SŌ-HITSU GOJŪSAN-TSUGI* (The Fifty-three Stations [of the Tōkaidō] from Two Brushes)
55 vertical *ōban* prints by Hiroshige and Kuni-sada, 1854–57; publisher: Maru-ya Kishirō. For list of the highway stages see Series 1, above.

7 *GOJŪSAN-TSUGI MEISHO-ZUE* (The Fifty-three Famous Views [of the Tōkaidō])
55 prints, *ōban,* 1855; publisher: Tsuta-ya. For list of the highway stages see Series 1, above.

8 *TŌKAIDŌ GOJŪSAN-TSUI* (Fifty-three Pairs of the Tōkaidō)
62 vertical *ōban* prints, 1855, by Hiroshige (22 designs), Kunisada and Kuniyoshi; publishers: Iba-Sen, Iba-Kyū and others.

木曾街道六十九駅

9 *KISO-KAIDŌ ROKUJŪKYŪ-TSUGI NO UCHI* (From the Sixty-nine Stations of the Kiso Highway)
70 prints, *ōban,* late 1830s, Eisen and Hiroshige in collaboration; publishers: Hōeidō, Kinjudō

127 1 *Nihon-bashi* (Eisen)

128 2 *Itabashi* (Eisen)

129 3 *Warabi* (Eisen)

130 4 *Urawa* (Eisen)

131 5 *Ōmiya* (Eisen)

132 6 *Ageo* (Eisen)

133 7 *Oke-gawa* (Eisen)

136 10 *Fukaya* (Eisen)

140 14 *Takasaki* (Hiroshige)

134 8 *Kōnosu* (Eisen)

137 11 *Honjō* (Eisen)

141 15 *Itahana* (Eisen)

134a 8a *Kōnosu* (Eisen), second state

138 12 *Shimmachi* (Hiroshige)

142 16 *Annaka* (Hiroshige)

135 9 *Kumagaya* (Eisen)

139 13 *Kuragano* (Eisen)

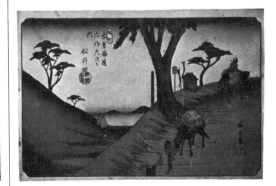

143 17 *Matsuida* (Hiroshige)

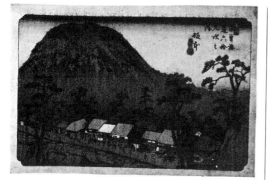

144 18 *Sakamoto* (Eisen)

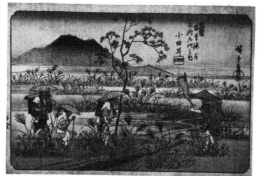

148 22 *Odai* (Hiroshige)

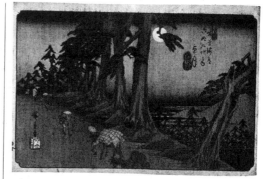

152 26 *Mochizuki* (Hiroshige)

145 19 *Karuizawa* (Hiroshige)

149 23 *Iwamura* (Eisen)

153 27 *Ashida* (Hiroshige)

146 20 *Kutsukake* (Eisen)

150 24 *Shionata* (Hiroshige)

154 28 *Nagakubo* (Hiroshige)

47 21 *Oiwake* (Eisen)

151 25 *Yawata* (Hiroshige)

155 29 *Wada* (Hiroshige)

156 30 *Shimo-Suwa* (Hiroshige)

160 34 *Nie-kawa* (Hiroshige)

164 38 *Fukushima* (Hiroshige)

157 31 *Shiojiri* (Eisen)

161 35 *Narai* (Eisen)

165 39 *Agematsu* (Hiroshige)

158 32 *Seba* (Hiroshige) [plate 186]

162 36 *Yabuhara* (Eisen)

166 40 *Suhara* (Hiroshige)

159 33 *Motoyama* (Hiroshige)

163 37 *Miyanokoshi* (Hiroshige) [plate 185]

167 41 *Nojiri,* Inagawa-bashi (Eisen) [plate 194]

168 42 *Midono* (Hiroshige)

172 46 *Nakatsu-gawa* (Hiroshige)

176 49 *Hosokute* (Hiroshige)

169 43 *Tsumago* (Hiroshige)

173 46a *Nakatsu-gawa* (Hiroshige), alternate version

177 50 *On-take* (Hiroshige)

170 44 *Magome* (Eisen)

174 47 *Ōi* (Hiroshige)

178 51 *Fushimi* (Hiroshige)

171 45 *Ochiai* (Hiroshige)

175 48 *Ōkute* (Hiroshige)

179 52 *Ōta* (Hiroshige)

180 53 *Unuma* (Eisen)

184 57 *Akasaka* (Hiroshige)

188 61 *Kashiwabara* (Hiroshige)

181 54 *Kanō* (Hiroshige)

185 58 *Tarui* (Hiroshige)

189 62 *Samegai* (Hiroshige)

182 55 *Gōto, Nagae-gawa* (Eisen)

186 59 *Sekigahara* (Hiroshige)

190 63 *Bamba* (Hiroshige)

183 56 *Mieji* (Hiroshige)

187 60 *Imasu* (Hiroshige)

191 64 *Toriimoto* (Hiroshige)

242

192 65 *Takamiya* (Hiroshige)

193 66 *Echi-kawa* (Hiroshige)

194 67 *Musa* (Hiroshige)

195 68 *Moriyama* (Hiroshige)

196 69 *Kusatsu, Oiwake* (Hiroshige)

197 70 *Ōtsu* (Hiroshige)

10 TŌTO MEISHO (Famous Places of the Eastern Capital)
10 prints, *ōban*, ca. 1831; publisher: Kawaguchi [At least ten other varieties of *Tōto meisho* sets were issued by Hiroshige in later years, by different publishers.]
1 *Takanawa no meigetsu* (Moonlight at Takanawa) [plate 177]
2 *Ryōgoku no yoizuki* (Twilight Moon at Ryōgoku)

198

Hiroshige: *Ryōgoku no yoizuki,* from the series *Tōto meisho*

3 *Susaki, yuki no hatsuhi* (Susaki, New Year's Sunrise after Snow)
4 *Shibaura, shiohi-gari no zu* (Shell-gathering at Shibaura)
5 *Shin-Yoshiwara, asazakura no zu* (Morning Cherry Blossoms at Yoshiwara)
6 *Goten-yama no yūzakura* (Twilight Cherry Blossoms at Goten-yama)
7 *Masaki, boshun no kei* (Late Spring at Masaki)

8 *Sumida-gawa, hazakura no kei* (Cherry Trees in Leaf by the Sumida River)
9 *Tsukuda-jima, hatsu-hototogisu* (First Cuckoo of the Year at Tsukuda-jima)
10 *Shinobu-ga-oka, hasu-ike no zu* (Lotus Pond at Shinobu-ga-oka)

199

Hiroshige: *Shibaura, shiohi-gari no zu,* from the series *Tōto meisho* (no. 10)

11 TŌTO MEISHO (Famous Places of the Eastern Capital [Edo])
Ca. 40(+) prints, *ōban*, ca. 1833–43; publisher: Kikakudō. [At least ten other series of this title by Hiroshige are known, from various publishers.]

200

200a

Hiroshige: *Kameido Shrine in Snow,* from the series *Tōto meisho,* ca. early 1830s (alternate impressions)

京都名所

12 KŌTO MEISHO (Famous Places of Edo)
10 prints, *chūban*, ca. 1836; publisher: Kikakudō

江戸高名会亭尽

13 EDO KŌMEI KAITEI-ZUKUSHI (Series of Famous Teahouses in Edo)
30 prints, *ōban*, ca. 1835–42; publisher: Fuji-Hiko

江戸近郊八景

14 EDO KINKŌ HAKKEI NO UCHI (From Eight Views of the Suburbs of Edo)
8 prints, *ōban*, ca. 1837–38; publisher: Kikakudō
1 *Shibaura seiran* (Clearing Weather at Shibaura)
2 *Azuma-no-mori yau* (Evening Rain at Azuma-no-mori)

243

3 *Gyōtoku kihan* (Fishing-boats returning to Gyōtoku)
4 *Ikegami banshō* (Evening Bells at Ikegami)
5 *Koganei sekishō* (Sunset at Koganei)
6 *Haneda rakugan* (Geese Flying Home at Haneda)
7 *Tamagawa shugetsu* (Autumn Moon at Tama River)

201

8 *Asuka-yama bosetsu* (Evening Snow at Asuka-yama)

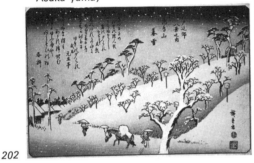

202

15 *TŌTO HAKKEI* (Eight Views of the Eastern Capital [Edo])
8 prints, *aiban*, ca. 1837–38; publisher: Fuji-Hiko. (Several other Hiroshige series also appeared under this title.)

203

Hiroshige: *Ryōgoku* from the series *Tōto hakkei*

16 *SHIBA HAKKEI* (Eight Views of Shiba)
8 prints, *ōban*, ca. 1839–40; publisher: Echizen-ya

204

Hiroshige: *Returning Sailboats at Takanawa*, from the series *Shiba hakkei*

17 *KŌTO SHŌKEI* (Fine Views of Edo)
8 prints, *ōban*, early 1840s; publisher: Kawa-Shō

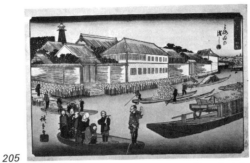

205

Hiroshige: *Yoroi Ferry*, from the series *Kōto shōkei*

四季江戸名所 18 *SHIKI KŌTO MEISHO* (Famous Places of Edo in the Four Seasons)
4 prints, *chū-tanzaku*, ca. 1834; publisher: Kawa-Shō
1 *Goten-yama Cherry Blossoms*
2 *Moonlight at Ryōgoku*

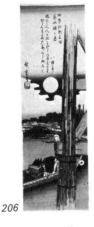

206

3 *Maple Leaves at Kaianji*
4 *Snow on the Sumida River*

19 *TŌTO MEISHO* (Famous Places of Edo)
20 prints, *chū-tanzaku*, ca. 1840–41; publisher: Fuji-Hiko [Shōgendō]

隅田川八景 20 *TŌTO MEISHO NO UCHI: SUMIDA-GAWA HAKKEI* (Famous Places of Edo: Eight Views of the Sumida River)
8 prints, *aiban*, ca. 1840–42; publisher: Sano-Ki

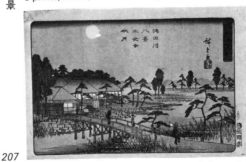

207

Hiroshige: *Autumn Moon at Mokuboji*, from the series *Tōto meisho no uchi: Sumida-gawa hakkei*

208

Hiroshige: *Evening Glow at Imado*, from the series *Tōto meisho no uchi: Sumida-gawa hakkei*

江戸名所 21 *EDO MEISHO* (Famous Places of Edo)
45 prints, *ōban*, 1853; publisher: Yamada-ya (Several other Hiroshige series also appeared under this title.)

名所江戸百景 22 *MEISHO EDO HYAKKEI* (One Hundred Famous Views of Edo)
119 prints, *ōban*, Spring 1856–early 1859; publisher: Uo-Ei [Uo-ya Eikichi]. (Includes 4 supplementary prints by Hiroshige II, plus decorated table of contents issued after the series was completed, arranged by seasons, the order of which is followed here. For locations of these scenes see map under Edo.)

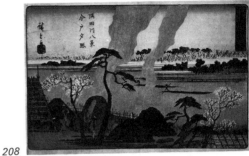

209 1 *Nihon-bashi, yuki-bare* (Nihonbashi, Clearing Weather after Snow). 1856
210 2 *Kasumi-ga-seki*. 1857

211 3 *Yamashita-chō Hibiya, soto Sakurada* (Yamashita Quarter, Sakurada Outside Hibiya). 1857
212 4 *Eitai-bashi, Tsukuda-jima* (Eitai Bridge, Tsukuda Island). 1857

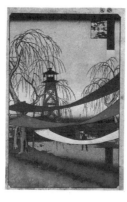

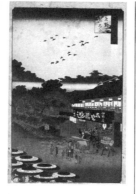

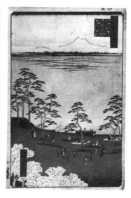
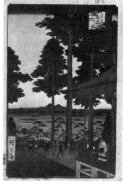

213 5 *Ryōgoku Ekō-in, Moto-yanagi-bashi*
 (Ekōin [temple] and Moto-yanagi Bridge,
 Ryōgoku). 1857
214 6 *Bakuro-chō, Hatsune-no-baba* (Hatsune
 Riding Ground, Bakuro-chō). 1857

219 11 *Ueno Kiyomizu-dō, Shinobazu-no-ike*
 (Kiyomizu Temple and Shinobazu Pond,
 Ueno). 1856
220 12 *Ueno Yamashita* (Yamashita Quarter,
 Ueno). 1858 [Hiroshige II]

225 17 *Asuka-yama kita no chōbō* (Northward
 View from Asuka Hill)]. 1856
226 18 *Ōji Inari-no-yashiro* (Inari Shrine, Ōji).
 1857

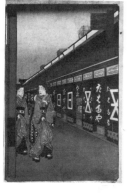
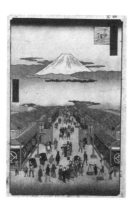

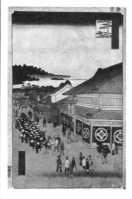
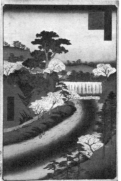

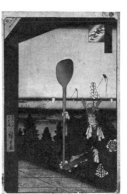

215 7 *Ōdemma-chō, Momen-dana* (Cotton-
 goods Street, Ōdemma-chō). 1858
216 8 *Suruga-chō* (Suruga Street). 1856

221 13 *Shitaya Hirokōji* (Hirokōji [Avenue], Shi-
 taya). 1856
222 14 *Nippori, jiin no rinsen* (Nippori, Temple-
 Gardens). 1857

227 19 *Ōji Otonashi-gawa entai, sezoku Ōtaki to*
 tonau (Otonashi-River Dam, Ōji, popular-
 ly called "Great Waterfall"). 1857
228 20 *Kawaguchi-no-watashi Zenkōji* (Ferry at
 Kawaguchi and Zenkōji [Temple]). 1857.

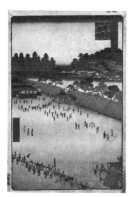
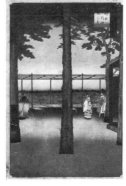

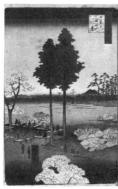

217 9 *Suji-chigai-uchi, Yatsukōji* (Yatsukōji
 [Junction], Suji-chigai). 1857
218 10 *Kanda Myōjin, akebono no kei* (Dawn at
 Kanda Myōjin [Shrine]). 1857

223 15 *Nippori, Suwa-no-dai* (Suwa Bluff, Nip-
 pori). 1856
224 16 *Sendagi, Dango-zaka Hana-yashiki*
 (Flower Pavilion, Dango Hill, Sendagi).
 1856

229 21 *Shiba, Atago-yama* (Mount Atago, Shi-
 ba) 1857
230 22 *Hiroo, Furu-kawa* (Furu-kawa [River],
 Hiroo). 1857

231 23 *Meguro, Chiyo-ga-ike* (Chiyo Pond, Meguro). 1856
232 24 *Meguro, Shin-Fuji* (New Fuji, Meguro). 1857

237 29 *Sunamura Moto-Hachiman* (Former Hachiman Shrine, Sunamura). 1856
238 30 *Kameido, Ume yashiki* (Plum Garden, Kameido). 1857

243 35 *Sumida-gawa, Suijin-no-mori, Masaki* (Suijin Grove and Masaki on the Sumida River). 1856
244 36 *Masaki atari yori Suijin-no-mori uchikawa, Sekiya-no-sato-wo-miru-zu* (View of Suijin Grove and Sekiya Village, seen from near Masaki). 1857

233 25 *Meguro, Moto-Fuji* (Original Fuji, Meguro). 1856
234 26 *Hakkei-zaka, Yoroikake-no-matsu* ("Armour-hanging Pine", Hakkei Slope). 1856

239 31 *Azuma-no-mori, renri no azusa* (The Catalpa Tree with Entwined Branches, Azuma Grove). 1856
240 32 *Yanagi-shima* (Willow Island). 1857

245 37 *Sumida-gawa, Hashiba-no-watashi, kawaragama* (Hashiba Ferry and Tile Kilns, Sumida River). 1857
246 38 *Kakuchū shinonome* (Dawn in the Yoshiwara). 1857

235 27 *Kamata no Umezono* (Plum Garden, Kamata). 1857
236 28 *Shinagawa, Goten-yama* (Shinagawa, Goten Hill). 1856

241 33 *Yotsugi-dōri, yōsui hikifune* (Hauling Canal Boats, Yotsugi Road). 1857
242 34 *Matsuchi-yama, San-ya-bori yakei* (Night View of Sanya Canal, Matsuchi Hill). 1857

247 39 *Azuma-bashi, Kinryūzan embō* (View of Kinryūzan Temple from Azuma Bridge). 1857
248 40 *Sekiguchi jōsui-bata, Bashō-an Tsubaki-yama* (Basho's Hut, Camelia Hill, at Sekiguchi Aqueduct). 1857

 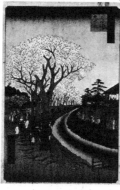 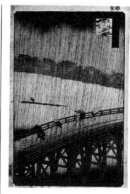

249 41 *Ichigaya Hachiman* (Hachiman Shrine, Ichigaya). 1858 [Hiroshige II]

250 42 *Tamagawa-zutsumi no hana* (Cherry Blossoms, Tama River Embankment). 1856

255 47 *Ōji, Fudō-no-taki* (Fudō Waterfall, Ōji). 1857

256 48 *Akasaka, Kiri-bata* (Paulownia Plantation, Akasaka). 1856

260 52 *Ōhashi, Atake no yūdachi* (Ōhashi [Great Bridge], Sudden Shower at Atake). 1857 [plate 187]

261 53 *Ryōgoku-bashi, Okawa-bata* (Ryōgoku Bridge, [Sumida] Riverbank). 1857

251 43 *Nihon-bashi, Edo-bashi* (Edo-bashi [Bridge] from Nihon-bashi). 1857

252 44 *Nihon-bashi, Tōri-itchōme ryaku-zu* (View of First Street, Nihon-bashi). 1858

256a 48a *Akasaka Kiri-bata, uchū yūkei* (Evening View, Paulownia Plantation at Akasaka in Downpour). [Second version, by Hiroshige II]. 1859

257 49 *Zōjōji-tō, Akabane* (Pagoda of Zōjōji [Temple], Akabane). 1857

262 54 *Asakusa-gawa, Shubi-no-matsu, Ommaya-gashi* ("Good Results Pine" at Ommaya Bank, Asakusa River). 1856

263 55 *Komagata-dō, Azuma-bashi* (Komagata Temple, Azuma Bridge). 1857

253 45 *Yoroi-no-watashi, Koami-chō* (Yoroi Ferry, Koami-chō). 1857

254 46 *Shōhei-bashi, Seidō, Kanda-gawa* (Seidō Shrine and Kanda River from Shōhei Bridge). 1857

258 50 *Tsukuda-jima, Sumiyoshi no matsuri* (Sumiyoshi Festival, Tsukuda Island). 1857

259 51 *Fukagawa, Mannen-bashi* (Mannen Bridge, Fukagawa). 1857

264 56 *Horikiri no hana-shōbu* (Iris Garden at Horikiri). 1857

265 57 *Kameido Tenjin keidai* (Grounds of Kameido Tenjin Shrine). 1856

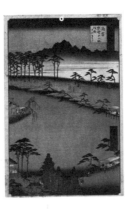 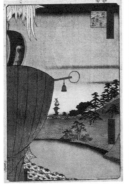

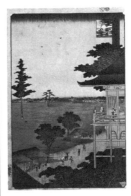 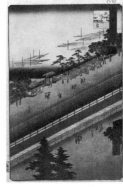

266 58 *Sakasai-no-watashi* (Sakasai Ferry). 1857
267 59 *Fukagawa Hachiman, yama-hiraki* (Open Garden, Hachiman Shrine, Fukagawa). 1857

272 64 *Tsunohazu Kumano Jūni-sha, zokushō Jūni-sō* (Kumano Jūnisha [Shrine] at Tsunohazu, popularly called Junisō). 1856
273 65 *Kōji-machi itchōme, Sannō-matsuri neri-komi* (Sannō-Festival Procession at First Street, Kōji-machi). 1856

278 70 *Gohyaku-rakan, Sazaidō* (Sazai Hall, "Five Hundred Rakan" [Temple]). 1857.
279 71 *Fukagawa, Sanjūsangendō* (The Sanjū-sangendō [Temple], Fukagawa). 1857

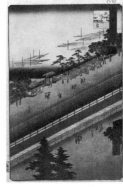

268 60 *Nakagawa-guchi* (Mouth of the Naka River). 1857
269 61 *Tone-gawa, Barabara-matsu* (Scattered Pines along Tone River). 1856

274 66 *Soto-Sakurada, Benkei-bori, Koji-machi* (Kōjimachi at Benkei Moat, from Sakurada Gate). 1856
275 67 *Mitsumata, Wakare-no-fuchi* ("Fairwell Deep" at Mitsumata). 1857

280 72 *Haneda-no-watashi, Benten no yashiro* (Haneda Ferry and Benten Shrine). 1858
281 73 *Shichū han-ei, Tanabata-matsuri* (Town Prosperous with Tanabata Festival). 1857

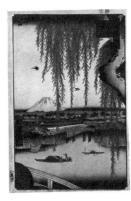 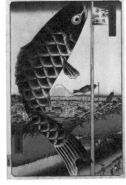

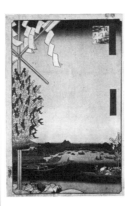 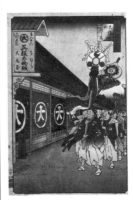

270 62 *Yatsumi-no-hashi* (Yatsumi Bridge). 1856
271 63 *Suidō-bashi, Surugadai* (Suidō Bridge, Surugadai). 1857

276 68 *Asakusa-gawa Ōkawa-bata, Miyato-gawa* (Miyato River by Great Bank of Asakusa River). 1857
277 69 *Ayase-gawa, Kane-ga-guchi* (Kane-ga-fuchi, Ayase River). 1857

282 74 *Ōdemma-chō, Gofuku-dana* (Drapery Lane, Odemma Street). 1858
283 75 *Kanda, Konya-chō* (Dyers' Street, Kanda). 1857

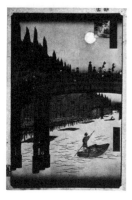
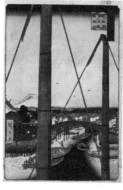

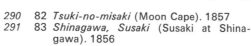

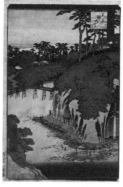
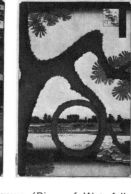

284 76 *Kyōbashi, Take-gashi* (Bamboo Bank, Kyōbashi). 1857/58
285 77 *Teppōzu, Inari-bashi, Minato-jinja* (Inari Bridge and Minato Shrine, Teppōzu). 1857

290 82 *Tsuki-no-misaki* (Moon Cape). 1857
291 83 *Shinagawa, Susaki* (Susaki at Shinagawa). 1856

296 88 *Ōji, Taki-no-gawa* (River of Waterfalls, Ōji). 1856
297 89 *Ueno sannai, Tsuki-no-matsu* ("Moon Pine", Ueno Temple Precincts). 1857

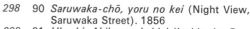

286 78 *Teppōzu, Tsukiji-monzeki* (Tsukiji [Honganji] Temple, Teppōzu). 1858. Variant main title for nos. 78–79: *Edo hyakkei yokyō* (One Hundred Additional Scenic Pleasures).
287 79 *Shiba-shimmei, Zōjōji* (Shimmei Shrine and Zōjōji [Temple], Shiba). 1858

292 84 *Meguro, Jiji-ga-chaya* ("Elder's Tea Shop", Meguro). 1857
293 85 *Kinokuni-zaka, Akasaka Tameike enkei* (View of Akasaka Reservoir, Kinokuni Slope). 1856

298 90 *Saruwaka-chō, yoru no kei* (Night View, Saruwaka Street). 1856
299 91 *Ukechi, Akiba no keidai* (Inside the Precincts of Akiba Shrine). 1857

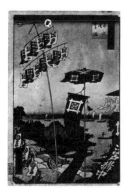
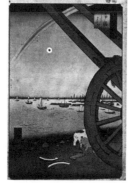

288 80 *Kanasugi-bashi, Shibaura* (Kanasugi Bridge, Shibaura). 1857
289 81 *Takanawa, Ushi-machi* (Ox Fair, Shinagawa). 1857

294 86 *Yotsuya, Naitō-Shinjuku* (Yotsuya, Naitō New Station). 1857
295 87 *Inokashira-no-ike, Benten-no-yashiro* (Benten Shrine, Inokashira Pond). 1856

300 92 *Mokuboji uchikawa, Gozen saihata* ("Lord's Garden" beside Mokuboji Temple). 1857
301 93 *Niijuku-no-watashi* (Niijuku Ferry). 1857

302 94 *Mama-no-momiji, Tekona-no-yashiro tsugihashi* (Mama Maple Trees with Tekona Shrine and Bridge). 1857

303 95 *Kōnodai, Tone-gawa fūkei* (View of Tone River at Kōnodai). 1856

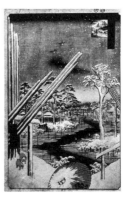

308 100 *Yoshiwara, Nihon-zutsumi* (Nihon Embankment, Yoshiwara). 1857

309 101 *Asakusa-tambo, Tori-no-machi-mōde* (Asakusa Ricefields during the Cock Festival). 1857

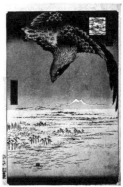

314 106 *Fukagawa, Kiba* (Timber Yard, Fukagawa). 1856

315 107 *Fukagawa, Susaki, Jūman-tsubo* (Jūman-tsubo [10,000-acre] Plain at Suzaki, Fukagawa). 1857

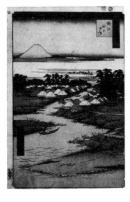
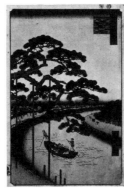

304 96 *Horie, Nekozane* (Nekozane at Horikiri [Canal]). 1856

305 97 *Onagi-gawa, Gohon-matsu* ("Five Pines" on Konagi River). 1856

310 102 *Minowa, Kanasugi, Mikawa-jima.* 1857

311 103 *Senju no Ōhashi* (Great Bridge at Senju). 1856

316 108 *Shibaura no fūkei* (View of Shiba Coast). 1856

317 109 *Minami-Shinagawa, Samezu-kaigan* (Samezu Seashore, South Shinagawa). 1857

306 98 *Ryōgoku, hanabi* (Fireworks at Ryōgoku). 1858

307 99 *Asakusa, Kinryūzan* (Kinryūzan [Temple], Asakusa). 1856

312 104 *Koume-zutsumi* (Koume Embankment). 1857

313 105 *Ommaya-gashi* (Ommaya Riverbank). 1857

318 110 *Senzoku-no-ike, Kesagake-matsu* ("Robe-hanging Pine", Senzoku Pond). 1856

319 111 *Meguro, Taiko-bashi, Yūhi-no-oka* (Drum Bridge and "Setting-Sun Hill", Meguro). 1857

320 112 *Atagoshita, Yabu-kōji* (Yabu Street below Atago). 1857
321 113 *Tora-no-mon-gai, Aoizaka* (Aoi Hill, outside Tora-no-mon). 1857

322 114 *Bikuni-bashi, setchū* (Bikuni Bridge in Snow). 1858 [Hiroshige II]
323 115 *Takata-no-baba* (Takata Riding Grounds). 1857

324 116 *Takata, Sugatami-no-hashi, Omokage-no-hashi, Jariba* (Gravel Pits, Sugatami and Omokage Bridges, Takata). 1857
325 117 *Yushima Tenjin, Sakaue-chōbō* (Hilltop View, Yushima Tenjin Shrine). 1856

326 118 *Ōji, Shōzoku-enoki, ōmisoka no kitsune-bi* (New Year's Eve Foxfires, at Nettle Tree, Ōji). 1857
326a 118a Table of Contents to the completed Series

326b 118b Van Gogh: copy of No. 30 above; painting in oils, 1888

326c 118c Van Gogh: copy of No. 52 above; painting in oils, 1888

金
沢 23 *KANAZAWA HAKKEI* (Eight Views of
八 Kanazawa)
景 8 prints, *ōban*, ca. 1835–36; publisher: Koshi-Hei

24 *FUJI SANJŪ-ROKKEI* (Thirty-six Views of Mount Fuji)
36 prints, *chūban*, ca. 1852–53; publisher: Sano-Ki

25 *FUJI SANJŪ-ROKKEI* (Thirty-six Views of Mount Fuji)
36 prints, *ōban*, ca. 1858–59; publisher: Tsuta-ya

327

Hiroshige: *The Hoda Coastline* [near Moronobu's birthplace] from the series *Fuji sanjū-rokkei*

近 26 *OMI HAKKEI NO UCHI* (From the Eight
江 Views of Lake Biwa)
八 8 prints, *ōban*, ca. 1834; publishers: Hōeidō
景 and Eikyūdo
 1 *Karasaki no yau* (Night Rain at Karasaki) [plate 182]
 2 *Hira no bosetsu* (Evening Snow at Mount Hira)

328

 3 *Awazu no seiran* (Weather Clearing at Awazu)

329

251

4 *Yabase no kihan* (Boats Sailing back to Yabase)

330

5 *Mii no banshō* (Evening Bell at Miidera [Temple])

331

6 *Katata no rakugan* (Geese Homing at Katata)

332

7 *Seta no sekishō* (Sunset at Seta)

333

8 *Ishiyama no shūgetsu* (Autumn Moon at Ishiyama)

334

[N.B. In various sizes and from different publishers, Hiroshige issued at least twenty-four other *Ōmi hakkei* series.]

27 *KYŌTO MEISHO NO UCHI* (From the Famous Places of Kyōto)
10 prints, *ōban*, ca. 1834; publisher: Eisendō

1 *Arashiyama, manka* (Cherry Blossoms at Arashiyama)

335

2 *Yodo-gawa*

336

3 *Kiyomizu*
4 *Kinkakuji*
5 *Tadasu-gawara no yudachi* (Twilight Shower at Tadasu Bank)
6 *Shijō-gawara yūsuzumi* (Cool of the Evening at Shijō Riverbed)
7 *Yase-no-sato* (At Yase Village)
8 *Tsūten-kyō no kōfu* (Maple Trees at Tsūten Bridge)
9 *Shimabara, Deguchi-no-yanagi* ("Exit-Willow" at Shimabara)
10 *Gion-sha setchū* (Gion Shrine in Snow)

28 *NANIWA MEISHO ZUE* (Famous Places of Naniwa [Ōsaka])
10 prints, *ōban*, ca. 1834; publisher: Eisendō

29 *SHOKOKU MU-TAMAGAWA* (Six Tama Rivers in the Various Provinces)
6 prints, *ōban*, ca. 1835–36; publisher: Tsuta-ya

30 *HONCHŌ MEISHO* (Famous Places of Japan)
15 prints, *ōban*, ca. 1832, 1837–39; publisher: Fuji-Hiko

337

Hiroshige: *The Grotto at Enoshima* from the series *Honchō meisho*

338

Hiroshige: *Akiba Shrine*, from the series *Honchō meisho*

31 *OMOTE-URA EKIJI-HAKKEI* (Eight Views of Stations Front and Back)
4 prints known, *ōban*, in fan shape, ca. 1839; publisher:

339

Hiroshige: *Hakone Lake*, from the series *Omote-ura ekiji-hakkei*

日本港尽 **32** *NIHON MINATO-ZUKUSHI* (The Harbors of Japan)
11 prints, *ōban*, early 1840s; publisher: Maru-Sei

340

Hiroshige: *Uraga Port* from the series *Nihon minato-zukushi*

33 *ROKUJŪ-YOSHŪ MEISHO-ZUE* (Famous Places: the 60-odd Provinces)
70 prints, *ōban*, 1853–56; publisher: Koshi-Hei [Koshimura-ya Heisuke]

341

Hiroshige: *The Whirlpools of Awa*

34 *SANKAI MITATE-ZUMŌ* (Wrestling Matches between Mountain and Sea)
20 prints, *ōban*, ca. 1858: publisher: Yamada-ya

35 *WAKAN RŌEI-SHŪ* (Japanese and Chinese Verses for Recitation)
7 prints, *ōban*, early 1840s; publisher: Jō-Kin

342

Hiroshige: *Snow Scene with Chinese Verse*

36 *E-BANGIRE [LETTER-PAPER] SERIES*
13 prints, in *surimono* style (7½×20½ in./ 19.1 × 52.1 cm), ca. 1839–40; publisher: Wakasa-ya

343

Hiroshige: *Koganei Cherry Blossoms*, from *E-bangire* series

37 *KOKON JŌRURI-ZUKUSHI* (Famous Jōruri Dramas)
15 prints, *ōban*, ca. late 1840s; publisher: Sano-Ki

38 [*FISH SERIES*]
10 prints, *ōban*, early 1830s; publisher: Eijudō

39 [*FISH SERIES*]
10 prints, *ōban*, ca. 1840; publisher: Yama-Shō (Later this series combines with series 38 above in album format.)

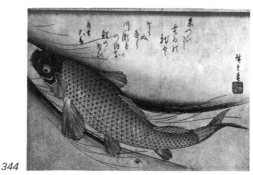

344

Hiroshige: *Swimming Carp. Ōban*, from the *Fish series*, (no. 39), ca. 1840s

II SOME ILLUSTRATED BOOKS BY HIROSHIGE:

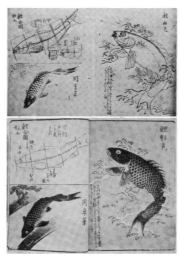

345

Hiroshige: manuscript and printed plates from *Ehon tebiki-gusa*, *chūbon*-size books, 1849

絵本手引草 *Ukiyo gafu* (3 vols., ca. 1836)
Ehon tebiki-gusa (1 vol., 1849)
[For a more extended comparison of the manuscript and printed versions, see the chapter "A Hiroshige Sketchbook" in our *Hokusai and Hiroshige*.]
Sōhitsu gafu (4 vols., 1848–51)
Ehon Edo-miyage (8 vols., 1851–67)
Kyōka Edo meisho-zue (14 vols., ca. 1858–60)

III HIROSHIGE: SELECTED BIBLIOGRAPHY

Fenollosa, Mary McNeil. *Hiroshige: The Artist of Mist, Snow and Rain*. San Francisco, 1901.
Amsden, Dora and John Stewart Happer. *The Heritage of Hiroshige: A Glimpse at Japanese Landscape Art*. San Francisco, 1912.
Matsuki, Kihachirō. *Hiroshige uchiwa-e* [The Fan Prints of Hiroshige]. (in Japanese). Kyōto, 1923.
Strange, Edward F. *The Colour-Prints of Hiroshige*. London, n.d.
Happer, John Stewart. *Hiroshige wakagaki* [The Early Prints of Hiroshige]. Tōkyō, 1925.
● Uchida, Minoru. *Hiroshige*. (in Japanese) Tōkyō, 1930; rev. ed., 1932.
Matsuki, Kihachirō. *Hiroshige's Edo Landscape Prints*. (in Japanese). Tōkyō, 1939.
Noguchi, Yone. *Hiroshige*. 2 vols. London and Tōkyō, 1940.
Takahashi, Seiichiro. *Ando Hiroshige*. (English adaptation by Charles S. Terry). Tōkyō, 1956.
Seckel, D. (intro.) *Ando Hiroshige Tokaido-Landschaften*. Baden-Baden, 1958.
Suzuki, Takashi. *Hiroshige*. London, n.d.
Tokuriki, Tomikichirō. *Tōkaidō Hiroshige*. (English translation by Thomas I. Elliott.) Ōsaka, 1963.
Robinson, B. W. *Hiroshige*. London, 1964. (Dutch translation, Utrecht, 1963).
● Suzuki, Jūzō. *Hiroshige*. Tōkyō, 1970.
● Lane Richard. *Hokusai and Hiroshige*. (in English and Japanese). Tōkyō, 1976. [Also issued 1977, Tōkyō/Cologne/Baltimore, in 2 limited editions with original specimen plates.]
▷ pp. 170–184, plates 177–187

重宣 **Hiroshige II** (1829–69): ukiyo-e painter and print artist; pupil and adopted son of Hiroshige; first *nom d'artiste* used was Shigenobu; when Hiroshige died in 1858, married his daughter and took his name. About 1865 his marriage was dissolved, and he went to Yokohama,

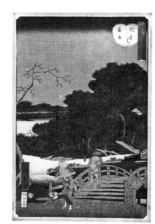

346

Hiroshige II: *Night Rain at Pillow Bridge*, from the series *Sumida-gawa hakkei*, 1861

again using the name Shigenobu, as well as Ryūshō

*Utagawa (Suzuki, Morita), Chimpei, Shigenobu, Ichiyūsai, Ichiryūsai, Kisai, Ryūsai, Ryūshō [Risshō]

Selected print series by Hiroshige II:
1 *SHOKOKU MEISHO HYAKKEI* (One Hundred Famous Views of the Provinces)
 81 (+) prints, *ōban,* 1859–64; publisher: Uwo-Ei [plate 196]
2 *TŌTO SANJŪ-ROKKEI* (Thirty-six Views of Edo)
 36 prints, *ōban,* 1859–62; publisher: Aito
3 *SUMIDA-GAWA HAKKEI* (Eight Views of the Sumida River)
 8 prints, *ōban,* 1861
4 *EDO MEISHO-ZUE* (Noted Views in Edo)
 71 (+) prints, *ōban,* 1861–64; publisher: Fuji-Kei
▷ p. 192, plate 196

Hiroshige III (1843–94): ukiyo-e print artist, pupil of Hiroshige; after Hiroshige II went to Yokohama about 1865, he took the *nom d'artiste* Hiroshige III.
*Utagawa (Andō, Gotō), Tokubei, Torakichi, Isshōsai, Shigemasa, Shigetora

347
Hiroshige III. *Sukiya-bashi Gate. Ōban,* from the series *Tokyō meishō-zue,* 1869

hirugao [noon face]: the calystegia plant
Hisanobu (fl. ca. 1801–15): ukiyo-e print artist, follower of Toyohisa but influenced by Utamaro
*Hyakusai, Kantō

Hisaoi, Arakida (1746–1804): scholar of Japanese studies in the mid Edo Period

Hishikawa School ▷ Moronobu

Hitomaro, Kakinomoto no (d. ca. 729): celebrated *waka* poet, honored as the god of poetry

hitsu: term meaning *delineavit,* "drawn by," in artists' signatures

Hitsugi-no-miko, Karuno (5th century): *waka* poet and Crown Prince

Hiyoku-no-chō yume-no-Yoshiwara: a Kabuki play, commonly called *Gompachi Komurasaki,* the names of the two lovers involved in the plot

Honchō Nijūshi-kō: a Kabuki play written for the puppet theater in 1766 and later adapted to Kabuki; the role of the princess Yaegaki-hime is renowned.

Hōchū (fl. late 18th–early 19th century): Kōrin-School painter, produced some genre work
*Nakamura, Tatsuji, Kakō

Hōei (1704–1711): the Hōei Period, dating from III/13/1704 to IV/25/1711, marks the beginning of the second great period of printed ukiyo-e. In Kyōto, Sukenobu and Yoshikiyo provided elegant picture books for the cultivated masses; while in Edo, Kiyonobu, Kiyomasu, Masanobu and the painters Kaigetsudō Andō and Chōshun formed the style that was to carry ukiyo-e through the next half century. ▷ *nengō*

Hōei-zan: the mound produced on the south slope of Mt. Fuji during the eruption of 1707–1708

hōgen: secondary honorary rank ▷ *hokkyō*

Hōgen monogatari: historical tales about the Hōgen Period (ca. 1156)

hōin: top honorary rank ▷ *hokkyō*

Hōjō: a family whose head was the effective ruler of Japan from 1200 to 1333

Hōjō-ki: a famous diary by Kamo no Chōmei (1153–1216) written in 1212; published with early ukiyo-e illustrations in 1658, these being, at one time, erroneously ascribed to Moronobu

hōju: Buddhist symbolic jewel, represented as a ball with flames at the top

Hokkai (fl. ca. 1832): ukiyo-e print artist, Ōsaka School
*Tōhōnan, Hokuei, Shunshisai

Hokkaidō [north-sea circuit]: these northern provinces are depicted rarely in ukiyo-e prior to Meiji, and the official designation "Hokkaidō" only dates from 1868:
1 Ōshima 2 Shiribeshi 3 Ishikari 4 Teshio 5 Kitami 6 Iburi 7 Hidaka 8 Tokachi 9 Kushiro 10 Nemuro (the above 10 form Ezo Island) 11 Chi-shima (Kurile Islands)

Hokkei (1780–1850): ukiyo-e painter, print artist and illustrator; originally a fishmonger [hence the name Toto-ya], he studied painting under the Kanō master Yōsen-in, later becoming a pupil of Hokusai. Hokkei excelled in elaborately executed *surimono* and in landscape panoramas that convey well the technique of Hokusai but add a vaguely formal yet other-worldly atmosphere seldom found in that earthy master.
*Toto-ya [Uoya] (Iwakubo), Tatsuyuki, Shogorō, Kin-emon, Kien, Kikō, Kyōsai

348
Hokkei: *Lobster, Charcoal and Leaf. Chūban surimono,* ca. 1830s

Hokkei's most famous series is the *Shokoku meisho* (Famous Views of the Provinces), thirteen prints in the long, narrow, large-*tanzaku* format, published in the 1830s:
1 *Shimotsuke, Nikkō Urami-ga-taki*

2 *Jōshū, Mikuni-goei Fudō-toge*
3 *Musashi, Sumida-gawa*

349
Hokkei: *Musashi, Sumida-gawa,* from the series *Shokoku meisho*

4 *Nagato, Nuno-Kari-jinji*
5 *Etchū, Tate-yama*
6 *Sunshū, Ōmiya-guchi tozan*

350
Hokkei: *Sunshū, Ōmiya-guchi tozan,* from the same series

7 *Izu, Chinuki-no-hi*
8 *Izu, Goseiki no Mida*
9 *Sōshū, Hakone-no-seki*
10 *Musashi-no-sato*
11 *Sesshū, Sumiyoshi*
12 *Suruga, Satta-yama*
13 *Hizen, Inasa-yama*

351
Hokkei: *Shintō Sea Rites. Chūban surimono,* ca. 1830s

Illustrated books by Hokkei include:
Kyōka banka-shū (1 vol., 1810)
Hokkei manga (2 vols., 1814)
Fusō meisho kyōka-shū (3 vols., 1824; later reissued as *Yamato meisho ichiran*)
▷ p. 172

Hokkei (fl. ca. 1820s): ukiyo-e print artist, Ōsaka School
*Kintarō, Shun-yō, Shun-yōsai; Santōkaku

Hokkei (fl. ca. 1830s): ukiyo-e print artist, Ōsaka School
*Ran-yōsai

Hokke-shū: the Nichiren sect of Buddhism

Hokki (fl. early 19th century): ukiyo-e print

artist, pupil of Hokusai
*Katsushika (Edogawa), Sumpō
Hokkō (fl. ca. 1820s): ukiyo-e print artist, Ōsaka School
*Katsushika, Gakyōjin
Hokkō (fl. ca. 1810s–30s): ukiyo-e print artist, Ōsaka School, pupil of Hokusai
hokku: the opening lines to a *renga* (linked verse) series; these later evolved into *haiku* poetry
hokkyō: lowest honorary rank; originally a Buddhist rank, later bestowed upon literati and artists by the Emperor
Hōkoku-jinja (Toyokuni no yashiro): the Shintō temple in Kyōto erected to the memory of Hideyoshi in 1599
北馬蹄斎 **Hokuba** (1771–1844): ukiyo-e painter, print artist and illustrator; an outstanding pupil of Hokusai; designed many *surimono* and illustrated a number of *kyōka* books; also known for his figure paintings
*Arisaka (Hoshino), Teisai, Gorohachi, Shūen, Shunshunsai, Shunshuntei
Illustrated books by Hokuba include *Kyōka maku-no-uchi* (2 vols., 1802) and *Kyōka shikishi Ogura-gata* (1 vol., ca. 1830).
北頂 **Hokuchō** (fl. ca. 1820s): Ōsaka ukiyo-e print artist, pupil of Hokushū
*Inoue, Shunshosai, Shunsho
北長 **Hokuchō** (fl. ca. 1850s): ukiyo-e print artist, Ōsaka School
*Shungyōsai, Shunchōsai
Hoku-chō: the Northern Dynasty (1336–1392)
北英 **Hokuei** (fl. ca. 1830s): Ōsaka ukiyo-e print artist, pupil of Hokushū
*Sekka, Sekkarō, Shumbaisai, Shumbaitei, Shunkō, Shunkōsai, Shun-yōsai
Hokuei (fl. early 19th century): ukiyo-e print artist, pupil of Hokusai
*Tōkōen
北鷲 **Hokuga** (fl. early–mid 19th century): print artist, illustrator, pupil of Hokusai
*Mita, Kosaburō, Hōtei, Manjirō
Hokuga (fl. ca. 1820s): ukiyo-e print artist, Ōsaka School
*Nan-yō, Nan-yōsai
北雅 **Hokuga** (fl. ca. 1830): painter, print artist, pupil of Hokusai
*Katsushika (Yamadera), Nobuyuki, Myōnosuke, Karyōsai
北雁 **Hokugan** (fl. ca. 1820s): ukiyo-e print artist, Ōsaka School, pupil of Yoshikuni
*Toyokawa, Toshikuni, Rodō, Juyōdō, Shun-yōdō, Shunkisai, Magari
Hokui (fl. ca. 1830s): ukiyo-e print artist, Ōsaka pupil of Hokusai
*Fukao, Haku-sanjin
北一 **Hokuichi** (fl. ca. 1804–30): skilled ukiyo-e painter and print artist, pupil of Hokusai
*Katsushika, Kōgyōsai, Shikōsai
昇亭北寿 **Hokuju** (fl. late 1790s to mid 1820s): ukiyo-e painter and print artist, one of the foremost pupils of Hokusai. Of all Hokusai's pupils Hokuju made the largest contribution as an original landscapist; his cubist landforms, highly stylized clouds and near-photographic figures and dwellings provide a curiously modern concept of the world. This is not entirely coincidence, for Hokuju was influenced by what little he knew of European art: yet the result must be considered one of the most notable of the Japanese variations upon what were the only dimly apprehended concepts of Western forms.
*Shōtei, Shōsai, Kazumasa
▷ pp. 171–72, plate 175

352

Hokuju: *Net-Fishing at Kujūkuri. Oban,* ca. 1820s

353

Hokuju: *View of Ochanomizu. Oban,* ca. 1820s

北樹 **Hokuju** (fl. ca. 1830s): Ōsaka ukiyo-e print artist, pupil of Hokuei
*Goryūken, Shun-eisai, Shunshōsai
北明 **Hokumei** (fl. ca. 1810s–20s): ukiyo-e painter and print artist, pupil of Hokusai
*Katsushika, Gakyōjin, Kyūkyūshin
Hokumei (fl. ca. 1830): ukiyo-e print artist, Ōsaka School, pupil of Shunkōsai
*Ikuta (Tezuka), Kisseidō, Togatsu
Hokumei (fl. ca. 1830): ukiyo-e print artist, Ōsaka School, pupil of Shunkōsai
*Shunkyokusai
北妙 **Hokumyō** (fl. ca. 1830s): ukiyo-e print artist, Ōsaka School; probably identical with Shun-yōsai Shinshi
*Shumpusai, Sekkōtei
Hokurai (fl. ca. 1810s–20s): ukiyo-e print artist, Ōsaka School
北斎 葛飾 **Hokusai** (1760–1849): Katsushika Hokusai (IX/1760–IV/18/1849). This leading master of the final century of ukiyo-e was born in the year 1760 in the Honjo quarter, east of Edo; his parentage is uncertain. First apprenticed to a woodblock engraver, at the age of eighteen Hokusai entered the studio of the leading Kabuki artist Katsukawa Shunshō and, early in the following year, he published his first known works, actor prints, under the name Shunrō. Influenced by Shigemasa and Kiyonaga as well, Hokusai produced notable figure prints during the 1780s, but his first important prints were done under the name Kakō in the mid 1790s. From 1797 he adopted the *nom d'artiste* "Hokusai" and began his first major period of print and book production. Attracted to many different artistic influences, Hokusai even flirted with Western art briefly and, from about the year 1805, he began a concentrated study of Chinese painting and graphic art, which tended to remove his style from ukiyo-e in a strict sense. Prominent among Hokusai's major productions are his Edo picture books of the early 1800s, the fifteen *Manga* sketch-

books published from 1814 onward, the print series *Thirty-six Views of Mt Fuji* (ca. early 1830s) and the three-volume *One Hundred Views of Mt Fuji* (1834–ca. 1835). Hokusai's energy was prodigious, though his work was not all of equal quality, but at his best he was able to revive the waning grandeur of the ukiyo-e print, as well as to raise, almost single-handedly, the landscape and flower-and-bird prints to the level of dominant genres in ukiyo-e.
Principal pupils: Shinsai, Hokuju, Hokuba, Hokkei, Shigenobu, Taitō II, Bokusen, Ōi (O-Ei; daughter), Iitsu II
As he had a long, productive life, Hokusai's career can best be summarized in relation to his numerous *noms d'artiste* and his many books and print series.

HOKUSAI'S PRINCIPAL PEN-NAMES AND THE APPROXIMATE PERIODS OF THEIR USE:
Shunrō: 1779–94
Banri: ca. 1780–82 (hypothetical pseudonym of Hokusai)
Zewasai: 1781–82
Gyobutsu: 1782
Gumbatei: 1785–94
Shishoku Gankō [Kari-daka]: ca. 1788–mid 1810s (thought to be a pseudonym used by Hokusai for erotica; also used later by Eisen)
Sōri: 1795–98
Hyakurin Sōri: 1795–97 (identity with Hokusai questioned)
Tawara-ya Sōri II [or IV]: 1796 (questioned)
Hokusai Sōri: 1797–98
Hokusai: 1797–1819
Kakō: 1798–1811
Fusenkyo Hokusai: 1799
Tatsumasa [Shinsei]: 1799–1810
Senkōzan: 1803
Kintaisha: 1805–ca. 1809
Gakyōjin: 1800–08
Kyūkyūshin: 1805
Gakyō-rōjin: 1805–06, 1834–49
Katsushika: ca. 1807–24
Taitō: 1811–20
Kyōrian Bainen: 1812
Raishin: 1812–15
Tengudō Nettetsu: 1814
Iitsu: 1820–34
zen[*saki no*] Hokusai Iitsu: 1821–33
Fusenkyo Iitsu: 1822
Getchi-rōjin: 1828
Manji: 1831–49
Tsuchimochi Nisaburō: 1834
Hyakushō Hachiemon: 1834–46
Miura-ya Hachiemon: 1834–46
Fujiwara Iitsu: 1847–49
(N.B. Some of these names were later used by Hokusai's pupils also; for these, see Index and list given under each pupil's name.)

TYPICAL HOKUSAI SIGNATURES:

Katsu·kawa Shun·rō *ga* Katsu Shun·rō *ga*

春朗画 Shun·rō ga

可候画 Ka·kō ga

Hoku·sai sha

Ga·kyō·rō·jin·Hoku·sai

Ho·ku·sa·i e·ga·ku (in kana)

Ga·kyō·rō·jin· Hoku·sai

zen Hoku·sai I·itsu hitsu

Hoku·sai aratame I·itsu hitsu

zen Hoku·sai Manji

rei hachi·jū· kyū·sai· ("at age 89")

Manji-rō-jin hitsu

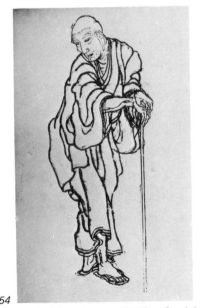

354
Hokusai: *Self-Portrait as an Old Man. Sumi* sketch on paper, ca. 1840s

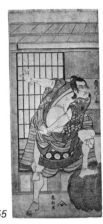

355
Hokusai: *Monnosuke II on Stage. Hosoban,* ca. 1780 (signed Shunrō).

356
Hokusai: *Travelers at Teashop. Yoko-nagaban surimono,* dated 1804

SUMMARY CATALOGUE OF HOKUSAI'S WORKS
I HOKUSAI'S PRINT SERIES
(The more important works are marked with a circle; prints issued singly are generally omitted. At the end of each entry is a number referring to M. Forrer's useful *Hokusai: A Guide to The Serial Graphics,* much of whose dating has been tentatively followed and in which more detailed listings of most of these series will be found.)

1 *MIBU KYŌGEN* (Mibu Farces)
11 prints known, *chūban tate-e,* ca. 1780–82; signature: Shunrō *ga,* publisher: Tsuta-ya Jūzaburō [F-7]

2 *NAKASU HAKKEI* (Eight Views of Nakasu)
3 prints known, *koban tate-e,* ca. 1782; signature: Banri *ga* [possibly an early pen-name of Hokusai] [F-17]

3 *FŪRYŪ SHIKI NO TSUKI* (The Stylish Moon in the Four Seasons)
1 print known, *chūban tate-e,* ca. 1782–85; signature: Katsukawa Shunrō *ga* [F-1]

4 *TŌJIBA HAKKEI* (Eight Views of Health Resorts)
1 print known, *chūban tate-e,* ca. 1783–84; seal: Shunro [F-5]

5 [title prefix] *UKI-E* (Perspective Print)
4 prints known, *ōban,* ca. 1785–86; signature: Katsu Shunrō *ga,* publisher: Eijudō [F-3]

6 [title prefix] *SHIMPAN UKI-E* (New Edition: Perspective Print)
4 prints known, *ōban,* ca. 1786–87; signature: Katsu Shunrō *ga,* publishers: Eijudō and Iwato-ya [F-4]

7 *FŪRYŪ UJI NO MICHI-NO-KI* (Fashionable Record of the Road to Uji)
2 prints known, *koban,* ca. 1787–89; signature: Shunrō *ga* [F-8]

8 *HAIKAI ODAMAKI* (Verse Series)
2 prints known, *koban tate-e,* ca. 1787–89; signature: Shunrō *ga,* publisher: Tsuta-ya Jūzaburō [F-9]

9 *HAIKAI SHŪITSU* (Haiku Selections)
2 prints known, *koban tate-e,* 1787–89; signature: Shunrō *ga,* publisher: Eijudō [F-10]

10 *FŪRYŪ KODOMO-ASOBI GOSEKKU* (Children at Play: Five Fashionable Festivals)
3 prints known, *ōban tate-e.* ca. 1788–89; signature: Katsukawa Shunrō *ga,* publisher: Ōmi-ya [F-2]

11 (Eight Views of Edo)
1 print known, *chūban tate-e,* ca. 1787–89; signature: Shunrō *ga* [F-11]

12 *TŌTO HŌGAKU* (The Four Directions of the Eastern Capital)
2 prints known, *ōban,* ca. 1788–90; signature: Shunrō *ga,* publisher: Eijudō [F-12]

13 *FŪRYŪ OTOKODATE HAKKEI* (Eight Fashionable Views of *Otokodate*)
5 prints known, *koban tate-e surimono,* ca. 1789; signature: Shunrō *ga,* publisher: Eijudō [F-13]

14 (Children at Play)
5 prints known, *ōban tate-e,* ca. 1789; signature: Shunrō *ga,* publisher: Eijudō [F-14]

15 *TŌSEI ASOBI* (Modern Games)
1 print known, *chūban tate-e,* ca. 1790; signature Shunrō *ga* [F-15]

16 *FŪRYŪ MITATE KYŌGEN* (Stylish *Kyōgen* Parodies)
1 print known, *koban,* ca. 1790; signature: Shunrō *ga*

17 *TAKEDA NI-JŪ-YON-SHŌ E-ZUKUSHI SHIMPAN* (New Edition: Twenty-four Generals under Takeda)
1 print known, *aiban tate-e,* ca.1792 (censor's seal: *kiwame*); signature: Shunrō *ga,* publisher: Tsuta-ya Jūzaburō [F-6]

18 (Yoshiwara Festivals in the Twelve Months)
12 prints, *koban tate-e,* ca. 1793 (censor's seal: *kiwame*); signature: Shunrō *ga,* publisher: Tsuta-ya Jūzaburō [F-16]

19 (The Seven Gods of Luck)
7 prints (of which 2 by Utamaro), *chūban surimono,* ca. 1796–98; signatures: Sōri *ga* and Hokusai Sōri *ga* [F-21]

20 *SHIMPAN UKI-E CHŪSHINGURA* (New Edition: *Chūshingura* Perspective Pictures)
11 prints, *ōban,* ca. 1798; signature: Kakō *ga,* publisher: Ise-ya Rihei [F-27]

21 (Famous Loving Couples)
5 prints known, small-*chūban tate-e,* ca. 1798; signature: Kakō *ga* [F-28]
1 *O-Hatsu Tokubei: shūgetsu* (O-Hatsu and Tokubei: the Autumn Moon) The lovers stand at the bank of the Sumida River.
2 *Azuma Yogorō: zansetsu* (Azuma and Yogorō: the Lingering Snow) The lovers sit by a window.

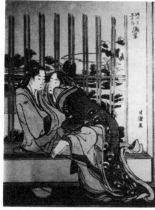

357
Hokusai: *The Lovers Azuma and Yogorō*

3 *Date Yosaku Seki no Koman: sekishō* (Date Yosaku and Seki no Koman: the Evening Glow) The lovers sit on a bench by a teahouse.
4 *O-Some Hisamatsu: shunka* (O-Some and Hisamatsu: the Spring Flowers) The lovers stand sheltered by a tree.

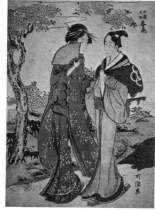

358
Hokusai: *The Lovers O-Some and Hisamatsu*

5 *O-Ume Kumenosuke: banshō* (O-Ume and Kumenosuke: the Evening Bell) The lovers on a road; Kumenosuke kneels behind O-Ume to bind her *obi.*

22 *FŪRYŪ NAKUTE NANA-KUSE* (Seven Fashionable Bad Habits)
2 prints known, *ōban tate-e.* ca. 1798–99; signature: Kakō *ga,* publisher: Tsuta-ya Jūzaburō [F-26]

23 *DŌBAN ŌMI HAKKEI* (Eight "Copperplate" Views of Lake Biwa)
8 prints, *koban,* ca. 1798–1800; signature: Hokusai *ga* [F-32]

359
Hokusai: *Two Girls.* From the series *Fūryū nakute nana-kuse*

24 *TSUCHINOTO-HITSUJI: BIJIN-AWASE NO UCHI* (Series of Beautiful Women of 1799)
3 prints known, *koban surimono,* 1799; signature: Sōri *aratame* Hokusai *ga*

25 *TŌSEI BIJIN-AWASE* (A Comparison of Modern Beauties)
9 prints known, *koban surimono,* ca. 1799; signature: Sōri *aratame* Hokusai *ga* [F-22]

26 (Winter Scenes)
2 prints known, *koban surimono,* ca. 1799; signature: *saki no* Sōri Hokusai *ga* [F-23]

27 *FŪRYŪ YAMATO NISHIKI* (Fashionable Yamato Brocades)
1 print known, *koban,* ca. 1799; signature: *saki-no* Sōri Hokusai *ga* [F-24]

28 (The Deaf, The Dumb, The Blind)
3 prints, *koban surimono tate-e,* ca. 1799; signature: *saki no* Sōri Hokusai *ga* [F-25]

29 *KANAZAWA HAKKEI* (Eight Views of Kanazawa)
1 print known, *koban,* ca. 1799–1800; signature: Hokusai *egaku* [F-29]

30 *EDO HAKKEI* (Eight Views of Edo)
8 prints, *koban,* ca. 1798–1800; signature: Hokusai *sensei zu* [F-33]

360
Hokusai: *Suruga-chō* from the series *Edo hakkei*

31 (Landscape Prints in Western Style)
5 prints known, *aiban,* ca. 1799–1800; signature: none [F-30]

1 *Haneda Benten no zu* (View of the Haneda Benten Shrine)

361
Hokusai: *Haneda Benten no zu,* from a series of Landscape Prints in Western Style

2 *Kanagawa oki Hommoku no zu* (View of Great Wave off Kanagawa)
3 *Takinogawa Iwama no zu* (View of Iwama at Takinogawa)
4 *Nihon-zutsumi yori Tanaka mo miru no zu* (View of the Fields Seen from Nihon Embankment)
5 *Azumabashi yori Sumida mo miru no zu* (View of the Sumida [River] from Azuma Bridge)

362
Hokusai: *Azumabashi yori Sumida mo miru no zu,* from a series of Landscape Prints in Western Style

32 (Landscape Prints in Western Style)
5 prints known, *chūban,* ca. 1799–1800; signature: Hokusai *egaku* [F-31]
1 *Takahashi no Fuji* (Fuji Seen under High Bridge)

363
Hokusai: *Takahashi no Fuji,* from a series of Landscape Prints in Western Style

2 *Yotsuya Jūnisō* (Jūnisō at Yotsuya)

3 *Kudan Ushigafuchi* (Ushigafuchi at Kudan)

364

Hokusai: *Kudan Ushigafuchi,* from a series of Landscape Prints in Western-Style

4 *Ōshiokuri hatō tsūsen no zu* (Rowing Boat in Waves)
5 *Gyōtoku shiohama yori Noboto no higata o nozomu* (Seashore seen at Noboto in Gyōtoku)

365

365a

365b

Hokusai: *Shinagawa, Fuchū* and *Kanaya* from The Fifty-three Stations of the Tōkaidō (no. 33)

33 (The Fifty-three Stations of the Tō-kaidō)
54 prints, *koban,* ca. 1799–1802; signature: Hokusai *ga.* [F-34]

34 *SHŌFŪDAI SHICHI KEN* (The Fashionable Seven Sages of the Bamboo Grove)
8 (not 7) prints, *hosoban surimono tate-e,* dated 1800; signature: Hokusai *ga* [F-40]

35 (The Childhood of Fifteen Heroes)
15 prints (?), *surimono,* ca. 1800 [F-46]

36 *EDO HAKKEI* (Eight Views of Edo)
1 print known, *chūban tate-e,* ca. 1800–02; signature: none, publisher: Ise-ya Rihei [F-35]

37 *TŌTO JŪNIKEI* (Twelve Views of the Eastern Capital)
17 prints, *koban,* ca. 1800–02; (9 prints by Hokusai, 8 by Shuntei; but overlapping of signatures for 5 of the designs); signature: Hokusai *ga,* publisher: Ise-ya Rihei [F-36]

38 (Eight Views of Lake Biwa)
8 prints, *chūban tate-e,* ca. 1800–02; signature: Hokusai *ga,* publisher: Ise-ya Rihei [F-37]

39 *ŌMI HAKKEI* (Eight Views of Lake Biwa)
8 prints, *chūban tate-e,* ca. 1800–02; signature: Hokusai *ga* [F-38]

40 *SHIMPAN ŌMI HAKKEI* (New Edition: Eight Views of Lake Biwa)
8 prints, *chūban tate-e,* ca. 1800–02; signature: Hokusai *ga* [F-39]

41 *KANA-DEHON CHŪSHINGURA* (The Syllabary *Chūshingura*)
1 print known, *koban,* ca. 1800–02; signature: Hokusai *ga,* publisher: Ise-ya Rihei [F-41]

42 *KANA-DEHON CHŪSHINGURA* (The Syllabary *Chūshingura*)
12 prints, *chūban tate-e,* ca. 1800–03; signature: Hokusai *ga,* publisher: Ise-ya Rihei [F-42]

43 *SANKEI* (Three Views)
3 prints, *surimono,* ca. 1800–10; signature: Hokusai *ga* [F-43]

44 [Untitled *Surimono* Set]
6 prints known, *surimono,* ca. 1800–10; signature: Hokusai *ga* [F-44]

45 *SANSEKI* (Three Evenings)
2 prints known, *surimono,* ca. 1800–10; signature: Hokusai *ga* [F-45]

46 (The Sixty-nine Stations of the Kiso-kaidō)
4 prints known, *koban,* ca. 1800–10; signature: Hokusai *ga* [F-47]

47 *ROKKASEN NO UCHI* (Six Famous Poets)
6 prints, *koban tate-e,* ca. 1801–04; signature: Hokusai *ga,* publisher: Ise-ya Rihei [F-48]

48 *MU-TAMAGAWA* (The Six Jeweled Rivers)
1 print known, *koban,* ca. 1801–04; signature: Hokusai *ga* [F-49]

49 (The Four Directions)
2 prints known, *e-goyomi* series, *koban suri-mono,* ca. 1801–03; signature: Gakyōjin Hokusai *ga* [F-82]

50 *BYŌBU ISSŌ NO UCHI* (Pair of Folding Screens)
11 prints known, *koban surimono,* ca. 1802–1803; signature: Gakyōjin Hokusai *ga* [F-83]

51 *NANA KOMACHI* (The Seven Komachi)
3 prints known, *koban surimono,* ca. 1802–03; signature: Gakyōjin Hokusai *ga* [F-84]

52 (Noted Places of Edo)
8 prints known, *ōban,* ca. 1802–03; signature/seals: Hokusai [F-50]

53 *FŪRYŪ MU-TAMAGAWA* (The Fashionable Six Jeweled Rivers)
6 prints, *koban surimono,* ca. 1802–03; signature: Hokusai *ga* [F-51]

54 *MU-TAMAGAWA* (The Six Jeweled Rivers)
1 print known, *koban surimono,* ca. 1802–03; signature: Hokusai *ga* [F-52]

55 *TAMAGAWA* (Jeweled Rivers)
1 print known, *koban surimono,* ca. 1802–03; signature: Hokusai *ga* [F-53]

56 *ZASHIKI HAKKEI* (Eight Views of the Parlor)
6 prints known, *koban surimono,* ca. 1802–03; signature: Hokusai *ga* [F-54]

57 *TŌKAIDŌ GOJŪSAN-TSUGI* (The Fifty-three Stations of the Tōkaidō)
56 prints, *koban,* ca. 1802–03; signature: Hokusai *ga,* publisher: Ise-ya Rihei [F-55]

58 *SHŪITSU MU-TAMAGAWA* (The Splendid Six Jeweled Rivers)
5 prints known, *chūban tate-e,* ca. 1802–04; signature: Hokusai *ga,* publisher: Ise-ya Rihei [F-56]

59 (Eight Views of Edo)
1 print known, *koban,* ca. 1802–04; signature Gakyōjin Hokusai *ga*

60 *Godairiki* (The Five Strengths)
4 prints known, *koban surimono,* ca. 1802–04; signatures: Gakyōjin Hokusai *ga*/Hokusai *ga* [F-80]

61 *MITATE CHŪSHINGURA* (*Chūshingura* Pastiche)
8 prints known, *koban surimono,* ca. 1802–04; signature: Gakyōjin Hokusai *ga* [F-85]

62 *JŪNI-SHI NO UCHI* (The Twelve Zodiac Symbols)
4 prints known, *surimono,* ca. 1802–04; signature: Gakyōjin Hokusai *ga* [F-87]

63 (*Chūshingura* Series)
2 prints known, *koban tate-e,* ca. 1802–05; signature: none [F-57]

64 *SANSEKI NO UCHI* (Three Evenings)
3 prints, *koban surimono,* ca. 1802–05; signature: Hokusai *ga*

65 *HACHIBAN-TSUZUKI* (Series of Eight)
1 print known, *koban surimono,* ca. 1802–05; signature Hokusai *ga*

66 (The Four Seasons)
4 prints, *surimono*, ca. 1802–07; signatures: Hokusai *ga*/Gakyōjin Hokusai *ga* [F-79]

67 *HANA-AWASE* (A Set of Flowers)
2 prints known, *surimono*, ca. 1802–07; signature: Gakyōjin Hokusai *ga* [F-88]

68 *EZŌSHI-AWASE* (A Set of Picture Books)
1 print known, *surimono*, ca. 1802–07; signature: Gakyōjin Hokusai *ga* [F-89]

69 *ODORI-ZUKUSHI* (Series of Dances)
10 prints known, *koban surimono*, 1803; signature: Gakyōjin Hokusai *ga* [F-86]

70 *SHOGEI SANJŪROKU* (Thirty-six Poems of Accomplishments)
2 prints known, *koban surimono*, 1803; signature: Gakyōjin Hokusai *ga* [F-90]

71 (Set of *Surimono*)
4 prints known, *koban surimono*, 1803; signature: Gakyōjin Hokusai *ga* [F-91]

72 *NIJŪSHI KŌ* (Twenty-four Paragons of Filial Piety)
8 prints known, *koban surimono*, ca. 1803–1805; signature: Gakyōjin Hokusai *ga* [F-92]

73 *JIKKAN NO UCHI* (The Ten Celestial Stems)
2 prints known, *koban surimono*, ca. 1803–1805; signature: Gakyōjin Hokusai *ga* [F-93]

74 (The Six Jeweled Rivers)
6 prints, *koban*, ca. 1803–05; signature: Hokusai *ga*, publisher: Ise-ya Rihei [F-58]

75 *FŪRYŪ TŌTO HAKKEI* (Eight Fashionable Views of the Eastern Capital)
8 prints, *chūban tate-e*, ca. 1803–05; signature: Hokusai *ga*, publisher: Ise-ya Rihei [Only one of the series is signed; we have seen very similar prints by Sekijō and Utamaro (II?).] [F-59]

76 *SAN BENTEN* (Three Goddesses)
2 prints known, *koban surimono*, ca. 1803–1805; signature: Hokusai

77 *SANKYOKU* (Three Instruments)
1 print known, *koban surimono*, ca. 1803–05; signature: Gakyōjin Hokusai *ga*

78 *WAKA SANJIN* (Three *Waka* Poets)
2 prints known, *koban surimono*, ca. 1803–1805; signature: Hokusai *ga* [F-63]

79 [title prefix] *SHIMPAN UKI-E* (New Edition: Perspective Prints)
11 prints known, *ōban*, ca. 1803–06; signatures: *eshi* Hokusai *ga*/ Hokusai *ga*, publishers: Ise-ya Rihei and Yamaguchi-ya Tōbei [F-60]

80 (The Fifty-three Stations of the Tōkaidō)
59 prints, *koban* or *tanzaku*, dated 1804 [The first edition includes 8 prints in the long, horizontal, *tanzaku* format, which were replaced with *koban* scenes by Hokusai's pupil, Yanagawa Shigenobu, in later editions.]; signature: Gakyōjin Hokusai *ga*/Hokusai *ga* [F-81]

366

366a

366b

Hokusai: *Sakanoshita, Odawara* and *Minaguchi* from The Fifty-three Stations of the Tōkaidō (no. 80)

81 (Rat Series)
4 prints known, *koban surimono*, 1804; signature: Gakyōjin Hokusai *ga*

82 *ŌMI HAKKEI* (Eight Views of Lake Biwa)
1 print known, *chūban tate-e*, ca. 1804–05; signature: none [F-61]

83 *TOBA-E* (Caricatures)
9 prints known, *chūban tate-e*, ca. 1804–06; signature: Hokusai *ga*, publisher: Yamaguchi-ya Tōbei [F-62]

84 *TOBA-E* (Caricatures)
6 prints known, *chūban tate-e*, ca. 1804–06; signature: Hokusai *ga*, publisher: Ise-ya Rihei [F-63]

85 *TOBA-E* (Caricatures)
84 prints known, *koban*, ca. 1804–06; signature: Hokusai *ga*, publisher: Ise-ya Rihei [F-64]

86 *FŪRYŪ ODOKE HYAKKU* (One Hundred Fashionable Comic Verses)
30 prints known, *koban*, ca. 1804–06; signature: Hokusai *ga*, publishers: Ise-ya Rihei and Yamaguchi-ya Tōbei [F-65]

87 (Tenjin Series)
3 prints known, *koban surimono*, ca. 1804–06; signature: Gakyōjin Hokusai *ga*

88 *ROKUJO SŌSHI* (Six Females)
1 print known, *koban surimono*, ca. 1804–06; signature: Gakyōjin Hokusai *ga*

89 *SHIMPAN KUMIAGE TŌRŌ-E. KYŌ KIYOMIZU HANAMI NO ZU* (Newly Published Assemblage Lantern: Flower-viewing at the Kiyomizu Temple in Kyōto)
2 prints, *tate-banko ōban*, ca. 1804–10; signature: Hokusai *ga* publisher: Maru-ya Bun-emon [F-67]

90 (Public Bath-House)
5 prints, *tate-banko ōban*, ca. 1804–13; signature: Hokusai *ga*, publisher: Maru-ya Bun-emon [F-66]

91 *GOGEN NO UCHI* (The Five Elements)
1 print known, *surimono*, ca. 1805; signature Kyūkyūshin Hokusai *ga* [F-94]

92 ... *KYŌGEN* (Farces)
2 prints known, *koban surimono*, ca. 1805-07; signature: Gakyōjin Hokusai *ga*

93 (The Hundred Poets)
100 prints, *surimono koban tate-e*, ca. 1805–1810; signatures: Hokusai *ga*/Kyūkyūshin Hokusai *ga* [F-68]

94 (Still-Life Series)
Number of prints unknown, *surimono koban*, ca. 1805–10; signature: Hokusai [F-69]

95 *MU-TAMAGAWA* (The Six Jeweled Rivers)
1 print known, *chūban tate-e*, 1806 (date seal: Tiger/ 11, censor's seal: *kiwame*); signature: Hokusai *ga* [F-70]

● 96 *KANA-DEHON CHŪSHINGURA* (The Syllabary *Chūshingura*)
11 prints, *ōban*, 1806 (date seals: Tiger/4, Tiger/6, censor's seal: *kiwame*); signature: none, publisher: Tsuru-ya Kinsuke [F-71]

97 *TŌKAIDŌ GOJŪSAN-TSUGI* (The Fifty-three Stations of the Tōkaidō)
56 prints, *chūban tate-e*, ca. 1806; signature: none [F-72]

367

Hokusai: *Kusatsu* and *Ōtsu*, from *Tōkaidō gōjūsan-tsugi*

98 *TŌTO MEISHO* (Noted Places of the Eastern Capital)
12 prints known, *ōban yoko-e*, ca. 1806; signature: Hokusai *ga*, publishers: Eijudō/Yamamoto-ya [F-73]

99 *SANGOKU YŌKO-DEN* (The Three Kingdoms' Magic Fox Legend)
2 prints known, *ōban diptych*, 1807 (date-seal: Hare/2, censor's seal: *kiwame*); signature: Hokusai *ga*, publisher: Tsuru-ya Kiemon [F-74]

100 (Actor Prints)
2 prints known, *ōban tate-e*, 1807 (date-seal: Hare/1, censor's seal: *kiwame*); signature: Hokusai *ga* [F-75]

101 *FUJI HAKKEI ZU* (Eight Views of Mt. Fuji)
1 print known, *ōban surimono*, ca. 1807–08; signature: Katsushika Hokusai [F-95]

102 *NANA YŪJO* (Seven Courtesans)
7 prints, *koban surimono*, ca. 1807–08; signature: Katsushika Hokusai *ga* [F-96]

103 *SHISUI SHUNSHO* (The Four Sleepers in Spring Dawn)
3 prints known, large *surimono*, ca. 1807–15; signature: Katsushika Hokusai *ga* [F-97]

104 (Large *Surimono* Series)
12 prints known, *ōban surimono*, ca. 1808–10; signatures: Hokusai *ga* and Katsushika Hokusai *ga* [F-98]

105 (The Six Poets)
6 prints, *ōban*, ca. 1809–10; signature: Katsushika Hokusai *ga*, publisher: Ezaki-ya [F-99]

106 (Fish and Shellfish)
15 prints known, *koban*, ca. 1815–18; signature: none [F-76]

107 *WASHO-KURABE* (A Comparison of Texts)
1 print known, *surimono chūban*, ca. 1815–20; signature: Hokusai *ga* [but another impression is signed Hokkei] [F-77]

108 *FŪRYŪ SUMIDA-GAWA HAKKEI* (Eight Fashionable Views of the Sumida River)
2 prints known, *koban*, ca. 1819; signature: Hokusai *ga* [F-78]

109 *MUKASHI-BANASHI: CHI-JIN-YŪ* (Legends of Wisdom, Benevolence, Courage)
1 print known, *chūban surimono*, ca. 1820–21; signature: Katsushika Iitsu *hitsu* [others of the series are by Shuntei] [F-100]

110 *KUMAYA-REN WAKAN BUYŪ-AWASE SAMBAN NO UCHI* (A Collection of Chinese and Japanese Poems of the Kumaya Club)
6 prints known, *koban surimono*, ca. 1820–21; signature: Hokusai Taitō *aratame* Katsushika Iitsu *hitsu* [F-101]

111 *SHISEI NO UCHI* (The Four Clans of Japan)
4 prints, *chūban surimono*, ca. 1822; signature: Fusenkyo Iitsu *hitsu* [F-102]

112 *UMA-ZUKUSHI* (Horse Series)
33 prints known, *chūban surimono*, ca. 1822; signature: Fusenkyo Iitsu *hitsu* [F-103]

113 *HITOMANE-SURU* (Imitations of People)
5 prints known, *koban surimono*, 1824 (Year of the Monkey); signature: Katsushika *no oyaji* Iitsu *hitsu* [F-104]

114 *GOKASEN* (The Five Poets)
5 prints, *chūban surimono*, ca. 1827; signature: Hokusai *aratame* Iitsu *hitsu* [F-105]

115 *GAYŪKEN SAMBAN-TSUZUKI NO UCHI* (Series of Three Elegant Accomplishments)
1 print known, *chūban surimono*, ca. 1827; signature: Hokusai *aratame* Iitsu *hitsu* [F-106]

116 *UMEGAKI-REN GOBAN-NO-UCHI WAKAN E-KYŌDAI* (Five Japanese-Chinese "Brother Pictures" of the Umegaki Club)
5 prints known, *chūban surimono*, ca. 1828; signature: Getchi-rōjin Iitsu *hitsu* [F-125]

117 *GENROKU-KASEN KAI-AWASE* (Genroku Poetry Shell-Game)
37 prints, *chūban surimono*, ca. 1828; signatures: Getchi-rōjin Iitsu *hitsu*/Getchi-rōjin *hitsu* [F-126]

118 (Fighting Heroes)
5 prints, *ōban*, ca. 1829–30 (censor's seal: *kiwame*); signature: *zen* Hokusai Iitsu *hitsu*, publisher: Yama-Kyū [F-108]

● 119 *FUGAKU SANJŪ-ROKKEI* (Thirty-six Views of Mt. Fuji)
Hokusai's most famous series, 46 prints in *ōban* size, ca. 1829–33, (censor's seal: *kiwame*), published by Eijudō. [F-107]
In addition to the original 36, there are ten supplementary prints—the so-called *ura-Fuji* [Fuji from the Other Side]. These are only known with black key-block impressions, whereas early impressions of the first 36 designs feature outlining in dark blue. This series is neither numbered nor dated. For convenience of reference, our order follows that of vol. 13 in the Shūeisha *Ukiyo-e taikei* series [Tokyo, 1975]. In the deluxe edition, the complete set is illustrated full size and in color but not always from the best impressions.
Signatures: Hokusai *aratame* Iitsu *hitsu*/zen [*saki no*] Hokusai Iitsu *hitsu*/Hokusai Iitsu *hitsu*

Hokusai: *Fugaku sanjū-rokkei*, title and subtitle

Hokusai: signature to *Fugaku sanjū-rokkei*

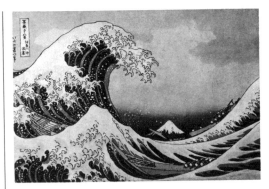

368 1 *Kanagawa-oki nami-ura* (Under the Wave off Kanagawa) Three boats at the foot of a great wave in the wild sea
▷ pl. 168

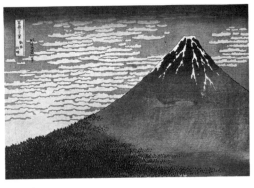

369 2 *Gaifū kaisei* (Fine Wind, Clear Morning) Reddish-brown mountain against blue sky with cloud-strata.
▷ pl. 166

369a 2a Variant state showing the summit in white

370 3 *Sanka haku-u* (Rainstorm beneath the Summit) Clouds in the distance and lightning at the foot of the dark mountain. ▷ pl. 167

372 5 *Tōto sundai* (Surugadai in Edo) Wayfarers and buildings in the foreground

375 8 *Bushū Tamagawa* (The Tama River in Musashi Province [Edo]) A cargo boat crossing the stream; peasant leading packhorse at the river's edge

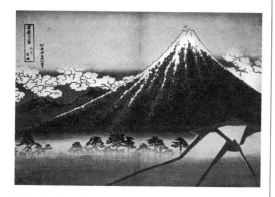

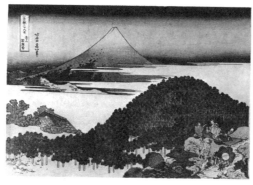

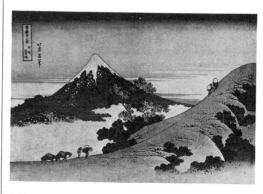

370a 3a A variant, late state adds row of trees in the foreground.

373 6 *Aoyama enza-no-matsu* (The "Cushion Pine" at Aoyama [Edo]) Picknickers on lower right

376 9 *Kōshū inume-toge* (Inume Pass in Kai Province) Travelers and trees in the center

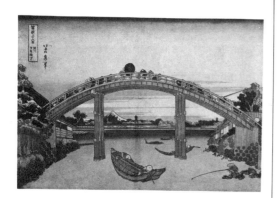

371 4 *Fukagawa Mannen-bashi no shita* (Under Mannen Bridge at Fukagawa [Edo]) Figures on arched bridge, cargo boat and fisherman in foreground

374 7 *Bushū Senju* (Senju in Musashi Province [Edo]) A peasant with packhorse, and two men fishing

377 10 *Bishū Fujimigahara* (Fujimigahara [Fuji-view Fields] in Owari Province) In the foreground a carpenter caulks a large tub.

378 11 *Tōto Asakusa honganji* (Honganji Temple at Asakusa in Edo) Rooftilers at work; a kite flying

381 14 *Sōshū umezawa-zai* (Umezawa Manor in Sagami Province) Cranes in the foreground and in the air. (The last character of the title is assumed to be a misprint for *zai* [or *shō*], "Manor.")

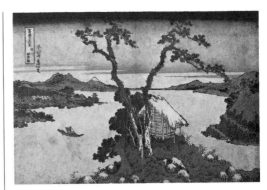

384 17 *Shinshū Suwa-ko* (Lake Suwa in Shinano Province) Trees and a small shrine on promontory in the foreground.

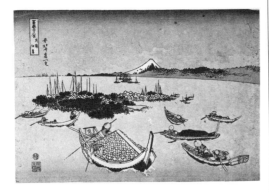

379 12 *Buyō Tsukuda-jima* (Tsukuda Island in Musashi Province [Edo]) Cargo and fishing boats in the foreground. Seals: *kiwame,* Eijudō

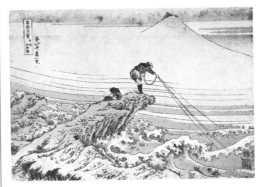

382 15 *Kōshū Kajikazawa* (Kajikazawa in Kai Province) A fisherman and his little helper on a promontory. Early impressions are generally in shades of blue; later issues sometimes add brick red, orange, yellow; seals are sometimes omitted. ▷pl. 169 Seals: *kiwame,* Eijudō

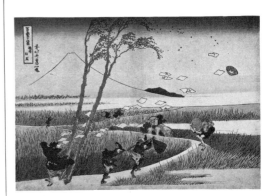

385 18 *Sunshū Ejiri* (Ejiri in Suruga Province) Travelers struggle with the wind under bare trees.

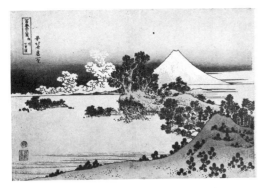

380 13 *Sōshū Shichiri-ga-hama* (Shichiri-ga-hama in Suruga Province) Enoshima in the middle background. (This print and the previous *Tsukuda-jima* design are mentioned in the publisher's advertisement of 1831—the only specific evidence of publication date for the series.) Seals: *kiwame,* Eijudō

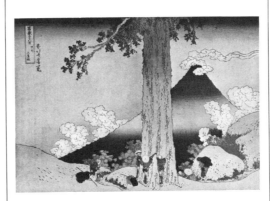

383 16 *Kōshū Mishima-goe* (Mishima Pass in Kai Province) Three travelers try to encircle a huge cryptomeria tree. ▷pl. 170

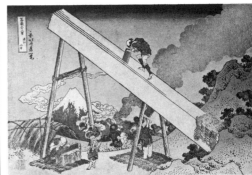

386 19 *Tōtōmi sanchū* (In the Tōtōmi Mountains) Lumbermen at work in the foreground. (There is also a variant, later state with lumber, foreground and horizon, all heavily colored.) Seals: *kiwame,* Eijudō

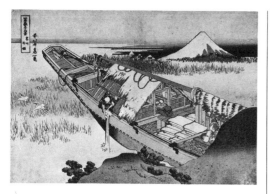

387 20 *Jōshū Ushibori* (Ushibori in Hitachi Province) A large, inhabited junk moored in the foreground.

390 23 *Gohyaku-rakanji Sazaidō* (Sazai Hall of the Five-Hundred-Rakan Temple [Edo]) Pilgrims on the temple balcony.
Seals: *kiwame,* Eijudō

393 26 *Onden no suisha* (Waterwheel at Onden) Peasants working in the foreground.

388 21 *Edo Suruga-chō Mitsui-mise ryakuzu* (Suruga Street in Edo; the Mitsui Shop, Abridged View)
Rooftilers, and flying kites.

391 24 *Koishikawa yuki no ashita* (Snowy Morning at Koishikawa) Teahouse on left, ravens in the sky.
Seals: *kiwame,* Eijudō

394 27 *Sōshū Enoshima* (Enoshima in Sagami Province) A distant view, showing inns on the island.
Seals: *kiwame,* Eijudō

389 22 *Ommayagashi yori Ryōgoku-bashi no sekiyō wo miru* (Viewing Sunset over Ryōgoku Bridge from the Ommaya Embankment [Edo].) A crowded ferryboat in the foreground on the Sumida River.
Seals: *kiwame,* Eijudō

392 25 *Shimo-Meguro* (Lower Meguro) Rustic scene, two falconers on lower right.

395 28 *Tōkaidō Ejiri tago-no-ura ryakuzu* (The Shore at Tago near Ejiri on the Tōkaidō, Abridged View) Two junks in the foreground.

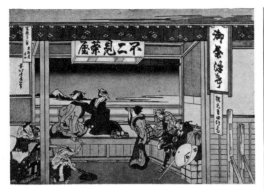

396 29 *Tōkaidō Yoshida* (Yoshida on the Tōkaidō) Travelers in the foyer of the Fuji-view Teahouse

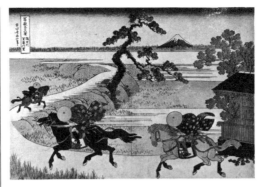

399 32 *Sumida-gawa Sekiya no sato* (Sekiya Village on the Sumida River [Edo]) Three express riders departing from Edo at dawn

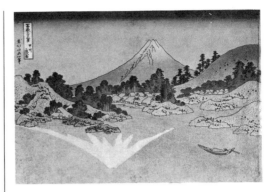

402 35 *Kōshū Misaka suimen* (Reflection in Lake Misaka, Kai Province) The reflection is shown off-center, doubtless for variety of composition.

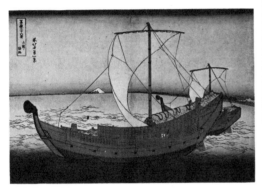

397 30 *Kazusa no kairo* (At Sea off Kazusa) Two large junks in the foreground

400 33 *Noboto-ura* (The Coast of Noboto [Shimōsa Province]) Shellfish-gatherers in the foreground; two *torii* in the water

403 36 *Tōkaidō Hodogaya* (Hodogaya on the Tōkaidō) Travelers seen before a row of pines

398 31 *Edo Nihon-bashi* (Nihon-bashi [Bridge], Edo) Crowds crossing the bridge in foreground, storehouses along the canal, Edo Castle at rear

401 34 *Sōshū Hakone no kosui* (Hakone Lake in Sagami Province) Placid lake with trees and hills

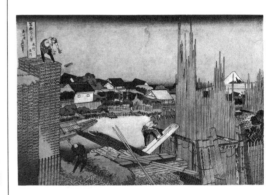

404 37 *Honjo Tatekawa* (Tatekawa in Honjo [Edo]) The timber yard at Tatekawa [Canal] in Edo. (On the improvised gate at lower right appear the publisher's name and address and the notice "New Edition, 36 Fuji Completed," probably indicating that this represents the first of the supplementary series of 10 prints.)

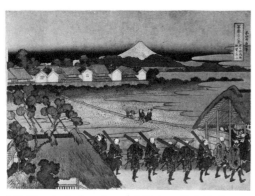

405 38 *Senju kagai yori chōbō no Fuji* (Fuji Seen from the Senju Pleasure Quarter [Edo]) A *daimyō's* procession and a teashop

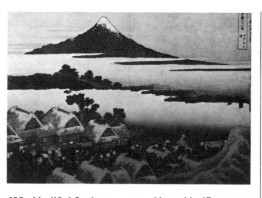

408 41 *Kōshū Isawa no Akatsuki* (Dawn at Isawa in Kai Province) A rustic village with travelers departing at dawn.
Seals: *kiwame,* Eijudō

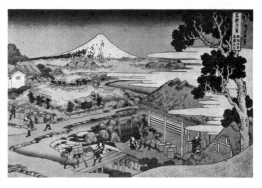

411 44 *Sunshū Katakura chaen no Fuji* (Fuji from the Tea Plantation of Katakura in Suruga Province) Women picking tea leaves, which workers carry into a storage shed

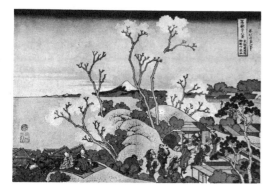

406 39 *Tōkaidō Shinagawa Goten-yama no Fuji* (Fuji from Goten-yama, at Shinagawa on the Tōkaidō [Edo]) Sightseers and revelers amid cherry trees in bloom
Seals: *kiwame,* Eijudō

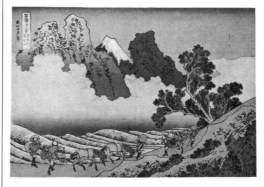

409 42 *Minobu-gawa ura Fuji* (Fuji behind Minobu River) Porters, travelers and packhorses in the foreground

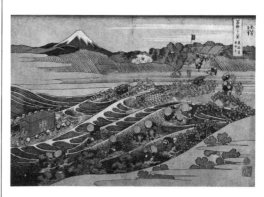

412 45 *Tōkaidō Kanaya no Fuji* (Fuji from Kanaya on the Tōkaidō) Travelers and freight being carried over the turbulent Ōi River by porters.
Seals: *kiwame,* Eijudō

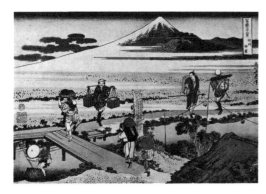

407 40 *Sōshū Nakahara* (Nakahara in Sagami Province) Peasants and travelers at a stream with plank bridge.
Seals: *kiwame,* Eijudō

410 43 *Sunshū Ōno-shinden* (The Paddies of Ōno in Suruga Province) Peasants lead oxen laden with bundles of rushes; women carry the harvest on their backs.
Seals: *kiwame,* Eijudō

413 46 *Shojin tozan* (Groups of Mountain Climbers) Pilgrims at the summit of Mt. Fuji

120 *HYAKU-MONOGATARI* (Ghost Tales)
5 prints known, *chūban,* ca. 1830; signature: *zen* Hokusai *hitsu,* publisher: Tsuru-ya Kiemon [F-130]
1 *O-Iwa-san* ▷ plate 173
2 *Warai-Hannya* (Laughing Demon)
3 *Kohada Koheiji*

414

4 *Sara-yashiki* (The Plate Mansion)

415

5 *Shūnen* (Haunted)

121 (Flower-and-Bird Series)
At least 14 prints known, *ōban,* in Hokusai's style of the 1830s; signature: *zen* Hokusai Iitsu *hitsu.* [A disputed work, often given to Taito II, but the impressions most commonly seen would appear to be Meiji prints, done after Hokusai's designs.] [F-109]

122 (Large-Flower Series)
11 prints known, *ōban,* ca. 1830–31 (censor's seal: *kiwame*); signature: *zen* Hokusai Iitsu *hitsu,* publisher: Eijudō [F-110]
1 Chrysanthemums and Butterfly
2 Irises
3 Lilies
4 Convolvulus and Tree-toad
5 Orange Orchid
6 Peonies and Butterfly
7 Narcissus
8 Sparrow and Hibiscus
9 Poppies
10 Swallow and Hydrangea
11 Chinese Bellflower and Dragonfly

416

Hokusai: *Peonies and Butterfly,* from a Large-Flower Series

123 (*Ai-zuri* Series)
9 prints known, *chūban,* 1831 (censor's seal: *kiwame*); signature: *zen* Hokusai *hitsu,* seals: *Iitsu/Shichijūni-o/Kakō/Fuji-no-yama/Nishi-nishi-nishin/Jimbutsu-nitai,* publisher: Mori-ya Jihei [F-127]

124 (*Tanzaku* Series)
2 prints known, *tanzaku-ban,* ca. 1831; signature: *zen* Hokusai *ga,* publisher: Mori-ya Jihei [F-128]

● 125 *SHOKOKU MEIKYŌ KIRAN* (Wondrous Views of Famous Bridges in All the Provinces)
[probably identical with the proposed print series *Hyakkyō Ichiran* (View of One Hundred Bridges), announced in Hokusai's book *Imayō sekkin hinagata* (1823). 11 prints known, *ōban,* ca. 1831–32 (censor's seal: *kiwame*); signature: *zen* Hokusai Iitsu *hitsu,* publisher: Eijudō [F-111]
1 *Yamashiro Arashiyama Togetsu-kyō* ("Reflected-Moon Bridge" at Arashiyama, Yamashiro Province)
2 *Kōzuke Sano funabashi no kozu* (Pontoon Bridge at Sano, Kōzuke Province: Ancient View)

417

3 *Ashikaga Gyōdōzan Kumo-no-kakehashi* ("Hanging-Cloud Bridge" at Mt. Gyōdō, Ashikaga)

418

4 *Hi-etsu no sakai tsuribashi* (Suspension Bridge between Hida and Etchū Provinces)

419

5 *Suō-no-kuni Kintai-bashi* (Kintai Bridge, Suō Province)

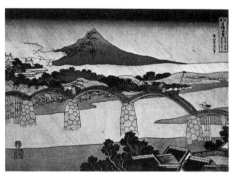

420

6 *Tōkaidō Okazaki Yahagi-no-hashi* (Yahagi Bridge at Okazaki on the Tōkaidō)
7 *Kameido Tenjin taiko-bashi* (Drum Bridge at the Tenjin Shrine)

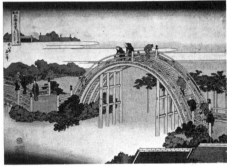

421

8 *Sesshū Aji-kawa-guchi Tempozan* (Mouth of the Aji River, Tempozan, Setsu Province)
9 *Sesshū Temma-bashi* (Temma Bridge, Setsu Province)
10 *Echizen Fukui-no-hashi* (Fukui Bridge, Echizen Province)
11 *Mikawa no Yatsu-hashi no kozu* ("Eight-Parts Bridge" in Mikawa Province, Ancient View)

● 126 *SHOKOKU TAKI-MEGURI* (A Journey to the Waterfalls of All the Provinces)
8 prints known, *ōban,* ca. 1831–32 (censor's seal: *kiwame*); signature: *zen* Hokusai Iitsu *hitsu,* publisher: Eijudō [F-112]

Keyes, Roger and Peter Morse. "Hokusai's Waterfalls and a Set of Copies." In *Oriental Art* XVIII-2 (1972).

1 *Shimotsuke Kurokami-yama, Kirifuri-no-taki*

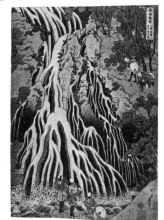

422

2 *Kiso-kaidō, Ono-no-bakufu*
3 *Tōkaidō Sakanoshita, Kiyotaki Kannon*
4 *Washū Yoshino, Yoshitsune Umaarai-no-taki*

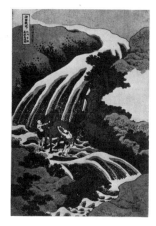

423

5 *Kisoji no oku, Amida-ga-taki*
6 *Tōto, Aoigaoka-no-taki*
7 *Sōshū Ōyama, Rōben-no-taki*
8 *Mino-no-kuni, Yōrō-no-taki*

127 (Small-Flowers Series)
10 prints known, *chūban*, ca. 1832 (censor's seal: *kiwame*); signature: *zen* Hokusai Iitsu *hitsu*, publisher: Eijudō [F-113]
1 *Crossbill and Thistle*
2 *Bullfinch and Weeping Cherry*
3 *Cuckoo and Azaleas*
4 *Java Sparrow on Orange Tree*
5 *Canary and Small Peony*

424

6 *Wagtail and Wisteria*
7 *Nightingale on Roses*
8 *Grosbeak on Mirabilis*

425

9 *Swallow and Shrike with Strawberry and Begonia*
10 *Kingfisher with Pinks and Iris*

128 *SETSUGEKKA* (Snow, Moon, Flowers)
3 prints, *ōban*, ca. 1832 (censor's seal: *kiwame*; signature: *zen Hokusai* Iitsu *hitsu*, publisher: Eijudō [F-114]
1 *Sumida* [*yuki*] (Snow on the Sumida River)

426

2 *Yodo-gawa* [*tsuki*] (Moonlight on the Yodo River)
3 *Yoshino* [*hana*] (Cherry Blossoms at Mt. Yoshino)

427

129 (Humorous *Surimono*)
7 prints known, *chūban surimono*, ca. 1832 (censor's seal: *kiwame*); signatures: *zen* Hokusai *ga*/*zen* Hokusai *hitsu*, publisher: Mori-ya Jihei [F-129]

130 (Large Flower-and-Bird Prints)
5 prints known, *naga-ban, tate-e*, 1832–33 (censor's seal: *kiwame*); signature: *zen* Hokusai Iitsu *hitsu*, publisher: Mori-ya Jihei [F-115]
1 *Falcon and Plum Blossoms*
2 *Turtles and Seaweed*
3 *Carp in Cascade*
4 *Cranes on Pine Tree*

428

5 *Horses in Pasture*

千絵の海 131 *CHIE-NO-UMI* (Oceans of Wisdom)
10 prints known, *chūban*, ca. 1832–33 (censor's seal: *kiwame*); signature: *zen* Hokusai Iitsu *hitsu*, publisher: Mori-ya Jihei [F-116]
1 *Kōshū hiburi* (Fishing by Torchlight, Kai Province)
2 *Sōshū Tonegawa* (Tone River, Shimosa Province)

429

3 *Sōshū Chōshi* (Chōshi, Shimōsa Province)

430

4 *Sōshū Uraga* (Uraga, Sagami Province)
5 *Gotō kujira-tsugi* (Whaling off the Gotō Islands)

431

6 *Kabari-nagashi* (Fly-hook Fishing)
7 *Shimōsa Noboto* (Noboto, Shimōsa Province)
8 *Miyato-gawa naga-ami* (Net Fishing in the *Miyato River*)
9 *Machi-ami* (Fishing with Net on Poles)
10 *Kinu-gawa hachi-fuse* (Fishing with Baskets in the Kinu River)

詩歌写真鏡 ● 132 *SHIKA SHASHIN-KYŌ* (A True Mirror of Chinese and Japanese Poems)
10 prints known, *naga-ban tate-e*, ca. 1832–33 (censor's seal: *kiwame*); signature: *zen Hokusai Iitsu hitsu*, publisher: Mori-ya Jihei [F-117]
1 *Haku Rakuten* (Po Chü-i)
2 *Minamoto no Tōru*
3 *Tokusa-kari* (Peasant Carrying Rushes)
4 *Ri Haku* (Li Po)
5 *Ariwara no Narihira*
6 *Tōba* (Su Tung-p'o)
7 *Shōnenkō* (Ode)
8 *Sei Shōnagon*
9 *Abe no Nakamaro*
10 *Harumichi no Tsuraki*

432 433

Hokusai: *Ri Haku* and *Tōba*, from the series *Shika shashin-kyo*

133 (*Tanzaku* Series)
9 prints known, *tanzaku-ban*, ca. 1832–33 (censor's seal: *kiwame*); signature: *zen Hokusai Iitsu hitsu*, publisher: Mori-ya Jihei [F-118]

134 (*Ai-zuri Tanzaku* Series)
3 prints known, *tanzaku-ban*, ca. 1832–33 (censor's seal: *kiwame*); signature: *zen Hokusai Iitsu hitsu*, publisher: Mori-ya Jihei [F-119]

135 *SHŌKEI SETSUGEKKA* (Fine Views of Snow, Moon, Flowers)
9 prints known, *koban*, ca. 1832–33 (censor's seal: *kiwame*); signature: *zen Hokusai Iitsu hitsu*, publisher: Akamatsu-ya Shōtarō [F-120]

434

Hokusai: *Shinagawa*, from the series *Shōkei setsugekka*

435

Hokusai: *Arashi-yama*, from the series *Shōkei setsugekka*

136 *SHIMPAN DAIDŌ-ZUI* (New Edition: Highway Scenes)
12 prints known, *koban surimono*, ca. 1832–1836; signature: none [F-121]

137 *EDO HAKKEI* (Eight Views of Edo)
8 prints, *kōban*, ca. 1833; signature: *zen Hokusai Iitsu ga*, publisher: Akamatsu-ya Shōtarō [F-122]

琉球八景 138 *RYŪKYŪ HAKKEI* (Eight Views of the Ryūkyū Islands)
8 prints, *ōban*, ca. 1833; signature: *zen Hokusai Iitsu hitsu*, publisher: Mori-ya Jihei [F-123]
1 *Jungai sekishō* (Evening Glow at Jungai)
2 *Ryūdō shōtō* (Pines and Wave at Ryūdō)
3 *Rinkai kosei* (Sound of the Lake at Rinkai)

436

Hokusai: *Rinkai kosei*, from the series *Ryūkyū hakkei*

4 *Senki yagetsu* (Evening Moon at Senki)
5 *Jōgaku reisen* (Sacred Fountain at Jōgaku)
6 *Sanson chikuri* (Bamboo Grove of Sanson)
7 *Chōkō shūsei* (Autumn Weather at Chōkō)
8 *Chūtō shōen* (Banana Groves at Chutō)

139 *SHIMPAN ŌRAI SUGOROKU* (New Edition: Highway Backgammon)
2 prints, double-*aiban*, ca.1833; signature: *zen Hokusai Iitsu zu*, publishers: Nishimura-ya Yohachi, Tsuru-ya Kiemon and Jōshū-ya Jūzō [F-124]

140 *SHŌKEI KIRAN* (Wondrous Views of Famous Scenes)
8 prints known, large *chūban*, *uchiwa-e*, ca. 1834–35; signature: *zen Hokusai Manji* [F-131]

百人一首姥ケ絵とき ● 141 *HYAKUNIN ISSHU UBA-GA-ETOKI* (*The Hundred Poems* [by the Hundred Poets] explained by the Nurse)
27 prints known, each bearing the poet's name and his verse; *ōban*, ca. 1839 (censor's seal: *kiwame*); signature: *zen Hokusai Manji*, publishers: Eijudō and Eikōdō [F-132]
1 *Tenchi-tennō*
2 *Jitō-tennō*
3 *Kakinomoto no Hitomaro*
4 *Yamabe no Akahito*
5 *Sarumaru-daiyū*
6 *Chūnagon Yakamochi*
7 *Abe no Nakamaro*
8 *Ono no Komachi*
9 *Sangi Takamura*

437

10 *Sōjō Henjō*
11 *Ariwara no Narihira ason*
12 *Fujiwara no Toshiyuki ason*
13 *Ise*
14 *Motoyoshi shinnō*
15 *Kan-ke*
16 *Teishin-kō*
17 *Minamoto no Muneyuki ason*

18 *Harumichi no Tsuraki*
19 *Kiyowara no Fukayabu*

438

20 *Bunya no Asayasu*
21 *Sangi Hitoshi*
22 *Ōnakatomi no Toshinobu ason*
23 *Fujiwara no Yoshitaka*

439

24 *Fujiwara no Michinobu ason*

440

25 *Sanjō-in*
26 *Dainagon Tsunenobu*

441

27 *Gonchūnagon Sadaie* [*Teika*]

II HOKUSAI'S ILLUSTRATED BOOKS AND ALBUMS
(Unless otherwise stated all works are in one volume. Items in brackets have not been seen by us personally but are derived from secondary sources.)

1 *Iki-chonjon Kuruwa no chaban* (A Gallant's Farce in the Entertainment Quarter) Text by Banri (possible pseudonym of Hokusai). *Kibyōshi*, 2 vols., 1780. Signature: Shunrō [= Hokusai]

2 *Meguro no hiyoku-zuka* (The Love Mound of Meguro)
Kibyōshi, 2 vols., 1780. Signature: Katsukawa Shunrō

3 *Isshō Tokubyōe mitsu-no-den* (Three Tales of Tokubyōe) *Kibyōshi* by Tsūshō, 3 vols., 1780. Signature: Shunrō

4 *Nichiren ichidai-ki* (Life of St Nichiren)
2 vols., 1782. Signature: Katsukawa Shunrō

5 *Arigatai tsū-no-ichiji* (The Happy Word "Gallant")
Text by Zewasai (pseudonym of Hokusai). *Kibyōshi*, 2 vols., 1781. Signature: Katsukawa Shunrō

6 *Kōdai no mudagoto* (Idle Talk on Gallantry) *Share-hon*, 1781. Signature: Katsukawa Shunrō

7 *Kyoku-daiko* (Drumming up Trade)
Share-hon by Rihaku-sanjin; 1781. Signature: Shunrō

8 *Kamakura tsūshinden* (The Gallant Retainers of Kamakura)
Kibyōshi, 2 vols., 1782. Signature: Shunrō

9 *Shi-tennō daitsū-jitate* (The "Four Kings" as Gallants)
Text by Zewasai (Hokusai). *Kibyōshi*, 2 vols., 1782. Signature: Shunrō

10 *Fukagawa haiken* (A View of Fukagawa) *Share-hon*, 1782. Signature: Shunrō

11 *Kan-yōkyū tsū-no-yakusoku* (The Gallant's Promise in the Dragon King's Palace). *Kibyōshi*, 2 vols., 1783. Signature: Shunrō

12 *Un-wa-hiraku ōgi no hana-ga* (Luck of The Perfumed Fan)
Kibyōshi, 2 vols., 1784. Signature: Shunrō

13 *Kyōkun zō-nagamochi* (The Chest Replete with Various Teachings)
Kokkei-bon, 5 vols., 1784. Signature: Katsukawa Shunrō

14 *Nozoki-karakuri Yoshitsune yama-iri* (Peeping in on Yoshitsune's Entry into the Mountains)
Kibyōshi, 3 vols., 1784. Signature: Katsu Shunrō

15 *Oya-yuzuri hana-no-kōmyō* (Pride of High Parentage)
Kibyōshi, 3 vols., 1785. Signature: Shunrō *aratame* [changed to] Gumbatei.

16 *Onnen Uji no hotarubi* (Revenge: Fireflies on the River Uji)

Kibyōshi, 2 vols., 1785. Signature: Katsu Shunrō

17 *Niichi-tensaku nishinga-isshin* (Two-and-One Arithmetic Reckoning)
Kibyōshi by Tsūshō, 3 vols., 1786. Signature: Gumbatei [Hokusai]. [Later reissued under the title *Ningen banji Niichi-tensaku-no-go*, 1788 and 1800.]

18 *Zen-Zen Taiheiki* (The Earlier *Zen-Taiheiki*)
Kibyōshi, 5 vols., 1786. Signature: Katsu Shunrō

19 *Waga-ie raku no Kamakura-yama* (Our Happy Home at Mt. Kamakura)
Kibyōshi, 5 vols., 1786. Written and illustrated by Gumbatei (Hokusai).

20 *Jabara-mon hara no nakachō* (A Snakeskin Crest in Main Street)
Kibyōshi, 2 vols., 1786. Signature: Shunrō *aratame* Gumbatei

21 *Daibutsu hidari-yori* (The Left-handed Great Buddha)
Kibyōshi, 3 vols., 1786. Signature: Hakusanjin Kakō [Hokusai]. [Later retitled *Azuma-daibutsu momiji no meisho* (The Eastern Great Buddha: Famous for Autumn Maple Leaves), 1793]

22 [*Jinkōki nishiki-mutsuki* (Descriptions of Two Wars)]
1788. Signature: Gumbatei

23 *Fuku-kitaru warai no Kadomatsu* (The Pine over the Gate Inviting Happiness)
Kibyōshi, 2 vols., 1789. Signature: Katsukawa Shunrō

24 *Kusaki mo nabiku hirikura no sakae* (Wind-breaking of Good Fortune)
Kibyōshi, 2 vols., 1789. Signature: Shunrō

25 [*Yorozu-ya Tokuzaemon* (Rich Merchant of Kamakura)]
Kibyōshi, 2 vols., ca. 1789. Signature: Katsu Shunrō

26 *Rokkasen kyojitsu no tensaku* (The Six Poets Corrected)
Kibyōshi, 3 vols., 1789. Signature: Shunrō

27 *Hayari-uta torikomi shōbu* (Imbroglio to a Popular Tune)
Kibyōshi, 2 vols., 1789. Signature: Shunrō

28 [*Mitate Chūshingura* (The *Chūshingura* in Modern Dress)] 1780. Unsigned

29 *Tatsu-no-miyako sentaku-banashi: imo-tako no yurai* (Laundry at the Dragon's Palace: The Origins of "Fish and Chips" [potatoes and octopi in this case])
Kibyōshi, 2 vols., 1791. Signature: Shunrō

30 [*Miburi kowairo nadai no furisode* (The Imitation of the Voice and Action of a Celebrated Actor in His Fine Clothes)]
2 vols., 1791. Signature: Shunrō

31 *Tenjin shichidai-ki* (The Seven Generations of Tenjin)
(Alternate title: *Masumi no Kagami*.) *Kibyōshi*, 3+2 vols., 1792. Ascribed to Shunrō

269

32 *Nue Yorimasa meika-no-shiba* (Yorimasa and the Monster)
Kibyōshi, 3 vols., 1792. Signature: Shunrō. (A 2-vol. edition from 1788 is also recorded.)

33 *Jitsugo-kyō osana-kōshaku* (A Lecture for Children on the *Jitsugo-kyō*)
Kibyōshi, 3 vols., 1792. Signature: Shunrō

34 *Momotarō hottan-banashi* (The Origins of *Momotarō*)
Kibyōshi, 3 vols., 1792. Signature: Shunrō

35 *Onna-sōji kochō-no-yume* (The Woman Philosopher: Dream of the Butterfly)
Kibyōshi, 2 vols., 1792. Signature: Shunrō

36 *Hin-puku ryō-dōchū-no-ki* (The Two Roads of Poverty and Riches)
Kibyōshi, 3 vols., 1793 (second edition, 1795). Signature: Shunrō

37 *Chie-shidai Hakone-zume* (Keeping One's Wits at Hakone)
Kibyōshi, 3 vols., 1793. Signature: Shunrō

38 *Fukujukai muryō no shinadama* (Jewel of the Sea of Happiness and Everlasting Life)
Kibyōshi, 3 vols., 1794. Signature: Shunrō

39 *Kobito-jima nanasato fūki* (Happy Island of Midgets)
Kibyōshi, 2 vols., 1794. Signature: Shunrō

40 *Nozoite-miru tatoe no fushi-ana* (A Peek through the Proverbial Keyhole)
Kibyōshi, 2 vols., 1794. Signature: Shunrō

41 [*Ren-awase onna-shinasadame* (Conglomerate Types of Women)]
Kyōka anthology, 2 vols., 1794. Signature: Kusamura Shunrō

42 *Shiwamiuse-gusuri* (Prescription for Losing Wrinkles)
Kibyōshi, 3 vols., 1795. Signature: Shunrō

43 *Temaezuke akō-no-shiokara* (Spicy Tales of the *Chūshingura*)
Kibyōshi, 2 vols., 1795. Signature: Shunrō

44 [*Kyōka Edo murasaki* (The Purple of Edo)]
Kyōka anthology, 1795. Illustrated by Sōri (Hokusai), Utamaro *et al.*

45 [(*Kyōka* Anthology)]
1796. Signature: Hokusai Sōri

46 *Asaina ohige-no-chiri* (Dusting the Whiskers of Asaina)
Kibyōshi, 2 vols., 1796. [Signature: Hokusai]

47 *Shikinami-gusa* (Grasses of the Four Seasons)
Kyōka anthology, 1796. Signature: Hyakurin Sōri. [There is some question as to whether this name is identical with Hokusai.]

48 [*Yomo no haru* (Spring All Over)]
Kyōka anthology, 1796. Signature: Hokusai Sōri. (With Kyōden, Gentai, Sō-Shizan *et al.*)

49 [*Yomo no haru* (Spring All Over)]
Kyōka anthology, 1796. Signature: Hokusai Sōri. (With Eishi and Masayoshi.)

50 *Shioyaki bunta-monogatari* (The Story of Bunta the Salt-Gatherer in the Capital)
Kibyōshi, 3 vols., ca. 1797. Signature: Katsukawa Shunrō

左武多良加寸美 51 *Sandara-kasumi* (Mist of Sandara)
Kyōka anthology, 1797. One print signed Hokusai Sōri

442

Hokusai: Illustration from *Sandara-kasumi*

52 [*Haru no miyabi* (Elegance of Spring)]
Kyōka anthology, 1797. (With Shigemasa and Ittei.)

53 *Yanagi-no-ito* (Willow Branches)
Kyōka anthology, 1797. One print signed Hokusai Sōri (With Eishi, Shigemasa, Tōrin, Rinshō.)

54 *Shunkyō-jō* (Album of Springtime Diversions)
Kyōka anthology. One print signed Sōri in first vol., dated 1797; one signed Hokusai Sōri in second vol., dated 1798

55 *Miyama uguisu* (Nightingale in the Mountains)
Kyōka anthology, 1798 (with Shigemasa). Signature: Hokusai Sōri

56 *Bakemono Yamato-honzō* (History of Japanese Ghosts)
Kibyōshi, 3 vols., 1798. Signature: Kakō [Hokusai]

57 [*Bakemono iwa-no-sō* (History of Phantoms)]
2 vols., 1978. Signature: Kakō

男踏歌 58 *Otoko-dōka* (The New Year's Mime)
Kyōka anthology, 1798. (One design signed Hokusai Sōri, others by Shigemasa, Utamaro, Yōshi, Eishi) ▷ plate 163

59 [*Hatsu wakaba* (The First Green Leaves)]
Kyōka anthology, 1798. One print signed Sōri *aratame* [changed to] Hokusai

60 [*Rakumon binka-fu* (Flower Arrangements of the Raku School)]
1798. Signatures: Hokusai/Sōri/Kanchi [Later edition retitled *Sashiire hana no futami*]

61 [*Haikai shijiku-zōshi* (Book of the Four Seasons)]
Haiku anthology, 1798. One print signed Sōri *aratame* Hokusai Tatsumasa

62 [*Hana-no-e* (The Eldest of the Flowers)]
Kyōka anthology, 1798. Two prints, one signed *zen* Sōri Hokusai, the other Hokusai Tatsumasa

63 [*Tarō-zuki* (The First Moon)]
Kyōka anthology, ca. 1798. One plate signed Sōri

64 [*Shunkyō* (Springtime Diversions)]
Kyōka anthology, ca. 1798. (Illustrated by Sōri, Shiransai, Shigemasa *et al.*)

● 65 *Azuma asobi* (Amusements of the Eastern Capital)
Kyōka anthology, 1799. Signature: Hokusai. (Edition printed in color, 1802)

66 *Ema-awase onna kana-dehon* (Female *Chūshingura* in *Ema*)
Kyōka anthology, 1799. Signature: Hyakurin Sōri [cf. note to No. 47]

67 *Kozue no yuki* (Snow on the Branches)
Kyōka anthology, ca. 1799. Signature: Fusenkyo Hokusai

68 [*Kyōka hakuen isshu-shō* (Selected *Kyōka* on Danjūrō)]
Kyōka anthology, 1799. Signature: Tawara-ya Sōri (With Kunimasa, Shunkō, Shun-ei)

69 [(*Kyōka* Anthology)]
1799. One plate signed Sōri

70 [*Shunkyō-jō* (Album of Springtime Diversions)]
Kyōka anthology, ca. 1790s. Illustrated by Sōri, Utamaro, Toyohiro

71 [*Shunkyō-jō* (Album of Springtime Diversions)]
Kyōka anthology, ca. 1790s. (Illustrated by Sōri and Kyōden)

72 *Sangoku-shi* (The Secret "Three Kingdoms")
Share-hon, ca. late 1790s. Signature: Hokusai

73 *Momo-saezuri* (The Twittering of Birds)
Kyōka album, 1800. (Illustrated by Hokusai, Shumman *et al.*, distinguish from No. 112)

74 *Kyōka sanjū-rokka-sen* (Thirty-six Poets of *Kyōka*)
Kyōka anthology, 1800. Signature: Hokusai Tatsumasa

75 *Hitori-hokku* (Solo Verses)
Haiku anthology, 2 vols., 1800. (With Hōchū, Hōitsu, Kōkan *et al.*) Signature Gakyō-rōjin Hokusai

76 *Totō meisho ichiran* (Famous Views of the Eastern Capital)
Picture book, 2 vols., 1800. Signature: Hokusai Tatsumasa (Alternate title: *Totō shōkei ichiran*)

443

Hokusai: *Yoshiwara Scene.* Detail from the picture book *Totō meisho ichiran, ōbon,* 2 vols., 1800.
The effect of the Japanese picture book is a cumulative one of many delightful images indelibly inscribed in the viewer's subconscious memory. The present detail (part of a double-page scene including many figures) shows three courtesans of the Yoshiwara on procession – the background crowded with all the variegated life of the pleasure quarter. This ideal of frail feminine beauty harks back to the late Primitives and Harunobu and lasted only a brief generation, to be revived again with Yoshitoshi in the 1880s.

77 *Kamado shōgun kanryaku-no-maki* (Tactical History of General Oven)
Kibyōshi, 3 vols., 1800. Written and illustrated by Tokitarō Kako

78 [*Anata yomo-no-haru* (Poems on Spring)]
Kyōka anthology, ca. 1800. Signature: Hokusai. (With Tsunegaki and Eishi)

79 [*Totō meisho zuka shū* (Collection of Views of Yedo with Poems)]
Ca. 1800

80 *Chigo-Monju osana-kyōkun* (Juvenile Instructions of the Boy Monju)
Kibyōshi, 3 vols., 1801. Text and illustrations by Tokitaro Kakō.

81 *Haru no tawamure-uta* (Playful Verses of Spring)
(With Eiri) 1801. Signature: Gakyōjin Hokusai

82 *Nishiki-zuri onna-sanjū-rokkassen* (Brocade Prints of the Thirty-six Poetesses)
1801. Frontispiece signed Gakyōjin Hokusai (the plates of the poetesses, by Eishi).

83 *Asama-yama fumoto no ishi* (Stones of Mt. Asama)
Kyōka anthology, 1801, Illustrations by Sōri [possibly not identical with Hokusai here], Shumman, Seiboku.

84 [(*Kyōka* Anthology)]
Ca. 1801. One plate signed Gakyōjin Hokusai

85 [*Shishōan-ren kyōka* (Comic Poems of the Shishōan Club)]
Kyōka anthology, ca. 1801. Signatures: Hokusai/Gakyōjin Hokusai

86 *Ada-dehon* (Models of Rakish Vendetta)
Share-hon, 1801. Signature: Gakyōjin Hokusai (For sequel see following item.)

87 *Tsūshin-muda* (The Rakish *Rōnin's* Revenge)
Share-hon, 1802. Signature: Gakyōjin Hokusai (Alternate title: *Tsūshin-gura;* a sequel to the preceding item.)

88 *Isuzu-gawa Kyōka-guruma: fūryū gojūnin isshu* (Humorous Odes of Isuzu River: Fifty Fashionable Poets, One Poem Each)
1802. Signature: Hokusai Tatsumasa

89 *Miyako-dori* (Birds of the Capital)
Kyōka anthology, 1802. Signature: Gakyōjin Hokusai

90 *Itako zekku-shū* (Songs of Itako)
Kyōshi anthology, 2 vols., 1802. Unsigned but known from contemporary records to be illustrated by Hokusai.

91 *Ehon Azuma-asobi* (Amusements of the Eastern Capital)
Picture book, 3 vols., 1802. Reissue of the 1799 book (No. 65) with poems omitted and colors added.

92 *Ehon Chūshingura* (Picture Book *Chūshingura*)
2 vols., 1802. Signature: Tatsumasa (Inner title: *Chūshingura yakuwari kyōka* [Humorous Poems on the *Chūshingura* Roles])

93 [*Saifu-no-himo shirami-use-gusuri* (History of a Miser)]
Ca. 1802. Signature: Hokusai

94 *Munazanyō uso-no-tanaoroshi* (Facetious Calculations)
Kibyōshi, 3 vols., 1803. Text and illustrations signed Tokitarō Kako (Subtitle and turnover title: *Jinkō-ki*)

95 *Hashika otoshi-banashi* (Jokes on Measles)
Hanashi-bon, 1803. Signature: Senkōzan

96 *Ama-no-sutegusa* (The Fisherman's Reeds)
Yomi-hon by Hirozumi: 6 vols., 1803. Signed: Katsushika Hokusai

97 *Buchōhō sokuseki-ryōri* (An Improper Impromptu Supper)
Kibyōshi, 3 vols., 1803. Text and illustrations by Tokitarō Kako

98 *Wakaran-monogatari* (Incomprehensible Tale of Three Countries)
Kibyōshi, 3 vols., 1803. Signature: Kakō

99 *A-a shinkirō* (Ah, The Mirage)
Kibyōshi, 3 vols., 1803. Signature: Katsushika Hokusai

100 *Haru-no-Fuji* (Fuji in Spring)
Kyōka anthology, 1803. Signature: Gakyōjin Hokusai

101 *Ogura hyakku* (Verses after the *Hundred Poets*)
By Hakuen (the actor Danjūrō V), 1803. Signature: Hokusai Tatsumasa

102 [(*Hinauta*) *Tsuki kuwashi* (Rustic Moonlit Verses)]
Kyōka anthology, 1803. Signature: Gakyōjin Hokusai

103 [*Fujimi no tsura* (On Viewing Mt. Fuji)]
Kyōka anthology, 1803. Signature: Gakyōjin Hokusai

104 [*Kyōka iso-no-kami* (Verses on the Gods)]
1803. Signature: Hokusai Tatsumasa (Possibly confused with a work of this title and date by Hokusai's pupil Shinsai.)

山滿多山 ● 105 *Yama mata yama* (Range upon Range of Mountains)
Picture book with *kyōka,* 3 vols., 1804. Signature: Gakyōjin Hokusai

106 *Kyōka kayu-zue* (Cane of Verses)
1804. Illustrations by Sōri [possibly not identical with Hokusai here], Hokuba *et al.*

107 [*Misoka-tsuzura* (A Month-end Collection)]
1804. Collection of poetry and designs, four of which are signed Gakyōjin Hokusai

108 *Musume katakiuchi imose-no-tomozuna* (The Faithful Daughter's Revenge)
Kibyōshi by Korori, 2 vols., 1804. Signature: Tokitarō Kako

109 *Shōsetsu hiyoku-mon* (A Novel of Two Lovers)
Yomi-hon by Bakin; 2 vols., 1804. Signature: Hokusai Tatsumasa (for later reissue see No. 125)

110 *Toshi-otoko warai-gusa* (New Year's Jokes)
Hanashi-bon by Ki-Osamaru; 1804. Signature: Takitarō Kako

111 *Hanashi-kame* (Turtle Tales)
Hanashi-bon by Fukusuke; 1804. Signature: Tokitarō Kako

112 *Momo-saezuri* (The Twittering of Birds)
Kyōka anthology; 1805. Signature: Gakyōjin Hokusai

113 *Ehon Azuma futaba-nishiki* (Young Brocade of the East)
Yomi-hon by Shigeru; 5 vols., 1805. Signature: Gakyō-rōjin Hokusai

両岸一覧 ● 114 *Sumida-gawa ryōgan ichiran* (Views of Both Banks of the Sumida River)
Picture book, 3 vols., ca. 1805. Hokusai's name is mentioned in the preface.

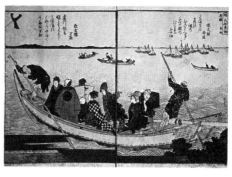

444

115 *Shimpen Suiko-gaden* (The New Illustrated *Suihuchuan* [Chinese novel])
Yomi-hon by Bakin and Ranzan; 91 vols., 1805–38. Various signatures

116 [*Shimpan ōmi hakkei* (New Edition, Eight Views of Omi)]
Ca. 1806–08. Signature: Hokusai

117 *Ehon tama-no-ochibo* (Picture Book of Jeweled Gleanings)
Yomi-hon by Shigeru; 10 vols., 1806–08. Signature: Katsushika Hokusai (for later reissue see No. 121)

118 [*Uwaki sōshi* (Book of Philandering)]
Kibyōshi, 3 vols., 1806. Signature: Hokusai

119 *Jimoku-shū* (Ears and Eyes)
Kyōka anthology, 1806. Frontispiece by Hokusai

120 *Jiraiya setsuwa* (Legends of Jiraiya)
Yomi-hon by Onitake; 11 vols., 1806. Signature: Hokusai

121 *Ehon Nitta kōshinroku* (The Loyal Retainers of Nitta)
Reissue of No. 117

122 *Karukaya kōden Tama-kushige/Ishidō-maru Karukaya monogatari* (The Tale of Karukaya)
Yomi-hon by Bakin; 5 vols., 1806. Signature: Katsushika Hokusai (Reissued in *gōkan-bon* format, 3 vols., 1809)

123 *Kataki-uchi urami kuzu-no-ha* (The Vengeance of the Fox)
Yomi-hon by Bakin; 5 vols., 1807. Signature: Katsushika Hokusai

124 *Chinsetsu yumihari-zuki* (Strange Tale of the Crescent Moon)
Yomi-hon by Bakin; 29 vols., 1807–11. Signature: Katsushika Hokusai

125 *Yūkun-no-misao renri no mochibana* (The Flower of a Courtesan's Fidelity)
Reissue of No. 109 in *gōkan-bon* format, 2 vols., 1807. Signature: Gakyōjin Hokusai

126 *Sono-no-yuki* (Snow in the Garden)
Yomi-hon by Bakin; 5 parts in 6 vols., 1807. Signature: Katsushika Hokusai

127 *Sumida-gawa bairyū shinsho* (New Book of Plums and Willows on the Sumida River)
Yomi-hon by Bakin; 6 vols., 1807. Signature: Katsushika Hokusai

128 *Shin kasane-gedatsu monogatari* (New Tale of the Salvation of Kasane)
Yomi-hon by Bakin; 5 vols., 1807. Signature: Katsushika Hokusai

129 *Yuriwaka nozue-no-taka* (The Wild Falcon of Yuriwaka)
Yomi-hon by Sōba; 5 vols., 1808. Signature: Katsushika Hokusai

130 *Kyōkun onore-ga-tsue* (Didactic Tales)
Gōkan-bon by Ikku; 5 vols., 1808. Signature: Gakyōjin Hokusai

131 *Onna-moji nue monogatari* (Story of the Monster Nue)

132 *Hitori-hokku* (Collection of Single Poems)
2 vols., 1808. The second volume has one plate signed Gakyōjin Hokusai

133 *Kataki-uchi migawai-myōgo* (Vengeance by Sacred Invocation)
Gōkan-bon by Bakin; 6 vols., 1808. Signature: Katsushika Hokusai

134 *Shimoyo no hoshi* (Stars of the Frosty Night)
Yomi-hon by Tanehiko; 5 vols., 1808. Signature: Katsushika Hokusai

135 *Kitabatake onna-kyōkun* (Instructions in Women's Bravery)
Gōkan-bon by Ikku; 5 vols., 1808. Signature: Gakyōjin Hokusai (for later reissue see No. 156)

136 *Kasa-zukushi* (Medley of Caps)
Theater booklet by Bakin; 1808. Frontispiece signed Katsushika Hokusai

137 *Kataki-uchi mukui no ja-yanagi* (The Vengeance of the Snake Willow)
Gōkan-bon by Sanwa; 6 vols., 1808. Signature: Katsushika Hokusai

138 *San-Shichi zenden Nanka no yume* (Complete Story of Sankatsu and Hanshichi: A Dream of Nanka)
Yomi-hon by Bakin; 6 vols., 1808. Signature: Katsushika Hokusai

139 *Raigō-ajari kaiso-den* (The Mysterious Rat and the Priest Raigō)
Yomi-hon by Bakin; 10 vols., 1808. Signature: Katsushika Hokusai

140 *Awa-no-naruto* (The Whirlpools of Awa)
Yomi-hon by Tanehiko; 5 vols., 1808. Signature: Katsushika Hokusai

141 *Anokutara kashiko monogatari* (A Tale of Peerless Wisdom)
Yomi-hon by Shinrotei; 5 vols., 1808. Signature: Katsushika Hokusai

142 *Kana-dehon gojitsu-no-bunshō* (A Sequel to the *Chūshingura*)
Yomi-hon by Emba; 5 vols., 1809. Signature: Katsushika Hokusai

143 *Hida-no-takumi monogatari* (Story of the Craftsman of Hida)
Yomi-hon by Rokujuen; 6 vols., 1809. Signature: Katsushika Hokusai

144 *Yume-no-ukihashi* (The Bridge of Dreams)
Yomi-hon by Tōei; 3 vols., 1809. Second part, 5 vols., 1814. Signature: Katsushika Hokusai

145 *Chūkō Itako-bushi* (Valiant Songs of Itako)
Yomi-hon by Emba; 5 vols., 1809. Signature: Katsushika Hokusai

146 *Ki-no-hana-zōshi* (Tale of Umegawa and Chūbei)
Yomi-hon by Shigeru; 1809. Signature: Katsushika Hokusai

147 *Sanshō-dayō eiko-monogatari* (The Rise and Fall of Sanshō-dayu)
Yomi-hon by Kokuga; 5 vols., 1809. Signature: Katsushika Hokusai

148 *Agemaki monogatari kōhen* (The Story of Agemaki: A Sequel)
Yomi-hon by Tanehiko; 2 vols., 1809. Signature: Hokusai [The first part was illustrated by Tōsen the previous year.]

149 *San-ai-shū* (Three Loves)
Kyōka anthology, ca. early 1800s. Signature: Hokusai

150 *Ō-tsudoi* (The Great Gathering)
Kyōka anthology, ca. early 1800s. Illustrations by Hokusai and Rankei

151 *Kyōka tō-megane* (The Verse Telescope)
Kyōka anthology, 1810. Illustrated by Hokusai and others

152 *Shiraito sōshi* (Story of Shiraito)
Yomi-hon by Nagane; 6 vols., 1810. Signature: Katsushika Hokusai Tatsumasa

153 *Onnyo imose-yama* (The Mountains of Husband and Wife)
Yomi-hon by Shinrotei; 6 vols., 1810. Signature: Katsushika Hokusai

154 [*Chamise Suminoe-zōshi* (The Teashop Suminoe Booklet)]
Theater book, 9 vols., 1810. Frontispiece signed Katsushika Hokusai

155 [*Tōkaidō gojūsan-tsugi ezukushi* (Designs of the Fifty-three Stations of the Tōkaidō)]
1810

156 *Yūryaku onna-kyōkun* (Instructions in Women's Tactics)
A reissue of No. 135, ca. 1810.

157 *Yume-awase Nanka kōki* (New Dreams of Nanka)
Yomi-hon by Bakin. 8 vols., 1811. A sequel to *San-Shichi zenden* (No. 138). Signature: Katsushika Hokusai Tatsumasa (It was controversy over this work that caused the eventual break-up of the Bakin-Hokusai collaboration.)

158 *Zoku Hizakurige* (*Hizakurige* Sequel), Series II
Kokkei-bon by Ikku; 2 vols., 1811. Frontispiece by Hokusai

159 *Horikawa tarō hyakushu* (One Hundred Verses at Horikawa)
Kyōka anthology, 2 vols., 1811. (With Shigemasa, Shumman, Kanrin, Kikkei, Seikei, Shūri) Signature: Katsushika Hokusai

160 *Shimpen tsuki-no-Kumasaka* (The New History of the Brigand Kumasaka)
Gōkan-bon, 3 vols., 1811. Signature: Tokitarō Kakō

161 *Kokkei futsuka-yoi Jōdan futsuka-yoi* (A Comic Hangover)
Kokkei-bon by Ikku; 2 vols., 1811. Illustrated by Hokusai and Hokusū.

162 *Seta-no-hashi ryūnyo-no-honji* (The Female Dragon of the Bridge of Seta)
Yomi-hon by Tanehiko; 3 vols., 1811. Signature: Katsushika Hokusai (also reissued in 1813 and 1823)

163 *Aoto Fujitsuna moryō-an* (The Ambiguity of Aoto Fujitsuna)
Yomi-hon by Bakin. In two series of 5 vols. each, 1811–12. Signature: Katsushika Hokusai

164 *Hokuetsu kidan* (Strange Tales of Northern Echigo)
Yomi-hon by Shigeyo; 6 vols., 1812. Signature: Katsushika Hokusai

445

Hokusai: *Travelers in the Snow.* Detail of a book illustration from *Hokuetsu kidan, hanshi-bon,* 6 vols., 1812.
Hokusai illustrated well over 200 books during his long career, with literally thousands of plates. This scene is typical of his best work in the *yomi-hon* genre, the "Gothic novels" that came into popularity with the 1810s and to which Hokusai devoted much of his energy during that decade. Here the strong sense of dramatic design that was at the basis of all Hokusai's work is evident; the faces of the anonymous figures are doubtless concealed on purpose: man, beast and nature are thus accorded equal status in a picture where the design itself becomes the central theme. (Though printed in monochrome, the plate is lent variety by the employment of "lowering," a process by which; on the left and lower right, the paper is pressed by hand against the inked woodblock to obtain soft, shadowy effects.) Signature at the top: Katsushika Hokusai *ga.* On the left is the turnover, abridged title, volume and page of the book; *Hokuetsu,* Volume I, Frontispiece 6. (The right half of the plate continues the snow scene.)

165 *Matsuō monogatari* (The Story of Matsuō)
Yomi-hon by Shigeru; 6 vols., 1812. Signature: Hokusai

166 *Ryakuga haya-oshie* (Quick Guide to Drawing)
Series I, 1812; Series II, 1814; Series III, 1815 (see also under No. 178). Signature: Hokusai

167 [*Nichiren-shōnin ichidai-zue* (A Picture Book of the Life of St. Nichiren)]
6 vols., 1813

168 *Bei-bei kyōdan* (A Rustic Tale of Two Heirs)

Yomi-hon by Bakin; 8 vols., 1813. Signature: *zen* Hokusai Taitō

169 *Katsushika-zushi teguri-bune* (The Fishing Boat of Katsushika)
Kyōka anthology, 1813. One design by Hokusai

170 *Oguri gaiden* (The Legend of Prince Oguri)
Yomi-hon by Shigeru; 16 vols., 1813. Signature: Hokusai

漫画 171 *Hokusai manga* (Random Sketches by Hokusai), Series I
1814. Signature: Katsushika Hokusai
(Preface dated "Autumn 1812," thought to have been issued first, in early Spring 1814, under the title *Denshin kaishu* ["Transmitting the True Image," i.e. a primer for aspiring artists] and from different blocks than the general edition.)

446

Hokusai: *Figures on a Street.* Page from the *Hokusai manga,* Series I, *hanshi-bon,* 1814; *sumi* with light colors.
In this series of 15 volumes, designed from around 1813 through his final years, Hokusai produced a veritable pictorial encyclopedia of Far Eastern life and legend. The series was originally intended as a set of copybooks for art students but soon made the artist's name known throughout Japan and, eventually, throughout the world.

● 172 *Hokusai shashin gafu* (Album of Drawings from Life by Hokusai)
1814. Unsigned (There is also a re-engraved edition dated 1891.)

173 *Ehon chōsei-den* (Picture Book of Longevity-Hall)
2 vols., 1815. (for later reissue see No. 197.)

174 *Mongaku-shōnin hosshini-ki: hashikuyō* (The Awakening of Mongaku: Mass for the Bridge)
Yomi-hon by Shigeru; 5 vols., 1815. Signature: Katsushika Hokusai (with Raishū)

175 *Hokusai manga* (Random Sketches by Hokusai), Series II
1815. Signature: Katsushika Hokusai

176 *Hokusai manga* (Random Sketches by Hokusai), Series III
1815. Signature: Katsushika Hokusai

● 177 *Santai gafu* (Drawings according to Three Methods)
1815. Signature: Hokusai *aratame* Katsushika Taito

178 *Odori hitori-geiko* (Instruction in Dancing)
1815. Signature: Katsushika Hokusai. Constitutes series III of No. 166 above. (Alternate title: *Gadō hitori-geiko*)

179 *Nihon saijiki kyōka-shū* (*Kyōka* of Japanese Festivals)
Ca. mid 1810s. Signature: Taito

180 *Hokusai manga* (Random Sketches by Hokusai), Series IV
1816. Signature: Hokusai *aratame* Katsushika Taito

181 *Hokusai manga* (Random Sketches by Hokusai), Series V
1816. Signature: Hokusai *aratame* Katsushika Taito

182 *Ehon hayabiki* (A Picture Book for Quick Reference)
Series I, 1817: Series II, 1819. Signature: Katsushika Taito *zen* Hokusai Katsushika Taito (a sequel to *Ryakuga haya-oshie,* No. 166 above.)

183 *Hokusai manga* (Random Sketches by Hokusai), Series VI
1817. Signature: Hokusai *aratame* Katsushika Taito

184 *Hokusai manga* (Random Sketches by Hokusai), Series VII
1817. Signature: Hokusai *aratame* Katsushika Taito

185 *Hokusai gakyō* (Mirror of Designs by Hokusai)
2 vols., 1818. Alternate title: *Denshin gakyō*

186 *Shūga ichiran* (Excellent Pictures in One Glance)
1818. Color edition of preceding *Hokusai gakyō*

187 *Hyōsui kiga* (Strange Pictures of Aquatic Plants)
Haiku anthology; 2 vols., 1818. Landscapes after Ryūkōsai, figures by Hokusai. Signature: Hokusai Taito. (Later reissued separately as *Ehon ryōhitsu* [Picture Book from Two Brushes] and *Hakoya-no-yama* [Mountain of the Immortals], 1 vol. 1821.)

188 *Hokusai manga* (Random Sketches by Hokusai), Series VIII
1818

189 *Sakayagura no matsu* (The Tower Pine)
Yomi-hon by Kiraku; 6 vols., 1819. Signature: *zen* Hokusai Taito (With Hokuun)

190 *Hokusai gashiki* (Designs of Hokusai)
1819. Signature: *zen* Hokusai Katsushika Taito

191 *Hokusai manga* (Random Sketches by Hokusai), Series IX
1819. Signature: Hokusai *aratame* Katsushika Taito

192 *Hokusai manga* (Random Sketches by Hokusai), Series X
1819. Signature: Hokusai *aratame* Katsushika Taito

193 *Hokusai gafu* (A Hokusai Album)
1820. Supplement to the preceding *Hokusai gashiki*, No. 190.

● 194 *Ryōbi saihitsu* (Beautiful Pictures)
2 vols., 1820. Signature: Katsushika Taito

195 *Hokusai sōga* [Designs by Hokusai].

196 *Wago inshitsu-bun eshō* (Divine Providence Illustrated)
1820. Signature: Katsushika Taito

197 *Ehon jōruri zekku* (Picture Book: Chinese Verses on *Jōruri*)
Ca. 1820. Signature: Katsushika Hokusai. Reissue of No. 173.

198 *Kusa-no-hara* (Grassy Plains)
Kyōka anthology, 1821. Illustrations by Hokusai, Hokkei, Hōitsu *et al.*

199 *Tōkai tango* (Searching the East Highway)
Share-hon by Miyoshino, 1821. Signature: *zen* Hokusai Iitsu. Illustrations by Hokusai and Hokushū

200 *Renge-dai* (The Lotus Pedestal)
Kyōka anthology, 1822. Illustrations by Hokusai, Hōitsu *et al.*

201 *Shunju-an yomihatsu-mushiro* (Shunju's New Year Poems)
Ca. 1822. Signature: Getchi-rōjin Iitsu

202 [*Kyōka muma-zukushi* (Comic Poems on Horses)]
Ca. 1822. One design signed Getchi-rōjin Iitsu

203 *Imayō sekkin* [*kushi-kiseru*] *hinagata* (New Designs for Combs and Pipes)
3 vols., 1822–23. Signature: *zen* Hokusai [Katsushika] Iitsu

204 [*Iitsu sensei keikoku gafu* (The Master Iitsu's Landscape Album)]
[publisher's announcement appears at the end of No. 203 above.]

205 [*Fugaku hakkei/fugaku hattai* (Eight Views of Mt. Fuji)]
[publisher's announcement appears at the end of No. 203 above.]

● 206 *Ippitsu gafu* (A Book of Sketches of One Brush Stroke)
1823. Signature: Katsushika Hokusai (according to the preface and wrappers, Hokusai's inspiration was a series of sketches in similar abbreviated manner done by the early Nagoya *nanga* master Fukuzensai [Niwa Kagen—1742-1786]; no such work has yet been traced.)

447

Hokusai: *Courtesans Walking*. Detail from the *Ippitsu gafu, hanshi-bon*, 1823; *sumi* with light colors. Hokusai was master of many styles and in this impressionistic volume he chose to explore the Far Eastern tradition of "outline sketching." Here all manner of figures and nature subjects are reduced to their barest essentials — a single jet-black line.

207 *Kachō-fūgetsu-shū* (Poems on Birds, Flowers, Wind and Moon)
Kyōka anthology, 1824. Signature: Katsushika Iitsu (in collaboration with Hokusen)

208 *Shingata komon-chō* (New Designs for Craftsmen)
1824. Signature: *zen* Hokusai Iitsu

209 [*Kyōka sanjū-rokkassen* (Comic Verses on the Thirty-six Poets)]
Ca. 1824. Signature: *zen* Hokusai

210 [*Yodogawa shiki-no-shōkei* (Celebrated Views of the Yodo River in the Four Seasons)]
1824. Signature: Hokusai-rōjin

211 *Edo ryūkō ryōri-tsū* (The Connoisseur of Fashionable Edo Cookery)
A guide to cookery of the Yao-Zen Restaurant in Edo. 4 Series, 1822–34. Various illustrators, Hokusai's contributions appearing in Series II (1825, signed Hokusai *aratame* Iitsu *hitsu*) and Series IV (Preface 1834, signed *zen* Hokusai Iitsu *hitsu*, aged 75)

212 *Kyōka kuni-zukushi* (Verses on the Provinces)
Ca. 1825. Illustrations by Hokusai and pupils

213 *Suki-gaeshi* (A Random Miscellany)
By Tanehiko, 2 vols., 1826. Illustrations copied by Hokusai from earlier works. Signature: Iitsu

214 [*Aki no hana-tori shū* (Autumn Flower Gathering)]
1826. Poems Illustrated by Hokusai, Hokkei and Gyōkkei

215 *Seiryū hyakkachō* (One Hundred *Kachō* Verses of Orthodoxy)
1826. Illustrated by Hokusai and Hokkei

216 *Bonga hitori-geiko* (Lessons in Drawing Tray Pictures)
1828. Frontispiece signed Iitsu (with Kōitsu)

217 *Shokkō hinagata kintai gasō* (Models for Craftsmen)
1828. Signature: Hokusai

218 *Ehon teikin ōrai* (Illustrated *Home Precepts*)
Series I: 1828; Series II: ca. 1830s; Series III: 1848. Signature: *zen* Hokusai Iitsu

219 *Suikoden yūshi-no-ezukushi* (Portraits

of the Heroes of the *Sui-hu-chuan*)
1829. Signature: Katsushika *zen* Hokusai Iitsu-rōjin [although the *kana* reading remains the same, the title page appears in two forms: with the *kanji* written *Hyaku-hachi seitan shōzō* (Portraits of the 108 Stars) and *Ehon Suikoden*. Cover title: *Chūgi Suikoden ehon.*]

220 *Kyōka shoga-jō* (Pictorial Album of Verses)
Kyōka anthology, ca. 1820s. Signature: Hokusai *aratame* Iitsu

221 *Ehon onna Imagawa* (A Picture Book of Women's Precepts)
Signature: Hokusai (stylistically this work would seem to date from the late 1820s; the only dated edition is marked from 1844.)

222 *Kyōkun kana-bumi shikimoku* (Ethical Laws in Popular Language)
Ca. 1828–31. Signature: *zen* Hokusai Iitsu

223 [*Kyōka ressen gazō-shū* (Portraits of the Immortals in Humorous Verse)]
3 vols., ca. 1829. Signature: *zen* Hokusai Iitsu (With Hokuga)

224 *Hokusai dōchū gafu* (Hokusai's Pictures of a Journey)
1830. Signature: *zen* Hokusai Iitsu-rōjin (revised version of a work by Hokusai's pupil Hokkei, second edition, 1835; also found in a 2-vol. edition)

225 *Onna ichidai eiga-shū* (Lives of Flourishing Women)
Kyōka anthology, 1831. Signature: Iitsu *zen* Hokusai, aged 72 years

226 *Hana-fubuki en no shigarami* (Snow-blown Chains of Fate)
Gōkan-bon by Isobe; 6 vols., 1832. Cover design by Hokusai, illustrations by Kuniyoshi

227 *Sōhitsu gafu* (Sketches in the Cursive Style)
1832. Signature: *zen* Hokusai Manji-ō.

228 *Ehon Tōshisen* (Picture Book: Chinese Poems of T'ang)
Series VI (signed *zen* Hokusai Iitsu), 5 vols., 1833; Series VII (signed Gakyōjin Manji-ō), 5 vols., 1836 [the earlier series were illustrated by Seppō, Fuyō, Enjō, Shigemasa and Suikei]

229 *Shusse yakko-koman-den* (The Story of Koman's Success)
Gōkan-bon by Tanehiko; 4 vols., 1833. Cover by Hokusai, illustrations by Kuninao

230 *Ehon Senji-mon* (The Illustrated *Senji-mon* [Chinese Poem of 1,000 Characters])
1833. Signature: Katsushika *zen* Hokusai Iitsu (frontispiece by Shōdō; second edition, 1835)

231 *Ehon saiyū-zenden* (An Illustrated Record of the Western Trip)
Translation of the Chinese Novel *Hsi-yu-chi* ["*Monkey*"] by Kōmoku and Kyūzan; *yomi-hon*, 20 vols., 1833–35. (the first two parts were illustrated by Tōya and Toyohiro). Signature: Hokusai

232 *Ehon chūkyō* (The Illustrated *Book of Loyalty*)
1834. Signature: *zen* Hokusai Iitsu-rōjin

一筆画譜

233 *Hokusai manga* (Random Sketches by Hokusai), Series XI
Ca. 1834

234 *Hokusai manga* (Random Sketches by Hokusai), Series XII
1834.

富嶽百景 ● 235 *Fugaku hyakkei* (One Hundred Views of Mt. Fuji)
Vol. I, 1834; vol. 2, 1835; vol. 3, ca. 1835. Signature: *zen* Hokusai Iitsu/ Gakyō-rōjin Manji ▷ plate 171

448

Hokusai: *Wild Geese and Mt. Fuji.* Illustration from *Fugaku hyakkei,* Series I, *hanshi-bon,* 1834.
Hokusai went to practically any lengths to create a novel design. This striving for the unusual and bizarre was not always accompanied by resounding artistic success but did assure him a popular following, much publicity in his own day and world fame long after his death. The present design may be counted among Hokusai's more successful attempts at the unusual: the huge reflection of Fuji is placed so perfectly in the composition that we have not the wits to wonder how it could possibly get there. (Title on upper right: *Demmen no Fuji* [Fuji on the Paddy Surface]; turnover title: *Fugaku hyakkei,* Series I, with page number and name of the engraver, E-Sen.)

236 [*Hokusai manga haya-shinan* (Hokusai's Book of Quick Sketching)]
Ca. 1834–35. Signature: *zen* Iitsu-rōjin

237 *Ehon Kōkyō* (The Illustrated *Book of Filial Piety*)
2 vols., 1834. Signature: *zen* Hokusai Manji-rōjin (inner title: *Ehon Kobun Kōkyō*; reissued in 1850 and 1864)

238 *Ehon sakigaki* (The Picture Book of Warriors)
1836. Signature: *zen* Hokusai Iitsu *aratame* Gakyō-rōjin Manji, age 77 (second edition of 1887; for sequel see following item)

239 *Ehon Musashi-abumi* (Picture Book: The Stirrups of Musashi)
1836. Signature: *zen* Hokusai *aratame* Gakyō-rōjin Manji, aged 77 years (second edition of 1887; a sequel to the preceding item)

240 *Ehon Wakan-homare* (A Picture Book in Praise of Chinese and Japanese Heroes)
1836. Signature: Gakyō-rōjin Manji (reissued in 1850) ▷ plate 174

241 *Shoshoku ehon* [*Katsushika*] *shin-hinagata* (Picture Book of New Designs by Katsushika for Craftsmen)
1836. Signature: Gakyō Manji-rōjin

242 *Nikkōsan-shi* (A Description of Nikkō)
5 vols., 1837. One four-page plate in vol. 4 signed Gakyō-rōjin Manji

243 *Kachō gasan-shū* (In Praise of *Kachō* Pictures)
Kyōka anthology, ca. 1830s. Signature: Hokusai

244 *Wakan inshitsu-den* (A History of Divine Providence in Japan and China)
1840. Signature: *zen* Hokusai *aratame* Gakyō-rōjin Manji

245 *Shaka goichidai-zue* (A Pictorial Life of Sakyamuni)
6 vols., 1841. Signature: Hokusai Manji-rōjin (reissued in 1845 and 1884)

246 *Ehon musha-burui* (A Pictorial Classification of Warriors)
1841. Signature: Hokusai *aratame* Katsushika Iitsu

247 *Ippitsu ehon* (A Picture Book with One Brushstroke)
1842 (reduced-size version of the *Ippitsu gafu* of 1823, No. 206 above.)

248 [*Hokusai manga. sōhitsu-no-bu* (Hokusai's Sketches in Cursive Style)]
1843 (a reissue of *Sōhitsu gafu* [No. 227] with colors added.)

249 *Hokusai gaen* (A Garden of Hokusai's Sketches)
3 series, 1843. Signature: *zen* Hokusai Manji-ō (reissued in 1877)

250 *Ehon Kan-So gundan* (The Wars of Han and Ch'u)
Yomi-hon adapted from a Chinese novel, translated by Shunsui after an earlier version by Bakin; 20 vols., 1845. Signature: Katsushika Manji-rōjin Hachiemon

251 *Hokusai manga* (Random Sketches by Hokusai)
1845. Signature: Katsushika Hokusai (a separate work from the famous 15-volume series)

252 *Genji ittō-shi* (The History of the Minamoto Unification)
Yomi-hon, 5 vols., 1846. Signature: Hokusai Iitsu-rōjin Hachiemon

253 *Retsujo hyakunin isshu* (One Hundred Poems by Famous Women)
In collaboration with Kunisada; 1847. Signature: Katsushika Manji-rōjin

254 *Ehon* [*Gahon*] *saishiku-tsū* (An Illustrated Book on the Use of Colors)
2 Series, 1848. Signature: Gakyōjin Manji-rōjin

255 *Shūga hyakunin-isshū* (One Hundred Poems of Elegance)
1848. Hokusai in collaboration with Kuniyoshi, Shigenobu, Eisen, Kunisada

256 *Sokuseki hōchō* (The Ready Cleaver)
A miniature cookbook with colored frontispiece by Hokusai, ca. 1848. Signature: Manji Iitsu, aged 89

257 [*Hokusai gafu* (A Hokusai Album)]
3 vols., 1849. A combined edition of the *Gashiki* [No. 190], *Gafu* [No. 193], and *Soga* [No. 195]

258 *Zoku eiyū hyakunin isshu* (One Hundred Poems of Heroes: A Sequel)
1849. In collaboration with Kuniyoshi, Shigenobu, Kunisada and Sadahide. Signature: *zen* Hokusai Manji-rōjin

259 *Hokusai manga* (Random Sketches by Hokusai), Series XIII
1849

Posthumously Published Works

260 *Giretsu hyakunin isshu* (One Hundred Poems of Celebrated Men and Women)
1850. In collaboration with Kuniyoshi, Yoshitora, Kunisada, Sadahide. Signature: *zen* Hokusai Manji-rōjin

261 *Shōzan chomon-kishū* (Strange Tales by Shōzan)
5 vols., 1850. Two designs signed Manji, aged 88

262 *Hokusai manga* (Random Sketches by Hokusai), Series XIV
Ca. 1850s. (Though undated, the first impression features advertisements, paper and coloring very similar to Series XIII.)

263 *Hokusai manga* (Random Sketches by Hokusai), Series XV
Ca. 1878. (Hokusai's sketches supplemented by the work of the Meiji Nagoya artist, Oda Kyōsai.)

264 [*Hokusai koppō fujin-atsume* (A Collection of Women in Hokusai's Structural Brushwork)]
1897. (From drawings made ca. 1822)

III HOKUSAI'S SHUNGA: PRINTS, ALBUMS, BOOKS
(The order follows that of our monograph "Hokusai's Erotica," in *Hokusai and Hiroshige,* 1977.)

1 *Ehon kuragari-zōshi* (Erotica for Groping in the Darkness)
Preface datable to 1782. Signature: Katsu Shunrō

2 *Mame-batake* (The Bean Field)
Ca. 1792. Signature: Shunrō

3 [*Ehon haru-no-iro* (The Colors of Spring)]
Ca. early 1790s. Signature: Katsukawa Shunrō

4 [*Ehon matsu-no-uchi* (The New Year's Season)]
3 vols., ca. 1794. Signature: Shishoku Gankō

5 [*Ehon iro-no-wakaba* (Young Leaves of Eros)]
Ca. mid 1790s. Signature: Shishoku Gankō

6 *Miniature shunga print series*
Well over a hundred unsigned, *koban*-size, shunga *surimono* printed in color are known, done in the distinctive style of Hokusai's middle period. Many of them are *e-goyomi* [calendar-prints], datable to the years 1805, 1811–14. The formats are both vertical and horizontal. Some of these prints may originally have been issued in sets, enclosed in wrappers. (Several such prints from 1811–12 include a *shikake-e* [hinged] device.)

7 *Untitled* ōban *album*
Shunga album with 12 *ōban*-size color prints, ca. 1811. Unsigned. (Plates from this series are sometimes found combined with incomplete sets of Hokusai's better-known *Ehon tsuhi no hinagata* [No. 8] and were hitherto thought to be alternate plates of the latter work. However, our recent discovery of a complete set of 12 plates would seem to prove that this is an independent series, which may even antedate *Ehon tsuhi no hinagata*.)

つ
ひ
の
雑　**8** *Ehon tsuhi no hinagata* (Illustrated Models
形　of Couples)
Shunga album with 12 *ōban*-size color prints, ca. 1811. Signature: Shishoku Gankō (at least two versions are known, printed from different blocks.)

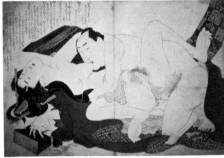

449

Hokusai: *Lovers. Ōban* plate from the album *Ehon tsuhi no hinagata* [Models of Loving Couples], ca. early 1810s

9 *Kinoe-no-komatsu* (Pining for Love)
3 vols., preface datable to 1814. Signature: Shiun-an Gankō ▷ plate 165

10 *Tsuma-gasane* (Overlapping Skirts)
3 vols., ca. late 1810s. Unsigned.

11 *Fukujusō* (The Adonis Plant)/"*Nami-chidori*" (Plovers above the Waves)/ [*Ehon sasemo-ga-tsuyu* (Dew on Love's Grasses)]
Shunga album with 12 *ōban*-size color prints, ca. late 1810s. Unsigned. Several variant editions of this famous work are known:
A. *Fukujusō* employs full color printing; the text is printed above the figures and this may represent the earliest version of the album, but there are also late impressions of this state.
B. "*Nami-chidori*" is the popular title of the set in general; it is derived from the pattern appearing on the covers of this edition. This state, which is from different blocks, features a white mica ground and extensive hand-coloring but omits the text above the figures, as well as many printed details. [In one variation the eleventh plate features a *shikake-e* section.]

C. [*Ehon sasemo-ga-tsuyu* is basically similar to "*Nami-chidori*" but features a pink mica ground.]
D. A later (Kamigata?) version employs coloring by stencil.
E. There is also a Meiji facsimile edition of six plates from "*Nami-chidori*," combined with six other *ōban*-size plates by Eiri *et al.*

12 "*Nami-chidori*" see *Fukujusō* above.

13 *Ehon sasemo-ga-tsuyu.* See *Fukujusō* above.

14 [*Tama-kazura* (The Jeweled Merkin)]
3 vols., ca. 1820. Unsigned.

萬　**15** *Mampuku wagō-jin* (The Gods of Inter-
福　course)
和　3 vols., postface datable to 1821. Unsigned.
合　(There is also a reworked, Meiji reproduction
神　of this set—combining two scenes on one *ōban*-size plate—under the title *Kuni-no-sakae*; the cover bears the notation "By Katsushika Hokusai."

16 [*En-musubi Izumo no sugi* (The Lusty God of Love)]
Shunga album with 12 *chūban-size* color plates, preface datable to 1822. Unsigned. (Meiji reissue under the title *Tsuyu-no-hinuma.*)

IV HOKUSAI'S SKETCHES AND PAINTINGS
Forgeries and school copies abound, and definitive research on Hokusai's sketches and paintings has yet to be commenced. None of the existing publications on the subject can be recommended.
Lane, Richard: "*Ukiyo-e* Paintings Abroad," (*Monumenta Nipponica*, 1968, reprinted in *Studies in Edo Literature and Art.*)

V HOKUSAI: SELECTED BIBLIOGRAPHY
Dickins, F. V. *Fugaku Hiyaku-kei* or *A Hundred Views of Fuji* (*Fusiyama*): *By Hokusai.* London, 1880.
Fenollosa, Ernest F. *Hokusai and His School: Catalogue of Special Exhibition No. 1.* Museum of Fine Arts, Boston, Mass., 1893.
Goncourt, Edmond de. *Hokusai.* Paris, 1896.
Revon, H. *Etude sur Hok'sai.* Paris 1896.
Holmes, C. J. *Hokusai.* London, 1899 and New York, 1901.
Fenollosa, Ernest F. *Catalogue of the Exhibition of Paintings of Hokusai Held at the Japan Fine Art Association, Uyeno Park.* Tōkyō, 1901.
Perzynski, Friedrich. *Hokusai.* Bielefeld and Leipzig, 1904.
Strange, Edward F. *Hokusai: The Old Man Mad with Painting.* London, 1906.
Focillon, Henri. *Hokusai.* Paris, 1914.
Salaman, Malcolm C. *Hokusai.* London, 1930.
● Muneshige, Narazaki. *Hokusai ron.* (in Japanese) Tōkyō, 1944
Winzinger, Franz. *Hokusai.* Munich, 1954.
● Hillier, J. *Hokusai: Paintings, Drawings and Woodcuts.* London, 1955. Reprinted 1978. German edition, *Hokusai: Gemälde, Zeichnungen, Farbholzschnitte.* Cologne, 1956.)
Hloucha, Joe. *Hokusai.* Prague, n.d. (Originally published in German; Prague, 1955.)

Kondō, Ichitarō *Katsushika Hokusai.* (English adaptation: Elise Grilli) Tōkyō, 1955.
Boller, Willi. *Hokusai.* Stuttgart, 1955.
Anon. *Fujiyama der ewige Berg Japans.* n.p., 1956.
Oda, Kazuma. *Hokusai.* (in Japanese). Tōkyō, 1957.
Kikuchi, Sadao. *Hokusai.* (In Japanese). Tōkyō, 1957.
Dickins, F. V. *One Hundred Views of Fuji.* (Introduction by Jack Hillier; descriptions of the plates by F. V. Dickens.) First published London, 1880; new edition New York, 1958.
● Michener, James A. *The Hokusai Sketchbooks: Selections from the Manga.* (With translations by Richard Lane.) Tōkyō, 1958.
Swann. Peter C. *Hokusai.* London 1959.
Terry, Charles S. *Hokusai's Thirty-six Views of Mt. Fuji.* Tōkyō, 1959.
Muneshige, Narazaki. "Ukiyo-e: Hokusai/Hiroshige." (in Japanese). In *Nihon hanga bijutsu zenshū,* vol. V, (Tōkyō, 1960).
Connor, R. *Hokusai.* Hanover, 1962.
Suzuki Jūzō. *Katsushika Hokusai.* (In Japanese) Tōkyō, 1963.
Bowie, Theodore. *The Drawings of Hokusai.* Bloomington, Ind., 1964. [For corrections see our "Ukiyo-e Paintings Abroad." in *Monumenta Nipponica.* 1968, reprinted *Studies in Edo Literature and Art;* subsequent study has indicated that a majority of Dr. Bowie's illustrations are school copies.]
● Muneshige, Narazaki. *Hokusai to Hiroshige.* 8 vols. Tōkyō, 1964–65 (In Japanese; English version, *Masterworks of Ukiyo-e,* 8 vols. Tōkyō, 1967–69.)
Hillier, J. *Japanese Drawings from the 17th Century to the End of the 19th Century.* London, 1966. [For corrections see our "Ukiyo-e Paintings Abroad," in *Monumenta Nipponica* 1968, reprinted *Studies in Edo Literature and Art;* subsequent study has indicated that many of Mr. Hillier's illustrations are school copies.]
———. *Hokusai Drawings.* London, 1966.
Yasuda, G. *Gakyō Hokusai.* (In Japanese). Tōkyō, 1971.
● Muneshige, Narazaki. *Zaigai hihō/Ōbei shuzō ukiyo-e shūsei.* vol. 4: *Katsushika Hokusai.* Tōkyō, 1972 (in Japanese).
● Oka, Izaburō "Hokusai." (in Japanese) in *Ukiyo-e Taikei,* vol. 8, Tōkyō, 1974.
● Forrer, Matthi. *Hokusai—A Guide to the Serial Graphics.* Philadelphia, Penn. and London, 1974.
● Kobayashi, Tadashi. "Fugaku Sanjū-Rokkei." (in Japanese) in *Ukiyo-e Taikei,* vol. 13, Tōkyō, 1975.
Oka, Izaburō, ed. *Hokusai.* (in Japanese) Tōkyō, 1975.
Voronova B. G. *Hokusai, Katsushika.* (in Russian) 2 vols., Moscow, 1975.
Schneeberger, P. F. *Hokusai et le japonisme avant 1900.* Geneva, 1976.
Lane, Richard. *Hokusai and Hiroshige.* (in English and Japanese) Tōkyō, 1976.
———. *Hokusai and Hiroshige.* Tōkyō, Baltimore and Cologne, 1977; reissue of the 1976 work with addition of the pamphlet "Hokusai's Erotica" and original print specimens.
▷ pp. 159–72, 184, plates 161–174

北　**Hokusei** (fl. ca. 1820s): ukiyo-e print artist,
晴　Ōsaka School, pupil of Shunkōsai
　　　*Shungyōsai

北　**Hokusetsu** (fl. ca. 1830s): ukiyo-e print artist,
雪　Ōsaka School
　　　*Shun-yūsai

北　**Hokushin** (fl. ca. 1830s): ukiyo-e print artist,
信　Ōsaka School, pupil of Hokuei
　　　*Shunkantei, Shunkōsai

北　**Hokushō** (fl. ca. 1820s): ukiyo-e print artist,
升　Ōsaka School
　　　*Shunchō, Shunchōsai

北　**Hokushū** (fl. ca. 1820s–30s): Ōsaka ukiyo-e
洲　print artist, pupil of Hokusai; also studied under Shōkōsai Hambei

*Sekkatei, Shōkōsai (ca. 1811), Shunkō (until 1818), Hokushū (from 1818), Shunkōsai

450

Hokushū: *Utaemon as O-Sono. Ōban,* 1825

北水 **Hokusui** (fl. ca. 1860): ukiyo-e print artist, Ōsaka School

北岱 **Hokutai** (fl. late 18th–early 19th century): ukiyo-e print artist and illustrator; an early pupil of Hokusai
*Katsushika, Eisai, Raito, Shinshinshi

Hokuto (fl. ca. mid 1830s): ukiyo-e print artist, Ōsaka School
*Shōkōsai, Shunkōsai

北雲 **Hokuun** (fl. early 19th century): Nagoya ukiyo-e painter and print artist, pupil of Hokusai
*Katsushika (Ōkubo), Gorō, Bungorō, Kyūgorō, Tōnansei

Hokuun (fl. ca. late 1820s): ukiyo-e print artist, Ōsaka School; pupil of Shunkōsai
*Shun-yūsai

Hokuyo (fl. ca. 1820s): ukiyo-e print artist, Ōsaka School
*Katsushika, Tanseidō, Senkakutei, Senkakudō

北山 **Hokuzan** (fl. ca. 1810s): ukiyo-e print artist, Kyōto School
*Kanō Hokuzan

Hōmotsu-shū: a collection of Buddhist stories, early 13th century

Hōnen (1133–1212): poet and priest, founder of the Jōdo Sect of Buddhism

Honganji: the principal branch of the Buddhist Jōdo Shinshū [sect]

hōnō: a votive offering

honya nakama (*jihon-don-ya no nakama, shorin nakama*): publishers' and booksellers' guilds

hōō: the fabulous phoenix

Hōrai-zan: the Island of the Immortals

宝暦 **Hōreki** (1751–1764): the Hōreki Period dates from X/27/1751 to VI/2/1764 and is a key pivotal point of Edo culture. The influence of the older, Kamigata (Kyōto-Ōsaka) culture had long predominated among the upper classes of Edo, but now this influence spread to even the lowest classes, encouraged as much by the increasing influence of Kamigata financial institutions and resources as by the gradual weakening of the sumptuary Kyōhō Reforms. The romantic, Kamigata style of Kabuki came to prevail over the rougher forms of Edo Kabuki; the *share-hon* (witty depictions of life in the Kamigata pleasure quarters) were adapted to Edo locales, and prosperity created a new class of merchant playboys and bons vivants to patronize the Yoshiwara and all kinds of cultural and profligate activities (including the geisha who

were introduced into the Yoshiwara in 1751). Although shunga had still not revived strongly, its sublimation, the semi-erotic *abuna-e*, became a prominent feature of figure prints. This was a period of fads many of which appear in the prints: exhibitions and fairs, flower-viewing parties, outings in the sixty-odd roofed boats on the Sumida River, the Dutch *biidoro* (glass whistle) and a variety of popular songs. In ukiyo-e, such older masters as Masanobu, Kiyonobu II, Kiyomasu II, Shigenaga and Toyonobu were completing their final work, while younger men like Kiyomitsu, Kiyohiro, Kiyotsune and Settei were in their prime. The masters of the coming age were still in their apprenticeship: Harunobu, Bunchō, Shunshō, Shigemasa. Their work was still in the *benizuri-e* form, but featured that increasing complexity of color technique that presaged the development of *nishiki-e* only a year after the end of the era. ▷ *nengō*

hori-shi (*hori-kō*): an engraver or carver

芳柳 **Hōryū** (1827–92): western-style painter, lived in Yokohama and Tōkyō; studied Kanō-School painting under Tangetsu, then ukiyo-e under Kuniyoshi; became acquainted with western-style painting in Nagasaki, subsequently taking lessons in oil painting from Charles Wirgman in Yokohama; specialized in portraits of photographic realism
*Goseda (Asada), Iwakichi, Denjirō, Hanshichi, Jūjirō, Kinjirō, Yaheiji

Hōryū II (1864–1943): western-style painter, adopted son of Hōryū; studied oil painting under Charles Wirgman

hōsho: a handmade paper used for deluxe color prints

細判 **hosoban** (*hoso-e*): small print format, about 13×5⅝ in./33×14.5 cm; the smallest general size of print

Hōshū (1840–90): Nagoya *bunjin-ga* artist
*Shibata

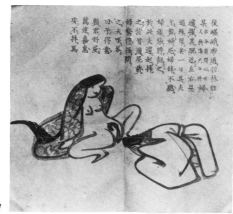

451

Hōshū: Shunga plate, illustration to *Daitō keigo* (Boudoir Tales from the East). Woodblock-printed album, Nagoya, 1867; narrow *chūbon*. The original designs to this album are attributed to Taigadō; this scene: a courtier's wife was beloved of the Emperor Go-Saga, who, as a result, bestowed great honors upon her husband; here, the cuckolded husband is seen paying homage to the source of his worldly success

Hosshin-shū: a collection of stories of conversion to Buddhism, ca. 1215

芳水 **Hōsui** (fl. ca. 1850s): ukiyo-e print artist, Kyōto School
*Miyagawa Hōsui

Hotei: one of the Seven Gods of Luck, usually depicted carrying on his shoulder a cane and large cloth bag, often accompanied by children

hotoke: Buddha

Hotoke-no-hara: a Noh drama featuring the fateful heroine Hotoke-gozen

hototogisu: the cuckoo (harbinger of spring)

hōzuki: a Chinese lantern

Hozumi-no-Miko (d. 715): *waka* poet and statesman of the Asuka Period

百亀小松軒 **Hyakki** (d. 1794): ukiyo-e print artist, studied under Sukenobu, but style closer to that of Harunobu
*Komatsu-ya, Komatsu-ken [Shōshōken], Fuchisoku-sanjin

Hyakki (fl. ca. 1810s): ukiyo-e print artist, Ōsaka School

Hyakunen (1825–91): Shijō-School painter in Kyōto, did some genre work
*Suzuki, Seiji, Shikō, Zusho, Daishin-ō, Gasendō, Tekiseikakū-shujin, Tokinrō

百人一首 **Hyakunin isshu** [A Hundred Poems by a Hundred Poets]: a verse anthology, of which the most famous selection is *Ogura Hyakunin isshu;* compiled in 1235 by Fujiwara no Teika. The hundred poets, often depicted in ukiyo-e, are 1 Tenji-*tennō* (38th sovereign of Japan) 2 Jitō-*tennō* (Empress, 41st sovereign) 3 Kakinomoto no Hitomaro 4 Yamabe no Akahito 5 Sarumaru-dayū 6 *Chūnagon* (Ōtomo no) Yakamochi 7 Abe no Nakamaro 8 Kisen-*hōshi* (priest) 9 Ono no Komachi (poetess) 10 Semimaru (courtier) 11 Sangi (Ono no) Takamura 12 *Sōjō* Henjō (Yoshimine Munesada, bishop) 13 Yōzei-in (57th sovereign) 14 Kawara-no-*sadaijin* (Minamoto no Tōru) 15 Kōkō-*tennō* (58th sovereign) 16 *Chūnagon* Ariwara no Yukihira 17 Ariwara no Narihira *ason* 18 Fujiwara no Toshiyuki *ason* 19 Ise (poetess) 20 Motoyoshi-*shinnō* (prince) 21 Sosei-*hōshi* (priest, Yoshimine Harutoshi) 22 Bunya [Fumiya] no Yasuhide 23 Ōe no Chisato 24 Kanke (Sugawara no Michizane) 25 Sanjō-*udaijin* (Sadakata) 26 Teishin-*kō* (Tadahira) 27 *Chūnagon* Kanesuke 28 Minamoto no Muneyuki *ason* 29 Ōshikōchi no Mitsune 30 Mibu no Tadamine 31 Sakanoue no Korenori 32 Harumichi no Tsuraki 33 Ki no Tomonoti 34 Fujiwara no Okikaze 35 Ki no Tsurayuki 36 Kiyowara no Fukayabu 37 Fumiya [Bunya] no Asayasu 38 *Ukon* 39 *Sangi* Hitoshi 40 Taira no Kanemori 41 Mibu no Tadami 42 Kiyowara no Motosuke 43 *Chūnagon* Atsutada 44 *Chūnagon* Asatada 45 Kentoku-*kō* 46 Sone no Yoshitada 47 Ekyō-*hōshi* 48 Minamoto no Shigeyuki 49 Ōnakatomi no Yoshinobu *ason* 50 Fujiwara no Yoshitaka 51 Fujiwara no Sanekata *ason* 52 Fujiwara no Michinobu *ason* 53 *Udaishō* Michitsuna *no haha* (mother of Michitsuna) 54 *Gidō-sanshi no haha* (Takako, mother of Korechika) 55 *Dainagon* Kintō 56 Izumi-*shikibu* (daughter of Masamune) 57 Murasaki-*shikibu* (daughter of Tametoki) 58 *Daini-sammi* (KataKo, daughter of Nobutaka) 59 Akazome-emon (daughter of Kanemori) 60 Koshikibu-no-*naishi* (daughter of Michisada) 61 Ise-no-*tayū* (daughter of Sukechiba) 62 Sei-*shōnagon* (daughter of Motosube) 63 *Sakyō-no-tayū* Michimasa 64 *Gon-chūnagon* Sadayori 65 Sagami (wife of Kinsuke) 66 *Dai-sōjō* Gyōson (archbishop) 67 Suō-no-*naishi* (daughter of Tsuginaka) 68 Sanjō-in (67th sovereign) 69 Nōin-*hōshi* (Tachibana no Nagayasu) 70 Kyōzen-*hōshi* (priest) 71 *Dainagon* Tsunenobu 72 *Yūshi-naishinnō-ke* Kii (poetess) 73 *Gon-chūnagon* Masafusa

74 Minamoto no Toshiyiri 75 Fujiwara no Mototoshi 76 Hōshōji-*nyūdō Saki-no-kampaku Dajōdaijin* (Tadamichi) 77 Sūtoku-in (75th sovereign) 78 Minamoto no Kanemasa 79 *Sakyō-no-tayū* Akisuke 80 Taikemmon-in Horikawa (daughter of Akinaka) 81 Go-Tokudaiji *sadaijin* 82 Dōin-*hōshi* (Atsuyori, priest) 83 Kōtai-kōgū-no-*tayū* Toshinari 84 Fujiwara no Kiyosuke *ason* 85 Shun-e-*hōshi* (priest) 86 Saigyō-*hōshi* (Satō Norikiyo, priest) 87 Jakuren-*hōshi* (Sadanaga, priest) 88 Kōkamon-in no gettō 89 Shikishi-*naishin-nō* (princess) 90 Impumon-innoōsuke 91 Go-Kyōgoku-*sesshō saki-no-dajōdaijin* 92 Nijō-in Sanuki (poetess) 93 Kamakura-*udaijin* (Sanetomo, 3rd shōgun) 94 *Sangi* Masatsune 95 *Saki-no-daisōjo* (Jichin, archbishop) 96 *Nyūdō Saki-no-dajōdaijin* (Saionji Kintsune) 97 Gonchūnagon Sadaie 98 *Junii* Ietaka 99 Go-Toba-no-in (82nd sovereign) 100 Jun-toku-in (84th sovereign) ▷ *Uta-garuta*

hyōbanki: critique or compilation of critical comments on courtesans or Kabuki actors

Hyōgo: a port now part of Kōbe

hyōshi (**-byōshi**): book covers

hyōshigi: wooden clappers used in Kabuki for dramatic emphasis

hyotan-ashi [gourd-shaped legs] and *mimizu-gaki* [earth-worm lines]: graphic devices used by the Torii-School artists to convey a dynamic effect in depicting Kabuki actors

I

Ibaraki ▷ Rashōmon

Ibuki-yama: a mountain in Ōmi, the scene of several legendary tales

Ichiga (1798–1855): Kano-style painter, did some genre prints
*Oki, Tansan, Tansansai, Seisai, Tei, Shigyō, Shikei, Teizō, Ensen

Ichikawa: a famous family of Kabuki actors ▷ actors' crests, *Jūhachi-ban*

ichimai-e: a single-sheet print usually issued independently

Ichimaru (fl. 1820s): ukiyo-e print artist, Ōsaka School
*Jipposha

ichimonji: in printing, a narrow horizontal band of color; in *kakemono* mountings, the narrow strips of cloth set above and below the painting

Ichimura-za: one of the main Kabuki theatres in Edo

Ichi-no-miya: the principal Shintō shrine of a province

Ichi-no-tani: valley in Settsu (near Hyōgo) where Yoshitsune defeated the Heike forces in 1184 and where the famous combat between Naozane and Atsumori took place

Ichi-no-tani futaba-gunki: a Kabuki play, written in 1751 for the puppet theater, later adopted by Kabuki; the role of Kumagae in it is one of the great roles of Kabuki

ichiri-zuka: highway mile-stones

Ichiyō, Higuchi (1872–96): noted Meiji novelist and poetess

Ida-ten: a tutelary god of Buddhism, symbol of speed

Ieharu, Tokugawa (1737–86): 10th shōgun ruled from 1760–86

Iemitsu Tokugawa (1603–51): 3rd shōgun, ruled from 1622–51; he closed the country to contacts with abroad, suppressed the Shimbara insurrection (1638), established the *sankin-kōdai* system and protected Buddhism and Confucianism

Iemochi, Tokugawa (1846–66): 14th shōgun, ruled from 1858–66; went to Kyōto in the beginning of 1863 for political consultations with the Emperor

Ienari, Tokugawa (1773–1841): 11th shōgun; during his rule the foreign powers—Russia, England, America—renewed their efforts to enter into relations with Japan but met with refusal.

Ienobu, Tokugawa (1662–1712): 6th shōgun, ruled from 1709–12; corrected the excesses of his predecessor Tsunayoshi

Iesada, Tokugawa (1824–58): 13th shōgun, ruled from 1853–58, at a time when foreigners and their petitions to enter into relations with Japan placed the government in a difficult situation.

Ieshige, Tokugawa (1712–61): 9th shōgun, ruled from 1745–60

Ietaka, Fujiwara no (1158–1237): *waka* poet of the early Kamakura Period and rival of Teika

Ietsugu, Tokugawa (1709–16): 7th shōgun, ruled from 1713–16

Ietsuna, Tokugawa (1639–80): 4th shōgun, ruled from 1651–80

Ieyasu, Tokugawa (1542–1616): warlord and initial Tokugawa shōgun, ruled from 1603–05; he was the first unifier of Japan, taking over the task started by Hideyoshi; an administrative genius, patron of learning and of the arts

Ieyoshi, Tokugawa (1792–1853): 12th shōgun, ruled from 1837–53, during which time French, English and Russian ships frequently appeared in Japanese waters and, in July 1853, the American fleet under Commodore Perry arrived at Kurihama

Ihachi (fl. ca. 1824): ukiyo-e print artist, Ōsaka School
*Naraya Ihachi

Iitsu II (fl. ca. 1850s–60s): Nagoya ukiyo-e print artist, pupil of Hokusai
*Kondō, Getchi-rōjin, Meimeikyo, Kozen

ikebana: the art of flower arrangement

Ikenushi, Ōtomo no (mid 8th century): *waka* poet of the Nara Period

Ikkaku-sennin: a Noh drama about the "Horned Hermit"

Ikkei (1749–1844): Hanabusa-School painter, pupil of Sūkoku, later of Issen
*Hanabusa, Nobushige, Sūkei, Yūshōan

Ikkei (1795–1859): neo-*Yamato-e* painter, also did some genre work
*Ukita (Toyotomi), Kiminobu, Yoshitame, Shishi, Kuranosuke, Shume, Sekinan, Shōja, Tameushi [Igyū]

Ikkei (fl. ca. 1870): ukiyo-e print artist, pupil of Hiroshige III
*Isshōsai, Shōsai

Ikku, Jippensha (1765–1831): noted fiction writer of the late Edo period and occasional ukiyo-e print artist. When young, Ikku traveled to Ōsaka to work as a Kabuki writer; in 1794 he returned to Edo to establish himself as an author. He is best known for his picaresque novel *Hizakurige,* which relates the comic adventures of two travelers on the Tōkaidō.
*Jippensha, Shigeta, Teiichi, Suisai

Ikkyū (1394–1481): Zen priest and poet known for his unconventional behavior; abbot of the Daitokuji, Kyōto

Ikoma-yama: a small mountain range between Yamato and Kawachi, a favorite theme for poets

Ima kagami: a historical tale, 1170

Ima monogatari: an anthology of brief stories compiled ca. 1240

Imoseyama Onna-teikin: a play originally written for the puppet theater in 1771

impression: a single printing, all the copies printed in one continuous operation (usually about 200 per printing). In Japanese prints the earlier impressions are normally the finest, having been made under careful supervision of both publisher and artist and before the blocks became worn by over-use. ▷ *ippai*

Inari: popular god of rice and crops, whose festival is in the Second Month; often symbolized as a fox

Ingyō (fl. late 18th–early 19th century): Ōsaka ukiyo-e print artist, pupil of Ryūkōsai
*Nagasawa Ingyō

inkoku: the technique of engraving in reserve

inrō: small lacquered box used to hold medicines

inu-ou mono: a Samurai sport: dogs being pursued on horseback

ippai: print edition; the number of print impressions printed in one batch (usually 200)

Ippō (1798–1871): Ōsaka Shijō-School painter, also did some genre work
*Mori, Keishi, Shikō, Bumpei

Ippō II (1691–1760): Hanabusa-School painter, pupil of Itchō, from whom he took his name
*Hanabusa, Isshō, Shunsōsai

Ippō III (d. 1788): Hanabusa-School painter, son of Ippō II, pupil of Sūkoku
*Hanabusa, Ichien, Sūrin

Iratsume, Ishikawa no (7th century): *waka* poetess of the *Man-yō-shū*

Iratsume (Ōtomo), **Kasa no** (8th century): *waka* poetess of the mid Nara Period

Iratsume, Kono (mid 8th century): *waka* poetess of the mid Nara Period

Iratsume, Sakanoue no (mid 8th century): *waka* poetess of the mid Nara Period

iro: color; also passion, sex

iroha-uta: a poem composed of the 48 syllables of the Japanese language

iro-ita: the color block(s) used in polychrome printing

iro-naoshi: the second stage in a wedding ceremony

Isaburō (fl. ca. 1822–36): *dōban* print artist; a Kyōto doctor who learned copperplate engraving from Dutch publications
*Nakao, Gen, Tan, Ōtotsudō, Chūgai, Shirantei

Isai (1821–80): ukiyo-e painter and print artist; studied under Hokusai (who lived in his house for some time)
*Katsushika (Shimizu), Sōji, Suirōrō

Ise (early 10th century): *waka* poetess of the early Heian Period

Ise monogatari [Tales of Ise]: the first Japanese love novel, a collection of stories and poems centered on the amorous adventures of the courtier Ariwara no Narihira (825–80) a frequent source of ukiyo-e themes

Ise-ondo: a dance performed by geisha at Ise.

Ise-ondo; koi no netaba: a Kabuki play, first staged in Ōsaka in 1796, featuring the tragic hero Mitsugi and his malevolent "Bloodthirsty Sword"; based on an actual mass murder in Ise

Ishibashi-yama: a mountain in Sagami, where the young Yoritomo was defeated in 1184

ishidōrō: a stone lantern

Ishiyama-dera: a celebrated Buddist temple of the Shingon sect in Ōmi, where Lady Murasaki is said to have composed the *Tale of Genji*

石刷絵 **ishizuri-e** [stone-printed pictures] : *sumizuri-e* made in imitation of Chinese stone-rubbings in intaglio with design in white on black ground

452

Anonymous: *Falcon on Rock. Kakemono-e ishizuri-e* with hand-coloring (such prints have traditionally been ascribed to Koryūsai)

Issa, Kobayashi (1763–1827) : noted *haiku* poet of the late Edo Period

isse ichidai : the retirement performance [of an actor]

Issen (1698–1778) : Hanabusa-School painter, pupil of Isshū
*Hanabusa, Sōtaku, Sōhō, Shōkaan

Isshi (fl. early 19th century) : ukiyo-e painter, follower of Eishi
*Rekisentei, Shōseikō, Shōseki-koji

Isshō (fl. ca. 1740s–50s) : ukiyo-e painter, pupil of Chōshun; exiled to the island of Niijima for a time for his part in Chōshun's dispute (1751) over payment for restoration work at Nikkō
*Miyagawa, Kiheiji, Kohensai

Isshō (d. 1858) : Hanabusa-School painter, son of Sūkoku; adopted by Ikkei
*Hanabusa, Nobutoshi, Kashu

Isshū (fl. ca. 1720s–80s) : Hanabusa-School painter, son of Itchō
*Hanabusa, Nobusuke, Gennai, Hyakushō, Kosoō, Koun

Isshū (1698–1768) : Hanabusa-School painter, pupil of Itchō, adopted by Isshū
*Hanabusa, Nobutane, Hikosaburō, Yasaburō, Chōsoō, Tōsoō

Issuisai (fl. ca. 1820s–30s) : ukiyo-e print artist, Kyōto School

Issun-bōshi : a tale of adventures akin to *Tom Thumb*, probably 15th century

Isuzu-gawa : sacred river at the Ise Shrines

itame-mokuhan : printing with the woodgrain visible

一蝶 **Itchō** (1652–1724) : founder of the Hanabusa-School of painting. Born in Ōsaka, Itchō studied under Kanō Yasunobu but was expelled from the studio as a rebel against the Kanō tradition. In 1698, he was exiled to Miyakejima for a pictorial parody of the shōgun's concubine; pardoned in 1709 he returned to Edo. Itchō was the creator of an original style, halfway between Kanō and ukiyo-e.
*Hanabusa (Taga), Shinkō, Chōko, Kunju, Isaburō, Jiemon, Sukenoshin, Gyōun, Hokusoō, Hōshō, Ikkan-sanjin, Ippō-kanjin, Kansetsu, Kyōundō, Kyūsōdō, Rinshōan, Rintōan, Rokusō, Sasuiō, Sesshō, Shurinsai, Suisaiō, Undō, Ushimaro, Waō

Publication of non-ukiyo-e albums was not yet widespread during Itchō's lifetime, and his sketches were thus published only posthumously:
Ehon zuhen (3 vols., 1751; after copies by Ippō)
Hanabusa-shi [Ei-shi] gahen (3 vols., 1754; copies by Ippō)
Ryōtorin (1 vol., 1758; copies by Ippō)
Eihitsu hyakuga (6 vols., 1758; copies by Ippō and Rinshō)
Eiga zukō (3 vols., ca. 1770; copies by Rinshō)
Itchō gafu (3 vols., 1770; copies by Rinshō)
Eirin gakyō (3 vols., 1773; copies by Ippō)
Gunchō gaei (3 vols., 1778; copies by Rinshō)
Lane, Richard. *Studies in Ukiyo-e.*
▷ p. 92

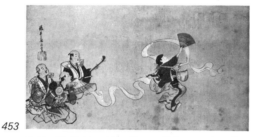

453

Itchō: *Cloth-bleaching Dance. Kakemono* in colors on paper, ca. 1600s

Itchō II (1677–1737) : Hanabusa-School painter, son and pupil of Itchō
*Hanabusa (Taga), Nobukatsu, Chōhachi, Mohachi

Itsuku-shima : a shrine-island in the province of Aki, one of the most beautiful landscapes of Japan; also called Miya-jima

Iwakuni : a town in Suō with the famous Kintai Bridge [plate 196]

Iwaya no sōshi : a tale of a stepchild, probably 15th century

Izanagi and Izanami : Shintō gods in mythology, the divine couple who are credited with having created the Japan Islands

Izayoi nikki : literary diary by the nun Abutsu-ni, mid 13th century

Izumi-shikibu : a poetic tale, probably 15th century

Izumi-shikibu (b. ca. 976) : a celebrated *waka* poetess of the middle Heian Period; mother of Ko-Shikibu

Izumo : site of the Great Shrine of Izumo, whose god is patron of marriage

Izumo, Takeda (1691–1756) : puppet-drama playwright of the mid Edo Period; his works include the famous *Kana-dehon Chūshingura* of 1748

Izu no shichi-tō [The Seven Islands of Izu] : Ō-shima, Toshima, Nii-jima, Shikine-jima, Kōzu-shima, Miyake-jima, Mikura-jima; often these were sites for banishment for political offenders

J

Jakuchū (1716–1800) : Kyōto painter in Chinese style; also did some genre work and *ishizuri* prints

*Itō, Shukyū, Jokin, Keiwa, Tobeian, Tobei-ō
Lane, Richard. *Studies in Ukiyo-e.*

Jakuren (ca. 1139–1202) : *waka* poet of the early Kamakura Period

janken : a choosing game, played with fingers

Japan, map of ▷ Provinces of old Japan

-ji : suffix meaning "Buddhist temple"

耳鳥斎 **Jichōsai** (fl. ca. 1781–1803) : Ōsaka painter and illustrator, known for his *kyōga* caricatures
*Jichōsai [Nichōsai], Matsu-ya Heizaburō
Lane, Richard. *Studies in Ukiyo-e.*

jidai-mono : the historical category of Kabuki and *jōruri* drama

Jien (1155–1225) : *waka* poet and writer of the early Kamakura Period

jihon-don-ya : book publisher and wholesaler

jikkan : the 10 Cyclical Stems or 10 calendar signs ▷ calendar, Japanese

Jikkinshō : a collection of moral tales from China and Japan, 1252

Jimmu (ca. 3rd century A.D.) : legendary poet and 1st emperor of Japan

Jinen-koji : a Noh drama concerning the lay-priest Jinen

-jinja : a suffix meaning "Shintō shrine"

Jinsai, Itō (1627–1705) : Confucian scholar of the early to middle Edo Period

Jiraiya : Ogata Shume, a famous robber chief, often shown in prints with his magic toad spirit

jitō : the administrators of domains

Jitō (d. 702) : *waka* poetess and 41st sovereign of Japan

jitsu-aku : roles of monstrous villains in Kabuki

jitte : a short iron club carried by *bakufu* policemen

Jizō : the Buddhist deity, patron of children

Jō and Uba : the spirits of the dual pine trees at Takasago; usually depicted as an old couple: Jō with a rake, Uba with besom and fan

Jōban (d. 1356) : Buddhist priest and *waka* poet of the Northern and Southern Court Period

jōboku : term meaning published, used in colophons, etc.

Jōdo : the Buddhist Pure Land Sect

Jōdo-kyō-ban : books printed by the temples of the Jōdo sect of Buddhism

Jōei shikimoku : a code of the samurai

Jōhaku (fl. ca. 1691–93) : Kyōto textbook illustrator of the early Genroku Period, working in the style of Hambei
*Naemura, Sōdenshi, Sankei

jōhan : term meaning published, used in book colophons

jōhiki-maku : cloth curtain employed in Kabuki theaters

Joka : the mythical Chinese Empress Nü Kua

如慶 **Jokei** (1599–1670) : founder and painter of the Sumiyoshi School, son of Tosa Mitsuyoshi and younger brother of Mitsunori; connected with the Tosa School in Kyōto but later established his own branch in Edo; specialized in genre scenes
*Sumiyoshi (Tosa), Hiromichi, Tadatoshi, Naiki, Nagashige-maru

貞享 **Jōkyō** (1684–88) : the Jōkyō [Teikyō] Period (II/21/1684 to IX/30/1688) is brief but marks the magnificent end of the first phase of Japan's plebeian renaissance. In literature, Saikaku and Bashō produced the major works of their middle period, and in ukiyo-e, Moronobu, Sugimura and Hambei completed their impressive series of illustrated books and albums which portray so vividly the life of the times. ▷ *nengō*

Jomei (593–641) : *waka* poet and 34th sovereign of Japan

jōmon : the usual identifying crest most commonly used by Kabuki actors ▷ actors' crests

承応 **Jō-ō** (1652–55): the Jō-ō Period, dating from IX/18/1652 to IV/13/1655, saw the banning of "Young Men's Kabuki," with increasing emphasis being placed on art and skill in Kabuki rather than on sex appeal. The mixed genre-ukiyo-e style of painting reached an early peak of popularity in the work of Hanada Takumi and appears more and more in the book illustration of the period. ▷*nengō*

Jōō (1502–55): *waka* poet and tea-ceremony master of the late Muromachi Period

如蓮 **Joren** (fl. ca. 1820s): ukiyo-e print artist, pupil of Hokusai
*Hokutei

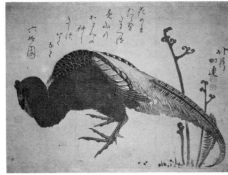

454 Joren: *Pheasant. Ōban surimono*, ca. 1820s (cf. similar scene in Hokusai's album *Shashin gafu*, 1813)

女郎 **jorō**: a harlot

浄瑠璃 **jōruri**: epic or narrative drama of the 17th and 18th centuries, chanted to the accompaniment of the samisen; originally written for the puppet drama, but also borrowed by Kabuki for both plots and dialogue ▷Chikamatsu, Gidayū, Bunraku

Hironaga, Shūzaburō. *The Bunraku Handbook*. Tōkyō, 1976.

jōruri-bon: *jōruri* texts, often accompanied with illustrations by masters of the ukiyo-e Primitives

上竜 **Jōryū** (fl. ca. 1830s–40s): leading ukiyo-e painter from Kyōto, first studied Shijō-style painting under Toyohiko
*Mihata, Jōryū [Jōryō]
Lane, Richard. *Studies in Ukiyo-e.*

乗良 **Joryū** (fl. ca. 1840s): ukiyo-e painter in Kyōto, pupil of Jōryū

jōshi: term meaning published, used in book colophons

Jōsō, Naitō (1662–1704): *haiku* poet of the early to mid Edo Period

juban: an underskirt

十八番 **Jūhachi-ban** [The Eighteen Plays]: a repertory of the most popular short plays performed by the Ichikawa family from the days of Danjūrō I: *Kanjin-chō, Shibaraku, Sukeroku, Gedatsu, Ya-no-ne, Kagekiyo, Narukami, Kamahigc, Kenuki, Fudō, Fuwa, Kan-u, Nanatsu-men, Zōbiki, Oshi-modoshi, Uwanari, Uiro-uri, Jayanagi* ▷Ichikawa

Juni-dan zōshi: the first of the dramatic recitations known as *jōruri*, developed during the Middle Ages

Jūni-shi: the 12 Zodiacal Branches ▷calendar, Japanese

jūni-ten: the Twelve Guardian Deities

Juntoku-in (1197–1242): *waka* poet and 84th sovereign of Japan

Jurō: one of the Seven Gods of Luck, god of longevity; traditionally represented as an old man with beard, cap and cane, accompanied by an aged black deer

jūroku-Musashi: game played with 16 round paper pawns on a divided board

Juseki (1851–?): *dōban* artist, pupil of Mori Kinseki (possibly identical with Iwata Taizō)

K

歌舞伎 **Kabuki**: the popular theater of Japan

Bowers, F. *Japanese Theatre*. New York, 1952.
Ernst, E. *The Kabuki Theatre*. New York, 1956.
Gunji, M. and C. Yoshida. *Kabuki*. Tōkyō, 1969.
Inouye, J. *Chushingura, or the Treasury of Loyal Retainers*. Tōkyō, 1910.
Kawatake, S. *Nihon koten zensho: kabuki Jūhachiban shū* (in Japanese). Tōkyō, 1954.
Kawatake, S., K. Takeshiba and S. Atsumi. *Nihon gikyoku zenshū*. Vols. 1–32. Tōkyō, 1930–32.
Keene, D. *The Battles of Coxinga*. London, 1951.
Keene, D. and H. Kaneko. *Bunraku, The Art of the Japanese Puppet Theatre*. Tōkyō, 1965.
Kincaid, Z. *Kabuki: The Popular Stage of Japan*. London, 1925.
Maybon, A. *Le théâtre japonais*. Paris, 1925.
Miyake, S. *Kabuki Drama*. Tōkyō, 1953.
Miyamori, A. *Tales of Old Japanese Dramas*. London, 1915.
Miyamori, A. *Masterpieces of Chikamatsu*. London, 1926.
Scott, A. C. *Genyadana: A Japanese Kabuki Play*. Tōkyō, 1953.
Scott, A. C. *Kanjincho: A Japanese Kabuki Play*. Tōkyō, 1953.
Scott, A. C. *The Kabuki Theatre of Japan*. London, 1955.
Shively, D. H. *The Love Suicide at Amijima*. Cambridge, Mass., 1953.
Toita, K. *Kabuki meisaku-sen* (in Japanese). Tōkyō, 1953.
Toita, Y. *Kabuki, The Popular Theater*. New York, 1970.

▷pp. 26–29, 63–65, 150–54; plates 4, 62, 64, 153

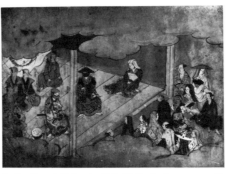

455 Early Genre School: *Kabuki Performance by O-Kuni*. Illustration from *O-Kuni-jo kabuki ekotoba. Nara-e-hon yokobon*, early 17th century

Kabuki-e: theater print

禿 **kaburo** (also *kamuro*): a girl attendant to a courtesan

kabuse-bori: facsimile engraving from a print or book

勝絵 **kachi-e** [victory picture]: a term for a famous pair of early shunga scrolls

花鳥 **kachō-e**: bird-and-flower print or painting ▷p. 160, plate 172, 184

kadomatsu: pine branches set up for New Year decorations

嘉永 **Kaei** (1848–1854/55): with the Kaei Period, which dates from II/28/1848 to XI/27/1854/55, diplomatic problems tended to take precedence over all else for the *bakufu* government. This culminated in the arrival of the squadrons of Perry and Putiatin in Kaei VI (1853). Meanwhile the populace, though generally unified in patriotic indignation at the foreign invaders, had no outlet for expression. Popular isolation from the government was complete, and the ruling military clique itself was already overstaffed with hereditary soldiers and samurai hangers-on. Criticism of the authorities was rife, and Kuniyoshi and several of his pupils were punished for offenses of *lèse majesté*. Hokusai and Eisen were dead by the early Kaei period; Hiroshige, Kuniyoshi and Kunisada remained prolific but were already in their declining years. ▷*nengō*

kaemon: alternative crest used by actors ▷actors' crests

Kaempfer, Engelbert (1651–1716): German doctor attached to the Dutch East India Company; came to Japan in 1690 for two years; author of the first detailed Western books on Japan

Kafū, Nagai (1879–1959): novelist and essayist

Kagami-yama kokyō-no-nishiki-e: a Kabuki drama, first staged in 1782, featuring the trials and tribulations of the Court ladies Iwafuji, Onoe and O-Hatsu

Kageki, Kagawa (1768–1843): a celebrated *waka* poet of the mid Edo Period

Kagekiyo: a Noh drama concerning the young daughter of the Taira warrior Kagekiyo, when he was an old man, blind and destitute

Kagekiyo, Taira: warrior of great valor, who fought Yoshinaka and Yukiie, but was made prisoner at Dan-no-ura in 1185 and starved himself to death

Kagematsu (fl. ca. 1830s–40s): ukiyo-e print artist, Ōsaka School, probably identical with the Edo artist Utagawa Kagematsu
*Utagawa, Ippōsai, Goryūtei

Kagetoki, Kajiwara: a samurai who first fought against Yoritomo, but who allowed Yoritomo to escape and afterwards became his ally.

Kagetoshi (fl. ca. 1830s): ukiyo-e print artist, Ōsaka School, pupil of Sadakage

kagi [key]: in woodblock printing, the right-angle guide mark of *kentō* registration

kago: a palanquin

Kagoshima: capital of Satsuma Province. Saint Francis-Xavier landed here in 1549; in 1863 the English bombarded the city; in 1877 it formed the center of the Satsuma Rebellion.

kagura ["god-music"]: rustic Shintō mimes and dances, accompanied by flute and drum

Kagura-ga-oka: a hill northeast of Kyōto, the scene of several battles

Kahoku (mid-19th century): Kyōto *dōban* artist
*Umegawa Kahoku

kai-awase (*kai-ōi*): a shell game, played with 360 clam shells, one valve bearing an inscribed verse and the other a corresponding painting

kaichō: a Buddhist ceremony

kaigen: a change of a *nengō* ▷calendar, Japanese

懐月堂派 **Kaigetsudō School**: painters and print artists specializing in large-scale paintings and prints of courtesans during the first half of the 18th century. Kaigetsudō Ando was the founder of the school followed by his pupils Dohan, Doshin, Doshu, Doshū and Anchi. Although in their own day these artists were known only as

painters, it is with good reason that the occasional prints of the Kaigetsudō School have come to symbolize the spirit of ukiyo-e and of their period. They are the most powerful representation we have of the Japanese courtesan, that arbiter of taste and of love in an age when these were a cultivated man's principal concerns. More than anything by Moronobu, Sugimura, Kiyonobu, Kiyomasu or Masanobu—all masters of the strong black line—the Kaigetsudō prints stand out as bold memorials to Japanese womanhood.
Lane, Richard. *Kaigetsudō*. Tōkyō, 1959.

kaihan: term meaning "first issued or published by"

開化 **kaika**: term for the opening of Japan to the influence of Western material civilization in early Meiji

kaimyō [*hōmyō*]: name given posthumously to the deceased and inscribed on funeral tablets; usually ends in an honorific title such as *-in*, *-koji*, *-shinji* (for males), *-shinnyo* (for females), *-dōji* (for children)

Kaion, Ki no (1663–1742): poet and dramatist of the mid Edo Period

kaishi: paper both for calligraphy and for domestic use

kaisho: the "printed" style of writing Chinese characters

Kaitaku-shi: the Hokkaidō Colonization Agency (1869–81)

Kaji[ko], Gion (early 18th century): poetess of the mid Edo Period, proprietress of a Gion teahouse in Kyōto; mother of Yuri[ko]

掛物 **kakemono**: hanging scroll, with weight at the bottom, hung in the *tokonoma*

kakemono-e: vertical *ōban* diptych; large upright print about 30×9 in./76.5×23 cm in size; also loosely applied to wide *hashira-e*

kakihan (*kaō*): initials, hand-seal

Kakimon-in (mid 14th century): *waka* poetess of the Northern and Southern Court Period

kakko: drum in hour-glass shape

Kakuhō (Meiji): *dōban* artist, pupil of Suisan *Ōmura Kakuhō

kakurembo: game of hide-and-seek

角判 **kaku-surimono** [**kakuban shikishi-ban**]: print size, about 8¼×7 in./21.3×18 cm, used for square-shaped *surimono*

Kamatari, Fujiwara (614–69): statesman who took an active part in public affairs during the reigns of the Emperors Kōtoku, Saimei and Tenji; minister of state [Taishok(k)an] of the Emperor Kōtoku, famous for his part in the recovery of sacred jewels stolen by the Dragon King, in which Kamatari's wife (a pearl-diver) perished; celebrated in the tale *Taishokan* and a frequent subject of ukiyo-e

Kamakura: town in Sagami, for several centuries the military capital of Japan under the Minamoto, Fujiwara and Ashikaga regents

Kamakura bakufu: the Kamakura shogunate, 1185–1333, commonly called the Kamakura Period

看板 **kamban**: theatrical posters

寛文 **Kambun** (1661–1673): the Kambun [Kammon] Period, as an era-name, dates from IV/25/1661 to IX/21/1673. By now Edo had recovered from the Meireki conflagration (1657), and the decade of the 1660s saw the rapid development of urban culture—Kabuki, *jōruri*, genre art, books, printing—forming a basis for the more famous Genroku Period. This period also saw the first consolidation of the Ukiyo-e School, under Moronobu's anonymous mentor the "Kambun Master," many of whose printed works were in the shunga

genre, the favored subject for limited editions at the time. *Kakemono* paintings of girls also became a standardized genre of ukiyo-e, later to be known as *Kambun bijin*. ▷ *nengō*

Kambun bijin [Kambun Beauties]: the generic term for the early ukiyo-e *kakemono* paintings of solitary beauties, which flourished in and around the Kambun Period

Kambun Master (fl. ca. 1660–73): the cognomen given by the present writer to Moronobu's anonymous Edo mentor, who worked almost entirely within the Kambun Period (1661–73). The Kambun Master's oeuvre has often been assumed to be the early work of Moronobu, and the two artists' relationship is still a mystery; indeed, more than one artist may have worked in this style during the period. The Kambun Master's style is powerful, almost primitive, yet features a dramatic intensity of depiction that was to influence and sustain ukiyo-e for many decades to come. This artist

456 The Kambun Master: *Courtesan and Lover. Tan-e* woodblock print of *chūban* size but printed in scroll format. Edo, late Manji Period (ca. 1660). From the second scene, this notable printed scroll plunges into bold depitions of sex without reserve. The execution is less graceful than that of the opening scene (plate 20) partly due to the influence of the subject matter and partly to the fact that the nude as such was not a customary subject for the Japanese artist.

457 吉原枕 The Kambun Master: Detail from the *Yoshiwara makura*, an early shunga courtesan critique, dated 1660 (cf. plate 18)

consolidated, in effect, the various styles of early genre work into a school which, under Moronobu, was to become known as ukiyo-e. The Kambun Master produced no signed work, but his characteristic style will be found in some 50 illustrated books of the period 1660–73: novels and tales, guidebooks, verse anthologies, *jōruri* plays, courtesan critiques and shunga, as well as in numerous paintings. He also designed the earliest known ukiyo-e prints, principally shunga in *chūban* and *ōban* format.

Lane, Richard. *Shunga Books of the Ukiyo-e School: II – Moronobu.* (in English and Japanese) Series Two. Tōkyō, 1974.
Lane, Richard. *Shunga Books of the Ukiyo-e School: III – Prints by Moronobu and the Kambun Master.* Tōkyō, 1976.
Lane, Richard. *Shunga Books of the Ukiyo-e School: IV – Moronobu and the Kambun Master.* Tōkyō, 1977.
Kisho fukusei-kai, facsimile series.
Mizutani, Yumihiko. *Kohan shōsetsu soga-shi.*
Shibui, Kiyoshi. *Shoki hanga.*
Lane, Richard. *Studies in Ukiyo-e.*
▷ pp. 37–41, plates 14–15, 18–25

Kameido: an eastern suburb of Edo; its Tenjin Shrine was celebrated for its plum blossoms and wistaria

Kameyama: town in Tamba; since the Restoration name changed to Kameoka

Kameyama: town in Ise Province with an ancient castle

kami: paper

kami: the gods and goddesses of Shintō

Kamigata: the Kyōto/Ōsaka region

上方 **kamigata-e**: prints and paintings of the Kyōto/Ōsaka region; more specifically the school of printmakers and book illustrators who worked in Kyōto and Ōsaka in the 18th and 19th centuries ▷ Ōsaka-Print School
Kuroda, Genji. *Kamigata-e ichiran.* (in Japanese) Kyōto, 1929.

Kamigata Prints ▷ Ōsaka-Print School

kamishimo: a formal suit worn over kimono by men

Kammon ▷ Kambun

kammuri: a headdress worn by nobles

鴨川 **Kamo-gawa**: river which crosses the eastern part of Kyōto

kampaku: highest official at the Imperial Court

kampan: books published under the auspices of the *bakufu* government

寛保 **Kampō** (1741–44): the Kampō Period, dating from II/27/1741 to II/21/1744, formed yet another extension of the age of the Kyōhō Reforms. In ukiyo-e, the hand-colored lacquer print gradually lost popularity, and the development of popular color printing began. Older masters such as Masanobu, Shigenaga, Sukenobu and Toyonobu continued to thrive. ▷ *nengō*

Kan: the Chinese Han dynasty (206 B.C.–A.D. 221)

kana: the Japanese syllabary; below are some of the variant forms seen in ukiyo-e and other Edo-Period documents (given in alphabetical order):

a	あ あ あ い 河 ア
chi	ち ち ち ち 地 チ ち
fu	不 ふ フ 家 婦 弓
ha	八 八 波 波 は む れ
he	へ 戸 戸 戸

Column 1 (kana variants):

hi · ho · i · i (wi) · ka · ke · ki · ko · ku · ma · me · mi · mo · mu · n [final] and see mu · na · ne · ni · no · nu · o · ra · re · ri

Column 2 (kana variants):

ro · ru · sa · se · shi · so · su · ta · te · to · tsu · u · wa · wo · ya · [y]e · [y]e (we) · yo · yu

repeat signs:

Koop, A. and Inada. H. *Japanese Names and How to Read Them*. London, 1926

仮名手本忠臣蔵

Kana-dehon Chūshingura [The Treasury of Loyal Retainers]: famous Kabuki drama; first staged as a puppet play in 1748, but soon after adapted for the Kabuki stage. The most popular Kabuki play, regularly performed every year (an English rendering was made by John Masefield under the title *The Faithful*). The play is based on actual events of the years 1701 to 1703. The twelve acts of the *Chūshingura* [*Chūshingura jūni-dan*] are entitled (with some variations):

Act I (*daijo*): *Tsurugaoka shinzen* [Before the Shrine at Tsurugaoka (Kamakura)]: After insulting his ceremonial aide, Momonoi, the evil minister Moronao makes improper advances to the Lady Kaoyo, wife of his other aide, the Lord Enya-hangan, but is rebuffed.

Act II (*nidamme*): *Momonoi no yashiki* [At Momonoi's mansion]: The young lovers Rikiya and Ko-Nami meet briefly; Ko-Nami's father Momonoi vows to take no more insults from the evil Moronao.

Act III (*sandamme*): *Kamakura denchū Ashikaga-yakata monzen-no-ba* [In the palace at Kamakura; before the gate of the Ashikaga Palace]: Momoni's chief retainer secretly bribes the villain Moronao in order to save his master; the evil Moronao vents his frustration on his other aide Enya-hangan, provoking the latter to draw his sword in the palace, a capital offence.

Act IV: *Hangan seppuku* [The suicide of (Enya-) Hangan]: Enya-hangan is sentenced to *harakiri*, which he performs valiantly, while waiting anxiously for the arrival of his trusted chief retainer (and father of Rikiya), Yuranosuke, who appears as his master is dying and vows to take revenge on the evil Moronao. Yuranosuke and his companions are now *rōnin*, samurai without lord, fief, or emolument.

Act V: *Yoichibei ōshi* [The Murder of Yoichibei]: Kampei, one of the forty-seven *rōnin*, has retreated to the country, staying with the parents of his wife, O-Karu, who (unknown to him) has been sold as a courtesan to raise funds so that he can join the other *rōnin* in their vendetta. O-Karu's father is robbed and murdered on the way home; in the dark Kampei, who is out hunting, accidentally shoots the robber and retrieves the money.

Act VI: *Kampei Sumika* [At the dwelling of Kampei]: O-Karu is being taken away by the brothel-mistress, but is stopped by Kampei's return home. Kampei mistakenly assumes that, in the darkness, he has killed his wife's father (whose body has been discovered) and commits *harakiri*, but before he dies, he is exonerated.

Act VII: *Ichiriki ageya* (*chaya*) [At the Ichiriki Courtesan House]: In Kyōto, Yuranosuke has apparently given himself to dissipation: in reality a disguise to conceal his vendetta scheme. Receiving a letter of encouragement from the Lady Kaoyo, he is spied upon by Kudayū, a minion of the evil Moronao, and by O-Karu, now a courtesan. Yuranosuke adroitly disposes of the spy.

Act VIII: *Tōkaidō michiyuki* [The Journey along the Tōkaidō]: A lyrical interlude, the bridal journey of Ko-Nami to Kyōto to marry her lover Rikiya (Yuranosuke's son).

Act IX: *Yamashina bessō* (*kankyō*) [The Villa at Yamashina]: Yuranosuke returns home from the pleasure quarter. Ko-Nami arrives with her mother, but they are treated coldly, for it was her father Honzō who prevented their master from killing Moronao. Honzō appears, disguised

as a *komusō* and provokes Rikiya to stab him, thus expiating his offence and making the marriage possible again.

Act X: *Amakawa-ya sumika* [At the dwelling of Amakawa-ya]: Amakawa-ya Gihei, a merchant of Sakai, has been secretly supplying the forty-seven *rōnin* with arms, but is apparently discovered by the police (actually they are Yuranosuke's men, who wish to test Gihei's loyalty).

Act XI: *Gishi yo-uchi* [The Night Attack of the Loyal Samurai]: At last the *rōnin* attack Moronao's mansion in Edo on a snowy night near the end of the year. The act is comprised of stylized sword fights, ending in the death and beheading of the villain Moronao.

[See plate 164]

Act XII: *Sengakuji hikiage* [The Withdrawal to the Sengaku Temple]: The triumphant *rōnin* attach Moronao's head to a halbard and march to the temple of Sengakuji to report their success to Enya-hangan's spirit and to submit themselves to mass *harakiri*.

Both in ukiyo-e and on the stage, the most famous act of the *Chūshingura* is the seventh, which features the scene in which Yuranosuke, leader of the forty-seven *rōnin*, reads an important and highly secret letter on the veranda of a Gion teahouse; he is overseen by two people: the courtesan O-Karu, who covertly reads the letter in her handmirror, and a spy of the enemy, who is hiding under the porch. Often in ukiyo-e parodies the courtesan and samurai are replaced by a maiden and a fair young man, and the spy sometimes by a dog (a pun on the Japanese word *inu,* which means both "dog" and "spy").

Kan-ami (1333–84): leading Noh actor and playwright of the Northern and Southern Court Period

Kanamura, Kasa no (early 8th century): *waka* poet of the *Man-yō-shū*

Kanazawa: village in Musashi, south of Yokohama, renowned for its fine scenery
▷ Hokusai, series 29

仮
名
草
子
kana-zōshi: popular fiction of the 17th century prior to Saikaku, so called from their being written largely in the easily read *kana* syllabary; the illustrations were usually by the early ukiyo-e masters.
Lane, Richard. "The Beginnings of the Modern Japanese Novel: *Kana-zōshi*, 1600–1680." In *Harvard Journal of Asiatic Studies.* 1957; reprinted in *Studies in Edo Literature and Art.*
▷ Book illustration, early ukiyo-e

Kaneakira, Minamoto (10th century): classical *waka* poet and prince

kanehira: Noh drama concerning the story of Imai no Kanehira and Kiso no Yoshinaka

Kan-ei (1833–97): Shijō-School painter, some genre work
*Nishiyama, Ken, Ken-ichirō

寛
永
Kan-ei (1624–44/45): the Kan-ei [Kan'ei] Period, which dates from II/30/1624 to XII/16/1644/45, marked the consolidation of the Tokugawa administration in both political and social fields, as well as the severance of diplomatic relations with most foreign countries. The city of Edo was developed into a center of both government and culture: Kabuki and *jōruri* theaters were opened (the "Women's Kabuki" being banned and replaced by the "Young Men's Kabuki"), and the Yoshiwara thrived (but still, mainly under samurai rather than plebeian patronage). Kyōto remained the center of the arts, but Iwasa Matabei and his followers commenced the establishment of a characteristically eastern ukiyo-e style. In book illustra-

tion, genre depiction began to replace the classical styles, and larger editions (with increasing primary education) enabled a new form of illustrated literature, the *kana-zōshi,* to achieve popularity among the masses. First experiments were made in color printing, but hand-coloring proved more practical for limited editions. Kan-ei represents the consolidation period of genre painting in the ukiyo-e style, and many screens and scrolls have been preserved from this era. ▷ *nengō*

Kan-eiji [Kan'eiji]: major Buddhist temple at Ueno with the tombs of the Shōguns Ietsuna, Tsunayoshi, Yoshimune, Ieharu, Ienari and Iesada; burnt down in 1868 during the battle of Ueno between the Imperial army and the shōgun's followers

寛
延
Kan-en (1748–51): the Kan-en [Kan'en] Period, dating from VII/12/1748 to X/27/1751, was a time of anticipation of the events of the succeeding Hōreki Period. The older masters Masanobu, Sukenobu, Shigenaga and Chōshun were turning out their final major works, and of the artists of the new age, Toyonobu was in his prime, while Settei and Harunobu were still apprentices. ▷ *nengō*

Kanemori, Taira no (d. 990): *waka* poet of the mid Heian Period

鐘
成
Kanenari (fl. ca. 1793–1860): ukiyo-e print artist, author and illustrator, Ōsaka School
*Kimura, Akatsuki no Kanenari, Keimeisha, Seio, Izumi-ya Yashirō, Akihiro

Kanera [Kaneyoshi], **Ichijō** (1402–81): *waka* poet and classical scholar of the mid Muromachi Period

漢
画
Kanga: Chinese-style painting, usually *sumi-e*

kangen: orchestra for the *bugaku* dance

関
月
Kangetsu (1747–97): Ōsaka genre painter and illustrator, pupil of Settei
*Shitomi, Tokki, Shion, Genji, Genjirō, Iyōsai, Seigadō
Illustrated books by Kangetsu include:
Ehon musha-roku (3 vols., 1768)
Nippon sankai meisan-zue (5 vols., 1799)
Ise sangū meisho-zue (8 vols., 1797)
Ōmi meisho-zue (4 vols., 1797; with Chūwa)

Kangetsudō (Meiji): *dōban* artist
*Shibata Kangetsudō

関
牛
Kangyū (d. 1843): Ōsaka genre painter, son and pupil of Kangetsu
*Shitomi, Tokufū, Shien, Iyōsai

kanji: a Chinese character as used in writing Japanese

Kanjin-chō: Kabuki play, the most popular of the *Jūhachi-ban*: adapted from the Noh piece *Ataka* and first performed in 1840 by Ebizō (Danjūrō VII); features Yoshitsune, Benkei and Togashi.

kanjin nō: subscription performances of Noh for the nobility

kanjō: Buddhist ceremony of baptism

Kankyō no tomo: a collection of stories on Buddhist themes, 1222

Kanna-gawa: river in Kōzuke and Musashi Provinces, by which numerous battles were fought

Kannon (*Kuan Yin*): the Buddhist goddess of Mercy

狩
野
Kanō: leading school of Japanese painters in semi-Chinese style from the mid 15th century onward, based on Muromachi *suiboku-ga*; official art school of the Edo shogunate

Kanōji: Buddhist temple at Yanaka, near Ueno

kanoko: dappled cloth

寛
政
Kansei (1789–1801): the Kansei Period dates from I/25/1789 to II/5/1801 and, despite extensive governmental reforms and regulations,

proved an extension of the Golden Age of popular culture. Indeed, the "Kansei Reforms" might be suspected of providing a kind of backbone for the resistance movements of the plebeian renaissance. Without the reforms, the renaissance might have succumbed more readily to the temptation to license and decadence. The corrupt Tanuma administration was purged by the new Shōgun Ienari in Temmei VII (1787) and replaced by the austere regime of Lord Sadanobu. He immediately called for a return to the spirit of the Kyōhō Reforms with emphasis on "reward and punishment for good and evil," the revival of samurai ideals, financial reform and "correction" of popular customs. The latter included bans on luxury, whether in food, clothing, decorations or toys, and in the Fifth Month of Kansei II (1790) this was extended to the realm of publishing and ukiyo-e. Tacit government approval was required for all new publications, and there was an outright ban on erotica. In the Ninth Month of the same year this edict was repeated and extended to require specific approval, i.e. censorship, of any publication. It is from this time that the *kiwame* or censor's seal, appears widely on the prints. Once a design was officially approved, however, strict control was not exercised. This led to the deluxe, print masterpieces with mica grounds, which date from the mid Kansei Period. After a decade or more of relative freedom, the ukiyo-e artists did not relinquish their prerogatives easily, and several of them—Shigemasa, Kyōden, Masayoshi, Utamaro, Chōki and Hokkei—received brief sentences (e.g. house arrest for fifty days in handcuffs) for transgressions, sometimes for publishing unauthorized work such as shunga, but more often for veiled pictorial satires of the administration. The Kansei Reforms were not yet fully established when Sadanobu resigned—forced out by court intrigues—in the Seventh Month of Kansei V (1793); yet the influence of the reforms remained strong until the beginning of the following century. This was indeed a Golden Age in the fields of literature, theater and popular arts such as ukiyo-e. Artists such as Utamaro, Sharaku, Hokusai, Toyokuni, Toyohiro, Eishi, Chōki, Shun-ei and their followers were in their prime, while some of the older masters—Kiyonaga, Shigemasa, Kyōden and Shumman—remained active. Indeed, probably a quarter of the masterpieces of the ukiyo-e print were produced during the Kansei decade. ▷ *nengō*

kanseki: non-Buddhist books written in classical Chinese

寛
志
Kanshi (fl. second half of the 18th century): ukiyo-e painter, late Masanobu style
*Tōensai

kanshi ▷ calendar, Japanese

Kanshin: Japanese name for the celebrated Chinese worthy Han Shin, often shown crawling between the legs of a coolie, a symbol of forebearance

Kan-Shōjō: Kabuki role depicting the vengeful aspect of the exiled courtier Sugawara Michizane

kansu-bon: book in scroll format

Kantan: Noh drama concerning the legend of the "Pillow of Kantan"

Kantō: the provinces situated east of the Hakone Barrier Station

Kantō-hasshū: the 8 provinces east of the Hakone Barrier Station: Musashi, Awa, Kazusa, Shimōsa, Shimotsuke, Hitachi, Kōzuke, Sagami

Kan-u [Kwan-yū]: a celebrated Chinese gen-

eral; also, god of War

Kan-yōkyū: Noh drama concerning the Palace of Hsienyang and the Emperor Shi-kōtei (Shih Huang-ti)

寒山拾得 **Kanzan and Jittoku**: famous Chinese Zen monks; Kanzan (a poet) is usually represented with a scroll, Jittoku with a broom; in ukiyo-e pastiches, often depicted as fair maidens

Kanze: a family that excelled in performing Noh; including Kan-ami Kiyotsugu (1354–1406), and Zeami Motokiyo (1375–1455)

顔見世 **kao-mise**: abbreviation of *kaomise kōgyō* or *kaomise kyōgen*; the gala Kabuki performance of the Eleventh Month, marking the beginning of the theater season

kao-mise banzuke: poster showing Kabuki actors in costume for a gala performance

kappa: a winter raincoat

合羽摺 **kappa-zuri**: stencil printing; also, prints colored by stenciling

Kara: ancient name for China; also the Tang dynasty (618–936)

kara-e: Chinese-style painting

kara-e mekiki: Official Expert on Chinese Paintings (at Nagasaki)

Karagoromo-Kisshū (1743–1802): noted *kyōka* poet of Edo
*Kojima, Gennosuke

kara-jishi: mythical Chinese lion

karakuri: automated toy

karakusa: floral pattern in scroll form

kara-zuri [blank printing]: technique of embossing or gauffrage with uninked block ▷ *nishiki-e*

kari-hanamichi: supplementary passageway in Kabuki theater

karō: the chief retainer of a *daimyō*

Karukaya-dōshin: alternate name for Katō Saemon, hero of a popular tale, who fled from home, because of his wife's and mistresses' jealousy; later he met but did not acknowledge his own son Ishidō-maru.

Kasagi-yama: mountain in Yamato, where the Emperor Go-Daigo took refuge from usurpers

Kashi (fl. ca. 1830): ukiyo-e print artist, Ōsaka School

kashihon-ya: commercial lending library

Kashima jinja: important Shintō shrine in Hitachi (rebuilt for ritual purposes every 21st year)

kashira-bori: cutting of the most important details of a woodblock, done by the senior engraver

Kashō (1726–83): a noted *kibyōshi* writer

Kashō (fl. ca. mid 1820s): ukiyo-e print artist, Kyōto School
*Nampitsu

Kasuga-ban: books or scrolls printed in the Nara temples during the Heian, Kamakura and Muromachi Periods

Kasuga jinja: Kasuga Shrine, a major Shintō center in Nara

Kasuga-no-tsubone (1579–1643): Influential court lady, nurse of the Shōgun Iemitsu

kasumi: mist, haze

-kata [-**gata**]: standardized acting styles or roles

katakana: the formal syllabary of the Japanese language

kataki-yaku: role of villain in Kabuki

Katori jinja: major Shintō shrine in Shimōsa

Katsuie, Shibata (1530–83): famous warlord, defeated by Hideyoshi at Shizu-ga-take in Ōmi

Katsumasa (fl. ca. 1720s): ukiyo-e print artist, Torii School
*Kishikawa Katsumasa

Katsunō (fl. ca. 1800s): Kyōto ukiyo-e print artist

Katsuragi-yama: mountain in Yamato

Katsunobu (fl. ca. 1720s): ukiyo-e print artist, pupil of Kondō Kiyoharu
*Kondō Katsunobu

勝信 **Katsunobu** (fl. ca. 1720s): ukiyo-e painter, print artist, follower of the Kaigetsudō School. Katsunobu's extant work often shows as much influence of the school of Sukenobu in Kyōto as it does of the Kaigetsudō in Edo.
*Baiyūken

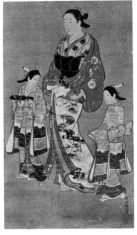

458

Katsunobu: *Courtesan and Maidservants*. Detail of *kakemono* in colors on silk, ca. 1720s

勝重 **Katsushige, Nabeshima** (1580–1657): Kyūshū warlord who took part in suppressing the Shimabara insurrection of 1637

Katsushige (d. 1673): Tosa-School genre painter in Fukui, vassal of Lord Matsudaira, son and pupil of Iwasa Matabei. Like his father, painted manners and customs in semi-ukiyo-e style.
*Iwasa, Gembei, Matabei II

kawa-biraki: river festival celebrated with firework displays

kawagishi [riverbank]: term for a type of lower-class harlot

Kawanaka-jima: district in Shinano, from 1553 to 1563, the scene of recurrent battles between the warlords Kenshin and Shingen

kawara-mono [river-bed rascals]: derogatory term for Kabuki actors

Kawarasaki-za: leading Edo Kabuki theater

Kawazu no Saburō (Sukeyasu): a celebrated wrestler of ancient times

Kayoi-Komachi: Noh drama concerning Ono no Komachi and her ardent but unsuccessful suitor Fukakusa-no-shōshō

Kazan (1784–1837): Shijō-School painter, did some genre work
*Yokoyama, Isshō, Shunrō

Kazan (1793–1841): *nanga* painter, did some genre work
*Watanabe, Noboru, Sadayasu, Gūkaidō, Zenrakudō

Kazan (Meiji): *dōban* artist, pupil of Ryokuzan
*Fukuyama Kazan

Kegon-no-taki: famous waterfall at Nikkō

慶安 **Keian** (1648–52): the Keian Period, dating from II/15/1648 to IX/18/1652, marked an end to overt guerilla activities (whether by *rōnin* or Christians) and the consolidation of feudal institutions. The genre-ukiyo-e style reached its culmination in painting and began to spread its influence more widely in printed book illustra-

tion. ▷ *nengō*

慶長 **Keichō** (1596–1615): the Keichō Era, which dates from XI/27/1596/97 to VII/13/1615, marked both the peak of the Momoyama Period in Kyōto and the commencement of the Edo Period, with the new city Edo (Tōkyō) as the political capital. The nation was unified by the Tokugawa Clan and urban culture took strong root; Kabuki and *jōruri* drama began to flourish, and the courtesan quarter in Kyōto became a center of upper-class social and cultural life in that ancient city. During the Keichō Period the amorphous Tosa and Kanō styles first began to develop in the direction of ukiyo-e, and printed book illustration in Japanese style was introduced. Within a generation these two forces were to combine to create the first ukiyo-e in printed form. ▷ *nengō*

Keichū (1640–1701): *waka* poet, Buddhist priest and scholar of Japanese studies

慶賀 **Keiga** (fl. early 19th century): leading Nagasaki genre painter; depicted the Europeans at Deshima and illustrated Siebold's *Nippon*
*Kawahara, Toyosuke

Keiho (1674–1755): Kanō-style painter, teacher of Shōhaku and Settei
*Takada, Takahisa, Chikuin, Chikuinsai, Koraku, Miken-gōō

Keikai (early 9th century): *waka* poet, writer and Buddhist priest of the early Heian Period; author of *Nihon reiiki*

Keiki [Yoshinobu], **Tokugawa**: 15th and last shōgun, ruled from 1866–68; in the middle of 1867, he was forced to turn his power over to the hands of the Emperor; a number of great *daimyō* protested, resulting in battles the following year at Fushimi, Toba, Ōsaka, Ueno (Edo), Utsuno-miya, Nikkō, Wakamatsu and (in 1869) Hakodate

慶応 **Keiō** (1865–68): the Keiō Period, dating from IV/8/1865 to IX/8/1868, marks the end of the Edo Period and, in many respects, of ukiyo-e as well. The populace was still afflicted with inflation, crime and unrest, forces against which the Government proved powerless. Late in Keiō III (1867/68) the reins of government were formally handed over to the Imperial Family which had long been powerless, and firm steps were made toward the formation of modern Japan. The ukiyo-e masters of the Genji Period continued their prolific output but produced little of special note. Ironically, ukiyo-e made its first major impression abroad at the Paris International Exhibition of 1867, creating a fervent interest that proved, needless to say, too late to revive this moribund art form. ▷ *nengō*

keiraku-ban: early Buddhist texts printed in the temples of Kyōto

渓里 **Keiri** (fl. mid-19th century): ukiyo-e painter and print artist, pupil of Hokkei
*Kyōichi

Keisai (fl. ca. 1780s): ukiyo-e print artist and designer of theater programs
*Tsukioka Keisai

傾城 **keisei** [destroyer of castles]: euphemism for a courtesan

keisei-kai: the practice of patronizing courtesans

keisei-machi: courtesan quarter

Keishi (1719–86): ukiyo-e print artist, painter and illustrator, Ōsaka School; *nom d'artiste* of the actor Nakamura Tomijūrō I
*Hanabusa, Reikinsha

Keiun [Kyōun] (early 14th century): Buddhist priest and *waka* poet of the Northern and Southern Court Period

kekoro: a type of unlicensed prostitute popular in the An-ei Period

kemari: ceremonial court football

拳 **ken**: a finger game

軒月堂 **Kengetsudō** (fl. ca. 1730s): ukiyo-e painter, Kaigetsudō School; his naive manner is reminiscent of Katsunobu, though without the latter's grace

Kengyū: the divine herdsman of the *Tanabata* Festival

Kenkō (1283–1350): a courtier who entered the priesthood and wrote the famous *Tsurezuregusa*, a collection of random thoughts

Kenninji: a major Zen temple in Kyōto

Kenreimon-in (Toku-ko) (1155–1213): daughter of the tyrant Kiyomori; in 1171 she married the Emperor Takakura and in 1178 gave birth to the future Emperor Antoku; she escaped death at the Battle of Dan-no-ura and became a nun

Kensai, Inawashiro (1452–1510): *waka* and *renga* poet of the mid Muromachi Period

Kenshin, Uesugi (1530–78): *daimyō* of Tochio (Echigo), famous rival of Takeda Shingen

Kenshō (1130–ca. 1210): *waka* poet and literary critic of the late Heian Period

見当 **kentō**: register mark in woodblock printing

Kenzaburō (Meiji): *dōban* artist, pupil of Ryokuzan
*Azuma Kenzaburō

kerai: vassal of a *daimyō*

kesa: Buddhist sash or surplice

Ki-Bun (Kinokuni-ya Bunzaemon): a famous millionaire merchant and spendthrift

黄表紙 **kibyōshi** [yellow covers]: picture novelettes bound in yellow covers, popular from 1775 to ca. 1821; they were usually in two or three volumes, each containing ten pages with each page illustrated. This fiction genre began in 1775 with the appearance of *Kinkin-sensei eigano-yume*, by Harumachi (1774–89). Among other popular authors were Hōseidō Kisanji (1735–1813), Shiba Zenkō (1750–93), and Ichiba Tsūshō (1739–1812); but the greatest master was Santō Kyōden, whose *Edo-umare uwaki no kabayaki* (1785) is the masterpiece of the genre. Cf. our translation of the latter work in *Chant de L'Oreiller*, Fribourg, 1974

Akimoto, Shunkichi. *The Twilight of Edo: Kibyōshibon.* Tōkyō, 1952.

Kichijōten: goddess of Fortune

Kido-maru: minion of the bandit-demon Shuten-dōji, often depicted concealed under an ox-hide waiting to ambush the warrior Usui Sadamitsu

Kigin (1624–1705): scholar of early Japanese literature and noted *waka* and *haiku* poet

Kihō (1778–1852): Kishi-School painter and illustrator; also did some genre work
*Kawamura (Takeuchi), Shun, Goitsu, Chikurikan

Kiichi-hōgen: famous strategist and mentor of Yoshitsune

Kikaku (1661–1707): Edo *haiku* poet (disciple of Bashō) and amateur painter (studied painting under Itchō)
*Enomoto (Takeshita), Hōshinsai, Shinsai, Shinshi

Kikei (fl. ca. 1770s): ukiyo-e print artist and designer of theater programs, Kyōto School
*Takahashi Kikei

菊慈童 **Kiku-Jidō** (Kikusui-Jidō/Makura-Jidō): mythological youth (based on Chinese legends) symbol of immortality and longevity

Kiku-zuki: poetic name for the Ninth Month

kimekomi: in woodblock printing, blind-printing of full-length figures

kimono: in the Edo Period refers mainly to the *kosode*, a type of short-sleeved robe worn both indoors and out

金平 **Kimpira-bon**: early illustrated books mainly concerning the bombastic hero Sakata Kimpira

Kinkakuji: the Gold Pavilion, built in 1397 by the Shōgun Yoshimitsu, northeast of Kyōto

Kinkō: Taoist sage, usually depicted riding on a large winged carp

Kinkoku (1761–1832): *nanga* painter, did some genre work
*Yokoi, Myōdō, Kōmori-dōjin
Lane, Richard. *Studies in Ukiyo-e.*

Kinō-wa-kyō no monogatari: a collection of tales edited by Anrakuan Sakuden (1544–1642), a monk of Kyōto

Kinri: the Imperial Palace; also, the Emperor

Kinryūzan: the Buddhist temple Sensōji, or Asakusa Kwannon; also, its subordinate temple Honryūin, at nearby Matsuchi-yama

Kinseki (1843–1921): Ōsaka painter and *dōban* artist
*Mori Kinseki

kiō: a yellow pigment, compounded from sulphur and arsenic ▷ pigments

Kintarō (Kintoki): child of the forest, picked up by the mountain hag Yama-uba (Yamamba), who adopted and named him Kaidō-maru; a frequent subject in ukiyo-e

Kintō, Fujiwara no (966–1041): *waka* poet of the mid Heian Period

kinuta: wooden beater used in fulling cloth

Kin-yō-shū: Imperial verse anthology, assembled in 1127

kiō ▷ pigments

Kira, Kōzuke-no-suke (Yoshinaka): master of ceremonies in the Shōgun's palace, villain of the *Chūshingura* vendetta of 1702

kirara-e: prints with mica background

雲母摺 **kira-zuri**: mica-ground impression, usually printed with mother-of-pearl dust

kiri: finale of a Kabuki play

kiri: the pawlonia tree

切支丹 **Kirishitan**[-shū] (from the Portuguese *Cristan*): The Christian [= Roman Catholic] religion, introduced to Japan by St. Francis-Xavier in 1549, but repressed after 1638

Kirishitan-ban: books printed from movable type at the Jesuit Mission Press, during the late 16th and early 17th centuries
Lane, Richard. *Studies in Ukiyo-e.*

Kisei (Meiji): *dōban* artist
*Yasuda, Yoshitarō

Kisen-hōshi (early 9th century): Buddhist priest and *waka* poet of the early Heian Period

Kishibojin: Buddhist goddess, patroness of children

Kishikuni (fl. ca. 1820s): ukiyo-e print artist, Ōsaka School
*Hōgadō

Kishi School: Kyōto painting school founded by Ganku, influenced by Ch'ing painting and by the Maruyama School

木會 **Kiso**: mountainous region of Shinano and Mino Provinces; also the Noh drama concerning the valiant general Kiso no Yoshinaka

Kiso-gawa: river flowing through Mino, Owari and Ise (109 miles/175 km long)

Kiso-kaidō ▷ Naka-sendō; Highways, map

Kitano jinja: major Shintō shrine northwest of Kyōto

狐 **Kitarō** (fl. ca. 1810s): ukiyo-e print artist, Kyōto School

kitsune-ken: a game of hand-movements

極 **kiwame**: censorship seal used on prints from about 1790 to 1842 ▷ censors' seals

Kiyochika (fl. ca. 1750s): ukiyo-e print artist,

pupil of Kiyomitsu
*Torii Kiyochika

清親 小林 **Kiyochika** (1847–1915): ukiyo-e painter, print artist; son of a minor official, Kiyochika studied Western painting under Charles Wirgman, Japanese painting with Kyōsai and Zeshin and was influenced as well by imported lithographs, etchings and photography. He sought a fusion of Western and Japanese styles, as Kuniyoshi had before him, and succeeded to a considerable degree.
*Kobayashi, Katsunosuke
Kondo, Ichitarō, *Kiyochika to Yasuji* (in Japanese), Tōkyō, 1944.
Yoshida, Susugu, *Kobayashi Kiyochika* (in Japanese), Tōkyō, 1969.
Kumata, Ryōji. *Meiji no hanga.* (in Japanese) Tōkyō 1976.
▷ pp. 193–195, plates 198–199

459

Kiyochika: *Night Illumination. Oban*, 1877

460

Kiyochika: *Cat, Mouse and Lantern. Large-ōban*, 1877

Kiyoharu (fl. ca. 1700–30): ukiyo-e painter and print artist, pupil of Kiyonobu
*Torii Kiyoharu, Ryūsōshi

清春 **Kiyoharu** (fl. ca. 1704–20): ukiyo-e painter, print artist and writer; follower of Kiyonobu
*Kondō, Sukegorō

清晴 **Kiyoharu** (fl. ca. 1820s–30s): ukiyo-e print artist, Ōsaka School
*Fujiwara (Hishikawa), Shun-yōsai, Seiyōsai, Keisensai, Settei, Yōsai, Kichizaemon, Ono Noritaka, Hirotaka

清広 **Kiyohiro** (fl. ca. 1750s–60s): a ukiyo-e print artist of the Torii School; his figures are modeled closely on those of Kiyomitsu and Toyonobu, but in his general compositions Kiyohiro reveals a special genius; his best work ranks among the masterpieces of the late Torii style.
清廣 *Torii, Shichinosuke
▷ p. 89, plate 78

461 Kiyohiro: *Couples under Umbrellas.* Uncut *hosoban* triptych, *benizuri-e,* 1750s

462 Kiyohiro: *Hikosaburō and Kichiji in a Kabuki Dance.* Large-*ōban benizuri-e,* 1753 (collector's seal on lower right: Shūgyō)

463 Kiyohiro: *Kinsaku as a Fan-seller.* Large-*hosoban benizuri-e,* ca. 1760

464 Kiyohiro: *Lovers Eloping.* Large-*ōban benizuri-e,* ca. early 1760s

清 **Kiyohisa** (fl. ca. 1760s): ukiyo-e print artist,
久 pupil of Kiyomitsu
*Torii Kiyohisa
Kiyokata (1878–1973): leading neo-ukiyo-e painter and illustrator; studied under Yoshitoshi and Toshikata
清 **Kiyokuni** (fl. ca. 1820s): Ōsaka ukiyo-e
国 print artist, pupil of Yoshikuni
*Jushodō
Kiyokuni (fl. ca. 1830s–40s): ukiyo-e print artist, son of Kiyomitsu II
*Torii Kiyokuni

465 Kiyokata: *Lovers in Suicide Pact. Kakemono* in colors on silk, ca. 1920

Kiyomaro, Wake (733–99): advisor to the Empress Shōtoku; exiled to Ōsumi in 769 by the svengalic monk Dōkyō

清政 **Kiyomasa** (fl. ca. 1790s): Torii-School print artist, son and pupil of Kiyonaga
清政 *Torii, Tamekichi
▷ p. 135

466 Kiyomasa: *Hanshirō IV as Shirabyōshi Dancer. Ōban,* 1793

Kiyomasa, Katō (1562–1611): famous warrior and governor of Higo; commanded the vanguard of the Korean expeditions in 1592 and 1597

清 **Kiyomasu** (fl. ca. late 1690s–early 1720s):
倍 important ukiyo-e painter and print artist. Little

467 Style of Kiyomasu: *Chōryō and O-Sekkō.* Large-*ōban tan-e* diptych (a rare format), ca. 1705

468 Style of Kiyomasu: *Actor as Girl on Travels.* Large-*ōban tan-e,* ca. 1705

469 Kiyomasu: *Courtesan with Maidservant and Sparrow.* Large-*ōban tan-e.* ca. 1705

470 Kiyomasu: *Poet on Travels.* Large-*ōban tan-e;* early Shōtoku Period (early 1710s). Unsigned.
Here the famous classical poet Fujiwara no Teika (1162–1241) is on horseback with attendants, near Lake Biwa; he is on his way back to Kyōto from the East. In the background are some of the "famous views" of Lake Biwa, and on the left is the hermitage of the blind poet and musician Semimaru. Beginning with the Yamamura-za play *Teika Azuma-*

asobi of Hōei VII/11 (December, 1710) several Kabuki plays featured such a *michiyuki* interlude about Teika's travels, and two other ukiyo-e versions of the same subject are known. In addition to the customary orange, yellow and mustard colors of *tan-e*, this print features unusual blue tinting, which lends it a special, almost ethereal quality.

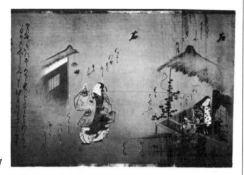

471

Style of Kiyomasu: *Details from the "Insect Scroll".* Picture scroll in colors on paper, ca. early 1710s

472

Kiyomasu: *Asahina and Gorō.* Large-*ōban tan-e,* ca. early 1710s

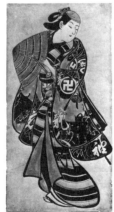

473

Style of Kiyomasu: *Actor as Young Man.* Large-*ōban tan-e,* ca. 1708

清 倍

is known of Kiyomasu's early work but during the 1710s his signed prints far outnumber those by Kiyonobu, who may have been his elder brother. Kiyomasu's style is somewhat more graceful than the work of Kiyonobu's middle years, but the two are often difficult to tell apart.
*Torii, Shōjirō
Link, Howard A. *A Theory on the Identity of Torii Kiyomasu I.* Doctoral dissertation, University of Pittsburg, 1969; partially extracted in *Ukiyo-e Art* No. 19 (1968) and No. 34 (1972).
▷ pp. 61–63, plates 47–51

474

Kiyomasu: *Danjurō in* Shibaraku *Role.* Large-*ōban* with hand-coloring, ca. 1714

Kiyomasu II (fl. 1720s–early 1760s): ukiyo-e painter, print artist. The work of Kiyomasu II is uneven, but at his finest his prints represent one of the unostentatious heights of ukiyo-e. Like Kiyonobu II, he is at his best in his hand-colored lacquer prints: the firmer lines of color printing tend to emphasize a certain awkwardness of composition inherent in both these artists.
*Torii, Hanzaburō
▷ p. 74, plate 63

475

Kiyomasu II: *The Poetess Komachi.* Hosoban *urushi-e,* ca. late 1720s (one sheet of a triptych)

清 峰

Kiyomine (Kiyomitsu II) (1787–1868): ukiyo-e painter and print artist, pupil of Kiyonaga; grandson of Kiyomitsu and fifth in the Torii line. As a young man, he made prints under the name Kiyomine, his best work; later works carry the name Kiyomitsu [II].
*Torii, Shōnosuke

清 峯

476

Kiyomine: *Girl Tying Hair Ribbon. Ōban,* ca. mid 1800s

清 満

清 満

Kiyomitsu (ca. 1735–85): leading ukiyo-e painter and print artist, son and pupil of Kiyonobu II and third head of the Torii line. Kiyomitsu represents the final period of glory of the traditional Torii School; his output was extensive, and many of his actor prints are dull, but in his more imaginative scenes he displays a dreamlike grace that equals the best of his follower Harunobu.
*Torii, Kamejirō
▷ p. 89, plates 79–80

477

Kiyomitsu: *Ebizō II as "Yanone gorō." Ōban beni-zuri-e,* 1758

478

Style of Kiyomitsu: *Lovers with Mirror. Chūban,* mid 1760s

Kiyomizu-dera: famous temple of the Hossō and Shingon sects, east of Kyōto

Kiyomori, Taira (1118–81): warlord and most renowned of the Heike rulers, rival of Yoritomo: a great tyrant, he lived in the splendid palace he built at Fukuhara (Settsu); Kiyomori was the object of numerous plots, all unsuccessful, and died a natural death before his clan was routed by the Minamoto.

Kiyomoto: a voluptuous genre of Kabuki musical recitation

清元 **Kiyomoto** (1645–1702): genre painter, worked first in Ōsaka, then Edo. An actor in the Ōsaka Kabuki under the name Torii Shōshichi; he was also a painter of theatrical billboards. In 1687 he moved to Edo and, unsuccessful on the stage there, took the name Kiyomoto and became a popular painter of theatrical signs. Father and teacher of Kiyonobu; no known work survives.

*Torii (Kondō), Shōshichi

清長 **Kiyonaga** (1752–1815): leading ukiyo-e painter, print artist and illustrator; influenced by Harunobu, Koryūsai, Shigemasa. Son of a bookseller, Kiyonaga was a pupil of Kiyomitsu, last of the great figures in the traditional Torii line. Although Kiyonaga maintained his responsibilities as head of "Torii generation IV," his genius led him far beyond the limits of this school of Kabuki artists, and even in treating the theater Kiyonaga devised quite new forms and approaches. His special field, however, was the depiction of elegant young men, graceful girls and courtesans, against broad and fully realized backgrounds of the Edo he knew so well. He utilized elements that had been standard in ukiyo-e since its origins but combined them on a grand scale with solid, realistic draftsmanship that is also poetic and evocative, a style that was to dominate ukiyo-e for 20 years or more. It was Kiyonaga's vision that

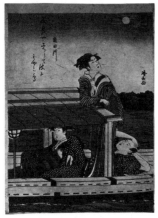

479
Kiyonaga: *On the Sumida River. Chūban*, ca. early 1780s

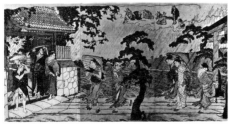

480
Kiyonaga: *Sudden Shower at the Mimeguri Shrine. Ōban* triptych, mid 1780s (in the clouds are shown the forces of rain and thunder, personified as fashionable Edoites).

formed Utamaro's style, but when the latter rose to predominance in the early 1790s Kiyonaga returned to his original work of theater posters and paintings, designing few prints during the last two decades of his life.
*Torii (Sekiguchi), Shinsuke, Ichibei

Titled print series by Kiyonaga:
(Bracketed numbers refer to Chieko Hirano's monumental *Kiyonaga*, whose dating has been generally followed here.)

1 *Konrei jūni-shiki, koban*, ca. 1775 [45–49]
2 *Edo hakkei*, horizontal *hosoban*, ca. 1776 [277]
3 *Fūryū yatsushi nana-Komachi, hosoban*, ca. 1776 [69]
4 *Fūryū shichi-fukujin, hosoban*, ca. 1777 [79–81]
5 *Fūzoku Fukagawa hakkei, koban*, ca. 1778 [92–98]
6 *Fūryū Edo hakkei, chūban*, ca. 1778 [99]
7 *Fūryū Edo hakkei, tanzaku*, ca. 1778 [136–143]
8 *Haru-asobi temari-uta, chūban*, ca. 1778 [102, 1022]
9 *Fūryū zashiki hakkei, koban*, ca. 1778 [104–110]
10 *Zashiki hakkei, chūban*, ca. 1778 [118–125]
11 *Fūryū Yoshiwara hakkei, koban*, ca. 1778 [131–135]
12 Seven Gods of Luck Series, *hosoban*, ca. 1778 [1035–1070]
13 *Tōsei yūri hakkei, tanzaku*, ca. 1778 [144–151]
14 *Fūryū jūni-kō, koban*, ca. 1779 [161–172]
15 *Yasa-sugata shi-nō-kō-shō, koban*, ca. 1779 [174–177]
16 *Shiki hakkei, chūban*, ca. 1779 [182–189]
17 *Fūryū jūni-kikō, chūban*, ca. 1779 [191–201]
18 *Kuruwa gosetsu-asobi, aiban*, ca. 1779 [214–218]

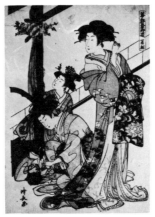

491
Kiyonaga: *The Iris Festival*, from the series *Kuruwa gosetsu-asobi*

19 *Kanda go-sairei, chūban*, ca. 1779 [202–211]
20 *Minami hakkei, chūban*, ca. 1780 [225–231]
21 *Sannō go-sairei, chūban*, ca. 1780 [232–238]
22 Chinese Children at Play, *chūban*, ca. 1780 [246–251]
23 *Fūryū yatsushi nana-Komachi, chūban*, ca. 1780 [252–258]

24 Actor Series, *chūban*, ca. 1780 [289–295]
25 *Seirō shiki juni-hanagata, chūban*, ca. 1780 [259–266; 1048]
26 *Gidō juni-kikō, chūban*, ca. 1780 [267–268]
27 *Jūni-kō kuruwa-hanagata, aiban*, ca. 1780 [287]
28 *Seirō sato-menuki, ōban*, ca. 1780 [288]
29 *Fūryū yatsushi mu-Tamagawa, koban*, ca. 1780 [296–301]
30 *Ukiyo nana-Komachi, chūban*, ca. 1780 [302–308]
31 *Hakone shichi-tō meisho, chūban*, ca. 1781 [239–245]
32 *Iro-kurabe onna-sugata, chūban*, ca. 1781 [365–372]

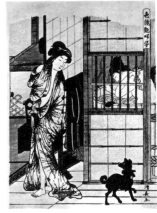

482
Kiyonaga: from the series *Iro-kurabe onna-sugata, chūban*, ca. 1781

33 *Edo hakkei* [landscapes], *chūban*, ca. 1781 [309–316]
34 *Edo hakkei* [figures], *chūban*, ca. 1781 [373–379]
35 *Tōsei yūri bijin-awase, ōban*, ca. 1781 [327–347]

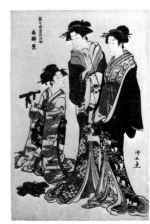

483
Kiyonaga: *Three Courtesans of Shinagawa. Ōban*, from the series *Tōsei yūri bijin-awase*, ca. 1781

36 *Seiro niwaka kyōgen-zukushi, chūban*, ca. 1781 [348–352]
37 *Nakasu no hana, chūban*, ca. 1781 [357–364]
38 *Fūryū yūri hakkei, koban*, ca. 1781 [356]
39 *Wakoku bijin ryakushū, chūban*, ca. 1781 [380–388]

40 *Enshoku hana-fūzoku,* chūban, ca. 1782 [390–391]
41 *Hinagata wakana no hatsu-moyō,* ōban, ca. 1782 [423–431]
42 Actors in Private Life, *aiban,* ca. 1782 [433–443]
43 *Fūzoku jūni-tsui,* chūban, ca. 1782 [444–447]
44 *Asakusa Kinryūzan hakkyō,* chūban, ca. 1782 [448–455]
45 *Edo meisho-shū,* chūban, ca. 1782 [456–466]
46 *Gidōjūni-kō,* chūban, ca. 1783 [486–489]
47 *Seirō niwaka-zukushi,* chūban, ca. 1783 [495–499]
48 *Fūzoku jūni-tsui,* hashira-e, ca. 1783 [524–534]
49 *Edo meisho,* chūban, ca. 1783 [500–501]
50 *Chamise jikkei,* chūban, ca. 1783 [545–554]
51 *Asakusa Kinryūzan jikkyō,* chūban, ca. 1783 [536–543]
52 *Minami jūni-kō,* chūban, ca. 1783 [560–571]
53 *Fūzoku Azuma-no-nishiki,* ōban, ca. 1783 [527–591]

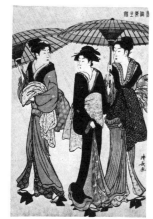

484

Kiyonaga: *Three Geisha in Rain.* Oban, from the series *Fūzoku Azuma-no-nishiki,* ca. 1783

54 Actors in Private Life, *hosoban,* ca. 1783 [592–603]
55 Actors in Private Life, *ōban,* ca. 1783 [605–607]
56 Child Musicians, *chūban,* ca. 1783 [555–559]
57 *Edo hana-jikkei,* koban, ca. 1783 [476–485]
58 *Fūryū mitsu no koma,* ōban, ca. 1784 [616–617]
59 *Minami jūni-kō,* ōban, ca. 1784 [625–631]
60 *Setsu-gekka mitsu no irodori,* ōban, ca. 1784 [621–623]
61 Court Ladies, *ōban,* ca. 1784 [634–638]
62 *Fūryū shiki no tsuki-mairi,* chūban, ca. 1784 [645–656]
63 *Jijo-hōkun onna-Imagawa,* chūban, ca. 1784 [657–669]
64 *Ongyoku tegoto no asobi,* aiban, ca. 1785 [708–711]
65 *Shiki no Fuji,* chūban, ca. 1785 [712–721]
66 *Haifū yanagi-daru,* chūban, ca. 1785 [722–729], ca. 1790 [899–906]

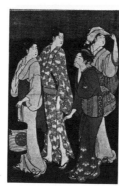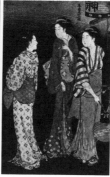

485

Kiyonaga: *Evening Scene at Shinagawa.* Oban diptych, from the series *Minami jūni-kō* (no. 59), ca. 1784

67 *Kyōka jisshu,* chūban, ca. 1785 [730–734, 1053]
68 *Rokkasen,* koban, ca. 1785 [749–753]
69 *Ukiyo jisshu-hō,* koban, ca. 1785 744–748]
70 *Sankanotsu suzumi jikkei,* chūban, ca. 1785 [754–757, 1055, 1068]
71 *Sanseki no waka,* hashira-e, ca. 1785 [761–763]
72 *Edo hakkyo,* chūban, ca. 1785 [735–740)
73 *Edo sakura jikkei,* koban, ca. 1785 [1057]
74 *Go-Taihei-ki shiraishi-banashi,* chūban, ca. 1785 [798–806]
75 *Gosetsu-asobi,* chūban, ca. 1786 [769–772]
76 *Azuma natsu jikkei,* chūban, ca. 1786 [773–776]
77 *Fūzoku jūni-tsui,* chūban, ca. 1786 [777–784]
78 *Minami hakkei,* chūban, ca. 1786 [225–231]
79 *Ise monogatari,* ōban, ca. 1786 [810–811]
80 *Shin-Yoshiwara jikkei,* koban, ca. 1787 [812–815]
81 *Fūryū Edo no higashi,* chūban, ca. 1787 [823]
82 *Fūryū Edo no minami,* chūban, ca. 1787 [825]
83 *Fūryū Edo no nishi,* chūban, ca. 1787 [824]
84 *Fūryū Edo no kita,* chūban, ca. 1787 [826]
85 *Furyu Edo no mannaka,* chūban, ca. 1787 [827]
86 *Edo natsu jikkei,* chūban, ca. 1787 [828–834]
87 *Fūryū jūni-toki,* koban, ca. 1787 [835–842]
88 *Gidō jūni-tsuki,* chūban, ca. 1787 [816–822]
89 *Edo kanoko,* chūban, ca. 1787 [871–872]
90 *Ongyoku-shū,* ōban, ca. 1789 [880–883]
91 *Setsu-gekka Azuma fūryū,* chūban, ca. 1789 [891–898]
92 *Onna-fūzoku masu-kagami,* aiban, ca. 1790 [916–920]
93 *Onna fūzoku masu-kagami,* chūban, ca. 1790 [907–915]
94 *Yōdō-yū koitsu wa Nippon, ezōshi wo mite yori sono gai wo asobu,* chūban, ca. 1791 [922–929, 1059]
95 *Edo shichi-fukujin-mairi,* chūban, ca. 1792 [935–938]
96 *Seiro jisshu-kō,* chūban, ca. 1793 [943–949]

97 *Azuma-fūzoku yatsushi jisshu-kō,* chūban, ca. 1794 [951–956]
98 *Kodakara gosetsu-asobi,* ōban, ca. 1794, ca. 1801 [959–963]
99 *Jittai e-fūzoku,* ōban, ca. 1794 [966–970]
100 *Kintarō* Series, ōban, ca. 1775–1813 [979–1012, 1062]

Books illustrated by Kiyonaga:
(Numbering generally follows Chieko Hirano, *Kiyonaga*)

1 *Kuni no hana Ono no itsu-moji,* 1771
2 *Edo-katagi hikeya tsunazaka,* 1772
3 *Ōyoroi ebidō Shinozuka,* 1772
4 *Fūryū mono wa zuke,* 1775
5 *Mukashi-banashi hanasaka-otoko,* ca. 1775
6 *Hana-zumō Genji-biiki,* 1775
7 *Oyafune Taihei-ki,* 1775
8 *Kōriyama hinin no adauchi,* 1776
9 *Shizuka-zakura,* ca. 1776
10 *Warambe hashika no ato,* 1776
11 *Hikitsurete yagoe Taihei-ki,* 1776
12 *Sugata-no-hana yuki-no-Kuronushi,* 1776
13 *Gyoshō-hatsumono sato ga yoi ōhira-no-sakae,* 1777
14 *Himachi gorishō konogoro uwasa,* 1777
15 *Kindai Kimpira-musume,* 1777
16 *Santoku kembi Genke chōkyū,* 1777
17 *Saru-rikō ukiyo-banashi,* 1777
18 *Shikoku-zaru gonichi no kyokuba,* 1777
19 *Shizuka-no-mai suehiro-Genji,* 1777
20 *Taihei shusse-Nagoya,* 1777
21 *Temari-uta iromoyō sannin-musume,* 1777
22 *Tōsei Shikoku-zaru,* 1777
23 *Zeni-gassen,* ca. 1777
24 *Ane wa nijūichi imoto wa hatachi itoza-kura honchō-sodachi,* 1777
25 *Masakado kamuri no hatsuyuki,* 1777
26 *Bakemono Hakone no saki,* 1778
27 *Itchiku tatchiku kiku-no-yū no hana,* 1778
28 *Itchiku tatchiku otohime-banashi,* 1778
29 *Kanda no Yokichi ichidai-banashi,* 1778
30 *Meidai Higashiyama-dono,* 1778
31 *Myō-chiriki muragaru hato,* 1778
32 *Sano kazu-kazu sake no kuse,* 1778
33 *Uso-hajime mukashi wo Imagawa,* 1778
34 *Date-nishiki tsui no yumitori,* 1778
35 *Moto-mishi-yuki sakae Hachi-no-ki,* 1778
36 *Jūsan-gane kinu-kake-yanagi Imose-yama Onna-teikin,* ca. 1778
37 *Buyū kongō-rikishi,* ca. 1779
38 *Ane wa nijūichi imoto wa koi-muko,* 1779
39 *Dai-tsūjin ana-sagashi,* 1779
40 *Hayari-uta ankera konkera yan-shite do-shita kyoroku,* 1779
41 *Hideri ame kitsune no yomeiri,* 1779
42 *Kagome-kagome kago-no-naka no tori,* 1779
43 *Momotarō gembuku-sugata,* 1779
44 *Usotsuki Yajiro keisei-no-makoto,* 1779
45 *Kaeri-bana eiyū Taihei-ki,* 1779
46 *Azuma-sodachi o-Edo no hana,* 1780
47 *Chikagoro shima-meguri,* 1780
48 *Chinsetsu onna-tengu,* 1780
49 *Daitsuso sono omokage,* 1780
50 *Hon no yoi misemono,* 1780
51 *Imayō kikenjō,* 1780
52 *Kamakura-yama momiji-no-ukina,* 1780
53 *Nikumareguchi hentō-gaeshi,* 1780
54 *Oyaji no nunoko tombi ga saratta,* 1780
55 *Sanya-gayoi busui-no-toko,* 1780

Noguchi, Yone. *Torii Kiyonaga*. (in Japanese) Tōkyō, 1931. English and Japanese edition, Tōkyō, 1932.
• Hirano, Chieko. *Kiyonaga: A Study of His Life and Works*. Cambridge, Mass., 1939. (Abridged Japanese translation: *Torii Kiyonaga no shōgai to geijutsu*, Tōkyō, 1944.)
Yoshida, Teruji. *Kiyonaga* (in Japanese). Tōkyō, 1953.
Takahashi, Seiichiro. *Torii Kiyonaga*. (English adaptation by Thomas Kaasa) Tōkyō, 1956.
▷ pp. 130–34, plates 127–131

清信

清信

Kiyonobu (ca. 1664–1729): ukiyo-e painter, print artist and illustrator; son and pupil of Torii Kiyomoto; born in Ōsaka but in 1687 moved to Edo with his father; the founder of the Torii School. Kiyonobu began his work as an illustrator in the Moronobu style in 1687 and had illustrated a number of novels and dramas by the end of the century, when he began

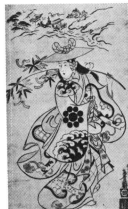
487
Kiyonobu: *Maiden on Journey.* Large-ōban sumizuri-e. ca. early 1700s

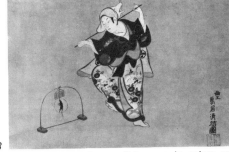
488
Koyonobu: *Fox Dance. Kakemono* in colors on paper, ca. 1710s

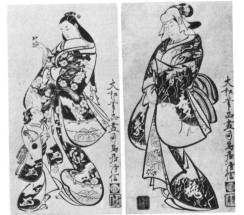
489 Koyonobu: *Courtesan and Maidservant* (left). Large-ōban sumizuri-e, ca. 1710s
490 Kiyonobu: *Girl Walking* (right). Large-ōban sumizuri-e, ca. 1710

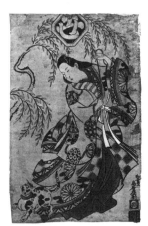
486
Kiyonobu: *Princess with Cat.* Large-ōban tan-e, ca. 1700s

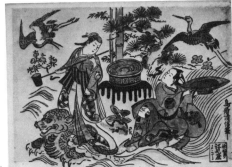
491
Kiyonobu: *Actors as Conjugal Couple. Chūban urushi-e*, ca. early 1720s

492
Kiyonobu: *Girl Peddler of Calligraphy Texts. Hoso-ban urushi-e*, ca. mid 1720s

issuing albums and independent prints. Linear power characterizes Kiyonobu's middle period; refined grace his later years; this style was to dominate most of the subsequent Torii work and is often difficult to distinguish from the early work of his pupils. There is doubt that the exact dates and relationships of the early Torii artists will ever become clear, but it seems best for the moment to assume that the names Kiyonobu and Kiyomasu each represent two generations of artists working under the same name.
*Torii, Shōbei
▷ Kiyomasu; pp. 58–60, plates 43–46
Kiyonobu II (fl. 1720s to ca. 1760): ukiyo-e print artist, thought to have been a son of Kiyonobu, who (on his father's death in 1729) took his name. Kiyonobu II probably collaborated in the late work of Kiyonobu I, making it difficult to distinguish the artist involved in the "Kiyonobu" prints of the 1720s. Like Kiyomasu II, he never attempted prints on the scale of the great work of the first generation of the Torii, but his small hand-colored prints are impressive in their own quiet way, as are his later prints and illustrations.
*Torii, Shōbei
▷ p. 74, plate 62
Kiyosada (fl. ca. 1840s): ukiyo-e print artist, Ōsaka School, follower of Hirosada
Kiyosada (1844–1901): ukiyo-e painter and print artist, pupil of Kiyomine
*Torii (Watanabe, Saitō), Chōhachi, Matsu-jirō
Kiyosato (fl. ca. 1760): ukiyo-e print artist, pupil of Kiyomitsu
*Torii Kiyosato
Kiyoshi (1897–1948): leading neo-ukiyo-e painter and print artist, pupil of Kiyokata
*Kobayakawa Kiyoshi
Kiyoshige (fl. late 1720s to early 1760s):

493
a, b Kiyoshige: *Warrior and Dancer. E-daisen* from vols. I and III of a children's book, *Shin-Matori jikki*, 1758

ukiyo-e painter and print artist. A late pupil of Kiyonobu I, Kiyoshige often lends a rather stiff, angular note to his figures. His large prints in the Masanobu manner, however, rank among the masterpieces of the Torii School.
*Torii, Seichōken
▷ p. 78, plate 65

494 Kiyoshige: *Yaozō as Gorō. Hosoban benizuri-e*, 1754

495 Kiyoshige: *Danjūrō IV on Stage. Ō-tanzaku beni-zuri-e*, ca. 1760

Kiyosuke, Fujiwara no (1104–77): *waka* poet and literary critic of the late Heian Period
Kiyotada (fl. 1720s to 1740s): ukiyo-e painter and print artist. An early pupil of Kiyonobu I. In his fusion of the Kiyonobu and Masanobu styles Kiyotada impresses one as being possessed of more talent than either Kiyotomo or Kiyonobu II; it is unfortunate that so little of his work is now known.
*Torii Kiyotada
▷ p. 78, plate 64

496
Kiyotada: *The Lovers O-Some and Hisamatsu. Hosoban urushi-e*, ca. 1720

Kiyotada II (fl. early 19th century): ukiyo-e print artist, pupil of Kiyonaga
*Torii (Yamaguchi), Zen-emon
Kiyotada III (fl. ca. 1820s): ukiyo-e print artist, son of Kiyotada II, pupil of Kiyomitsu II
*Torii (Yamaguchi), Zen-emon, Sanreidō
Kiyotada VII (1875–1941): neo-ukiyo-e painter and print artist, son of Kiyosada
*Torii (Saitō), Chōkichi, Gekigadō

Kiyotomo (fl. 1720s to 1740s): ukiyo-e print artist, probably a late pupil of Kiyonobu I. Kiyotomo's work greatly resembles that of his fellow-pupil Kiyonobu II, both in its strong points and its weaknesses.
*Torii Kiyotomo

497
Kiyotomo: *The Puppeteer Koheiji. Hosoban urushi-e*, ca. 1732

Kiyotsune (fl. ca. 1757–79): ukiyo-e print artist and illustrator, son of a publisher of theatrical programs; pupil of Kiyomitsu, but influenced as well by Harunobu
*Torii (Nakajima-ya), Daijirō
▷ p. 89, plate 82

498
Kiyotsune: *Circus Strong Woman. Hosoban*, ca. late 1760s

Kiyotsune: Noh drama featuring the Heike warrior Kiyotsune
Kiyoyasu (fl. ca. 1820s): ukiyo-e print artist, Kyōto School
Kiyoyoshi (1832–92): ukiyo-e painter and print artist, son of Kiyomitsu II. After his father's death in 1868 he became 6th-generation head of the Torii family, taking the name Kiyomitsu III
*Torii, Kameji, Eizō
kizuri-e: prints with yellow background
kō-awase: game involving the identification of types of incense
koban: format used for many different small print sizes, some 9×6¾ in./22.8×17.2 cm or smaller; often half of *aiban* or *chūban* size, the two halves being printed together from the same block and then divided
kobanashi-bon: books of anecdotal stories
Kōbō-daishi ▷ Kūkai

Kōchō (fl. early to mid 19th century): Shijō painter and illustrator; also did some genre work
*Ueda, Yūshū, Suiun

Kōchō (1830–?): *dōban* artist, studied with Bokusen in Nagoya
*Nakajō Kōchō

鴻台 **Kōdai** (fl. 1820s–40s): ukiyo-e painter, pupil (and patron) of Hokusai; resident of Obuse in Shinano Province
*Takai, Kōzan

Kōei (fl. second half 19th century). Kyōto ukiyo-e print artist, specializing in *surimono*

Koen (fl. ca. 1810s): ukiyo-e print artist and illustrator, Ōsaka School
*Ichirōsai

光悦 **Kōetsu** (1558–1637): leading Kyōto book designer, calligrapher, potter, lacquerer, landscape gardener and tea master. Collaborated with Suminokura Soan (1571–1632) in designing and publishing the *Kōetsu-bon,* deluxe editions of the Japanese classics.
*Hon-ami, Kōetsu [Kōyetsu], Jirosaburō, Jitokusai, Kūchūan, Yōhōsha, Taikyoan, Tokuyūsai
Wada, K. *Saga-bon-kō.* Tōkyō, 1916.
Kawase, K. *Kokatsuji-bon no kenkyū.* Tōkyō, 1944.
▷ p. 34, plate 16

Kōfu: capital of Kai province; formerly called Fuchū

Kogō: Noh drama featuring the courtier Nakaguni and Kogō-no-tsubone, the favorite of the Emperor Takakura

Kōgon-in (1313–64): *waka* poet and 1st Emperor of the Northern Court

耕漁 **Kōgyo** (1869–1927): neo-ukiyo-e print artist; his widowed mother married Yoshitoshi, under whom he studied; later, a pupil of Fūko and Gekkō
*Tsukioka (Hanyū), Sadanosuke, Kohan, Nenkyū

Kōgyō (1866–1919): Japanese-style painter and print artist; correspondent-artist during the Russo-Japanese War
*Terazaki, Kōgyō [Hironari], Norisato, Chūtarō, Shūsai, Sōzan [Shūzan], Tenrai-sanjin, Tōryūken

Kōgyū (fl. ca. 1720s–30s): ukiyo-e painter in the style of Chōshun; a neglected master of pre-Harunobu idealized *bijin-ga*
*Hozumi Kōgyū

499

Kōgyū: *Courtesan as Fugen.* Detail from a small *kakemono* painting in colors on paper, ca. 1730s

Koharu and **Jihei**: famous tragic lovers in Ōsaka, depicted in Chikamatsu's drama *Shinjū ten-no-amijima*

Kohitsu: a family of experts in works of art, among them: Ryūsa (1572–1662), Ryūnin (1614–77), Ryūei (1617–78), Ryūyū (1648–1687), Ryūchū (1656–1736), Ryūon (1664–1725), Ryūen (1704–74), Ryūe (1751–1834), Ryūhan (1790–1853), Ryūhaku (1836–62)

Koi-hakke hashira-goyomi: Kabuki play, commonly called *O-San Mohei,* the names of the two ill-fated lovers; originally written for the puppet theater by Chikamatsu in 1715.

Koi-hikyaku Yamato-ōrai: Kabuki play commonly called *Umegawa Chūbei,* the names of the two ill-fated lovers; the original puppet play was written by Chikamatsu in 1715.

Koi-minato Hakata no hitouchi: Kabuki play, commonly called *Kezori.* From Chikamatsu's puppet play of 1718, later adapted for the Kabuki stage, featuring Kezori, Sōshichi and his love Kojorō.

Koji-dan: a collection of historical and biographical anecdotes, 1212–15

Koji-ki: the first history of Japan, compiled in 711–12

Kōjin: deity of the kitchen

Kōka (1886–1942): neo-ukiyo-e painter, pupil of Gekkō
*Yamamura, Toyonari

弘化 **Kōka** (1844/45–1848): the Kōka Period, dating from XII/2/1844/45 to II/28/1848, witnessed the relaxation of the Tempō sumptuary reforms, as the government found itself confronted with an escalating restoration movement at home and foreign encroachment from overseas. The established masters of ukiyo-e—Hokusai, Hiroshige, Kunisada, Kuniyoshi, Eisen—continued their work but without any notable innovation. ▷ *nengō*

江漢
司馬
春重 **Kōkan** (1747–1818): ukiyo-e and Western-style painter and print artist; studied under Harunobu, Gennai, Sō-Shiseki; in 1783, the first Japanese artist to succeed at copperplate engraving. Suzuki Harushige (mid 1760s to 1770s) was the ukiyo-e nom de plume employed by Kōkan; he was a skilled imitator of Harunobu's style and (as he himself confessed in his diary) after Harunobu's sudden death in his prime, he affixed Harunobu's signature to a number of his own prints, which were accepted as genuine Harunobus by his contemporaries. Harushige's style is characterized by the influence of Western-style perspective, and his figures are often less delicate than Harunobu's.
*Shiba (Suzuki) Shun, Harushige, Kungaku,

春重

500

Harushige [Kōkan]: *Courtesan on Veranda.* Chūban, ca. 1771. The use of perspective and the calligraphy of the "Harunobu" signature are typical of these skilled forgeries.

Andō Kichijirō (Katsusaburō), Fugen-dōjin, Rantei, Shumparō
Nakai, Sōtarō. *Shiba Kōkan.* (in Japanese) Tōkyō, 1942.
French, Calvin L. *Shiba Kōkan.* Tōkyō, 1974. [Cf. the review by David Waterhouse in *Monumenta Nipponica,* 1976.]
Lane, Richard. *Studies in Ukiyo-e.*
▷ p. 110, plate 99

501

Kōkan: *View of Ocha-no-mizu.* Large-*ōban, dōban* with hand-coloring, 1784 (title in reverse)

kokatsuji-bàn: early books printed using movable type, ca. 1590 to 1650

kōken: tutor of the shōgun

Kokin-shū: the first Imperial verse anthology, A.D. 905–913

Kokkadō (fl. 1770s): ukiyo-e print artist, Kyōto School

滑稽本 **kokkei-bon**: comic novels of the later Edo period

Kōko (1875–1912): traditional Japanese painter
*Takahashi (Urata), Kyūma

Kōkō (fl. ca. 1770): ukiyo-e print artist, Kamigata School
*Namioka, Hōshi [Yoshiko]

Kokon chomonjū: famous collection of short Japanese tales, 1254

koku: unit of about 5 bushels for measuring rice, used to calculate the annual stipends of samurai

Kokubun-ji: name given to the major provincial temples

国姓爺 **Kokusenya-gassen**: Kabuki play, originally written for the puppet theater by Chikamatsu in 1715, featuring the famous hero Coxinga

Kōkyō (1864–1915): Shijō-style painter, did some genre work
*Taniguchi (Tsuji), Tsuchinosuke

kokyū: the Japanese violin

koma-asobi: top-spinning

koma-biki: annual ceremony in which horses were presented to the Emperor in Kyōto

小町 **Komachi Ono no**: famous *waka* poetess and beauty of the early Heian Period
▷ nana-Komachi

koma-e: pictorial cartouche within a print

Koman: valiant woman of Ōmi who rescued a Genji leader's wife and saved the banner of the clan

Kōmei: the Japanese name for the celebrated Chinese sage and general Chu-ko Liang

Komparu: family of Noh actors, among them: Ujinobu (1316–1401), Toyouji (d. 1458), Yasuteru (d. 1628), Kunihisa (1680–1828), Hiroshige (d. 1896)

kompekiga: screen paintings on gold foil background

komuro-bushi: packhorse leader's chant

komusō [*komosō*]: mendicant Buddhist min-

strels, priests of the Fuke-shū, a branch of Zen, who wore straw hats and played the *shakuhachi*

Kongō: family, famous for performing the Noh drama, to which the actor Shinroku (1507–1576) belonged

Konjaku monogatari-shū: a collection of some 1100 stories, late 11th century

小信 **Konobu** (fl. later 19th century): Ōsaka ukiyo-e print artist, son and pupil of Sadanobu
*Hasegawa, Sadanobu II

Konohana-sakuya-hime: a Shintō goddess, the deity of Mt. Fuji

Ko-ochikubo: a stepchild tale, probably 15th century

Ko-otoko no sōshi: a tale of adventures akin to Tom Thumb, probably 15th century

Korenori, Sakanoue no (10th century): classical *waka* poet

kōro: incense burner

湖竜斎 **Koryūsai** (fl. mid-1760s to 1780s): leading ukiyo-e painter, print artist and illustrator. Originally a samurai in the service of the lord of Tsuchiya, who relinquished his rank, moved to Edo and became an ukiyo-e artist. Though possibly a pupil of Shigenaga, he was most influenced by his friend Harunobu, and his first works employed the derivative name Haruhiro. The best of his early prints reach the level of Harunobu's, and some critics consider Koryūsai's work in the pillar-print and shunga categories among the glories of ukiyo-e. Koryūsai's later prints are more massive and feature the elaborate coiffures then developing in the pleasure quarters. In the 1780s Koryūsai abandoned popular prints and devoted himself to production of the more prestigious ukiyo-e paintings.
*Isoda, Koryūsai [Koriūsai], Koryū, Haruhiro, Masakatsu, Shōbei

502 a, b

Koryūsai: *Hashira-e,* ca. early 1770s (left: *Outside Women's Bathhouse;* right: *Girl Watching Boy Playing Kick-ball*)

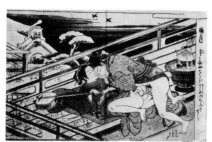

503

Koryūsai: *Veranda Love Scene,* from *Fūryū juniki-no eiga,* a series of *chūban* shunga prints on the Twelve Months of the Year, ca. 1774

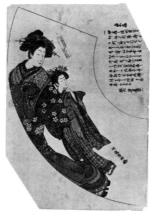

504

Koryūsai: *The Courtesan Hanaōgi and Maidservant.* Large-*ōban* fan print, from the series *Azuma-ōgi,* ca. 1778

Some print series by Koryūsai:

1 *Fūryū yatsushi musha-kagami,* ca. 1767
2 *Edo irozato hakkei,* ca. 1770
3 *Fūryū jinrin mitate hakkei,* ca. 1770
4 *Fūryū jūni-shi,* ca. 1770; ca. 1771
5 *Azuma-no-sato eiga hakkei,* ca. 1771
6 *Fūryū juni-setsu,* ca. 1771
7 *Fūryū meisho-kagami,* ca. 1771
8 *Fūryū mitsu-no-hajime,* ca. 1771
9 *Fūryū rokkasen,* ca. 1771
10 *Fūryū Yamato nijūshi-kō,* ca. 1771
11 *Fūryū jūni-tsuki,* ca. 1772
12 *Fūryū kodomo-asobi ongaku-hichiriki,* ca. 1772
13 *Fūryū kodomo-jūni-shi,* ca. 1772
14 *Fūryū mitate iro-buyū,* ca. 1772
15 *Fūryū mu-Tamagawa,* ca. 1772
16 *Fūryū Shinagawa hakkei,* ca. 1772
17 *Haikai myōto-maneemon,* ca. 1772 [see plate 103]
18 *Fūryū kyōgen-zukushi,* ca. 1773
19 *Fūryū nana-Komachi,* ca. 1773
20 *Fūryū shogei-zukushi,* ca. 1773
21 *Fūryū yatsushi-Genji,* ca. 1773
22 *Edo meisho jūni-tsuki,* ca. 1774
23 *Fūryū go-kotohajime,* ca. 1774
24 *Seirō meifu hakkei,* ca. 1774
25 *Ukiyo rikugei-yatsushi,* ca. 1774
26 *Fūryū ryaku-gojō,* ca. 1775
27 *Seirō geiko niwaka-kyōgen,* ca. 1775
28 *Seirō niwaka-kyōgen/Seirō niwaka kyōgen-zukushi,* ca. 1775
29 *Seirō tokiwa-nishiki,* ca. 1775
30 *Fūzoku kenjin-ryaku,* ca. 1776
31 *Imayō-fūzoku rokkasen,* ca. 1776
32 *Seirō ryaku nana-Komachi,* ca. 1776

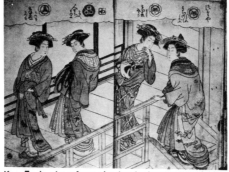

505

Koryūsai: plate from the book *Azuma-no-nishiki-tayū-no-kurai,* 1777

33 *Ukiyo mu-Tamagawa,* ca. 1776
34 *Fūryū kinki-shoga,* ca. 1774; ca. 1777
35 *Fūryū ryaku-go-sekku,* ca. 1777
36 *Hokkaku jūni-moyō,* ca. 1777
37 *Azuma-ōgi,* ca. 1778
38 *Fūryū Edo hakkei,* ca. 1778
39 *Hinagata wakana no hatsumoyō,* late 1770s

Important illustrated books by Koryūsai include:

Azuma-no-nishiki tayū-no-kurai, (2 vols. 1777)
Ehon yakusha-tekagami (1 vol., 1779)
Konzatsu Yamato-sōga (3 vols., 1781)
Hokuri-no-uta (1 vol., ca. 1784)

● Gentles, Margaret O. with Richard Lane and Kenji Toda. *The Clarence Buckingham Collection of Japanese Prints: Harunobu, Koryūsai, Shigemasa, Their Followers and Contemporaries.* Chicago, 1965.
▷ pp. 111–114, plates 100–105

Kōshi: Confucius (551–479 B.C.)

Koshibagaki-zōshi [The Brushwood Fence Scroll]: a famous early shunga scroll, also known as *Kanjō no maki* [The Initiation Scroll]
Lane, Richard. *Erotica Japonica: Masterworks of the Shunga Scroll.*

506

From *Koshibagaki-zōshi.* Woodblock print in shades of *sumi,* by Maruyama Ōshin; copied from an early original in the artist's collection (from the *Kagetsujō* of 1836, an album of plates in chiaroscuro manner by leading Kanō, Tosa, Maruyama, Shijō and other neo-classical artists, after early shunga models)

kōshi-jorō: middle rank of courtesan

Ko-Shikibu-no-naishi (early 11th century): daughter of Izumi-shikibu and noted *waka* poetess in her own right

koshimoto: lady-in-waiting

Kōshin: festival and night vigil (*Kōshin-machi*)

koshō: boy or girl attendant to a noble person

Kōshoku ichidai-otoko: the first of the ukiyo-zōshi [floating-world novels] by Saikaku, published late in 1682

Koshū (1760–1822): Maruyama-School painter, did some genre work
*Hatta [Yata], Kiken, Shiei, Kunai

Kōshu-kaidō: highway from Edo to Kōfu (86 miles/139 km long)

Kosode Soga: Noh drama featuring the Soga Brothers

ko-tanzaku: narrow print size, about 13½× 3 in./34.5×7.6 cm (*aiban* cut into three longitudinally)

kotatsu: a framed foot-warmer

koto: a long lute, played with ivory plectra

Kotō (b.1869): neo-ukiyo-e painter, studied under Yoshitoshi, Kumagai Naohiko and Arihara Kogan
*Yamanaka (Satō), Kotō [Kodō]

kotobuki: felicitations, congratulations

Kotobuki Soga no taimen: Kabuki play, written by Ichikawa Danjūrō I, featuring the Soga Brothers

kotohajime: day of starting some traditional activity

Kotohira (Kompira)jinja: major Shintō temple at Sanuki in Shikoku, especially revered by seamen and travelers

Kotomichi, Ōkuma (1798–1868): *waka* poet of the late Edo Period

kōtō-no-naishi: lady superintendent of the Imperial Court

kotoro-kotoro: game of follow-the-leader

Kō-u: Noh drama featuring the Chinese Lady Gu-shi (Yu Chi), wife of General Kō-u (Hsiang Yu)

Kōun (Nagachika) (d. 1429): *waka* poet and scholar of the Northern and Southern Court and early Muromachi Periods

kouri: term for "retail"; also, "a retailer"

kouta Ryūtatsu: melancholy songs composed by Takasabu no Ryūtatsu (1527–1611)

Kōwaka-mai: medieval dramatic dances

Kōya-ban: early Buddhist printed texts at the Mt. Kōya temples

ko-yaku: children's roles in the theater

Kōya-san [Takano-yama]: Mt. Koya in Kii, famous for its numerous Shingon Buddhist temples; a place of exile for persons of rank; the tombs of Kōbō-daishi, Atsumori, Naozane, Shingen, Mitsuhide, among others, are preserved there

Kōyō gunkan: a work on political and military science, 1656

Kōyō, Ozaki (1868–1903): noted popular novelist of the Meiji Period

ko-yotsugiri: print size, about 6¾×4½ in./ 17.2×11.4 cm (*aiban* cut into quarters)

Kōzan (early Meiji): *dōban* artist
*Ejima Kōzan

kōzo: plant fibre, used in making paper for prints

kubari-bon: privately printed books or albums

kubi-hiki: neck-pulling contest

kubi-jikken: inspection (and identification) of the severed head (after an execution scene in Kabuki)

Kūblai-Khan (1215–94): Mongol ruler who sent (in 1280) against Japan an expedition of 100,000 Mongolians and 10,000 Koreans, most of whom perished in a tempest at sea

Kudara: the ancient kingdom of Korea

kudari: traveling from the Kyōto/Ōsaka region to Edo

Kudayū: minor villain of the *Chūshingura*
▷ *Kana-dehon Chūshingura*

kuge: court aristocracy

kuiki: *kentō* adjustment in woodblock printing

Kujūkuri-no-hama: beach on the eastern coast of Kazusa and Shimōsa

Kūkai (774–835): monk, founder of the Shingon Sect and of the Mt. Kōya temples; said to have invented the Japanese *hiragana* syllabary, and the alphabetic *iroha-uta,* a poem composed of 47 syllables; posthumous name: Kōbō-daishi

kuma-dori: elaborate and dramatic make-up for *aragoto* roles in Kabuki

Kumano: southeastern part of Kii Province

Kumano-jinja: the 3 great shrines of Kumano (*Kumano no san-zan*); also, the Kyōto branch-shrine

Kumano no honji: a Buddhist tale treating of previous incarnation, probably 15th century

Kumasaka: Noh drama featuring Kumasaka Chōhan (a brigand killed by the young Ushi-waka)

久米 **Kume-[no]-sennin:** a Japanese immortal possessed of levitation powers, often depicted falling from the clouds, dumbstruck from looking at the reflection of a pretty laundry-girl's legs in a stream

kumi-uta: song-suite, with samisen or *koto*

国明 **Kuniaki** (fl. ca. 1850s): ukiyo-e print artist, samurai by birth; pupil of Kunisada
*Hirasawa Kuniaki

Kuniaki II (1835–88): ukiyo-e print artist, younger brother of Kuniaki; in 1844 he became a pupil of Kunisada. Noted for his prints of actors, *sumō* wrestlers and Yokohama Prints.
*Hachisuka (Hirasawa), Ippōsai, Onojirō, Hōsai

国周 **Kunichika** (1835–1900): ukiyo-e print artist, pupil first of Chikanobu, then of Kunisada
*Toyohara (Arakawa), Yasohachi, Beiō, Hōshunrō, Ichiōsai, Kachōrō, Shima-sanjin, Sōgenshi

国房 **Kunifusa** (fl. ca. 1810s–1830s): ukiyo-e painter and print artist, pupil of Toyokuni
*Utagawa, Tasaburō, Tsurukichi

Kunifusa (fl. ca. 1860s): Kyōto ukiyo-e print artist (mainly, *kappa-zuri*)

Kunihira (fl. ca. 1810s): ukiyo-e print artist, Ōsaka School, pupil of Kunihiro

国春 **Kuniharu** (fl. ca. 1820s–30s): ukiyo-e print artist and actor, Edo/Ōsaka School, studied under Toyokuni II; stage name of the actor Arashi Tokusaburō

国晴 *Gyokuyōtei, Samputei, Gusoku-ya Sahei, Arashi

Kuniharu (fl. ca. 1840–50s): ukiyo-e print artist, Ōsaka School
*Jirai-ya II, Ikkōsai

国広 **Kunihiro** (fl. ca. 1810s): ukiyo-e print artist, pupil of Toyokuni; said to be the *nom d'artiste* of the Lord of Hyūga, *daimyō* of Kameyama

Kunihiro (fl. ca. 1820s–30s): ukiyo-e print artist, pupil of Toyokuni II.
*Utagawa Kunihiro

Kunihiro (fl. ca. 1820s–30s): ukiyo-e print artist, worked both in Edo and Ōsaka
*Utagawa (Takigawa), Ganjōsai, Kōnantei, Sanshōtei
▷ Ōsaka-Print School

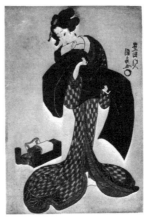

507

Kunihiro: *Geisha Tying Obi. Ōban,* ca. early 1810s

国久 **Kunihisa** (fl. ca. 1800s–10s): ukiyo-e painter and print artist, early pupil of Toyokuni
*Utagawa Kunihisa

Kunihisa II (1832–91): ukiyo-e print artist, pupil and son-in-law of Kunisada
*Katsuda, Hisatarō, Ichiunsai, Ritchōrō, Toyonobu, Yōryūsai, Yōsai

国景 **Kunikage** (fl. ca. early 1830s): ukiyo-e print artist, Ōsaka School

*Utagawa, Eisai, Kimparō, Kimpasai, Ichieisai, Ichirōsai

国員 **Kunikazu** (fl. ca. 1850s–60s): ukiyo-e print artist, pupil of Kunisada
*Utagawa Isshusai

国清 **Kunikiyo** (fl. early 19th century): ukiyo-e painter and print artist, pupil of Toyokuni. A petty official of the shogunate, who for reasons unknown was exiled to Hachijō-jima
*Utagawa (Emori), Yasuzō, Ichirakusai, Shōgyo

Kunikiyo II (fl. mid 19th century): ukiyo-e painter and print artist, pupil of Kunisada
*Utagawa, Ichirakusai, Shōgyorō

Kunimaro (fl. late 18th century): ukiyo-e print artist, pupil of Toyomaru
*Kusamura Kunimaro

国麿 **Kunimaro** (fl. ca. 1850–75): ukiyo-e print artist, pupil of Kunisada
*Utagawa (Kikkoshi), Kikutarō, Ichiensai, Kikuō, Shōchōrō

508

Kunimaro: *Caged Tiger. Ōban,* dated 1860 (a Yokohama Print, showing the first tiger exhibited in Japan)

Kunimaro II (fl. ca. 1860s): ukiyo-e print artist, pupil of Kunimaro
*Yokoyama, Kinji, Ichiensai, Kikusai

国丸 **Kunimaru** (1794–1829): ukiyo-e painter and print artist, son of an Edo pawnbroker; pupil of Toyokuni
*Utagawa (Maeda), Bunji, Ise-ya Ihachi, Gosairō, Honchōan, Ichiensai, Keiuntei, Saikarō

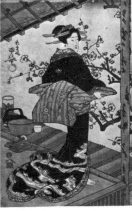

509

Kunimaru: *Geisha on Veranda. Ōban,* one sheet of a triptych, ca. early 1820s

国政 **Kunimasa** (1773–1810): leading ukiyo-e painter, print artist; a native of Aizu, first apprenticed to a dyer, he eventually became the favorite pupil of Toyokuni. Kunimasa's earliest prints date from 1795; he excelled in actor portraits, which strove to combine the intensity of Sharaku with the decorative grace of his master Toyokuni.

*Utagawa, Jinsuke, Ichijusai
▷ p. 152–153, plates 158–160

510

Kunimasa: *Noshio II as Sakura-maru. Ōban*, 1796

511

Kunimasa: *Danjūrō VI in* Mie *Pose. Ōban*, ca. 1796

512

Kunimasa: *Yaozō III and Omezō. Ōban*, 1799

国升 **Kunimasu** (fl. ca. 1830s–40s): Ōsaka ukiyo-e print artist, pupil of Kunisada
*Utagawa, Sadamasu (to 1848), Kanaya, Wasaburō, Gochōsai, Gochōtei, Ichijuen, Ichijutei

国松 **Kunimatsu** (fl. mid-late 19th century): ukiyo-e print artist, pupil of Toyokuni II and of his father, the Ōsaka print artist Kunitsura
*Utagawa, Toyoshige, Ichiryūsai, Fukudō

国満 **Kunimitsu** (fl. 1800s–10s): ukiyo-e print artist and illustrator; pupil of Toyokuni
*Utagawa, Kumazō, Ichiōsai

国盛 **Kunimori** (fl. ca. 1820s–30s): ukiyo-e print artist, pupil of Toyokuni II
*Utagawa, Kochōan

Kunimori II (fl. ca. 1850s): ukiyo-e print artist, pupil of Kunisada
*Utagawa, Ichireisai, Ichiryūsai, Ippōsai, Shungyōsai

国宗 **Kunimune** (fl. ca. 1810s): ukiyo-e print artist, pupil of Toyokuni
*Utagawa (Yamashita), Matsugorō, Chōbunsai, Sanrei

Kunimune II (fl. 1830s): ukiyo-e print artist, pupil of Toyokuni
*Utagawa, Chōbunsai, Kunimasa II

国長 **Kuninaga** (d. 1829): ukiyo-e painter, print artist, pupil of Toyokuni
*Utagawa, Kayanosuke, Ichiunsai

513

Kuninaga: *Bridge of Babylon. Ōban*, ca. 1820s

国直 **Kuninao** (1793–1854): ukiyo-e painter, print artist and illustrator; first studied Ming painting, then ukiyo-e under Toyokuni; later, follower of Hokusai
*Utagawa (Kikkawa), Taizō, Shirobei, Dokusuisha, Enryūrō, Gosoen, Ichiensai, Ichiyōsai, Ryūendō, Sharakuō, Shashinsai, Tōuntei, Ukiyoan

514

Kuninao: *Summer Domestic Scene. Ōban,* censor's seal of 1811

Kuninao (fl. mid 1820s): ukiyo-e print artist, Ōsaka School
*Eisen, Yanagawa, Eisensai

国信 **Kuninobu** (fl. 1770s — early 1780s): ukiyo-e print artist in the manner of Harunobu. Kuninobu's work is typical of several obscure but skilled artists in the Harunobu style who attempted to fill the gap caused by that master's early death in 1770.

515

Kuninobu: *Lovers under Willow. Hashira-e,* early 1770s

Kuninobu (fl. mid 1810s–30s): ukiyo-e print artist, pupil of Toyokuni
*Kaneko, Yashirō (Sōjirō), Ichireisai, Ichiyōsai, Isekirō, Yōgakusha, Shima-sanjin

Kuninobu (fl. ca. 1860s): ukiyo-e print artist, pupil of Kunisada
*Utagawa (Tanaka), Chūjun

Kuniomi, Hirano (1827–64): *waka* poet of the late Edo Period

国貞
五渡亭
国貞 **Kunisada** (1786–1865): leading ukiyo-e painter, print artist, illustrator. At 15 he became a pupil of Toyokuni under the name Kunisada; in 1807, he produced his first book illustrations, in 1808 his first actor prints; from 1833 he studied the style of Itchō under Hanabusa Ikkei, taking the name Kōchōrō; in 1844 he took over the studio name of Toyokuni. Kunisada was Toyokuni's third notable pupil and one of the leading artists of his day. The general decline of grace and quality in 19th-century figure work is epitomized in his prints, but occasionally in his *surimono* and his early prints of girls or actors he achieves distinction, and in his rare landscapes are some of the most striking works of the period.

516

Kunisada: *Girl in Snow.* Ōban, from the series *Nana-Komachi,* ca. 1810s

517

Kunisada: *Girl with Infant.* Ōban, from the series *Edo jiman,* ca. late 1810s

518

Kunisada: *Danjūrō VII as Kan-Shōjō.* Ōban, ca. 1814 (from the same series as plate 189)

519

Kunisada: *Courtesan at Toilette.* Ōban, from the series *Tōsei sanjūni-sō,* ca. early 1820s

色の詠

520

Kunisada: *The Uses of Shunga.* Illustration to *Shiki-no-nagame* [Views of the Exotic Seasons]. *Ōbon,* ca. 1827 (in the background, the shunga scroll's box; on the right, a smoking stand with filed love letters)

521

Kunisada: *Landscape in Mist.* Ōban, ca. 1830s

522

Kunisada: *Landscape in Summer Rain.* Oban, ca. 1830s

 *Utagawa (Tsunoda), Shōzō, Fubō-sanjin, Fu-chōan, Gepparō, Gototei, Hokubaiko, Ichiyūsai, Kinraisha, Kōchōrō, Shōzō, Tōjuen, Toyokuni II. Kunisada's illustrations include *Nise-Murasaki inaka-Genji* (160 vols., 1829–42), *Yakusha-sugao natsu-no-Fuji* (2 vols., 1828) and *Yakusha kijin-den* (4 vols., 1838).

Hayashi, Yoshikazu. *Empon kenkyū: Kunisada.* (in Japanese) Tōkyō, 1960.

Ushiyama, Mitsuru. *Kunisada fūzoku-ga hyakusen.* (in Japanese) Tōkyō, 1976.

▷ pp. 186–187, plate 189

Kunisada II (1823–80): ukiyo-e print artist, pupil of Kunisada. At first he signed his prints Baidō Kunimasa III or Kunimasa; in 1846 he married his master's daughter, taking the names Kunisada II, Kōchōrō and Ichijusai; from about 1870, after Kunisada's death, he used the name Toyokuni III [actually, IV].

*Utagawa (Takenouchi), Munehisa, Masakichi, Seitarō, Baidō, Hōraisha, Ichijusai, Ichiyōsai, Kōchōrō, Kunimasa III, Toyokuni III

Kunisada III (1848–1920): ukiyo-e print artist, pupil of Kunisada II

*Utagawa (Takenouchi), Hidehisa, Baidō Hōsai, Kōchōrō, Kunimasa IV, Toyokuni IV

国
郷 **Kunisato** (d. 1858): ukiyo-e print artist, pupil of Kunisada

*Utagawa, Masajirō, Ichiyōsai, Rissensai

Kunitada (fl. ca. 1850s): ukiyo-e print artist, Ōsaka School

*Utagawa Kunitada

国
照 **Kuniteru** (1808–76): ukiyo-e print artist, studied first under Kunisada, then under Toyokuni; began to use the name Kuniteru from about 1844

*Utagawa (Yamashita), Hikosaburō, Jin-emon, Sōemon, Ban-an, Kinshō-tōkei, Kōbairō, Nao-teru

Kuniteru (fl. mid 19th century): ukiyo-e print artist, pupil of Kunisada; first used the name Sadashige, later Kuniteru

*Utagawa (Ōta), Kinjirō, Dokusuisha, Gochō-tei, Ichiyūsai, Sadashige, Shinteitei, Yūsai

Kuniteru (fl. early Meiji): ukiyo-e print artist, pupil first of Kunisada, then of Kunichika

*Utagawa (Okada, Toyohara), Tōshirō, Ichiyūsai

国
輝 **Kuniteru II** (1829–74): ukiyo-e print artist, pupil of Kunisada

*Yamada, Kunijirō, Ichiyōsai, Ichiyūsai, Kunitsuna II, Sadashige, Yōsai

国
富 **Kunitomi** (fl. ca. 1810s–30s): ukiyo-e print artist, pupil of Toyokuni II

*Utagawa, Kasentei, Tominobu

国
虎 **Kunitora** (fl. ca. 1810s–30s): ukiyo-e print artist, pupil of Toyokuni; left some interesting landscape prints in pseudo-Western style

*Utagawa (Maeda), Bokunenjin, Ichiryūsai

523

Kunitora: *View of Katada.* Aiban, from a set of *Eight Views of Lake Biwa,* ca. early 1820s

524

Kunitora: *The Colossus of Rhodes.* Ōban, ca. late 1820s

国
利 **Kunitoshi** (fl. 1847–99): ukiyo-e print artist, pupil of Kunisada and of Kunitsugu
*Utagawa Kunitoshi

Kunitsugu (1800–61): ukiyo-e print artist, pupil of Toyokuni
*Utagawa (Nakagawa), Kōzō, Ichiōsai, Ōshōtei

Kunitsuna (1805–68): ukiyo-e painter, print artist, pupil of Toyokuni
*Utagawa Kunitsuna

Kunitsuru (fl. ca. 1830s): ukiyo-e print artist, pupil of Toyokuni II; also visited Ōsaka
*Utagawa, Ichijusai

国
安 **Kuniyasu** (1794–1832): ukiyo-e print artist, pupil of Toyokuni
*Utagawa (Nishikawa), Yasugorō, Yasujirō, Ippōsai

國
安

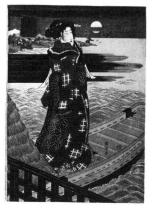

525

Kuniyasu: *Harlot on Boat.* Ōban, from a series of 3 prints, ca. mid. 1810s

国
芳 **Kuniyoshi** (1798–1861): leading ukiyo-e painter, print artist, illustrator; trained first in the family craft of dyer, then was probably a pupil of Shun-ei, later of Toyokuni; also studied Tosa, Kanō and Maruyama-School painting, and was influenced as well by Kuninao. Kuniyoshi was hardly mentioned by the older critics but is now generally recognized as one of the outstanding figure designers of the latter days of ukiyo-e, a skilled landscapist and an interesting experimentalist in the harmonious fusion of Japanese and Western styles.
*Utagawa (Igusa), Magosaburō, Taroemon, Chōōrō, Ichiyūsai, Ryūen

SAMPLE KUNIYOSHI SIGNATURES:

ca. 1827 ca. 1836 ca. 1842 ca. 1852

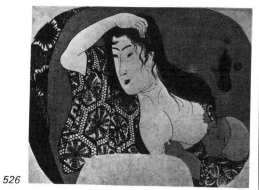

526

Kuniyoshi: *Mother with Infant.* Aiban fan print, ca. mid 1840s (cf. Utamaro's "Shell Divers," in figure 686)

527

Kuniyoshi: *Chūshingura: The Night Attack.* Ōban, ca. 1830

Print series by Kuniyoshi:
(Dating and numbering generally follow that of B. W. Robinson's useful *Kuniyoshi,* which is arranged by such categories as Early Work, Landscapes, Heroic, Women and Children, the *Chūshingura,* Women, Theatrical, Comic, Miscellaneous. Size is *ōban* unless otherwise noted. Number at end indicates known or surmised designs in each series.)

1 *Shokoku meisho-zuga,* ca. 1820
2 *Tōryū onna shorei shitsuke-kata,* ca. 1830 (7+)
3 *Tsūzoku-Suikoden gōketsu hyakuhachi-nin no hitori,* 1827–30 (108)
4 *Suikoden gōketsu hyakuhachi-nin,* ca. 1830 (12)
5 *Honchō-Suikoden gōyū happyaku-nin no hitori,* ca. 1830–45 (25+)
6 *Tsūzoku-Suikoden gōketsu hyakuhachi-nin no uchi, chūban,* ca. 1845–50 (9+)
7 *Tōto...* [prefix], ca. 1833 (5)

528

Kuniyoshi: *Scene at Shubi-no-matsu.* Ōban, from a series with the prefix *Tōto*

8 *Tōto meisho,* ca. 1834 (10)

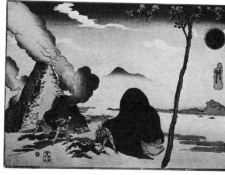

529

Kuniyoshi: *Tile Kilns at Imado.* Ōban, from the series *Tōto meisho*

530

530a

Kuniyoshi: *Moonlight outside the Yoshiwara.* Ōban, from the series *Tōto meisho* (alternate states, lower example trimmed at margins)

9 *Tōto Fuji-mi sanjū-rokkei,* ca. 1843 (5) [see plate 191]
10 *Tōkaidō gojūsan-eki rokushuku meisho,* ca. 1835 (12)

高
祖
御
一
代
略
図

11 *Kōso goichidai ryakuzu,* ca. 1835–36 (10)

531

Kuniyoshi: *Priest in Snow.* Ōban, from the series *Kōso goichidai ryakuzu*

171 *Kōto-nishiki imayō kuni-zukushi,* 1852 (30?)
172 *Date-otoko kishō-kurabe,* ca. 1850 (4+)
173 *Satomi Hakkenden,* 1852 (8)
174 *Date-moyō kekki-kurabe,* ca. 1845
175 *Yakusha-kidori hiiki-biiki,* ca. 1840 (5+)
176 *Yakusha kodakara-awase,* 1842
177 *Omou-koto kanou Fukusuke,* ca. 1845
178 *Ōmi hakkei,* ca. 1851 (8)
179 *Nitakaragura kabe no mudagaki,* 1847 (6)

533

Kuniyoshi: *Scribbling on the Storehouse Wall.* Ōban; one of a series

180 *Dōke-miburi juni-shi,* ca. 1848 (3)
181 *Nanatsu iroha Tōto Fuji-zukushi,* 1852
182 *Haku-mensō kabe no mudagaki,* ca. 1848 (3) [companion series to 179 above]
183 *Kaiun shusse gattai shichi-fukujin,* ca. 1844
184 *Kyōkaku giyū-den,* ca. 1851
185 *Tōsei-mitate ningyō no uchi,* 1855–56; diptychs and triptychs (12?)
186 *Kawanaka-jima hyakuyūshōsen no uchi,* ca 1845
187 *Tōto ryūkō sanjū rokkaiseki,* 1852 (36?)
188 *Koma-kurabe shōgi no tawamure,* ca. 1840
189 *He-no-yōna dōke hezukushi,* ca. 1845
190 Variant of 124
191 *Dōke Daruma-asobi,* 1847–48
192 *Mitade juni-shi no uchi,* 1852 (12)
193 *Sankai meisan-zukushi,* 1833 (10)
194 *Fukurokuju atama no tawamure,* ca. 1840 (6+)
195 *Ryūkō dōke koma-zukushi,* ca. 1843
196 *Neko no ateji,* ca. 1842 (4+)
197 *Ryūkō neko no tawamure,* 1847
198 *Tatoe-zukushi no uchi,* ca. 1850
199 *Jimbutsu kami-kuzu-kago,* ca. 1848
200 *Mitate hyakunin-sō,* 1847
201 *Neko no hyaku-menso,* fan prints, ca. 1840
202 *Hyaku iro-banashi,* 1849–51 (6+)
203 *Sumida-gawa shichi-fukujin no uchi,* 1853
204 *Hizakurige gojūsan-eki,* 1854; diptychs and triptychs
205 *Soga monogatari no uchi,* 1854
206 *Chūshin giyū-kagami,* 1852 (47?)
207 *Harimaze jōruri-kagami,* 1854 (4+)
208 *Ichiryū-kyoku-dokuraku,* ca. 1843 (6+)
209 *Tanuki no...* [prefix], ca. 1842
210 *Edo-meisho-mitate jūnikagetsu no uchi,* 1852 (12)
211 *Miburi jūni omoi-zuki,* 1847–48 (5)
212 *Ōtsu-e hakkei,* fan-prints, 1849–51 (8)

213 *Setsugekka no uchi,* fan prints, 1849–51 (3)
214 (*Fuji hatazao*) *Hayatake Torakichi,* 1857
215 *Dōke jōruri-zukushi,* 1855
216 *Myōna-isō kyōchū gojūsan-tsura,* 1847–48 (9?)
217 *Imayō hyakunin-shū,* 1850
218 *Jūnidan-tsuzuki Kana-dehon Chūshin-gura,* 1852 (12)
219 *Enchū hassen-ka,* fan prints, ca. 1845 (8)
220 *Jikken onna-ōgi, chūban,* ca. 1843 (10)
221 *E-kyōdai mitate,* fan prints, 1847–50
222 *Kyōga e-dehon,* 1859
223 *Setsugekka no uchi,* 1853
224 *Tōkaidō gojūsan-tsugi,* 1860 [with Hiro-kage] (55?)

Illustrated books by Kuniyoshi include:
Ichiyū gafu (1 vol., 1820)
Ichiyūsai gafu (1 vol., 1846)
Kanjaku tsuizen hanashi-dori (1 vol., 1852, with Kunisada and others)
Ansei kemmon-shi (3 vols., ca. 1858–59)
Inoue, Kazuo. *Kuniyoshi.* (in Japanese) Kyōto, 1930.
● Robinson, B.W. *Kuniyoshi.* London, 1961. [Cf. our corrections in *Monumenta Nipponica* 1963, reprinted in *Studies in Edo Literature and Art.*] German adaptation, with different illustrations: *Kuniyoshi: Ein Meister des Japanischen Farbholzschnittes.* Essen, 1963.
Hayashi, Yoshikazu. *Empon konkyū: Kuniyoshi.* (in Japanese) Tōkyō, 1964.
▷ pp. 187–89, plates 190–191

Kuniyoshi (fl. 1850s): ukiyo-e print artist, Kyōto School

Kuniyuki (fl. mid 19th century): ukiyo-e painter and print artist, pupil of Kuninobu and Toyokuni
*Utagawa Kuniyuki

Kunō-zan: hill near Shizuoka, the Shōgun Ieyasu's place of retirement

Kurama-dera: temple north of Kyōto, where Ushiwaka-maru (Yoshitsune) was confined while a child

Kuramae: a section of Edo at Asakusa, noted for its rice storehouses

Kurama Tengu: Noh drama featuring the Goblin Chief and Ushiwaka

kurogo: stagehand

黒本 **kuro-hon** [black books]: picture novelettes printed on coarse paper with every page illustrated, ca. 1720s–60s, often by Torii artists

Kuronushi, Ōtomo no (late 9th century): *waka* poet of the early Heian Period

Kurotani: temple northeast of Kyōto

廓 **kuruwa:** the licensed entertainment quarter of a town

Kuruwa bunshō: Kabuki play more commonly called *Yūgiri Izaemon,* the names of the two lovers involved; written by Chikamatsu in 1679 for the leading Kamigata actor Tōjūrō

Kurozuka: Noh drama featuring an angry demon, who is overcome by Buddhist incantations

Kusatsu: village in Ōmi, junction of the Tōkaidō and Naka-sendō highways

Kusatsu: village in Kōzuke renowned for its hot springs

草雙紙 **kusa-zōshi:** generic name for picture novels: *aka-hon, kuro-hon, ao-hon, kibyōshi*

kusazuri-biki [pulling off the skirt of armor]: an incident from the Soga Brothers drama

kusa-zuri-e [*rokushō-e*]: prints in green and yellow

Kusu-no-tsuyu: Noh drama featuring Kusunoki Masashige and his son Masatsura

Kuzu-no-ha: the legendary fox-wife of Abe

no Yasuna; often depicted with a writing brush in her mouth

kwa: archaic spelling of *ka* (e.g., Kwaigetsudō)

kyara: wintergreen oil used for hairdressing

kyōdai: a mirror stand

京伝政演 山東 **Kyōden** (Masanobu) (1761–1816): ukiyo-e painter, print artist, illustrator and novelist. Under the name Kitao Masanobu, Kyōden was the most precocious of Shigemasa's several brilliant pupils and might well have developed into the stature of a Kiyonaga had he continued to work in the print field. But the rewards of the print designer were seldom financial, and after the success in 1785 of his novelette *Edo-umare uwaki no kabayaki,* he chose to devote most of his later life to fiction-writing under the name Santō Kyōden and to running his shop, which sold tobacco pouches and pipes with great success. Kyōden produced few prints, but his remarkable album of the Yoshiwara beauties, *Yoshiwara keisei shin-Bijin-awase jihitsu-kagami,* has served to win him a place in any selection displaying the wonders of the Japanese color print. [In Japanese characters his name is written quite differently from that of the pioneer Okumura Masanobu; to distinguish the two in romanization, the form K. Masanobu is sometimes used for the later artist, but we have chosen to use his other, equally well-known nom de plume, Kyōden.]

政演 吉原傾城新美人合自筆鏡

*Kitao Masanobu, Santō Kyōden, Iwase (Haida), Sei, Yūsei, Denzō, Jintarō, Rissai

Kyōden's other important illustrative work includes: *Azuma-buri kyōka-bunko* (1 vol.,1786) and *Kokon kyōka-bukuro* (1 vol., 1787).
▷ pp. 128–29; plate 126, figure 20

534

Kyōden: *Three Geisha.* Ōban, from the series *Tōsei-bijin iro-kurabe,* ca. early 1780s

kyōga: comic sketches

狂言 **kyōgen:** comic interludes between Noh plays; the term is also used to signify Kabuki performances

kyōgen-bon: illustrated theatrical books, abridged scenarios of Kabuki plays

校合 **kyōgen-tsuzuki:** complete Kabuki play

kyōgō-zuri: proof impression

摺 **Kyōhaku-shū:** a drinking song collection, 1649, by Chōshōshi (1569–1649)

享保 **Kyōhō** (1716–36): the Kyōhō Period dates from VI/22/1716 to IV/28/1736 and forms a turning-point in Japanese cultural history. With the Kyōhō Reforms the Tokugawa government turned to an oppressively benign Confucianism, giving increasing attention to every

aspect of its subjects' lives. Austerity edicts warned against luxury and excesses and punished commensurately. Under government sponsorship local industry was encouraged, the samurai arts were revived and scholarship flourished. The bans on the importation of foreign books and pictures were lifted, leading to the development of the perspective print. But popular arts such as ukiyo-e received a powerful setback: in Kyōhō VI (1721) deluxe publications were banned, as were erotica; single-sheet prints were limited in size and coloring and all forms of popular publication were restricted. It is no wonder then that the ukiyo-e works of the 1720s rarely match the grandeur of those of the preceding decade, even though they were produced by the same masters: Kiyonobu I, Masanobu and Sukenobu, as well as painters such as the Kaigetsudō and Chōshun. The new artists of this age were even more pronouncedly the product of their times, and a miniaturistic charm rather than exuberant power characterizes the work of Kiyonobu II, Kiyomasu II, Shigenaga, Toshinobu, and their confrères. Increasingly complex hand-coloring became a feature of the new genre, *urushi-e* [*beni-e*], a trend that was to lead to the development of color printing in the next generation. ▷*nengō*

kyōka: a type of humorous poem in *waka* form; notable *kyōka* poets included Uchiyana Gatei (1723–88), Karagoromo Kisshū (1743–1802), Yomo no Akara (Shokusanjin). (1749–1823), Akera Kankō (1740–1800), Heishū Tōsaku (1726–89), Taiya Teiryū (1734–1810) and Moto-no-Mokuami (1724–1811)

Kyō-Kanō: branch of the Kanō School founded by Sanraku in Kyōto

Kyokkō: *dōban* artist, possibly Gengendō's pupil
*Inoue, Kyūkō

kyōku: light verse (a late variety of *senryū*)

Kyokuzan (Taishō): *dōban* artist, pupil of Ryokuzan
*Ishida Kyokuzan

Kyorai, Mukai (1651–1704): *haiku* poet of the early to mid Edo Period

kyōran: mad scene in a play

Kyoroku, Morikawa (1656–1715): *haiku* poet of the early to mid Edo Period

Kyōsai [Gyōsai] (1831–89): ukiyo-e, later Kanō-style painter, print artist and illustrator. Son of a samurai, Kyōsai studied as a child under Kuniyoshi, then under Maemura Tōwa and Kanō Tōhaku; at 27 he became an independent painter, settling in the Hongō section

535
Kyōsai: *Crow on Branch. Oban,* ca. late 1870s

536
Kyōsai: *Goddess and Demon.* Narrow *koban,* ca. 1860s. (*Kappa* river-demon attacking the Japanese equivalent of Neptune's daughter.) One of a set of 12 small *surimono* prints, mounted back-to-back in pairs. One side shows a detailed shunga tableau in late Utagawa ukiyo-e style; the other side, as here, shows a more impressionistic scene in semi-Shijō manner

of Edo. Kyōsai is one of the most individualistic of 19th-century painters. His illustrated books include *Kyōsai gaden, Kyōsai gafu,* and *Kyōsai manga.*
*Kawanabe, Gyōsai (from 1871), Nobuyuki, Shūsaburō, Tōiku, Chikamaro, Baiga, Baigadōjin, Baiga-kyōsha, Gaki, Hata-kyōsha, Kyōsha-gaishi, Nyoku [Jokū]-nyūdō, Raisui, Shōjoan, Shōjō, Shōjōsai, Shuransai, Suiraibō
Conder, Josiah. *Paintings and Studies by Kawanabe Kyōsai.* London, 1911.
Lane, Richard. *Studies in Ukiyo-e.*

Kyosen (fl. 1760s): ukiyo-e print designer and *haiku* poet, said to have been a samurai named Ōkubo Jinshirō. A leader of the circle of aesthetes who commissioned many of the 1765 calender prints, his name appears on several Harunobu prints, as well as on a few prints of his own.
*Kikurensha, Jōsai-sanjin

Kyōsui (fl. 1740s): ukiyo-e print artist in the later Masanobu style

Kyōsui (1816–67): ukiyo-e painter and illustrator, son of the writer Kyōzan (brother of Kyōden), lived in Kyōto
*Iwase, Baisaku, Umesaku, Santōan

Kyōto: city in Yamashiro Province, founded in A.D. 794 as Heian-Kyō; also called Kyōto, Kyō, Miyako, Raku, Rakuyō or Keishi (all meaning Capital); from 794 to 1868 the residence of the Imperial Court and hence the capital city of Japan

Kyōto nana-kuchi: the 7 entrances to the capital: Higashi-Sanjō, Fushimi, Toba, Shichijō-Tamba, Nagasaka, Kurama and Ōhara

Kyōwa (1801–04): the Kyōwa Period, dating from II/5/1801 to II/11/1804, in ukiyo-e represents both a subdued continuation of the glories of Kansei and of the Kansei Reforms (during Kyōwa II/1802 Toyokuni, Shun-ei, Tsukimaro and Shuntei all suffered penalties from the official censors). Of the established artists, Utamaro, Toyokuni, Toyohiro and Hokusai all did notable work, and such Ōsaka masters as Ryūkōsai and Shōkōsai also flourished. This was a significant age for the Kabuki drama as well, and numerous books about the actors and the theater were published with illustrations by Toyokuni, Shun-ei, Ryūkōsai and Shōkōsai. ▷*nengō*

Kyūkō (fl. ca. 1818–54): Kyōto print artist, producing copperplate prints of Kyōto scenes
*Inoue, Tatsu

Kyūsai (1284–1378): *renga* poet of the late Kamakura and Northern and Southern Court Periods

Kyūshū: southern-most large Japanese island

Kyoyu and Sōfu: the ancient Chinese sage Kyoyu (Hsü Yu) was offered the throne of China by the Emperor Yao; he hurried to a waterfall to cleanse his ear of the taint of worldly ambition. Hearing of this, his friend Sōfu (Ch'ao Fu) went a step further and hastened to stop his ox from drinking the contaminated waters. A Zen story popular in Japan, well illustrating the spirit of resistance to worldly temptation.

Kyūsō, Muro (1658–1734): poet and Confucian scholar in the mid Edo Period

L

large-ōban: print size about 22½×12½ in./ 58×32 cm; frequent in the Primitives

lobsters [*Ise-ebi*]: symbolic of honorable old age; also used in New Year's decorations; emblem of the actor Ebizo

longevity: symbolized by pine, bamboo, crane, deer, stork, tortoise, gourd, peach, lobster, as well as by such celebrated personages as Seiōbo, Tobō-Saku, Urashima Tarō and the old Takasago couple, Jō and Uba

long months ▷ calendar, Japanese

lotus flowers [*hasu/hasuna*]: symbolic of purity and of Buddhahood

M

mabuchi, Kamo no (1697–1769): noted scholar of Japanese classics and *waka* poet

machi-bugyō: governors of the cities of Edo, Kyōto, Ōsaka and Sumpu (Shizuoka)

machi-eshi: plebeian painters

machi-yakko: semi-outlaws among the commoners

mae-gashira: lesser category of *sumō* wrestlers

maiko: apprentice geisha in Kyōto/Ōsaka

mai-no-hon: *Kōwaka-mai* texts

maki [*kan*]: volume, chapter

Mako: a female *sennin* with long fingernails

makura: pillow (often, with erotic implications)

Makura-jidō (*Kiku-jidō*): Noh drama featuring a child who discovers the elixir of life

makura-kotoba: a rhetorical device used in Japanese prose and poetry, a "pillow word"

Makura no sōshi: the "Pillow Book" of Sei Shōnagon (ca. 965–1024), a collection of witty essays by a Heian court lady

mame-ban: any miniature print size smaller than *ko-yotsugiri*

mame-hon: miniature books

Mampuku-ji: major temple near Uji (Yamashiro), the seat of the Ōbaku Zen sect

mandara [mandala]: schematic diagram of Buddhist deities

万延 **Man-en** (1860–61): the brief Man-en Period dates from III/18/1860 to II/19/1861 and was an eventful time, witnessing the assassination of Minister Ii and of Townsend Harris's interpreter Heusken, as well as the first thriving of Yokohama Port with the resultant flood of Yokohama Prints to celebrate the exotic phenomenon of foreigners for the first time stationed *en masse* in Japan. The Yoshiwara burned down as well, resulting in numerous prints featuring the *kataku* ["temporary quarters"] that were opened in five alternative areas pending reconstruction. ▷ *nengō*

万月堂 **Mangetsudō** (fl. 1740s): possibly a ukiyo-e print artist. All of the rare prints bearing the name Mangetsudō are done in late Masanobu style, and among them are several that are simply pirate editions of Masanobu's work. This makes one wonder if Mangetsudō was really an individual artist or simply a name used by the publisher for his pirating activities. Whatever the ethics of his business, however, the Mangetsudō publisher printed with care, and these prints are only inferior to Masanobu's originals in a certain hardness of the facial features.

万月堂

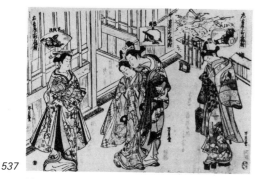

537

Mangetsudō: *Yoshiwara Komachi*. Uncut *hosoban* triptych, *benizuri-e*, ca. late 1740s (with insets from 3 of the *nana-Komachi* episodes; as is often the case, the notations "left, right" on such designs should be read as "stage left, stage right," i.e. as seen by the characters within the picture)

万治 **Manji** (1658–61): the Manji Period (VII/23/1658 to IV/25/1661), though brief, forms a key point in the development of ukiyo-e. For it was during this period in Edo (reconstructed after the Meireki Fire of early 1657), that the first illustrations and prints in fully developed ukiyo-e style appeared; they were the work of that anonymous artist we call the "Kambun Master." Manji marks a minor peak both in Kyōto and Edo illustration, and many of the masterpieces of early Japanese book illustration date from this brief period. ▷ *nengō*

Manjū (*Nakamitsu*): Noh drama featuring Tada no Manjū and Fujiwara no Nakamitsu

Manjū [Mitsunaka]. **Tada no**: a legendary warrior, befriended by the daughter of the Dragon King

man-yō-gana: a system used to transcribe the sounds of the Japanese language in formal Chinese characters

Man-yō-shū: the earliest anthology of Japanese poetry, late 8th century

萬歳 **manzai** (and *saizō*): New Year's performers of song and dance; also, the performance itself

maple [*momiji*] **and deer**: together, a symbol of autumn

Marishi-ten: deity, Queen of Heaven

Marugame: port city in Sanuki (Shikoku) with ancient castle and Kompira Shrine

marumage: a style of coiffure worn by married women

円山 **Maruyama School**: founded by Ōkyo, based on Kanō, Ch'ing and Western styles, plus an emphasis on preliminary sketching from nature

masa: handmade paper, a variety of *hōsho*

Masaaki (1840–1904): *dōban* artist, pupil of Sōshū
*Yūki Masaaki

Masafusa, Ōe no (1041–1111): late Heian-Period *waka* poet and scholar of Chinese studies

政房 **Masafusa** (fl. ca. 1740 s): Ōsaka ukiyo-e print artist and illustrator, pupil of Okumura Masanobu
*Okumura, Bunshi

昌房 **Masafusa** (fl. ca. 1750s–70s): Kamigata ukiyo-e print artist and illustrator
*Okamoto, Sekkeisai

Masahira, Ōe no (952–1012): mid Heian-Period *waka* poet and scholar of Chinese studies

Masajirō (Meiji): *dōban* artist, pupil of Ryokuzan
*Ishii Masajirō

Masakado, Taira (d. 940): famous warlord; killed in the battle of Kōjima (Shimōsa)

Masakazu (d. 1886): ukiyo-e print artist, pupil of Kunisada II
*Baien, Ōen

政国 **Masakuni** (fl. ca. 1820s): ukiyo-e print artist, Ōsaka School, pupil of Yoshikuni
*Jukakudō

Masamochi, Ishikawa (1753–1830): *kyōka* poet, novelist and scholar of the classics

Masamochi (1809–57): genre painter
*Satō, Risaburō, Hokumei

政信 奥村 政信 **Masanobu** (ca. 1686–1764): major ukiyo-e painter, print artist, illustrator and publisher. Masanobu's work covers the whole range of early ukiyo-e, from *sumizuri-e* and *tan-e* through *urushi-e*, *ishizuri-e* and *beni-e* on to the *benizuri-e* that just precede the development of full-color prints. His prints abound in the wit and Edo verve that typified the best in 18th-century popular art. He was often his own

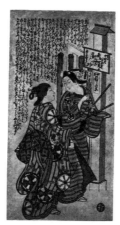

538

Style of Masanobu: *O-Shichi and Kichisa*. Large-*ōban tan-e*, ca. 1708

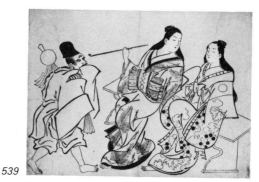

539

Masanobu: *Mendicant Shintō Priest and Courtesans*. Ōban *sumizuri-e* album sheet, ca. mid 1710s

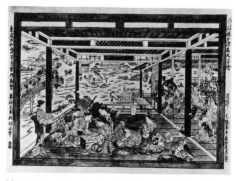

540

Masanobu: *Evening Cool by Ryōgoku Bridge*. Extra-large *ōban* (48×67 cm), *urushi-e* 1740s

541

Masanobu: Shunga illustration to *Genkurō-gitsune sembon-zakura* [Yoshitsune and the Thousand Cherry Trees]. Woodblock-printed book with *benizuri-e* frontispiece. Edo, ca. 1750; *yokobon*. The young warrior Yoshitsune receives initiation into the Arts of Love from a female *tengu*.

publisher and thus exercised a greater control over the final printed result of his designs than most ukiyo-e artists. In his early work he shows a great fondness for parody and novel designs. With maturity, and with the increasing importance of coloring in the success of a print, Masanobu concentrates his attention more on design and harmony of composition. Some critics speak of a "decline" in his later work; but this author thinks they are simply expressing a preference for the strength of the earlier ukiyo-e.
*Okumura, Shimmyō [Chikatae], Genroku (Gempachi), Baiō, Bunkaku, Hōgetsudō, Shidōken, Tanchōsai

Some *sumizuri-e* print series by Masanobu:
(After K. Shibui and R. Vergez; each series consists of 12 prints unless otherwise noted and dates from the early 1700s to mid 1710s.)

1 [Theatrical Prints]
2 *Yamato irotake* [Theatrical Prints]
3 [Warriors]
4 [Theatrical Prints]
5 *Yūkun mitate-Genji*
6 *Yoshiwara hakkei,* 8 sheets
7 [Amateur Theatricals]
8 [Comical Prints]
9 *Ukiyo-fūzoku okashii-kotobukuro*
10 *Shōjō Ebisu Daikoku*
11 *Yoshiwara yūkun sugata-mi*
12 *Yoshiwara-gayoi*
13 *Yūkun sakemuki sankyō*
14 *Jūni-tsuki,* 1706 (plate 52)

Some illustrated books by Masanobu:

1 *Kōshoku hana-zumō,* 1703
2 *Yōrō no taki,* 1704
3 *Kōshoku matane-no-toko,* 1705
4 *Yūshō otogi-zōshi,* 1706
5 *Wake no rikō,* 1706
6 *Nanshoku hiyokū-dori,* 1707
7 *Hiyoku renri-maru,* 1707
8 *Wakakusa Genji monogatari,* 1707
9 *Fūryū kuretake-otoko,* 1708
10 *Hinazuru Genji monogatari,* 1708
11 *Fūryū kazō-gura,* 1708
12 *Kantō nagori-no-tamoto,* 1708
13 *Motozō-daishi omikuji-shō,* 1708
14 *Tō-Gensō,* 1708
15 *Kōhaku Genji monogatari,* 1709
16 *Kanjun iro-habutae,* 1709
17 *Fūryū Kagami-ga-ike,* 1709
18 *Kōshoku yūgao toshioi-gusa,* 1709
19 *Wakakusa Genji monogatari,* 1710 (sequel)
20 *Hachiman Tarō,* 1710
21 *Sankō gunki,* 1710
22 *Sanshō-dayū,* 1711
23 *Buke-shoku genshō,* 1716
24 *Ehon fūga nana-Komachi,* ca. 1723
25 *Ehon Kinryūzan, Asakusa sembon-zakura,* 1734
26 *Ehon Ogura-nishiki,* 1740
27 *Ukiyo-ehon tsuru no kuchibashi,* 1752
28 *Ehon Edo-e sudare-byōbu,* n.d.
29 *Ukiyo-ehon atatame-dori,* n.d.
30 *Musha-ehon kongō-rikishi,* n.d.
31 *Ehon-musha Edo-murasaki susokon,* n.d.
32 *Ehon-musha heiyūshi kaname-ishi,* n.d.
33 *Bijin fukutoku sanjūni-sō,* n.d.

Shibui, Kiyoshi. "Masanobu no sumi-e" (in Japanese). In *Ukiyo-e no kenkyū,* VI-3 (Tōkyō, 1929).
Vergez, Robert. "Masanobu..." In *Ukiyo-e Art,* (Tōkyō, 1974).
▷ pp. 65–68, 78–79, plates 52–55, 66–68

Masanobu (fl. ca. 1710s): ukiyo-e *bijin-ga* painter; though usually treated among the Kaigetsudō artists, he displays considerable skill as a painter in the later Moronobu manner
*Yoshikawa Masanobu

Masanobu (fl. ca. 1750s–70s): ukiyo-e painter and print artist
*Ueda Masanobu

Masanobu, Kitao ▷ Kyōden

Masanobu (fl. ca. 1820s–50s): ukiyo-e print artist, Ōsaka School
*Ichiyōsai

Masanori (fl. ca. 1710s): ukiyo-e painter; though nominally of the Moronobu School, he displays an even greater allegiance to the Kaigetsudō style, delineating a female that seems almost a parody on the feline manner of Anchi.
*Hishikawa Masanori

Masatoshi (fl. ca. 1650–70s): obscure early genre painter
*Ukiyo Masatoshi

Masatsugu (fl. ca. 1765–80): ukiyo-e print artist and illustrator, pupil of Hidenobu
*Terasawa Masatsugu [Masaji]

Masatsune, Asukai (1170–1221): *waka* poet of the early Kamakura Period

政美 蕙斎 改美 蕙齋

Masayoshi (1764–1824): ukiyo-e painter, print artist and illustrator. A pupil of Shigemasa, he worked in the ukiyo-e style until 1797, when he became the official painter to the *daimyō* of Tsuyama and developed a new semi-Kanō genre style (studying under Eisen-in)
*Kitao (Kuwagata, Akabane), Keisai, Shōshin [Tsuguzane], Sanjirō, Shōsai

542

Masayoshi: *Spring Outing.* Chūban, ca. late 1780s

正幸

Masayuki (fl. ca. 1720s): ukiyo-e painter and illustrator, pupil of Chōshun
*Miyagawa Masayuki

masu: a square box-measure; emblem of the Ichikawa line of actors ▷ actors' crests

Masuharu (fl. ca. 1850s): ukiyo-e print artist, Ōsaka School, pupil of Kunimasu

Masu kagami/Mizu kagami: historical tales of the 12th century

Masunao (fl. ca. 1840s): ukiyo-e print artist, Ōsaka School

Masunobu (fl. ca. 1740s–50s): ukiyo-e print artist, follower of Kiyomasu and Masanobu
*Tanaka, Sanseidō

益信

Masunobu (fl. 1770s): ukiyo-e print artist, produced a number of delicate prints in the style of Harunobu; nothing is known of him, though he may possibly be the same artist as Tanaka Masunobu, who designed prints and illustrated books in the Masanobu manner during the 1740s and 1750s.
*Zenshinsai

益信

543

Masunobu: *"Chūshingura" Pastiche.* Hashira-e, ca. early 1700s

Masunobu (fl. ca. 1850s): Ōsaka ukiyo-e print artist, pupil of Kunimasu
*Ittōsai

Masusada (fl. ca. 1850): ukiyo-e print artist, Ōsaka School

Masutsuru (fl. ca. early 1850s): ukiyo-e print artist, Ōsaka School
*Utagawa Masutsuru

又兵衛 勝以

Matabei (1578–1650): important Tosa-genre painter; in Kyōto studied under Tosa Mitsunori and possibly Kanō Shōei; from about 1616 he resided in Fukui, painting for the Matsudaira *daimyō*; in 1637 he went to Edo to work for the Shōgun Iemitsu. Sometimes called the "father of ukiyo-e"; his paintings most often depict scenes from classical tales, but also some genre subjects.
*Iwasa, Dōun, Hekishōkyū, Shōei [Katsumochi], Un-ō
Yata, Michio. *Iwasa Matabei.* (in Japanese) Tōkyō, 1934.
▷ p. 14, plate 3

Matahei (fl. early 18th century?): semi-legendary genre painter, said to have been the originator of *Ōtsu-e*
*Ōtsu (or Ukiyo) Matahei

真虎

Matora (1794–1833): Tosa-genre painter and illustrator in Nagoya
*Ōishi (Koizumi), Matora [Shinko], Jumpei, Monkichi, Komonta, Jutarō, Shichiemon, Haisha, Shōkoku

Matsudaira: eminent family related to the Tokugawa

Matsue: port town in Izumo Province

Matsuho-no-ura monogatari: a tale of pederasty, probably 15th century

Matsukaze: Noh drama featuring the two sisters Matsukaze and Murasame, both loved by the poet Yukihira during his period of exile (See plate 31)

Matsumoto: capital of Shinano Province

Matsuura Screen [*Matsuura-byōbu*]: a noted early genre screen
▷ pp. 18–20, plate 6

mawari-dōro: revolving lantern

mawashi: elaborate ceremonial apron worn by wrestlers

眼鏡絵 **megane-e:** perspective pictures, designed in reverse for use in optical viewers

Meiboku Sendai-hagi: noted Kabuki play, first written in 1777 for the puppet theater, featuring as protagonists Niki Danjō, Masaoka and Semmatsu

meibutsu: noted product of a locality

明治 **Meiji** (1868–1912): the Meiji Period, which dates from IX/8/1868 to VII/30/1912, commenced with the Emperor moving to the eastern capital of Edo (renamed Tōkyō), followed by the abolishment of the feudal clans, the establishment of army, navy, postal and telegraph systems and of the Tōkyō-Yokohama Railway. Western customs grew in popularity, gradually replacing many of the surviving aspects of old Japan. By now the ukiyo-e print was more a means of journalistic expression than an art form, and in this field it could hardly compete with photography. The Sino-Japanese War (1894–95) and Russo-Japanese War (1904–05) provided the final material for the remaining ukiyo-e artists and illustrators. Of the Edo artists, Yoshitoshi continued notable work in the figure print, and Kiyochika in the genre-landscape print, but their work was a mere relic of the former glories of ukiyo-e. ▷ *nengō*

明暦 **Meireki** (1655–58): the Meireki [Meiryaku] Period dates from IV/13/1655 to VII/23/1658

and in its third year marks a crucial point in Edo culture. Within two days the Great Fire of Edo (I/18/1657) burned down most of the city, from Hongō through Kanda, Asakusa, Kyōbashi, Fukagawa, Koishikawa and Nihonbashi, down to Atago-shita and Fuda-no-tsuji. In the conflagration literally thousands of mansions and great temples were destroyed, and well over a hundred thousand lives were lost. However, from the ashes of Edo a new city soon arose, partially freed from the oppressive influence of Kyōto civilization and gradually successful at fostering a characteristically Edo style of life and culture. In ukiyo-e, the Meireki Period marked an early high point of genre book illustration in Kyōto, including courtesan critiques that were to influence strongly the Edo ukiyo-e of the following decade. ▷ *nengō*

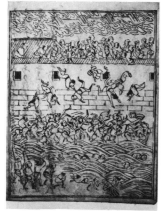

544

Early Genre-School: *The Great Fire of Edo.* Illustration to the principal contemporary account of the disaster, *Musashi-abumi; ōbon,* Kyōto, 1661

Meiryaku ▷ Meireki
名所 **meisho:** a famous place, renowned for its scenic beauty
名所記 **meisho-ki** [records of famous places]: illustrated guidebooks for pilgrims and travelers as well as for the general reader
明和 **Meiwa** (1764–72): the Meiwa Period, dating from VI/2/1764 to XI/16/1772, marks a climax in the influence of Kamigata culture in Edo, presaging the advent of a more characteristically Edo culture a decade later. With respect to ukiyo-e, the Meiwa period is the dividing line between the Primitives and the Golden Age. The distinction was first of all a technical one: the calendar prints for the New Year of Meiwa II (1765) featured the innovation of multi-colored printing (an influence of Chinese books but also a logical extension of the *benizuri-e*) which was to revolutionize ukiyo-e technique. Harunobu in his genius exploited this new art form; under his skilled hands a new style of color print evolved, strongly influenced by the Kyōto master Sukenobu but going beyond that veteran to create a new, sublimated yet realistic world of colorful fancy. In the field of actor prints, as well, the new technique had revolutionary results: the use of coloring encouraged realism in portraiture, and under Bunchō and Shunshō, the actors no longer needed to be recorded by name, for their faces and forms identified them at once to the Kabuki aficionado. Meiwa is thus primarily the period of Harunobu and the brocade print, with more fully realized Kabuki depiction a major by-product. This was once again a time of fads;

those most closely related to ukiyo-e were the fashion for elaborately printed New Year prints in 1765 and 1766 and the popularity of famous plebeian beauties, tea-house girls and waitresses, such as O-Sen, O-Fuji, O-Yoshi and O-Fude, who figure widely in the prints of the period. ▷ *nengō*
men: a mask
metsuke: official inspectors
Michikatsu, Nakanoin (1558–1610): *waka* poet of the Momoyama Period
Michimori: Noh drama featuring Taira no Michimori and his wife
Michinaga, Fujiwara (966–1027): *kampaku* who brought the power of the Fujiwara to its zenith; he is celebrated in the *Eiga monogatari*
Michinobu (fl. ca. 1720s–30s): ukiyo-e painter and illustrator; an Ōsaka artist, pupil of Shumboku, but also worked in the style of Sukenobu
*Ōoka Michinobu
Michinoku: ancient name of the Mutsu region
Michitoshi, Fujiwara no (1047–99): *waka* poet of the late Heian Period
Michitsuna-no-haha (937?–995): *waka* poetess and diarist, author of the *Kagerō nikki*
道行 **michiyuki** [road-going]: the journey of a pair, usually lovers, given as interlude in a longer play
mie: a dramatic pose in Kabuki
mi-gawari: substitution of one person for another in a play
Mii-dera: temple northwest of Ōtsu, a seat of the Tendai sect; formal name Onjōji
巫女 **mikado:** the Emperor or Empress
miko: Shintō vestal virgin and shrine dancer
mikoshi: a portable shrine
mimizu-gaki ▷ *hyōtan-ashi*
Minato-gawa: river in Settsu, scene of the famous battle where the valiant loyalist general Masashige killed himself after his defeat by Takauji
minazuki: poetic name for the Sixth Month
Minekuni (fl. ca. 1820s): ukiyo-e print artist, Ōsaka School
峰麿 **Minemaro** (fl. ca. 1800s–10s): ukiyo-e painter and print artist, pupil of Utamaro
mingei: folk art
岷江 **Minkō** (fl. ca. 1760s): ukiyo-e painter and print artist; an embroiderer first in Kyōto and Ōsaka, then said to have studied ukiyo-e under Nishikawa Sukenobu. In 1762 Minkō went to Edo, there becoming a follower of Harunobu; he designed several calendar prints and, in 1770, published *Saiga shokunin-burui,* an impressive, color-printed set of volumes illustrating craftsmen at work.
*Tachibana, Masatoshi, Gyokujuken

545

Minkō: *Girls and Mirror Polisher.* Illustration from *Saiga shokunin-burui, ōbon,* 1770

mino: raincoat made of straw
Minobu: village in Kai, site of the great temple Kuonji, built in 1273 by Nichiren; the principal seat of the Nichiren sect
minogame: ancient turtle, symbol of longevity
minogami: a sturdy paper, used for *hanshita-e*
岷和 **Minwa** (d. 1821): Ōsaka ukiyo-e painter and illustrator; first studied with Ganku, later turning to the ukiyo-e style
*Aikawa, Aikawatei, Hidenari, Shichin, Setsuzan
misasagi: tombs of emperors
misogi [*ō-harae*] ceremonial ablution
mirrors [*kagami*]: symbolic of truth and of a woman's soul
misu: split-bamboo curtain
mitarashi: stone ablution tank
見立 **mitate:** facetious depictions featuring pastiche, allusion or parody
Mito: chief town of Hitachi, ruled by a branch of the Tokugawa family
Mitsuatsu (1734–64): Tosa-School painter, did some genre work; eldest son and pupil of Mitsuyoshi
*Tosa, Tōmanmaru
Mitsubumi (1812–79): Tosa-School painter, did some genre work
*Tosa, Shihei, Kansui
mitsu-domoe: pattern of three commas in a circle
mitsu-giri: small print size, about 8¾×5 in./ 22.5×12.8 cm (*ōban* sheet cut in three horizontally)
Mitsuhide, Akechi (1526–82): *daimyō* of Sakamoto, famous as the assassin of Nobunaga
Mitsui: famous family of merchants and manufacturers
Mitsukuni (fl. ca. 1820s): ukiyo-e print artist, Ōsaka School
Mitsukuni, Tokugawa (1628–1700): *daimyō* of Mito; man of letters and historian; supervised the compilation of the great historical work *Dai-Nihon-shi.*
三極 **mitsumata:** shrub used in the making of Japanese paper
Mitsumata (or Sakō): a delta on the Sumida River at Nakasu
光成 **Mitsunari** (1646–1710): Tosa-School painter, did some genre work; son of Mitsuoki, he succeeded to his father's official position as *edokoro azukari* (1681–96)
*Tosa, Mitsunari [Mitsushige], Jōzan
Mitsune, Ōchikōchi no (early 10th century): *waka* poet of the early Heian Period
光信 **Mitsunobu** (fl. ca. 1720s–50s): an Ōsaka follower of Sukenobu who produced a number of interesting ukiyo-e picture books and miscellanea, as well as work in the *Toba-e* manner

546

Mitsunobu: *Courtesans with Patron. Ōban sumizuri-e* album sheet, ca. 1720

(his identification with the Kaigetsudō artist Baiōken Fishun seems erroneous).
*Hasegawa, Ryūsuiken, Shōsuiken
Nakata, Katsunosuke. *Ehon no kenkyū.*
Weatherby, Meredith (ed.). *A Cure for Gloom.* Tōkyō, 1968.

光則 **Mitsunobu** (fl. ca. 1730s): ukiyo-e print artist in the style of Tominobu
*Shimizu Mitsunobu

光則 **Mitsunori** (1583–1638): leading Tosa-School painter, did some genre work; son and pupil of Mitsuyoshi, father of Mitsuoki; lived first at Sakai but later in Kyōto, where he painted for the Court
*Tosa, Genzaemon, Sōnin

光起 **Mitsuoki** (1617–91): leading Tosa-School painter, did some genre work. Son and pupil of Mitsunori; in 1634 went to Kyōto, where he was appointed *edokoro-azukari* in 1654; in 1681 he passed this position on to his son Mitsunari; in 1685 named *hōgen*
*Tosa, Jōshō, Tōman-maru, Shunkaken

光貞 **Mitsusada** (1738–1806): Tosa-School painter, did some genre work. Second son of Mitsuyoshi, in 1754 he was appointed *edokoro-azukari.*
*Tosa, Shigematsu, Shikyō

Mitsusuke (1675–1710): Tosa-School painter, did some genre work; son and pupil of Mitsunari
*Tosa, Mitsutaka, Tōmanmaru, Jōshin

Mitsuyoshi (1539–1613): leading Tosa-School painter in Kyōto, did some genre work. Pupil and perhaps younger son of Mitsushige; became head of the Tosa School in 1569 on the death (in battle) of Mitsumoto; given rank of *edokoro-azukari*; later, moved to Sakai
*Tosa, Hisayoshi (Gyōbu), Genzaemon, Kyūyoku

Mitsuyoshi (1700–72): Tosa-School painter, did some genre work; son of Mitsusuke, he served the court as official painter
*Tosa, Tōmanmaru, Jōkaku

Mitsuzane (1780–1852): Tosa-School painter, also did some genre work; son and pupil of Mitsusada; served as *edokoro-azukari*
*Tosa Mitsuzane [Mitsutaka], Shisei, Kakusai

mi-uri: selling into bondage

Miwa: Noh drama concerning the god Miwa-no-myojin

宮 **miya**: palace of the emperor; also, prince and Shintō shrine

都 **Miyako**: the capital, Kyōto

Miyako-za: a leading Edo Kabuki theatre

水絵 **mizui-e** [water pictures]: prints in pale blue, fl. mainly 1760s

mochi: rice cake

Modori-bashi: Kabuki dance based on the Noh play *Rashōmon,* featuring the combat of Watanabe no Tsuna and a ferocious demon

Mogami-gawa: river that separates Ugo from Uzen (150 miles/242 km. long)

文字絵 **moji-e**: picture composed of written words

Mokuami, Kawatake (1816–93): Kabuki dramatist of the late Edo and Meiji Periods

木版 **mokuhan**: woodblock printing

版 **mokume-zuri**: printing with the pattern of the woodgrain

目録 **mokuroku**: list, catalogue

紅葉 **momiji**: maple leaves or tree

Momiji-gari: Noh drama featuring the combat between Taira no Koremochi and a devil-woman

Momiji-yama: hillock by the old castle of Edo

桃太郎 **Momiji-zuki**: poetic name for the Ninth Month

Momotarō: "Little Peachling," a favorite fairy tale of an adventurous lad

元服姿 **Momoyama**: hill near Fushimi, Kyōto, on which Hideyoshi built a magnificent castle in 1593, subsequently giving its name to the opulent period of the late 16th–early 17th century: the Momoyama Period: 1568–1615

Momozono: peach orchard at Nakano, northwest of Edo

紋 **mon**: heraldic crest ▷ actors' crests

mondō: confrontation scene of "questions and answers" in Kabuki

文覚 **Mongaku-shōnin** (1120–?): a warrior who, at the age of 18, then known as Endō Moritō, became violently enamored of his cousin Kesa-gozen, who purposely took the place of her husband, thus receiving the fatal slash destined for him. Moritō then entered the priesthood under the name Mongaku; in later life he was banished to Izu (1179), where he met Yoritomo and assisted in plans to overthrow the Heike. After Yoritomo died in 1199, Mongaku became involved in another political plot and was exiled to the island of Sado where he died.

monjin: student, pupil

文珠 **Monju** (Manjusri): the bodhisattva of Wisdom; often depicted riding a lion; sometimes having pederastic connotations

monkey [*saru*]: the three monkeys [*sambiki-zaru*]: *mizaru* [see no evil], *kikazaru* [hear no evil], *iwazaru* [speak no evil]

monogatari: story, tale, novel

Monogusa-tarō: a success tale, probably 15th century

monomane: imitation of reality (in acting)

Monto-shū: Jōdo-shinshū

Morihisa: Noh drama concerning Taira no Morihisa and the Shōgun Yoritomo

守国 **Morikuni** (1679–1748): Ōsaka Kanō-style painter, illustrator and writer; studied under Tsuruzawa Tanzan (a pupil of Kanō Tan-yū)
*Tachibana (Narahara), Yuzei, Sōbei, Kōsoken
Illustrated books by Morikuni include:
1 *Ehon Koji-dan* (9 vols., 1714)
2 *Morokoshi Kimmō-zui* (15 vols., 1719)
3 *Ehon shahō-bukuro* (10 vols., 1720)
4 *Gaten tsūkō* (10 vols., 1727)
5 *Ehon tsūhō-shi* (10 vols., 1729)
6 *Honchō gaen* (6 vols., 1729)
7 *Utai gashi* (10 vols., 1732)
8 *Fusō gafu* (5 vols., 1735)
9 *Ehon ōshukubai* (7 vols., 1740)
10 *Ehon jikishihō* (10 vols., 1745)
11 *Umpitsu soga* (3 vols., 1749)

Morinaga-shinnō: (1308–55): a noted general, son of the emperor Go-Daigo

Morita-za: a leading Edo Kabuki theater

師房 **Morofusa** (fl. ca. 1690–1700): ukiyo-e painter and illustrator; eldest son and pupil of Moronobu. In his extant work Morofusa is but a weak reflection of his father's achievement, and in his later years he gave up ukiyo-e and became a dyer. (Moronobu's late and posthumous publications were probably copied for the engraver by his son Morofusa—hence their lack of vitality.)
*Hishikawa, Kichizaemon, Kichibei

師平 **Morohira** (fl. ca. late 17th century): ukiyo-e painter, pupil of Moronobu
*Hishikawa Morohira

Morokoshi: poetic name for China and sometimes for "abroad" or for "the West"

師政 **Moromasa** (ca. 1712–72): ukiyo-e painter and print artist, son and pupil of Moroshige,

but more a follower of Kiyonobu and Masanobu in style
*Furuyama, Shinshichirō, Shinkurō, Bunshi, Getsugetsudō

師永 **Moronaga** (fl. ca. late 17th century): ukiyo-e painter, son or son-in-law of Moronobu
*Hishikawa, Okinojō, Sakunojō

Moronaga, Fujiwara no (1137–92): *biwa* virtuoso, hero of the Noh drama *Kenjō*

師宣 **Moronobu** (d. 1694): this major early ukiyo-e master (d. VI/4/1694) was born at Hoda (Awa Province now Chiba Prefecture), son of the famous brocade artisan Hishikawa Kichizaemon. Moronobu presumably studied under his father but several years after the latter's death in 1662 came to nearby Edo and became an ukiyo-e artist, most likely under the tutelage of the Kambun Master. Moronobu's first signed and dated works are the illustrated book *Buke Hyakunin isshu* [One Hundred Samurai Poets] and sections of a painted handscroll depicting Yoshiwara scenes (plate 27), both from Spring 1672. These early works already reveal a mastery of genre depiction and group composition, indicating considerable prior study and practice (including training in the classical Kanō and Tosa styles), as well as showing the influence of the Tosa/genre pioneer Matabei.

With the death or retirement around 1674 of his mentor the Kambun Master, Moronobu became the preeminent ukiyo-e artist of Edo, a position he was to maintain until his death two decades later. In addition to his numerous paintings (widely copied but only rarely extant in the originals today), Moronobu's illustrated books and albums number at least 150. They are divided among novels, verse anthologies, guidebooks, *jōruri* plays, courtesan critiques, kimono-pattern books, shunga texts and albums and ukiyo-e picture books. In particular, the last two categories feature some of the classic masterpieces of ukiyo-e illustration, and among the frontispiece plates to Moronobu's shunga albums several of the major prints of early ukiyo-e are to be found (plates 26–28, 30, 32).

Moronobu's importance lay in his effective consolidation of the ephemeral styles of early genre painting and illustration, creating, in effect, the Ukiyo-e School. His style is one of controlled, powerful brushstrokes and solid, dynamic figures, a manner eminently suited to

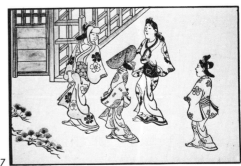

547

Moronobu: *Ladies on Pilgrimage.* Detail from an *ōban tan-e* woodblock print with hand-coloring; Tenna Period (early 1680s).
Besides his several series of *ōban* shunga, each consisting of 12 prints, Moronobu also treated genre and legendary subjects in this format. The present detail is from a series entitled *Ueno hanami no tei* [Cherry-blossom Viewing in Ueno Park], in which landscape and figure are equally prominent.

the woodblock medium and a style that provided the necessary groundwork for the ukiyo-e masters of the following two centuries.

Moronobu's principal pupils or followers were Moroshige, Tomonobu [Ryūsen] and Sugimura, but lesser work (mainly in the field of ukiyo-e painting) is also known by his son Morofusa and his pupils Moronaga, [Hishikawa] Masanobu, Tomofusa, Shimpei and Morohira. Although Moronobu was not favored by direct pupils of genius, his style was revived, modified and transmitted to the next generation within a decade of his death by Kiyonobu, Kiyomasu, Masanobu and the Kaigetsudō.
*Hishikawa (Furuyama), Kichibei, Yūchiku

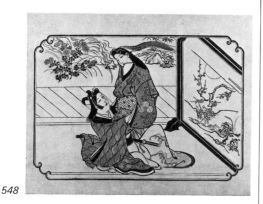

548

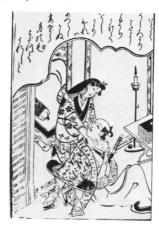

548 a

Moronobu: *Young Lovers*. Ōban tan-e, early 1680s; from the same series as plates 29—30.

A selection of Moronobu's picture books:
1 *Buke Hyakunin isshu*, 1672
2 *Wakoku bijin-asobi*, early 1670s (plate 26)
3 *Genji kyara-makura*, 1676

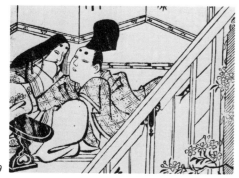

549

Moronobu: *Nobleman and Princess*. Detail from the shunga picture book *Genji kyara-makura* [Genji's

Perfumed Pillow]; *ōbon sumizuri-e*; Edo, dated Empō IV (1676)
This is Moronobu's earliest dated shunga book; here his style at last comes out from under the shadow of the Kambun Master. It will be yet another year, before his style becomes peculiarly his own and another half-decade before he reaches the peak of his achievement. With its many love episodes, *The Tale of Genji* was a natural subject for the shunga genre during the Edo Period; the present work seems, however, to be the first such erotic version extant. This is a scene from one of the later chapters, in which Kashiwagi seduces Genji's young wife, Princess Sannomiya, producing a child that Prince Genji fatalistically accepts as his own.

4 *Edo suzume*, 1677
5 *Yoshiwara koi no michibiki*, 1678
6 *Wagō dōjin*, 1678

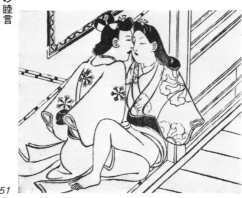

550

Moronobu: *Man and Wife*. Detail from the shunga picture book *Wagō-dōjin* [Love-making à la Mode]; *ōbon sumizuri-e*, Edo, dated Empō VI (1678).
Moronobu's fully formed style reached its first culmination with such works from the later 1670s; here he at last succeeds in escaping from the pervading influence of the Kambun Master and creates his own special mood, composition and sense of inherent drama.

恋の睦言

7 *Koi no mutsugoto*, 1679

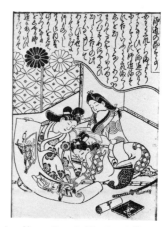

551

Moronobu: *Lovers*. Detail from the shunga picture book *Koi no mutsugoto* [Love's Whisperings]; *ōbon sumizuri-e*, 2 vols.; Edo, dated Empō VII (1679).
From this famous guide to the "Forty-eight Positions of Lovemaking" we illustrate one of the more restrained scenes: the "no hands" posture. Due, doubtless, to its didactic function, this book is characterized by less freedom of composition and expression than that found in the artist's other picture books; among its details, however, will be found some of his best work of the period.

8 *Yamato shinō ezukushi*, 1680
9 *Chiyo no tomozuru*, 1682
10 *Imayō Yoshiwara makura*, ca. early 1680s (plate 28)
11 *Iwaki ezukushi*, 1683
12 *Bijin ezukushi*, 1683
13 *Koi no minakami*, 1683
14 *Yamato no ōyose*, 1683
15 *Tōfū shina ezukushi (Ukiyo-tsuzuki)*, 1684
16 *Kyasha-otoko nasake no yūjo*, 1685
17 *Wakoku shoshoku ezukushi*, 1685
18 *Makura-e-zukushi*, ca. 1685

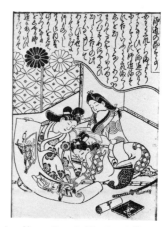

552

Moronobu: *Young People Viewing A Shunga Scroll*. Detail from the shunga picture book *Makura-e-zukushi* [Pillow Pictures]; *ōbon sumizuri-e*, 3 vols.; Edo, early Jōkyō Period (ca. 1685).
Entitled "While Their Teacher is Away," this plate shows two girls and a boy savoring the mysteries of a shunga scroll: these were, evidently, sometimes placed in parlors and waiting rooms for the amusement of guests.

Miyatake, Gaikotsu. *Hishikawa Moronobu gafu*. (in Japanese) Tōkyō, 1909.
Mizutani, Yumihiko. *Kohan shōsetsu sōga-shi*. *Nihon fūzoku zue*.
Kisho fukusei-kai: facsimile series.
Hayashi, Yoshikazu. *Empon kenkyū: Moronobu*. (in Japanese) 2 vols., Tōkyō, 1968.
Lane, Richard. *Shunga Books of the Ukiyo-e School: I—Moronobu*, Series One. 6 vols. of reproductions, plus text volume. Tōkyō, 1973.
Lane, Richard. *Shunga Books of the Ukiyo-e School: II—Moronobu*, Series Two. 7 vols. of reproductions, plus text volume. Tōkyō, 1974.
Lane, Richard. *Shunga Books of the Ukiyo-e School: III—Prints by Moronobu and the Kambun Master*. 8 vols. of reproductions, plus text volume. Tōkyō, 1976.
Lane, Richard. *Shunga Books of the Ukiyo-e School: IV—Moronobu and the Kambun Master*. 7 vols of reproductions, plus text volume. Tōkyō, 1978.
Lane, Richard. *Studies in Ukiyo-e*.
Lane, Richard. *Shunga Books of the Ukiyo-e School VI—Sugimura and Moroshige*. 7 vols. of reproductions, plus text volume. In press.
▷ pp. 44—51, plates 26—33

師重 **Moroshige** (fl. ca. 1684—95): the most interesting of Moronobu's direct pupils, he illustrated (and signed) 5 notable novels and volumes of miscellanea during the period 1686—1695, as well as a dozen or more unsigned novels, picture books and shunga. His most impressive works are in the latter category, including at least 6 series of *ōban* shunga plates (some signed) that rank among the masterpieces of the genre.

*Furuyama (Hishikawa), Tarobei
Lane, Richard. *Shunga Books of the Ukiyo-e School: VI – Sugimura and Moroshige.* 7 vols. of reproductions, plus text volume. Tōkyō, in press.
Mizutani. Yumihiko. *Kohan shōsetsu sōga-shi.* ▷ p. 51, plate 34

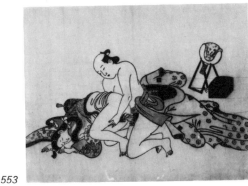

553

Moroshige: *Lovers.* Ōban print with hand-coloring in *tan-e* style, ca. mid 1680s

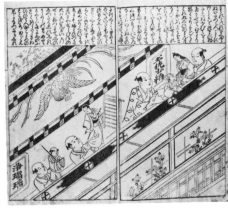

554

Moroshige: *Performance at Puppet Theater.* From *Yakusha e-zukushi,* ōbon, ca. 1685

師胤 **Morotane** (fl. ca. 1720s–30s): ukiyo-e painter, pupil of Moroshige
*Furuyama Morotane

師継 **Morotsugu** (fl. ca. early 18th century): ukiyo-e painter, pupil of Moroshige
*Furuyama Morotsugu

Moroyasu (fl. ca. early 18th century): ukiyo-e painter of the Moronobu School, but worked more in the Kaigetsudō manner
*Hishikawa Moroyasu

Mōshi: the Chinese philosopher Mencius (371–289 B.C.)

Mosui, Toda (1629–1706): *waka* poet and scholar of Japanese studies of the early Edo Period

Motoharu (fl. ca. 1858–1903): ukiyo-e print artist and painter, Ōsaka School
*Hayashi Sutezō, Kōsai

motome ni ōjite [*ni ōzu*]: "by special request," "on commission," said of a print or painting

Mototoshi, Fujiwara no (d. 1142): noted poet in both Japanese and Chinese

Mt. Fuji ▷ Hokusai, print series 119

moyō: a pattern or design

muda-bori: in the keyblock, a guide for color-block engraving, later deleted

Mujū (1226–1312): compiler of collections of popular tales during the mid Kamakura Period: *Shaseki-shū, Shozai-shū* and *Zōdan-shū*

向島 **Mukō-jima:** scenic area on the east bank of the Sumida River

mulberry tree [*kuwa*]: supposed to protect against lightning

Munakata, Shikō (1903–75): leading modern print artist and painter. Munakata reverted to the simple traditional techniques of printing in the *tan-e* manner, imbuing his work with a strange power and near religious intensity.

555

Munakata Shikō: *Ubari* and *Kasen-en.* Large *kakemono-e, sumizuri-e,* 1939 (from a series of 12 prints showing *The Great Disciples of Buddha*)

宗広 **Munehiro** (fl. ca. late 1840s–60s): Ōsaka print artist, pupil of Hirosada
*Hasegawa Munehiro

Munemori, Taira (1147–85): son of Kiyomori, executor of his father's evil designs; put to death after the Battle of Dan-no-ura

Munenaga-shinnō (1318–85): Imperial prince and *waka* poet of the Northern and Southern Court Period

宗信 **Munenobu** (fl. ca. 1780s): ukiyo-e print artist and illustrator, Ōsaka School
*Katsura, Gengo, Bizan, Tsūjin-dōjin

紫式部 **murasaki:** violet ▷ pigments

Murasaki-shikibu (ca. 979–1016): court lady and poetess, famous authoress of the *Genji monogatari* and *Murasaki-shikibu nikki*; in ukiyo-e Lady Murasaki is often depicted in modern dress, samisen at her feet, in a pastiche on the famous scene showing her composing the *Tale of Genji* on the balcony of the Ishiyama Temple near Kyōto.

Muro-gimi: Noh drama concerning the courtesans of Muro

室町 **Muromachi:** district in the city of Kyōto where, in 1368, Ashikaga Yoshimitsu established the government of the shōgun

Muromachi Period: the period of the shogunate of the Ashikaga, beginning in 1368 and lasting until 1573

Muro-no-tsu: ancient port in Harima

武者絵 **musha-e:** prints of warriors or of military subjects

Musha monogatari: collection of anecdotes about medieval military figures, 1654

mushrooms and fungi: symbols of longevity

Musō Soseki (1275–1351): poet and Zen monk of the late Kamakura Period

Mustard-Seed Garden [*Kaishi–en gaden/ Chieh-tzu-yüan hua-ch'üan*]: color-printed Chinese painter's manual, published in 1679 and reprinted in Japan; had great influence on Japanese painting, illustration and printing

musume: a girl or virgin

Musume Dōjōji: Kabuki dance, adapted from the Noh play *Dōjōji,* first staged in 1753

musume-gata: female impersonator specializing in young girls' roles

六玉川 **mu-Tama-gawa:** the Six Tama Rivers, celebrated in many print series; from south to north they are
1 Ide (or Hagi) no Tama-gawa, in Yamashiro Province (Kyōto)
2 Nose no Tama-gawa, in Yamato Province
3 Tōi (or Kinuta) no Tama-gawa, in Settsu Province
4 Kōya no Tama-gawa, in Kii Province [plate 134]
5 Chōfu no Tama-gawa, in Musashi Province (Edo)
6 Noda (or Chidori) no Tama-gawa, in Mutsu Province
▷ figure 616, plate 134

Mutsuki [*Mutsumashi-zuki*]: poetic name for the First Month

Myōchin: family of artisans, ca. 1220 to 1750, famous for forging and tempering swords; best known are Munesuke, and his son Munekiyo

Myōe (1173–1232): poet and Buddhist scholar of the early Kamakura Period

Myōgi-san: famous mountain in Kōzuke

myōji: family name (before the Restoration only permitted to samurai and nobles)

Myōkū (late 13th century): poet and priest of the Tendai sect

N

長判 **naga-ban:** print size used from the later 18th century, about 20¼×9 in./51.5×23 cm; the term is also sometimes used for *surimono* about 4¾×7 in./12×18 cm

Nagahama: town in Ōmi, formerly called Imahama; Hideyoshi rebuilt its castle.

長秀 **Nagahide** (fl. ca. 1810s–30s): ukiyo-e print artist of the Kamigata area; his early style follows that of Ryūkōsai and Shōkōsai
*Nakamura, Aritsune (Arichika), Nagahide [Chōshū], Chōshūsai, Yūrakusai

有楽斎 **Nagakuni** (fl. ca. 1814–20s): ukiyo-e print artist, Ōsaka School, pupil of Nagahide
*Shūei

Nagamura (fl. ca. 1790s–1810s): ukiyo-e print artist and illustrator, Ōsaka School
*Keikō-sanjin, Keikōtei

Nagamasa, Yamada (1578–1633): famous merchant adventurer who, in 1615, sailed secretly first to Formosa and then to Siam where he became minister to the King

Nagara-gawa: river in Mino (76 miles/122 km. long), famous for fishing with cormorants

naga-ōban: large print size, about 23¾×11¾ in./60.5×30.2 cm

Nagasaki: city of northwest Kyūshū; due to its strategic importance, in 1587 Hideyoshi made it an Imperial City, under the direct control of

the government; from 1640 to 1859 Nagasaki was the only place in Japan where foreigners were legally permitted to reside

556

Nagahide: *Kikugorō as Kan-Shōjō.* Oban, 1826 (signature: Yūrakusai)

長崎絵 **Nagasaki-e** [Nagasaki Prints]: souvenir pictures made in Nagasaki showing foreigners, their ships, exotic animals, etc.
Special Exhibition of Nagasaki-e and Other Prints of Foreigners by Ukiyoye Artists. (Collected and loaned by H. E. Dr. Solf, German Ambassador.) Foreword by J. S. Happer. Tōkyō, 1928.
Mody, N.H.N. *A Collection of Nagasaki Colour Prints and Paintings Showing the Influence of Chinese and European Art on That of Japan.* 2 vols., London, 1939.
Boxer, C. R. *Jan Compagnie in Japan. 1600–1850: An Essay on the Cultural, Artistic and Scientific Influence Exercised by the Hollanders in Japan from the Seventeenth to the Nineteenth Centuries.* 2nd rev. ed. The Hague 1950.
Higuchi, Hiroshi. *Nagasaki ukiyo-e* (in Japanese). Lane, Richard. *Studies in Ukiyo-e.*
▷ p. 196, plate 200

557

Nagasaki-e: Dutchman with Servant and Dogs. Oban, publisher: Yamato-ya, ca. 1840s

Nagasaki School: Japanese school of painting based on late Chinese models
長唄 **naga-uta:** type of samisen and Kabuki lyrical music, popular on the stage from the 1720s onward
Nagoya: capital of Owari Province; the Owari branch of the Tokugawa family ruled there from 1610 to 1868.
Nahiko (1723–82): *nanga* painter; teacher of Shumman
*Katori (Ino), Kagetoyo, Kageyoshi, Moemon, Chishōan, Seiran

nai-daijin: minister of the Home Department
Naikū: Shintō headquarters at Uji-Yamada (Ise); for ritual reasons, rebuilt every 20 years
nai-shinnō: honorific title for an Imperial princess
Naizen (1570–1616): Kanō-School painter, did some genre work; a pupil of Kanō Shōei, he served the Shōgun Hideyoshi. A noted *namban* screen bears his signature, as does a pair of screens (dated 1606) depicting festivities at the Hōkoku Shrine in Kyōto.
*Kanō, Shigesato, Kyūzō, Ichiō
Nakamaro, Abe no (701–70): classical poet and man of letters; sent to China in 716 to complete his studies, he stayed there for the rest of his life.
Nakamura-za: a leading Kabuki theater in Edo (first called Saruwaka-za)
中仙道 **Naka-no-chō:** main street of the Yoshiwara
Nakasendō (Kiso-kaidō): mountain highway from Edo to Kyōto (337 miles/542 km long)
▷ Highways, map
Nakatsukasa (late 10th century): *waka* poetess of the mid Heian Period
Nakatsukasa-no-naishi (late 13th century): *waka* poetess and diarist of the late Kamakura Period
鯰絵 **namazu-e:** prints depicting catfish (thought to be the cause of earthquakes), often in human guise
Ouwehand, C. *Namazu-e and Their Themes.* Leyden, 1964.

558

School of Kuniyoshi: *Namazu-e.* Ōban

南蛮 **namban** [southern barbarians]: term for the first Europeans in Japan, mid 16th century onward
Namban-ji: early church-temple of the Jesuit missionaries in Kyōto
Namboku [IV], Tsuru-ya (1755–1829): Kabuki dramatist of the late Edo Period
Namboku-chō: Northern and Southern Court Period (1336–92)
Nampo ▷ Shokusanjin
Nampō (fl. ca. 1820s): Shijō-School painter, also did some genre work
*Oda, Kan, Shishō
南画 **nanga** (*bunjin-ga*): literary men's painting in Chinese style, favored by Japanese dilettantes and scholars from the mid 18th century
Nangaku (1767–1815): Maruyama-School painter, also did some genre work. Pupil of Ōkyo in Kyōto but also influenced by Kōrin and by ukiyo-e; later moved to Edo, introducing the Maruyama style there
*Watanabe, Iwao [Gen], Iseki, Isaburō, Kozaemon
七小町 **nana-Komachi:** seven episodes in the life of the 9th-century poetess Ono no Komachi, often depicted in prints:

1 *soshi-arai-Komachi* [Komachi Washing the Book]
2 *Sekidera-Komachi* [Komachi at the Barrier Temple]
3 *Kiyomizu-Komachi* [Komachi at the Kiyomizu Temple]
4 *kayoi (kaigyō) Komachi* [Komachi Visiting in Penance]
5 *amagoi-Komachi* [Komachi Praying for Rain]
6 *ōmu-Komachi* [Parrot Komachi]
7 *sotoba-Komachi* [Komachi Seated by a Grave Post]
浪花 **Naniwa:** ancient name for the Ōsaka district
Nankaku, Hattori (1683–1759): scholar of Chinese classics, writer and literati painter
Nanrei (1775–1844): Shijō-School painter, did some genre work; teacher of Zeshin
*Suzuki, Jun, Shishin, Isaburō, Kansuiken
Nansō Satomi hakken-den: Bakin's famous semi-historical novel, the story of the eight dogs, retainers of Satomi, published between 1814 and 1841
Nantai-zan: mountain in Shimotsuke
楠亭 **Nantei** (1775–1834): Maruyama-School painter, pupil of Ōkyo, also did some genre work
*Nishimura, Yoshō, Shifū
Nanto [Southern Capital]: Nara (so called after removal of the capital to Kyōto)
nanushi: mayor of a town, village or country
Nanzen-ji: major Zen temple in Kyōto
Naobumi, Ochiai (1861–1903): *waka* poet and scholar of Japanese literature
Naokuni (fl. 1750s–60s): ukiyo-e print artist and illustrator, Ōsaka School
*Mori Naokuni
Naoyoshi, Kumagai (1782–1862): *waka* poet of the later Edo Period
Nara: capital of Yamato Province and the capital of Japan from 710 to 784
Nara-ban: pre-Edo books printed in Nara
奈良絵本 **Nara-e-hon** [Nara Picture Books]: hand illustrated, private manuscript editions, issued from the later 16th to the 19th century

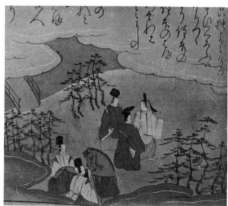

559

Narihira at the Sumiyoshi Shrine. Detail from a *Nara-e-hon* edition of the *Tales of Ise*; large-*ōbon*, ca. early 17th century

Nara-emaki: Nara-Picture scrolls
Nara Period: 710–84
Nariaki, Tokugawa (1800–60): *daimyō* of Mito; a staunch supporter of the Imperial restoration
業平 **Narihira, Ariwara** (825–80): distinguished poet whose verses and romantic adventures furnish the theme of the *Ise monogatari*

Narita: town in Shimōsa famous for its temple dedicated to Fudō, a focus for pilgrimages from all parts of Japan

Narukami: Kabuki play (one of the *Jūhachiban*), first staged by Danjūrō I in 1684.
▷ plate 45

Naruto: famous strait between Awa and Awaji

Natsu-matsuri Naniwa-kagami: Kabuki play, written for the Ōsaka actor Nizaemon I in 1745, featuring Kurobei and Giheiji.

nazorae: a comparison; also in the theater, a pastiche

negi: a Shintō priest

涅槃 **nehan:** the Buddhist nirvana; scene showing the death of the Buddha

Nehan-e: festival on the anniversary of Shaka's entrance into nirvana

ne-hon: Kabuki scenario

nemaki: night attire

nembutsu-odori: Buddhist prayer dance

年号 **nengō** [era-names] represent the principal Japanese method of dating from early times to the present day. Before the Meiji Restoration of 1868, they were often used independently from the reigns of individual Emperors, being changed by the *bakufu* authorities more or less at will (sometimes, simply to indicate a hoped-for change of luck after a government reorganization or natural calamity). Of the thirty-six *nengō* of the Tokugawa Period (1600–1868) some were as brief as a year or two, others extended over two decades. The more famous *nengō*—Kan-ei, Genroku, Kansei, Tempō—have come to represent and embody the characteristics of their times, and *nengō* are customarily used in Japanese to indicate special phases of an artist's or writer's career—e.g (for the early work of these masters), *Empō Moronobu, Temmei Utamaro, Kansei Toyokuni*. The following list covers all the *nengō* used in connection with ukiyo-e history, in chronological order. Under the separate *nengō* entries of this Dictionary will be found the writer's attempt to characterize ukiyo-e and related developments during each of the *nengō* periods, as well as to record the exact dates to which they correspond in the Japanese calendar. A consecutive reading of these Dictionary entries will provide an overall view of ukiyo-e development and decline during the three centuries in which it flourished.

N. B. The Japanese lunar calendar was several weeks behind that used in the West, resulting in much of the Japanese Twelfth Month falling in the following solar year, a fact we have indicated by such forms as "1644/45." Thus, although the Kan-ei Period is generally spoken of loosely as "1624–44" (or even, "43" in references that do not duplicate the final year of one era and the first of the next), the actual period corresponds to April 17, 1624 to January 12, 1645 in the Gregorian calendar. Such exact correspondences are usually not vital in ukiyo-e studies, unless there are specific references to foreign contact (in which case, of course, attention must be paid to the calendar in use by the foreign country concerned: English-speaking nations retained the Julian calendar until 1752, and Russia until after the First World War).

Naimushō, Chirikyoku (ed.). *Sansei sōran* (in Japanese). Tōkyō, 1932.

Tsuchihashi, P.Y. *Japanese Chronological Tables.* Tōkyō, 1952.

Lane, Richard. "Historical Eras in Ukiyo-e" in *Ukiyo-e Studies and Pleasures.* The Hague, 1978.

Keichō (1596–1615)	慶長元
Genna (1615–1624)	元和元
Kan-ei (1624–1644/45)	寛永元
Shōhō (1644/45–1648)	正保元
Keian (1648–1652)	慶安元
Jō-ō (1652–1655)	承應元
Meireki (1655–1658)	明暦元
Manji (1658–1661)	萬治元
Kambun (1661–1673)	寛文元
Empō (1673–1681)	延寶元
Tenna (1681–1684)	天和元
Jōkyō (1684–1688)	貞享元
Genroku (1688–1704)	元祿元
Hōei (1704–1711)	寶永元
Shōtoku (1711–1716)	正德元
Kyōhō (1716–1736)	享保元
Gembun (1736–1741)	元文元
Kampō (1741–1744)	寛保元
Enkyō (1744–1748)	延享元
Kan-en (1748–1751)	寛延元
Hōreki (1751–1764)	寶暦元
Meiwa (1764–1772)	明和元
An-ei (1772–1781)	安永元
Temmei (1781–1789)	天明元
Kansei (1789–1801)	寛政元
Kyōwa (1801–1804)	享和元
Bunka (1804–1818)	文化元
Bunsei (1818–1830/31)	文政元
Tempō (1830/31–1844/45)	天保元
Kōka (1844/45–1848)	弘化元
Kaei (1848–1854/55)	嘉永元
Ansei (1854/55–1860)	安政元
Man-en (1860–1861)	萬延元
Bunkyū (1861–1864)	文久元
Genji (1864–1865)	元治元
Keiō (1865–1868)	慶應元
Meiji (1868–1912)	明治元
Taishō (1912–1926)	大正
Shōwa (1926–)	昭和

nenjū-gyōji: term for the events of the year

ne-no-hi no asobi: festival of the First Day of the Mouse in the First Month of the year, when people gathered young pines (symbols of longevity)

鼠 **nezumi-iro** ▷ pigments

日蓮 **Nichiren** (1222–82): celebrated militant monk, founder of the Nichiren sect of Buddhism; violently attacking other sects, he was exiled first to Izu and later to the island of Sado (1271).

Nichiren-shū (Hokke-shū): Buddhist sect founded by Nichiren in 1253, always comprising the most turbulent and fanatic Buddhists in Japan

Nichirō (d. 1319): noted disciple of Nichiren

nigao-e: actor's portrait

日本橋 **Nihon-bashi:** bridge in the center of Edo, starting point of the Tōkaidō highway

Nihon jūni-kei: the 12 landscapes traditionally considered the most beautiful in Japan: Tago-no-ura (Suruga), Matsushima (Rikuzen), Hakozaki (Rikuchū), Ama-no-hashidate (Tango), Waka-no-ura (Kii), Lake Biwa (Ōmi), Itsuku-shima (Aki), Kisakata (Ugo), Asama-yama (Ise), Matsue (Izumo), Akashi (Harima) and Kanazawa (Musashi)

Nihon san-kei: the 3 landscapes considered the most beautiful in Japan: Itsukushima (Aki), Ama-no-hashidate (Tango) and Matsushima (Rikuzen)

Niigata: capital of Echigo Province; formerly called *Tsuchifuta-no-sato*

Nijō-jō: Kyōto shogunate castle

nijū-butai: raised platform in Kabuki theater

nijū-go bosatsu: the 25 most revered bodhisattvas of Buddhism: Kannon. Seishi, Fugen *et al.*

廿四孝 **nijūshi-kō:** the twenty-four [Chinese] Paragons of Filial Piety, often depicted in ukiyo-e:

1 Taishun (Ta Shun)
2 Mōsō (Mêng Tsung) or Kōbu (Kung Wu)
3 Kan no Buntei (Han Wên-ti)
4 Teiran (Ting Lan)
5 Binson (Min Sun)
6 Sosan (Tsêng Ts'an)
7 Ōshō (Wang Hsiang)
8 Rōraishi (Lao Lai-Tzu)
9 Kyōshi (Chiang Shih)
10 Saishi (Ts'ui Shih) or Tō-*fujin* (T'ang *fu-jên*:
11 Yōkō (Yang Hsiang)
12 Tōei (Tung Yung)
13 Kōkō (Huang Hsiang)
14 Kakkyo (Kuo-Chiü)
15 Shujushō (Chu Shou-ch'ang)
16 Enshi (Yen Tzu)
17 Saijun (Ts'ai Shun)
18 Yukinrō (Yü Ch'ien-lou)
19 Rikuseki (Lu Chi)
20 The brothers Denshin (T'ien Chên), Denkei (T'ien Ch'ing) and Denkō (T'ien Kuang) or Ōhō (Wang Pao)
21/22 The brothers Chōkō (Chang Hsiao) and Chōrei (Chang Li) or Chūyū (Chung Yu) and Kōkaku (Chiang Ko)
23 Gomō (Wu Mêng)
24 Kōteiken (Huang T'ing-chien) or Sankoku (Shan Ku)

Nikka (d. 1845): Shijō-School painter; also did some genre work
*Tanaka, Hakki, Benji, Fumei, Getcho, Tsuki-o-nagisa

日光 **Nikkō:** town in Shimotsuke Province renowned for its scenery and temples, where the remains of Ieyasu are interred

Nikkō-kaidō: highway from Edo to Nikkō (91 miles/146 km long)

ningyō-shibai: puppet theater

人情本 **ninjō-bon** [books of sentiment.]: love novels of the 19th century

ni-no-kawari: New Year's Kabuki performance

Niō-mon: gate of a Buddhist temple decorated with a guardian statue on each side

Nipponsai (fl. ca. early 19th century): ukiyo-e print artist in Kyōto; did actor prints in the style of Ryūkōsai

Nippori: picturesque area northeast of Edo, noted for its temple flower gardens

Nise-Murasaki inaka-Genji: novel by Tanehiko published between 1829 and 1842; a pastiche of the *Genji monogatari* and a veiled parody on the Shōgun Ienari and his harem

Nishikido: Noh drama concerning Nishikido no Tarō

錦絵 **nishiki-e** [brocade pictures]: the full-color print, a development of 1764–65 and a natural extension of the technique of *benizuri-e* to a full scale of colors; most of the prints from Harunobu onward employ *nishiki-e* techniques. Among the more unusual devices found in *nishiki-e* is that of *karazuri* [empty printing: gauffrage]; it consists of heavy embossing with a block to which no color is applied; *karazuri*

is particularly effective in giving dimension to snow, waves and kimono patterns, but is of course hardly susceptible to ordinary reproduction methods.

俳 **niwaka** (*niwaka kyōgen*): an impromptu performance in the Yoshiwara, customarily enacted 仁 in the Eighth Month by geisha
和 **nobori**: travel to the Kyōto-Ōsaka region
嘉

信 **Nobufumi** (fl. ca. 1720s): ukiyo-e painter of 文 the Kaigetsudō School; worked in the stolid, matronly manner of Rifū

信 **Nobufusa** (fl. ca. 1720s): ukiyo-e print artist, 房 pupil of Masanobu
*Okumura Nobufusa

信 **Nobuharu** (fl. ca. early 1832): ukiyo-e print 春 artist, Ōsaka School
*Nishikawa Nobuharu

信 **Nobuhiro** (fl. ca. 1830s): Ōsaka ukiyo-e 広 print artist, pupil of Sadanobu
*Hasegawa Nobuhiro

信 **Nobukatsu** (fl. ca. 1830s): Ōsaka ukiyo-e 勝 print artist, pupil of Sadamasu and of Yanagawa Shigenobu
*Utagawa, Tessai

Nobukazu (fl. late 19th century): print artist, pupil of Chikanobu
*Watanabe, Jirō, Yōsai

叙 **Nobukiyo** (fl. 1713–27): a follower of 清 Sukenobu in Kyōto, working principally in the illustration of novels and verse anthologies. He was perhaps the most skilled artist of Sukenobu's school but does not seem to have worked in the more popular fields of the picture book or shunga.
*Kawashima Nobukiyo
Mizutani, Yumihiko. *Kohan shōsetsu sōga-shi*

信 **Nobumasa** (fl. 1830s–40s): ukiyo-e print 政 artist, Ōsaka School
*Yanagawa Nobumasa

Nobumitsu (fl. 1850s): ukiyo-e print artist, Ōsaka School

Nobunaga, Oda (1534–82): military dictator of Japan in the 16th century; famous warlord who first occupied Ōmi and Kyōto Provinces, then much of central Japan, governing from his castle on the shores of Lake Biwa at Azuchi; assassinated by Akechi Mitsuhide at the Honnōji in Kyōto, where he had set up his temporary residence

信 **Nobusada** (fl. 1823–32): ukiyo-e print 貞 artist, Ōsaka School, pupil of Shigenobu
*Yanagawa, Yukinobu

Nobusuke (mid 19th century): Ōsaka *dōban* artist
*Nakagawa, Naniwa Bungadō

信 **Nobuyuki** (fl. ca. 1720s): ukiyo-e painter in 之 the later Kaigetsudō manner
*Kūmeidō

Nobuyuki (fl. ca. 1790s): ukiyo-e painter, pupil of Eishi
*Unkei, Ashi

能 **Noh** [**Nō**]: the classical, masked drama of the pre-Edo Period, often influencing Kabuki; maintained as official entertainment by the military ruling class in the Edo Period

Nōin-hōshi: classical *waka* poet of the Heian Period

Nomi-no-Sukune: the fabled originator of *sumō* wrestling

-no-kami: title of the governor of a province, but sometimes only honorary in nature

No-no-miya: Noh drama featuring Prince Genji's love, the Lady Rokujō

noren: shop curtain, portière; by extension, the reputation of a shop or firm

Noriaki (1833–83): *dōban* artist
*Iwahashi Noriaki

Norinaga, Motoori (1730–1801): scholar and poet, famous for his studies of Japanese antiquity, which contributed to the revival of Shintoism and to the Imperial Restoration

至 **Norinobu** [Shishin] (fl. ca. 1770s): ukiyo-e 信 painter in the style of Harunobu

Northern and Southern Court [*Nambokuchō*] **Period** (1336–92): a time of civil war, when the Emperor Go-Daigo was banished and set up a rival "Southern Court" at Yoshino

鵺 **nue**: Noh drama featuring the *nue* [a monster with the head of a monkey, body of a badger, tail of a serpent] killed by Minamoto no Yorimasa

Nukada-no-ōkimi (late 7th century): *waka* poetess of the *Man-yō-shū*

nunome-zuri: printing with cloth texture

nureba: love scenes in Kabuki

nuregoto: sentimental play or story

-nyōgo: the Emperor's second wife

-nyo-in: title given to the widowed mother of an Emperor

Nyo-san-no-miya [Onna-san-no-miya]: a tragic heroine in the *Tale of Genji* (often depicted leading a kitten on a cord)

ōatari: great [stage] success

大 **ōban**: print size, ca. 15×10 in./38×25 cm; the 判 standard format (half of an *ō-bōsho* sheet)
▷ *baiōban*, large-*ōban*

obi: wide long sash on a kimono

obi-hiki [pulling off the *obi*]: indicates sexual violence in Kabuki

ōbon: the most common large book size, ca. 10½×7½ in./27×19 cm

Ōboshi Yuranosuke: fictional name for Ōishi Kuranosuke, leader of the 47 *rōnin*

ō-bōsho: large print size, about 20¼×9 in./51.2×23 cm

Ochikubo monogatari: an early tale, ca. 980

Odawara: town in Sagami Province on the Tōkaidō, the Hōjō rulers' residence; Hideyoshi captured it in 1590

Odawara-chōchin: lantern with folding case

odori: a dance

odoriko: dancing girl, predecessor of the geisha

お **O-Ei** (fl. 1820s–40s): ukiyo-e painter, 栄 print artist and illustrator; third daughter of Hokusai
*Nakajima, Ōi
▷ p. 172

大 **Ōe-yama**: mountain on the boundaries of Ya-江 mashiro and Tamba Provinces; also, Noh drama 山 featuring Minamoto no Yorimitsu [Raikō] and his conquest of the demon Shuten-dōji at Ōeyama

Ōgai, Mori (1862–1922): noted realistic novelist and physician

ogasawara-ryū: rules of etiquette in the arts of archery, horseback riding, etc., as formulated first by Ogasawara Nagahide

ōgata-chūban: print size, about 11×8½in./28.3×21.7 cm (a quarter of the size *ōbiro-bōsho*); the size of most of Harunobu's prints; usually abbreviated as *chūban*

ōgi: folding fan

ōgi-otoshi (*tōsen-kyō*): a fan-throwing game

Ogura-yama: hill near Saga west of Kyōto, where Fujiwara no Teika [Sadaie] is said to have compiled the famous verse anthology *Hyakunin isshu*

Oguri-hangan (1398–1464): medieval warrior, hero of many adventures (together with his love Terute-hime)

O-Han and **Chōemon**: famous lovers in fiction (a maiden and her middle aged neighbor), who both drowned themselves in the Katsura River near Kyōto

Ohara gokō: Noh drama featuring the ex-Empress Kenrei-mon-in and the retired Emperor Go-Shirakawa

大 **Ohara-me**: a peasant woman from Ohara 原 [Ohara], near Kyōto
女

O-Hatsu and **O-Nami**: shrine dancers, famous for their performance at the Yushima Tenjin Shrine in IV/1769, the subject of Harunobu (and Bunchō) prints

O-Hisa (Takashima O-Hisa): one of the reigning beauties among Edo girls during the 1790s. She was the daughter of a prosperous cake merchant near Ryōgoku Bridge and was only about fourteen when, around 1791, she began to attract favorable attention at her father's shop.

ō-hosoban: print size, about 14¾×6¾ in./38×17 cm
▷ *ō-tanzaku*

ohyakudo: a pilgrim's insistant, ritual act of supplication at a temple or shrine

Oie-ryū: official school of calligraphy in the Edo Period (also called Son-en-ryū)

Ōi-gawa: river which forms the limits between Suruga and Tōtōmi (108 miles/180 km. long)

Ōiratsume, Karu no (mid 5th century): *waka* poetess, daughter of the Emperor Ingyō (412–654)

Ōishi Yoshio (1659–1703): chief of the 47 *rōnin* of Akō, heroes of the *Chūshingura*

Ōita: capital of Bungo Province, formerly called Funai

ōju ▷ motome ni ōjite

ōka-basho: unlicensed houses of pleasure in Fukagawa, Nakasu and other plebeian sections of Edo

Ōkagami: an historical tale, probably 1118–23

Okakura, Tenshin (Kakuzō) (1862–1913): noted Meiji art critic and curator

O-Karu: a tragic heroine in the *Chūshingura*

Okina: Noh drama, consisting of a group of dances by an Elder, symbolic of longevity

O-Kita (Naniwa[-ya] O-Kita): a famous beauty of the 1790s. A waitress in the Naniwa-ya teahouse at Asakusa, she is often seen carrying a cup of tea on a tray; such beautiful girls were often the major attractions of their respective shops.

Okitsugu, Tanuma: (1719–88): minister who served the Shōguns Ieshige and Ieharu; in 1772 named *rōjū*, but his bad administration eventually caused him to be dismissed (1787)

大 **ōkubi-e**: bust portrait
首
絵 **Ōkura, Yamanoue no**: important *waka* poet of the *Man-yō-shū*

okuri-na: a posthumous name given to persons of rank

okuzuke: book colophon

応 **Ōkyo** (1733–95): founder of the Maruyama 挙 School; did some genre work
*Maruyama, Ōkyo [Masataka], Chūkin, Chūsen, Iwajirō, Mondo, Senrei

ō-metsuke: official inspectors under the Edo shōgun

Ōmi-hakkei [The Eight Views of Lake Biwa

(Ōmi)]: often the subject of ukiyo-e print series (as with many such series, there does not seem to be any universally recognized order of depiction):

1 *Ishiyama no shūgetsu* [The Autumn Moon at Ishiyama (Temple)]
2 *Hira no bosetsu* [Snow at Dusk on Mt. Hira] ▷ plate 73
3 *Seta no sekishō* [Evening Glow at Seta Bridge]
4 *Mii no banshō* [Evening Bell at Mii (Temple)]
5 *Yabase no kihan* [Returning Sailboats at Yabase]
6 *Awazu no seiran* [Sunset Sky at Awazu]
7 *Karasaki no yau* [Night Rain at Karasaki (Pine)] ▷ plate 182
8 *Katata no rakugan* [Wild Geese Descending at Katata]

Ōmu-Komachi: Noh drama concerning Komachi and the "Echoing Poem"

Ōmura: town in Hizen, residence of the Ōmura *daimyō*

onagori-kyōgen: a Kabuki actor's farewell performance

Onchi, Kōshiro (1891–1955): important modern print artist and book-designer; founder-member of the Nihon Sōsaku-hanga Kyōkai

560

Onchi: *Poem Number Nineteen: The Sea.* Extra-large *ōban*, mixed medium, 1952

鬼 **oni:** demons and goblins, famous in Japanese folklore; called *hyakki-yakō* when they march at night in bands of a hundred or so

oni-gokko: game of puss-in-the-corner

Ōnin-no-ran: the civil war of the years 1467–1477, when much of Kyōto and its environs were laid waste

Onitsura, Kamijima (1661–1738): *haiku* poet of the mid Edo Period

Onjōji ▷ Mii-dera

onna-gata: female impersonator in Kabuki

onna-kabuki: Women's Kabuki of the early 17th century

Onomichi: town in Bingo Province, port on the Inland Sea

Ontake: "holy mountain" on the borders of Shinano and Hida Provinces

Onzōshi shima-watari: a tale of the diplomatic mission of Yoshitsune, probably 15th century

ōrai-mono: instructive books of enlightenment or etiquette for women and children

阿 **Oranda:** term for Holland
蘭
陀 **origami:** folded paper toys

O-Ryū (fl. ca. early 18th century): ukiyo-e painter in Edo; a precocious artist, she began to

女 paint at 7; her style shows the influence of
竜 Moronobu and of Sukenobu

*Yamazaki O-Ryū (Joryū, Ryū)

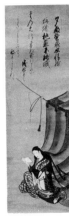

561

O-Ryū: *Courtesan by Mosquito Netting.* Detail of a *kakemono* in colors on paper, ca. 1720s

大 **Ōsaka:** capital of Settsu Province, in ancient
坂 times called Naniwa-no-tsu; the greatest commercial center of Japan from the 17th century

Ōsaka-e: Ōsaka Print ▷ Ōsaka-Print School

Ōsaka-jō: Ōsaka Castle, built by Hideyoshi in 1583–87; partly destroyed in the civil war of 1615

Ōsaka-no-seki: a barrier-station between Kyōto and Ōmi

Ōsaka-Print School: a branch of ukiyo-e consisting mainly of theatrical subjects characterized by a certain hardness of treatment, brilliance of coloring and impeccable printing; greatest popularity between 1820–45.
▷ pp.192–193

お **O-Sen** (Kagi-ya O-Sen): a famous waitress
仙 and beauty of the late 1760s; O-Sen is usually depicted in front of her teashop, the Kagi-ya, which stood beside the *torii* of the Kasamori Inari Shrine north of Edo.

お **O-Shichi** (Yao-ya O-Shichi) and **Kichisa:**
七 famous tragic lovers: O-Shichi (daughter of a wealthy grocer), in love with a page, Kichisa, in the Kichijōji Temple, burned down her own house in order to see him and subsequently was executed at the stake

oshidori: mandarin ducks (symbol of marital happiness)

押 **oshi-e:** patchwork picture; also, a euphemism
絵 for Kyōta-Ōsaka color prints

Ōshima: the largest of the Seven Isles of Izu; also known as "Vries Island," famous as a place of banishment

Ō-Shohei: the Chinese Immortal Huang Ch'u p'ing, often depicted touching his staff to stones that come alive in the shape of goats

Ōshū-kaidō: highway from Edo to Aomori (488 miles/786 km. long)

ōshukubai: a standard painting subject, plum tree with nightingale

O-Shun and **Dembei:** famous lovers: Dembei, a merchant in Kyōto, and O-Shun, a courtesan of the Gion quarter

osokuzu-no-e [posture pictures]: an early term for shunga ▷ shunga

O-Some and Hisamatsu: famous lovers in Ōsaka; their tragic liaison ended in double suicide

Ōta Dōkan (1432–86): founder of the castle and city of Edo; often represented standing in the rain, talking to a girl from whom he requested the loan of a raincoat but instead received a *yamabuki* flower (missing the poetic allusion)

ō-tanzaku: print size, about 14¾×6¾ in./ 38×17 cm ▷ *ō-hosoban*

O-Tatsu (fl. ca. 1810s): ukiyo-e painter, pupil and probably daughter of Hokusai; painted *bijin-ga* in the manner of Hokusai's work in the 1810s

御 *Katsushika, O-Tatsu (Tatsu, Tatsu-jo)
伽
草 **otogi-zōshi:** novelettes and fairy tales of the
子 Muromachi Period

otoko-date: a chivalrous commoner and man about town, always ready to assist the oppressed; the *otoko-date* formed several groups, among their leaders were Mizuno Jūrōzaemon, Baozuiin Chōbei, Karainu Gombei

otoko geisha: male entertainers

Otoko-yama: hill south of Kyōto, with the famous temple Iwashimizu Hachiman

Ōtsu: capital of Ōmi Province, with the castle of Sakamoto

大 **Ōtsu-e:** folk painting produced in the Ōtsu
津 region, near Kyōto
絵 ▷ p. 92, plate 86

Ōtsu-no-miko (663–86): *waka* poet, 3rd son of Emperor Temmu

O-Ume and **Kumenosuke:** famous lovers, whose liaison ended in a double suicide

owl [*fukurō*]: symbol of filial ingratitude; also, sometimes depicted being attacked by sparrows in daytime, when it is blind

o-zatsuma: special Kabuki samisen music for bold effects

P

pans on the head: (1) at the festival of a shrine in Ōmi, adulterous women carried on their heads the number of iron pans equal to that of their secret lovers during the previous year; (2) the maiden with a wooden bowl over her head, heroine of the famous fairy tale *Hachi-kazuki*

pawlonia [*kiri*]: symbol of rectitude; used by the Imperial family

peach [*momo*]: symbol of longevity

peas/beans [*mame*]: symbol of vitality and health; thrown about on New Year's Eve to cast out devils

pentaptych: a composition of five sheets side by side

petonies [*botan*]: symbol of regal power, often shown with *kara-jishi*

Perry, Commodore Matthew C. (1794–1858): officer in the American navy; his mission to Japan in 1853–54 resulted in a treaty that opened the ports of Shimoda and Hakodate to foreign vessels.

Statler, Oliver with Richard Lane. *The Black Ship Scroll. An Account of the Perry Expedition at Shimoda in 1854 and the Lively Beginnings of People-to-People Relations between Japan and America.* San Francisco and New York, 1963.

pigments: the colors employed in ukiyo-e prints and paintings have yet to be studied

scientifically, and the following notes are thus tentative. Some of the most common pigments, which vary from period to period, are

sumi: Chinese black ink, mixed in tones from deep black to light gray; a lustrous black is produced by adding rice-paste

tan: red oxide of lead, an anistropic pigment; tends to blacken on exposure

shōenji: red made from St. John's wort

beni: pink or rose made from the safflower, ranging in color from crimson to pale peach; tends to fade

kiō: yellow made from turmeric

ōdo: yellow ochre

ai: indigo, a fugitive color

olive tints: turmeric yellow or yellow ochre mixed with indigo

cha-no-iro: a mixture of red and yellow

beni-gara: mixture of red, yellow and black; also vermilion; later red ochre was also used, an opaque color varying from brick-red to chocolate, which often oxidizes to metallic blue

rokushō: verdigris green

murasaki: violet made from *shōenji* and indigo; customarily fades to a light reddish brown

asa-murasaki: lilac purple, made from indigo and carmine, much used by Toyokuni and later artists

airō: blue derived from *Mercurialis leiocarpa;* usually fades to a delicate buff

shido: red oxide of iron

nezumi-iro: pearl-gray made from mixing *sumi* with lead-white and mica

taisha-seki: red ochre

yū-ō: orpiment

shiō: gamboge (imported from Siam); fades very easily

Prussian blue: imported from Europe around 1820 and seen in the landscapes of Hokusai and Hiroshige; also mixed with orpiment to make green and with carmine to produce purple

aniline colors: introduced after 1860

In comparing different specimens, it should be remembered that the number of colors shown for a given print is, even in a careful catalogue, only a rough guide to the complexity of the printing. Such data usually include neither related shades of a single color nor the color of the keyblock (though black may be counted if applied other than by the keyblock); nor is such data a guide to the number of blocks used, since a single color may be printed several different times from different blocks to achieve numerous shade variations, or, on the other hand, different colors may be applied at different times by printing from portions of a single block. ("Gradation" usually indicates that a gradation of coloring has been achieved by wiping portions of the wet block before printing.) Note that, theoretically, an analysis of pigments should provide crucial evidence for determining authenticity; it must be remembered, however, that unless the control samples are absolutely genuine and unretouched, the results may be meaningless and even misleading.

pines [*matsu*]: symbol of strength, endurance, longevity, happy marriage

Pinto, Fernand Mendez: Portuguese traveler, the first Occidental to land in Japan (1542), carried by a storm to the island of Tane-ga-shima

plum tree [*ume*]: symbol of the New Year and of longevity

Primitives, ukiyo-e: the period from the first ukiyo-e prints, ca. 1660, until the development of full-color printing in 1765

proof [*kyōgo-zuri*]: a test impression of a print, often made only from the *sumi-ban* or keyblock

Provinces of Old Japan ▷ map, pp. 312–13

Rokujūyo-shū [the Sixty-odd Provinces]; also called *sho-koku* [the various provinces]. These were 68 in number from A.D. 823 to the Restoration of 1868; in formal use, -*no-kuni,* "province of," may be added as a suffix, and the names for the provinces are also often contracted—in Chinese-style readings, adding *shū* [province]; the most common abbreviations are given here in parentheses:

Kinai [The Home Provinces]:
1 Yamashiro (Jōshū)
2 Yamato (Washū)
3 Kawachi (Kashū)
4 Izumi (Senshū)
5 Settsu (Sesshū)
Tōkaidō [East-sea Circuit]:
6 Iga (Ishū)
7 Ise (Seishū)
8 Shima (Shishū)
9 Owari (Bishū)
10 Mikawa (Sanshū)
11 Tōtōmi (Enshū)
12 Suruga (Sunshū)
13 Kai (Kōshū)
14 Izu (Zushū)
15 Sagami (Sōshū)
16 Musashi (Bushū, also Bukō)
17 Awa (Bōshū)
18 Kazusa
19 Shimōsa (both, Sōshū)
20 Hitachi (Jōshū)
Tōsandō [East-mountain Circuit]:
21 Ōmi (Gōshū)
22 Mino (Nōshū)
23 Hida (Hishū)
24 Shinano (Shinshū)
25 Kōzuke [Kōtsuke] (Jōshū)
26 Shimotsuke (Yashū)
27 Mutsu/Michinoku (Ōshū)
28 Dewa (Ushū)
Hokurikudō [North-land Circuit]:
29 Wakasa (Jakushū)
30 Echizen (See 33, 34)
31 Kaga (Kashū)
32 Noto (Nōshū)
33 Etchū
34 Echigo (33–34 combined with 30 as Esshū)
35 Sado [Island] (Sashū)
San-indō [Mountain-shade Circuit]:
36 Tamba
37 Tango
38 Tajima (36–38 combined, as Tanshū)
39 Inaba (Inshū)
40 Hōki (Hakushū)
41 Izumo (Unshū)
42 Iwami (Sekishū)
43 Oki [Island] (Inshū)
San-yōdō [Mountain-sun Circuit]:
44 Harima (Banshū)
45 Mimasaka (Sakushū)
46 Bizen
47 Bitchū
48 Bingo (46–48 combined as Bishū)
49 Aki (Geishū)
50 Suō (Bōshū)
51 Nagato (Chōshū)
Nankaidō [South-sea Circuit]:
52 Kii [Ki-no-kuni] (Kishū)
53 Awaji [Island] (Tanshū)
54 Awa (Ashū)
55 Sanuki (Sanshū)
56 Iyo (Yoshū)
57 Tosa (Toshū) [54–57 comprise the large island of Shikoku]
Saikaidō [West-sea Circuit]:
58 Chikuzen
59 Chikugo (58–59 combined as Chikushū)
60 Buzen
61 Bungo (60–61 combined as Hōshū or Nihō)
62 Hizen
63 Higo (62–63 combined as Hishū)
64 Hyūga (Nisshū)
65 Ōsumi (Gūshū)
66 Satsuma (Sasshū) [58–66 comprise the large island of Kyūshū]
67 Iki [Island] (Ishū)
68 Tsushima [Island] (Taishū)

Prussian blue ▷ pigments

publishers' seals: print (and book) publishers generally had four names: surname and personal name, plus informal and formal shop-names (*yagō, dōgō*); for example, *Yamamoto, Kohei, Maru-ya, Hōsendō.* Often, however, more than one publisher used the same informal shop-name, and hence the most commonly used form was a contraction of this plus the personal name: in the present case, *Maru-Ko.* The following listing of the most frequently encountered publishers' trademarks is arranged (very roughly), by squares (including diamond shapes and angles), oblongs (including ovals), circles (including rhombus and other rounded designs), triangles (including marks under inverted V or Vs) and irregular shapes. No really comprehensive study of print publishers has yet been made, and dates are only approximate, based on a survey of actual publications extant rather than upon historical documentation. Seal shapes may vary, and in the Primitives, full publication data is often combined with the artist's signature (often in a box), falling beyond the range of readily classifiable trademarks.

Hangi-ya Shichirobei (ca. 1680s–1700s)

Sakai-ya (ca. 1720s–70s)

Kiku-ya (ca. 1720s–30s)

Yamato-ya (ca. 1710s–30s)

Komatsu-ya (Dembei) (ca. 1700s–40s)

Murata (ca. 1720s–1840s)

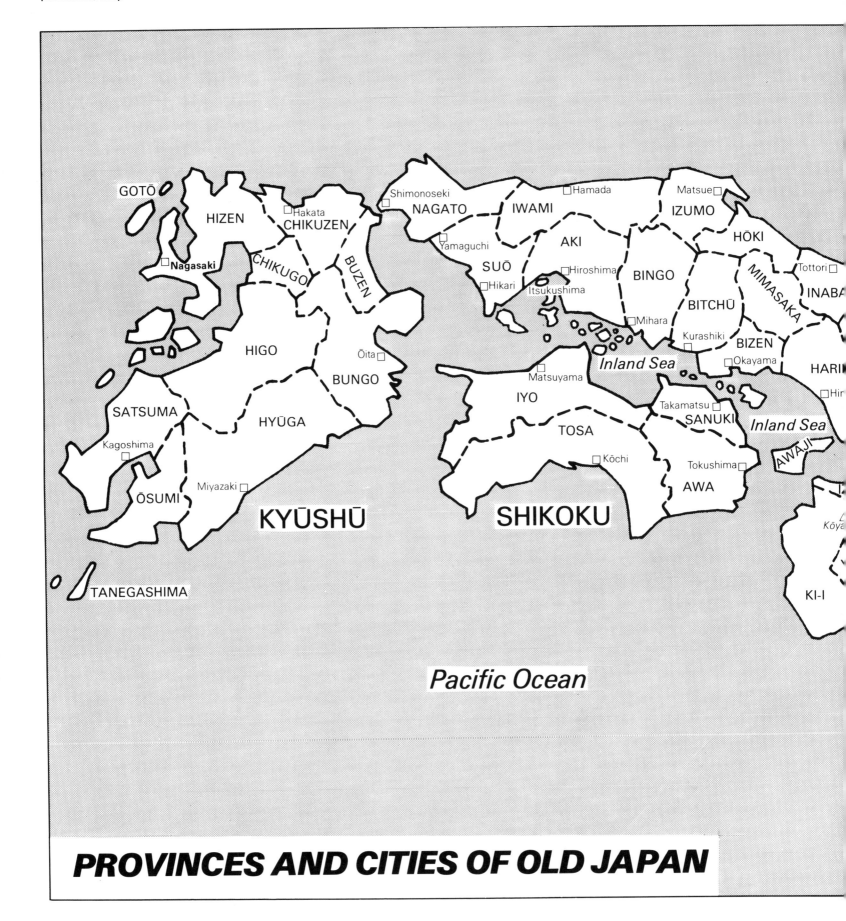

PROVINCES AND CITIES OF OLD JAPAN

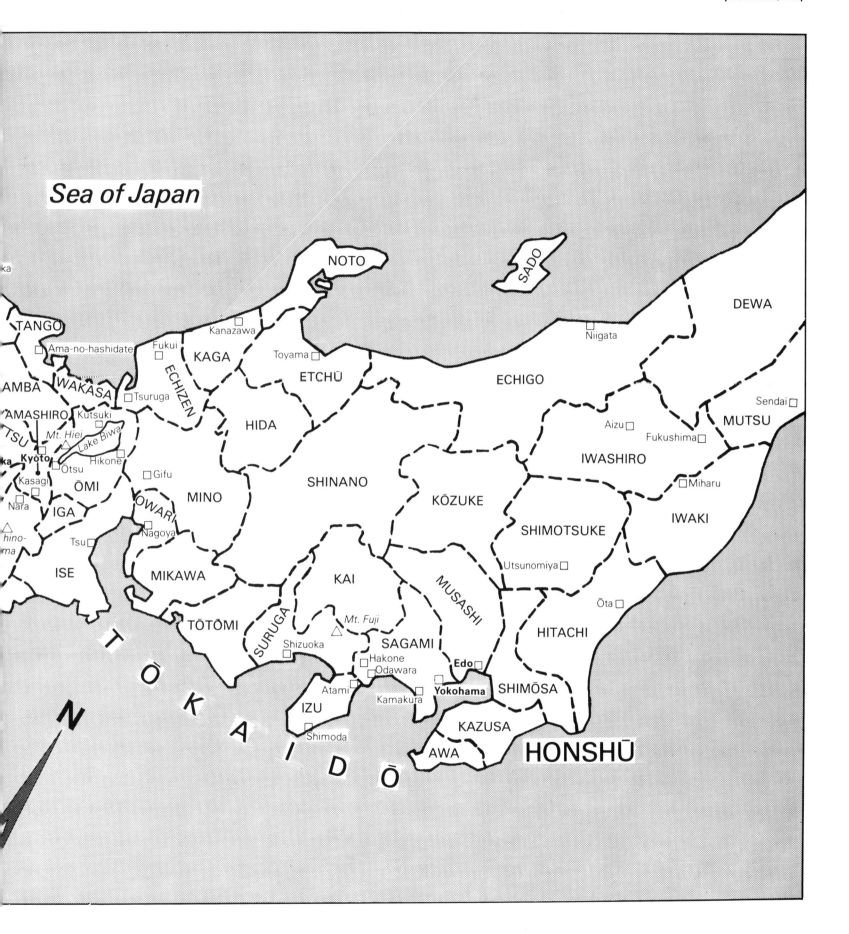

Sea of Japan

NOTO

SADO

DEWA

TANGO

Kanazawa

Niigata

Ama-no-hashidate

Fukui

KAGA

Toyama

ECHIGO

AMBA WAKASA

ECHIZEN

ETCHŪ

Sendai

Tsuruga

MUTSU

AMASHIRO Kutsuki

HIDA

Aizu

TSU Mt. Hiei Lake Biwa

Fukushima

ka Kyoto

IWASHIRO

Ōtsu Hikone

Kasagi Gifu

OMI

SHINANO

Miharu

Nara

OWARI

KŌZUKE

IWAKI

IGA

MINO

hino-ma

Nagoya

SHIMOTSUKE

Tsu

ISE

MIKAWA

KAI

Utsunomiya

Ōta

Mt. Fuji

MUSASHI

TŌTŌMI

SURUGA

HITACHI

Shizuoka

SAGAMI

Hakone

Odawara

Edo

Atami

Kamakura

Yokohama

SHIMŌSA

N

IZU

KAZUSA

Shimoda

AWA

HONSHŪ

T Ō K A I D Ō

313

 Eiyūdō (*dōgō* of Murata)

 Mikawa-ya (ca. 1740s–60s)

 Eijudō

 Nishimura Eijudō (Nishimura-ya Yohachi)

 Karamaro

 Kikaku [Kikakudō] = Sano-ya Kihei (ca. 1790s–1860s)

 Sano-Ki (ca. 1790s–1860s) Eisendō (Mita-ya Kihachi)

 Izutsu-ya Chūzaemon, Seisuidō (ca. 1680s–1860s)

 Izutsu-ya San-emon (ca. 1700s–40s)

 Yamato-ya (ca. 1710s–30s)

 Iga-ya Kan-emon, Bunkidō (ca. 1710s–40s)

 Enami (ca. 1750s–60s)

 Masu-ya (ca. 1740s–80s)

 Sakai-ya Kurobei (ca. 1750s–60s)

 Daikoku-ya Heikichi, Shōjudō (ca. 1818– Taishō)

 Tsuru-ya Kinsuke (Tsuru-Kin), Sōkakudō (ca. 1790s–1830s)

 Wakasa-ya Yoichi, Jakurindō (ca. 1790s– 1850s)

 Iga-ya Kan-emon II (ca. 1810s–50s)

 Azuma-ya Daisuke, Kinshūdō (ca. 1810s–20s)

 Sano-ya Kihei (Sano-Ki), Kikakudō (ca. 1790s–1860s)

 Nakamura-ya Katsugorō (ca. 1810s–40s)

 Sumimaru-ya Jinsuke (ca. 1800s–20s)

 Kiku-ya Ichibei (ca. 1830s–50s)

 Kawaguchi-ya Chōzō (ca. 1830s–40s)

 Fujiwara-ya Bunjirō (ca. 1830s–50s)

 Arita-ya Seiemon, Yūeidō (ca. 1840s–50s)

 Hamada-ya Tokubei (ca. 1810s–50s)

 Ebi-ya Rinnosuke (ca. 1830s–50s)

 Ise-Kane (ca. 1840s–50s)

 Ningyō-ya Takichi (ca. 1830s–50s)

 Tojima-ya Hikobei (En-Hiko) (ca. 1840s–50s)

 Ueda-ya Kyūjirō (ca. 1830s–40s)

 Sumiyoshi-ya Masagorō, Hōraidō (ca. 1800s–40s)

 Iga-ya (ca. 1710s–1840s)

 Suruga-ya (ca. 1740s–50s)

 Izutsu-ya (ca. 1680s–1740s)

 Ise[ya]-Kim[bei] (ca. 1720s–1800s)

Emi-ya (ca. 1710–1810s)

 Uemura (ca. 1740s–1810s), Emi-ya (Kichiemon)

 Iwai-ya (ca. 1730s–40s)

 Sagami-ya (ca. 1720s–30s)

 Komatsu-ya (ca. 1700s–40s)

 Masu-ya (ca. 1740–70s)

 Murata-ya Jirobei (ca. 1720s–1840s)

 Maru-Ko (ca. 1720s–80s)

 Yamamoto (Maru-ya Kohei—ca. 1720s–80s)

 Maru-ya Mikawa-ya (ca. 1740s–60s)

 Ise-Ri (ca. 1800s–40s)

 Kinjudō (*dōgō* of Ise-Ri)

 Tsuru-ya Kiemon

 Iwato-ya (Gempachi—ca. 1760s—70s) [later used by Sen-Ichi]

 Jakurindō (Wakasa-ya Yoichi)

 Wakasa-ya (Yoichi—ca. 1790s—1850s)

 Takasu

 Izumi-ya Ichibei (Sen-Ichi), Kansendō (ca. 1780s—1800s)

 Sano-Ki (ca. 1790s—1860s)

 Kawa-Shō[-zō] (ca. 1810s—40s)

 Shōeidō (dōgo of Kawa-Shō)

 Shōgendō (Fuji-Hiko)

 Fujioka [-ya] (Hikotarō)

 Jō-Kin (Jōshū-ya Kinzō) (ca. 1830s—50s)

 Ise-Kane (ca. 1840s—50s)

 Kawaguchi (Kawaguchi-ya Uhei, ca. 1790s— 1840s)

 Okumura-ya Genroku, Kakujudō (ca. 1750s—70s)

 Omi-ya Kuhei (ca. 1730s—40s)

 Sagami-ya (ca. 1720s—30s)

 Tomita (ca. 1740s—60s)

 Yamada-ya Sanshiro, Sanrindō (ca. 1680s— 1810s)

 Mikawa-ya Rihei II (ca. 1780s—1820s)

 Edo-ya Matsugorō (ca. 1810s—50s)

 Wakamatsu-ya Yoshirō (ca. 1830s—50s)

 Shio-ya Shōsaburō, Bunkadō (ca. 1830s—40s)

 Nakajima-ya (ca. 1710s—40s)

 Iga-ya (ca. 1710s—1840s)

 Nishimura Eijudō (Nishi-mura-ya Yohachi)

 Kōshodō (Tsuta-ya Jūsaburō)

 Takatsu-[ya Isuke]

 Take-Mago, Tsuru-Ki

 Hōeidō

 Take [no] uchi

 Kinoshita Jin-emon (ca. 1690s—1720s)

 Komatsu-ya Dembei (ca. 1700s—40s)

 Urokogata-ya Magobei, Rikakudō (ca. 1700s— 1780s)

 Nakajima-ya Risuke (ca. 1710s—1750s)

 Hirano-ya Kichibei, Aikindō (ca. 1720s—30s)

 Tsuru-ya Kiemon, Senkakudō (ca. 1670s— 1860s)

 Izumi-ya Gonshirō (ca. 1710s—30s)

 Edo-ya (ca. 1730s—50s)

 Maru-ya Kyūzaemon (ca. 1730s—40s)

 Murata-ya Jirobei, Eiyūdō (ca. 1720s—1840s)

 Maru-ya Kohei (Maru-Ko), Hōsendō (ca. 1720s—80s)

 Mikawa-ya Rihei (ca. 1740s—60s)

Ise-ya Kimbei (ca. 1720s—1800s)

 Fushimi-ya Zenroku, Daikandō (ca. 1767– Taishō)

 Nishimura-ya Genroku, Bunkakudō (ca.1720s– 1770s)

 Iwato-ya Kisaburō, Eirindō (ca. 1790s–1820s)

 Matsumura Yahei

 Emi-ya Kichiemon, Rankōdō (ca. 1710s– 1810s)

 Maru-ya Bun-emon (Maru-Bun), Bunjudō (ca. 1790s–1810s)

 Ise-ya Jisuke (ca. 1770s–1810s)

 Wakamatsu-ya Gensuke (ca. 1750s–60s)

 Ezaki-ya Kichibei, Tenjudō (ca. 1790s–1840s)

 Ise-Mago (ca. 1790s–1810s)

 Maru-ya Jimpachi (Maru-Jin), Enjudō (ca. 1760s–1850s)

 Nishimi-ya Shinroku, Gangetsudō (ca. 1760s– 1810s)

 Ise-ya Sōemon, Taieidō (ca. 1780s–Taishō)

 Ise-ya Sanjirō (ca. 1790s–1840s)

 Maru-ya Seijirō (Maru-Sei), Jukakudō (ca. 1810s–50s)

 Ōsaka-ya Shōsuke (ca. 1800s–40s)

 Iba-ya Sensaburō, Dansendō (ca. 1810s–50s)

 Iba-ya Kyūbei (ca. 1840s–50s)

 Sawamura-ya Rihei (ca. 1830s–50s)

 Take [no] Uchi Magohachi, Hōeidō (ca.1830s)

 Tsuru-Shin (ca. 1750s–60s) [later used by Mori-Ji]

 Ogawa Shichirobei (ca. 1720s–30s); also Enomoto Kichibei (ca. 1780s–1800s)

 Yamashiro-ya, Shōkakudō (ca. 1730s–50s)

 Iwai-ya (ca. 1730s–40s)

 Suruga-ya (ca. 1740s–50s)

 Nishimura-ya Yohachi, Eijudō (ca. 1730s– 1840s)

 Tsuta-ya Jūzaburō (Tsuta-Jū), Kōshodō (ca. 1770s–1840s)

 Takasu Sōshichi, Fuyōdō (ca. 1780s–1800s)

 Iwato-ya Gempachi (ca. 1760s–70s)

 Matsumura Yahei (ca. 1730s–1810s)

 Kaga-ya Kichibei (ca. 1810s–50s)

 Toshima-ya Bunjiemon, Bunkindō (ca.1770s– 1800s)

 Mori-ya Jihei (Mori-Ji), Kinshindō (1800s– 1850s)

 Matsumoto Sahei (ca. 1800s–50s)

 Yamada-ya Sasuke (ca. 1790s–1810s)

 Yamashiro-ya Tōkei (ca. 1790s–1820s)

 Izumi-ya Ichibei, Kansendō (ca. 1780s–1860s)

 Yamamoto-ya Heikichi, Eikyūdō (ca. 1800s– 1850s)

 Takatsu-ya Isuke (ca. 1780s–1810s)

 Yama-den (ca. 1790s–1810s)

 Kinshodō (ca. 1800s–30s)

 Kawaguchi-ya Uhei, Fukusendō (ca. 1790s– 1840s)

 Sōshū-ya Yohei (ca. 1790s–1850s)

 Tsuta-ya Kichizō (ca. 1800s–60s)

 Kawaguchi-ya Shōzō (Kawa-Shō), Shōeidō (ca. 1810s–40s)

 Ōmi-ya Yohei (ca. 1790s–1810s)

 Yamazaki-ya Kimbei (Yama-Kin), Sankindō (ca. 1760s–1820s)

 Ezaki-ya Tatsukura (E-Tatsu) (ca. 1810s–50s)

 Jōshū-ya Jūzō, Kinchōdō (ca. 1840s)

 Ebisu-ya Shōshichi, Kinshōdō (ca. 1840s–50s)

 Ise-ya Rihei (Ise-Ri), Kinjudō (ca. 1800s–40s)

 Yorozu-ya Kichibei (ca. 1830s–50s)

 Jōshū-ya Kinzō (ca. 1830s–50s)

 Echizen-ya Heisaburō (ca. 1830s–50s)

 Yamada-ya Shōbei (ca. 1850s–60s)

 Fujioka-ya Keijirō (Fuji-Kei), Shōrindō (ca. 1840s–60s)

 Echigo-ya Chōhachi (ca. 1780s–1850s)

 Fujioka-ya Hikotaro (Fuji-Hiko), Shōgendō (ca. 1820s–50s)

 Tsujioka-ya Bunsuke, Kinshōdō (ca. 1820s– 1850s)

 Morita-ya Hanjirō (ca. 1830s–50s)

 Omi-ya Heihachi (ca. 1820s–50s)

 Shin Ise-ya Kohei (ca. 1840s–50s)

 Yamada-ya Jūhei (ca. 1830s–50s)

 Daikoku-ya Kyūbei (ca. 1830s–50s)

 Maru-ya Kyūshirō (ca. 1820s–50s)

 Chichibu-ya (ca. 1780s)

 Harima-ya Shinshichi (ca. 1760s–90s)

 Kiri-ya (ca. 1730s–50s)

 Yamaguchi-ya Tōbei, Kinkōdō (ca. 1780s– 1860s)

Yamaguchi-ya Chūsuke (ca. 1790s–1810s)

Akamatsu Shōtarō (ca. 1820s–40s)

Ise-ya Heibei (ca. 1830s–50s)

*Ishii, Kendo and Kikuo Hirose. *Jihon nishiki-e tonya-fu.* (in Japanese) Tōkyō, 1920.

punishments: for commoners under the Tokugawa regime these were handcuffing [*tejō*] for 30 to 100 days; scourging [*tataki*] with 50 or 100 strokes; banishment [*tsuihō*]; exile to a distant island [*entō*]; execution [*shizai*], by simple decapitation [*kubi-kiri* or *zanzai*], by burning at the stake [*hi-aburi*], by decapitation with subsequent exhibition of the head [*sarashi-kubi*], by crucifixion [*haritsuke*], by dismemberment with a saw [*nokogiri-biki*] and quartering by 4 oxen [*ushi-zaki*]—a penalty reserved for major criminals. These punishments were not administered to the samurai, who had the privilege of committing *harakiri*. ▷ banishment

Putiatin [Poutiatine], **Admiral**: Russian naval officer who arrived at Nagasaki in 1853 and, in the beginning of 1855, signed a port convention similar to that of Perry

R

Raiden (*Tsumado*): Noh drama concerning the thunder god (here the angry spirit of the exiled minister Michizane)

Raidō (fl. 1750s–70s): ukiyo-e painter, influenced by Sukenobu

Raijin (Raiden): the thunder god

Raishō (1796–1871): Maruyama-School painter, did some genre work
*Nakajima, Shikei, Shintsūdō, Shumbunsai, Tōkō

雷洲 **Raishū** (fl. ca. 1830s–50s): *dōban* print artist in Edo; studied first under Hokusai, then with Aōdō Denzen and Shiba Kōkan
*Yasuda, Bunkaken, Bajō, Sadakichi, Willem van Leiden [in romanized form], Naoyoshi, Nobusuke, Shigebei, Shimpo, Mohei

rakan [*lohan*]: Buddhist sages; often depicted in groups of 16, 18 or 500

rakuchū rakugai: in and around Kyōto

落語 **rakugo**: a variety of story-telling, begun by Katsura Bunji (1773–1815)

Rakusai (fl. ca. early 1810s): ukiyo-e print artist, Kyōto School, possibly identical with Nagahide

蘭画 **ranga**: early Western-style painting by Japanese artists

rangakusha: Japanese scholars of Dutch (and other Western) matters

藍江 **Rankō** (1766–1830): Ōsaka painter, poet and tea master; pupil of Kangetsu
*Nakai, Tadashi, Hakuyō, Yōsei, Shiko

Rankōsai (fl. ca. 1800s): Ōsaka ukiyo-e print artist

Ransetsu, Hattori (1654–1707): *haiku* poet of the early to mid Edo Period, disciple of Bashō

Ranzan (fl. ca. early 19th century): *dōban* artist
*Takai Ranzan

羅生門 **Rashōmon**: the ancient southern gate of Kyōto; scene of the famous combat between Watanabe no Tsuna and the ogre Ibaraki

Razan, Hayashi (1583–1657): noted Confucian and scholar of Chinese learning, advisor to the Shōgun Ieyasu

Rei-jo, Arakida (1732–1806): *renga* poetess and writer of the mid Edo Period

Reikyō (fl. ca. early 19th century): *dōban* artist, pupil of Aōdō Denzen
*Arai Reikyō

Reizan (fl. ca. 1871): ukiyo-e print artist, Ōsaka School

rendai: litter used for crossing a large river without bridge

renga: "linked verse"; a verse form popular in the Muromachi and early Edo Periods, in which poets engaged in group composition, each participant taking his turn at contributing a stanza to the verse series on a given theme.

Rengetsu, Ōtagaki (1791–1875): noted *waka* poetess of the late Edo Period

renjū: a society of literati

Rennyo-shōnin (1415–99): noted reformer of the Shinshū Buddhist sect

Resanoff, Count: Russian diplomat, sent to negotiate a treaty with Japan at Nagasaki in 1804 but unsuccessful; often depicted in *Nagasaki-e*

ri: a league (2.439 miles/3.927 km); also 36 *chō* (3927 m/12,884 ft)

里風 **Rifū** (fl. ca. 1720s): ukiyo-e painter, Kaigetsudō School; worked in the manner of Anchi's later work
*Tōsendō

李伯 **Ri-Haku**: Li Po, the most celebrated of the Chinese T'ang poets (699–762), often shown gazing at a waterfall or riding on a dragon

Rijō, Ryūtei (d. 1841): *kokkei-bon* writer of the late Edo Period

Riken, Nakai (1732–1816): Ōsaka man of letters and translator from the Dutch

Rikō (fl. ca. mid 1820s): ukiyo-e print artist, Ōsaka School
*Keichū

rikugei [the Six Accomplishments]:
1 *rei*: etiquette
2 *gaku*: music
3 *sha*: archery
4 *gyo*: horsemanship
5 *sho*: literature and calligraphy
6 *sū*: mathematics

Rikyū, Sen (1520–91): a master of the arts of flower arrangement and of the tea ceremony

Rimpa School: the decorative school founded by Sōtatsu and consolidated by Kōrin

Rimpū, Sasakawa (1870–1949): critic, art historian and *haiku* poet

林和靖 **Rin-Nasei**: the Chinese poet Lin Ho-ching, usually represented, with one or two cranes, under a plum tree

riu: archaic spelling of *ryū* (e.g., Koriusai)

Roan, Ozawa (1723–1801): *waka* poet and literary critic of the mid Edo Period

Rōben (689–773): abbot of the Tōdaiji temple in Nara; erected the famous *daibutsu*

廬朝 **Rochō** (1748–1836): an ukiyo-e painter, print artist and illustrator; a samurai, he was a pupil of Shigemasa
*Mizuno, Kōjirō, Genkyū, Chōkōsai, Hanrinsai, Seisenkan, Suirochō

Rodriguez, John (1559–1633): Portuguese Jesuit who came to Japan in 1585, studied the Japanese language and was chosen by Hideyoshi and Ieyasu as interpreter; published the first dictionary and grammar of the Japanese language in 1604

rōei: song versions of Chinese poetry, prose or of Japanese *waka*

Rohan, Kōda (1867–1947): novelist, dramatist and essayist

rōjū [*rōchū*]: members of the shōgun's council

Roka, Tokutomi (1868–1927): novelist and essayist

Rokei (fl. ca. 1800s): ukiyo-e print artist, Ōsaka School, possibly the father of Ashikuni
*Asayama Rokei

Rokkakudō: Kyōto temple, headquarters of the Ike-no-bō School of traditional flower arrangement

六歌仙 **rokkasen** [The Six Poetical Genii (of the 9th century)]:
1 Ariwara no Narihira
2 Sōjō Henjō
3 Ono no Komachi
4 Kisen-hōshi
5 Ōtomo no Kuronushi
6 Bunya [Fumiya] no Yasuhide

露好 **Rokō** (fl. ca. 1790s–1800s): Ōsaka ukiyo-e print artist, pupil of Shōkōsai or of Ryūkōsai

盧谷 **Rokoku** (fl. mid 19th century): Nagasaki painter and *dōban* artist
*Taguchi Rokoku

roku: mineral green (from malachite)

Rokugō: river south of Edo, the upper current being called Tamagawa

Rokuhara: ward of Kyōto, where the representative of the Kamakura shōgun resided

roku-Jizō: the 6 names by which the deity Jizō is honored

Rokujō-gawara: dry bed of the Kamo River, near Rokujō in Kyōto; a famous execution ground

Rokujō: 79th sovereign of Japan (1166–68), deposed at the age of 6

rokuro-kubi: long-necked goblin

rokushō ▷ pigments

Rongo: the Confucian Analects (*Lün-yü*)

rōnin: a lordless knight, a samurai who has lost his position and emoluments

roppō [six directions]: a roughly acted Kabuki role

Rosei: the Chinese Chao Lu-shêng, whose daydreams of glory proved so vivid that he gave up his worldly ambitions

Rosetsu (1754–99): Maruyama-School painter (pupil of Ōkyo); sometimes borrowed themes from ukiyo-e
*Nagasawa, Gyo, Hyōkei, Kazue, Gyosha, Inkyo, Kanshū

rōshu: proprietor of a courtesan house

rufu-bon: standard edition of a manuscript in printed form

Russo-Japanese War [*Nichiro-sensō*]: 1904–05

ryō: unit of gold currency

Ryō-daishi: a shrine on Ueno Hill

両国 **Ryōgoku**: large bridge across the Sumida River; also, the districts on either side of the river ▷ Edo, map

Ryōkan (1758–1831): *waka* poet and Zen priest of the mid to late Edo Period

Ryokuzan (1837–1903): *dōban* artist, son of Gengendō
*Matsuda (Matsumoto), Gengendō II, Atsutomo, Rankōtei, Rankōsai, Rankodō, Shinsendō

ryōmen-gajō: album with illustrations on both sides of the paper

Ryōshun, Imagawa (1326–?): *waka* and *renga* poet of the early Muromachi Period

Ryōun (ca. mid 19th century): Nagoya *dōban* artist, pupil of Bokusen

-ryū: school of art, etc.

立圃 **Ryūho** (1599–1669): Kyōto writer and illustrator in Tosa style (studied with Tanyū and Sōtatsu); best known for his *Jūjō Genji* of 1661

十帖源氏 *Hina-ya (Nonomura), Ryūho [Rippo], Shō-ō, Chikashige, Beni-ya Shōemon, Ichibei, Jirozaemon, Sōzaemon, Shōsai

Ryūjin (Ryū-ō): the mythical Dragon King of

the Sea, who lives in the submerged palace Ryūgū-jō

Ryūko (1801–59): neo-*Yamato-e* painter, did some genre work
*Takahisa (Hata, Kawakatsu), Takatsune, Jutsuji, U, Udō, Omoshirō, Baiju, Baisai, Ekiu, Kiryū, Kō Ryūko, Mudō-dōja, Mudō-sanjin

柳谷 **Ryūkoku** (fl. ca. 1800s): skilled ukiyo-e painter and print artist, in the late style of Utamaro
*Hishikawa, Enshūsai, Shungyōsai, Tenseisai

流光斎如圭 **Ryūkōsai** (1772–1816): ukiyo-e painter, print artist and illustrator. A founder of the Ōsaka-Print School, perhaps a pupil of Kangetsu, but influenced by the Edo Katsukawa School.
*Taga, Jokei Jihei
▷ pp.192–93, Ōsaka-Print School

562 Ryūkōsai: *Kinsaku on Stage* (left). *Hosoban*, ca. 1793

563 Ryūkōsai: *Shinshichi I as Yūki-no-kami* (right). *Hosoban*, 1793

Ryūkyū: the islands including Okinawa, Miyako and Yaeyama; an independent kingdom, which paid tribute both to Japan and to China

Ryūsetsu (mid 19th century): *dōban* artist, teacher of Shintarō
*Yanagida Ryūsetsu

Ryūsen (fl. ca. 1720s): ukiyo-e painter of the Kaigetsudō School; he combines the heavy sensuality of Dohan with the archness of Anchi
*Kanō Ryūsen

Ryūsen ▷ Tomonobu

柳村 **Ryūson** (fl. ca. 1880s): ukiyo-e print artist, influenced by Kiyochika. Surprisingly, little is known of this skilled Meiji print-maker. His works are few but marked by poetic distinction; in imaginative employment of atmospheric

564 Ryūson: *Yatsuyama by Moonlight*. *Ōban*, 1880

565 Ryūson: *Moonlight at Yushima*. *Ōban*, 1880

effects he often surpasses Kiyochika and follows in the line of Hiroshige. (Ryūson's prints frequently appeared in two versions, one of them coated with varnish to simulate Western oil painting.)
*Ogura Ryūson

Ryūsui (Ryōsui) (1711–96): illustrator and calligrapher in Edo; a member of Harunobu's circle. Illustrator of *Umi-no-sachi* (1762) and *Yama-no-sachi* (1765), both notable examples of early polychrome printing
*Katsuma, Antei, Shinsen, Haikōrin, Kōhairin, Ryūsuiō, Sekijudō, Sekijukan, Shūkoku

Ryūunsai (fl. ca. 1780s): ukiyo-e print artist, follower of Kiyonaga
*Fujiwara Ryūunsai

Ryūzan (1853–1907): *dōban* artist, younger brother of Ryokuzan and son of Gengendō
*Matsuda (Tami-ya)

S

貞房 **Sadafusa** (fl. ca. mid 1820s–40s): ukiyo-e print artist, first in Edo, then Ōsaka; pupil of Kunisada
*Utagawa, Gofūtei, Gohyōtei, Gokitei, Shinsai, Tōchōrō

貞春 **Sadaharu** (fl. ca. 1830s–early 40s): Ōsaka ukiyo-e print artist
*Hasegawa, Goryūtei, Goshōtei

貞秀 **Sadahide** (1807–73): notable ukiyo-e painter and print artist, working in Edo and Yokohama; pupil of Kunisada

566 Sadahide: *Maiden under Cherry Blossoms*. *Ōban*, one sheet of a triptych, ca. 1830s

*Utagawa (Hashimoto), Kenjirō, Gountei, Gyokuō, Gyokuran, Gyokuransai, Gyokurantei
▷ p. 192, plate 195

貞広 **Sadahiro** (fl. ca. 1825–75): Ōsaka ukiyo-e print artist; studied under the Ōsaka Shijō-School painter Kōchō and in Edo under Kunisada
*Utagawa (Nanakawa), Gochōtei, Gokitei, Gorakutei, Gōsotei, Kōgadō
▷ Ōsaka-Print School

567 Sadahiro: *At the Mouth of the Aji River*. *Ōban*, from the series *Naniwa fūkei no uchi*, ca. 1840

Sadahiro II (fl. ca. 1864–76): ukiyo-e print artist, Ōsaka School; student of Hirosada
*Mitani, Hirokane, Shōkōtei, Matasaburō

Sadaijin, Kawara-no (10th century): a classical *waka* poet

貞景 **Sadakage** (fl. ca. 1820s–30s): ukiyo-e print artist, first in Edo, later in Ōsaka; pupil of Kunisada
*Utagawa (Kojima), Gokotei

568 Sadakage: *Women of Edo*. *Ōban* triptych, ca. early 1830s

Sadakatsu (fl. ca. 1840s): ukiyo-e print artist, Ōsaka School

Sadakazu (fl. ca. mid 1820s): ukiyo-e print artist, Ōsaka School
*Kudaradō, Isshinsai, Shinsai

Sadakichi (Taishō): *dōban* artist, pupil of Kyokuzan
*Noda Sadakichi

Sadamaru (fl. ca. 1830s): Ōsaka ukiyo-e print artist
*Utagawa Sadamaru [Sadamaro]

Sadamasa (fl. ca. 1840s): Ōsaka ukiyo-e print artist, pupil of Sadanobu
*Hasegawa Sadamasa

Sadamasu II (fl. ca. 1830s): Ōsaka ukiyo-e print artist, pupil of Kunisada or Kunimasu
*Utagawa Sadamasu

Sadanobu (fl. ca. 1730s): ukiyo-e print artist in the manner of Masanobu and Kiyomasu II
*Tamura Sadanobu

貞信 **Sadanobu** (1809–79): Ōsaka ukiyo-e print artist, pupil first of the Shijō-School painter Kōchō and in the early 1830s of Sadamasu

*Hasegawa, Bunkichi (Tokubei), Kinkadō, Nansō, Nansōrō, Ryokuitsusai, Sekken, Shin-ō, Shinten-ō
▷ Ōsaka-Print School
Sadanobu II (fl. 1848–86): ukiyo-e print artist, Ōsaka School, son of Sadanobu
*Hasegawa, Tokutarō, Konobu
Sadanobu, Matsudaira (1758–1829): *rōjū* of the Shōgun Ienari (1790) and author of the sweeping Kansei-era reforms
Sadataka (fl. ca. late 1830s): ukiyo-e print artist, Edo/Ōsaka School
貞武 **Sadatake** (fl. ca. 1720s–40s): ukiyo-e illustrator, a follower of Sukenobu in Kyōto; his principal work was the picture book *Ehon Waka-no-ura*, 1734
*Takagi, Kōsuke

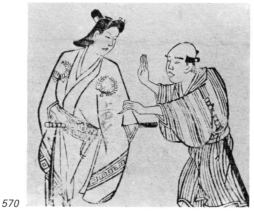

和歌浦
569 Sadatake: plate from *Ehon Waka-no-ura*, ōbon, Kyōto, 1734

貞虎 **Sadatora** (fl. ca. 1817–1830s): ukiyo-e print artist and illustrator, pupil of Kunisada
*Utagawa, Yonosuke, Gofūtei
Sadatoshi (fl. ca. 1720s): ukiyo-e print artist and illustrator in Kyōto
Sadatsugu (fl. ca. late 1830s): ukiyo-e print artist, Ōsaka School, pupil of Kunisada
*Goshōtei
Sadayoshi (fl. ca. 1760s): ukiyo-e print artist, Ōsaka School
*Yoshikawa Sadayoshi
Sadayoshi (fl. ca. 1837–60s): Ōsaka ukiyo-e print artist, pupil first of Kunisada, later of Sadamasu
*Utagawa, Higo-ya Sadashichirō, Baisoen, Kinkin, Gofūtei, Gohyōtei, Kaishuntei, Koku-hyōtei
Sadayoshi (fl. ca. 1850s): ukiyo-e print artist, Ōsaka School, pupil of Kunisada
*Utagawa Sadayoshi
Sadayuki (fl. ca. late 1830s): ukiyo-e print artist, Ōsaka School, pupil of Sadamasu
Sado: a large island off the west coast of Japan, renowned for its gold mines and for many years a place of exile for important personages: the Emperor Juntoku, St. Nichiren, *et al.*
Saga: village west of Kyōto
Saga: the chief city of Hizen Province in Kyū-shū
Saga (786–842): *waka* poet and 52th sovereign of Japan
saga-bon: quality books printed privately from movable type by Hon-ami Kōetsu and Suminokura Soan at Saga, near Kyōto, ca. 1608–24; also called *suminokura-bon*
▷ *Kōetsu-bon*
Sagami: a famous *waka* poetess of the 11th century
Sagi-musume: the legendary Heron Maiden
Sagoromo monogatari: an early poetic tale, composed between 1045 and 1058

saibara: early folk songs
Saigyō-hōshi (1118–90): famous wandering priest and *waka* poet; when the Shōgun Yoritomo presented him with a precious silver cat, Saigyō gave it to the first child he met in the street, a scene sometimes depicted in prints
Saigyō-zakura: Noh drama about the poet-priest Saigyō
再版 **saihan**: term meaning reprint, facsimile
sairei banzuke: printed program for a festival
Sakai: a port in Izumi Province; during the Middle Ages, the principal seaport of Japan
西鶴 **Saikaku** (1642–93). Ōsaka poet, writer and illustrator. Apart from his achievement as the most important novelist of the Edo Period, during the years 1682–86 Saikaku also illustrated several of his own novels, in a unique style rather closer to the Kambun Master than to such Kamigata artists as Hambei.
*Ihara [Ibara], Kakuei, Man-ō, Niman-ō, Shōjuken, Saihō
Lane, Richard. *Studies in Edo Literature and Art.*
Lane, Richard. "Saikaku: Novelist of the Japanese Renaissance." Doctoral dissertation, Columbia University, 1958.
▷ p. 22

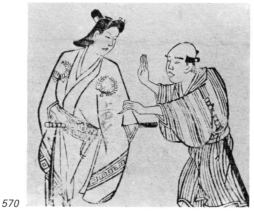

570 Saikaku: *Young Actor and Admirer*. Detail from *Naniwa no kao wa Ise no oshiroi*, ōbon, Ōsaka, 1681

Saikoku [The Western Provinces]: Kyūshū and the neighboring islands
Saiseki (fl. late 18th century): ukiyo-e painter
saitan: term meaning New Year, often appearing on greeting cards and pamphlets
歳旦 **saitan surimono**: *surimono* issued as New Year's greetings
Saiyū-ki [Journey to the West]: famous Chinese novel (English translation by Arthur Waley entitled *Monkey*), adapted by Bakin and illustrated by Hokusai
sajiki: screened theater boxes
sakazuki: saké cup
saké: Japanese rice wine
莎鶏 **Sakei** (fl. ca. mid 1760s): ukiyo-e print designer; did calendar prints in the Harunobu manner
*Suikōdō
Sakimaro, Tanabe no (mid 8th century): *waka* poet of the later *Man-yō-shū* period
Samba, Shikitei (1776–1822): fiction writer of the late Edo period, famous for his *kokkeibon* such as *Ukiyo-buro* and *Ukiyo-doko*
三番叟 **Sambasō**: a popular dance derived from the Noh play *Okina*
三幅対 **sambō**: a wooden tray used for votive offerings
sambuku-tsui: a set of three hanging scrolls; also (rarely) a print triptych

三味線 **samisen**: a three-stringed, guitar-like instrument, regularly used by geisha
sammai-tsuzuki: triptych
samurai [one who serves]: the knights of feudal Japan
sanchō-gake: narrow print size, an *ōban* sheet divided into three, longitudinally
Sanemori: a Noh drama concerning tales related by the ghost of the warrior Sanemori
Sanetaka, Sanjō-Nishi (1455–1537): *waka* and *renga* poet of the late Muromachi Period
Sanetomo, Minamoto-no (1192–1219): classical *waka* poet; son of Yoritomo and 3rd Kamakura shōgun; Yoriie's brother, assassinated by Yoriie's son near Kamakura
sangi: a high-ranking counselor
Sanjō-in nyokurōdo sakon: classical *waka* poetess
Sanjū-rokkasen: the Thirty-six Famous Poets, an 11th-century anthology of verse
sankin-kōtai [alternate attendance]: a legal institution of the shogunate (between 1634 and 1862) which obliged all *daimyō* to reside alternately in their provincial domains and in Edo; the occasion for all the *daimyō* processions seen in ukiyo-e
san-kyō: term for the 3 great religions of Japan: Shintōism, Buddhism, Confucianism
Sannin-hōshi: a religious tale, probably 15th century
Sano: old castle-town in Shimotsuke
山楽 **Sanraku** (1559–1635): major Kanō-School painter; taught by Kanō Eitoku, whose son-in-law he became; did some genre paintings
*Kanō (Kimura), Mitsuyori, Heizō, Shuri
san-senjin: the 3 gods of War: Marishiten, Daikokuten, Bishamonten; in art depicted as a man having 3 heads and 6 arms and mounted on a wild boar
Sanshō: a Noh drama about "Laughter among the Three Sages": the priest E-on (Hui Yuan), Tō Emmei (T'ao Yuan-ming) and Riku Shusei (Lu Hsiu-ching)
山水 **sansui**: a landscape
Sanuki-no-suke (early 12th century): *waka* poetess of the late Heian Period
Sanzu-gawa [Sōzu-gawa]: a river in the Buddhist Hell
Sao-yama: a Noh drama featuring Fujiwara no Toshiie and Sao-yama-hime, the goddess of Spring
sarasa: batik
sarashi-uri: a seller of printed cotton cloth
Saris, John: the founder of the English factory at Hirado (1613)
Saru-gani kassen: traditional tale of a feud between the monkey and the crab
Saru-Genji sōshi: a tale of a fishmonger winning a courtesan, probably 15th century
Saruta-hiko: a Shintō god
sasara: brushes used as percussion instruments in folk music
挿絵 **sashi-e**: a book illustration
sashimi: sliced raw fish, a delicacy
Satō (early Meiji): *dōban* artist
satsu: term meaning volume, fascicle
Satsuki: poetic name for the Fifth Month
Satta-yama (Satta-toge): a mountain pass in Suruga, near Okitsu
鞘絵 **saya-e**: a design appearing in normal proportions only when viewed with a curved mirror
Sayohime, Matsuura: the legendary wife of Sadehiko; when her husband was sent to Korea, she waited so patiently for him that she turned into a stone
Sayū (fl. 1760s): ukiyo-e print artist, painter and illustrator, Ōsaka School

*Katsura Sayū
Schools of Ukiyo-e ▷ Ukiyo-e School
script forms ▷ calendar, Japanese
Seia (fl. ca. mid 1760s–70s): ukiyo-e print artist
Seidō: the major temple to Confucius built in 1690 at Edo
Seiganji: a Noh drama featuring the priest Ippen-shōnin and the poetess Izumi Shikibu at the Seiganji [Temple] in Kyōto
Seihō (1864–1942): leading Shijō-School painter in Kyōto, did some genre work
*Takeuchi, Tsunekichi
Seijirō (early Meiji): dōban artist
*Shirai Seijirō
Seijurō (1841–96): dōban artist, studied with Ryōkuzan
*Nakamuru, Kimpo
Seika, Fujiwara (1561–1619): noted Confucian scholar
Seiki (1793–1805): Shijō-School painter, did some genre work
*Yokoyama, Kizō, Seibun, Shōsuke, Shume, Gogaku, Kajō, Kibun
Seikō (fl. 1810s–20s): surimono artist and illustrator of the Ōsaka School
*Seikō [Kiyoyoshi]
Seikyō (later 18th century): genre painter in the Jichōsai vein
Seimei, Abe no (d. 1005): a celebrated astronomer
西
王
母 **Sei-ōbo:** a Noh drama featuring the Emperor of China, the goddess Sei-ōbo (Hsi-Wang-mu) and a miraculous peach
Seiran (fl. ca. 1790s): ukiyo-e print artist, pupil of Eishi, only one of his print series is known: Seirō bijin rokkasen, ōban, ca. 1794.
青
楼 **seirō** [Green House]: a courtesan house
Seiryū (fl. mid 1810s): ukiyo-e print artist, Kyōto School
Seisai (fl. 1830s–40s): ukiyo-e print artist, Ōsaka School
Seishiki (fl. mid 19th century): dōban artist, pupil of Gengendō
*Matsuoka Seishiki
Seisui-shō: a collection of tales edited by Anrakuan Sakuden (1544–1642), a Kyōto monk
Seitei [Shōtei] (1851–1918): Japanese-style painter, pupil of Yōsai
*Watanabe (Yoshikawa), Yoshimata, Ryōsuke
井
特 **Seitoku** (1781–ca. 1829): Maruyama-School ukiyo-e painter in Kyōto, owner of the Izutsu-ya drug shop and geisha house in the Gion quarter; a leading painter of genre scenes, especially of geisha in a semi-realistic manner
*Gion, Tokuemon, Hokuryū ▷ genre painting
seki (sekisho): principal barrier-stations where travelers and their passports (fuda, warifu) were examined
石
版 **sekiban:** a lithograph
Sekichō (fl. ca. 1770s): ukiyo-e painter and print artist, pupil of Sekien
*Ensensha
Sekidera-Komachi: a Noh drama featuring Komachi at Sekidera [Temple]
石
燕 **Sekien** (1712–88): Kanō-School genre painter, print artist and book illustrator in Edo; pupil of Kanō Gyokuen and Kanō Chikanobu; later, the teacher of Utamaro, Chōki and other print artists
石
燕 *Toriyama (Sano), Toyofusa, Gessō, Gyokujuken, Reiryōdō, Sengetsudō, Sentandō
Illustrated books by Sekien include:
Sekien gafu (2 vols., 1774)
Ehon hyakki yakō (3 vols., 1776)
Suiko gasenran (3 vols., 1777)

Kaiji hiken (3 vols., 1778)
Konjaku zoku-hyakki (3 vols., 1779)
Hyakki yakō shūi (3 vols., 1789)
Gato saiyūdan (3 vols., 1783)
Gato hyakki tsurezure-bukuro (3 vols., 1784)
Kamakura no chikabito kashū (1 vol., 1781, with Sekiryū and Utamaro)
石
賀 **Sekiga** (fl. ca. 1770s): ukiyo-e print artist, pupil of Sekien
*Kinchōdō
Seki-ga-hara: a village in Mino where, in the year 1600, Ieyasu gained a decisive victory over Hideyori's forces, thus raising the Tokugawa to supreme power over Japan
Sekihō (fl. ca. 1800s): ukiyo-e print artist, pupil of Sekien; influenced by Utamaro
石
上 **Sekijō** (fl. ca. 1800s): ukiyo-e print artist and writer; originally a samurai of the Yamagata fief who moved to Edo; a pupil of Sekien, influenced by Utamaro
*Juka (Kajio), Gorobei, Hyakusai
Sekiran (1834–95): Shijō-School painter, did some genre work
*Okumura, Gengo
sekiwake: a category of champion sumō wrestlers
Sekkei (fl. early 19th century): Ōsaka genre painter, the second son of Settei; worked in his father's style
*Tsukioka Sekkei
Sekkō (fl. ca. mid 1810s): ukiyo-e print artist, Ōsaka School
Sekkō (fl. ca. 1830s): ukiyo-e print artist, Ōsaka School
Sekkō (fl. ca. 1830s): genre painter in Edo
*Hasegawa, Tōei, Chōsan, Tokutokusai
雪
嶠 **Sekkyō** (fl. ca. 1790s–1800s): ukiyo-e print artist, pupil of Tōrin
*Sawa Sekkyō
sembei: rice crackers
Semimaru: a Noh drama featuring the blind poet-minstrel Semimaru and his sister the Princess Sakagami
sencha: a school of the tea ceremony, favored by the literati
泉
晁 **Senchō** (fl. ca. 1830s–40s): ukiyo-e print artist, pupil of Eisen
*Kikukawa, Kichizō, Seichōtei, Sogetsuen, Teisai
Sendai Prints: generally large-ōban sumizuri-e, depicting legendary and Kabuki figures in ukiyo-e style, issued in Sendai from the 1770s until the mid 19th century; intended as advertisements, hence the name and address of the sponsor are usually recorded, but not those of the artist or publisher
sengoku-jidai: the period from ca. 1490 to 1600, during which Japan was involved in civil wars
Sen-hime [Princess Sen], Tokugawa (1597–1666): the daughter of Hidetada; after being widowed she came to Edo, where her name was connected with various amorous adventures (see plate 5)
Senji-mon [Book of 1,000 Characters]: a classic Chinese work
Senjō-dake: a mountain on the borders of Kai and Shinano
Senju: a Noh drama featuring Taira no Shigehira and Senju-no-mae
Senjū-shō: stories of monks and marvels, attributed to Saigyō-hōshi
senryū: satirical haiku epigrams, first devised by the poet Karai Senryū (1718–90)
Sensai (fl. ca. 1820s): ukiyo-e print artist, Ise School
sensu: a type of light, folding fan

Senzai-shū: Imperial verse anthology, 1188
seppuku [hara-kiri]: self-destruction by disemboweling
seridashi: Kabuki effect using trapdoor
雪
斎 **Sessai** (d. 1839): noted Ōsaka ukiyo-e painter, son and pupil of Settei; received ranks of hokkyō, hōgen
*Tsukioka, Shūei, Taikei, Kaikōsai
Lane, Richard. Studies in Ukiyo-e.

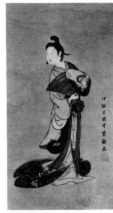

571
Sessai: *Courtesan with Fan. Kakemono* in colors on paper, ca. 1790s

Seta: a village in Ōmi, famous for its Chinese Bridge, and scene of numerous battles
setsuwa: brief folk tales
Settai (1887–1940): neo-ukiyo-e painter and illustrator
*Yasunami (Komura), Taisuke
Settai: a Noh drama featuring Yoshitsune and the old mother of Saitō Tsuginobu, Yoshitsune's faithful retainer, who sacrificed himself at the battle of Yashima
雪
旦 **Settan** (1778–1843): genre painter, print artist and illustrator in Edo; a pupil of Toyokuni, he later received the rank of hokkyō. Noted illustrator of Edo Meisho-zue and Tōto saiji-ki
*Hasegawa (Gotō), Munehide [Sōshū], Moemon, Gakutei, Gankakusai, Gangakutei, Ichiyōan, Ichiyōsai
雪
鼎 **Settei** (1710–87): this Kamigata master (d. XII/4/1786/7) began his artistic life as a pupil of the Sesshū-School painter Keiho but soon turned to the ukiyo-e style, creating his own school in Ōsaka. During his lifetime Settei was most famous for his paintings (including shunga), but he also produced over 30 different picture books and volumes of miscellanea, ca. 1753–71, as well as several notable shunga

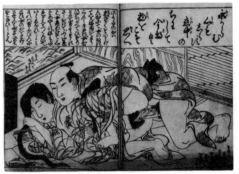

572
Settei: Shunga plate, illustration to *Onna-shime-kawa oshie-fumi* [Erotic Instruction for Women]. Ōbon, Kyōto, ca. 1750s (husband accosts wife at morning toilette)

volumes. In common with most early Kamigata artists he did not produce *ichimai-e* [independently issued prints], but his noted set of 12 double-size, color-printed shunga plates (issued in scroll format) ranks among the masterpieces of the period. Settei's Tsukioka School forms one of the main branches of Kamigata ukiyo-e painting, among Settei's pupils being his sons Sessai and Sekkei, as well as Munenobu [Sōshin], Kangetsu, Buzen and Gyokuzan.

Illustrated books by Settei include:
1 *Yūjo gojū-nin isshu* (2 vols., 1753)
2 *Tōgoku meisho-ki* (5 vols., 1762)
3 *Ehon musha-tazuna* (3 vols., 1759)
4 *Onna-buyū yosooi-kurabe* (3 vols., 1757)
5 *Kingyoku gafu* (6 vols., 1771)
Lane, Richard. *Studies in Ukiyo-e.*
▷ pp. 94, plate 89

雪　**Settei** (1819–92): genre painter, son and
堤　pupil of Settan
*Hasegawa, Sōichi, Baikō, Ganshōsai, Shōsei

Setten (1735–90): Ōsaka ukiyo-e painter, print artist and illustrator; pupil of Settei
*Katsura, Tsunemasa, Gengorō, Shōshin, Bizan, Tsūjin-dōjin

sewa-mono: plays about domestic life

sha: term meaning *delineavit* "drawn by," or "copied by"

shachi [dolphins, gold]: guardian symbols placed on the roofs of castles

釈　**Shaka:** name for Sakyamuni, the historical
迦　Buddha

石　**Shakkyō** [stone bridge]: a Kabuki dance
橋　based on a Noh play that features a sacred lion/lioness amid peonies

shakuhachi: a flute-like wind instrument made of bamboo

shakyō-sho: a scriptorium

Shamu: name for Siam

写　**Sharaku** (fl. 1794–95): famous ukiyo-e print
楽　artist, protege of the leading publisher Tsuta-
東　ya Jūzaburō; his extant prints date almost
洲　entirely from a ten-month period in 1794–95.
斎　Although Sharaku's genius is universally recognized today, in his own time the new element of sharp realism and psychological caricature in his art was hardly appreciated by the Edo populace, which doubtless accounts for his short career. Sharaku's earliest prints (the large actor portraits) were among his greatest and most original; they show an individuality of expression and depth of psychological probing hitherto unknown in ukiyo-e. In dynamic group composition Sharaku also excelled; in his panels of single standing figures, however, he reveals his basic debt to the school of Shunshō and fails to find the opportunity to wield his

573 Sharaku: *Yaozō III as Bunzō.* Ōban V/1794

574 Sharaku: *Mitsugorō II as Genzō.* Ōban, V/1794

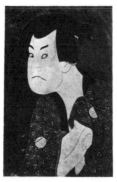
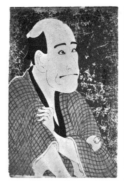

575 Sharaku: *Hangorō III as Mizuemon.* Ōban, V/1794

576 Sharaku: *Ryūzō as Kinkichi.* Ōban, V/1794

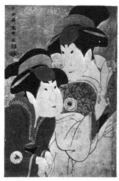
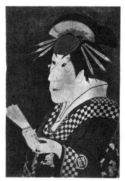

577 Sharaku: *Manyo and Tomisaburō II.* Ōban, V/1794

578 Sharaku: *Ichimatsu III as O-Nayo.* Ōban V/1794

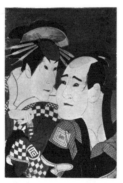
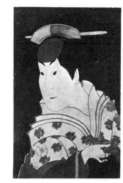

579 Sharaku: *Ichimatsu III and Tomiemon.* Ōban, V/1794

580 Sharaku: *Hanshirō IV as Shigenoi.* Ōban, V/1794

581 Sharaku: *Torazō as Hachiheiji.* Ōban, V/1794

582 Sharaku: *Ebizō as Sadanoshin.* Ōban, V/1794

583 Sharaku: *Omezō as Ippei.* Ōban, V/1794

584 Sharaku: *Tsuneyo II, probably as Sakuragi.* Ōban, V/1794

585 Sharaku: *Tomisaburō as Miyagino.* Ōban, V/1794

586 Sharaku: *Komazō II as Daishichi.* Ōban, V/1794

587 Sharaku: *Kōshirō IV as Gorobei.* Ōban, V/1794

588 Sharaku: *Konozō and Wadaemon.* Ōban, V/1794

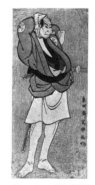

589 Sharaku: *Omezō as Hyōtarō.* Hosoban, VII/1794

590 Sharaku: *Oniji II as Jibugorō.* Hosoban, VII/1794

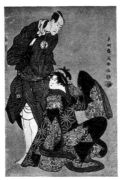

591 Sharaku: *Hikosaburō III and Hanshirō IV.* Ōban, VII/1794

592 Sharaku: *Sōjurō III and Kikunojō III.* Ōban, VII/1794

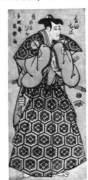

593 Sharaku: *Hangorō III and Yaozō III.* Ōban, VII/1794

594 Sharaku: *Kanya VIII as Nobutada.* Hosoban VIII/1794

595 Sharaku: *Komazō II as Munezumi.* Hosoban, VIII/1794

596 Sharaku: *Tomisaburō and Kōshirō IV.* Ōban, VIII/1794

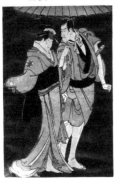
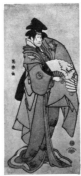

597 Sharaku: *Tomisaburō and Komazō II.* Ōban, VIII/1794

598 Sharaku: *Kikunojō III as Hisakata.* Hosoban, XI/1794

599 Sharaku: *Nakazō II as Mimishirō.* Hosoban, XI/1794

600 Sharaku: *The Boy Wrestler Bungorō.* Aiban, 1794

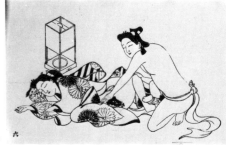

601 Sharaku: *Bungorō in the Arena.* Ōban triptych, 1794

incisive brush either in creative character portrayal or sinuous theatrical composition. To point out the limitations of Sharaku's genius at least serves to make the riddle of his existence more believable.
*Tōshūsāi
Kurth, Julius. *Sharaku.* Munich, 1910.
Rumpf, Fritz. *Sharaku.* Berlin, 1932.
● Henderson, Harold G. and Louis V. Ledoux. *The Surviving Works of Sharaku.* New York, 1939.
Inoue, Kazuo. *Sharaku.* (in Japanese) Tōkyō, 1940.
● Adachi, Toyohisa (ed.). *Sharaku: A Complete Collection* [woodblock reproductions]. Text by Yoshida, Teruji (in Japanese and English). Tōkyō, 1952 ff.
Kondō, Ichitarō. *Toshusai Sharaku.* (English adaptation by Paul C. Blum). Tōkyō, 1955.
Grilli, Elise. *Sharaku.* London, n.d.
Yoshida, Teruji. *Sharaku.* (in Japanese) Tōkyō, 1956.
Yashiro, Seiichi. *Sharaku-kō.* (in Japanese) Tōkyō, 1972.
Segi, Shin-ichi. *Sharaku.* (in Japanese) Tōkyō, 1975.
▷ pp. 122–27, plates 118–123

share-bon: novelettes of the mid to late Edo Period, portraying the amorous affairs of courtesans and gallants, also called *share-hon*
shari-tō: a miniature pagoda
Shaseki-shū: a collection of Buddhist stories in conversational style, 1279–83
Shazan (mid 19th century): *dōban* artist, possibly a pupil of Isaburō
*Genshindō Shazan, Kadō, Seiun, Woekiti/Oekiti [romanized forms for Ukichi]
Shiba: a district in Edo, southwest of the city, noted for its large Buddhist temples
shibai: term meaning theater, drama
shibai-e: a theater print
Shibakuni (fl. ca. 1820s): Ōsaka print artist, pupil of Yoshikuni
*Saikōtei
Shiba Onkō [Sze-ma Kuang]: Chinese statesman of the 11th century; in his boyhood he saved a companion from drowning in a large jar by breaking it with a stone

Shibaraku ["Wait a moment"]: a standard Kabuki interlude (one of the *Jūhachi-ban*), featuring a heroic samurai rescuing innocent young lovers from being executed; invented by Danjurō I as part of the drama *Sankai Nagoya* in 1697 and; annually revived thereafter in *kaomise* performances [see plates 64 and 112]
shibori (*shibori-zome*): cloth decorated by the tie-and-dye method
Shichibei (Meiji): *dōban* artist, pupil of Suisan
*Mitsuma Shichibei
Shichi-fukujin: The Seven Gods of Luck, derived from the legends of India, China and Japan: Benten, Bishamon, Daikoku, Ebisu, Fukurokuju, Hotei and Jurō
shichi-go-chō: a verse rhythm composed of seven and five syllables
Shichiki-ochi: a Noh drama featuring Minamoto no Yoritomo after his defeat at Ishibashiyama
Shichirobei (fl. ca. 1680–93): Ōsaka ukiyo-e artist, follower of Hambei. His principal signed work is the shunga picture book *Kōshoku meijo-makura* of 1686.
*Shimomura, Fusatomo
Lane, Richard. *Shunga Books of the Ukiyo-e School: V—Hambei and the Kamigata Masters.* 7 vols. of reproductions, plus text volume. Tōkyō, in press.
▷ p. 55

602

Shichirobei: *Young Man and Sleeping Sweetheart.* Ōban sumizuri-e, print no. 6 of a shunga series; Ōsaka, final plate dated Empō VIII (1680).

Though Ōsaka was not yet a thriving center of art in the 17th century (much of the book illustration done there was commissioned from the Kyōto master Hambei), it did produce one ukiyo-e artist, Shimomura Shichirobei. His *ōban* shunga album, shown here, owes much in style to Hambei but adds a certain rustic flavor typical of this provincial capital.

shichō-gake: a narrow print size, an *ōban* sheet divided into four longitudinally
shidō ▷ pigments
Shidōken: a noted Edo vaudeville raconteur

603

Masanobu: *Shidōken: The Storyteller; Kakemono-e urushi-e,* ca. mid 1740s

of the mid 18th century, famous for his eccentricities (such as the use of a wooden phallus to "pound home" the climax of a recitation)

Shifū (fl. ca. 1720s): ukiyo-e painter of the Kaigetsudō School; as both his names and artistic style imply, he was probably a direct pupil of Rifū, displaying a manner lighter and in some ways more pleasant than his master's
*Ryūsendō

Shiga: town in Ōmi, the Imperial Residence from 668 to 672

Shigefusa (fl. ca. 1750s): Kamigata ukiyo-e illustrator; a follower of Sukenobu
*Terai, Sesshōsai, Shōsen, Naofusa

Shigefusa (fl. ca. late 1820s): ukiyo-e print artist, Ōsaka School
*Shūgansai

Shigefusa II (fl. ca. 1850): ukiyo-e print artist, Ōsaka School
*Yoshino, Katsunosuke

Shigeharu (1803–53): Ōsaka ukiyo-e print artist, pupil of Yanagawa Shigenobu and perhaps of Hokusai
*Yamaguchi (Takigawa), Yasuhide (Kunishige), Jinjirō, Baigansai, Gyokuryūsai, Gyokuryūtei, Kiyōsai, Kiyōtei, Ryūsai, Ryūtei
▷ Ōsaka-Print School

Shigehiko (fl. ca. 1850s): ukiyo-e print artist, Ōsaka School
*Ichiryūsai

Shigehira, Taira (1158–85): a son of Kiyomori; made prisoner at the Battle of Ichi-no-tani and beheaded

Shigehiro (fl. ca. 1865–78): ukiyo-e print artist, Ōsaka School
*Kikusui, Shūgansai, Shūgan, Shūho

Shigeichi (Meiji): *dōban* artist
*Sasaki Shigeichi

Shigekatsu (fl. ca. mid 1820s): ukiyo-e print artist, Ōsaka School
*Yamaguchi, Ukiyo

Shigemaro (fl. ca. mid 1810s): ukiyo-e print artist, Ōsaka School

Shigemaru (fl. ca. 1850s): ukiyo-e print artist, pupil of Hiroshige
*Utagawa Shigemaru

Shigemasa (1739–1820): leading ukiyo-e painter, print artist, illustrator and poet. Largely self-taught (perhaps a late pupil of Nishimura Shigenaga) but influenced strongly by Harunobu, Shigemasa was the son of an Edo publisher and, in his prime, was considered one of the great artists of ukiyo-e, though today he is little known even among collectors. The rea-

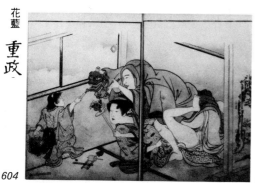

604

Style of Shigemasa: Shunga plate, illustration to *Keika tori-dasuki* [Boudoir Flowers of Brocade]. Woodblock-printed book with unusual coloring in *fukibokashi* style. *Obon*, Edo, ca.1776 (also ascribed to Shunshō) shows baby being distracted with an array of festival toys

sons for this are that his signed work is rare and that his prints, though always distinguished by fine draftsmanship, frequently reflect the general artistic fashions of his time rather than the individual personality of the artist. Shigemasa, like his good friend Shunshō, was one of the great teachers of his age, and he has been eclipsed in fame if not in natural genius by his pupils: Shumman, Kyōden (Masanobu), Masayoshi, as well as such unofficial pupils as Utamaro and Hokusai. Shigemasa's finest prints were probably his rare geisha series (see plate 125).
*Kitao (Kitabatake), Kyūgorō, Hekisui, Hokuhō, Hokusu-dempu, Ichyōsei, Itsujin, Karan, Kōsuifu, Kōsuiken, Kōsuisai, Kyūkaikyo, Shigure-oka-itsumin, Suihō, Tairei

Some print series by Shigemasa:
1 *Sumida-gawa hakkei*, ca. 1764
2 *Ukiyo mu-Tamagawa*, ca. 1769
3 *Tōsei-mitate bijin-hakkei*, ca. 1776
4 *Tōei fumoto-hakkei*, ca. 1777
5 *Jochū tedōgu-hakkei*, ca. 1777
6 *Ade-sugata odori-fūzoku*, ca. 1778
7 *Tōto hana-meisho*, ca. 1778
8 *Tōzai-namboku no bijin*, late 1770s

605

Shigemasa: *Two Geisha. Aiban*, from the series *Tōzai-namboku no bijin*, late 1770s (inscription on left is MS)

Illustrated books by Shigemasa include:
1 *Ehon asa-murasaki* (2 vols., 1769)
2 *Ehon azuma-no-hana* (2 vols., ca. 1769)
3 *Ehon isaoshi-gusa* (3 vols., 1769)
4 *Seirō bijin-awase sugata-kagami* (1776, with Shunshō)

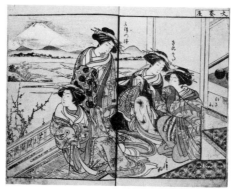

606

Shigemasa and Shunshō: *Courtesans on Veranda.* Plate from *Seirō bijin-awase sugata-kagami: Hanshi-bon*, 1776. (Traditionally the 1st and 2nd volumes of this work have been ascribed to Shigemasa, the 3th and 4th to Shunshō.)

5 *Ehon takara-no-ito* (1786, with Shunshō)
6 *Ehon Yasouji-gawa* (3 vols., 1786)
7 *Ehon musha-waraji* (2 vols., 1787)
8 *Kyōka ehon Amanokawa* (1 vol., ca. 1790)
9 *Ehon fukuju-sō* (1 vol., 1791)
10 *Ehon Azuma-karage* (3 vols., ca. 1791)
11 *Otoko-dōka* (with Shumman *et al.,* 1798)
Hayashi, Yoshikazu. *Empon kenkyū: Shigemasa.* Tōkyō, 1966.
▷ pp. 128–29, plate 125

Shigemasu (fl. ca. 1740s): ukiyo-e painter and print artist; follower of Shigenaga
*Nishimura Shigemasu

Shigemitsu (fl. ca. 1850s): ukiyo-e print artist, pupil of Yanagawa Shigenobu

Shigemori, Taira (1138–79): the eldest son of Kiyomori; he endeavored to moderate the impetuous character of his father.

Shigenaga (ca. 1697–1756): ukiyo-e painter, print artist and illustrator. Shigenaga, though not one of the artistic geniuses of ukiyo-e, proved one of its great teachers and innovators. He experimented with perspective and was the earliest ukiyo-e master to work extensively in the landscape-with-figures genre. He popularized the triptych form and, taking hints from Chinese art, developed the *ishizuri-e* and *mizu-e* [water print, employing pale blue pigment] genres. His own style was an individual one but based on Kiyonobu, Sukenobu and Masanobu; his pupils Toyonobu and Harunobu were to prove the leaders of the following generation.
*Nishimura, Magojirō, Magosaburō, Eikadō, Hyakuju, Senkadō
▷ pp. 84–86, plates 73–74

607 Shigenaga: *Homing Geese at Katada. Hosoban urushi-e,* from a set of *Eight Views of Lake Biwa,* 1720s

608 Shigenaga: *Ichimatsu as Hisamatsu. Hashira-e urushi-e,* ca.1743

Shigenao (fl. ca. mid 1820s–30s): Ōsaka ukiyo-e print artist, pupil of Shigeharu and Kunimasa
*Utagawa (Yanagawa), Gokyōtei, Nobukatsu, Ryūkyōtei, Tessai

Shigenobu (fl. ca. 1720s): ukiyo-e print artist, Torii School
*Hirose Shigenobu

Shigenobu (fl. ca. 1720s): noted ukiyo-e painter, a follower of Kaigetsudō Ando. Takizawa Shigenobu was one of the finest of the artists who followed directly in the tradition of the Kaigetsudō painters; he maintains the

majestic grace of the early masters while contributing a certain freshness of expression of his own devising. His paintings have several points in common with Katsunobu (they may well have been associates or pupil and teacher, Shigenobu probably being the older of the two).
*Takizawa, Ryūkadō
Shigenobu (fl. ca. 1720s–30s): ukiyo-e print artist, worked in the style of Masanobu and Kiyomasu II
*Tsunekawa Shigenobu
Shigenobu (fl. ca. 1730s): ukiyo-e painter in the style of the Nishikawa School
*Kawashima, Ichiichidō
Shigenobu (fl. 1730s–early 1740s): ukiyo-e print artist of the mid Primitive Period. Nishimura Shigenobu has been traditionally considered the early name of Ishikawa Toyonobu, but the matter is by no means certain. Shigenobu's work follows in the direct style of his teacher Nishimura Shigenobu during the 1730s and early 1740s, whereas the prints signed Toyonobu appear in the early 1740s in quite a new style; it would seem best to treat Shigenobu as a separate entity for the time being.
*Nishimura Shigenobu

609
Shigenobu: *Girl Selling Flowers. Hosoban urushi-e,* 1730s

Shigenobu (fl. ca. early 1770s): ukiyo-e print artist in the style of Harunobu
*Hanabusa Shigenobu
Shigenobu (fl. ca. 1770s): ukiyo-e painter and illustrator
*Yamamoto Shigenobu
Shigenobu (1787–1832): ukiyo-e print artist and illustrator who worked in Edo and, for a short time, in Ōsaka; became successively pupil, son-in-law and adopted son of Hokusai
*Yanagawa, Jūbei, Kinsai, Raito, Rinsai [Reisai], Ushōsai
Illustrated books by Shigenobu include:
Satomi hakken-den (106 vols., 1811–42 with Eisen and Sadafusa)
Ryūsen [*Yanagawa*] *gajō* (2 vols., 1820s)
Ryūsen manga (2 vols., 1820s)
Kyōka meisho-zue (1 vol., ca. 1826)
▷ Kaigetsudō School

610
Shigenobu: *Chickens and Rabbit. Chūban surimono* (the rabbit delineated in mica), ca. 1820s

611
Shigenobu: *Ōsaka Masquerade. Ōban,* mid 1820s

Shigenobu II (fl. ca. 1820s): ukiyo-e print artist and illustrator, pupil of Yanagawa Shigenobu
*Yanagawa (Tanishiro), Jūzan, Shiki, Kisanta, Sesshōsai, Shōei
Shigesada (fl. ca. 1830s): ukiyo-e print artist, Ōsaka School
Shigeyoshi (fl. ca. 1730s): ukiyo-e painter of girls with rather ungainly figures, somewhat in the manner of Eishun or Shigenobu
*Ryūunshin
Shigeyoshi (fl. ca. 1830s): ukiyo-e print artist, Ōsaka School
Shigeyuki, Minamoto no: a classical *waka* poet
Shigi-san: sacred mountain between Kawachi and Yamato
Shiichi (1843–1905): *dōban* artist, pupil of Ryokuzan
*Kamei Shiichi
Shijō: name of the leading Kyōto school of impressionistic painting in the 19th century, founded by Goshun, an offshoot of the Maruyama School

Holloway, Owen E. *Graphic Art of Japan: The Classical School.* London, 1957.
Mitchell, C.H. *The Illustrated Books of the Nanga, Maruyama, Shijo and Other Related Schools of Japan.* Los Angeles, 1972.
Hillier, Jack. *The Uninhibited Brush.* London, 1975.
Lane, Richard. *Studies in Ukiyo-e.*

Shijō-nawate: site in Kawachi, where the samurai leader Kusunoki Masatsura was defeated and killed in 1348
Shijūshichi-gishi [The Forty-seven Loyal Samurai *Rōnin*]: the famous avengers of their martyred lord, celebrated in the drama *Kanadehon Chūshingura*
Shikan (fl. ca. 1778–1838): ukiyo-e print artist, Ōsaka School, pen name of the Kabuki actor Nakamura Utaemon III
Shika-shū: a noted verse anthology, ca. 1140
Shiken (fl. ca. 1810s): ukiyo-e print artist and painter, Ōsaka School, son of Ryūkōsai; possibly identical with Umekuni
*Taga, Baikoku [Umekuni], Bokusen, Ryūkōsai, Shiō-sanjin
Shiki, Masaoka (1857–1902): *waka* and *haiku* poet of the Meiji Period
Shikimaro (fl. ca. 1810): ukiyo-e print artist, pupil of Tsukimaro
*Kitagawa (Shōji), Heijiemon

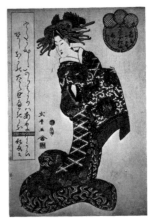

612
Shikimaro: *The Courtesan Koginu. Ōban,* ca. 1810

Shiki-no-miko (d. 716): a *waka* poet, 7th son of the Emperor Tenji
shikishi: a squarish heavy sheet of paper for calligraphy or painting, ca. 9×7.5–11.5×10.5 in./ 22.9×19–29×26.7 cm, often decorated with designs; also, prints of similar shape
Shikishi nai-shinnō (d. 1201): a *waka* poetess of the late Heian Period, daughter of the retired Emperor Go-Shirakawa
Shikō (1880–1916): neo-ukiyo-e painter, pupil of Fūko
*Imamura, Jusaburō
Shikō, Kagami (1665–1731): a *haiku* poet of the mid Edo Period
Shikoku: the large island comprising the four provinces of Awa, Sanuki, Iyo and Tosa; famous for the 88 temples of the Shingon sect, a focus of pilgrimages
shikoro-biki: a Kabuki scene in which actors tear at each other's armor
shimadai: a low wooden stand used for setting decorations on during a wedding ceremony
Shimabara: a peninsula south of Hizen, site of the Shimabara insurrection of persecuted Christians in 1637–38; also the major courtesan quarter of Kyōto
Shimamaru (fl. ca. 1830): ukiyo-e print artist, Ōsaka School
shime-nawa (*shime-kazari*): ropes made of rice straw, a symbol of purification at sacred places

新町 **Shimmachi**: the major courtesan quarter of Ōsaka

Shimoda: the port southeast of Izu peninsula

Shimonoseki: a port at the southwestern point of Nagato; bombarded by the French and English in 1863–64

新板 **shimpan**: a newly printed work

Shimpan uta-zaemon: a Kabuki play, commonly called *O-Some Hisamatsu*, the names of the two lovers involved; first written for the puppet theater in 1780 and later adapted to Kabuki

Shimpei (fl. ca. mid 1810s): ukiyo-e print artist, Kyōto School

shin- [*shim-*]: prefix meaning new, newly; also, true, genuine

Shinagawa: a southern suburb of Edo; the site of a flourishing pleasure quarter, and first station of the Tōkaidō

shinan-sha: the "south-pointing" carriage of a Chinese emperor, i.e. equipped with a mariner's compass

shinchō: term meaning newly printed

Shin-Chokusen-shū: an Imperial verse collection, 1234

Shindō, Tsukubako (mid 18th century): an Edo *waka* poetess

Shingen, Takeda (1521–73): a famous warlord; the long-time rival of Uesugi Kenshin; war between the two powerful *daimyō* lasted for 20 years, their principal battlefield was Kawanakajima, northeast of Shinano (1553, 1554, 1555, 1556 and 1563)

Shingon: the Esoteric Sect of Buddhism

shini-e: a memorial portrait

shinjū: a double love-suicide

Shinjū tenno-Amijima: a Kabuki play, commonly called *Tenno-Amijima* or *Kami-Ji*, first written by Chikamatsu in 1720 for the puppet theater; features the tragedy of the merchant Jihei, his sweetheart Ko-Haru and O-San, his faithful wife.

Shinkei (1406–75): a Buddhist priest, *waka* and *renga* poet of the mid Muromachi Period

shinkiro: the clam's dream; a mirage

Shinkō (fl. ca. mid 1810s): ukiyo-e print artist, Ōsaka School

Shin-Kokinshū: a collection of *waka* verses, 1206

shinkoku: a new edition

Shinnō: the Chinese god Shên-nung, traditionally shown chewing an herb; the patron of botany and medicine

shinnō: suffix designating a prince of the Imperial family

Shinobi-ne monogatari: a romance, probably 15th century

Shin-Ōhashi: the bridge across the Sumida River north of Ryōgoku

Shinran (1173–1262): a poet, Buddhist monk and founder of the Jōdo Shinshū sect

Shinrei Yaguchi-no-watashi: a Kabuki play, commonly called *O-Fune*; first produced for the puppet theater in 1770 and later adapted for the Kabuki stage; it features the tragedy of the ferryman Tombei and his love-lorn daughter O-Fune

真竜 **Shinryū** (1804–56): Kyōto ukiyo-e painter, studied under Jōryu; received title of *hōgen*
*Yoshihara [Yoshiwara], Nobuyuki, Yosaburō, Shinryū [Shinryō], Ōhō, Tōin

辰斎 **Shinsai** (ca. 1764–1820): ukiyo-e painter, print artist and illustrator; studied first under Sōri I, then under Hokusai; noted for his *surimono* and for his landscape prints in semi-European style
柳々居 *Masayuki, Hanji, Hanjirō, Mannō, Ryūryūkyo,

否斎 Ryūkaen

613

Shinsai: *View of Ryōgoku. Ōban,* 1810s (unsigned)

Shinsen inu-Tsukuba-shū: a collection of *renga* verses, ca. 1545

Shinsen rōei-shū: a collection of *rōei* verses, 10th century

Shinsen Tsukuba-shū: a collection of *renga* verses, 1495

Shinshichi, Kawatake: a family of actors and dramatists: Shinshichi I (1747–95); Shinshichi II (1816–93), also called Furukawa Mokuami; Shinshichi III (1842–1901)

薪水 **Shinsui** (1896–1972): neo-ukiyo-e painter and print artist; pupil of the noted *bijin-ga* artist Kiyokata; Shinsui was a specialist in highly stylized paintings of women in neo-ukiyo-e style; his work in the print field dates back to 1916
*Itō Shinsui

Shintarō (1846–1922): *dōban* artist, studied with Ryūsetsu
*Nakamura Shintarō

Shintō: the national religion of Japan, consisting of a mixture of nature worship and veneration of ancestors

Shin Usuyuki monogatari: a noted Kabuki play, first written for the puppet theater in 1741, later adapted for the Kabuki stage; features the Princess Usuyuki-hime and her lover Sonobe Saemon

新吉原 **Shin-Yoshiwara**: until 1657 the Yoshiwara pleasure quarter was located near Nihonbashi, but after a major fire it was moved to a northern suburb, which was then often termed "New Yoshiwara"

Shin-yō-shū: a verse collection, 1381

新造 **shinzo**: an apprentice courtesan

Shinzoku-Kokin-shū: an Imperial verse anthology, 1439

shiō ▷ pigments

Shiojiri-tōge: a mountain pass in Shinano

shio-kumi: a gatherer of salt water

白拍子 **shira-byōshi**: a woman dancer in man's costume, fashionable in the medieval period; the dancers were often shrine prostitutes

Shiragi [Shinra]: one of the ancient kingdoms of Korea

Shirai Gompachi: famous Kabuki hero, a young samurai fleeing justice who is befriended by the chivalrous townsman Banzuiin Chōbei and falls in love with Komurasaki, a noted beauty of the Yoshiwara

Shirakawa: a town in Iwaki province with a noted barrier station

Shira-kawa: a small river east of Kyōto

shiranami [white waves]: euphemistic term for thieves as heroes of Kabuki plays

shiro [*jō*]: a castle or redoubt

Shirō, Nitta no: valiant mythical warrior,

often shown astride and killing a wild boar at the hunting party in which the Soga Brothers' revenge took place

shishi-mai: the lion dance ▷ *aioi-jishi*

Shishū hyakuin-en-shū: a collection of Buddhist stories, 1257

下絵 **shita-e** [underpainting]: the preliminary design for a print

Shitagou, Minamoto no (911–83): a *waka* poet of the early Heian Period

Shitarō (Meiji): *dōban* artist, pupil of Suizan and of Smollick
*Uchida Shintarō

shite: the protagonist in a Noh play

四天王 **shi-ten** [*no*]: term for any group of 4 faithful retainers, those of Minamoto Raikō [Yorimitsu] being best known: Watanabe no Tsuna, Sakata no Kintoki, Usui no Sadamichi, Urabe no Suetake; also the Four Guardians of the Buddhist world

指頭画 **shitōga**: technique of painting using the finger tip and fingernail in place of brush

shizoku: term in Meiji times for the former samurai class

Shizu-ga-take: a mountain in Ōmi Province

Shizuko, Yuya (1733–52): an Edo *waka* poetess

shō: a large mouth-organ made of reeds

shō-chiku-bai: pine, bamboo and plum (symbols of longevity)

Shōdō (1776–1841): Kishi-School painter; also did some genre work
*Murakami, Shigeatsu (Genkō), Tokugō, Kōdai

Shōen (1875–1949): neo-ukiyo-e painter in Kyōto; studied with Shōnen, then with Seiho and Bairei; her elegant Kyōto *bijin-ga* form a graceful record of traditional customs as preserved through modern times.
*Uemura, Tsuneko

Shōen (1888–1917): neo-ukiyo-e painter, wife of Terukata; first studied under Toshikata, then under Kawai Gyokudō; active in revival of the ukiyo-e style
*Ikeda (Sakakibara), Yuriko

shōenji ▷ pigments

Shōgetsu (fl. ca. 1880s–90s): Meiji ukiyo-e print artist
*Kojima, Katsumi, Tōshū

shōgi: the Japanese game of chess

Shōgorō (fl. ca. mid 17th century): said to have been the predecessor of Hambei in Kamigata ukiyo-e illustration (cited in *Kankatsu Heike-monogatari,* 1710)

shōgun: term for the military dictator of Japan from 1185 to 1868

Shōha (fl. ca. mid 1760s): ukiyo-e print designer; known for calendar prints in the style of Harunobu for the year 1765
*Ueno Shōha

Shōha (1877–1968): neo-ukiyo-e woman painter; studied under Kōkyō and Seiho
*Itō (Futami), Sato

Shōhaku, Botanka (d. 1527): a noted *renga* poet, usually depicted riding on a bull gaily decorated with peonies

Shōhaku (1730–81): Kyōto Soga-School painter. Studied with Settei under the Kanō-Style artist Keiho; also did some genre work
*Soga, Shiryū, Kiyū, Kiichi, Hiran, Jasokuken, Joki, Kishinsai, Ranzan
Lane, Richard. *Studies in Ukiyo-e.*

初版 **shohan**: a first edition

shōheiga: painted wall panels

shōhitsu: term for "genuine brush"

Shōhō (fl. ca. 1810s): ukiyo-e print artist and illustrator, Ōsaka School
*Suga Shōhō

正保 **Shōhō** (1644/45–1648): the Shōhō Period dates from XII/16/1644/45 to II/15/1648 and though brief, marks a significant stage of development in the genre-ukiyo-e style, particularly in the field of book illustration for tales and *jōruri* plays, which were still a product of artists working in Kyōto rather than in Edo. ▷ *nengō*

Shōin, Yoshida (1830–59): a *waka* poet and thinker of the late Edo Period

Shoindō (Taishō): *dōban* artist, pupil of Kyokuzan
*Shoinsan

猩々 **shōji**: sliding wall panels made of paper

shōjō: mythical red-haired creatures with a weakness for drink

鐘馗 **Shōki** [the demon queller]: Originally a benign Chinese Tao god, he was adopted by the Japanese and became associated with Boy's Day, when his picture was displayed. Besides being a queller of bad devils, he was traditionally a woman-hater; hence his frequent depiction by facetious ukiyo-e artists in rather compromising situations.

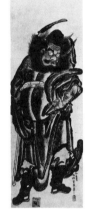

614

Shigenaga: *Shōki the Demon Queller. Kakemono-e urushi-e,* 1740s

Shōki: Noh drama featuring Shōki (Chung K'uei), a protective Taoist deity

松好斎 **Shōkōsai** (fl. ca. 1795–1809): leading Ōsaka ukiyo-e print artist and illustrator, pupil of Ryūkōsai; one of the founders of the Kamigata-Print School; Hokushū was among his pupils
*Shōkō, Hambei [Hanbei]

Shoku-Gosen-shū and **Shoku-Kokin-shū**: Imperial verse anthologies; compiled respectively in 1251 and 1265

Shōkun: a Noh drama featuring Ō-Shōkun (Wang Chao-chün), favorite courtesan of the Han Emperor

shokunin-zukushi: a series of depictions of artisans at work

蜀山人 **Shokusanjin** (1749–1823): poet, calligrapher, scholar and amateur ukiyo-e painter; compiler of the basic reference work *Ukiyo-e ruikō*
*Ōta, Naojirō, Shichizaemon, Yomo-no-Akara, Yomo-sanjin, Kyōkaen, Nampo, Tan Tamabayashi, H. *Shokusanjin no kenkyū.* Tōkyō, 1944.
Lane, Richard. *Studies in Ukiyo-e.*

正銘 **shōmei**: term for "genuine name"

shōmen-zuri: polishing on the surface of a print

Shōmu (701–50): a *waka* poet and 45th sovereign of Japan

shōmyō: the lower ranking *daimyō*

-shōnin: suffix meaning His Eminence, "Saint" or holy man

Shōraku, Miyoshi (ca. 1696–1772): a playwright of the puppet theater in the mid-Edo Period

Shōraku (fl. ca. late 1810s): ukiyo-e print artist, Ōsaka School

Shōrakusai (fl. ca. 1790s–1800s): Ōsaka ukiyo-e painter and print artist
*Shōju

Shōroku (1779–1845): ukiyo-e painter, a samurai in Edo; pupil of Eishi
*Takao, Nobuyasu, Einojō, Hokōsai, Suimutei

short months ▷ calendar, Japanese

Shōryū (1829–98): Shijō-style painter, also did some genre work
*Kawada, Kakaku, Banzan

shosa (*shosa-goto*): a Kabuki dance interlude with *degatari*

Shōsai (Meiji): *dōban* artist, pupil of Gengendō VII
*Mizuguchi, Garyūkan, Ryūnosuke

Shosha-zan: a famous hill in Harima

shoshidai: the official representative of the shōgun in Kyōto

Shōshindō (Meiji): Kyōto *dōban* artist, pupil of Shunsen
*Sai

Shōshun, Tosa-bō: a Buddhist monk at Nara, famous for his attempt to murder Yoshitsune in 1185

古邨 **Shōson** (1877–1945): traditional-style painter and print artist, pupil of Kason
*Ohara, Matao, Koson

shō-tanzaku: a print size, about 10×3¾ in./25.5×9.5 cm (*ōban* divided into four vertically)

Shōtei ▷ Seitei

Shōtei (1871–1944): traditional-style painter and print artist; nephew of Fūko, under whom he studied·
*Takahashi, Hiroaki, Katsutarō

正徳 **Shōtoku** (1711–16): the Shōtoku Period dates from IV/25/1711 to VI/22/1716 and marks the end of the Genroku spirit of gaiety and adventure, soon to be superseded by a period of Confucian austerity, anti-sumptuary edicts and incidents like the Ejima-Ikushima Scandal of Shōtoku IV (1714), because of which the ukiyo-e master Kaigetsudō Ando was banished from Edo. The majestic age of primitive ukiyo-e came to an end in this period. Its products are among the masterpieces of the genre: the great *kakemono-e* of Kiyonobu I, Kiyomasu I, Masanobu and the Kaigetsudō masters all date from this brief age. ▷ *nengō*

Shōtoku-taishi (574–622): 2nd son of Emperor Yōmei; a *waka* poet and Regent of Japan

Shō-utsushi asagao nikki: a Kabuki play, first written for the puppet theater in about 1804; the Kabuki version of 1850 was staged with great success by the actor Tanosuke II. It features the maiden Miyuki and her lover Asojirō.

昭和 **Shōwa** (1926–): the Shōwa Period, which dates from XII/25/1926 to the time of writing, saw further attempts to restore the ukiyo-e flavor to modern genre painting and prints; but these tended to emphasize the form rather than the spirit of ukiyo-e and were largely unsuccessful. As prints, the new creations of the *sōsaku hanga* [creative print] artists proved of international significance, although most of their work was in western style. In the past half-century ukiyo-e research has made significant strides both at home and abroad, and much relevant early material has been uncovered and

published. At the same time, many major collections have been formed. Some were later dispersed; others are now preserved in museums, and enthusiastic collectors are found scattered throughout the world. Many of them know Japan only through the prints and paintings, irresistibly attracted by an exotic world of sublimated art, in an absorption quite removed from any rational *raison d'être* ▷ *nengō*

Shōyō, Tsubouchi (1859–1935): a novelist, playwright, critic, translator and scholar of the theater

Shōzen: a Noh drama featuring Tosa Shōzen, Benkei, Yoshitsune and Shizuka-gozen

Shōzuka-no-baba: the old hag of the Japanese netherworld

初摺 **sho-zuri**: an early or first impression of a print

Shūa (mid 14th century): a *renga* poet of the early Muromachi Period

舟調 **Shūchō** (fl. ca. 1790s–early 1800s): ukiyo-e print artist, pupil of Ippitsusai Bunchō. Shūchō is one of several minor artists of the Kansei Period who followed in the wake of the great Utamaro; although no great master, he formed a readily recognizable style of his own, somewhere between Utamaro and Chōki (but lacking the erotic vitality of the one, the refinement of the other).
*Tamagawa Shūchō

615

Shūchō: *Mother with Infant. Ōban,* from the series *Fūryū keshō-kagami,* ca. early 1800s

shudō: pederasty

Shūen: *dōban* artist, pupil of Bokusen in Nagoya
*Kondō, Kyūkokaku, Itarō

Shūgetsu (fl. 1820s): ukiyo-e print artist, Ōsaka School
*Kitagawa Shūgetsu

Shūho (1898–1944): neo-ukiyo-e painter, pupil of Kiyokata and Shūho

Shūhō (1874–1944): traditional-style painter, did some neo-ukiyo-e work
*Ikegami, Kunisaburō
*Yamakawa, Yoshio

Shui-shū: an Imperial verse anthology, completed between 1005 and 1007

春卜 **Shumboku** (1680–1763): painter and illustrator, who worked both in Ōsaka and Edo. Trained as a Kanō painter, he published many volumes of copies from the ancient Chinese and Japanese masters, including, in 1746, a striking early example of color printing based on the *Mustard-Seed Garden* anthology. Influenced Hokusai; received the title of *hōgen*
*Ōoka, Shumboku [Shunboku], Aiyoku (Aitō), Ichiō, Jakushitsu, Setsujōsai, Suishō
Illustrated books by Shumboku include:
1 *Ehon te-kagami* (6 vols., 1720)
2 *Wakan meiga-en* (6 vols., 1750)

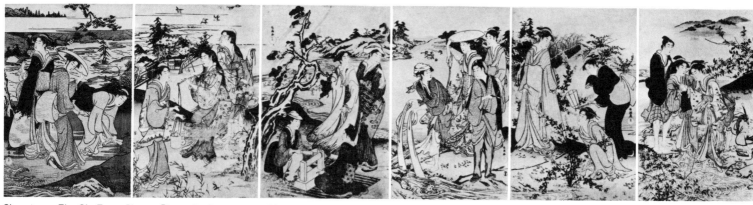

616

Shumman: *The Six Tama Rivers. Ōban,* six-sheet composition, mid 1780s (see plate 134 for a detail of the left sheet)

3 *Gashi kaiyō* (6 vols., 1751)
4 *Minchō seidō gaen* (2 vols., 1746; reissued as *Minchō shiken,* 3 vols., 1812)
5 *Ramma zushiki* (3 vols., 1734)
6 *Tansei kinnō* (6 vols., 1753)
shūmei: succession to a traditional family name by an artist or actor
Shumman (1757–1820): leading ukiyo-e painter, print artist, illustrator, poet and author; pupil of Nahiko and Shigemasa, but much influenced by Kiyonaga; he is famous for his *surimono, bijin-ga* paintings and rare genre prints
*Kubo (Kubota), Shumman [Shunman, Toshimitsu], Yasubei, Hitofushi-Chizue [Issetsu-senjō], Kōzandō, Nandaka-Shiran, Sashōdō, Shōsadō
Illustrated books by Shumman include:
1 *Haru no iro* (1794)
2 *Otoko-dōka* (with Shigemasa *et al.,* 1798)
3 *Kyōka hidari-domoe* (2 vols., 1802)
4 *Kyōka kotoba no taki-mizu* (2 vols., ca. 1810)
Lane, Richard. *Studies in Ukiyo-e.*
▷ p. 135, plate 134
Shumpō (fl. ca. mid. 1820s): ukiyo-e print artist, Ōsaka School
*Gashōken
Shunchō (fl. late 1770s–late 1790s): leading ukiyo-e print artist of the Temmei Period. Shunchō, though a pupil of Shunshō and much indebted to that master for his perfect color harmonies, found his ideal in the work of Kiyonaga at his peak and seldom deviated from that style.
*Katsukawa, Kichizaemon, Chūrinsha, Kichisadō, Shien, Tōshien, Yūbundō, Yūshidō
Hayashi, Yoshikazu. *Kiyonaga to Shunchō.* (in Japanese) Tōkyō, 1976.
▷ pp. 135–36, plates 132–133

617

Shunchō: *Man Seducing Maiden. Ōban* plate from the shunga album *Imayo irokumi-no-iro,* ca. mid 1780s

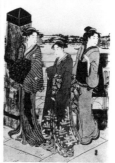

618

Shunchō: *Scene at Ryōgoku Bridge. Ōban* diptych, ca. mid 1780s

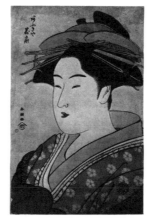

619

Shunchō: *The Courtesan Hanaōgi. Ōban,* ca. late 1780s

Shunchō (fl. ca. 1815–21): ukiyo-e print artist, Kyōto School
*Hotta (Harukawa) Shunchō
Shunchō (fl. ca. 1815–23): ukiyo-e print artist, Ōsaka School, pupil of Shunkōsai
Shunchō (fl. ca. mid 1820s): ukiyo-e print artist, Ōsaka School
*Gajuken
Shunchōsai (fl. ca. 1770s–90s): an Ōsaka ukiyo-e illustrator (pupil of Shumboku) who produced many volumes of guidebooks and miscellanea, as well as some notable shunga books
*Takehara (Matsumoto), Nobushige

Illustrated books by Shunchōsai include:
Miyako meisho-zue (6 vols., 1780)
Yamato meisho-zue (7 vols., 1791)
Toba-e akubi-dome (3 vols., 1793)
Settsu meisho-zue (8 vols., 1796–98)
Shundō (fl. ca. 1780s): ukiyo-e painter and print artist, pupil of Shunsui, then of Shunshō; did some actor prints and book illustrations
*Katsukawa, Rantokusai
Shun-e (d. 1113): a monk and *waka* poet of the late Heian Period
Shun-ei (ca. 1762–1819): ukiyo-e painter, print artist and illustrator. A leading pupil of Shunshō, Shun-ei adds a modern touch to the Katsukawa School, as well as a pronounced

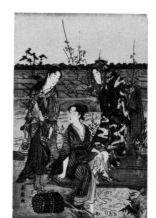

620

Shun-ei: *Rustic Girls. Aiban,* ca. late 1780s

621 Shun-ei: *Kikunojō III as O-Some. Ōban,* 1796

622 Shun-ei: *Kabuki Dance. Ōban,* ca. mid 1790s

element of facial exaggeration which enhances the individuality and dramatic force of his actor prints, but which, in lesser hands, was to lead to the decline of figure work in the 19th century. Sharaku and, most of all, Toyokuni, were among those influenced by Shun-ei's style. He was eccentric in behavior but had a wide circle of friends, among them Shunchō, Utamaro and Toyokuni, with each of whom he sometimes collaborated on prints. His illustrated books include *Shibai Kimmō-zui* (1803), a valuable encyclopedia of the Kabuki theater.
*Katsukawa (Isoda), Kyūjirō, Kyūtokusai
▷ pp. 120–22, plate 117

Shun-ei (fl. ca. mid 1810s–20s): ukiyo-e print artist, Ōsaka School
*Shungyōsai

春艶 **Shun-en** (fl. ca. 1780–90s): ukiyo-e print artist, pupil of Shunshō; known for his actor prints in fan format
*Katsukawa Shun-en

春画 **shunga** [spring pictures]: the generic Japanese term for erotic paintings, prints and illustrations. As opposed to the native term *makura-e* [pillow pictures], shunga was originally an elegant, Chinese-derived expression but is today somewhat in disrepute in Japan, the term *higa* [secret pictures] being considered more refined.
[The following bibliography is general but will show the extent of publication on shunga to date. Items with ● are of particular reference value; modern publications in Japan are all expurgated.]

Anon. *Japanische Erotik, Sechsunddreissig Holzschnitte von Moronobu, Harunobu, Utamaro.* (Attributed to Julius Kurth.)
● Shibui, Kiyoshi. *Genroku ko-hanga shūei: Estampes Erotiques Primitives du Japon.* (in Japanese) 2 vols., Tōkyō, 1926–28.
Poncetton, François. *L'Estampe Erotique du Japon.* Paris 1927.
Shibui, Kiyoshi. *Ars Erotica: Old Documents Concerning Human Life Instincts and Emotions as Interpreted by Japanese Artists in the Eighteenth and Earlier Part of the Nineteenth Centuries.* Tōkyō, 1930.
Hara, Kōzō. *Nihon kōshoku bijitsu* (in Japanese). Tōkyō, 1930.
Shibui, Kiyoshi: *Ukiyo-e Naisi: Old Documents Concerning Human Life Instincts and Emotions as Interpreted by Japanese Artists in the Eighteenth and Earlier Part of the Nineteenth Centuries.* (in Japanese) 2 vols. Tōkyō, 1932–33.
Gichner L. E. *Erotic Aspects of Japanese Culture.* Washington, D.C., 1953.
Shibui, Kiyoshi. *Shoki hanga.* Tōkyō. 1954.
Anon. *Nihon empon dai-shūsei* (in Japanese). Tōkyō. 1954.
● Shibui, Kiyoshi. *Shoki hanga.* (in Japanese) Tōkyō. 1954.
● Hayashi, Yoshikazu: *Empon kenkyū: Kunisada, Utamaro* (2 vols.) *Shunshō, Kuniyoshi, Harunobu, Toyokuni, Hiroshige/Utamaro, Shigemasa, Eisen/ O-Ei, Hokusai, Moronobu, Kiyonaga/Shunchō* (In Japanese). 14 vols. Tōkyō, 1960–76.
● Densmore, Marianne. *Les Estampes Erotiques Japonaises.* Paris, 1961.
Yoshida, Teruji. *Ukiyo-e higa/Ukiyo-e enga.* (in Japanese). 2 vols., Tōkyō, 1961, 1963.
Takahashi, Tetsu. *Takahashi Tetsu Collection.* (in Japanese) 2 vols., Tōkyō, 1962–63.
Grosbois, Charles. *Shunga: Images of Spring.* Geneva, 1964. [cf. our corrections in "New Voices in Ukiyo-e" *Ukiyo-e Art,* No.10 (1965), pp. 16–21, reprinted in *Studies in Edo Literature and Art*].
Takahashi, Tetsu. *Hihō emaki-kō* (in Japanese). Tōkyō 1965.
Anon. *Utamaro Shunga.* Munich 1966.
● Lane, Richard. "The Shunga in Japanese Art." In Rawson P. (ed.). *Erotic Art of the East.* New York and London 1968.

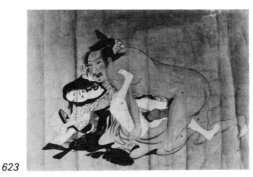

623

From a shunga scroll of 12 scenes in Muromachi genre style. Colors on paper, a copy from around the mid 17th century. (Court rank was indicated by the style of headgear, which was, as a result, worn by the courtiers at all times.)

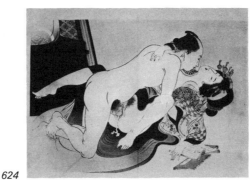

624

Meiji Ukiyo-e School: *Yoshiwara Lovers.* From *Yakumo no chigiri* [Poetic Intercourse], an album of 12 ōban prints; Tōkyō, ca. 1899; the illustrations are ascribed to Tomioka Eisen or to his pupil Hamada Josen

Lesoyalc'h, Theo. *Erotique du Japon.* Paris 1968.
Kronhäusen, E. and P. *Erotic Art, Series I/II.* New York and London, 1968, 1970.
Anon. *Fleurs du Japon.* Paris, 1969.
Bowie, Theodore, *et al. Studies in Erotic Art.* New York and London, 1970.
Hanfstaengl, Franz. *Kitagawa Utamaro—Erotische Holzschnitte.* Munich, n.d. (ca. 1970).
Beurdeley, Michel, Lane, Richard *et al. Le Chant de L'Oreiller.* Genève, 1973.
Lane, Richard. *Shunga Books of the Ukiyo-e School: I—Moronobu: Series I.* 6 vols. of reproductions, plus text volume. Tōkyō, 1973.
Lane, Richard. *Shunga Books of the Ukiyo-e School: II—Moronobu: Series II.* 7 vols. of reproductions, plus text volume. Tōkyō, 1974.
Winzinger, Franz. *Shunga: Meisterwerke der Erotischen Kunst Japans.* Nürnberg, 1975.
● Evans, T. and M. *Shunga, The Art of Love in Japan.* London, 1975.
Lane, Richard. *Shunga Books of the Ukiyo-e School: III—Prints by Moronobu and the Kambun Master.* 8 vols. of reproductions, plus text volume. Tōkyō, 1976.
Winzinger, Franz. *Masterpieces of Japanese Erotic Art.* Munich, 1977.
Lane, Richard. *Shunga Books of the Ukiyo-e School: IV—Moronobu and the Kambun Master.* 7 vols. of reproductions, plus text volume. Tōkyō, 1977.
Faglioli, M. *Utamaro, Koi No Hutozao.* Florence, 1977.
● Lane, Richard. *Erotica Japonica: Masterworks of Shunga Painting.* New York, 1978.
● Lane, Richard. *The Erotic Theme in Japanese Painting and Prints: I—The Early Shunga Scroll.* Tōkyō, 1978.
Lane, Richard. *Shunga Books of the Ukiyo-e School: V—Hambei and the Kamigata Masters.*

7 vols. of reproductions, plus text volume. [In press].
Lane, Richard. *Shunga Books of the Ukiyo-e School: VI—Sugimura and Moroshige.* 7 vols. of reproductions, plus text volume. [In press].
● *Ukiyo-e: A Journal of Floating-World Art.* Tōkyō, 1962–, 78 issues to date. [A valuable source of current research on shunga prints, books, paintings.]
▷ The Kambun Master, Moronobu, Moroshige, Sugimura, Hambei, *et. al.*; pp. 30, 95; plates 12, 13, 18, 19, 20, 22, 23, 28, 29, 30, 34, 36, 41, 44, 53, 66, 83, 88, 89, 96, 103, 140, 141, 144, 165, 193

春暁 **Shungyō** (fl. ca. 1790s–1800s): ukiyo-e painter and print artist, pupil of Shunshō
*Katsukawa, Kakusensai

春暁斎 **Shungyōsai** (ca. 1760–1823): leading Ōsaka ukiyo-e painter and illustrator, follower of Gyokuzan
*Hayami, Tsuneaki
Illustrated books by Shungyōsai include:
Nenju-gyōji taisei (6 vols., 1806)
Ehon ken-yū-roku (10 vols., 1810)
Miyako-fūzoku kewaiden (3 vols., 1813)

Shungyōsai II (fl. 1820s–67): ukiyo-e print artist, Ōsaka School, son of Shungyōsai
*Hayami, Gyōunsai, Shummin, Tsuneshige, Taminosuke

春常 **Shunjō** (d. 1787): notable ukiyo-e print artist and illustrator, an early pupil of Shunshō
*Katsukawa (Yasuda), Iwazō
▷ p. 121, plate 114

春常

625

Shunjō: *Kabuki Scene. Hosoban* pentaptych, 1781/ 82 (from left to right: Kintoki, Suetake, *shira-byōshi* dancer [actually, the spirit of *Tsuchigumo,* the ground spider], Tsuna and Sadamitsu)

Shunjō (fl. ca. early 1830s): ukiyo-e print artist, Ōsaka School, pupil of Shunshi

Shunju (fl. ca. late 1820s): ukiyo-e print artist, Ōsaka School, pupil of Hokuei

Shunka (fl. ca. 1820s–30s): ukiyo-e print artist, Ōsaka School

Shunkaku (fl. ca. 1790s): ukiyo-e painter and print artist, pupil of Shunshō
*Katsukawa Shunkaku

Shunkan: a Noh drama featuring the despair of the exiled Shunkan (1142–78), a famous Buddhist monk who plotted to destroy the Heike and was banished to Kikai-ga-shima (1177)

Shunkei (fl. ca. 1840): Ōsaka ukiyo-e print artist
*Baikōsai

Shunki (fl. ca. 1850s–87): ukiyo-e print artist, Kyōto School
*Okamoto (Utagawa), Nobusada, Harusada II, Shōtarō

Shunkin (fl. ca. mid 1810s): ukiyo-e print artist, Ōsaka School

春好 **Shunkō** (1743–1812): leading ukiyo-e painter and print artist, pupil of Shunshō. Of Shunshō's disciples who devoted their work to the theater

春好 Shunkō ranks first; in his finest prints he is fully the equal of his master. Shunkō's work extends from the early 1770s until his final years; in the late 1780s his right arm become paralyzed

but, switching to his left hand, he worked on to produce the type of large actor heads which were one of his main contributions to ukiyo-e.
*Katsukawa (Kiyokawa), Denjirō, Sahitsuan, Sahitsusai
▷ pp. 120–21, plate 115–116

626

Shunkō: *Sukeroku (played by Yaozō II), Agemaki (Rikō), Ikyū (Danjūrō V). Hosoban* triptych, 1784

627

Shunkō: *Komazō II as Izu-no-Jirō. Ōban,* 1788

628

Shunkō: *Nizaemon VII as a Villain. Ōban,* ca. 1790

Shunkō (fl. ca. mid 1790s): ukiyo-e print artist, Ōsaka School
Shunkō (fl. ca. mid 1820s): ukiyo-e print artist, Ōsaka School
春鄉 **Shunkyo** (fl. ca. mid 1810s): ukiyo-e print artist, Ōsaka School

春喬 **Shunkyō** (fl. ca. 1800s): ukiyo-e print artist, pupil of Shunshō and Shuntei
*Hishikawa (Katsukawa), Ryūkoku
Shunkyō (1871–1933): traditional-style painter, did some genre work
*Yamamoto, Kin-emon
春旭 **Shunkyoku** (fl. ca. 1770s–90s): ukiyo-e print artist, pupil of Shunshō
*Katsukawa Shunkyoku
Shunri (fl. ca. 1790s): ukiyo-e print artist, pupil of Shunshō
*Katsukawa Shunri
Shunrin (fl. ca. 1780s–90s): ukiyo-e print artist, pupil of Shunshō
*Katsukawa Shunrin
Shunsei (fl. ca. mid 1820s): ukiyo-e print artist, Ōsaka School
*Gayūken
春川 **Shunsen** (1719–73): painter and illustrator, adopted son and pupil of Shumboku; received title of *hōgen*
*Ōoka, Sukemasa, Tange
Shunsen (fl. ca. 1780–90s): ukiyo-e print artist, pupil of Shunshō
*Katsukawa Shunsen
春泉 **Shunsen** (1762–ca. 1830): ukiyo-e print artist and illustrator; studied under Tōrin III, then under Shun-ei (from whom he received the name Shunsen)
*Katsukawa, Seijirō, Kashōsai, Shunrin, Shunkō II, Tōryōsai

春扇

Shunsen: *The Susaki Benten Shrine. Ōban,* ca. 1820 (signed "Shunsen *aratame* Shunkō *ga,*" marking his change of name to Shunkō [II] at this time)

Shunsendō (fl. mid 19th century): *dōban* artist, pupil of Shuntōsai
*Tōyama, Shunsentei
Shunsensai (fl. ca. 1790s–1810s): ukiyo-e print artist and illustrator, Ōsaka School
*Takehara, Kiyohide
Shunsensai (fl. mid 19th century): *dōban* artist, pupil of Shuntōsai
Shunshi (fl. ca. 1820s): Ōsaka ukiyo-e print artist, pupil of Hokushū
*Shunshi (Harushiba)
Shunshi (fl. ca. mid 1820s–30s): ukiyo-e print artist, Ōsaka School, pupil of Shunshi
*Gatōken
Shunshi (fl. ca. 1826–28): ukiyo-e print artist, Ōsaka School; possibly early name of Hokumyō
*Shun-yōsai, Seiyōsai, Seiyōdō, Shumpu
Shunshin (fl. ca. 1820s): ukiyo-e print artist, Ōsaka School, pupil of Hokushū
春章 勝川 **Shunshō** (1726–93): leading ukiyo-e painter, print artist and illustrator, founder of the Katsukawa School. Shunshō first studied under the painters Shunsui and Sūkoku, turning to the print medium about 1767, when he began to develop a more realistic style of his own; he learned much from the color harmonies of Harunobu and Shigemasa, and in his special

630

Shunshō: *Samurai Pair before Torii. Hosoban* diptych, dated An-ei II (1773/74); Hiroji III and Matatarō on stage

631

Shunshō: *Nakazō in Samurai Role.* Large-*ōban* fan print, ca. mid 1770s

632

Shunshō: *Sukeroku Scene. Hosoban* pentaptych, 1782 (from left to right: saké vendor, Sukeroku, Ikyū, Mompei and Agemaki)

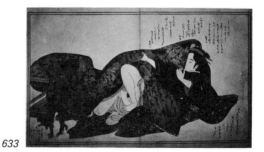

633

Shunshō: *Lovers in Kotatsu. Ōban,* from the shunga album *Haikai yobuko-dori,* 1788

field (the actor print) soon overshadowed the hitherto dominant Torii School. Though no startling innovator, Shunshō ranks with Kiyonobu and Sharaku in his influence on the way in which Kabuki was depicted. Like several other ukiyo-e greats, Shunshō devoted his final years more to paintings than to popular prints. He taught many pupils, including Shunjō, Shunkō, Shunchō, Shundō, Shun-ei, Shunzan and Hokusai.

*Katsukawa, Shunshō [Haruaki], Yūsuke, Jūgasei, Kyokurōsai, Kyokurōsei, Ririn Rokurokuan, Shuntei, Yūji

Illustrated books by Shunshō include:

Ehon butai-ōgi (3 vols., 1770; with Bunchō)
Ehon zoku-butai-ōgi (2 vols., 1778)
Ehon yakusha natsu-no-Fuji (1 vol., 1780)
Nishiki Hyakunin-isshu Azuma-ori (1 vol., 1774)
Seirō bijin-awase sugata-kagami (with Kitao Shigemasa, 3 vols., 1776)
Ehon Ibuki-yama (3 vols., 1778)
Ehon takara-no-ito (1 vol., 1786, with Shigemasa)
Succo, Friedrich. *Katsukawa Shunshō (Haruaki).* Plauen im Vogtland, 1922.
Gookin, Frederick William. *Katsukawa Shunshō, 1726–1793: A Master Artist of Old Japan.* Chicago, 1931 (edition of 10 mimeographed copies only).
Boller, Willy. *Japanische Farbholzschnitte von Katsukawa Shunshō.* Bern, 1953 (French Translation: *Estampes Japonaises de Katsukawa Shunshō,* Lausanne, n.d.)
Hayashi, Yoshikazu. *Empon kenkyū: Shunshō.* (in Japanese) Tōkyō, 1963.
▷ pp. 116–20, plates 110–113

Shunshō (fl. ca. 1830s–40s): ukiyo-e print artist
*Utagawa (Matsuo), Shunshō [Harumasu], Hōrai, Kochōen

Shunshoku ume-goyomi: a famous series of romantic novelettes by Tamenaga Shunsui, published 1832–42

春水 **Shunsui** (fl. ca. 1740s–60s): ukiyo-e painter, print artist and illustrator; a pupil of Chōshun (who may have been his father). Changed his surname to Katsukawa when Chōshun was exiled; teacher of Shunshō
*Katsukawa (Miyagawa), Tōshirō

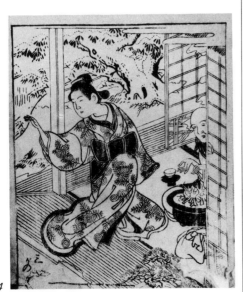

634
Shunsui: *Veranda Scene.* Detail from *Ehon tomochidori. Hanshi-bon,* 1761

Shunsui, Tamenaga (1790–1843): a fiction writer of the late Edo Period who often collaborated with Kunisada
Shunsui (fl. ca. 1880s): Kyōto *dōban* artist
*Yomo Shunsui, Hirano-ya Mohei, Shigebei, Shōsuien, Mokuzan

春亭 **Shuntei** (1770–1820): ukiyo-e print artist, pupil of Shun-ei
*Katsukawa (Yamaguchi), Chōjūrō, Gibokuan, Shōkōsai, Shōkyūko, Suihō-itsujin

635
Shuntei [Katsukawa]: *Yaozō and Kikunojō in Kabuki Roles. Ōban,* ca. 1801

Shuntei (fl. ca. mid 1810s–early 1820s): ukiyo-e print artist, Ōsaka School; possibly the same person as Harusada
Shuntei (fl. ca. mid 1820s): ukiyo-e print artist, Ōsaka School
*Gachōken

Shuntoku (fl. ca. 1820s): ukiyo-e print artist, pupil of Shun-ei
*Katsukawa, Sentarō

春燈斎 **Shuntōsai** (fl. ca. mid 1840s–mid 60s): *dōban* artist, associated with Ryokuzan; produced notable copperplate engravings of Nagasaki and its foreigners
*Okada, Yoshifusa, Suigetsudō, Ryūsen, Gishichirō

Shun-yo (fl. ca. 1820s): ukiyo-e print artist, pupil of Shun-ei
*Katsukawa Shun-yo

Shun-yo (fl. ca. early 1820s): ukiyo-e print artist, Ōsaka School
*Shunshō

Shun-yū (fl. ca. 1820): ukiyo-e print artist, Ōsaka School

春山 **Shunzan** (fl. ca. 1780s–90s): ukiyo-e print artist, pupil of Shunshō; strongly influenced by Kiyonaga
*Katsukawa (Izumi), Shōyū

春山 **Shunzan** (fl. ca. late 1820s): ukiyo-e print artist, Ōsaka School, pupil of Shunkōsai
*Hokushlnsai

Shunzei, Fujiwara no (1114–1204): a *waka* poet of the late Heian and early Kamakura Periods

Shunzei Tadanori: a Noh play featuring Fujiwara Shunzei and the ghost of Taira no Tadanori

Shuri: the capital of the Kingdom of Ryūkyū and residence of its king

秋鯉 **Shūri** (ca. 1810s–30s): ukiyo-e print artist, pupil of Hokuba
*Yoshimi, Teisai, Teitei

Shūrin (fl. ca. mid 1780s): ukiyo-e print artist and illustrator, Ōsaka School
*Suzuki Shūrin

Shūsai (fl. ca. 1860s): ukiyo-e print artist, worked in the style of Kyōsai

Shūseki (1639–1707): Nagasaki painter, pupil of Itsunen; painted genre scenes of the Dutch establishment at Nagasaki
*Watanabe, Motoaki, Genshō, Chikyō, Enka, Jinjusai, Ran-dōjin, Yūran-dōjin

Shūshō (fl. ca. late 1840s): ukiyo-e print artist, Ōsaka School, follower of Sadamasu

拾水 **Shūsui** (fl. ca. 1764–1800): first trained as a Kanō painter, Shūsui later became a leading follower of Sukenobu, producing a large number of picture books and other illustrations in the decades following Sukenobu's death. Shūsui's most notable work is a series of *ōban*-size *sumizuri-e* shunga plates, unsigned but in his characteristic style.
*Shimokōbe Shūsui [Jūsui]
▷ pp. 99, plate 88

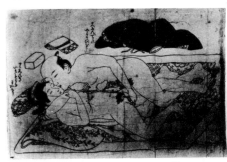

636
Style of Shūsui: *Courtesan and Lover. Ōban,* Kyōto, ca. later 1760s (▷ plate 88)

Shūtei (fl. ca. 1820s): Kyōto ukiyo-e print artist

酒吞童子 **Shuten-dōji:** a more-or-less mythical brigand, slaughtered by Raikō and his four retainers at Ōe-yama; also, the title of various tales on the subject, probably dating from the 15th century

Shūzenji: a village in Izū, known as a place of banishment

Siebold, Philipp-Franz von (1796–1866): a German doctor in Nagasaki 1823–30, 1859–62; his book *Nippon* is a very useful source of information.

sodegaki: a low fence

sode-zukin: a cloak with hood

曾我 **Soga Brothers:** heroes of the *Soga monogatari,* based on an actual event of the early Kamakura Period; it relates the tale of the samurai brothers Jūrō Sukenari (1172–93) and Gorō Tokimune (1174–93), who take revenge upon Kudō Suketsune (who had assassinated their father) in his camp at the foot of Mt. Fuji, where the Shōgun Yoritomo was giving a hunting party. Noh and Kabuki dramas featuring this tale are numerous, as are depictions in prints. Besides the two brothers, the protagonists include Jūrō's sweetheart Tora-gozen and Gorō's love Kewaizaka no Shōshō—both courtesans—as well as their relative the valiant Asaina [Asahina].

Sōgi (1421–1502): a famous *renga* poet of the mid Muromachi Period

Sōgorō, Sakura: the mayor of the village of Kōzu (Shimōsa), famous for bravely presenting his petition to the shōgun against oppressive taxes and thus, with his entire family, being crucified (1655)

sōhei: the mercenaries maintained by large temples as protection.

Sōjō Henjō: a classical *waka* poet and Buddhist priest

Soken (1759–1818): Kyōto Maruyama-School painter, pupil of Ōkyo; his figure paintings show strong ukiyo-e influence, as do the woodblock illustrations to such books as *Yamato jimbutsu gafu* (1800) and *Yamato jimbutsu gafu kōhen* (1804).
*Yamaguchi, Takejirō, Hakugo, Hakuryō, Sansai

Sonezaki shinjū: a noted Kabuki play, first written for the puppet theater by Chikamatsu in 1703, later adapted for the Kabuki stage; features the tragic lovers O-Hatsu and Tokubei.
▷ Hokusai series 21

Sorai, Ogyū (1666–1728): a poet and Confucian scholar of the mid Edo Period

Sōri (fl. ca. 1760s–80s): Kōrin-School painter; studied first with Sumiyoshi Hiromori, later influenced by the Kōrin style; an early teacher of Hokusai
*Tawara-ya, Genchi, Hyakurin, Ryūryūkyo, Seisei

Sori II ▷ Hokusai

Sōri III (fl. ca. 1790s–1800s): ukiyo-e print artist, an early pupil of Hokusai, who gave him his own name Sōri in 1798. His *surimono* are often confused with Hokusai's.
*Hishikawa (Tawara-ya), Sōji

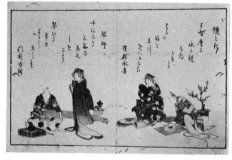

637

Sōri III: *Craftsmen and Beauties*. Illustrations from *Ehon shokunin-zukushi*; *ōbon*, 1802 (some of these plates originally appeared in small *surimono* form)

Sōrin (fl. ca. 1800s): ukiyo-e print artist
*Rekisentei

soroban: abacus

sōrō-bun: formal epistolary language

soroi-mono: a set or series

Sorori Shinzaemon: a famous raconteur, one of the favorites of the Shōgun Hideyoshi

sōsaku hanga: the modern creative print movement
Statler, Oliver. *Modern Japanese Prints: An Art Reborn.* (Introduction by James A. Michener) Tōkyō, 1956.

Sōshi: the early Chinese sage Chuang-tze, often shown with a butterfly hovering about him, in reference to his famous dream

Sōshi-arai-Komachi: a Noh drama featuring the poet Ōtomo no Kuronushi and the "Forged Verse Entry"

Sō-Shiseki (1712–86): Nagasaki-School painter and illustrator who introduced the Ming-derived Nagasaki style to Edo; books after his designs, such as *Sō-Shiseki gafu* (1765), are among the early masterpieces of Japanese multiple-color printing.
*Kusumoto (Sō), Shiseki, Konkaku, Kōhachiro, Katei, Sekkei, Sekko, Sōgaku

Sō-Shizan (1733–1805): Nagasaki-School painter in Edo, son and pupil of Sō-Shiseki; also did some genre work
*Kusumoto (Sō), Shizan, Hakkei, Kunshaku, Manju, Sekko, Taikei

sōsho: the abbreviated, cursive style of calligraphy

Sōshū (fl. ca. mid 19th century): *dōban* artist
*Aono Sōshū

Sōson-shinnō (1242–74): an Imperial prince and *waka* poet of the mid Kamakura Period

Sōtaku (d. 1611): Hasegawa-School painter, second son and pupil of Tōhaku; also did some genre work, including shunga
*Hasegawa Sōtaku
Lane, Richard. *The Erotic Theme in Japanese Painting and Prints: I – The Early Scroll.*

sotoba (Sanskrit *stūpa*): the monument of a sacred place or Buddhist temple; also, a wooden tombstone

Sotoba-Komachi: a Noh drama featuring "Komachi at the Tombstone"

衣通姫 **Sotōri-hime**: the sister-in-law and mistress of the Emperor Inkyō (412–53), remarkable for her beauty; in art she is often depicted intently regarding a spider's nest, in reference to her verse on the infrequency of the Emperor's visits

Sōun (1815–98): Edo *nanga* painter, did some genre work
*Tasaki, Un, Baikei, Hakuseki-sambō, Kendennōfu, Rentai-sanjin, Shichiri-Kōsodō

Sōzei, Takayama (d. 1455): a *renga* poet of the mid Muromachi Period

spiders [*kumo*]: often the symbol of magical craft

states: a term used to indicate the differences existing between the variant editions of a print (cf. plate 194 A/B for a typical example)

Suekichi (Taishō): *dōban* artist, pupil of Shintarō and of Chiossone
*Oyama Sukeichi

Suetaka (1752–1842): Shintō priest, poet and calligrapher in Kyōto; often inscribed genre paintings
*Kamo (Yamamoto), Unkintei

嵩岳 **Sūgakudō** (fl. 1850–60s): ukiyo-e print artist, pupil of Hiroshige, best known for two sets of prints: *Shō-utsushi shijū-hattaka* (1858) and *Shiki no kachō* (1861)
*Nakayama Sūgakudō

Sugawara-denju tenarai-kagami: Kabuki play, first written for the puppet theater in 1746, later adapted to Kabuki; famous for its "Terakoya" scene

Sugawara Michizane (845–903): scholar and minister of the Kyōto court, worshiped as patron of learning

杉村治兵衛 **Sugimura** (fl. ca. 1681–97): ukiyo-e print

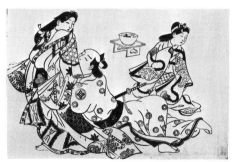

638

Sugimura: *Courtesan and Lover*. *Ōban sumizuri-e*, from a shunga series. Jōkyō Period (mid 1680s)
Here again is Sugimura's favorite triangular composition and characteristic movement toward the outer margins of the print. The man clasps his sweetheart as the maidservant turns her head shyly away. The girl's outer kimono bears in bold letters the artist's surname, *SUGI/MURA*, and on the man's sash is the given name *JIHEI*. It is difficult for us to realize today that all such prints were once ascribed to Moronobu, until Kiyoshi Shibui's researches of half a century ago.

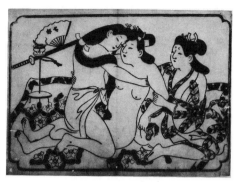

639

Sugimura: *Three Lovers*. *Ōban* print with hand-coloring in *tan-e* style, ca. mid 1680s

640

Sugimura: *Girl Walking*. Large-*ōban* with heavy hand-coloring, ca. 1690

artist and illustrator; the most striking of Moronobu's followers, Sugimura Jihei illustrated at least a dozen novels and picture books, as well as several series of *ōban* shunga prints. He seems to have specialized in shunga, and in this field his flamboyant style often surpasses Moronobu in erotic effectiveness. His peak years also coincided with the rising popularity of large-sized prints, and his extant works include several of the early masterpieces in this format.
*Jihei, Masataka
Hillier, J. "Sugimura Jihei." *Oriental Art.* v. 1 (1959): 2–10.
Horioka, Chimyō. "Sugimura Jihei ron." *Ukiyo-e Art.* No. 40 (1973): 5–33.
Mizutani, Yumihiko. *Kohan shōsetsu sōga-shi.*
Lane, Richard. *Shunga Books of the Ukiyo-e School: VI – Sugimura and Moroshige.* 7 vols. of reproductions plus text volume. Tōkyō [in press].
▷ pp. 51–53, plates 35–38

双六 **sugoroku**: a term comprehending two different sorts of backgammon: one played with dice on a wooden block; the other played on a large picture diagram, often consisting of a print with ukiyo-e decorations

suiboku-ga: term for *sumi-e* ink painting

翠釜亭 **Suifutei** (fl. ca. early 1780s): Ōsaka ukiyo-e illustrator, known for his *Suifutei gafu* (1782), a book of masterful caricature-portraits of Kamigata actors that influenced Ryūkōsai and others of the school
*Kunitaka, Shito
▷ Ōsaka-Print School

Suiindō (mid 19th century): Kyōto *dōban* artist, pupil of Shuntōsai
*Takomuro, Seiho

Suijin: the Shintō god of water, springs, wells, etc.

Suiko-den: the famous Chinese picaresque novel *Suihu-chuan* [English adaptation by Pearl Buck: *All Men are Brothers*]. In Japan the *Suiko-den* boom began with Kyōden's *Chūshin Suiko-den* (1799–1801), and following this novels combining these stories with elements from the world of Japanese theater were published by Bakin and Shinrotei. In the print world, Kuniyoshi's *Suiko-den* prints are justly famous.

水
鵬 **Suiō** (fl. ca. 1710s–30s): notable ukiyo-e painter, his style modeled on that of Moronobu but with Kaigetsudō influence as well
*Tamura, Bōkanshi

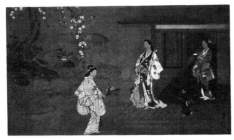

641

Suiō: *Women at Garden. Kakemono* in colors on silk, ca. 1720s

Suiseki (fl. ca. 1805–40): Shijō-School painter and illustrator; also did some genre work
*Satō, Masuyuki, Shiki

Suishō (Meiji): *dōban* artist, studied with Ryokuzan
*Ōyama Suishō

Suitengū: generic term for temples to the gods of the sea

Suizan (1840–1906): Tōkyō *dōban* artist
*Umemura, Inokichi, Fushikian, Keigandō

Sūkei (1762-1817): Hanabusa-School painter, adopted son and pupil of Sūkoku
*Kō, Yoshinobu, Suiunshi

祐
信 **Sukenobu** (1671–1750): this leading Kyōto master (d. VII/19/1750) studied first under Kanō Einō and Tosa Mitsusuke, but from 西 about 1699 turned from classical subjects to 川 genre depictions of the current world, soon developing his own special style of ukiyo-e, strongly influenced by Moronobu, which he 祐 continued with surprisingly little variation 信 through the remainder of his long career.

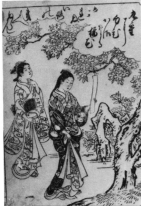

642

Sukenobu: *Girls under Cherry Blossoms. Sumizuri-e* illustration to *Chiyomi-gusa, ōbon,* Kyōto, 1733

Sukenobu first illustrated novels and Kabuki texts, particularly for the noted Kyōto publisher Hachimonji-ya, producing about 60 during the period 1699–1745. Sukenobu's best-known works are, however, his picture books depicting the life and legends of old Japan; these, too, comprise at least 60 separate works and date from 1718 to 1750. In addition, he did several volumes of kimono designs (often with figure prints as frontispieces), as well as some two dozen or more shunga books that rank among his finest work. Although picture books were favored in Kamigata ukiyo-e rather than single-sheet prints, Sukenobu also did several albums of *ōban* prints and shunga designs that rank among the masterpieces of ukiyo-e. He was also a leading painter, though genuine works by him are now rare. A quiet grace was the ideal of the Kyōto ukiyo-e artists, of whom Sukenobu is the representative par excellence. Pupils: Suketada (son), Sukeyo, possibly Harunobu and Shunshō. Followers: Nobukiyo, Mitsunobu, Sadatake, Tokinobu, Shūsui, Settei, Shunchōsai, Kyosen, Minkō, *et al.*
*Nishikawa, Magoemon, Yūsuke, Ukyō, Jitokusai, Jitokusō, Bunkadō
Principal signed books illustrated by Sukenobu:

1 *Shin-Kannin-ki* (Alternate titles: *Honchō shin-Kannin-ki/Kokon Kannin-ki*, 1708
2 *Kōshoku natori-gawa*, 1714
3 *Kōshoku ichidai-nō*, 1715
4 *Shinshiki neya-no-torigai*, 1715
5 *Kyōhō hinagata*, 1716
6 *Sanjūni-sō sugata-kurabe* (*Jochū kyōkun shinasadame*), 1717
7 *Fukusa-hinagata*, 1718
8 *Nishikawa hiinagata*, 1718
9 *Enshoku tama-sudare*, 1719
10 *Fūryū bijin-sō*, ca. 1710s (folding album)
11 *Yamato-fūryū Nishikawa tsuya-sugata* (*Nishikawa tsuya-sugata*), ca. 1710s
12 *Nishikawa fude no yama* (*Fūryū Yamato-e-zukushi: Nishikawa fude no yama*), ca. 1720 (folding album)
13 *Gijo neya-no-otogi*, ca. 1721
14 *Kōshoku tsuno-me ashi*, 1722
15 *Nure-sugata aizome-gawa*, 1722
16 *Hyakunin-jorō shinasadame*, 1723
17 *Ehon tamakazura*, 1726
18 *Onna man-yō keiko-zōshi*, 1728 1742-edition retitled: *Jokyō bunshō-kagami* (*Joyō bunshō*)
19 *Ehon tōwa-kagami*, 1729
20 *Ehon tokiwa-gusa*, 1730
21 *Ehon Tatsuba-yama*, 1730
22 *Ehon tatoe-gusa* (*Ehon tōwa-kagami kōhen*), 1731
23 *Nishikawa fude no nishiki*, 1732
24 *Fūryū iro-medoki* (*Nishikawa-hitsu saishiki-e: fūryū iro-medoki*), 1733
25 *Ehon Shimizu-no-ike* (*Saimyōji-dono kyōkun hyakushu*), 1734
26 *Ehon Makuzu-ga-hara*, 1736
27 *Ehon kawana-gusa*, 1736
28 *Ehon Tsurezure-gusa*, 1738
29 *Ehon Asaka-yama*, 1739
30 *Ehon ike no kokoro* (*Shimizu-no-ike kōhen, Saimyōji dono zoku-hyakushu*), 1739
31 *Ehon Asahi-yama*, 1740
32 *Ehon Chitose-yama*, 1740
33 *Ehon Narabi-no-oka*, 1740
34 *Ehon chiyomi-gusa*, 1740
35 *Ehon Yamato-hiji*, 1742
36 *Ehon Yamato-nishiki*, 1743
37 *Ehon nezame-gusa*, 1744
38 *Ehon fude-tsu-bana*, 1745

39 *Ehon Fukurokuju*, 1745
40 *Ehon hime-tsubaki*, 1745
41 *Ehon Wakakusa-yama*, 1745
42 *Ehon Azuma-warabe*, 1746
43 *Ehon miyako-zōshi*, 1746
44 *Ehon kame-no-oyama* (*Heigo waka, kame-no-oyama*), 1747
45 *Ehon hana-momiji*, 1748
46 *Ehon hana no kagami*, 1748
47 *Ehon Masu-kagami* (*Ehon onna shitsuke-kagami*), 1748
48 *Ehon setsugekka*, 1748
49 *Ehon shinobu-gusa* (*Tsurezure-gusa kōhen*), 1750
50 *Ehon mitsuwa-gusa*, 1758 [posthumous]
51 *Ehon Komatsu-bara*, 1761 [posthumous]
52 *Onna Imagawa hime-kagami*, 1763 [posthumous]

Miyatake, Gaikotsu. *Nishikawa Sukenobu gafu.* Tōkyō 1911.
Mizutani, Yumihiko. *Kohan shōsetsu sōga-shi.*
Nakata, Katsunosuke. *Ehon no kenkyū.*
Nihon fuzoku zue.
Graybill, Maribeth. "The Illustrated Books of Nishikawa Sukenobu: A Preliminary Catalogue." Master's essay, University of Michigan, 1975.
▷ pp. 56–58, plates 41–42

助 **Sukeroku**: a 17th-century plebeian hero (in 六 Kabuki, depicted as one of the Soga Brothers), often shown with his love, the Yoshiwara courtesan Agemaki, and his rival, the aged Ikyū

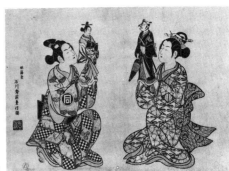

643

Toyonobu: *Sukeroku Puppets. Double-ōban beni-zuri-e,* 1749

Sukeroku yukari no Edo-zakura: a Kabuki play, commonly called *Sukeroku*; one of the *Jūhachi-ban,* written and first staged in 1713 by Danjūrō II; in 1716 assimilated into the Soga Brothers' cycle.
▷ Sukeroku; plate 127

祐 **Suketada** (1706–62): Kyōto illustrator, son 尹 of Sukenobu; produced a number of picture books in his father's style during the period ca. 1749–59
*Nishikawa, Sukezō, Tokuyūsai, Bunseidō

祐 **Sukeyo** (fl. ca. 1761–87): Kyōto illustrator, 代 possibly Sukenobu's daughter; produced several picture books in the Sukenobu style
*Nishikawa Kagetsutei

嵩 **Sūkoku** (1730–1804): Hanabusa-School 谷 genre painter, pupil (and perhaps son) of Sūshi; also did much genre work
*Kō (Takaku [Takahisa]), Kazuo, Shiei, Koren-sha, Rakushisai, Suiandō, Toryūō

-sukune: suffix designating a class of government officials

Suma: a village in Settsu, renowned for its scenery and for being the site of Prince Genji's exile

Suma Genji: a Noh drama about Prince Genji's period of exile at Suma

墨 **sumi**: term for India ink ▷ pigments
Sumida-gawa: a river entering the Edo Bay after passing through the eastern part of the city; also called Ō-kawa, Asakusa-gawa, Miyato-gawa
隅 **Sumida-gawa**: a Noh drama featuring the
田 mother of Umewaka-maru, whose mind had
川 become unbalanced since the time when her son was abducted by slave-traders
sumi-e: painting in India ink
Sumiyoshi (Suminoe): a famous Shintō temple in Settsu, built in honor of the gods of the sea
Sumiyoshi-mōde: a Noh drama featuring Prince Genji and the Lady Akashi at the Sumiyoshi Shrine
墨 **sumizuri**: term meaning "black-printed" or
摺 "monochrome-printed"
sumizuri-e: a monochrome black and white print
相 **sumō**: a variety of wrestling unique to Japan
撲 ▷ Nomi-no-Sukune
sumō-e: a wrestling print
Sumoto: the principal town of Awaji Island
Sumiyoshi School: a school of artists founded by Jokei, a branch of the Tosa style
suō: a samurai costume worn over a kimono
-suri [-zuri] suffix meaning impressit, "printed"
suri-butsu: early Buddhist prints
摺 **surimono**: privately commissioned prints,
物 often elaborately printed
Exhibition of Egoyomi. Surimono, etc. Collected by H.E. Dr. Solf, German Ambassador. (Foreword and catalogue notes by J. S. Happer) Tōkyō, 1927.
Ouwehand, C. Surimono. Rotterdam, 1953.
▷ e-goyomi

suri-shi: a printer
Suruga-chō: a Nihon-bashi shopping area, where the Echigo-ya (Mitsukoshi) dry goods store was located
Sūryō (1800–75): Hanabusa-School genre painter, son and pupil of Sūkei
*Kō, Sūkoku
Susano-ō: a Shintō god of violent character
Sūsetsu (1736–1804): Hanabusa-School genre painter, son of Sūshi
*Sawaki, Kuraji, Chūgakusai, Kanta, Suiundō, Yoshirō
嵩 **Sūshi** (1707–72): genre painter, pupil of
之 Hanabusa Itchō
*Sawaki (Sa, Michikata), Shigaku, Jinnai, Jinzō, Chūgakudo, Dōken, Issuisai, Kōkōkan, Tōshuku, Yūkōtei
susuhaki: house-cleaning
susuki: pampas grass
sutra [o-kyō]: the Buddhist canon
Suzuka-yama: the mountains on the borders of Ise, Iga and Ōmi; site of a famous barrier station
Suzume no hosshin: a religious tale, probably 15th century
suzuri-bako: a box containing writing utensils

T

tabako-bon: a tray containing equipment for smoking

tabi: Japanese-style socks
Tabito, Ōtomo no (665–731): a waka poet of the Man-yō-shū
tachibana: the citrus tree
tachi-mawari: a sword fight on the stage
tachi-yaku: the leading male roles in Kabuki
Tadami, Mibu-no (10th century): a classical waka poet
Tadanobu: a Noh drama featuring Satō Tadanobu and Yoshitsune
Tadanori: Noh drama featuring Taira no Tadanori
Taema: a Noh drama featuring the lady Chūjō-hime
Taga: an ancient stronghold in Rikuzen
tagasode: byōbu; a type of painted screen, on which komonos are depicted hung on racks
Tago-no-ura: a bay and village in Suruga, famous for its scenery and for its view of Mt. Fuji
tai: the sea bream, symbol of good fortune
Taiga (1723–76): famous nanga painter, also did some genre work
*Ikeno, Arina, Kyūka-sanshō, Sangaku-dōja, Taigadō
戴 **Taigaku** (fl. ca. 1820s–30s): ukiyo-e print
岳 artist, pupil of Hokusai
*Endō, Han-emon, Keisai, Unkaku
Taihei-ki: a military tale describing the civil war years 1318 to 1367, and the struggles between the Northern and Southern Courts; completed about 1370, it features Prince Morinaga, Nitta no Yoshisada, Kusunoki no Masashige, Emperor Go-Daigo and the revolt of Ashikaga no Takauji.
taiko: a large drum
taikō: a title taken by retired warlords; used especially for Toyotomi Hideyoshi
taiko-mochi: a professional jester common in the entertainment quarter
Taiotsu [Taiitsu] (1804–81 or 1800–69): Nanga-style painter, also did some genre work
*Murase, Taiichi
Takabumi, Kinoshita (1779–1821): a waka poet of the late Edo Period
Takadachi: a town in Rikuchū, where Yoshitsune was trapped and committed suicide in 1189
Takakuni, Minamoto no (1004–77): a waka poet of the mid Heian Period
Taira ▷ Heike
tairō (genrō, ō-toshiyori): the first minister of the shōgun
Taishakuten: a Buddhist deity with a lordly manner
taisha-seki ▷ pigments
大 **Taishō** (1912–26): during the Taishō Period,
正 dating from VII/30/1912 to XII/25/1926, Japan was further westernized and emerged as a powerful modern nation. Ukiyo-e as a creative art was dead, but from the late Meiji Period interest in this unique art form had revived, resulting in scholarly studies both at home and abroad, in artists such as Goyō and Kiyokata attempting to revive the ukiyo-e tradition adapted to the new times, in the appearance of fervent collectors in both East and West and in the production of skillful reproductions and copies of the ukiyo-e masters (which were later sometimes sold as originals by unscrupulous dealers). The massive export of ukiyo-e abroad flourished during the late Meiji and Taishō periods. A fortunate trend, as it turned out, for the disastrous Taishō Earthquake of 1923 probably destroyed half of the art treasures of the Kantō area. ▷ nengō
Taito II (fl. ca. 1810s–53): ukiyo-e painter,

戴 print artist and illustrator; pupil of Hokusai,
斗 who in 1820 gave him his name, Taito; he spent his final decade (from 1843) in Ōsaka.
*Katsushika (Fujiwara, Kondō), Fumio, Banemon, Kisaburō, Beikasai, Beika-dōjin, Beika-sanjin, Dōteisha, Genryūsai, Hokusen, Shōzan, Toenrō
Takamasa [Kōga] (1791–1864): Nagoya ukiyo-e painter, studied under Bokusen and Mitsuzane
*Mori, Hachisuke, Umon, Gyokusen, Kaō, Kikutei, Sankōdō, Shisentei, Sodō
Lane, Richard. Studies in Ukiyo-e.
Takamatsu: the chief town of Sanuki, residence of the Matsudaira daimyō
Takamitsu (Meiji): dōban artist, pupil of Suisan
*Shimomura Takamitsu
Takamori, Saigō (1827–77): a noted general who played a brilliant part in the Restoration wars, but later led the Revolt of 1877, dying in the Battle of Shiroyama
Takamura, Ono no (802–52): a noted writer and Imperial envoy
Takano monogatari: a religious tale, probably 15th century
Takanori, Kojima (Bingo Saburō) (d. ca. 1352): a samurai general and ally of the Emperor Go-Daigo
takara-bune: the treasure-ship of the Seven Gods of Luck
takara-mono: a collection of treasures associated with the Seven Gods of Luck
Takasago: a harbor in Harima, famous for its scenery and legends
Takasago: a Noh drama featuring an old couple, the spirits of the Takasago and Sumiyoshi pine trees
Takasue-no-musume (b. 1008): a waka poetess and writer of the mid Heian Period
Takata Mizu-Inari: a shrine to Inari at Takata, northwest of Edo, pilgrimages to which were said to cure eye troubles
Takatō: a town in Shinano
Takauji, Ashikaga (1305–58): the first Ashikaga shōgun, from 1338 until 1358
Takayama: the principal city of Hida, a part of the shōgun's domain
Takechi-no-miko (654–96): a waka poet, eldest son of Emperor Temmu
Takeda Izumo-no-jō (1646–1726): next to Chikamatsu, the greatest dramatist (and jōruri chanter) of his time
Takejirō (Taishō): Ōsaka dōban artist, pupil of Kyokuzan
*Hayano Takejirō
Takemoto-za: a famous Ōsaka puppet theater, fl. 1685–1767
Take[shi]uchi-no-sukune: First Minister to the Emperor Seimu; supported the Empress Jingō in the expedition to Korea of 201
Taketori monogatari: the oldest Japanese novel (10th century); the story of an old bamboo-cutter and the moon child Kaguya-hime
take-uma: bamboo stilts
Takuan (1573–1645): a Buddhist monk of the Jōdo sect; famous for his travels throughout the provinces
Takumi (fl. ca. 1650s): said to have been a leading Kyōto ukiyo-e artist of the mid 17th century (cited in Saikaku's Nanshoku Ōkagami, 1687)
Takushū (d. 1788): Kano-style genre painter in Kyōto; studied first under O-Ryū, later turned to the neo-Yamato-e style
*Katsuyama, Akifumi

Tama-gawa: a river passing through the province of Musashi and entering Edo Bay at Haneda; also called Rokugō-gawa; utilized for an aqueduct that brought water to the city of Edo (86 miles/139 km. long) ▷ mu-Tama-gawa

Tamakuni (fl. ca. early 1820s): ukiyo-e print artist, Ōsaka School
*Shunshōdō

Tamamo-no-mae: a favorite concubine of Emperor Toba (1108–23); actually a witch, originally possessing the shape of a fox and of the *sesshō-seki* or "death stone"

Tamayori-hime: the legendary sister of Toyotama-hime; made pregnant by a red arrow winged with duck's feathers

Tamechika (1823–64): leading neo-*Yamato-e* painter in Kyōto; also did some genre work
*Okada, Tamechika [Tametaka, Tameyasu], Saburō, Shinzō, Matsudono

Tamehide, Reizei (d. 1372): *waka* poet of the late Kamakura Period

Tameie, Fujiwara no (1198–1275): *waka* poet of the mid Kamakura Period, son of Teika

Tamekane, Fujiwara no (Kyōgoku) (1254–1333): *waka* poet of the late Kamakura Period

Tameko (late 13th century): *waka* poetess of the Kamakura Period

Tamesuke, Reizei (1263–1328): *waka* poet of the late Kamakura Period

Tametomo, Minamoto [Chinzei Hachirō] (1139–70): a Herculean warrior and archer, later banished to the island of Ōshima

Tameuji, Fujiwara no (1222–86): *waka* poet of the mid Kamakura Period

Tameyo, Fujiwara no (Nijō) (1251–1338): *waka* poet of late Kamakura Period

Tamiko, Kada no (1722–86): *waka* poetess and literary critic of the mid Edo Period

Tamikuni (fl. ca. 1820s): ukiyo-e print artist, Ōsaka School
*Toyokawa, Kōgadō, Jiryūsai

Tamura: a Noh drama featuring the ghost of Sakanoe no Tamuramaro (758–811), a famous early general and founder of the Kiyomizu Temple

tan: a pigment made of red lead, saltpeter and sulphur, giving an orange color which readily oxydized to a metallic blue ▷ pigments

Tanabata: the festival of the Weaving Princess and the Divine Herdsman Kengyū; the Star Festival or Lovers Festival, 7th Day of the Seventh Month

tan-e: early *sumizuri-e* hand-colored in *tan* and other pigments, popular from the 1660s to the 1710s ▷ p. 39

Tane-ga-shima: an island dependent on Ōsumi Province; in 1542, the Portuguese Fernand Mendez Pinto was shipwrecked on this island, the first European to set foot in Japan; "tanegashima" soon came to mean arquebus in Japanese, from the first appearance of this weapon there

tango: the Boys Festival, celebrated on the 5th Day of the Fifth Month; large carp-shaped banners made of paper or cloth are raised on bamboo poles; festival also called *ayame no sekku*

Tanehiko, Ryūtei (1783–1843): a late Edo Period writer of popular fiction, often illustrated by Kunisada

Tangetsusai (fl. ca. 1800s–20s): ukiyo-e print artist and illustrator, Ōsaka School

T'ang Dynasty: Chinese dynasty that ruled from A.D. 618 to 907

tanka ▷ *waka*

tanroku-bon: illustrated printed books of the first half of the 17th century, hand-colored in orange (*tan*) and green (*roku*), often with yellow, brown or purple as well ▷ plate 17

Tansui (Meiji): *dōban* artist
*Fukutomi Tansui

Tansui (Meiji): Kyōto *dōban* artist, pupil of Ryokuzan
*Katsura Tansui, Tōkeidō

Tan-yū (1602–74): leading Kanō-School painter; also did some genre work
*Kanō, Tan-yū [Tan'yū], Morinobu, Shirōjirō, Uneme, Byakurenshi, Hippō-daikoji, Seimei, Tan-yūsai

tarashikomi: a painting technique: application of one color on to another that is still wet

tatami: a floor mat

tateban [*tate-e*]: vertical prints

tate-banko: prints designed to be cut out and mounted on cardboard assemblages

Tate-yama: a mountain in the eastern part of Etchū, noted for the Ōyama Shrine

Tatsumi: the entertainment quarter of Fuka-gawa

Tatsuta-gawa: a river in Yamato; its maple leaves were often the theme of poets and artists

tattooing [*bunshin*]: in fashion from around the end of the 18th century among the lower classes

tayū: the first rank of courtesan, more often called *oiran* in Edo

Teigetsudō [Jōgetsudō] (fl. ca. 1740s): ukiyo-e print artist, follower of Masanobu

Teika: a Noh drama featuring the Princess Shokushi and the poet Fujiwara no Teika

Teika-ryu: style of calligraphy, introduced in the 13th century by the poet Fujiwara no Teika

Teitoku, Matsunaga (1571–1653): a pioneer *haiku* poet, classical scholar and writer of *waka* and *kyōka*

Teiun (fl. first half 18th century): Tosa-style painter, may be an artistic descendant of Matabei
*Iwasa Teiun

tejō ▷ punishments

Tekkai: the Chinese *sennin* Li T'ieh-kuai, usually depicted as a beggar blowing his spirit into space in the form of a miniature figure riding on a staff

tekomai: a comic dance; also, a female participant in a Shintō festival or *niwaka* performance

Tekoshi-ga-hara: a plain in Suruga, beside the Abe River

temari: a girl's game played with a bouncing ball

Temmei (1781–89): the Temmei Period, dating from IV/2/1781 to I/25/1789, was a summit of plebeian culture, encouraged by the laissez-faire attitude of the corrupt Tanuma administration, a regime characterized by graft. The result was a general trend toward decadence, inflation and famine among the populace. As had been the case in the Genroku Period nearly a century earlier, lax government proved a boon to the popular arts. But, whereas the Genroku era had been characterized by a spread of traditional Kyōto and Ōsaka culture to Edo, by the Temmei Period Edo had absorbed and digested Kamigata influences and was ready to create a new culture of its own. In contrast to the refined, leisurely, sometimes effete quality of Kyōto culture, the *Edokko* or born Edo-ite took pride in a showy wit and élan, in chic and savoir-faire, expressed respectively in such terms as *share, hade, iki,* *tsū.* In literature these concepts formed the basis of the Yoshiwara *share-hon* gossip books, the witty *kibyōshi* novelettes, the satirical *senryū, kyōka* and *kyōshi* verses and *kyōbun jiguchi* tales. All of these were flavored by the classical revival then prevalent in more scholarly circles and most often they were illustrated by the leading ukiyo-e artists of the age. For ukiyo-e, this was indeed a Golden Age. Kiyonaga, Shunchō, Shigemasa, Kyōden, Shunshō and Shun-ei were in their prime, and Utamaro, Eishi and Hokusai were starting to produce important work. Detailed backgrounds enhanced the evocative realism of the prints, and multiple-sheet *ōban* prints and *ōkubi-e* increased the scale and grandeur of the prints. In related fields, Shiba Kōkan produced the first Japanese *dōban* (copper engravings) in Temmei III (1783) with, as a consequence, a revival in the popularity of the more Japanese-style perspective print (*uki-e*). ▷ *nengō*

Temmu (d. 686): a *waka* poet and 40th sovereign of Japan

Tempō (1830/31–1844/45): the Tempō Period, which dates from XII/10/1830/31 to XII/2/1844/45, saw the government preoccupied with diplomatic problems, worldly pleasures, palace intrigue and a populace oppressed by inflationary trends that made day-to-day consumption and ostentatious living the favored way of life. Both literature and art fell into extravagant *tours de force* or broad satires on the times, lacking in either refinement or sophistication, and government regulations (including restrictions on figure prints) increasingly limited means of expression. At the same time publishing, which had been an art at one time tended to decline to the level of a primarily commercial venture, with artists overworking whatever limited themes happened to appeal to a fickle public, continually seeking novelty. Only in the new field of the landscape print did the times prove propitious: Hokusai and Hiroshige produced much of their finest work during the early Tempō Period. ▷ *nengō*

tengai: a deep reed hat worn by *komusō*

tengu: a legendary winged goblin with beak, dressed as *yamabushi*, said to live in the deep mountains

Tenjiku: archaic term for India

Tenjiku Tokubei (1618–86): an adventurer who sailed to India and Macao and wrote an account of his travels

Tenji (d. 671): a *waka* poet and 38th sovereign of Japan

Tenna (1681–84): the Tenna [Tenwa] Period dates from IX/29/1681 to II/21/1684 and though brief, forms one of the important eras of Japanese culture. In literature, Saikaku created the modern novel out of the amorphous *kana-zōshi*, while in ukiyo-e, Moronobu reached his ultimate mastery in book illustration and in albums of print masterpieces ranging from scenic or genre views to legendary tales and bold erotica. Moronobu's follower and late competitor, Sugimura, likewise published widely in Edo, as did Hambei in Kyōto. This period featured a combination of economic stability and widespread education, resulting in an affluent, appreciative audience for new trends in art and literature. ▷ *nengō*

tennin: the *apsarasas,* the angels of Buddhism

tennō: term for Emperor or Empress (also called *tenshi, heika, gosho, dairi, kinri, ōkimi, mikado*)

Tennōji (Shitennōji): a large Buddhist temple near Ōsaka

Tenryū-gawa: a river passing through Tōtōmi, famous for its rapids (137 miles/220 km. long)

tenshu: keep, the central tower of a castle

tenugi: a towel

Tenwa ▷ Tenna

teppō [*gun*]: a name for one of the lowest classes of Edo harlots

teppō-gata: officials who supervised the manufacture of guns and cannon and instructed in their use

tera [-dera, -ji]: a Buddhist temple and its dwellings

tera-koya: type of private school operated by Buddhist priests (or sometimes by laymen)

Terukata: (1883–1921): neo-ukiyo-e painter, pupil first of Toshikata, then of Kawai Gyokudō
*Ikeda, Seishirō

Terukuni (fl. ca. 1820s): ukiyo-e print artist, Ōsaka School, pupil of Yoshikuni

照信 **Terunobu** (fl. ca. 1720s): ukiyo-e painter; Terunobu stands close in style to the Kyōto School of Nishikawa Sukenobu, and the similarity of surname may well indicate some direct relation. (He appears to have been well known in his time, for one of Masanobu's picture books speaks of him as the founder of the style of depicting a courtesan's forehead with heightened brow.)
*Nishikawa Terunobu

輝重 **Terushige** (fl. ca. late 1710s–early 1720s): ukiyo-e print artist
*Katsukawa Terushige

煙重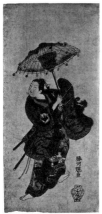

644

Terushige: *Actor in Parasol Dance. Hosoban urushi-e,* ca. 1730s

Terute-hime: the mistress of Oguri Hangan; she nursed him in illness and, captured by brigands and sold to a brothel, was soon rescued by her lover

tetraptych [*yommai-tsuzuki*]: a composition of four prints side by side

Tetsusaburō (Meiji): *dōban* artist, pupil of Ryokuzan
*Suganuma Tetsusaburō

Tetsuzan [Tessan] (1775–1841): Kyōto Maruyama-School painter, also did some genre work
*Mori, Shigen

Thirty-six Views of Mt. Fuji ▷ Hokusai, print series 119

Thunberg P.: the director of the Dutch factory at Deshima in 1775

Titsingh, Isaac (1740–1812): the director of the Deshima factory in 1779–1780 and 1781–1784; wrote several valuable works on Japan

toad [*gama*]: animal credited with magic powers ▷ Gama-*sennin,* Jiraiya, *kōshin*

Toba (1108–23): 74th sovereign of Japan; his reign was disturbed by continuous wars between the great temples that surrounded Kyōto, the Imperial authority steadily losing ground to the warlords

Tōba: the famous Chinese poet Su Tung-p'o (1036–1101), generally depicted riding on a mule in the snow, wearing an enormous hat

鳥羽絵 **Toba-e:** caricatural style of painting, first associated with the monk Toba-sōjo

Toba-sōjo [Kakuyū] (1053–1140): a Buddhist monk of the Tendai sect; cultivated the painting of humorous sketches, since then called *Toba-e*

Tōbō-saku: a Noh drama featuring the goddess Sei-ōbo (Hsi-wang-mu) and the hermit Tōbō-saku (Tung-fang So)

Tōda, Tawara (Fujiwara Hidesato): the governor of Shimotsuke; quelled the revolt of Masakado in 939 and famous in legend for his battle with a giant centipede

Tōei: a Noh drama featuring the child Tsukiwada (dressed as a priest) and Tōei

Tōeizan: Kan-eiji, a famous temple on Ueno Hill, noted for its cherry blossoms

Tō-Emmei: the Chinese poet T'ao Yuanming, usually depicted as a retired old man amidst chrysanthemums

tōfu: soy-bean curds

Tōfū [**Michikaze**], **Ono no** (896–966): a poet and courtier who excelled in penmanship; the patron saint of calligraphy

tohachi-ken [*kitsune-ken*]: a game of hands played by three people

Tōhaku (1539–1610): noted Kanō-style painter; also did some genre work
*Hasegawa (Okumura), Kyūroku, Nobuharu [Shinshun]

Tōjakushi (fl. early 19th century): Kyōto *dōban* artist

tōka-Ebisu: a festival celebrated on the 10th Day of the First Month, in honor of Ebisu, god of Wealth

東海道 **Tōkaidō** [Eastern Sea Road]: the main highway from Edo to Kyōto (319 miles/514 km long) ▷ Highways, map

Tōkei (1760–1822): Ōsaka genre painter and illustrator
*Niwa, Motokuni, Hakushō

Tokinari (fl. ca. 1810s): ukiyo-e painter, influenced in style by Eizan
*Fūryūan

雪坑斎 **Tokinobu** (fl. 1751–78): an Ōsaka follower of Sukenobu who did extensive illustrations to novels, miscellanea and shunga during the third quarter of the 18th century
*Kitao, Tokinobu [Tatsunobu], Sekkōsai, Jin-ō
Mizutani, Yumihiko. *Kohan shōsetsu sōga-shi.* ▷ p. 93

Tokiwa-gozen: the concubine of Minamoto Yoshitomo, mother of the famous Yoshitsune; later the concubine of the tyrant Kiyomori; often depicted fleeing with her children in the snow, at the time of the Heiji war of 1160

Tokiwa[-bushi]: a school of popular samisen music

tokonoma: a parlor alcove where a *kakemono* painting was hung and flowers were arranged

Tokugawa Period: the period of the Tokugawa regime, between 1600 or 1603 and 1868; also called the Edo Period.

Tokusa: a Noh drama featuring the child Matsuwaka, reunited with his father

Tokushima: the chief town of Awa (Shikoku); formerly called Iyama or I-no-tsu

Tokutarō (b. 1832): *dōban* artist, pupil of Suizan
*Kimura Tokutarō

Tōkyō: the capital of the Japanese Empire, called Edo until September 1868; in March 1869 it became the residence of the Emperor and the official seat of government. ▷ Edo

Tomigaoka: site in the Fukagawa district of Edo, containing the famous Hachiman Shrine

Tomikuni (fl. ca. early 1820s): ukiyo-e print artist, Ōsaka School
*Kōgadō

Tomimoto[-bushi]: a variety of *jōruri* chant to the accompaniment of the samisen

Tominobu (fl. mid 18th century): ukiyo-e print artist
*Miyagawa Tominobu

Tomiyuki (fl. ca. 1850s): Ōsaka ukiyo-e print artist and illustrator
*Rokkatei, Senkintei

Tomoakira: a Noh drama featuring Taira no Tomoakira, who met his death at the Battle of Ichi-no-tani

tomoe: a design of commas in a circle

Tomoe: a Noh drama featuring Tomoe-gozen, the warrior-mistress of Yoshinaka

Tomoe-gozen: the mistress of General Kiso Yoshinaka, remarkable for her beauty and courage; she herself led a troop of soldiers in battle. Defeated at Uji in 1184 and widowed, she retired to Echigo when she was 28 years old. ▷ Yoshinaka

Tomofusa (fl. ca. 1690s): ukiyo-e painter, pupil of Moronobu
*Hishikawa Tomofusa

Tomokuni (fl. ca. 1810s): ukiyo-e print artist, Ōsaka School

Tomomori, Taira no (1152–85): a son of Kiyomori, he defeated Minamoto no Yorimasa at Uji-bashi but was himself defeated at the Battle of Ichi-no-tani (1184), and at Dan-no-ura (1185), where he committed suicide.

Tomonaga: a Noh drama featuring Minamoto no Tomonaga, who committed suicide after the civil war of the Heiji Period

流宣 **Tomonobu** [Ryūsen] (fl. ca. 1687–1713): ukiyo-e print artist, illustrator and cartographer. A follower of Moronobu, Tomonobu illustrated a dozen novels and volumes of miscellanea in the period 1687–1713, in addition to designing maps and writing fiction. His ukiyo-e designs generally lack originality, varying between the Moronobu style and that of Sugimura; but one series of *ōban* semi-shunga is notable.
*Ishikawa, Ryūshū, Toshiyuki, Gahaiken, Kamatsuken
Lane, Richard. *Shunga Books of the Ukiyo-e School: VI—Sugimura and Moroshige.* 7 vols. of reproductions plus text volume. Tōkyō, in press.
Mizutani, Yumihiko. *Kohan shōsetsu sōga-shi.* ▷ p. 51

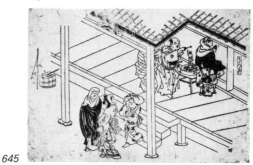

645

Style of Tomonobu: *Buddhist Festival. Ōban sumizuri-e,* ca. 1690

Tomo-no-tsu: a port in Bingo Province

Tomonori, Ki no: *waka* poet of the early Heian Period

Ton-a (1289–1372): a Buddhist priest and *waka* poet of the late Kamakura and Northern and Southern Court periods

Tone-gawa: a river forming the boundary between Musashi and Shimōsa; also called Bandō-Tarō (174 miles/280 km. long)

toneri: the guards of the Imperial Palace and of princes and lords

Tō-[Tamu] no-mine: a mountain in Yamato with a famous Buddhist temple

ton-ya [*toi-ya*]: term meaning wholesaler

Tora-gozen: a famous courtesan of Ōiso, mistress of Soga no Jūrō ▷ Soga Brothers

Tōrei: a poetic name for Tōeizan

torii: a symbolic gateway to the precincts of a Shintō shrine

等琳 **Tōrin** (fl. later 18th century): painter and print artist, founder of the Tsutsumi School; confrère of ukiyo-e artists with whom he often collaborated
*Tsutsumi, Magoji, Rō[Tsumbo]-Tōrin

Tōrin II (fl. ca. 1790s): painter and print artist, pupil of Tōrin
*Tsutsumi (Tsukioka, Morooka), Ginji, Chiyomatsu

Tōrin III (ca. 1743–1820): painter and print artist, pupil of Tōrin but influenced by Sekien
*Tsutsumi (Akizuki), Shinsensai, Sekkan, Setsuzan [Sessan], Shūei, Shūgetsu

tori-no-ko: a sturdy and lustrous handmade paper

tori-oi: a female street singer and player of the samisen

tortoise: a symbol of longevity ▷ Urashima Tarō, *minogame*

Tōru: a Noh drama featuring Minamoto no Tōru

Tosa: the leading traditional school of Japanese-style painters; carried on the native painting tradition of *Yamato-e*

年 **Toshihide** (1863–1925): painter and print
英 artist; studied ukiyo-e under Yoshitoshi, Western-style painting under Kunisawa Shinkurō
*Migita, Toyohiko, Bansuirō, Gosai, Ichieisai

Toshikage (fl. ca. 1850s): ukiyo-e print artist, Ōsaka School

年 **Toshikata** (1866–1908): ukiyo-e genre pain-
方 ter and illustrator; pupil first of Yoshitoshi, then studied Japanese-style painting with Seitei. Pupils: Kiyokata, [Ikeda] Terukata and Shōen
*Mizuno, Kumejirō

Toshimoto (fl. ca. 1870s): ukiyo-e print artist, Ōsaka School
*Suzuki, Raisai, Rainosuke

Toshinobu (fl. ca. 1710s): ukiyo-e painter, Kaigetsudō School

利 **Toshinobu** (fl. ca. 1717–40s): noted ukiyo-e
信 print artist, pupil and possibly adopted son of Masanobu. Toshinobu mainly designed small
利 lacquer prints featuring one or two figures of
信 actors or girls; within this limited field, however, he often surpassed at all but the finest work of his master Masanobu and in sustained performance maintained a remarkable standard of quality.
*Okumura, Kakugetsudō, Bunzen
▷ pp. 79–81, plate 69

Toshinobu (fl. ca. 1857–86): ukiyo-e print artist and illustrator, pupil first of Kunisada, then of Yoshitoshi; lived in Tōkyō and Yokohama
*Yamazaki, Shinjirō, Tokusaburō, Sensai, Shunkō

646 Toshinobu [Okumura]: *Kantarō as Nao-hime. Hosoban urushi-e,* ca. 1725

647 Toshinobu [Okumura]: *Gennosuke as Ushiwaka-maru. Hosoban urushi-e,* ca. 1729

Toshitsune (fl. 1888–1907): neo-ukiyo-e painter and illustrator; studied first under Yoshitoshi, later a pupil of Bairei
*Ineno, Takayuki

Toshiyori, Minamotono (d. 1129): classical *waka* poet of the late Heian Period

Toshiyuki, Fujiwarano: a classical poet

Tōshōgū: a shrine with the tomb of the Shōgun Ieyasu; the term is also applied to Ieyasu himself

Tōshū (1795–1871): genre painter in Ōsaka, pupil of Rankō
*Tamate Tōshū

Tōtei (fl. ca. 1770s): Kanō-style painter, but showing some ukiyo-e influence
*Kanō, Kyōshin

Totsugen (1760–1823): neo-*Yamato-e* painter, also did some genre work
*Tanaka, Bin, Kotō, Chiō, Daikōsai, Kafukyū-shi, Kaison, Kimpei, Kyūmei, Tokuchū

Tottori: the chief town in Inaba

Toun (d. 1789): minor ukiyo-e print artist in the style of Kiyonaga
*San-tosai, San-toun

Tōun (1625–94): Kanō-School painter, also did some genre work
*Kanō, Tōun [Dōun], Masunobu, Sanzaburō, Hakusa-kenshi, Hakuyūken, Shōinshi, Shōshin-dōjin

Tōwa (d. 1841): Kanō-School painter; early teacher of Kyōsai
*Maemura, Aitoku

Toyama: the chief town in Etchū

Toyama Prints: rustic print school, work was mainly provincial advertisements and *surimono* in the 18th–19th centuries

Tōyō (1755–1839): Maruyama/Kōrin-School painter, also did some genre work
*Azuma, Taiyō, Ginzō, Shuntarō, Gyokuga, Hakurokuen

豊 **Toyoharu** (1735–1814): noted ukiyo-e pain-
春 ter and print artist. In Kyōto he studied under
一 the Kanō-School master Tsuruzawa Tangei;
竜 went to Edo about 1763 and became a pupil
斎 of Shigenaga and of Sekien; also influenced by Toyonobu. Toyoharu is best remembered
豊 today as the founder of the Utagawa School
春 and the teacher of Toyokuni and Toyohiro, but he is an artist of considerable interest in his own right. His early prints are in the Harunobu manner but display a delicacy that almost borders on weakness.
Toyoharu's greatest achievement was the development of the *uki-e* or perspective print. Forming a kind of bridge between ukiyo-e and

Western art, these prints have been strangely neglected by Western students and collectors. Few subsequent ukiyo-e artists failed, however, to be influenced by Toyoharu's view of landscape and background; Hokusai's work would be difficult to imagine without it.
*Utagawa, Masaki, Shin-emon, Tajimō-ya, Shōjirō, Ichiryūsai, Sen-ō, Senryūsai, Shōjirō, Shōju
▷ pp. 146–50, plates 152, 153

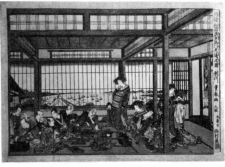

648

Toyoharu: *Party at Shinagawa. Ōban,* ca. late 1770s

649

Toyoharu: *Winter in Holland. Ōban,* ca. early 1780s

Toyohide (fl. ca. early 1840s): Ōsaka ukiyo-e print artist
*Kitagawa, Ichiryūtei, Isshintei

Toyohide (fl. ca. 1860s): ukiyo-e print artist, Ōsaka School
*Utagawa Toyohide

Toyohiko (1773–1845): Shijō-School painter, also did some genre work
*Okamoto, Shigen, Shiba, Shume, Chōshinsai, Kōson, Rikyō, Tangaku-sanjin

豊 **Toyohiro** (1773–1828): noted ukiyo-e pain-
広 ter, print artist and illustrator; studied under

650

Toyohiro: *Shinagawa Courtesan. Ōban,* ca. 1800

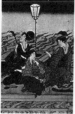

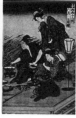

651

Toyohiro: *Summer Party on the Kamo River. Ōban* triptych, one of a series on the Twelve Months, *Ryōga jūni-kō,* in collaboration with Toyokuni; ca. early 1800s

Toyoharu, whose studio he entered about 1782
*Utagawa (Okajima, Okazaki), Tōjirō, Ichiryūsai
Toyohiro's illustrations include: *Musōbyōe kochō-monogatari* (9 vols., 1809–10) and *Asahina shima-meguri-no-ki* (30 vols., 1814–1827).
▷ p. 152, plate 157

豊久 **Toyohisa** (fl. ca. 1800s–10s): ukiyo-e print artist, pupil of Toyoharu
*Utagawa, Baikatei
Toyohisa II (fl. ca. 1830): ukiyo-e print artist, pupil of Toyohisa
Toyokichi (early Meiji): *dōban* artist, pupil of Ryokuzan
*Hosoki, Ryokuō
Toyokichi (b. 1856): *dōban* artist, pupil of Ryokuzan; owned a printing shop at Nihonbashi
*Kaneko Toyokichi

豊国 **Toyokuni** (1769–1825): noted ukiyo-e painter, print artist and illustrator, pupil of Toyoharu. Of the leading ukiyo-e designers Toyokuni was the least original but succeeded so well in emulating the finer points of his more creative contemporaries that, in his best work, he is universally accorded a place nearly equal to theirs. His greatest consecutive effort was the famous series *Yakusha butai no sugata-e* [Pictures of Actors in Character], of which at least 40 prints were produced during the years 1795–96. Though doubtless achieved under the stimulus of Sharaku's great work of the preceding months, they nevertheless represent individual masterpieces of their kind.
*Utagawa (Kurahashi), Kumaemon, Kumakichi, Ichiyōsai
Illustrated books by Toyokuni include:
Yakusha meisho-zue (1 vol., 1800)
Yakusha sangai-kyō (2 vols., 1801)

歌川

一陽斎

豊国

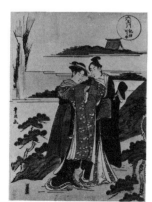

652

Toyokuni: *Lovers in the Wilderness. Chūban,* early-mid 1790s, from a *mu-Tamagawa* series

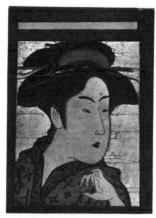

653

Toyokuni: *O-Hisa in Mirror. Chūban,* ca. mid 1790s

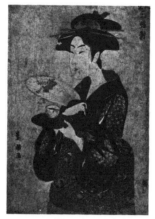

654

Toyokuni: *O-Kita. Ōban,* ca. mid 1790s, from a series of 3 prints featuring famous teahouse beauties

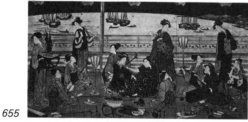

655

Toyokuni: *Scene at the Shinagawa Pleasure Quarter. Ōban* triptych, ca. mid 1790s

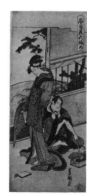

656

Toyokuni: *Parting Scene, Hosoban,* ca. mid 1790s, act VI of a *Chūshingura* series

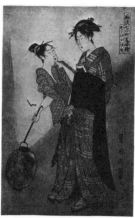

657

Toyokuni: *Geisha and Attendant. Ōban,* from the series *Fūryū nana-Komachi yatsushi-sugata-e,* ca. late 1790s

658

Toyokuni: *Modern Komachi and the Rain,* from the same series as no. 657

659

Toyokuni: *Courtesans on Staircase. Ōban,* ca. late 1790s; from the pastiche series *Yatsushi onna-Chūshingura,* act VII

Yakusha sanjūni-sō (1 vol., 1802)
Ehon imayō-sugata (2 vols., 1802)
Tsubouchi, Shōyō. *Shibai-e to Toyokuni oyobi sono monka.* (in Japanese) Tōkyō, 1920.
Inoue, Kazuo. *Toyokuni no yakusha butai no sugata-e.* (in Japanese) Tōkyō, 1922.
● Succo, Friedrich. *Utagawa Toyokuni und seine Zeit.* Munich, 1924.
Fujikake, Shizuya. *Toyokuni ukiyo-e-shū.* (in Japanese) Tōkyō, 1926.
Kikuchi, Sadao. *Utagawa Toyokuni.* (English translation by Roy Andrew Miller) Tōkyō, 1957.

337

660
a, b

Toyokuni: *Hanshirō IV as Sakurai* (XI/1795) and *Noshio II as Umegawa* (IX/1796), from *Yakusha butai no sugata-e; ōban* prints

661

Toyokuni: *Nakazō II as Matsuō-maru. Ōban,* 1796

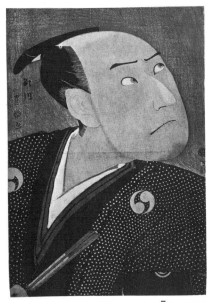

662 Toyokuni: *Sōjūrō III as Yuranosuke. Ōban,* 1796

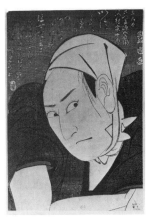

663

Toyokuni: *Sōjurō III as Gengobei. Ōban,* IX/1798

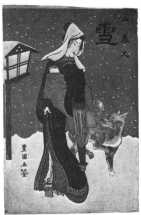

664

Toyokuni: *Harlot in Snow. Ōban,* from a series of 3 prints, ca. 1810

Hayashi, Yoshikazu. *Empon kenkyū: Toyokuni.* Tōkyō, 1964.
▷ pp. 150–52, plates 154–156

Toyokuni II (1777–1835): ukiyo-e painter, print artist and illustrator; pupil and son-in-law of Toyokuni. After the death of his master in 1828, he assumed the name Toyokuni II but, challenged in the succession by other followers of Toyokuni, changed his name to Toyoshige. From 1826 he signed his works Toyokuni or Kōsotei Toyokuni and, in later years, resumed use of the name Toyoshige.
*Utagawa, Toyoshige, Genzō, Kōsotei [Gosotei], Ichibetsusai, Ichieisai, Ichiryūsai, Kunishige, "Hongō Toyokuni"
▷ p. 189; plate 188

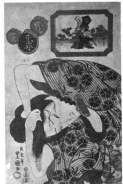

665

Toyokuni I' *Geisha at Toilette. Ōban,* ca. late 1820s (inset design by Kunihiro)

666

667

668

669

670

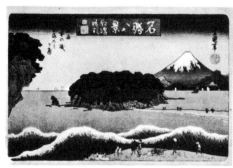

671

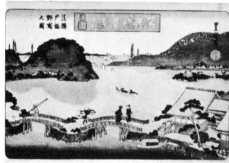

672

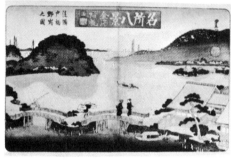

673

Toyokuni II: from *Meisho hakkei*. Ōban, early 1830s: *Atami, Tamagawa, Miho, Kamakura, Fuji, Enoshima, Kanazawa, Kanazawa* (variant state with alternate cartouche); for the eighth design see plate 188

Toyokuni (fl. 1810s–30s): ukiyo-e print artist, Kyōto School
*Hasegawa, Tōka
Toyomaro (fl. ca. 1810s–20s): ukiyo-e painter
*Kimpūsha
Toyomaru (fl. ca. 1785–97): ukiyo-e print artist, pupil of Toyoharu and later of Shunshō; also used the name Shunrō after Hokusai abandoned it about 1796
*Utagawa (Katsukawa, Katsushika)), Shunrō II, Juntei, Kusamura
Toyomasa (fl. ca. 1770s): ukiyo-e print artist, pupil and probably son of Toyonobu; influenced also by Harunobu, then by Shigemasa
*Ishikawa Toyomasa
Toyonobu (d. 1732): ukiyo-e painter and illustrator in Kyōto, after the manner of Sukenobu
*Kawaeda, Rakkatei
Toyonobu (1711–85): noted ukiyo-e painter, print artist and illustrator. Toyonobu owed as much to Masanobu as he did to his teacher Shigenaga (or Shigenobu–Toyonobu's relation to Shigenobu is discussed under that

artist). Again, in the grand impassivity of his girls there is something of the Kaigetsudō manner. Following the lead of Shigenaga, Toyonobu experimented in the depiction of the nude; such prints are almost sexless in their formalism yet are interesting as an early ukiyo-e attempt to escape from the domination of the kimono when depicting female beauty.
*Ishikawa, Magosaburō, Nuka-ya, Shichibei, Tanjōdō [Meijōdō], Shūha
Toyonobu's book illustrations include *Ehon chiyo no haru* (3 vols., 1769) and *Ehon oshiegusa* (2 vols., 1779).
▷ pp. 85–86; plates 75–77

674 Toyonobu: *Courtesan after Bath. Hashira-e urushi-e*, ca. early 1740s
675 Toyonobu: *Ichimatsu as Kōsuke and Kikunojō as O-Natsu. Large-ōban benizuri-e*, 1747

676

Toyonobu: *Actors as Itinerant Musicians. Large-ōban benizuri-e*, ca. early 1750s

Toyonobu (fl. ca. 1770s): ukiyo-e print artist, style of Toyoharu
*Utagawa Toyonobu
Toyonobu (d. 1886): ukiyo-e print artist, son of Kunihisa
*Utagawa, Kōchōrō
Toyotake-za: a leading puppet theater in Ōsaka
Toyotama-hime: the legendary Dragon Queen
triptych [*sammai-tsuzuki*]: a composition of three prints side by side
Tsu: the chief town in Ise Province; formerly called Anotsu
tsuba: a sword guard

tsubaki: the camelia
tsubo: a jar; also, the jar-shaped seal used by Shunshō and Shunkō
Tsuchi-gumo: a tribe of aborigines in Yamato
Tsuchi-gumo: a Noh drama featuring the combat between the "Ground-Spider" and Minamoto no Yorimitsu
Tsuchi-ura: a town in Hitashi
Tsugaru: a district in Mutsu; also, the present city of Hirosaki
tsuge: boxwood
tsuitate: a screen consisting of one panel on a stand
tsuji-banzuke: a theatrical street-billboard
tsuji-giri: decapitation in the street by a samurai, an activity sometimes practiced to test the quality of their swords
Tsukimaro (fl. ca. 1800s–20s): ukiyo-e painter and print artist, pupil of Utamaro; he signed his early works Kikumaro, but after 1804 Tsukimaro; turned more to painting after 1818 using the name Kansetsu.
*Kitagawa (Ogawa), Jun, Kikumaro, Shitatsu, Rokusaburō, Sensuke, Bokutei, Kansetsu[sai]

677

Tsukimaro: *Lovers at Music Lesson. Aiban*, ca. 1802 (signed with early name, Kikumaro)

678

Tsukimaro: *Two Courtesans. Ōban*, ca. 1806

Tsukimi-zuki: a poetic name for the Eighth Month
Tsukuba-san: a famous mountain range south of Hitachi; also called Tsukuba-ne; shown in the background of many landscape prints of Edo
Tsukuba-shū: the first collection of *renga* verses, dating from 1356

Tsukushi: the ancient name for Chikuzen and Chikugo Provinces; also used for the whole of Kyūshū

Tsumago: a town in Shinano, a relay station of the Naka-sendō; residence of the famous warrior Kiso Yoshimasa

居初 津奈 **Tsuna** [O-Tsuna] (fl. ca. 1690s): Kyōto ukiyo-e illustrator and calligrapher of *Onna Jitsugo-kyō* (1695) and other educational texts for women; she is possibly also identical with the Izome Tsune of *Onna Hyakunin isshu* (1688)
*Izome Tsuna

Tsuna, Watanabe no ▷ Rashōmon

Tsunayoshi, Tokugawa (1646–1709): 5th shōgun, ruled from 1680 to 1709. Though a patron of letters and science, he debased the national economy, adversely influenced by the svengalic minister Yanagisawa Yoshiyasu

Tsunemaru (fl. ca. late 1840s): ukiyo-e print artist, Ōsaka School
*Kasai

常 正 **Tsunemasa** (fl. ca. 1720s–40s): ukiyo-e painter of the Kawamata School, pupil of Tsuneyuki, also influenced by Sukenobu
*Kawamata Tsunemasa

Tsunemasa: a Noh drama concerning Taira no Tsunemasa, who met his death at the battle of Ichi-no-tani

Tsunenobu (1636–1713): noted Kanō-School painter, also did some genre work
*Kanō, Ukon, Bokusai, Kosensō, Yōboku

Tsunenobu, Minamoto no (1016–97): a *waka* poet of the late Heian Period

Tsunenobu-no-haha: a *waka* poetess of the late Heian Period

Tsunetoki (fl. ca. 1750s): ukiyo-e painter of the Kawamata School
*Kawamata Tsunetoki [Tsunetatsu]

Tsuneyori: a powerful wrestler of ancient times, usually depicted subduing a huge snake

Tsuneyori, Azuma [Tō] (1401–94): *waka* poet of the medieval period

常 行 川 又 **Tsuneyuki** (ca. 1676–ca. 1741): ukiyo-e painter of the Kawamata School, influenced by Sukenobu
*Kawamata Tsuneyuki

tsuno-kakushi: a silk headdress worn by woman of rank in the samurai and merchant classes (today worn only by brides)

Tsurayuki, Ki no (883–946): a distinguished *waka* poet and essayist, governor of Tosa

Tsurezure-gusa: a famous collection of essays composed between 1330 and 1332 by Yoshida Kenkō (1283–1350)

Tsuruga: a town in Echizen, main seaport on the western coast of Japan

Tsurugaoka Hachiman [-gu]: a famous Shintō shrine at Kamakura, dedicated to the god of war; scene of the Shōgun Sanetomo's assassination and of Act I in the *Chūshingura* ▷ *Kana-dehon Chūshingura*

Tsurukame (Gekkyū-den): a Noh drama concerning the Emperor Gen-sō (Hsuan Tsung) of the T'ang dynasty

Tsuru no sōshi: the tale of the crane who becomes human and marries her rescuer; probably 15th century

Tsūshō (1739–1812): a noted writer of *kibyōshi*

Tsutsumi chūnagon monogatari: a collection of short stories, 11th century

Tsuwano: a town in Iwami with an ancient castle

Tsuyama: a town in Mimasaka with an ancient castle

tsuya-dashi (*tsuya-zuri*): the technique of overprinting in black to give luster to special areas of a print

tsuzuki-e: a multipanel print

tsuzumi: a small drum of foxskin, struck with the hand

Tun-huang: site of Buddhist caves in China, where examples of early prints (dated 868–983) have been found

U

uchikake: a long robe, worn loosely

uchiwa: a flat, round fan

uchiwa-e: a fan print, made to be mounted as a fan

udonge: a fabulous Buddhist flower that is said to bloom but once in a thousand years; an omen of impending success

Ueda: a town in Shinano with an ancient castle

Ueno: hilly area northeast of Edo, famous for its temples; the scene of a battle in 1868, in which the shōgun's army was defeated by the adherents of the Emperor (and during which the famous Kan-eiji Temple was burned down)

Ueno: castle-town in Iga Province, the home town of the poet Bashō, and famous for a 17th-century vendetta which took place there in 1635 between Araki Mataemon and Watanabe Kazuma

Ugetsu: a Noh drama about the poet-priest Saigyō and Sumiyoshi-myōjin, the patron god of poetry

uji: a generic term for family name

Uji: a district in Yamashiro Province, famous for its tea production

Uji-bashi: a bridge near Uji, scene of many military encounters

uji-gami: the god of the hearth

Uji-gawa: a river which flows through Yamashiro; many battles were fought on its banks

Uji-Shūi monogatari: a collection of tales, early 13th century

浮絵 **uki-e** [perspective pictures]: prints or paintings imitating the European system of receding perspective; probably an innovation of Okumura Masanobu, ca. 1730
Toyama, Usaburō. *The Western-style Color Prints in Japan.* Tōkyō, 1936.
▷ pp. 78, 146, 148; plate 80

Ukifune: a Noh drama concerning the Lady Ukifune, who, when loved by two men, tried to end her unhappy life

ukiyo: the fleeting, floating world

ukiyo-e: pictures of the floating world

ukiyo-e hanga: the woodblock prints of the Ukiyo-e School

浮世絵 **Ukiyo-e School**: the school of "floating-world" artists that developed in the mid 17th century from the nebulous genre schools of the Momoyama Period; the principal subject of this book
Principal Schools of Ukiyo-e (*with name of founder*):
Hishikawa (Moronobu)
Kaigetsudō (Ando)
Torii (Kiyonobu)
Okumura (Masanobu)
Nishikawa (Sukenobu)
Miyagawa (Chōshun)
Nishimura (Shigenaga)
Kitao (Shigemasa)
Katsukawa (Shunshō)
Hosoda (Eishi)
Utagawa (Toyoharu)
Kitagawa (Utamaro)
Kikukawa (Eizan)
Katsushika (Hokusai)

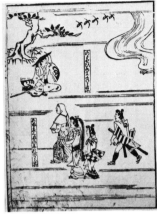

679

Early Ukiyo-e School: *Ladies Traveling*. An illustration to the novel *Bijin-kurabe* [A Comparison of Beauties]. *Obon*, 2 vols.; Kyōto/Edo, dated Manji II (1659).

The true Ukiyo-e School first became crystalized in Kyōto illustration of the 1650s, appearing in its more stylized Edo counterpart only about 1660. The present book (a reworking of the medieval tale *Fuseya-no-monogatari*) relates the story of the trials and tribulations of a downtrodden stepdaughter, shown here forlornly viewing the flight of wild geese, as a lay-nun of the nobility passes in the foreground with her entourage. Such works from Kyōto were often, as here, reprinted in Edo from recut clocks, prior to the full development of illustration in Edo itself in the following decade.

浮世草紙 **ukiyo-zōshi**: floating-world novels, popular from 1682 onward, when Saikaku began the genre

Ukiyo-zuka hiyoku-no-inazuma: a Kabuki play, commonly called *Nagoya Sanza*; written in 1824 for Danjūrō VII.

Umeharu (fl. ca. 1820s–30s): ukiyo-e print artist, Ōsaka School

梅 英 **Umehide** (fl. ca. 1870s): ukiyo-e print artist, Ōsaka School

梅 国 **Umekuni** [Mumekuni] (fl. ca. 1820s): ukiyo-e print artist, Ōsaka School, pupil of Yoshikuni
*Toyokawa, Shikitei, Jugyōdō, Kensan

Umesada (fl. ca. 1830s): ukiyo-e print artist Ōsaka School

Umewaka: a family famous for composing and performing Noh dramas (Kagehisa, Iehisa, Hironaga, *et al.*)

Ume-yashiki: a plum garden; the one near the Tenjin Shrine at Kameido was particularly renowned

Umeyuki (fl. ca. 1870s): ukiyo-e print artist, Ōsaka School
*Iwai, Umejirō

umi-bōzu: a sea-ghoul in the shape of a tortoise with human head

ummo: mica dust, applied to a print either during the process of papermaking, or by stencil or block later

Unchō (fl. late 18th century): genre painter

uneme: the female attendants at the Imperial Palace

Uneme: a Noh drama concerning a lady-in-waiting to an Emperor, who drowned herself

Unkoku School: school of artists founded by Tōgan (1547–1618); its style of painting was based on Sesshū's.

Unrin-in: a Noh drama featuring the courtiers Ashiya no Kimmitsu and Ariwara no Narihira

Unsen (fl. ca. 1870s): print artist

Unsen-ga-take: a volcano in Hizen (erupted in 1792)

Untan (1782–1852): *nanga* painter, also did some genre work
*Kaburagi, Yoshitane, Sankitsu, Shōsadō, Shōsasei

Uraga: a town in Sagami with a bureau for inspecting ships; the port where Commodore Perry landed in 1853

Urashima Tarō: a legendary hero; a fisherman transported by a sea tortoise to the submarine palace of the goddess Oto-hime, where he was detained for 200 years. Finally returning to his home village with a sealed casket containing the years of his life, he opened it out of curiosity and at once died of old age.

Uroko-gata: a Noh drama featuring Hōjō Tokimasa and the goddess Benten of Enoshima

urū: an intercalary, supplementary month of the Japanese calendar
▷ calendar, Japanese

urushi: term for lacquer

漆絵 **urushi-e:** a *beni-e* characterized by the addition of glue to the pigments, giving them a lustrous appearance; "gold dust" (generally bronze or brass) or powdered mica was sometimes also sprinkled on the wet pigments

Usa: a district and city in Buzen, site of the famous Usa Hachiman Shrine

Usa-yama: a hill in Ōmi Province, near Shiga village

ushidoki-mairi [pilgrimage at the Hour of the Ox]: a nocturnal mode of pilgrimage accompanied by incantation, to obtain revenge from the gods against a faithless lover

Ushi-no-gozen: a shrine north of Mimeguri, at Mukōjima

Usui: the eastern district of Kōzuke with a barrier station; scene of several battles

uta: a song or poem

uta-awase: a group competition to compose poems on a fixed theme

uta-garuta: a poetic matching game played with two sets of 100 poem-cards each, the most popular verses employed being the *Ogura Hyakunin isshu*

utai: the word for Noh texts

uta-bikuni [singing nun]: a type of itinerant prostitute

歌国 **Utakuni** (1777–1827): Ōsaka ukiyo-e print artist, illustrator and dramatist
*Hamamatsu, Busuke, Nuno-ya, Ujisuke, Seibei

歌麿 喜多川 **Utamaro** (1750–1806): ukiyo-e painter, print artist and illustrator, pupil of Sekien; influenced by Kyōden (Kitao Masanobu) and Kiyonaga; arrested and detained briefly in 1804 for publishing prints that violated censorship laws. Utamaro owed his greatest artistic debt to Kiyonaga, to whose graceful, lifelike women he added a strong element of eroticism and an intuitive grasp of female psychology. Harunobu and Utamaro are the great masters of ukiyo-e in the portrayal of femininity and love—but what a difference there is in their ideals!
*Kitagawa (Toriyama), Shimbi, Toyoaki [Hōshō], Yūsuke, Yūki Entaisai, Issōshurichōsai, Mokuen, Sekiyō, Murasaki-ya, Shiba-ya

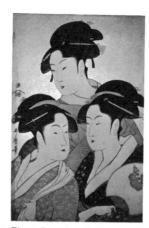

680

Utamaro: *Three Beauties (O-Hisa, O-Kita, O-Hina).* *Ōban* with mica ground, mid 1790s (later states have titles and/or girls' names added)

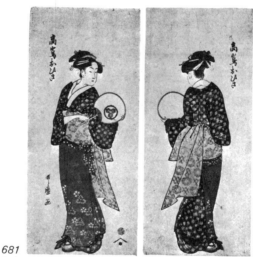

681 a, b

Utamaro: *O-Hisa, Front and Back.* *Hosoban* (printed on both sides of the paper with perfect registry), ca. mid 1790s

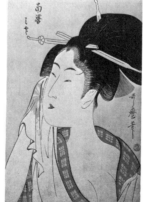

682

Utamaro: *Shinagawa Courtesan after Bath.* *Ōban,* ca. mid 1790s

683

Utamaro: *Women at Sewing.* *Ōban* triptych, ca. mid 1790s

684

Utamaro: *Above and Below the Bridge.* Six-sheet *ōban* composition, ca. mid. 1790s

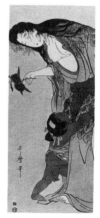

685

Utamaro: *Kintoki and Yamauba.* *Nagaban,* early 1800s

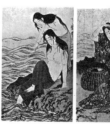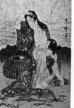

686

Utamaro: *Shell Divers.* *Ōban* triptych, ca. 1800

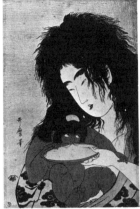

687

Utamaro: *Kintoki and Yamauba. Ōban*, ca. 1800

Print series and titled prints by Utamaro:
[The notation "mid 1800s" refers to Utamaro's œuvre of the early Bunka Period, from ca. 1804 until the posthumous publications of 1807, some of which may include the work of Utamaro II.]

1 *Fūryū hana-no-kōyū, ōban,* mid 1780s
2 *Kayoyanse yamashita-no-wata, chūban,* mid 1780s
3 *Keisei fumi-sugata, chūban,* mid 1780s
4 *Ki-no Waka-jo, chūban,* mid 1780s
5 *Seirō niwaka Kashima-odori-tsuzuki, ōban,* mid 1780s

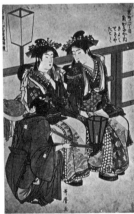

688

Utamaro: *Festive Geisha,* from the series *Seirō niwaka Kashima-odori-tsuzuki*

6 *Seirō niwaka onna-geisha bu, ōban,* mid 1780s
7 *Shiki-asobi hana-no-iroka, ōban,* mid 1780s
8 *Shinobu-ga-oka hana-no-arika, ōban,* mid 1780s
9 *Tōsei fūzoku-tsū, hosoban,* mid 1780s; also *ōban,* early 1800s
10 *Kasen: koi-no-bu, ōban,* late 1780s (plate 139)
11 *Bijin hana-awase, ōban,* late 1780s
12 *Kinki-shoga, ōban,* mid 1780s; also *ōban,* late 1780s
13 *Nangoku bijin-awase, ōban,* late 1780s
14 *Tōsei odoriko-zoroi, ōban,* late 1780s
15 *Fujin shokunin-bunrui, aiban,* early 1790s

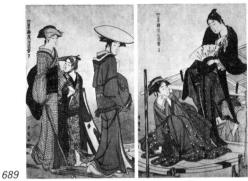

689

Utamaro: *Outing by Boat. Ōban* diptych, from the series *Shiki-asobi hana-no-iroka,* ca. mid 1780s

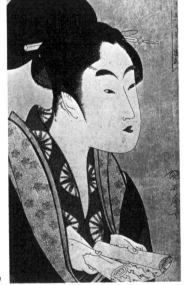

690

Utamaro: from the series *Kasen: koi-no-bu. Ōban,* late 1780s ▷ plate 139

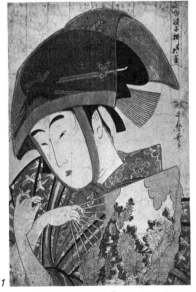

691

Utamaro: *Geisha in Dance. Oban* with mica ground, from the series *Tōsei odoriko-zoroi,* ca. late 1780s

692

693

694

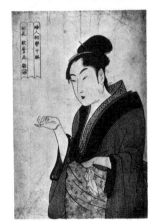

695

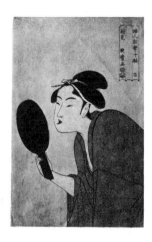

696

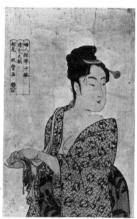

697

Utamaro: *Types of Females.* Oban prints with mica ground, from the series (nos. 16 and 17) *Fujo ninsō juppin* and *Fujin sōgaku juttai,* ca. early 1790s

16 *Fujo ninsō juppin, ōban,* early 1790s (see also plate 135)
17 *Fujin sōgaku juttai, ōban,* early 1790s; also *ōban,* early 1800s
18 *Fukurokuju senkyaku-banrai, ōban,* early 1790s
19 *Hokkoku goshiki-zumi, ōban,* early 1790s

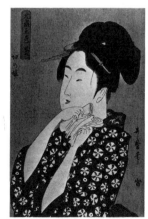

698

Utamaro: The complete 5-print series *Hokkoku goshiki-zumi*

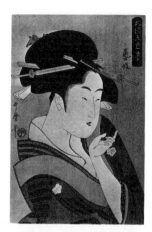

699

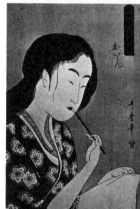

700

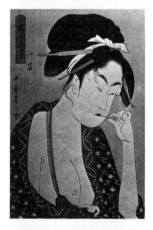

701

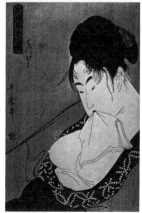

702

20 *Edo san-bijin, hosoban,* mid 1790s
21 *Enchū hassen, ōban,* mid 1790s
22 *Fujin tomari-kyaku no zu, ōban,* mid 1790s
23 *Fūryū rokkasen, ōban,* mid 1790s
24 *Fūzoku sandan-musume, ōban,* mid 1790s

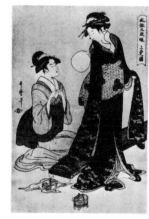

703

Utamaro: *Girls of the Upper Classes.* Ōban, from the set of 3 prints entitled *Fūzoku sandan-musume*

25 *Fūzoku ukiyo hakkei, aiban,* mid 1790s; also *ōban,* mid 1790s
26 *Kakoi san-bijin, hosoban,* mid 1790s
27 *Kinryūzan raijin-mon no zu, ōban,* 1795
28 *Kōmei bijin-rokkasen, ōban,* mid 1790s
29 *Meisho koshikake-hakkei, ōban,* mid 1790s
30 *Musume hi-dokei, ōban,* mid 1790s
31 *Mu-Tamagawa, ōban,* mid 1790s
32 *Naniwa-ya O-Kita, hosoban,* mid 1790s
33 *Ōmi hakkei* [landscapes], *ōban,* mid 1790s
34 *Seiro niwaka onna-geisha no bu* [*ni-no-kawari*], *ōban,* mid 1790s
35 *Seirō san bijin, ōban,* mid 1790s
36 *Sōshū Kamakura Shichiri-ga-hama fūkei, aiban,* mid 1790s
37 *Sugata-mi shichinin-keshō, ōban,* mid 1790s

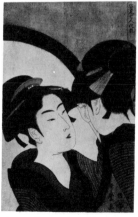

704

Utamaro: from the series *Sugata-mi shichinin-keshō.* Oban, mid 1790s

38 *Takashima O-Hisa, hosoban,* mid 1790s
39 *Tōji zensei nigao-zoroi, ōban,* mid 1790s
40 *Tomimoto Toyohina, ōban,* mid 1790s
41 *Uta-zaimon, chūban,* mid 1790s
42 *Baishoku shinajina nasake-kurabe, aiban,* late 1790s
43 *Bigan jūni-tate, ōban,* late 1790s

44 *Bijin jūyō, aiban*, late 1790s
45 *Bijin kiryō-kurabe, ōban*, late 1790s
46 *Gonin-bijin aikyō-kurabe, ōban*, late 1790s
47 *Goshiki-zumi, ōban*, late 1790s
48 *Karitaku-hakkei yūkun no zu, ōban*, late 1790s
49 *Karitaku kyōka-zuke, ōban*, late 1790s
50 *Kasumi-ori musume hinagata, ōban*, late 1790s
51 *Keisei sannin-ei, ōban*, late 1790s
52 *Kōmei bijin mitate-Chūshingura, ōban*, late 1790s
53 *Nakute nana-kuse, ōban*, late 1790s
54 *Natori-zake rokkasen, ōban*, late 1790s
55 *Nishiki-ori Utamaro-gata shin-moyō, ōban*, late 1790s

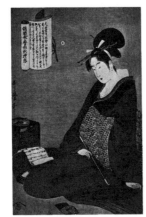

705

Utamaro: from the series *Nishiki-ori Utamaro-gata shin-moyō. Ōban*, late 1790s

56 *Seirō hana-sannin, ōban*, late 1790s
57 *Seirō jūni-toki, ōban*, late 1790s

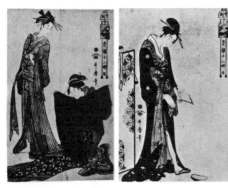

706
707

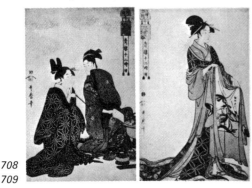

708
709

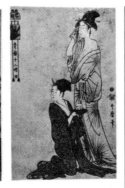

710
711

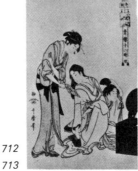

712
713

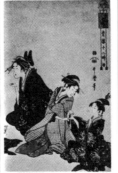

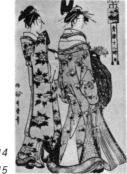

714
715

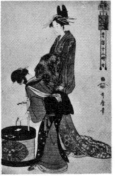

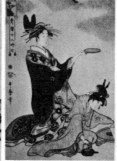

716
717

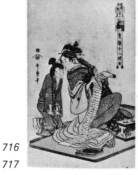

Utamaro: *Twelve Hours in the Yoshiwara. Ōban* series of 12 prints entitled *Seirō jūni-toki*, ca. late 1790s (the Japanese day was divided into 12 hours named after the signs of the zodiac, beginning with midnight, the "Hour of the Rat")

58 *Seirō nana-Komachi, ōban*, late 1790s
59 *Seirō niwaka bijin-awase, ōban*, late 1790s
60 *Seirō sambuku-tsui, ōban*, late 1790s

61 *Seirō setsugekka, ōban*, late 1790s
62 *Seirō shin-rokkasen, ōban*, late 1790s
63 *Setsugekka sambuku no uchi, ōban*, late 1790s
64 *Tōji zensei bijin-zoroi, ōban*, late 1790s

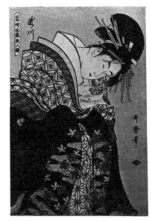

718

Utamaro: *The Courtesan Takigawa. Ōban*, from the series *Tōji zensei bijin-zoroi*, ca. late 1790s

65 *Tōsei onna fūzoku-tsū, ōban*, late 1790s
66 *Ukiyo Chūshingura, ōban*, late 1790s
67 *Azuma bijin-erami, ōban*, early 1800s
68 *Bijin gomen-sō, ōban*, early 1800s
69 *Bijin gosetsu-no-asobi, ōban*, early 1800s
70 *Bijin mensō jittai no zu, koban*, early 1800s
71 *Bijin shimada-hakkei, ōban*, early 1800s
72 *Chiwa-kagami tsuki-no-muragumo, ōban*, early 1800s
73 *Chūshingura* [three different *ōban* series: ca. 1802, ca. 1803, ca. 1804]
74 *Edo hakkei, ōban*, early 1800s
75 *Edo-meibutsu nishiki-e kōsaku, ōban*, early 1800s
76 *Edo-no-sono hana-awase, ōban*, early 1800s
77 *E-kyōdai, ōban*, early 1800s
78 *Fujin sōgaku jittai, ōban*, early 1800s
79 *Fujin tewaza jūni-kō, ōban*, early 1800s
80 *Fujin tewaza misao-kagami, ōban*, early 1800s
81 *Fūryū aikyō-kurabe, aiban*, early 1800s
82 *Fūryū goshiki-no-hana, ōban*, early 1800s
83 *Fūryū goyō-no-matsu, ōban*, early 1800s
84 *Fūryū kodakara-awase, ōban*, early 1800s
85 *Fūryū shiki-no-asobi, ōban*, early 1800s
86 *Futaba-gusa nana-Komachi, ōban*, mid 1800s
87 *Fūzoku bijin-tokei, ōban*, early 1800s
88 *Gosetsu no hana-awase, ōban*, early 1800s
89 *Hana-awase keshō-kurabe, ōban*, early 1800s
90 *Jimono rokkasen, ōban*, early 1800s
91 *Jitsu-kurabe iro-no-minakami, ōban*, early 1800s
92 *Jōruri nadai-shū, nagaban*, early 1800s
93 *Joshoku kaiko tewaza-gusa, ōban*, early 1800s
94 *Keichū no yosooi, ōban, early 1800s*
94 *Keichū no yosooi, ōban*, early 1800s
95 *Kodomo-asobi niwaka, ōban*, early 1800s
96 *Kodomo-asobi sanjū-rokkasen, ōban*, early 1800s
97 *Kokei no sanshō, ōban*, early 1800s
98 *Kyōkun oya-no-megane, ōban*, early 1800s

99 *Matsuba-ya Yoyoharu, Yosooi, Hatsu-fune,* ōban, early 1800s
100 *Meigetsu usu no kage-hoshi,* ōban, early 1800s
101 *Meikun no yosooi,* ōban, early 1800s
102 *Miru-ga-toku eiga-no-issui,* ōban, early 1800s
103 *Musha-e-gata kodomo-asobi,* ōban, early 1800s
104 *Ōmi hakkei* [figures], ōban, early 1800s
105 *Ongyoku koi-no-ayatsuri,* ōban, early 1800s
106 *Ongyoku hiyoku-no-bangumi,* ōban, early 1800s
107 *Osana-geisha odori-no-hatsukai,* aiban, early 1800s
108 *Ōtsu miyage,* ōban, early 1800s
109 *Ryūkō-moyō Utamaro-gata,* ōban, early 1800s
110 *Sankanotsu bijin fūzoku-kurabe,* ōban, early 1800s
111 *Sakiwake kotoba-no-hana,* ōban, early 1800s
112 *Seirō jūbi no zu,* chūban, early 1800s
113 *Seirō kabuki yatsushi-e-zukushi,* ōban, early 1800s
114 *Seirō kinki-shoga,* ōban, early 1800s
115 *Seirō-niwaka egao-kurabe,* ōban, early 1800s
116 *Seirō-niwaka ni-no-kawari,* ōban, early 1800s; *hosoban,* early 1800s
117 *Seirō-niwaka zensei-asobi,* ōban, early 1800s; also *aiban* mid 1800s
118 *Seirō rokkasen,* ōban, early 1800s
119 *Seirō tedori-hakkei,* ōban, early 1800s
120 *Seirō yūkun awase-kagami,* ōban, early 1800s
121 *Shichi-go-san kodakara-awase,* ōban, early 1800s
122 *Shinjū hana no iro-awase,* ōban, early 1800s
123 *Tarō-zuki mitsugumi-sakazuki,* ōban, early 1800s
124 *Tōji yūkun shō-utsushi,* ōban, early 1800s
125 *Tōryū fūzoku-tsū,* ōban, early 1800s
120 *Tōsei bijin sanyū,* nagaban, early 1800s
127 *Tōsei goshiki-zome,* aiban, early 1800s
128 *Tōsei jūni-tsuki,* kōban, early 1800s
129 *Tōsei kōbutsu hakkei,* ōban, early 1800s
130 *Tōsei koi-ka hakkei,* ōban, early 1800s
131 *Tōsei musume-jōruri,* ōban, early 1800s
132 *Tsurugaoka-Wakamiya ni okeru Shizuka,* ōban, early 1800s
133 *Uimago no aisuru zu,* ōban, early 1800s
134 *Ukiyo nanatsu-me-awase,* ōban, early 1800s
135 *Ukiyo san-seki,* nagaban, early 1800s
136 *Utsushi-jōzu hon-e no sugata-mi,* ōban, early 1800s
137 *Waka sanjin,* ōban, early 1800s
138 *Yoshiwara zashiki-hakkei,* chūban, early 1800s
139 *Yūkun kagami-hakkei,* ōban, early 1800s
140 *Zubu-roku no shichi-henjin,* ōban, early 1800s
141 *Fūryū nana-Komachi,* ōban, early 1800s; ōban triptych, mid 1800s
142 *Ayatsuri-moyō take-no-hitofushi,* ōban, 1804
143 *Taikō-gosai rakutō-yūkan no zu,* ōban, 1804
144 *Yūkun gosetsu ikebana-e,* ōban, 1804
145 *Ai-bore iro-no-gosekku,* aiban, mid 1800s
146 *Yūkun natori-awase,* ōban, mid 1800s
147 *Bijin-ichidai gojūsan-tsugi,* ōban, mid 1800s
148 *Bijin jūni-so,* ōban, mid 1800s

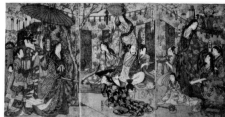

719

Utamaro: from the series *Taikō-gosai rakutō-yūkan no zu* (no. 143). Ōban triptych, 1804

149 *Chūshingura misao-kurabe,* ōban, mid 1800s
150 *Chūshingura osana-asobi,* aiban, mid 1800s
151 *Edo mu-Tamagawa,* ōban, mid 1800s
152 *Edo-no-hana musume-jōruri,* ōban, mid 1800s
153 *Fukujin ehō-asobi,* ōban, mid 1800s
154 *Fukutoku mutsumashi-zuki,* two different works, ōban, mid 1800s; ōban, mid 1800s
155 *Yūkun shiki-no-ippei,* ōban, mid 1800s
156 *Fūryū mu-lamagawa,* ōban, mid 1800s
157 *Fūzoku sannin-ei,* ōban, mid 1800s
158 *Go-sekku,* ōban, mid 1800s
159 *Goshiki-zome rokkasen,* aiban, mid 1800s
160 *Hako-iri ichidai-kagami,* koban, mid 1800s
161 *Ikebana hyakuhei no zu,* hosoban, mid 1800s
162 *Jūni-kō,* ōban, mid 1800s
163 *Jūni-tsuki shikishi-waka,* ōban, mid 1800s
164 *Kachō-fūgetsu,* ōban, mid 1800s
165 *Kayoi kuruwa-zakari hakkei,* ōban, mid 1800s
166 *Keisei jūni-sō,* koban, mid 1800s
167 *Kinkai nanatsu-musume shika,* nagaban, mid 1800s
168 *Kintarō sannin-kyōdai,* ōban, mid 1800s
169 *Kodakara tatoe-no-fushi,* ōban, mid 1800s
170 *Kyōdai mutsumashiki zu,* ōban, mid 1800s
171 *Matsubarō san-bijin harimise,* ōban, mid 1800s
172 *Meisho fūkei/bijin jūni-sō,* ōban, mid 1800s
173 *Mitōshi mitate-jōzu,* ōban, mid 1800s
174 *Natsu-ishō tōsei-bijin,* ōban, mid 1800s
175 *Nazorae-hakkei,* ōban, mid 1800s
176 *Ogura jūni-shikishi,* koban, mid 1800s
177 *Seirō-bijin meika-awase,* ōban, mid 1800s
178 *Seirō-niwaka zu,* hosoban, mid 1800s
179 *Shingata goshiki-zome,* ōban, mid 1800s
180 *Shunkyō shichi-fuku-asobi,* ōban, mid 1800s
181 *Shunkyō mitate kitsune-ken,* ōban, mid 1800s
182 *Tenarai-kagami,* ōban, mid 1800s
183 *Tenkachi-bijin ikebana-awase,* ōban, mid 1800s
184 *Tōfū shichifuku bijin,* ōban, mid 1800s
185 *Tōsei-fūzoku hakkei,* ōban, mid 1800s
186 *Tōsei kodomo-rokkasen,* ōban, mid 1800s
187 *Tōsei komochi-hakkei,* aiban, mid 1800s
188 *Tōsei ko-sodate-gusa,* ōban, mid 1800s
189 *Tōsei shusse-musume,* ōban, mid 1800s
190 *Ukiyo hakkei, hashira-e,* mid 1800s
191 *Ukiyo shichi-fukujin,* koban, mid 1800s
192 *Yaoya O-Shichi koshō Kichisaburō,* ōban, mid 1800s
193 *Yoshiwara-tokei,* koban, mid 1800s
194 *Yūkun geisha hana-awase,* ōban, mid 1800s
195 *Yūkun go-sekku,* ōban, mid 1800s
196 *Yūkun nana-Komachi,* ōban, mid 1800s

197 *Fūryū kodakara-bune,* ōban, 1805
198 *Fūzoku mitate-goshō,* oban, 1805
199 *Bijin aki-no-nanagusa,* ōban, 1806
200 *Fūryū zashiki-hakkei,* aiban, 1806 [published two months before Utamaro's death and possibly his last work]

Books illustrated by Utamaro:
1 *Shijūhatte koi no sho-wake,* 1775
2 *Asahina no tsurane,* 1778
3 *Ōtsu-e sugata no hana,* 1778
4 *Kayoikeri neko no wazakure,* 1778
5 *Daikagura no tsurane,* 1779
6 *Miyako kembutsu-zaemon,* 1779
7 *Susu-harai,* 1779
8 *Kojitsu ima-monogatari,* 1779
9 *Oki-miyage,* 1779
10 *Ōmi hakkei,* 1780
11 *Yobuko-dori,* 1780
12 *Miyako daitsūjin yatsushi-engi,* 1781
13 *Bakemono nise monogatari,* 1781
14 *Takao zange-no-dan,* 1782
15 *Uso shikkari gantori-chō,* 1783
16 *San-kyō-shiki,* 1783
17 *Keisei tekuda no chie-kagami,* 1783
18 *Saitan-jō,* 1783
19 *Kiyū-gaki-zōshi,* 1784
20 *Sorekara irai-ki,* 1784
21 *Nitta tsūsen-ki,* 1784
22 *Hito-shirazu omoi-somei,* 1784
23 *Michiyuki nobe no kakioki,* 1784
24 *Haru no yo shōji no ume,* 1784
25 *Tokoyo-gusa,* 1784
26 *Neya no shiori,* ca. 1784
27 *Tako-nyūdō Tsukuda-oki,* 1785
28 *Edo murasaki,* 1785
29 *Edo suzume,* 1786
30 *Waka-ebisu,* 1786
31 *Goshiki-zumi,* 1786
32 *Ada-gokoro nio no uki-su,* ca. 1786
33 *Chō-ja no mama-kuō,* 1787
34 *Chiri nokoru hana no kaotori,* 1787
35 *Omokage katori no kinu,* 1787
36 *Fujin yabu-kagami,* ca. 1787
37 *Kotoba no hana,* 1787
38 *Hana no kumo,* ca. 1787
39 *Bakusei-shi,* 1787
40 *Kyōgen sue-hiro no sakae,* 1788
41 *Soga nuka-bukuro,* 1788
42 *Hyaku-fuku monogatari,* 1788
43 *Taware-banashi mutsumi-tsūki,* ca. 1788
44 *Mushi-erami,* 1788

蟲撰

720

Utamaro: Plate from *Mushi-erami,* ōbon album, 1788

歌満くら

45 *Uta-makura,* 1788
46 *Shiohi-gata,* ca. 1788
47 *Yuki-onna sato no hassaku,* 1788
48 *Aa kikira kinkei,* 1789

49 *Kafuri-kotoba nanatsu-me no e-toki,* 1789
50 *Ade-sugata kakine no yuki,* 1789
51 *Chikaiteshi iro to yū nazo,* 1789
52 *Hana no iroka itazura-musume,* 1789
53 *Ro-biraki hanashi no kuchikiri,* 1789
54 *Tatoe no fushi,* 1789
55 *Shiohi no tsuto,* ca. 1789
56 *Kyō-getsu-bō,* 1789
57 *Yūchōrō nagaiki-banashi* 1790
58 *Chū-kō asobi-shigoto,* 1790
59 *Tama-migaku Aoto ga zeni,* 1790
60 *Gin-sekai,* 1790
61 *Azuma-asobi,* 1790
62 *Suruga-mai,* 1790
63 *Fugen-zō,* 1790
64 *Momo-chidori,* ca. 1790
65 *Fuyu amigasa sato no suisen,* 1795
66 *Haru no iro,* 1794
67 *Ikkō futsū kawarisen,* 1794
68 *Edo murasaki,* 1795
69 *Momo-saezuri,* 1795
70 *Seiten tōka-shū,* 1796
71 *Taoyame-sugata,* 1797
72 *Mime-katachi,* 1797
73 *Tatsumi Fugen,* 1798
74 *Keisei jitsu no maki,* ca. 1798
75 *Otoko-dōka,* 1798
76 *Iro no chigusa,* 1798
77 *Yakusha gakuya-tsū,* 1799
78 *Negai no itoguchi,* 1799

ねがひの糸ぐち

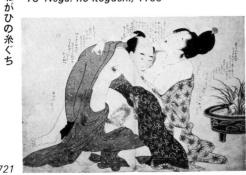

721

Utamaro: *Lovers in Summer. Ōban* plate from the shunga album *Negai no itoguchi,* 1799

79 *Kōshoku jūni-tai,* ca. 1799
80 *Enjo itazura-zōshi (Ehon ne-midare gami),* ca. 1799
81 *Byōbu no iro-e,* 1800
82 *Takara-kura,* 1800
83 *Hitachi-obi (Futa-bashira),* 1800
84 *Kara-nishiki,* ca. 1800
85 *Koi no odamaki,* ca. 1800
86 *Iro-sugata,* ca. 1800
87 *Tsukuma-nabe,* ca. 1800
88 *Yamato-fumi,* ca. 1800
89 *Masu-kagami,* ca. 1800
90 *Shiki no hana,* 1801
91 *On-atsurae-zome chōju no komon,* 1802
92 *Mimi-gakumon,* 1802
93 *Akureba hana no haru to keshitari,* 1802
94 *Komachi-biki,* 1802
95 *Toko no ume,* 1802
96 *Hana fubuki,* 1802
97 *Kiku no tsuyu,* 1802
98 *Warai-jōgo,* ca. 1802
99 *Mitsu no hana,* ca. 1802
100 *Nenjū-gyōji,* 1804
101 *Koi no ōgi,* 1804
102 *Koi no futosao (Shunshōku jūni-chōshi),* ca. 1804

Goncourt, Edmond de. *Outamaro: Le Peintre des Maisons Vertes.* Paris, 1891.
Kurth, Julius. *Utamaro.* Leipzig, 1907.
Noguchi, Yone. *Utamaro.* London, 1925.
●Yoshida, Teruji. *Utamaro zenshū.* (in Japanese) Tōkyō, 1942.
Anon. *Utamaro.* (in Japanese) Tōkyō, 1953.
Hàjek, Lubor. *Utamaro: Portraits in the Japanese Woodcut.* London, n.d. [Original edition in German: *Utamaro. Das Portrait im Japanischen Holzschnitt.* Prague, 1957.]
Kondō, Ichitarō. *Kitagawa Utamaro.* (English adaptation by Charles S. Terry). Tōkyō, 1956.
● Hillier, J. *Utamaro: Color Prints and Paintings.* London, 1961.
Shibui, Kiyoshi. *Utamaro.* New York, 1962.
●Hayashi, Yoshikazu. *Empon kenkyū: Utamaro/zoku Utamaro.* (in Japanese) 2 vols., Tōkyō, 1962–63.
●Shibui, Kiyoshi. *Ukiyo-e zuten: Volume 13 – Utamaro.* (in Japanese with some English) Tōkyō, 1964.
Suzuki, Jūzō. "An Analytical Study of Utamaro's Illustrated Books." (in Japanese) In *Ukiyo-e Art,* No. 7 (Tōkyō, 1964): 11–26.
Anon. *Utamaro Shunga.* Munich, 1966.
Hanfstaengl, Franz. *Kitagawa Utamaro – Erotische Holzschnitte.* Munich, n.d. [ca. 1970].
Faglioli, M. *Utamaro: Koi no hutozao.* Florence, 1977.
Hillier J. *Utamaro, Estampes et livres illustrés.* Paris, 1977.
▷ pp. 135–41; plates 138–141.

Utamaro II (d. ca. 1831): ukiyo-e print artist; pupil first of the popular author/illustrator Koikawa Harumachi, after his death adopting the name Koikawa Harumachi II. Said to have married the widow of his second mentor, Utamaro, thenceforth calling himself Utamaro II.
*Kitagawa (Ogawa, Koikawa), Ichitarō, Baigadō, Riteitei Yukimachi

722

Utamaro II: *Courtesans at Toilette. Oban,* ca. 1808

Utayoshi (fl. ca. early 1830s): ukiyo-e print artist and *kyoka* poet, Ōsaka School
*Ukiyo
Utō: a Noh drama featuring an old hunter suffering the agonies of Hell for taking life
Utsubo monogatari: an early tale, ca. 970–983
Utsu-no-miya: the chief town in the Province of Shimotsuke, with an ancient castle
Uwajima: a town in Iyo with an ancient castle
Uzuki: a poetic name for the Fourth Month
Uzumasa: a western district of Kyōto
Uzume: the goddess of mirth and carnal love, usually depicted with puffed-out cheeks and a smiling face; also called O-Kame and O-Tafuku

V

Valegnani, Alexander (1537–1606): a Visitor of the Society of Jesus; lived in Japan 1577–82, 1590–92, 1598–1601; established colleges, churches, hospitals, seminaries and a printing plant

W

waka: a Japanese lyric poem composed of 31 syllables
Wakakusa monogatari: a romance, probably 15th century
Wakamatsu: the chief town of the Aizu district, in Iwashiro Province
wakame-gari: a ritual gathering of seaweed at the temple of Hayato Momyōji in Nagato
wakamizu: the first well-water drawn at the New Year
Wakan rōei-shū: a collection of Chinese and Japanese *rōei* (verses), compiled in 1013
waka-onnagata: an actor who specialized in roles of girls and young women
若衆 **wakashu:** a young samurai man; also, a young Kabuki actor (and sometimes a catamite)
wakashu kabuki: young men's Kabuki, popular from 1629 until it was banned in 1652
▷ pp. 27–29
Wakayama: the main city of Kii Province
waki: the role of a foil in a play
和翁 **Waō** (fl. ca. 1690s): noted ukiyo-e painter of the Moronobu School
*Hishikawa (Kuwahara), Hōyōken, Sōshi-shikun
Lane, Richard. *Studies in Ukiyo-e.*
warai-e: another term for shunga
waraji: a type of straw sandals worn by travelers
washi: Japanese handmade paper
Wasobyōe: the hero of a Japanese romance, rather similar to the story of *Gulliver's Travels*
和藤内 **Watōnai** (1624–1662): Kokusenya [Coxinga] or Chêng Chêng-kung, a Chinese-Japanese patriot, often shown in ukiyo-e subduing a tiger in a bamboo grove
▷ Kokusenya-kassen
Western art, influence of ukiyo-e on:
Sullivan, Michael. *The Meeting of Eastern and Western Art.* London, 1973.
Ives, C. F. *The Great Wave.* New York, 1975.
Whitford, Frank. *Japanese Prints and Western Painters.* London, 1977.
▷ pp. 146–48; figs. 326 b, c

Y

–ya: a suffix meaning house or shop
Yachō (1782–1825): Shijō-School painter, also did some genre work
*Yano, Masatoshi, Chūkan, Mozume

yae-zakura: the double-petaled cherry blossom

yagō: an actor's nickname

Yaguchi: a village on the bank of the Rokugō River

yagura: a tower, such as those seen at the entrance to Kabuki theaters

yagura-tokei: a tower-shaped clock modeled on European designs

Yagyū: a town in Yamato, residence of the Yagyū *daimyō*

Yahagi-gawa: a river in Mikawa (57 miles/ 92 km. long)

Yaizu: a seaport in Suruga

Yakamochi, Ōtomo no (716–ca. 785): an important *waka* poet of the *Man-yō-shū*

Yakamori, Nakatomi no (mid 8th century): a *waka* poet of the Nara Period

焼絵 **yaki-e:** a pyrograph, drawn with a hot iron on thick *danshi* paper

奴 **yakko:** a manservant to a samurai

Yakko-no-Koman: a semi-legendary amazon who devoted her life to chivalrous deeds

役者絵 **yakusha-e:** an actor print

yakusha hyōbanki: an actor critique, a booklet rating the current actors

yamabuki: the yellow rose

yamabushi: ascetic holy men who lived in the mountains

Yamada (Uji-Yamada): a town in Ise Province, famous for its Shintō shrines

Yamagata: the chief city in Uzen Province; formerly called Mogami

Yamaguchi: the chief city in Suō Province (where, in 1551, Saint Francis Xavier preached for two months)

Yamamoto, Kanae (1882–1946): Western-style painter and print artist; he was trained early as a woodblock engraver in the Western style, later graduated from the Tōkyō Art School and studied for several years in Paris. A founder-member of the Nihon Sōsaku-hanga Kyōkai [Japan Creative Print Association], for which he arranged the first exhibition in 1919.

723

Yamamoto Kanae: *Woman of Brittany. Oban,* 1920

Yamashina: a village east of Kyōto

大和絵 **Yamato-e:** the traditional style of Japanese painting developed in the Heian Period, featuring purely native subjects and style; precursor of the Tosa and Ukiyo-e Schools

Yamato Takeru-no-mikoto: a *waka* poet and legendary hero of ancient times, son of Emperor Keikō

Yamato-toji (*Wa-toji*): traditional Japanese-style binding for books

Yama-uba: a Noh drama featuring Yama-uba, "the Old Woman of the Hills"

Yamazaki: a village in the south of Yamashiro Province

yama-zakura: the wild cherry tree, the material used to make woodblocks for printing

Yanagawa: a town in Chikugo with an ancient castle

Ya-no-ne: a Kabuki play, one of the *Jūhachiban*, first staged by Danjūrō II in 1729; it features Soga Gorō

Yao: a town in Kawachi with an ancient castle

Yari-ga-take: a mountain on the borders of Hida, Shinano and Etchū Provinces

yarite: a female superintendent in a brothel or house of assignation

野郎 **yarō:** derogatory term for a male or a fellow

yashiki: a mansion

Yashima: a village in Sanuki, the site of a famous battle

Yashima: a Noh drama featuring Minamoto no Yoshitsune at the Battle of Yashima

安治 **Yasuji** (1864–89): the ukiyo-e print artist Yasuji was a pupil of Kiyochika and before his death (at the age of 25) gave promise of sufficient genius perhaps to have effected a minor revival of the ukiyo-e style; his works are usually printed with care and display a restrained taste in coloring rare for this period.

探景 *Inoue, Yasuji [Yasuharu], Yasujirō, Tankei (after 1884)

Kondō, Ichitarō. *Kiyochika to Yasuji* (in Japanese) Tōkyō, 1944

724

Yasuji: *Yoshiwara at Night. Oban,* 1880

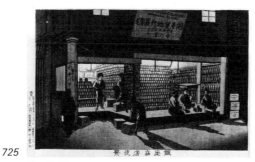

725

Yasuji: *Shop on the Ginza. Oban,* 1882

Yasuichi (fl. Taishō Period): *dōban* artist, pupil of Kyokuzan
*Noguchi Yasuichi

Yasukazu (fl. ca. late 1820s): ukiyo-e print artist, Kyōto School, pupil of Yasuyuki

Yasukiyo (fl. ca. 1820s): ukiyo-e print artist, pupil of Kuniyasu
*Utagawa Yasukiyo

保国 **Yasukuni** (1717–92): Kanō-School painter and illustrator in Ōsaka; *hokkyō*, son and pupil of Morikuni; did some genre work
*Tachibana, Daisuke, Kōso
Illustrated books by Yasukuni include *Ehon noyama-gusa* (5 vols., 1755) and *Ehon eibutsu-sen* (5 vols., 1779)

Yasumaro, Ō no (d. 723): a *waka* poet and compiler of the *Kojiki*

Yasumasa (fl. ca. mid 18th century): ukiyo-e painter in the late Kawamata style
*Hasegawa Yasumasa [Ansei]

Yasuna, Abe no: the father of Abe no Seimei; often shown with Kuzunoha, a white fox in the shape of a beautiful woman

Yasushige (fl. ca. 1820s): ukiyo-e print artist, pupil of Kuniyasu
*Utagawa Yasushige

保之 **Yasuyuki** (fl. ca. 1820s–30s): ukiyo-e print artist and illustrator, Ōsaka School
*Morikawa Yasuyuki

Yatarō (mid 19th century): *dōban* artist, son of Gengendō
*Matsumoto Yatarō

Yatsu-ga-take: a group of mountains on the borders of Kai and Shinano Provinces

yatsugiri: a small print format, about 3¾×5 in./ 9.5×12.7 cm

八つ橋 **yatsuhashi:** a type of plank bridge built in 8 parts

Yatsuhashi-kengyō: a *koto* artist of the 17th century

Yayoi: a poetic name for the Third Month

Yayū, Yokoi (1702–83): a *haiku* poet of the mid Edo Period

year-cycles ▷ calendar, Japanese

Yōan (mid 19th century): *dōban* artist
*Utagawa Yōan

Yōbutsu-kurabe [The Phallic Contest]: the earliest known shunga scroll; *Yamato-e* style, probably 11th century

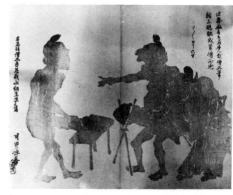

Yōbutsu-kurabe. Plate from *Kagetsu-jō* (1836), an album of woodblock-printed plates copied by leading neo-classical artists (this example, by Kanō Naganobu) after an original, now lost, of the 12th century

Yodo: a town in Yamashiro, the site of an ancient castle with renowned waterwheel

淀川 **Yodo-gawa:** a river that passes through Ōsaka (48 miles/78 km. long)

Yodo-gimi: the wife of Shōgun Hideyoshi and mother of Hideyori; she perished during the Battle of Ōsaka Castle

Yodo-ya Tatsugorō: a famous millionnaire merchant of the Edo Period

洋画 **yōga:** early term for Japanese painting in foreign-style, influenced by Western art or by illustrated books imported from Europe. ▷ Kōkan

Kuroda, Genji. *Nagasaki-kei yōga.* (in Japanese) Tōkyō, 1932.
Lane, Richard. *Studies in Ukiyo-e.*

yogi: a kimono-shaped bed covering

Yoichi, Nasu no: a famous Heike archer (see plate 74)

Yoi-gōshin: a Kabuki play, the tragic tale of O-Chiyo and her husband Hambei, first written for the puppet theater by Chikamatsu in 1722

楊貴妃 **Yō-kihi**: a Noh drama featuring the Emperor Gen-sō (Hsuan Tsung) of the T'ang dynasty and his beloved concubine Yō-kihi (Yang Kuei-fei)

yokoban [*yoko-e*]: the term for horizontal print formats

yokobon: a small, horizontal book size, ca. 4¼×6¾ in./11×17 cm.

Yokohama: a port near Edo, opened to foreigners in 1859

横浜絵 **Yokohama-e** [Yokohama Prints]: the branch of late ukiyo-e prints devoted to depicting foreigners at the port of Yokohama from the year after its opening in 1859 until the early 1880s. The Golden Age of the *Yokohama-e* was 1880–61, when Japanese curiosity about the strangers from abroad was at its peak, and several hundred different prints were issued. The artists were generally members of the then dominant Utagawa School.
*Tamba, Tsuneo. *Reflection of the Cultures of Yokohama in Days of the Port Opening.* (in Japanese) Catalogue of *Yokohama-e* in the Tamba Collection. Tōkyō, 1962.
▷ p. 196

横長判 **yoko-nagaban**: a print size, ca. 22¾×7¾ in./58×20 cm; frequent in *surimono*

Yokosuka: a port in Sagami Province, where Will Adams lived from 1600 to 1620

謡曲 **yokyoku**: Noh-drama texts

読本 **yomi-hon**: illustrated novels which flourished from the mid 18th century onward, usually relating the deeds of famous warriors; they were influenced by historical works and Chinese classics, with moral overtones

yomi-uri: broadsheets or news bulletins, sold on the streets

Yonoko, Udono (1729–88): *waka* poetess of Kii Province

Yoriie, Minamoto no (1182–1204): 2nd Kamakura shōgun, eldest son of Yoritomo; later, confined at Shūzenji and assassinated there

yoriki-dōshin: a minor Tokugawa official

Yorimasa: a Noh drama featuring Minamoto no Yorimasa, who was defeated in battle at Uji

Yorimasa, Minamoto no (Gen san-i-nyūdō) (1106–80): a *waka* poet and famous warrior; in 1153 he killed, with an arrow, the *nue* monster flying over the Imperial Palace; committed *harakiri* after defeat in the Battle of Uji

Yoritomo, Minamoto no (1147–99): 1st Kamakura shōgun; was first defeated at Ishibashi-yama, but rallied and routed the Heike clan at the battles of Kyōto, Ichi-no-tani, Yashima and Dan-no-ura

養老 **Yōrō**: a Noh drama featuring an old woodcutter and his son at a waterfall called Yōrō [care of the aged]

Yoro-bōshi: a Noh drama featuring Takayasu no Michitoshi and his son Shuntoku-maru

Yorukuni (fl. late ca. 1820s): ukiyo-e print artist, Ōsaka School

Yōsai (1788–1878): genre painter, son of a minor official; he was first the pupil of a Kanō painter but soon evolved his own eclectic style.

His *Zenken kojitsu* (20 vols., 1836–68) contains his collected drawings of figures from Japanese history.
*Kikuchi, (Kawabara), Takeyasu, Ryōhei

Yōsen-in (1753–1808): Kanō-School painter; first teacher of Hokkei
*Kanō, Korenobu, Eijirō, Genshisai, Yōsen

Yoshida: a town in Mikawa with an ancient castle; now called Toyohashi

芳藤 **Yoshifuji** (1828–87): ukiyo-e print artist, pupil of Kuniyoshi
*Utagawa (Nishimura), Tōtarō, Ippōsai

芳房 **Yoshifusa** (fl. ca. 1840s–50s): ukiyo-e print artist, pupil of Kuniyoshi
*Utagawa, Daijirō, Ippōsai

Yoshiharu (fl. ca. late 17th century): ukiyo-e painter
*Nanjō Yoshiharu

芳春 **Yoshiharu** (1828–88): ukiyo-e print artist and illustrator, pupil of Kuniyoshi
*Utagawa (Kida), Ikusaburō, Chōkarō, Ichibaisai, Ippōsai

芳秀 **Yoshihide** (1832–1902): ukiyo-e print artist, pupil of Kunisada
*Utagawa, Ikkyōsai, Sanjuen, Sessō, Shiidō

芳広 **Yoshihiro** (fl. ca. 1860s): ukiyo-e print artist, Ōsaka School

Yoshiie, Minamoto (1041–1108): a renowned hero of the Middle Ages, also called Hachiman Tarō

芳幾 **Yoshiiku** (1833–1904): ukiyo-e print artist and illustrator; son of a teahouse proprietor in the Yoshiwara, he became a pupil of Kuniyoshi; after the Meiji Restoration, popular as a newspaper illustrator.
*Utagawa (Ochiai), Ikujirō, Chōkarō, Ikkeisai, Keiami, Keisai, Sairakusai

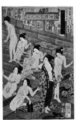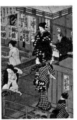
727
Yoshiiku: *Women's Bathhouse. Ōban* triptych, 1868

Yoshikage (fl. ca. 1870s): ukiyo-e print artist, Ōsaka School
*Gotō, Tokujirō, Hōsai

芳景 **Yoshikage** (d. 1892): ukiyo-e print artist, pupil of Kuniyoshi
*Utagawa (Saitō), Kamekichi

Yoshikage (1894–1922): neo-ukiyo-e print artist of Ōsaka; follower of Yoshitaki, but worked for a time in Tōkyō
*Gotō, Seijirō, Hōsai

芳形 **Yoshikata** (fl. ca. 1840s–60s): ukiyo-e print artist, pupil of Kuniyoshi
*Utagawa (Ōtomo) Yoshikata

芳勝 **Yoshikatsu** (fl. ca. 1840s–50s): ukiyo-e print artist, pupil of Kuniyoshi
*Utagawa (Ishiwatari), Shōsuke (Yūsuke), Isseisai, Isshūsai

Yoshikawa (fl. ca. 1730s): ukiyo-e print artist, follower of Masanobu
*Yoshikawa, Shōgindo

芳員 **Yoshikazu** (fl. ca. 1850s–60s): ukiyo-e print artist, pupil of Kuniyoshi
*Utagawa, Jirobei, Jirokichi, Ichijusai, Issen, Isshunsai

728
Yoshikazu: *Foreign Mélange. Ōban,* from the series *Yokohama Kembutsu-zue,* dated 1860

善清 **Yoshikiyo** (fl. ca. 1702–16): this Kyōto artist brought the flamboyant Edo style of Kiyonobu to Kamigata ukiyo-e, in such works as *Shidare-yanagi* (1702) and a dozen other albums, illustrated novels and guidebooks of the early 18th century. His work offers a welcome relief from the stereotyped illustrations of Hambei's followers, but the quality of Yoshikiyo's designs is uneven, and he failed to develop a lasting style or school.
*Ōmori Yoshikiyo
Mizutani, Yumihiko. *Kohan shōsetsu sōga-shi.*
Lane, Richard. *Studies in Ukiyo-e.*
▷ p. 55; plate 40

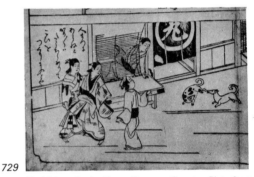
729
Yoshikiyo: *In the Kyōto Pleasure Quarter.* Plate from *Karaku saiken-zu,* Kyōto. *Ōbon orihon,* 1704

Yoshikoto (fl. ca. 1850s): ukiyo-e print artist, Ōsaka School
*Ittōsai

芳国 **Yoshikuni** (fl. ca. 1803–40): Ōsaka ukiyo-e print artist, pupil of Ashikuni and follower of Utamaro
*Toyokawa (Takagi/Kō), Ashimaro [Yoshimaro]/Ashimaru, Jukōdō, Yoshikuni, Kōjōdō

Yoshikuni (1855–1903): Kyōto ukiyo-e print artist, pupil of Yoshiume but influenced by Sadanobu
*Nomura, Yoshiichi, Ichiyōtei, Shōō

Yoshimaro (fl. ca. 1807–46): ukiyo-e print artist, pupil of Tsukimaro and of Utamaro; after Utamaro's death he studied under Masayoshi, employing the names Kitao Masayoshi II and Kitao Shigemasa II.
*Kitagawa (Ogawa) Yoshimaro

芳升 **Yoshimasu** (fl. ca. 1830s–70s): ukiyo-e print artist, Ōsaka School
*Utagawa Yoshimasu

Yoshimatsu (1855–1915): Western-style painter, also did some genre work; son of Goseda Hōryū. Lived in Yokohama and Tōkyō,

studying under Charles Wirgman and Antonio Fontanesi
*Goseda Yoshimatsu

Yoshimine (fl. ca. 1855–75): Ōsaka print artist, pupil of Yoshiume
*Utagawa (Takebe), Yasubei, Gyokutei, Ichibaisai, Kochōrō, Kyokutei

芳満 **Yoshimitsu** (fl. ca. 1870s): ukiyo-e print artist, Ōsaka School, younger brother of Yoshitaki
*Sasaki (Sasamoto), Yoshizō

芳盛 **Yoshimori** (1830–84): ukiyo-e print artist in Edo, later in Yokohama; pupil of Kuniyoshi
*Taguchi (Miki), Sakuzō, Ikkōsai, Kōsai, Kuniharu, Sakurabō

Yoshimori, Wada (1147–1213): a noted warlord who, with Yoshitsune, undertook the campaign against Kiso Yoshinaka, the battles of Ichi-no-tani (1184), Dan-no-ura (1185) and the expedition against Fujiwara Yasuhira (1189)

Yoshimoto, Nijō (1320–88): a *waka* and *renga* poet of the Northern and Southern Court Period

Yoshimune, Tokugawa (1677–1751): 8th shōgun, ruled from 1716 to 45; he attempted to extirpate abuses, enforce austerity measures, improve the trade system and revitalize the administration; a patron of learning who, however, enforced bans on books not to his liking

Yoshimune (1817–80): ukiyo-e print artist, pupil of Kuniyoshi
*Utagawa (Kashima), Isshōsai, Shōsai

義仲 **Yoshinaka, Minamoto no** (1154–84): called Kiso Yoshinaka, from his residence at Miyanokoshi in Kiso; a valiant general against the Heike, he aspired to personal gain and so incurred the wrath of the Shōgun Yoritomo, who placed his brothers, Noriyori and Yoshitsune at the head of an army of 60,000 men and sent them against Yoshinaka, who was defeated and killed at the battle of Awazu when he was 31 years old. ▷ Tomoe-gozen

Yoshinao (fl. ca. early 1820s): ukiyo-e print artist, Ōsaka School

Yoshinao (fl. 1840s–50s): ukiyo-e print artist, pupil of Kuniyoshi

Yoshino: a mountainous district, the southern half of Yamato province; site of the Emperor Go-Daigō's court-in-exile; famous for its cherry blossoms

吉信 **Yoshinobu** (fl. ca. 1730s): ukiyo-e print artist, a follower of Kiyonobu
*Fujikawa Yoshinobu

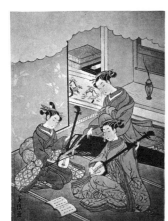

730
Yoshinobu [Komai]: *Girls in Concert. Chūban*, ca. 1771

義信 **Yoshinobu** (fl. ca. 1740s): ukiyo-e print artist and illustrator, possibly a pupil of Shigenaga
*Yamamoto, Heishichirō

美信 **Yoshinobu** (fl. ca. 1770): ukiyo-e print artist, follower of Harunobu
*Komai Yoshinobu

Yoshinobu (fl. ca. early 1840s): ukiyo-e print artist, Ōsaka School
*Utagawa, Ippyōtei, Ippyōsai

芳信 **Yoshinobu** (fl. ca. 1850s–60s): ukiyo-e print artist, pupil of Kuniyoshi
*Ichireisai, Ikkeisai

芳延 **Yoshinobu** (1838–90): ukiyo-e painter, studied under one of Hiroshige's pupils, then with Kuniyoshi
*Matsumoto, Yasaburō, Ichiunsai, Ikkeisai, Ikkyōsai

Yoshino Shizuka: a Noh drama featuring Tadanobu and the concubine of Yoshitsune Shizuka-gozen at Yoshino

Yoshisada Nitta (1301–38): a Minamoto general and defender of the Emperor Go-Daigō; husband of Kōtō-no-naishi; often depicted throwing his sword into the waves to propitiate the divinities of the deep; he put an end to the Hōjō rulers' domination, but was eventually defeated himself by Ashikaga Takauji

Yoshishige (fl. ca. 1720s): ukiyo-e print artist in the Torii style
*Hasegawa Yoshishige

Yoshishige (fl. ca. 1840s): ukiyo-e print artist, Ōsaka School, pupil of Kuniyoshi
*Utagawa, Ichiyōsai, Nan-yūsai

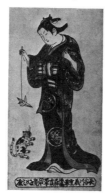

731
Yoshishige: *Courtesan with Cat. Hosoban urushi-e*, ca. late 1720s

Yoshitada, Sone no (late 10th century): a *waka* poet of the mid Heian Period

Yoshitaka (fl. ca. 1850s): ukiyo-e print artist, Utagawa School
*Utagawa, Ippōsai

芳滝 **Yoshitaki** (1841–99): ukiyo-e print artist in Edo and Ōsaka, pupil of Yoshiume
*Utagawa (Nakai), Tsunejirō, Handenshakyo, Hōgyoku, Ichiyōsai, Ichiyōtei, Ittensai, Jueidō, Noriya, Satonoya, Yōsui

芳富 **Yoshitomi** (fl. ca. 1850s–70s): ukiyo-e print artist, pupil of Kuniyoshi; moved to Yokohama in 1873 and changed his name to Hōshū
*Utagawa (Hagiwara), Ichigeisai

芳虎 **Yoshitora** (fl. ca. 1850s–70s): ukiyo-e print artist, pupil of Kuniyoshi
*Utagawa (Nagashima), Tatsugorō, Tatsunosuke, Tatsusaburō, Ichimōsai, Kinchōrō, Mōsai (after 1874)

芳鳥 **Yoshitori** (fl. ca. 1840s): ukiyo-e print artist, pupil and eldest daughter of Kuniyoshi
*O-Tori, Ichiensai

芳年 **Yoshitoshi** (1839–92): leading ukiyo-e print artist of the Meiji Era; pupil of Kuniyoshi, but also studied with Yōsai
*Tsukioka (Yoshioka) Taiso [after 1873], Kinzaburō, Yonejirō, Gyokuōrō, Ikkaisai, Kaisai, Sokatei

Some print series by Yoshitoshi:
1 *Kana-dehon Chūshingura*, 1860
2 *Tōkaidō meisho*, 1863
3 *Wakan hyaku-monogatari*, 1865
4 *Kinsei kyōgi-den*, 1865
5 *Suehiro gojūsan-tsugi*, 1865
6 *Biyū Suikoden*, 1866
7 *Eimei nijūhachi-shūku*, 1867
8 *Gōketsu Suikoden*, 1868
9 *Azuma-no-nishiki ukiyo-kōdan*, 1867–68
10 *Kaidai hyaku-sensō*, 1868–69
11 *Tōkyō-ryōri sukoburu-beppin*, 1871
12 *Ikkai zuihitsu*, 1872–73
13 *Meigetsu shijūhak-kei*, 1873
14 *Yūbin Hōchi-shimbun*, 1874+
15 *Kaiseki beppin-kurabe*, 1876
16 *Kaku-daiku matoi-kagami*, 1876
17 *Mitate tai-zukushi*, 1878
18 *Dai-Nippon meishō-kagami*, 1878
19 *Shinryū nijūshi-toki*, 1880
20 *Tōkyō-jiman junika-getsu*, 1880
21 *Tōkyō kaika kyōga-meisho*, 1879–81
22 *Shin rokkai-sen*, 1882
23 *Yoshitoshi ryakuga*, 1882
24 *Yoshitoshi musha-burui*, 1883
25 *Shinsen Azuma-nishiki-e*, 1885–86
26 *Kinsei jimbutsu-shi*, 1888
27 *Fūzoku sanjūni-sō*, 1888

732
Yoshitoshi: from the series *Fūzoku sanjūni-so*, 1888

733
Yoshitoshi: *Streetwalker in Moonlight*, 1887, from the series *Tsuki hyaku-shi* (no. 29)

349

月 28 *Shinkei san jūrokkaisen,* 1887–1892
百 29 *Tsuki hyaku-shi* [*Tsuki no hyaku-sugata*],
姿 1885–92
 30 *Setsugekka no uchi,* 1890
 ▷ p. 92, plate 197
Yoshitoyo (fl. ca. 1840s): Ōsaka ukiyo-e print artist
*Uehara, Hokusui, Heizō

芳 **Yoshitoyo** (1830–66): ukiyo-e artist, pupil of
豊 Kunisada, then of Kuniyoshi; worked in Edo and in Ōsaka
*Fukuyama, Kanekichi, Ichieisai, Ichiryūsai

Yoshitoyo II (fl. ca. 1890–1900s): ukiyo-e print artist, Ōsaka School, son of Yoshimine
*Takebe, Toyojirō

Yoshitsugu (fl. ca. late 1830s): ukiyo-e print artist, Ōsaka School, son of Yoshimine
*Utagawa Yoshitsugu

芳 **Yoshitsuna** (fl. ca. 1850s–60s): ukiyo-e print
綱 artist and illustrator, pupil of Kuniyoshi
*Utagawa, Ittosai

義 **Yoshitsune, Minamoto no** (1159–89): a fa-
経 mous warrior-general; called Ushiwaka in his childhood, he was first confined by the Heike in the temple Kurama-dera but escaped and took refuge in Mutsu, accompanied by his retainer Benkei. Raising troops to support his half-brother Yoritomo, he defeated Yoshinaka at Uji, Seta and Awazu in 1184, then entered Kyōto and continued his successful campaign against the Heike at the battle of Ichi-no-tani. His popularity bred jealousy in the mind of Yoritomo, and after his defeat of the Heike at the battle of Dan-no-ura (1185), he had to flee to Yamato, then Mutsu, where, being trapped, he committed *harakiri;* he was then only 31 years old. His story is told in the *Gikei-ki* and in numerous dramas, depicted in hundreds of prints. Yoshitsune (with Benkei, and his faithful mistress Shizuka-gozen) has always been one of the most popular heroes of Japan.

Yoshitsune sembon-zakura: a Kabuki play, first written for the puppet theater in 1747 and adapted for Kabuki soon after; the protagonists are Yoshitsune, Shizuka-gozen (his concubine) and Tomomori

芳 **Yoshitsuru** (fl. ca. 1840s): ukiyo-e print artist
鶴 and illustrator, pupil of Kunisada
*Utagawa, Isseisai, Ittensai

芳 **Yoshitsuya** (1822–66): ukiyo-e print artist
艶 and illustrator, pupil of Kuniyoshi
*Kōko, Mankichi, Ichieisai

Yoshitsuya II (fl. ca. 1870s): ukiyo-e print artist, pupil of Yoshitsuya
*Miwa, Ichieisai, Issensha-Kison

芳 **Yoshiume** (1819–79): ukiyo-e print artist and
梅 illustrator; first worked in Ōsaka but moved to Edo in 1847 to study under Kunisada, returning to Ōsaka in 1857
*Nakajima, Tōsuke, Ichiōsai, Yabairō

吉 **Yoshiwara:** the principal licensed entertain-
原 ment quarter of Edo, established near Nihon-bashi in 1618; after the great fire of 1657, moved to a more remote location, north of Asakusa, there often referred to as Shin [New]-Yoshiwara ▷ *shin-Yoshiwara*

Yoshiwara saiken: the annual guide pamphlets to the Yoshiwara quarter

Yoshiyasu, Yanagizawa (1658–1714): the infamous protege of the Shōgun Tsunayoshi

芳 **Yoshiyuki** (fl. ca. early 1820s): ukiyo-e print
幸 artist, Ōsaka School
*Takagi Yoshiyuki

Yoshiyuki (1835–79): ukiyo-e print artist, pupil of Yoshiume; in Ōsaka until 1868, when he moved to Tōkyō

*Mori, Hanjirō, Yonejirō, Keisetsu, Nansui, Rok-kaen, Rokkaken

芳 **Yoshiyuki** (fl. ca. 1850s–60s): ukiyo-e print
雪 artist, pupil of Kuniyoshi
*Utagawa, Ichireisai

Yotsugi monogatari: a collection of tales of the Heian and Kamakura Periods

yotsugiri: a small print size, about 7½×5 in./ 19×12.5 cm; an *ōban* quarter-sheet, all four designs being printed at once from an *ōban*-size block and then divided

Yotsuya kaidan: a Kabuki play written by Namboku; a ghost tale featuring Iemon, his young wife O-Iwa, and O-Ume, who has fallen in love with Iemon. (see plate 173)

Yo-uchi Soga: a Noh drama of the Soga Brothers' attack by night on their enemy Kudō Suketsune

Yo-wa-nasake ukina-no-yokogushi: a popular Kabuki play, commonly called *Genya-dana* or *Kirare-Yosa,* written in 1853; it features the outlawed lovers O-Tomi and Yosaburō

yu-agari bijin: a beauty shown after her bath (a favorite ukiyo-e subject)

yubi-zumō: a contest of strength, measured by pressing thumbs

yūgao [evening face]: the moon flower, or calabash

Yūgao: a Noh drama featuring the Lady Yūgao and her lover Prince Genji

Yugyō-yanagi: a Noh drama featuring the priest Yugyō at the barrier station of Shirakawa

Yuhara-no-ōkimi (mid 7th century): a *waka* poet of the early Nara Period

遊 **yūjo:** a courtesan
女

yūjo hyōbanki: a courtesan critique, a booklet containing critical ratings of popular courtesans, often illustrated by the early ukiyo-e artists (see plates 18, 21)

Yūkan (fl. ca. 1790s): ukiyo-e painter, pupil of Eishi
*Fujiwara Yūkan

yukata: an informal cotton kimono or bathrobe

Yukihira, Ariwara no (818–93): a poet and governor of the provinces; lover of the sisters Matsukaze and Murasame (see plate 31)

Yukikuni (fl. ca. 1815–20s): ukiyo-e print artist, Ōsaka School

行 **Yukimaro** (fl. ca. later 1780s): ukiyo-e print
麿 artist and illustrator, an early pupil of Utamaro
*Kitagawa Yukimaro

雪 **Yukimaro** (d. 1856): ukiyo-e painter and print
麿 artist, pupil of Tsukimaro

734

Yukimaro: *Geisha in Dōjōji Dance. Ōban,* ca. 1810

*Kitagawa (Tanaka), Zenzaburō, Bokusentei, Keitansha

Yukimi-zuki: a poetic name for the Eleventh Month

行 **Yukinaga** (fl. ca. 1800s–10s): ukiyo-e print
長 artist, Kyōto School
*Hotta, Shimpei, Riseki, Renzan

雪 **Yukinobu** (1643–82): female Kanō-School
信 painter, also did some genre work
*Kiyohara (Kanō), Yukinobu [Sesshin], Yuki

Yuki-onna: the legendary Woman of the Snow

Yumeji (1884–1934): neo-ukiyo-e painter and print artist
*Takehisa, Shigejirō

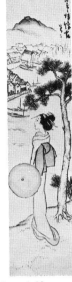

735

Yumeji: *Memories of Muro-no-tsu. Kakemono* in colors on paper, ca. 1920s

Yumiaki (fl. ca. 1780s): ukiyo-e print artist in the Kiyonaga manner
*Katsukawa Yumiaki [Yumishō]

yumi-ya san-ten: the 3 divinities that protect warriors: Marishi-ten, Benzai-ten, Daikoku-ten

湯 **yuna:** girls who were popular bathouse atten-
女 dants in the 17th century (see plate 8)

Yūnen (1844–1916): Kyōto *dōban* artist
*Ishida, Ubakutei, Sai

yū-ō ▷ pigments

Yuriko, Gion (mid 18th century): a noted poetess, author of the collection of verses entitled *Sayuri-shū;* mother of Gyokuran

Yūsai, Hosokawa (1534–1619): a *waka* poet and classical scholar in Kyōto

Yūshi (1768–1846): Nagasaki-School painter; also did some genre work, especially depictions of the Dutchmen at Deshima
*Ishizaki (Araki), Katarō, Hōrei, Shisai
Lane, Richard. *Studies in Ukiyo-e.*
▷ Western art

yūsoku kojitsu: term for court etiquette and customs

Yuya: a Noh drama featuring Taira no Munemori and his mistress Yuya

Yūzan (Meiji): *dōban* artist, pupil of Shunsui
*Kitamura Yūzan

友 **Yūzen** (1654–1736): noted Kyōto and Kana-
禅 zawa kimono designer and dyer, who also illustrated several books in the period 1688–1707
*Miyazaki (Kaga) Yūzen

Z

Zeami (1363–1443/45): a Noh actor and playwright of the mid Muromachi Period
Zegai: a Noh drama featuring Zegai-bō, the goblin king, and the goblin Tarō-bō (both dressed as *yamabushi* priests)
Zen [Ch'an]: a meditative sect of Buddhism, introduced into Japan from China in the 13th century
Zenchiku, Komparu (1405–68): a Noh actor and playwright of the mid Muromachi Period
zenga: Zen painting, as practiced by the monks of the Edo Period
Zeni-ya Gohei (1798–1855): a noted ship-builder and entrepreneur from Kaga
Zenji Soga: a Noh drama concerning Kugami no Zenji, the youngest of the Soga Brothers
Zenkōji: a famous Buddhist temple in Shinano, object of popular pilgrimages
是真 **Zeshin** (1807–91): Edo Shijo-School painter, print artist and lacquerer; studied painting with Nanrei and Toyohiko; did some genre work
*Shibata, Junzō, Kametarō, Tanzen, Chinryūtei, Koma, Reisai, Tairyūkyo
Zenshō (Meiji): *dōban* artist
*Shimizu Zenshō
Zeze: a town and castle in Ōmi Province on Lake Biwa
Zōdan-shū: a collection of miscellaneous tales, 1305
zōhan: colophon term meaning publisher or published by
zōho: a supplement (in book titles)
Zōjōji: a great Buddhist temple at Shiba (in Edo), patronized by the Tokugawa clan
Zoku Koji-dan: a collection of tales, 1219
zokumyō (*tsūshō*): a given name
zōri: a good quality sandal
zōri-kakushi [hide-the-sandal]: a type of game
zōri-uchi: slapping with footgear (a major insult)
zui: an illustrated compendium
Zuiken, Kawamura (1618–1700): a leading Edo contractor, who built many of that city's early landmarks
zuishin: the bodyguards at the Imperial court
Zuizan (1829–65): *nanga* painter, produced some genre work
*Takechi, Otate, Hampeita, Meikan, Suizan

Kikō ▷ Hokkei
Kikukawa ▷ Eiri, Eishō, Eizan, Senchō
Kikumaro ▷ Tsukimaro
Kikuō ▷ Kunimaro
Kikurensha ▷ Kyosen
Kikusai ▷ Kunimaro II
Kikusui ▷ Shigehiro
Kikutarō ▷ Kunimaro
Kikutei ▷ Takamasa
Kiminobu ▷ Ikkei
Kimparō ▷ Kunikage
Kimpasai ▷ Kunikage
Kimpūsha ▷ Toyomaro
Kimura ▷ Kanenari
Kinchōdō ▷ Sekiga
Kinchōrō ▷ Yoshitora
Kin-emon ▷ Hokkei
Kinji ▷ Kunimaro II
Kinjirō ▷ Horyū, Kuniteru
Kinkadō ▷ Sadanobu
Kinkin ▷ Sadayoshi
Kinoshita ▷ Hironobu, Hironobu II
Kinraisha ▷ Kunisada
Kinryōsai ▷ Gyokuzan
Kinsai ▷ Shigenobu
Kinshō-tōkei ▷ Kuniteru
Kintarō shun-yō ▷ Hokkei
Kinzaburō ▷ Yoshitoshi
Kinzō ▷ E-Kin
Kisaburō ▷ Taito II
Kisai ▷ Hiroshige II
Kisanta ▷ Shigenobu II
Kishikawa ▷ Katsumasa
Kishi Uemon ▷ Bunchō
Kisseidō ▷ Hokumei
Kita ▷ Busei
Kitagawa ▷ Chikanobu, Fujimaro, Hidemaro, Shikimaro, Shūgetsu, Toyohide, Tsukimaro, Utamaro, Utamaro II, Yoshimaro, Yukimaro
Kitao ▷ Kyōden, Masayoshi, Shigemasa, Tokinobu
Kiyohara ▷ Yukinobu
Kiyomizu ▷ Genshirō
Kiyōsai ▷ Shigeharu
Kiyoshi ▷ Goyō
Kiyosuke ▷ Baiju
Kiyōtei ▷ Shigeharu
Kiyū ▷ Goshichi
Kō ▷ Sukei, Sūkoku, Suryū
Kobairō ▷ Kuniteru
Kobayashi ▷ Eitaku, Kiyochika
Kochōan ▷ Kunimori
Kochōen ▷ Shunshō
Kōchōrō ▷ Kunisada, Kunisada II, Kunisada III, Toyonobu, Yoshimine
Kōen ▷ Gakutei
Kōgadō ▷ Sadahiro, Tamikuni, Tomikuni
Kōgyōsai ▷ Hokuichi
Kōhairin ▷ Ryūsui
Kohensai ▷ Isshō
Koikawa ▷ Haruga, Harumachi, Harumasa
Kōitsu ▷ Eishō
Kojima ▷ Kagaromo-Kisshū, Shōgetsu
Kōjirō ▷ Rōchō
Kōjōdō ▷ Yoshikuni
Kokasai ▷ Fujimaro
Kōko ▷ Yoshitsuya
Kokuhyōtei ▷ Sadayoshi
Koma ▷ Zeshin
Komai ▷ Genki, Yoshinobu
Komatsu-ken ▷ Hyakki
Komatsu-ya ▷ Hyakki
Komonta ▷ Matora
Kōnantei ▷ Kunihiro
Kondō ▷ Katsunobu, Kiyoharu
Kōno ▷ Bairei
Konobu ▷ Sadanobu II
Konsei ▷ Eisen
Korenobu ▷ Yōsen-in
Korensha ▷ Sūkoku
Koriūsai ▷ Koryūsai
Koryū ▷ Koryūsai
Kosaburō ▷ Hokuga
Kōsai ▷ Motoharu, Yoshimori
Kose ▷ Hidenobu
Kōso ▷ Yasukuni

Kōsoken ▷ Morikuni
Koson ▷ Shōson
Kōsōō ▷ Isshū
Kōsōtei ▷ Toyokuni II
Kōsuifu ▷ Shigemasa
Kosuiken ▷ Shigemasa
Kōsuisai ▷ Shigemasa
Kōsuke ▷ Sadatake
Koun ▷ Isshū
Kōzan ▷ Chōjirō, E-Kin
Kōzandō ▷ Shumman
Kōzō ▷ Kunitsugu
Kubo ▷ Shumman
Kubota ▷ Beisen
Kudaradō ▷ Sadakazu
Kuitaisha ▷ Hokusai
Kumaemon ▷ Toyokuni
Kumakichi ▷ Toyokuni
Kumazō ▷ Kunimitsu
Kūmeidō ▷ Nobuyuki
Kumejirō ▷ Toshikata
Kunai ▷ Gessai II
Kuniharu ▷ Yoshimori
Kunimasa II ▷ Kunimune II
Kunimasa III ▷ Kunisada II
Kunimasa IV ▷ Kunisada III
Kunishige ▷ Toyokuni II
Kunitaka ▷ Suifutei
Kunitomo ▷ Gennai
Kunitoshi ▷ Baiju
Kunitsuna II ▷ Kuniteru II
Kunju ▷ Itchō
Kurahashi ▷ Harumachi
Kuraji ▷ Sūsetsu
Kuranosuke ▷ Ikkei
Kusamura ▷ Kunimaro, Toyomaru
Kuzaemon ▷ Eishi
Kyōgadō ▷ Ashikuni
Kyōichi ▷ Keiri
Kyokaen ▷ Shokusanjin
Kyokurōsai ▷ Shunshō
Kyokurōsei ▷ Shunshō
Kyokutei ▷ Yoshimine
Kyōrian Bainen ▷ Hokusai
Kyōsai ▷ Hokkei
Kyōsha-gaishi ▷ Kyōsai
Kyōundō ▷ Itchō
Kyūgorō ▷ Hokuun, Shigemasa
Kyūjirō ▷ Shun-ei
Kyūkaikyo ▷ Shigemasa
Kyūkei ▷ Gennai
Kyūkyūshin ▷ Hokumei, Hokusai
Kyūrō ▷ Baitei
Kyūsōdō ▷ Itchō
Kyūtokusai ▷ Shun-ei
Kyūzaemon ▷ Fusanobu
Kyūzō ▷ Naizen

Maemura ▷ Towa
Magari ▷ Hokugan
Magoemon ▷ Sukenobu
Magoji ▷ Tōrin
Magojirō ▷ Shigenaga
Magosaburō ▷ Kuniyoshi, Shigenaga, Toyonobu
Maki ▷ Bokusen
Makieshi ▷ Genzaburō
Mangoro ▷ Eizan
Manji ▷ Hokusai
Manjirō ▷ Hokuga
Mankichi ▷ Yoshitsuya
Mannō ▷ Shinsai
Man-ō ▷ Saikaku
Maoyoshi ▷ Chikanobu
Maru-ya ▷ Fusanobu
Maruya ▷ Gakutei
Masajirō ▷ Kunisato
Masakatsu ▷ Koryūsai
Masaki ▷ Toyoharu
Masakichi ▷ Kunisada II
Masanobu ▷ Kyōden
Masanosuke ▷ Gekkō
Masatami ▷ Gessai
Masatoshi ▷ Minkō
Masayuki ▷ Shinsai
Masuyuki ▷ Suiseki
Matabei II ▷ Katsushige

Matao ▷ Shōson
Matasaburō ▷ Sadahiro
Matsugorō ▷ Kunimune
Matsujirō ▷ Kiyosada
Matsukawa ▷ Hanzan
Matsumoto ▷ Gengendō, Yoshinobu
Matsuno ▷ Chikanobu
Matsu-ya ▷ Jichōsai
Meijōdō ▷ Toyonobu
Meikyōsai ▷ Gekkō
Michihiro ▷ Buzen
Migita ▷ Toshihide
Mihata ▷ Jōryū
Mita ▷ Hokuga
Mitani ▷ Sadahiro
Miura-ya Hachiemon ▷ Hokusai
Miwa ▷ Yoshitsuya II
Miyagawa ▷ Chōki, Chōshun, Hosui, Isshō, Masayuki, Tominobu
Miyagi ▷ Gengyo
Miyazaki ▷ Yūzen
Mizuhara ▷ Gyokusō
Mizuno ▷ Rochō, Toshikata
Mohachi ▷ Itchō II
Mokuen ▷ Utamaro
Momokawa ▷ Chōki
Mori ▷ Ippō, Naokuni, Takamasa, Yoshiyuki
Morikawa ▷ Chikashige, Yasuyuki
Mōrōsai ▷ Buzen
Mōsai ▷ Yoshitora
Monkichi ▷ Matora
Muchūan ▷ Haryū
Mudō-dōja ▷ Ryūkō
Mudō-sanjin ▷ Ryūkō
Mumeiō ▷ Eisen
Munehisa ▷ Kunisada II
Murasaki-ya ▷ Utamaro
Myōnosuke ▷ Hokuga

Nagaharu ▷ Eishun, Chōshun
Nagai ▷ Chōkō
Nagakuni ▷ Ashiyuki
Nagami ▷ Gekkō
Nagasawa ▷ Ingyō
Nagashige-maru ▷ Jokei
Nagata ▷ Aōdō Denzen
Naiki ▷ Gukei, Jokei
Naka ▷ Isaburō
Nakagawa ▷ Chōjirō
Nakai ▷ Rankō
Nakajima ▷ O-Ei, Yoshiume
Nakamura ▷ Bunsan, Eiryū, Enkyō, Nagahide
Nakao ▷ Isaburō
Nakayama ▷ Sūgakudō
Nak-ya ▷ Toyonobu
Nampitsu ▷ Kashō
Nampo ▷ Shokusanjin
Nandaka-Shiran ▷ Shumman
Nanjō ▷ Yoshiharu
Nanryūsai ▷ Bunchō
Nansō ▷ Sadanobu
Nansōrō ▷ Sadanobu
Nansui ▷ Yoshiyuki
Nan-yō ▷ Hokuga
Nan-yūsai ▷ Yoshishige
Nanzan ▷ Gakutei
Naofusa ▷ Shigefusa
Naojirō ▷ Shokusanjin
Naoteru ▷ Kuniteru
Nara-ya ▷ Ihachi
Nenkōro ▷ Baikei
Nen-yū ▷ Gekkō
Nichōsai ▷ Jichōsai
Niman-o ▷ Saikaku
Nishikawa ▷ Nobuharu, Sukenobu, Suketada, Sukeyo, Terunobu
Nishimura ▷ Shigemasu, Shigenaga, Shigenobu
Nobukatsu ▷ Itchō II, Shigenao
Nobusada ▷ Shunki
Nobushige ▷ Ikkei, Shunchōsai
Nobutane ▷ Isshū
Nobutoshi ▷ Isshō
Nobuyasu ▷ Shoroku
Nobuyuki ▷ Hokuga, Kyōsai, Shinryū
Nomura ▷ Ginjirō, Yoshikuni

Norihide ▷ Doshū
Norishige ▷ Dohan
Noritane ▷ Doshu
Noritatsu ▷ Doshin
Noritoki ▷ Doshin
Noriya ▷ Yoshitaki
Numata ▷ Gessai
Nunoya ▷ Ashikuni
Nuno-ya ▷ Utakuni
Nyoku-nyūdō ▷ Kyosai

Ōen ▷ Masakazu
Ogata ▷ Gekkō
Ogawa ▷ Haryū
Ogura ▷ Ryūson
Ohara ▷ Shōson
Ōhō ▷ Shinryū
Ōi ▷ O-Ei
Ōishi ▷ Matora
Ōju ▷ Yoshitoshi
Okada ▷ Gyokuzan
Okamoto ▷ Masafusa, Shunki, Toyohiko
Oki ▷ Ichiga
Okinojō ▷ Moronaga
Okumura ▷ Genroku, Masafusa, Masanobu, Nobufusa, Toshinobu
Ōmori ▷ Yoshikiyo
Ono ▷ Kiyoharu
Onjirō ▷ Kuniaki II
Ōoka ▷ Michinobu, Shumboku, Shunsen
Osada ▷ Buzen
Osai ▷ Fusatane
Ōshōtei ▷ Kunitsugu
Ōta ▷ Chinchō, Shokusanjin
Ōtojiro ▷ Chikashige
O-Tori ▷ Yoshitori
Ototsudō ▷ Isaburō

Rainosuke ▷ Toshimoto
Raishin ▷ Hokusai
Raisui ▷ Kyōsai
Raito ▷ Hokutai, Shigenobu
Rakkatei ▷ Toyonobu
Rakushisai ▷ Sūkoku
Ran-eisai ▷ Ashikuni
Rankōtei ▷ Isaburō
Ransai ▷ Ashikuni
Rantokusai ▷ Shundō
Ran-yōsai ▷ Hokkei
Reikinsha ▷ Keishi
Reiryōdō ▷ Sekien
Reisai ▷ Zeshin
Rekisentei ▷ Eiri, Isshi, Sorin
Renzan ▷ Yukinaga
Rinsai ▷ Shigenobu
Rinshōan ▷ Itchō
Rintōan ▷ Itchō
Ririn ▷ Shunshō
Riseki ▷ Yukinaga
Rissai ▷ Kyōden
Rissensai ▷ Kunisato
Ritchōrō ▷ Kunihisa II
Riteitei ▷ Utamaro II
Rō [Tsumbo] ▷ Tōrin
Rodō ▷ Hokugan
Rokkaen ▷ Yoshiyuki
Rokkaken ▷ Yoshiyuki
Rokkatei ▷ Tomiyuki
Rokurokuan ▷ Shunshō
Rokusō ▷ Itchō
Rōsai ▷ Gekkō
Roshū ▷ Ashikuni
Rōshunsai ▷ Eikō
Ryūkoku ▷ Shunkyō
Ryokuitsusai ▷ Sadanobu
Ryōsa ▷ Gakutei
Ryōun ▷ Gessai
Ryūei ▷ E-Kin
Ryūen ▷ Kuniyoshi
Ryūendō ▷ Kuninao
Ryūkadō ▷ Shigenobu
Ryūkaen ▷ Shinsai
Ryūkōsai ▷ Shiken
Ryūkyōtei ▷ Shigenao
Ryūō ▷ Haryū
Ryūunshin ▷ Shigeyoshi
Ryūryūkyo ▷ Shinsai, Sōri
Ryūsai ▷ Hiroshige, Hiroshige II, Shigeharu

Ryūsen ▷ Tomonobu
Ryūsendō ▷ Shifū
Ryūshō [Risshō] ▷ Hiroshige II
Ryūshū ▷ Tomonobu
Ryūsōshi ▷ Kiyoharu
Ryūsuiken ▷ Mitsunobu
Ryūsuiō ▷ Ryūsui
Ryūtei ▷ Shigeharu
Ryūtō ▷ Hironobu II

Sadakichi ▷ Hambei
Sadamasu ▷ Kunimasu
Sadamichi ▷ Baisetsudō
Sadashige ▷ Kuniteru, Kuniteru II
Sahitsuan ▷ Shunkō
Sahitsusai ▷ Shunkō
Saihō ▷ Saikaku
Saikarō ▷ Kunimaru
Saikōtei ▷ Shibakuni
Sairakusai ▷ Yoshiiku
Saishū ▷ Bunsan
Sakai ▷ Eiju
Sakenoue no Furachi ▷ Harumachi
Sakunojō ▷ Moronaga
Sakura ▷ Bunkyō
Sakurabō ▷ Yoshimori
Sakuragawa ▷ Bunkyō
Sakuzō ▷ Yoshimori
Sanjirō ▷ Masayoshi
Sanjuen ▷ Yoshihide
Sankei ▷ Jōhaku
Sankōdō ▷ Takamasa
Sanputei ▷ Kuniharu
Sanrei ▷ Kunimune
Sanshōtei ▷ Kunihiro
Santō ▷ Kyōden
Santōan ▷ Kyōsui
Santōkaku ▷ Hokkei
Santosai ▷ Toun
Santoun ▷ Toun
Sasaki ▷ Yoshimitsu
Sashōdō ▷ Shumman
Sasuiō ▷ Itchō
Satonaya ▷ Yoshitaki
Sawa ▷ Sekkyō
Sawaki ▷ Sūsetsu
Sei ▷ Kyōden
Seibei ▷ Utakumi
Seichōken ▷ Kiyoshige
Seichōtei ▷ Senchō
Seigadō ▷ Kangetsu
Seigyokudō ▷ Bunsan
Seijirō ▷ Shunsen, Yoshikage
Seikoku ▷ Charakusai
Seima ▷ Fusatane
Seiō ▷ Kanenari
Seisai ▷ Ichiga
Seisei ▷ Sōri
Seisenkan ▷ Rochō
Seishi ▷ Bunchō
Seitarō ▷ Kunisada II
Seiunkan ▷ Getsurei
Seiyōdō ▷ Shunshi
Seiyōsai ▷ Ashikuni, Kiyoharu
Seizandō ▷ Aōdō Denzen
Sekijudō ▷ Ryūsui
Sekijukan ▷ Ryūsui
Sekinan ▷ Ikkei
Sekiyō ▷ Utamaro
Sekka ▷ Hokuei
Sekkan ▷ Tōrin III
Sekkarō ▷ Hokuei
Sekkatei ▷ Hokushū
Sekkeisai ▷ Masafusa
Sekken ▷ Sadanobu
Sekkōsai ▷ Tokinobu
Sekkōtei ▷ Hokumyō
Sengetsudō ▷ Sekien
Senju ▷ Eiju
Senkadō ▷ Shigenaga
Senkakudō ▷ Hokuyo
Senkakutei ▷ Hokuyo
Senkintei ▷ Tomiyuki
Senkōzan ▷ Hokusai
Sen-ō ▷ Toyoharu
Senryūsai ▷ Toyoharu
Sensai ▷ Eitaku, Toshinobu
Sensuke ▷ Tsukimaro

Sentandō ▷ Sekien
Sentarō ▷ Shuntoku
Sesshō ▷ Itchō
Sesshōsai ▷ Shigefusa, Shigenobu II
Sessō ▷ Yoshihide
Setsuzan ▷ Tōrin III
Settei ▷ Kiyoharu
Sharakuō ▷ Kuninao
Shashinsai ▷ Kuninao
Shiba ▷ Isaburō
Shibata ▷ Kangetsudō, Zeshin
Shiba-ya ▷ Utamaro
Shichibei ▷ Toyonobu
Shichiemon ▷ Matora
Shichinosuke ▷ Kiyohiro
Shichizaemon ▷ Shokusanjin
Shidōken ▷ Masanobu
Shiei ▷ Sūkoku
Shieidō ▷ Eishō
Shien ▷ Kangyū
Shigemasa ▷ Hiroshige III
Shigenobu ▷ Hiroshige II
Shigesato ▷ Naizen
Shigeta ▷ Ikku
Shigetora ▷ Hiroshige III
Shigure-oka-itsumin ▷ Shigemasa
Shigyō ▷ Ichiga
Shiho ▷ Fujimaro
Shii ▷ Gessai
Shiidō ▷ Yoshihide
Shikei ▷ Ichiga
Shiki ▷ Shigenobu II
Shikitei ▷ Umekumi
Shiko ▷ Chōki, Rankō
Shikō ▷ Ippō
Shikojin ▷ Harunobu
Shikōsai ▷ Hokuichi
Shima-sanjin ▷ Kunichika, Kuninobu
Shimbi ▷ Utamaro
Shimmyō ▷ Masanobu
Shimokobe ▷ Shūsui
Shimomura ▷ Shichirobei
Shin-ei ▷ Bokusen
Shin-emon ▷ Toyoharu
Shingakudō ▷ Gakutei
Shingetsu ▷ Buzen
Shinjirō ▷ Toshinobu
Shinkadō ▷ Gakutei
Shinkō ▷ Itchō
Shinkurō ▷ Moromasa
Shin-ō ▷ Sadanobu
Shinra-banshō-ō ▷ Gennai
Shinrōsai ▷ Buzen
Shinsai ▷ Sadafusa, Sadakazu
Shinsen ▷ Ryūsui
Shinsensai ▷ Tōrin III
Shinshichirō ▷ Moromasa
Shinshinshi ▷ Hokutai
Shinshō ▷ Ginkō
Shinsuke ▷ Kiyonaga
Shinteitei ▷ Kuniteru
Shinten-ō ▷ Sadanobu
Shintoku ▷ Gyokuzan
Shion ▷ Kangetsu
Shiō-sanjin ▷ Shiken
Shirantei ▷ Isaburō
Shirobei ▷ Kuninao
Shiryū ▷ Shōkaku
Shisai ▷ Yūshi
Shiseki ▷ Sō-Shiseki
Shisentei ▷ Takamasa
Shishi ▷ Ikkei
Shishin ▷ Busei
Shishoku Gankō ▷ Hokusai
Shishū ▷ Gyokuzan II
Shitatsu ▷ Tsukimaro
Shito ▷ Suifutei
Shitomi ▷ Kangyū, Kangetsu
Shizan ▷ So-Shizan
Shizen ▷ Buzen
Shōbei ▷ Kiyonobu, Kiyonobu II, Koryūsai
Shōchōrō ▷ Kunimaro
Shōei ▷ Matabei, Shigenobu II
Shōgindō ▷ Yoshikawa
Shogorō ▷ Hokkei
Shōgyo ▷ Kunikiyo
Shōgyorō ▷ Kumikiyo II

Shōja ▷ Ikkei
Shōjirō ▷ Kiyomasu, Toyoharu
Shōjō ▷ Kyōsai
Shōjōan ▷ Kyōsai
Shōjōsai ▷ Kyōsai
Shōju ▷ Shōrakusai, Toyoharu
Shōjuken ▷ Saikaku
Shōkaan ▷ Issen
Shōkei ▷ Baikan
Shōkō ▷ Haryū, Shōkōsai
Shōkoku ▷ Matora
Shōkōsai ▷ Hokuto, Hokushū, Shuntei
Shōkōtei ▷ Sadahiro
Shōkyūko ▷ Shuntei
Shōnosuke ▷ Kiyomine
Shōō ▷ Yoshikuni
Shō-ō ▷ Ryūho
Shōsadō ▷ Shumman
Shōsai ▷ Ginkō, Hokuju, Ikkei, Masayoshi, Ryūho, Yoshimune
Shōseikō ▷ Isshi
Shōseki-koji ▷ Isshi
Shōsen ▷ Shigefusa
Shōshichi ▷ Kiyomoto
Shōshin ▷ Masayoshi, Setten
Shōshōken ▷ Hyakki
Shōsuke ▷ Yoshikatsu
Shōtarō ▷ Shunki
Shōtei ▷ Chōki, Hokuju
Shōunsai ▷ Ginkō
Shōyū ▷ Gyokuzan, Shunzan
Shōzan ▷ Taito II
Shōzō ▷ Kunisada
Shuei ▷ Tōrin III
Shūei ▷ Nagakuni, Sessai
Shūen ▷ Hokuba
Shūgan ▷ Shigehiro
Shūgansai ▷ Shigefusa, Shigehiro
Shūgetsu ▷ Tōrin III
Shuhō ▷ Shigehiro
Shūjirō ▷ Eitaku
Shūkoku ▷ Ryūsui
Shumbaisai ▷ Hokuei
Shumbaitei ▷ Hokuei
Shume ▷ Ikkei
Shummin ▷ Shungyōsai II
Shumpu ▷ Shunshi
Shumpusai ▷ Hokumyō
Shūna ▷ Toyonobu
Shunchō ▷ Hokushō
Shunchōsai ▷ Harumachi
Shunchōsai ▷ Hokuchō
Shun-eisai ▷ Hokuju
Shungyōsai ▷ Hokusei, Hokuchō, Kunimari II, Ryūkoku, Shun-ei
Shunkantei ▷ Hokushin
Shunkisai ▷ Hokugan
Shunkō ▷ Hokuei, Hokushū, Toshinobu
Shunko II ▷ Shunsen
Shunkōsai ▷ Hokuei, Hokushin, Hokushū, Hokuto
Shunkyokusai ▷ Hokumei I
Shunrō ▷ Hokusai
Shunrō II ▷ Toyomaru
Shunsentei ▷ Shunsendō
Shunshisai ▷ Hokkai
Shunsho ▷ Hokuchō
Shunshō ▷ Shun-yō
Shunshōdō ▷ Tamakuni
Shunshosai ▷ Hokuchō
Shunshōsai ▷ Hokuju
Shunshunsai ▷ Hokuba
Shunshuntei ▷ Hokuba
Shunsōsai ▷ Ippō II
Shunsuidō ▷ Chōei
Shuntei ▷ Shunshō
Shun-yōdō ▷ Hokugan
Shun-yosai ▷ Kiyoharu
Shun-yōsai ▷ Hokkei, Hokuei, Shunshi
Shun-yusai ▷ Hokusetsu, Hokuun
Shuransai ▷ Kyōsai
Shurinsai ▷ Itchō
Shūsaburō ▷ Kyōsai
Shūtoku ▷ Gyokuzan II
Shutsusanjin ▷ Getsurei
Sōbei ▷ Morikuni

Sōdenshi ▷ Jōhaku
Sodō ▷ Takamasa
Sōemon ▷ Kuniteru
Sogenshi ▷ Kunichika
Sogetsuen ▷ Senchō
Sōhō ▷ Issen
Sōji ▷ Isai, Sōri III
Sokatei ▷ Yoshitoshi
Sōri ▷ Hokusai
Sōsai ▷ Eisen
Sōshi-shikun ▷ Waō
Sotaku ▷ Issen
Sōu ▷ Haryū
Sōyōan ▷ Bunchō
Sōzaemon ▷ Ryūho
Sozō ▷ Buzen
Sugai ▷ Baikan
Sugawaro ▷ Eibun
Suieidō ▷ Hanzan
Suigetsusai ▷ Eiga
Suihō ▷ Shigemasa
Suihō-itsujin ▷ Shuntei
Suikōdō ▷ Sakei
Suimutei ▷ Shoroku
Suiraibō ▷ Kyōsai
Suirochō ▷ Rochō
Suirōrō ▷ Isai
Suisai ▷ Ikku
Suisaiō ▷ Itchō
Suisenshi ▷ Gengyo
Suiundō ▷ Sūkoku, Sūsetsu
Suiunshi ▷ Sūkei
Sukegōrō ▷ Kiyoharu
Sūkei ▷ Ikkei
Sukemasa ▷ Shumsen
Sukenoshin ▷ Itchō
Sukezō ▷ Suketada
Sūkoku ▷ Sūryō
Sumie ▷ Buzen
Sumiyoshi ▷ Gukei, Jokei
Sumpō ▷ Hokki
Sunayama ▷ Gosei
Sūrin ▷ Ippō III
Suzuki ▷ Harunobu, Shūrin, Toshimoto

Tachibana ▷ Minkō, Morikuni, Yasukuni
Tadashi ▷ Rankō
Tadatoshi ▷ Jokei
Taga ▷ Ryūkōsai, Shiken
Taguchi ▷ Rokoku, Yoshimori
Taikei ▷ Sessai, So-Shizan
Tairei ▷ Shigemasa
Tairyukyo ▷ Zeshin
Taisuke ▷ Settai
Taito ▷ Hokusai
Taizan ▷ Bunsan
Taizō ▷ Kuninao
Tajima-ya ▷ Toyoharu
Takada ▷ Eichō
Takagi ▷ Sadatake, Yoshiyuki
Takai ▷ E-Kin
Takaji ▷ Hanzan
Takao ▷ Shōroku
Takayuki ▷ Toshitsune
Takebe ▷ Yoshitoyo II
Takeda ▷ Harunobu
Takehara ▷ Shunchōsai, Shunsensai
Takizawa ▷ Shigenobu
Takusai ▷ Eigyoku
Tamaki ▷ Gyokko
Tamekichi ▷ Kiyomasa
Tamenshi ▷ Ikkei
Taminosuke ▷ Shungyōsai II
Tamugawa ▷ Shūchō
Tamura ▷ Sadanobu, Suiō
Tan ▷ Isaburō, Shokusanjin
Tanaka ▷ Kuninobu, Masunobu, Totsugen
Tanchōsai ▷ Masanobu
Tangaku-sanjin ▷ Toyohiko
Tange ▷ Shunsen
Tanjōdō ▷ Toyonobu
Tankei ▷ Yasuji
Tansan ▷ Ichiga
Tansansai ▷ Ichiga
Tanseidō ▷ Hokuyo
Tanzen ▷ Zeshin
Tarobei ▷ Moroshige

Taroemon ▷ Kuniyoshi
Tasaburō ▷ Kunifusa
Tatsu ▷ O-Tatsu
Tatsugōrō ▷ Yoshitora
Tatsu-je ▷ O-Tatsu
Tatsumasa ▷ Hokusai
Tatsunobu ▷ Tokinobu
Tatsunosuke ▷ Yoshitora
Tatsusaburō ▷ Yoshitora
Tatsuyuki ▷ Hokkei
Tawara-ya Sōri IV ▷ Hokusai
Tawaraya ▷ Sōri
Tei ▷ Ichiga
Teiichi ▷ Ikku
Teikō ▷ Gakutei
Teisai ▷ E-Kin, Hokuba, Senchō
Teisuke ▷ Eisen
Teitei ▷ E-Kin
Teizō ▷ Ichiga
Tekiseikaku-shujin ▷ Hyokunen
Tengudō ▷ Hokusai
Tenjiku-rōnin ▷ Gennai
Tenseisai ▷ Ryūkoku
Terai ▷ Shigefusa
Terasawa ▷ Masatsugu
Tessai ▷ Nobukatsu, Shigenao
Tezuka ▷ Hokumei
Tōchōrō ▷ Sadafusa
Toenrō ▷ Taito II
Tōensai ▷ Kanshi
Togatsu ▷ Hokumei
Tōgensai ▷ Eishū
Tōhōnan ▷ Hokkai
Tōi ▷ E-Kin
Tōiku ▷ Kyōsai
Tōin ▷ Shinryū
Tojirō ▷ Toyohiro
Tōjuen ▷ Kunisada
Tōkaidō Utashige ▷ Hiroshige
Tōkinrō ▷ Hyakunen
Tokitomi ▷ Eishi
Tokki ▷ Kangetsu
Tōkōen ▷ Hokuei
Tokōrō ▷ Bokusen
Tokubei ▷ Hiroshige, Hiroshige III
Tokuchū ▷ Totsugen
Tokuemon ▷ Seitoku
Tokufū ▷ Kangyū
Tokujuō ▷ Yoshikage
Tokusaburō ▷ Toshinobu
Tokutarō ▷ Hiroshige
Tokuyūsai ▷ Suketada
Tomikawa ▷ Fusanobu
Tomioka ▷ Eisen
Tominobu ▷ Kunitomi
Tomo-no-ya ▷ Chitora
Tomotarō ▷ Chitora
Tōnansei ▷ Hokuun
Torakichi ▷ Hiroshige III
Torii ▷ Bunryūsai, Chinchō, Kiyochika, Kiyoharu, Kiyohiro, Kiyohisa, Kiyokuni, Kiyomasa, Kiyomasu, Kiyomasu II,

Kiyomine, Kiyomitsu, Kiyomoto, Kiyonaga, Kiyonobu, Kiyonobu II, Kiyosada, Kiyosato, Kiyoshige, Kiyotada, Kiyotada II, Kiyotada VII, Kiyotomo, Kiyotsune, Kiyoyoshi
Tōrin ▷ Hironobu
Toriyama ▷ Sekien
Tōryōsai ▷ Shunsen
Toryūō ▷ Sūkoku
Tosa ▷ Mitsuatsu, Mitsubumi, Mitsunari, Mitsunori, Mitsuoki, Mitsusada, Mitsusuke, Mitsuyoshi, Mitsuzane
Tōsai ▷ Baikan
Tōsendō ▷ Rifū
Tōshien ▷ Shunchō
Toshimitsu ▷ Shumman
Toshinobu ▷ Eibun, Eizan
Tōshirō ▷ Kuniteru, Shunsui
Toshiyuki ▷ Tomonobu
Tōshū ▷ Shōgetsu
Tōshūsai ▷ Sharaku
Tōsōō ▷ Isshū
Tōsuke ▷ Yoshiume
Tōtarō ▷ Yoshifuji
Toto-ya ▷ Hokkei
Tōuntei ▷ Kuninao
Tōyama ▷ Shunsendō
Toyoaki ▷ Utamaro
Toyofusa ▷ Sekien
Toyogawa ▷ Eishin
Toyohara ▷ Chikaharu, Chikanobu, Kunichika, Kuniteru
Toyohiko ▷ Toshihide
Toyokawa ▷ Hidekuni, Hokugan, Tamikuni, Umekuni, Yoshikuni
Toyokuni II ▷ Kunisada
Toyokuni III ▷ Kunisada II
Toyokuni IV ▷ Kunisada III
Toyonobu ▷ Kunihisa II
Toyoshige ▷ Kunimatsu, Toyokuni II
Toyosuke ▷ Keiga
Tsuchinochi Nisaburō ▷ Hokusai
Tsūjin-dōjin ▷ Setten, Munenobu
Tsukioka ▷ Keisai, Sekkei, Sessai, Yoshitoshi
Tsuneaki ▷ Shungyōsai
Tsunejirō ▷ Yoshitaki
Tsunekawa ▷ Shigenobu
Tsunemasa ▷ Setten
Tsuneshige ▷ Shungyōsai II
Tsurukichi ▷ Kunifusa
Tsutsumi ▷ Tōrin

Ueda ▷ Masanobu
Uehara ▷ Yoshitoyo
Ujisuke ▷ Utakuni
Ukiyo ▷ Shigekatsu, Utayosh
Ukiyoan ▷ Kuninao
Ukyō ▷ Sukenobu
Umekuni ▷ Shiken
Umesaku ▷ Kyōsui

Umon ▷ Takamasa
Undō ▷ Itchō
Ungeisai ▷ Hidenobu
Unkaku ▷ Taigaku
Unkei ▷ Nobuyuki
Unkintei ▷ Suetaka
Un-ō ▷ Matabei
Ushimaro ▷ Itchō
Ushōsai ▷ Shigenobu
Utagawa ▷ Fusatane, Hirokage, Hirosada, Hiroshige, Hiroshige II, Hiroshige III, Kagematsu, Kunifusa, Kunihiro, Kunihisa, Kunikage, Kunikazu, Kunikiyo, Kunikiyo II, Kunimaro, Kunimaru, Kunimasa, Kunimasu, Kunimatsu, Kunimitsu, Kunimori, Kunimori II, Kunimune, Kunimune II, Kuninaga, Kuninao, Kuninobu, Kunisada, Kunisada II, Kunisada III, Kunisato, Kunitada, Kuniteru, Kunitomi, Kunitora, Kunitoshi, Kunitsugu, Kunitsuna, Kunitsuru, Kuniyasu, Kuniyoshi, Kuniyuki, Masutsuru, Nobukatsu, Sadafusa, Sadahide, Sadahiro, Sadakage, Sadamaru, Sadamasu II, Sadatora, Sadayoshi, Shigemaru, Shigenao, Shunshō, Toyoharu, Toyohide, Toyohiro, Toyohisa, Toyokuni, Toyokuni II, Toyomaru, Toyonobu, Yasukiyo, Yasushige, Yoshifuji, Yoshifusa, Yoshiharu, Yoshihide, Yoshiiku, Yoshikage, Yoshikata, Yoshikatsu, Yoshikazu, Yoshimasu, Yoshimine, Yoshimune, Yoshinobu, Yoshishige, Yoshitaka, Yoshitaki, Yoshitora, Yoshitsugu, Yoshitsuna, Yoshitsuru, Yoshiyuki
Utamasa ▷ Bokusen, Gessai
Utamasa II ▷ Gessai II

Wakabayashi ▷ Chōei
Waō ▷ Itchō
Wasaburō ▷ Kunimasu
Watanabe ▷ Nobukazu

Yabairō ▷ Yoshiume
Yahan-o ▷ Buson
Yahantei ▷ Buson
Yaheiji ▷ Hōryū
Yamada ▷ Kuniteru II
Yamaguchi ▷ Shigeharu, Shigekatsu
Yamamoto ▷ Fujinobu, Shigenobu, Yoshinobu
Yamamura ▷ Baiju
Yanagawa ▷ Kuninao, Nobumasa, Nobusada, Shigenobu, Shigenobu II
Yamazaki ▷ Akera-Kankō, O-Ryū, Toshinobu
Yanagi ▷ Bunchō
Yasaburō ▷ Eishi, Isshū, Yoshinobu
Yashima ▷ Gakutei
Yashirō ▷ Kanenari, Kuninobu
Yasohachi ▷ Kunichika
Yasubei ▷ Shumman, Yoshimine

Yasuda ▷ Kisei
Yasugorō ▷ Kuniyasu
Yasuhara ▷ Yasuji
Yasuhide ▷ Shigeharu
Yasujirō ▷ Kuniyasu, Yasuji
Yasukawa ▷ Harusada
Yasunobu ▷ Hanzan
Yasuoki ▷ Gengendō
Yasuzō ▷ Kunikiyo
Yōgakusha ▷ Kuninobu
Yokoyama ▷ Kunimaro II
Yomishō ▷ Yumiaki
Yomo-no-Akara ▷ Shokusanjin
Yomo-sanjin ▷ Shokusanjin
Yonejirō ▷ Yoshitoshi, Yoshiyuki
Yonosuke ▷ Sadatora
Yōryūsai ▷ Kunihisa II
Yosaburō ▷ Shinryū
Yōsai ▷ Gakutei, Kiyoharu, Kunihisa II, Kuniteru II, Nobukazen
Yōsei ▷ Rankō
Yoshida ▷ Hambei
Yoshidawa ▷ Sadayoshi
Yoshihara ▷ Shinryū
Yoshiichi ▷ Yoshikimi
Yoshimaro ▷ Yoshikuni
Yoshimi ▷ Shūri
Yoshino ▷ Shigefusa II
Yoshinobu ▷ Eisen, Sūkei
Yoshirō ▷ Sūsetsu
Yoshitame ▷ Ikkei
Yoshitarō ▷ Kisei
Yoshū ▷ Chikanobu
Yōsui ▷ Yoshitaki
Yōtei ▷ Gakutei
Yu ▷ Yukinobu
Yūbundō ▷ Shunchō
Yūchiku ▷ Moronobu
Yūchikusai ▷ E-Kin
Yūji ▷ Shunshō
Yuki ▷ Yukinobu
Yūki ▷ Utamaro
Yukinobu ▷ Nobusada
Yūrakusai ▷ Nagahide
Yuryūdō ▷ Chōei
Yūsai ▷ Kuniteru
Yūsei ▷ Kyōden
Yūshidō ▷ Shunchō
Yushōan ▷ Ikkei
Yūsuke ▷ Shunshō, Sukenobu, Utamaro
Yūzei ▷ Morikuni

Zen ▷ Hokusai
Zenchinsai ▷ Masunobu
Zen-emon ▷ Kiyotada
Zenjirō ▷ Eisen
Zenkichi ▷ Aōdō Denzen
Zewasai ▷ Hokusai
Zenzaburō ▷ Yukimaro

Selected General Bibliography

For specialized monographs, see pertinent entries of the Dictionary. Items marked with an asterisk would constitute an essential reference library on ukiyo-e. This Bibliography is arranged chronologically.

Gonse, Louis. *Catalogue de l'Exposition rétrospective de l'art japonais.* Paris, 1883.

Douglas, Robert K. *Guide to the Chinese and Japanese Typographical and Illustrated Books Exhibited in the King's Library of the British Museum.* London, 1887.

Strange, Edward F. *Japanese Books and Albums of Prints in the National Art Library, South Kensington.* London, 1893.

*Tokuno, T. "Japanese Wood-Cutting and Wood-Cut Printing," from the *Report of the U.S. National Museum for 1892.* Washington, D. C., 1894.

Anderson, William. *Japanese Wood Engravings: Their History, Technique and Characteristics.* London, 1895.

Fenollosa, Ernest F. *The Masters of Ukiyo-e. A Complete Historical Description of Japanese Paintings and Color Prints of the Genre School as Shown in Exhibition at the Fine Arts Building.* New York, 1896.

Seidlitz, W. von. *Geschichte des japanischen Farbenholzschnittes.* Dresden, 1897 (also 1910, 1921, 1922, 1923, 1924, 1928); English trans.: *A History of Japanese Colour-Prints.* London, 1910; rev. ed. 1920; French trans.: *Les estampes japonaises.* Paris, 1911.

Fenollosa, Ernest F. *Catalogue of the Kobayashi Collection* (in Japanese). Tōkyō, 1898.

Duret, Théodore. *Livres et albums illustrés du Japon.* Paris, 1900.

Fenollosa, Ernest F. *An Outline of the History of Ukiyo-ye.* Tōkyō, 1901.

Netto, G. and G. Wagener. *Japanischer Humor.* Leipzig, 1901.

Perzynski, Friedrich. *Der japanische Farbenholzschnitt.* Berlin, n.d. [1903].

Strange, Edward F. *Japanese Colour Prints.* London, 1904 (rev. ed. 1908, 1910, 1913, 1923, 1931).

——————. *Japanese Illustration: A History of the Arts of Wood-Cutting and Colour Printing.* 2nd ed. London, 1904.

Gookin, Frederick William. *Catalogue of an Exhibition of Prints by Suzuki Harunobu.* Chicago, 1905.

Tajima, Shiichi (ed.). *Masterpieces Selected from the Ukiyo-e School.* 5 vols. Tōkyō, 1906–09.

Binyon, Laurence. *Painting in the Far East: An Introduction to the History of Pictorial Art in Asia. Especially China and Japan.* London, 1908.

Gookin, Frederick William. *Catalogue of a Loan Exhibition of Japanese Color Prints.* Chicago, 1908.

Morrison, Arthur. *Illustrated Catalogue of the Exhibition of Japanese Prints at the Fine Art Society.* London, 1909.

*Vignier, Charles, and H. Inada. *Estampes Japonaises exposées au Musée des Arts Décoratifs.* 6 vols. Paris, 1909–14.

Morrison, Arthur. *Illustrated Catalogue of the Exhibition of Japanese Prints at the Fine Art Society.* London, 1910.

Catalogue de cent peintures originales de l'ukiyo-e. Paris, n.d. [1911].

Hillditch, John. *The Graphic Arts of China and Japan.* London, 1911.

Kurth, Julius, *Der japanische Holzschnitt.* Munich, 1911 (rev. ed. 1922).

Morrison, Arthur. *The Painters of Japan.* 2 vols. London, 1911.

Fenollosa, Ernest F. *Epochs of Chinese and Japanese Art: An Outline History of East Asiatic Design.* 2 vols., New York and London, 1912. New and rev. ed. with copious notes by Prof. Petrucci, 1921. (Cf. corrections in the *Bulletin of the Museum of Fine Arts,* Boston, No. 25, October, 1927).

*Gookin, Frederick William. *Japanese Color-Prints and Their Designers.* New York, 1913.

Japanese Colour Prints Lent by R. Leicester Harmsworth, Esq., M.P. London, 1913.

*Aubert, Louis. *Les maîtres de l'estampe japonaise.* Paris, 1914.

Japanese Works of Art Selected from the Mosle Collection. 2 vols. Leipzig, 1914.

Lemoisne, P.-A. *L'estampe japonaise.* Paris, 1914.

*Ficke, Arthur. *Chats on Japanese Prints.* London and New York, 1915 (reprinted Tōkyō, 1958). (Japanese enlarged adaptation by N. Ochiai, Tōkyō, 1919).

Gookin, Frederick William. *Catalogue of a Memorial Exhibition of Japanese Color Prints from the Collection of Clarence Buckingham.* Chicago, 1915.

*Binyon, Laurence. *A Catalogue of Japanese and Chinese Woodcuts Preserved in the Sub-Department of Oriental Prints and Drawings in the British Museum.* London, 1916.

Catalogue of the Mitsukoshi Exhibition of Ukiyo-e Prints (in Japanese). Ōsaka, 1916.

Catalogue of the Mitsukoshi Exhibition of Ukiyo-e Paintings (in Japanese). Ōsaka, 1917.

Stewart, Basil. *On Collecting Japanese Colour-Prints. Being an Introduction to the Study and Collection of the Colour-Prints of the Ukiyo-e School of Japan.* London, 1917.

Album of Old Japanese Prints Reproduced from the Collection of Kenichi Kawaura. Tōkyō, 1918.

Watanabe, S. *Catalogue of the Memorial Exhibition of Hiroshige's Works on the 60th Anniversary of His Death.* Tōkyō, 1918.

*Stewart, Basil. *Subjects Portrayed in Japanese Prints: A Collector's Guide to all the Subjects Illustrated, Including an Exhaustive Account of the Chūshingura and Other Famous Plays. Together with a Causerie on the Japanese Theatre.* London and New York, 1922.

Kurth Julius. *Die Primitiven des Japanholzschnitts.* Dresden, 1922.

Bachhofer, Ludwig. *Die Kunst der japanischen Holzschnittmeister.* Munich, 1922.

Lœwenstein, Fritz E. *Die Handzeichnungen der japanischen Holzschnittmeister.* Planen im Vogtland, 1922.

*Binyon, Laurence, and J.J.O'Brien Sexton. *Japanese Colour-Prints.* London, 1923 (reprinted, New York, 1954). 2nd edition, Basil Gray, ed. London, 1960.

Ledoux, Louis V. *Exhibition of Japanese Figure Prints from Moronobu to Toyokuni.* New York, 1923.

Migeon, Gaston. *L'estampe japonaise*. 2 vols., Paris, 1923.

*Brown, Louise Norton. *Block Printing and Book Illustration in Japan*. London and New York, 1924.

Kurth, Julius. *Von Moronobu bis Hiroshige*. Berlin, 1924. English edition: *Masterpieces of Japanese Woodcuts from Moronobu to Hiroshige,* New York, 1925.

Ledoux, Louis V. *Exhibition of Japanese Landscape, Bird and Flower Prints and* Surimono *from Bunchō to Kyōsai*. New York, 1924.

*Rumpf, Fritz. *Meister des japanischen Farbenholzschnittes*. Berlin and Leipzig, 1924.

Victoria and Albert Museum. *Tools and Materials Illustrating the Japanese Method of Colour-Printing*. London 1924.

Winiwarter, H. de. *Kiyonaga et Choki, Illustrateurs de livres*. Paris, 1924.

Catalogue of Ukiyo-e Prints in the Collection of Mr. K. Matsukata. Ōsaka, 1925.

*Fujikake, Shizuya. *Ukiyo-e hanga seisui* (in Japanese). 3 vols., Kyōto, 1925.

Goto, Hakuzan. *Catalogue of an Exhibition at the Kyōto Museum of Paintings and Prints in European-Style Produced Prior to the Meiji Era* (in Japanese). Kyōto, 1925.

*Kurth, Julius. *Die Geschichte des japanischen Holzschnitts: I - Von den Anfängen bis Harunobu. II - Von Harunobu bis zur Eishi-Schule. III - Von der Sekien-Schule bis zu den Hiroshige.* 3 vols. Leipzig, 1925–29.

Inoue, Kazuo. *Catalogue of the Utamaro Memorial Exhibition* (in Japanese). Tōkyō, 1926.

Gookin, Frederick William *Descriptive Catalogue of Japanese Colour-Prints, the Collection of Alexander G. Mosle*. Leipzig, 1927.

Yoshida, Teruji. *Kabuki yakusha kaiga-shū* (in Japanese). Tōkyō, 1927.

Mihara, A.S. *Ukiyo-e hanga tenrankai mokuroku* (in Japanese). Tōkyō, 1930.

Ukiyo-e taisei (in Japanese). 12 vols., Tōkyō, 1930–31.

Yoshikawa, Kampō. *Takarabune* (in Japanese). Kyōto, 1930.

Horiguchi, Sozen. *Tōyō kodai-hanga-shū* (in Japanese). Tōkyō, 1931.

*Inoue, Kazuo. *Ukiyo-e-shi den* (in Japanese). Tōkyō, 1931.

*Toda, Kenji. *Descriptive Catalogue of Japanese and Chinese Illustrated Books in the Ryerson Library of the Art Institute of Chicago*. Chicago, 1931.

Ukiyo-e taika shūsei (in Japanese). 20 vols. Tōkyō, 1931–32 (Supplement, 6 vols., 1933).

*Ishii, Kendō. *Nishiki-e no kaiin no kōshō* (in Japanese). Tōkyō, rev. ed. 1932.

*Ikenaga, Hajime. *Hōsai-banka daihōkan: Ikenaga shushūhin mokuroku* 2 vols. Ōsaka, 1933. With English summary, *An Outline of Exotic Art of Japan,* trans. by Hogitarō Inada.

*Noguchi, Yone. *The Ukiyoye Primitives*. Tōkyō, 1933.

Catalogue of the Nakumura Collection of Hiroshige Prints (in Japanese). Tōkyō, 1934.

Clavery, Edouard. *L'art des estampes japonaises en couleurs*. Paris, 1935.

Fujikake, Shizuya. *Japanese Wood-Block Prints*. Tōkyō, 1938 (rev. ed. 1949, 1953, 1954, 1957, 1959).

Ledoux, Louis V. *An Essay on Japanese Prints*. New York, 1938.

Modderman, B. *Oude Japansche Prentkunst*. 'S-Gravenhage, 1938.

Yoshida, Hiroshi. *Japanese Wood-Block Printing*. Tōkyō, 1939.

*Iijima, Kyoshin. *Ukiyo-e-shi Utagawa retsuden* (in Japanese). Tōkyō, 1941.

Ledoux, Louis V. *Japanese Prints in the Occident*. Tōkyō, 1941.

*————. *Japanese Prints in the Ledoux Collection*. 5 vols. New York and Princeton, 1942–51.

*Fujikake, Shizuya. *Ukiyo-e no kenkyū* (in Japanese). 3 vols. Tōkyō, 1943.

Metzgar, Judson D. *Adventures in Japanese Prints*. Los Angeles, n.d. [1943].

*Narazaki, Muneshige, and Ichitarō Kondō. *Nihon fūkei-hanga shiron* (in Japanese). Tōkyō, 1943.

Boller, Willy. *Meister des japanischen Farbholzschnittes*. Bern, 1947. (English edition: *Masterpieces of the Japanese Color Woodcut*. Boston, 1957).

Priest, Alan. *Japanese Prints from the Henry L. Phillips Collection*. New York, 1947.

Schraubstadter, Carl. *Care and Repair of Japanese Prints*. Cornwall-on-Hudson, N.Y., 1948.

Wettergren, Erik. *Japanska Tränsnitt ur Martin Manssons Samling*. Stockholm, 1948.

Volker, T. *Ukiyo-e Quartet: Publisher, Designer, Engraver and Printer*. Leyden, 1949.

*Nakata, Katsunosuke. *Ehon no kenkyū* (in Japanese). Tōkyō, 1950.

Trotter, Massey. *Catalogue of the Work of Kitagawa Utamaro in the Collections of the New York Public Library*. Introduction by Harold G. Henderson. New York, 1950.

Blunt, Wilfrid. *Japanese Colour Prints from Harunobu to Utamaro*. London, 1952.

Rufy, Arthur W. *Japanese Colour-Prints*. London, 1952.

Hillier, J. *Japanese Masters of the Colour Print*. London, 1954. German trans.: *Die Meister des japanischen Farbendruckes*. Cologne, 1954. (Cf. our corrections in the *Far Eastern Quarterly,* reprinted in *Studies in Edo Literature and Art*).

*Michener, James A. *The Floating World: The Story of Japanese Prints*. New York, 1954. (Cf. our corrections in the *Harvard Journal of Asiatic Studies,* reprinted in *Studies in Edo Literature and Art*).

Österreichisches Museum für angewandte Kunst. *Japanische Holzschnitte*. Vienna, 1954.

*Gunsaulus, Helen C. *The Clarence Buckingham Collection of Japanese Prints: The Primitives*. Portland, Me., 1955. (Cf. our corrections in the *Harvard Journal of Asiatic Studies,* reprinted in *Studies in Edo Literature and Art*).

Masterpieces of Japanese Prints. An Exhibition at the Art Institute of Chicago. Foreword by James A. Michener. Notes by Margaret Gentles. Chicago, 1955.

Takahashi, Seiichiro. *The Evolution of Ukiyo-e: The Artistic, Economic and Social Significance of Japanese Woodblock Prints*. Yokohama, 1955.

Ukiyo-e zenshū (in Japanese). 6 vols., Tōkyō, 1956–58.

Catalogue of an Exhibition of Early Genre Paintings Held at the Tōkyō National Museum. Tōkyō, 1957.

Hempel, Rose. *Sammlung Theodor Scheiwe*. 2 vols., Münster, 1957–59.

Robinson, B.W. *Japanese Landscape Prints of the Nineteenth Century*. London, 1957.

Bjurström, Per. *Japanska Träsnitt*. Stockholm, 1958.

Catalogue of Hiroshige Exhibition. Catalogue by Heinz Brasch. Bern, 1958.

Kawakami, Sumio. *Hanga* (in Japanese). Tōkyō, 1958.

Narazaki, Muneshige. *Ukiyō-e kanshō* (in Japanese). Tōkyō, 1958.
Hájek, Lubor. *Der frühe japanische Holzschnitt.* Prague, 1959. (English edition: *Japanese Woodcuts: Early Periods.* London, n.d.).
──────. *Hirosada, Meister aus Kamigata.* Prague, 1959. (English edition: *The Ōsaka Woodcuts.* London, n.d., and New York, 1960).
Hibbett, Howard. *The Floating World in Japanese Fiction.* London and New York, 1959.
*Michener, James A., and Richard Lane. *Japanese Prints – from the Early Masters to the Modern.* Tōkyō, 1959. (German edition: *Japanische Holzschnitte,* Fribourg and Munich, 1961).
Stern, Harold P. *Figure Prints of Old Japan. Collection of Marjorie and Edwin Grabhorn.* San Francisco, 1959.

*Hillier, J. *The Japanese Print: A New Approach.* London and Tōkyō, 1960.
──────. *Landscape Prints of Old Japan: Collection of Marjorie and Edwin Grabhorn.* San Francisco, 1960.
Nihon hanga-bijutsu zenshū (in Japanese). 8 vols., Tōkyō, 1960–62.
Stern, Harold P. *Hokusai Paintings and Drawings in the Freer Gallery of Art.* Washington, D.C. 1960.
Suyama, Keiichi. *Nihon no giga* (in Japanese). Tōkyō, 1960.
Tamba, Tsuneo. *Hiroshige ichidai* (mainly in Japanese). Tōkyō, 1960.
*Tōkyō National Museum. *Illustrated Catalogues of the Tōkyō National Museum–Ukiyo-e Prints.* 3 vols., Tōkyō, 1960–63.

Exhibition of Prints by Kuniyoshi. Kunstmuseum Düsseldorf, 1961.
Narazaki, Muneshige. *Odaka uKiyo-e Shushū* (in Japanese). Tōkyō, 1961.
Sammlung Heinz Brasch. Kiel, 1961.

Exhibition of Prints by Kuniyoshi and Kunisada. Kunstmuseum Düsseldorf, 1962.
*Lane, Richard. *Masters of the Japanese Print.* London and New York, 1962. Also published in the following translations: *Japanische Holzschnitte,* Munich-Zurich, 1962; *L'estampe japonaise,* Paris, 1962; *Meesters der japanse Prentkunst,* The Hague, 1962; *Grafica giapponese,* Milan, 1962; *Maestros de la estampa japonese,* Mexico City, 1962.
Miyao, Shigeo. *Primitive Fan Prints in the Kaga Collection, Hibiya Public Library* (in Japanese). Tōkyō, 1962.
Ukiyo-e: "The Floating World." Collection of Marjorie and Edwin Grabhorn. San Francisco, 1962.

An Exhibition of Prints of the Taishō Era (1912–1926) by the Japan Ukiyo-e Society. Tōkyō, 1963.
An Exhibition of Masterpieces of Ukiyo-e by the Japan Ukiyo-e Society. Tōkyō, 1963.
Ausstellung in der Eigelsteintorburg—Kuniyoshi (1798–1861). Cologne, 1963.
Azechi, Umetarō. *Japanese Woodblock Prints: Their Technique and Appreciation.* English trans. by Charles A. Pomeroy. Tōkyō, 1963.
*Hempel, Rose. *Holzschnittkunst Japans.* Stuttgart, 1963.
Tamba, Tsuneo. *Ukiyo-e: Edo to Hakone* (in Japanese). Tōkyō, 1963.

Catalogue of International Exhibition of Ukiyo-e Masterpieces Depicting the Manners and Customs of Old Japan, Held at Shirokiya in Tōkyō on the Occasion of the Olympic Games. Tōkyō, 1964.
Catalogue of the Isetan Exhibition of Prints and Paintings by Kiyonaga (in Japanese). Tōkyō, 1964.
Exhibition of the Works of Utamaro and His Pupils by the Japan Ukiyo-e Society. Tōkyō, 1964.
*Gentles, Margaret. *Masters of the Japanese Print: Moronobu to Utamaro.* New York, 1964. (Cf. our review article "New Voices in Ukiyo-e" in *Ukiyo-e Art,* reprinted in *Studies in Edo Literature and Art*).
Ishida, Mosaku. *Japanese Buddhist Prints.* Adaptation by Charles S. Terry. Tōkyō, 1964.
Ouwehand, C. *Namazu-e and Their Themes.* Leyden, 1964.
*Waterhouse, D.B. *Harunobu and His Age: The Development of Colour Printing in Japan.* London, 1964. (Cf. corrections in "Floating-World Morals vs. Ukiyo-e Scholarship" in *Ukiyo-e Art,* reprinted in our review article *Studies in Edo Literature and Art*).

*Gentles, Margaret with Richard Lane and Kenji Toda. *The Clarence Buckingham Collection of Japanese Prints, Vol. II: Harunobu, Koryūsai, Shigemasa, Their Followers and Contemporaries.* Chicago, 1965.
*Takahashi, Seiichirō. *The Japanese Wood-block Prints Through Two Hundred and Fifty Years.* Tōkyō, 1965.

Dunn, C.J. *The Early Japanese Puppet Drama.* London, 1966.
Images du temps qui passe: peintures et estampes d'Ukiyo-e. An exhibition at the Musée des Arts Décoratifs, Paris, 1966. (Cf. our corrections in *Ukiyo-e Art,* reprinted in *Studies in Edo Literature and Art*).
Japanese Painters of the Floating World. Ithaca, N.Y., 1966. (Cf. our corrections in *Ukiyo-e Art,* reprinted in *Studies in Edo Literature and Art*).
Keene, D. *No: The Classical Theatre of Japan.* Tōkyō and New York, 1966.
Kondō, Ichitarō (with Charles Terry). *The Thirty-six Views of Mount Fuji by Hokusai.* Tōkyō and Honolulu, 1966.
Leach, Bernard. *Kenzan and His Tradition: The Lives and Times of Kōetsu Sōtatsu, Kōrin and Kenzan.* London, 1966.
McCullough, H.C. (trans.) *Gikeiki: A Fifteenth-century Japanese Chronicle.* Stanford, 1966.
Maeda, Isamu. *Kamigata engei jiten* (in Japanese). Tōkyō, 1966.
Mayuyama, Junkichi (ed.). *Japanese Art in the West.* Tōkyō, 1966.
Narazaki, Muneshige. *The Japanese Print: Its Evolution and Essence.* English adaptation by C.H. Mitchell. Tōkyō and Palo Alto, Cal., 1966.
Rakuchū-rakugai-zu (in Japanese). Tōkyō, 1966.
*Turk, F.A. *The Prints of Japan.* London and New York, 1966.
Yoshida, Teruji. "Shodai Toyokuni yakusha butai no sugata-e" in *Ukiyo-e.* No. 27 (Tōkyō, 1966).

Kawakita Michiaki. *Contemporary Japanese Prints* (trans. by John Bester). Tōkyō, 1967.
Keene, Donald. *Essays in Idleness (Tsurezure-gusa).* New York, 1967.

Ueda, Makoto. *Literary and Art Theories in Japan.* Ohio, 1967.
Miller, Roy. *The Japanese Language.* Chicago, 1967.
Miyagawa, Torao. *Modern Japanese Painting: An Art in Transition.* Adapted by Toshizō Imai. Tōkyō and Palo. Alto, Cal., 1967.
Ozaki, Shūdō. *Katsushika Hokusai* (in Japanese). Tōkyō, 1967.
Zolbrod, Leon. *Takizawa Bakin.* New York, 1967.

Dailey, Merlin C. and Mary Ann. *The Raymond A. Bidwell Collection of Prints by Utagawa Kuniyoshi, 1798–1861.* Springfield, Mass., 1968.
Furukawa, Miki. *Edo-jidai ō-zumō* (in Japanese). Tōkyō, 1968.
Hamada, Giichirō. *Edo senryū jiten* (in Japanese). Tōkyō, 1968.
Mc Cullough, Helen Craig. *Tales of Ise: Lyrical Episodes from Tenth-Century Japan.* Stanford, 1968.
Masterworks of Ukiyo-e. 11 vols. Tōkyō:
 Suzuki, Jūzō. *Sharaku.* 1968.
 Narazaki, Muneshige, and Kikuchi, Sadao. *Utamaro.* 1968.
 Narazaki, Muneshige. *Early Paintings.* 1968.
 Narazaki, Muneshige. *Hokusai.* 1968.
 Narazaki, Muneshige. *Hiroshige.* 1968.
 Suzuki, Jūzō, and Oka, Isaburō. *The Decadents.* 1969.
 Narazaki, Muneshige. *Kiyonaga.* 1969.
 Narazaki, Muneshige. *Hokusai: Sketches and Paintings.* 1969.
 Narazaki, Muneshige. *Hiroshige: The 53 Stations of the Tōkaidō.* 1969.
 Narazaki, Muneshige. *Studies in Nature: Hokusai-Hiroshige.* 1970.
 Takahashi, Sei-ichirō. *Harunobu.* 1968.
Michener, James A. *The Modern Japanese Print: An Appreciation.* Tōkyō, 1968.
Nakano, Eizō. *Edo higo jiten* (in Japanese). Ōsaka, 1968.
——————. *Immei goi* (in Japanese). Ōsaka, 1968.
——————. *Sei-fūzoku jiten* (in Japanese). Ōsaka, 1968.
Nihon rekishi daijiten (in Japanese) (rev. ed.). 12 vols. Tōkyō, 1968–70.
Pictorial Record of Kōbe City Museum of Namban Art. 5 vols., Kōbe, 1968–72.
*Kikuchi, Sadao. *A Treasury of Japanese Woodblock Prints.* New York, 1968.
Sorimachi, Shigeo. *Catalogue of Japanese Illustrated Books and Manuscripts in the Spencer Collection of the New York Public Library.* New York, 1968.
*Stern, H. P. *Master Prints of Japan.* New York, 1968.
Suzuki, Jūzō. *Sharaku.* Tōkyō, 1968.

Araki, James T. "Sharebon: Books for Men of Mode." In *Monumenta Nipponica,* XXIV, Nos. 1–2, 1969.
Cranston, Edwin. *The Izumi Shikibu Diary.* Cambridge, 1969.
Dunn, D. J. *Everyday Life in Traditional Japan.* London, 1969.
Goyō, Hashiguchi. "The Work of Hashiguchi Goyō." In *Ukiyo-e Art,* No. 23, 1969.
Kenrick, D. *The Book of Sumo.* New York, 1969.
Kikuchi, Sadao. *A Treasury of Japanese Woodblock Prints: Ukiyo-e* (trans. by Don Kenny). New York, 1969.
Piggott, J. *Japanese Mythology.* London, 1969.
*Shimada, Shūjirō. *Zaigai Hihō,* 3 vols., Tōkyō, 1969.

Allyn, J. *The Forty-seven Ronin Story.* Tōkyō, 1970.
Araki, James T. "The Dream Pillow in Edo Fiction, 1772–81." In *Monumenta Nipponica,* XXV, No. 1–2, 1970.
Grilli, E. *The Art of the Japanese Screen.* Tōkyō and New York, 1970.
Hillier, J. *The Harari Collection of Japanese Paintings and Drawings,* 2 vols., Boston, 1970.
——————. *Catalogue of the Japanese Paintings and Prints in the Collection of Mr. and Mrs. Richard P. Gale.* London, 1970.
Keene, Donald. *Twenty Plays of the Nō Theatre.* New York, 1970.
Longstreet, Stephen and Ethel. *Yoshiwara: City of the Senses.* New York, 1970.
Mills, D. E. *A Collection of Tales from Uji; A Study and Translation of* Uji shui monogatari. Cambridge, 1970.
Miyamori, Asatarō. *Anthology of Haiku Ancient and Modern.* 1970.
Schamoni, Wolfgang. *Die Sharebon Santô Kyôdens und ihre literaturgeschichtliche Stellung.* Dissertation. Bonn, 1970.
Scott, M. W. *Japan: Its History and Culture.* New York, 1970.
Segi, Shin-ichi. *Ukiyo-e-shi Sharaku* (in Japanese). Tōkyō, 1970.
*Hillier, J. *Suzuki Harunobu: An Exhibition of His Color-prints and Illustrated Books on the Occasion of the Bicentenary of His Death in 1770.* Philadelphia, 1970.
Takamizawa, Tadao. *Namban byōbu* (in Japanese). Tōkyō, 1970.
Yoshizawa, Chû and Muneshige Narazaki. *Nihon kaiga-kan* (in Japanese), 12 vols., Tōkyō, 1970.

Dolloff, F. W. and R. L. Perkinson. *How to Care for Works of Art on Paper.* Boston, 1971.
Higuchi, Hiroshi. *Nagasaki ukiyo-e.* Tōkyō, 1971.
Hisamatsu, Shin'ichi. *Zen and the Fine Arts* (trans. by Gishin Tokiwa). Tōkyō and Palo Alto, Cal., 1971.
Miyoshi, Ikkō. *Edo-go jiten* (in Japanese). Tōkyō, 1971.
Schamoni, Wolfgang, *et al. Yoshitoshi.* Cologne, Museum für Ostasiatische Kunst, 1971.
*Schmidt, Steffi. *Katalog der chinesischen und japanischen Holzschnitte im Museum für Ostasiatische Kunst Berlin.* Berlin, 1971.

Cahill, James. *Scholar Painters of Japan: The Nanga School.* New York, 1972.
Catalogue of the De Roos Collection of Japanese Illustrated Books. London, 1972.
Dawes, Leonard G. *Japanese Illustrated Books.* London, 1972.

Foreigners in Japan: Yokohama and Related Woodcuts in the Philadelphia Museum. Philadelphia, 1972.

Frederic, L. *Daily Life in Japan at the Time of the Samurai, 1185–1603.* Trans. from the French by E. M. Lowe. New York, 1972.

*Higuchi, H. *et al.* Ukiyo-e bunken mokuroku—ukiyo-e no ryūtsū, shushū, kenkyū, happyō no rekishi (in Japanese). 2 vols., Tōkyō, 1972.

*Mitchell, C.H. *The Illustrated Books of the Nanga, Maruyama, Shijō and Other Related Schools of Japan: A Biobibliography.* Los Angeles, 1972. (Cf. our notes in *Monumenta Nipponica,* reprinted in *Studies in Edo Literature and Art.*)

Okamoto, Yoshitomo. *The Namban Art of Japan.* New York and Tōkyō, 1972.

Chiba, Reiko. *The Making of a Japanese Print.* Tōkyō, 1972.

Takahashi, Sei-ichirō. *Traditional Woodblock Prints of Japan.* Trans. by Richard Stanley-Baker. New York, 1972.

*Crighton, R.A. *The Floating World of Japanese Popular Prints: 1700–1900.* London, 1973.

Harich-Schneider, E. *A History of Japanese Music.* 2 vols., London and New York, 1973.

*Keyes, R.S. and Keiko Mizushima. *The Theatrical World of Ōsaka Prints.* Philadelphia, 1973.

Okudaira, Hideo. *Narrative Picture Scrolls.* Adapted by Elizabeth ten Grotenhuis. New York and Tōkyō, 1973.

Rosenfield, John and Fumiko and Edwin Cranston. *The Courtly Tradition in Japanese Art and Literature.* Tōkyō, 1973.

*Stern, Harold. *Ukiyo-e Painting.* Washington, D.C., 1973.

Sullivan, Michael. *The Meeting of Eastern and Western Art from the Sixteenth Century to the Present Day.* London, 1973.

Tominaga, Makita. *Kirishitan-ban no kenkyū* (in Japanese). Tenri, 1973.

Verley, H.P. *Japanese Culture: A Short History.* New York, 1973.

Yamane, Yūzō. *Momoyama Genre Painting.* Trans. by John M. Shields. New York and Tōkyō, 1973.

Zaigai, Ihō. *Kitagawa Utamaro.* Tōkyō, 1973.

French, Calvin L. *Shiba Kokan: Artist, Innovator and Pioneer in the Westernization of Japan.* New York and Tōkyō, 1974.

Hillier, J. *The Uninhibited Brush: Japanese Art in the Shijō Style.* London, 1974.

Kenkyūsha's New Japanese-English Dictionary. 4th ed., Tōkyō, 1974.

*Yoshida, Teruji. *Ukiyo-e jiten* (in Japanese). 3 vols., Tōkyō, 1974.

Chibbett, D.G.; B.F. Hickman and S. Matsudaira. *A Descriptive Catalogue of the pre-1868 Japanese Books, Manuscripts and Prints in the Library of the School of Oriental and African Studies.* London, 1975.

Ukiyo-e taikei (in Japanese). 17 vols., Tōkyō, 1975–77. (Translated lists of plates also published London, 1977 and Cologne, 1978).

*Waterhouse, D. *Images of Eighteenth Century Japan.* Toronto, 1975.

Calza, G.C. *Le stampe del Mondo Fluttuante.* Milano, 1976.

*Hillier, J. *Japanese Prints & Drawings from the Vever Collection.* 3 vols., London, 1976.

Keyes, R.S. (ed.). *Eight Hundred Years of Japanese Printmaking.* Pittsburgh, 1976.

*Roberts, Laurence P. *A Dictionary of Japanese Artists.* Tōkyō and New York, 1976.

Seidensticker, E.G. *The Tale of Genji.* 2 vols., New York, 1976.

*Chibbett, D.G. *The History of Japanese Printing and Book-illustration.* Tōkyō and Palo Alto, Cal., 1977.

Illing, R. *Japanese Prints.* London, 1977.

Illing, R. *Later Japanese Prints,* London, 1978.

Kaempfer, H. (ed.). *Ukiyo-e Studies and Pleasures.* The Hague, 1978.

*Lane, Richard. Erotica Japonica: Masterworks of Shunga Painting. New York, 1978.

*——————. *Studies in Edo Literature and Art.* Tōkyō and Cologne, 1978.

*——————. *Studies in Ukiyo-e.* Tōkyō and Cologne, 1978.

Acknowledgments and Photo Credits

This book by its nature makes detailed reference to the writer's research in the ukiyo-e field over the past twenty-five years. He is grateful for permission to quote extensively from his previous works: *Kaigetsudō* (Tuttle, 1959), *Japanese Prints — from the Early Masters to the Modern* (with James A. Michener, Tuttle, 1959), *Masters of the Japanese Print* (Chanticleer Press/Doubleday, 1962), *Hokusai and Hiroshige* (Gabundō/Eike Moog/Marson, 1976–77), *Studies in Ukiyo-e* and *Studies in Edo Literature and Art* (Gabundō/Eike Moog, 1978), *Erotica Japonica: — Masterworks of Shunga Painting* (Elmsford Press, 1978), as well as from articles in the *Harvard Journal of Asiatic Studies, Monumenta Nipponica,* the *Encyclopaedia Britannica, Ukiyo-e Art* and *Ukiyo-e: A Journal of Floating-World Art.* Over the years, the author has benefited from the advice of his friends Jack Hillier and C. H. Mitchell, and to the latter he owes particular thanks for detailed suggestions on the main text. In addition, the comprehensiveness of the Hokusai sections of this book was made possible by a generous grant from The Japan Group of Philadelphia. The basic research of a decade or more ago that forms the background to this volume was enthusiastically supported by James A. Michener and the Honolulu Academy of Arts, while the active encouragement of the publisher, Office du Livre, made the final realization of this long-deferred project possible.

Grateful acknowledgement is due to the museums and collectors who have generously provided photographs for this book.

Institutions:

Art Institute of Chicago, Illinois: plates 35, 37, 43, 54, 60, 63, 73, 184;
 figures 10, 17, 20, 29, 32, 57, 59, 473, 486, 489, 504, 538, 562, 589, 594, 599, 640, 673
Atami Art Museum, Momoyama: plate 8
Beatty Library, Dublin: figure 559
Bibliothèque Nationale, Paris: figures 19, 24, 463, 597, 663
British Museum, London: plate 150; figures 5, 7, 13, 472, 491, 492, 554, 573, 574, 580, 593, 689
Cleveland Museum of Art, Ohio: figure 582
Honolulu Academy of Arts (Michener Collection), Hawaii: plates 14, 46, 51, 78, 82, 102, 125, 127, 131, 145, 160, 179, 182, 194B, 198; figures 6, 40, 43, 49, 51, 61, 342, 343, 349, 416, 418, 432, 452, 461, 462, 477, 480, 485, 494, 496, 497, 502, 515, 530, 535, 537, 539, 540, 543, 555, 560, 563, 565, 571, 581, 603, 607, 608, 609, 614, 618, 620, 626, 629, 635, 643, 646, 647, 659, 660, 661, 675, 694, 703, 704, 719, 723, 725
Ikeda Bunko, Ikedo: figures 450, 556
Kanagawa Prefectural Museum of Modern Art, Kamakura: figures 14, 23, 666–672, 728
Kyōto City Art Museum, Japan: plate 7
Kyōto University Library, Japan: figure 455
Metropolitan Museum of Art, New York: plates 31, 32, 58, 59, 66; figures 1, 359, 468, 591
Minneapolis Institute of Art (Gale Collection), Minnesota: plates 2, 124; figures 471, 488, 616
Musée Cinquantenaire, Brussels: plate 112
Musée Guimet, Paris: plates 71, 93, 94, 95, 97, 100, 105, 107, 110, 111, 117, 118, 120, 121, 122, 128, 129, 132, 138, 139, 142, 147, 149, 168, 172, 173, 183, 189, 191, 195; figures 33, 35, 44, 48, 348, 454, 508, 610, 684
Museum of Fine Arts, Boston: plates 9, 25, 52, 99
Museum für Ostasiatische Kunst, Cologne: plate 155
Nippon Tsūun Company, Japan: figure 557
Philadelphia Museum of Art, Pennsylvania: plate 45
Riccar Art Museum, Tōkyō: plates 38, 64, 75, 108, 109, 130, 134, 148, 157, 175; figures 36, 39, 47, 68, 201, 433, 511, 531, 548, 577, 586, 600, 648, 649, 676, 688, 734
Seikadō Bunko, Tōkyō: plate 4
Staatsbibliothek Preussischer Kulturbesitz, Berlin: figures 579, 598, 632
Tōkyō National Museum, Japan: plates 24, 27, 33, 48, 49, 50, 55, 56, 57, 61, 62, 68, 70, 77, 84, 91, 92, 104, 119, 148, 151, 153, 159, 161, 163, 164; figures 18, 31, 64, 356, 414, 415, 424, 458, 469, 490, 500, 534, 542, 567, 578, 590, 595, 596, 615, 631, 637,

641, 652, 656, 662, 683, 684, 686, 687, 691, 692, 697, 706, 708, 710, 711, 713, 714,
715, 718
Tokugawa Art Museum, Nagoya: plate 5
Tōyama Kinenkan, Japan: Figure 453
Ukiyo-e Library, Kamakura: figures 357, 621
Victoria and Albert Museum, London: figures 345, 619
William Rockhill Nelson Gallery of Art—Atkins Museum of Fine Arts, Kansas City,
 Missouri: figure 587
Worcester Art Museum, Massachusetts: figures 358, 487, 576
Yamato Bunkakan Museum, Nara: plate 6; figure 15

Private Collections:

Aoki Collection, Tōkyō: plate 69
Berès Collection, Paris: figures 575, 584
Caplan Collection, Tōkyō: plates 47, 115, 116, 135, 137, 169, 170, 178, 180, 181, 185A,
 190; figures 351, 467, 516, 680
Fukutomi Collection, Tōkyō: plate 113; figures 415, 499, 501, 735
Grabhorn Collection, San Francisco: figure 644
Hara Collection, Tōkyō: plate 10
Hillier Collection, Surrey: figure 606
Ii Collection, Hikone: plate 11
Mizuta Collection, Tōkyō: plate 140
Riese Collection, Geneva: figure 583
Sakai Collection, Tōkyō: figures 25, 199, 204, 205, 207, 337, 346, 350, 353, 365, 426,
 439, 466, 483, 484, 507, 512, 518, 521, 522, 622, 625, 630, 664, 682
Scheiwe Collection, Münster: plate 74
Schwartzenberger Collection, Tōkyō: plate 199
Shibui Collection, Tōkyō: plates 18, 20
Shinjō Collection, Ōsaka: plates 166, 167, 185B, 186
Takahashi Collection Tōkyō: figures 125, 125a, 329–334, 352, 438, 440, 460, 476, 548,
 592, 628, 653, 677, 709, 716, 717, 722
Tsuihiji Collection, Tōkyō: figure 16
Uchiyama Collection, Zushi: plates 177, 188; figures 69, 129
Uragami Collection, Tōkyō: plates 136, 156, 158, 162, 176, 200; figures 34, 56
Vergez Collection, Tōkyō: figures 11, 27, 532, 732

The remaining plates and figures are from anonymous collections in Japan.

Index

This index is limited to the main text and captions and does not duplicate the Dictionary entries. Consult also the index of ukiyo-e artists' alternate names at the end of the Dictionary.